DELINQUENT ELEMENTALS

Delinquent Elementals: A Pagan News Anthology
Edited by Phil Hine and Rodney Orpheus

FIRST PUBLISHED BY Strange Attractor Press in 2025, in an unlimited paperback edition and a hardback edition of 300 copies.

Cover artwork and new illustrations by Krent Able.

Layout by Stephen Thrower & Mark Pilkington.

ISBN: 978-1-907222-9-31

DISTRIBUTED BY The MIT Press, Cambridge, Massachusetts. And London, England.

PRINTED AND BOUND IN Estonia by Tallinna Raamatutrükikoda.

STRANGE ATTRACTOR PRESS
BM SAP, London, WC1N 3XX UK,
www.strangeattractor.co.uk

DELINQUENT ELEMENTALS

EDITED BY
PHIL HINE & RODNEY ORPHEUS

With new illustrations by
KRENT ABLE

MALCONTENTS

APPENDICES

HEAL THE EARTH

On the Summer Solstice (Sunday June 21) between Mid-day and 2pm there will be a mass raising of energy aimed at increasing Ecological Awareness. The power of directed and focused energy raised by meditation, chanting, dancing, music, prayer, ritual, or any kind of celebration will help to raise awareness of our Global Ecological crisis, and so promote change, in accordance with our visions THE ACE OF CUPS IS THE SYMBOL CHOSEN TO HELP EACH PERSON OR GROUP INVOLVED TO FOCUS THEIR THOUGHTS _ TO JOIN THE FLOW OF ENERGY.

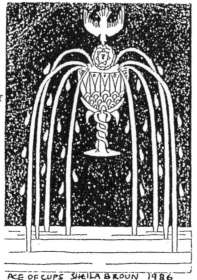

ACE OF CUPS SHEILA BROWN 1986

The Ace of Cups Symbolises the power of Love. Creativity, and nurturing Growth

"Under Heaven nothing is more soft and yielding than water, Yet for attacking the Solid and Strong, nothing is better. It has no equal "

LAO-TZU TAO TE CHING

Please help this endeavour by adding your power to the flow Thoughts are like water- a few drops may pass unnoticed, but enough drops flowing together become a River In celebration at the Solstice, we can let our energies flow together to become a great wave of power, aimed and focused This will help raise awareness, and so promote the changes neccesary to our survival

"Live your Beliefs and act. knowing that what you can do will make a difference. This will turn the World around "
 Thoreau

Please help by Displaying, Passing on, Or Copying this Leaflet — thanks

Introduction

The UK in the 1980s. Four television channels. A pint of beer for under a pound. Mass unemployment. The AIDS panic. Riots. IRA bombings. Margaret Thatcher as Prime Minister. It was a turbulent time, from the Falklands War in 1982, the Miners' Strike of 1984, to the Poll Tax riots at the decade's end. It saw the arrival of new technologies: the Sony Walkman, Compact Discs, Personal Computers, and the first incarnation of the Internet. The political stabilities that had dominated British life since the end of the Second World War were replaced by an assertion of individualism and the breaking of the power of the trade unions: the miners in 1984-5, and the print workers at Wapping in 1986. National industries were privatised.

Amidst these convulsions, the 1980s also saw the flowering of a new wave of lifestyles and resistances to mainstream culture: Punk; Raves; the so-called New Age Travellers; the Greenham Common Women's Peace Camp. Intertwined with those movements was a new generation of Pagans, witches, and occult practitioners, no longer content to lurk in the cracks and shadows of society, but increasingly publicly visible. As the decade progressed, Pagan and occult practitioners were increasingly open, and to an extent, given far more sympathetic treatments in the media than had been the case in the 1970s. In part this was due to a rise in interest in both feminist spirituality and ecological awareness. It was also helped by the popularity of "Psychic Fairs" across the country. Psychic Fairs were often held at hotels or conference centres; they were an eclectic mix of spiritualist mediums, Tarot readers, booksellers, and anything else that fell into the wide category of "the New Age". It was not unusual, at some of the larger events, to find a stall being run by Scientologists whilst in another part of the venue, a prominent witchcraft practitioner would be giving an introduction to practical spellcraft. These events were often attended by local Pagans and occultists, as informal points of contact.

By the mid-80s, Pagans had begun to organise themselves in new ways. PaganLink – a grassroots, loosely organised network, with the aim of bringing Pagans in the UK together, began to organise social gatherings ("Pagan moots") and other events across the country. Its founders, amongst which the late Rich

EARTH EMPOWERMENT

On 20th March 1992, between 10pm - Midnight, PaganLink Network is coordinating a mass raising of energy for the intention of *Earth Empowerment*. We wish to empower enthusiasm for Networking - to link hands across the Earth, so that by our shared vision, which is embracing the spirit of the Earth, we can bring about *change*. Power may be raised through meditation, dancing, chanting, prayer, ritual or celebration. Choose your favourite way of raising energy and join in!

Visualise the Networking symbol spinning deosil, and when your energy-raising 'peaks', send it spinning outwards, casting forth rays of fire flying out to link up with other people, irrespective of belief, creed, or colour - that we can join together, despite our differences, and find unity in our hearts. Feel the symbol empowering the Earth and connecting us together.

The Networking Symbol chosen denotes Fire - the fire of enthusiasm, motivation, and energy to promote action.

20th March
10pm-Midnight
Mars in Aquarius
Mercury in Aries.

Live your beliefs and act. Knowing that what you do will make a difference. This will turn the world around.

Please help by Photocopying, displaying or passing on this poster.

PaganLink Symbol designed by Chrys Livings. A Pagan News/PaganLink collaboration, 1992.
Thanks to Chaos International for scanning/typesetting assistance

Westwood was one of the most vocal, began to assert that to identify as Pagan was in itself a political act. This was something new. In previous decades, many Pagan and occult practitioners held themselves aloof from political activism, viewing it as mundane, or at worst, a sign of being on the "left-hand path". PaganLink activists advocated not only an ecological sensibility (such as recycling or tidying up local green spaces) but also the idea that magic could be utilised to effect collective changes in society. They began to organise "mass rituals" aimed at encouraging the public adoption of Pagan values and ethics. Moreover, they encouraged participants to communicate with each other by creating 'zines.

The 1980s saw a veritable explosion of Pagan and occult 'zines and small presses, and they became the premier means by which esoteric practitioners communicated with each other, exchanged ideas and, not infrequently, argued. Many 'zines were dedicated to one or another Pagan or esoteric tradition, featuring opinion pieces and essays. The 'zines that emerged from PaganLink activists were less insular. Instead, they offered local news, advertised social events and conferences, and commented on public activities of local interest. Often mimeographed, handwritten, or run out on dot-matrix printers, these free zines became a vital link in keeping readers abreast of events and news across the UK.

In 1987, Phil was a regional coordinator for PaganLink in Yorkshire – a rather grand title that in actuality meant that he was willing to act as a contact point for people who wanted to meet up. He helped organise local social gatherings and workshops, and together, we began to produce *Northern PaganLink News* – a free 'zine that publicised events, workshops, and news from around Yorkshire. This was the first incarnation of what would later become *Pagan News*. We had an Atari ST computer and a high-end Laser printer. We relied on the generosity of friends with access to photocopiers to circulate the 'zine.

Then along came the 'Satanic Panic'. Now read on.

Hello and welcome to the first issue of **Northern PaganLink News** - the Regional Newsletter for the National **PaganLink** Network.

The aim of the Newsletter is to present a broad spectrum of news and events of interest to members of PaganLink around the region. This includes a roundup of news, events, local issues, meetings, courses and services provided by **PaganLink** members.

This first issue is something of an experiment to see how things work out. Comments and Feedback are very welcome, also some info for the next issue please! We chose this format so that we can keep the costs down and (given enough input) bring the Newsletter out on a monthly basis. Hopefully, as **PaganLink** continues to grow, so will the range and scope of this Newsletter.

The content of the Newsletter is totally dependant upon what <u>you</u>, the reader, send in, in the way of information about what's going on in <u>your</u> area, that you think other members of PaganLink would like to hear about. News of courses, workshops, meetings or current projects - in fact <u>anything</u> you think might be of interest to other members of PaganLink, plus any particular gripes or great ideas you have about the Network.

NORTHERN PAGANLINK NEWS
NORTHERN PAGANLINK NEWS IS THE NEWSLETTER OF THE NATIONAL NETWORK: PAGANLINK.
 EDITORIAL ADDRESS
 MATRIX
 BOX 175
 52 CALL LANE
 LEEDS
 LS1 6DT

Pagan News – The Backstory

Rodney: Why Leeds?

I was born in Northern Ireland, and got interested in occultism in my teenage
years. Back then there was no easy way to get magical books and supplies,
but somehow I got to hear about this weird store in Leeds in England which
did mail order, called **The Sorcerer's Apprentice**. In 1980-something
(my memory is hazy on exactly when), I packed up everything I owned into
a rucksack and decided to hitchhike to England to make a new life for myself.
The only address I had in England was that store, so one cold Saturday morning
I ended up in Burley Lodge Road in Leeds 6 inside an imposing end-terrace
house completely covered in black, surrounded by strange occult paraphernalia
and even stranger occult people. The store had a small tea shop in an annex,
so I sat down there, had a hot cup of tea, and introduced myself to the people
around me. Several hours of fascinating conversation later, myself and my new
companions were kicked out at closing time. I was asked where I was headed to,
and I replied that I had no idea. "Come stay at our place mate, you can sleep on
the couch, it's just around the corner." That's how I ended up at 4 Ashville Avenue
in Headingley, Leeds, in a large Victorian house full of people doing magick – a
house where I would live for the next several years.

That morning in the tea shop I had also met another young man named Ken
Cox, who was just starting at Leeds University. We got together in a pub one
evening and hit upon the idea of starting Leeds University Occult Society, to take
advantage of the university Students' Union facilities to hold meetings.

Also on my very first day in Leeds I had befriended a beautiful young girl
called Linda who was working at the S.A., and who later introduced me to the
owner, Chris Bray. I immediately asked him for a job, and to my astonishment he
said yes. I turned up on my first day to be shown a derelict room upstairs at the
back of the store, which was full of trash up to waist level. "Here's a shovel," said
Chris, "There's a skip outside, you should have this room cleared later today, then
we'll start moving stuff into it." I just stood there in astonishment. This wasn't
what I was expecting *at all*.

"What's the problem?" asked Chris.

"Well, there's no way I can clear all this up in a day by myself!" I replied.

"Of course you can," says Chris. "Look, I'll help you get started, but I expect
you to work as hard as I do. Is that clear?"

I needed the money, so I nodded dumbly. And then Chris Bray attacked that trash like a bat out of hell. I tried hard to keep up. I would continue to try to keep up for the next 6 months, because the man worked like a demon. Every evening I would come home from work utterly exhausted and collapse on the couch. A couple of times my housemate Laurie (a big burly Scottish art student) would have to literally carry me upstairs and lay me on my bed, since I was too tired to climb the stairs.

I recite this story because it emphasises something about Leeds occultism that pervaded everything we did: we were *hard*. We worked hard, and played hard. That was part of the Leeds way of doing things. We were Northern hard men, not Southern softies. We thought nothing of trekking up into the wild moors on a cold, wet, dreary night to invoke some bizarre eldritch forces. Whatever it took to get the job done.

Working at the S.A. brought me into contact with everyone on the local occult scene. The wise old man of the area was Richard Bartle, aka The Magus of Dewsbury, who produced a ground-breaking Tarot deck called *The Sexual Tarot* and also claimed to have caught the notorious serial killer The Yorkshire Ripper (and I actually do believe he may have).

I also got to know two gentlemen called Ray Sherwin and Pete Carroll, who lived in a house in the countryside just outside Leeds and produced a magazine called *The New Equinox* which republished hard-to-find Aleister Crowley works, and writings by an almost-unknown artist called Austin Osman Spare. The S.A. would go on to publish several books by them, including *The Book of Results* and *The Theatre of Magick* by Ray, and the absolutely seminal *Liber Null* by Pete.

Liber Null hit the scene like a meteor crashing into the dinosaurs. It threw away all of the traditional rulebooks of ceremonial magic and witchcraft in favour of a minimalist, praxis-oriented system that encouraged everyone to *just do it*. Heavily influenced by the works of Spare (and indirectly Crowley, though that influence was well-hidden), *Liber Null* became the workbook of the new generation of people coming into magick via the S.A. and the Leeds University Occult Society. Much of the material that ended up in Pete Carroll's second work *Psychonaut* was beta tested by that first crop of us kids who grabbed the concepts expressed in *Liber Null* with both hands and ran with it.

I also became friends with a guy called P.D. Brown who was heavily involved in this new chaos magick movement (for so it would become named). He came up with a concept for a guided meditation/ritual based on a science fiction setting of some of these basic chaos magick concepts and he asked me to record him narrating it and to design some sounds that would play in the background. At the time I had a studio full of old second-hand analog synths and a 4-track tape recorder, so I took that challenge and together we created a fairly ground-

breaking cassette + book artifact called *The Chaochamber* which was sold by The
Sorcerer's Apprentice (of course). It was around this time I moved to Methley
Terrace in Leeds, and where one day Phil would turn up out of the blue looking
for me...

Phil: **From PaganLink to** *Pagan News*

I was born in Blackpool, Lancashire, and stayed there until 1978 when I left
for the bright lights of Huddersfield to pursue a degree in the Behavioural
Sciences (Psychology, Philosophy, and Sociology) at Huddersfield
Polytechnic (now the University of Huddersfield).

I first met Rodney shortly after I became involved with *PaganLink Network*. I
was one of a small group of occultists & Pagans who were coordinating a mass
ritual event – *Heal the Earth*. The basic idea of a mass ritual is to encourage
participants in different localities to perform a ritual or magical action (dancing,
drumming, perhaps simply meditating) at a particular day and time, focusing
their awareness and directing their intentionality on a common symbol. For *Heal
the Earth*, we had chosen the Summer Solstice 1987, between 12 and 2pm, the
stated aim of which was to raise public awareness of the global ecological crisis.

An important aspect of this project was to get as many local Pagans & occultists
participating as possible. So I was doing a good deal of running around Leeds &
Bradford talking to individuals and groups. One night a friend, Colin Millard,
took me over to visit Rodney, then living in Methley Terrace. Rodney was very
enthusiastic about the *Heal the Earth* project, and that's when our friendship
began. I had encountered him previously – he'd been at a lecture (my first ever
public lecture in fact) I gave on the subject of Kundalini at Leeds University
Occult Society in 1986. Rodney had disagreed with some part of the lecture (I
forget what exactly) but we hadn't really talked properly.

After the *Heal the Earth* project had run its course, I became interested in
setting up a *PaganLink* Newsletter. PaganLink emerged in the mid-1980s as a
loose network with the aims of making Pagan and magical ideas available to
those who were seeking, to promote cooperation between the various "paths"
and to actively campaign in support of Pagan issues.

There is some disagreement as to who was initially responsible for
PaganLink's founding, but the key players were Shan Jehan, Alawn Tickhill,
and Rich Westwood. Rich Westwood, from his shop **Prince Elric's** in Selly Oak,
Birmingham, edited with his wife Kate a Pagan magazine, *Moonshine* (and later,
Earthwise); and released a number of booklets such as *Awakening the Dragon:
Practical Paganism, Political Ritual and Active Ecology*. *Awakening the Dragon*

– with its thoughts on Pagan ethical living, networking, community building, urban shamanism, envisioning possible futures and suggested formats for "mass ritual" – was both ground-breaking and inspiring at a time when the majority of Pagan or occult texts (and groups) seemed to hold themselves aloof from the wider culture and from political activism.

A leaflet distributed by Rich Westwood and Alawn Tickhill described PaganLink Network in the following way:

> The Network has been set up in response to many requests we have had from all over the country to try and put isolated Pagans, Wiccans and other folk interested in the "occult" in general, alternative self-help, personal development and "Green" politics in contact with each other. Indeed, despite its name, the network exists to put in touch with each other people of all denominations who are interested in personal and planetary growth and development.

> The network will generate new avenues of communication, tuition, contact, development and mutual benefit – and will act both nationally and at a local level in every area of Britain. Our intent is to open this up to such a level that we can all potentially help each other even at a prosaic level – for instance, Networking in your area could mean giving your business to a Pagan craftsperson, such as having a Pagan electrician rewire your house, rather than a "normal" one. It could also mean like minded people discovering that they have lived in the same town for years unknown to each other, then being able to set up a group to their mutual benefit. It could also mean us being able to put you in touch with a local coordinator, a Pagan person prepared to offer guidance and advice, run workshops, coordinate group rituals at festivals, It could mean you finding a group, coven, teacher for you to train with: NETWORKING WILL MEAN WHATEVER YOU HAVE THE WILL TO MAKE IT.

Rich was a friendly and passionate man who strongly believed that to declare oneself to be a Pagan was a political act, and that part of that political sensibility was local and regional community-building through networking. One of the ways in which this was done was that various people agreed to act as "regional coordinators" – a fancy title for someone who was willing to give their address out, and help other local Pagans get in contact with each other, and to get active in some way – facilitating meetings, open rituals, networking with allied organisations. Whatever seemed appropriate, and to let other people in the area know what was going on. I became "regional coordinator" for West Yorkshire, and one of my first actions was to revive the Leeds Pagan Moot. There had been

a regular Pagan Moot in Leeds in the 1970s, but by the mid-1980s it had become defunct. Many of the small Pagan moots which regularly meet up and down the UK now owe their existence to PaganLink. The growth of PaganLink led to a proliferation of small, regional 'zines such as *The Pagan Prattle* or *The Manic Magpie* which featured events listings, local news (and gossip!), and PaganLink-related news. Whereas existing Pagan and occult 'zines tended to concentrate on the minutiae of practice and philosophy, this new generation of 'zines were more outwardly-directed, focused on what was happening in their local area.

The mid-1980s was both a turbulent, and an exciting time to be involved in Pagan activism. Fuelled by anger at the deprivation brought about by Margaret Thatcher's Conservative government, the closure of Stonehenge Free Festival in 1985 and the suppression of the Peace Convoy (where over 1,200 police attacked 600 New Age Travellers – leading to possibly the largest mass arrest in English history), there was a definite sense that alternative lifestyles were under threat. This was coupled with a growing awareness of the necessity for social and ecological activism, influenced, to a degree, by the work of Starhawk and Margot Adler's book, *Drawing Down the Moon*. Rich Westwood expressed this emerging sensibility in *Awakening the Dragon*:

> By declaring ourselves Pagan, we have stepped out of the mainstream of society, and to a certain extent put ourselves on the line both materially and spiritually... We maybe need to take the lead from such as "Pagans Against Nukes" or "Pagan Animal Rights" or from the Political Paganism described in Starhawk's *Dreaming the Dark*. Or are we content to be spare bedroom witches? ... We have to take our internal knowings and manifest them. We cannot sit on the fence. For soon they will replace it with razor wire and it won't be so comfortable then.

Pagans Against Nukes, founded in 1980, had already forged links with the protesters at Greenham Common and members had conducted magical rituals to support actions there. Some PaganLink activists had been at Greenham Common, but many Pagans in the UK at the time were wary of feminism and Goddess spirituality just as they were of ceremonial magicians or "occultists".

At the same time, awareness of Paganism was growing in British popular culture, through television shows such as Richard Carpenter's *Robin of Sherwood* (1984-1986) and the appearance of Pagan themes in comics such as *2000AD*. The growth of "Psychic Fairs" across the UK gave Pagans a space in which they could meet and share experiences, and PaganLink activists organised small regional events and conferences – the largest of which was the PaganLink "National Conference' held at Leicester University in 1988.

Attempting to "organise" Pagans past a certain point is very much akin to herding cats. There were many different factions and ideas being floated around concerning the future development of the network, especially after Rich Westwood announced he was stepping down as national coordinator. Many projects were launched by different caucuses within and allied to PaganLink – such as the "Pagan Manifesto" – which attempted to define a set of core values for Pagans; the Pagan Council of Elders; and HOBLink, the UK's first LGBTQ Pagan network. There were frequent tensions expressed over what constituted "proper" Paganism. For some of the more traditionally-minded Pagans, the New Age Travellers, for example, were not considered "proper" Pagans, and the same people were wary of networking with more *outré* groups such as the Temple of Psychick Youth or adherents of chaos magick. For many others though, being a Pagan was a matter of self-identification. You were a Pagan if you said you were a Pagan, regardless of what path you professed to follow.

My recollection of how Rodney and I started is that one – or perhaps both – of us did a magical working (a ritual) to "acquire" equipment for publishing. The first thing that "resulted" from this was an ancient photocopier. It was huge, had more moving parts than a car, and we never did manage to get it working. It was left in the lobby of 179 Belle Vue Road, where I was living at the time, until it was finally disposed of. The next occurrence however, was more useful. It was a pal of Rodney's who had "acquired" an Apple Postscript Laser Printer. Serious kit. Rodney managed to persuade this guy to let him keep it, with the understanding that he could get it working – and whenever the guy needed any typesetting doing, Rodney would do it. With a bit of effort, we managed to find the correct drivers to get the Laser Printer "talking" to the Atari ST computer that Rodney used to record music with. But at first it would only work as an emulated basic daisywheel printer, and this is what I used to run out the first issue of *Northern PaganLink News*. My recollection is that both Rodney & I worked on the content together – or at the very least discussed it. By that time, I was involved in the production of *Chaos International*, and through that, was able to use some artwork by the Liverpool artist, David Grimbleby[1] – who later provided the cover art for my three chapbooks on Urban Shamanism – *Walking Between the Worlds, Two Worlds & InBetween*, and *Touched by Fire*.

The first issue of *Northern PaganLink News (NPLN)* was produced in March 1988. It was four pages long and we did 25 copies and gave them out free at the local moots. Shortly after this first effort, we sat down with a great pile of Pagan zines and thrashed out our aims and editorial policy.

1 https://www.davidgrimbleby.co.uk/index.html

Rodney: How We Designed *Pagan News* – The *PN* Blueprint

Back in the 70s and 80s the Internet was still in its infancy, mainly inhabited by a few thousand university computer scientists. There were no social media systems or websites, so subcultures communicated largely by means of underground magazines and fanzines. The occult/Pagan world was no different. There were hundreds of tiny magazines in circulation, usually with amateur production values and fairly low quality content. Nonetheless they sometimes had a great deal of innocent charm, and they did provide some useful information, albeit frequently buried underneath a lot of junk.

When we decided to start *Pagan News* we were clear that we wanted to do something completely different than these magazines. We sat down and made a list of all the things we hated about small Pagan press, and pretty much inverted every single one of them to create the blueprint for *Pagan News*. This *modus operandi* was entirely planned and structured, right from the beginning.

News is Only News When It's New

Other Pagan magazines claimed to be giving people the news. But news is only news when it's *new*. In general, amateur magazines would come out whenever the publisher had enough content and enough cash to print them. This might be every 2-3 months, or it might be 6 months, or it might be a year. The one thing they all had in common was that you never knew when the next issue was coming.

If your magazine only comes out every 6-9 months, your news is dead before you even print it. If our publication was going to be called *Pagan News*, then it had to hit the market when that news was still relevant and hot. That meant no 6-month gap between publications.

It also implied that we needed to come out on a regular schedule, in order to ensure we *stayed* relevant. We decided that *Pagan News* would come out monthly – each and every month, come what may. That way people would always know and expect it to be there, and each new edition would become a topic of conversation about issues that were alive and mattered. It – very importantly – meant that we could produce calls to action so that people could actually *do* things in response to important issues while those issues were still happening.

It would also form the basis of our (gulp!) marketing/advertising strategy, as we could say to occult shops that they could depend on customers coming in regularly to get their monthly hit of *Pagan News*, so it was worth showing their support by advertising with us.

No Art, No Poetry

Pagan magazines almost all shared a common house style. Covers usually had a line drawing of some Tolkienesque hippy woman in a diaphanous dress riding a unicorn across Stonehenge with some runes around it. And inside there would always be at least a page of overblown word salad about Nature Goddesses under the heading of "Pagan poetry". We came from a generation of post-hippy punk rock and we *hated* that shit with a passion. That was clearly **out**.

But that begged the question of what were we going to put on the cover instead? The answer became kind of obvious when we looked back at point 1: newspapers don't have covers, they have *headlines*. We would dispense with covers completely and just hit the reader with the news right there on the front page.

We Weren't a Magazine, We Were a Newspaper

That led to point 3. What we were doing wasn't creating another, slightly better magazine. We were creating the first Pagan *newspaper*. As soon as we realised that, a lot of other stuff fell into place.

We established a production schedule on a 3-stage turnaround basis. One issue on the streets, one in production, and several future issues in various stages of planning. We put up a whiteboard in our office in the attic of Methley Terrace in Leeds and kept a tight track of everything we were doing and wanted to do. Although we were making a tiny little amateur publication, we worked it like we were pros.

Publishing is Expensive

We were living on tiny amounts of money earned from part-time jobs and/or from government welfare assistance. And printing cost money, especially in the amounts we wanted to produce. We didn't want to be printing 50 copies and selling only half of those, like most of the other Pagan publications. We wanted to have thousands of copies of each issue in circulation. So that meant page space was valuable. Artwork might be nice to have, but if it filled more than ¼ of a page it was taking up space that we needed for real information. We replaced it with small thumbnail style graphics, often repurposed free clip art.

At first we actually managed to keep *Pagan News* completely free, since it was a tiny 4 page publication. But then our friend Barry Hairbrush showed us the first pages of a satirical novella he had written called *The Computer Rides Out* and we instantly knew we had to serialise it. That meant we would have to add more pages, and that meant charging money. We still wanted to keep the price

really low though, in order to make sure that the magazine would be a must-buy. But how could we do that and still keep our heads above water? We didn't really expect to get a wage, but we needed money to pay for the computer tech we required, and that level of tech wasn't cheap back then!

We decided to do what *real* magazines did, and sell advertising. Now bear in mind we had zero idea of *how* to actually sell advertising, but we knew a bunch of people owning little occult businesses across the country, so we just went to them and said "Hey, please give us some money and we will make sure that thousands of qualified potential customers will know about your business." And this being well before the Age of Google, that turned out to be a pretty sweet proposition. Of course, the occult scene being a bunch of hippy Pagans used to everything being totally amateurish, many people thought we were completely crazy to expect any of that to happen. But some small businesses leapt at the chance and kept us going month after month – and we brought them good trade in return.

Tight Editing

One thing that many previous Pagan magazines all had in common was a bad combination of uncritical reverence for their subject matter (no matter how ludicrous it might be) and a lack of professional editorial control. Articles would frequently ramble on for pages and pages when the message could have been transmitted in a few sentences. There was also a shocking lack of editorial rigour – no citations, and no fact-checking. All sorts of ridiculous assumptions and assertions would pass without the magazines' editors bothering to verify them.

That wasn't going to fly at *Pagan News*. We determined that we would edit tightly. If you were a contributor you were going to have your writing cut by our editorial team – sometimes really, really, *really* cut. If we thought you were waffling but made some good points we would take out the waffle and just leave in the good stuff. Some of our authors were horrified by this at first, but it made everybody's work come across as really professional and well-written and kept the house style of *Pagan News* intense, sharp-edged, and to the point.

People Like People

We knew some great people who were struggling to become writers and we wanted people to like them as much as we did. So we established regular features for our best writers and made sure they got good bylines: Barry Hairbrush's cartoons and humour quickly made him an essential part of the whole *PN* experience, and other up-and-coming authors like Stephen Mace, Julian Vayne etc. got monthly columns.

The first regular columns we created were *Viewpoint* – an opinion-based slot for anyone to write about a particular subject close to their hearts, *Third Eye*, which examined media and special topics, and *Things to Do … And Things to Read*, initially a single column for introducing simple, practical magical exercises and rituals, with some follow-up reading. These initial features were soon joined by *Spotlight* – a two-pages plus slot for either special editorial features or interviews, *She Speaks* – a Women's Spirituality column, and a *Reviews* section for books, events, music, and anything else we thought was relevant. Initially we reviewed stuff we had bought ourselves and thought worth talking about (either positively or negatively), but as *Pagan News* became established we began to receive new books from publishers such as The Aquarian Press, Element Books, and small presses such as Temple Press. Where possible, we handed out books to friends who had interests or expertise in a particular subject, with the understanding that they could keep what they reviewed. Items which nobody wanted were sold to a nearby second-hand bookshop, although on one occasion the owner delicately queried how it was we kept turning up with newly-published books for sale – he thought we were stealing them!

Bitchcraft

We were accused of perpetrating Bitchcraft more than witchcraft, and we were completely on board with that. Right from the start we took an aggressively snarky, irreverent tone, influenced by British humour magazines like *Viz* and the computer periodicals that were starting to be released by the fledgling Future Publishing. We wanted to make a newspaper that would be fun to read, regardless of your particular interest in Pagan and occult themes.

Most importantly, many of the Christian Satanic Panic people we were writing about *needed* attacking, and attacking hard. We needed to show that they weren't afraid of these people. So we went for the jugular with them every time.

And also there was so much nonsense talked within Pagan circles, we felt that the scene needed someone to come along and slaughter some sacred cows. Not because we disliked the Pagan scene – quite the contrary, we thought it had potentially great value – but it needed the crap kicking out of it. Which we proceeded to do on a regular monthly basis.

Phil: **Making It All Work**

S hortly after we'd decided on this format I pawned a gold pocket watch I had – I was that poor – and bought a copy of *Timeworks DTP*. This was a cut-down Atari-compatible clone of *Ventura Publisher*, one of the first desktop publishing applications available for the IBM PC. It came on two 3.5" disks, and didn't need a hard drive to run, and had Apple postscript printer drivers. This was my first exposure to desktop publishing, and stood me in good stead later when I began to use more "professional" DTP applications such as *Pagemaker* or *Quark Xpress*. We also received a small "grant" (I forget how much) from Rich Westwood on behalf of PaganLink, to help us get up and running.

Coincidentally, just as we were setting up, came the first rumbles of what would be later called the UK's "Satanic Panic", which was to become a major theme in our reporting.

By June of that year, *Northern PaganLink News* had expanded to six pages, and we were experimenting with various methods of increasing the circulation. On one memorable occasion, the guy that ran the photocopier at Leeds Polytechnic Students' Union allowed us into the office, and "looked the other way" whilst we ran off as many copies as we could. We ran off sets of master sheets and posted them out to various friends and allies for them to photocopy too.

In September 1988, we took the momentous decision to drop the "Northern" and the "Link" from the title of the newsletter (as the distribution was wider than the North of England by now and the focus had enlarged from just doing PaganLink-related material) and *Pagan News*—"the monthly newspaper of Magick and the Occult" came into being, with a price tag of 30p for 8-12 pages. The printing was done by AGIT Press of Leeds, which was run by members of the band Chumbawamba.[2] Some PaganLink activists were aghast that we said we hoped to make a "profit" (eventually).

We were helped enormously by a number of volunteers who helped us distribute *Pagan News* to local shops up and down the country; by the few occult-oriented businesses that paid us to carry their adverts (our main source of income) and by the various columnists who agreed to write for us.

Pagan News' editorial aim was to be as eclectic as possible. We published articles on any aspect of the occult/Pagan spectrum as long as it met our editorial guidelines for particular sections, which had maximum word counts and set out our approach to editing. Our ethos was that Paganism could encompass a wide range of beliefs and we frequently expressed it in terms of the Vulcan philosophy of "Infinite Diversity in Infinite Combination" – we were both serious *Star Trek*

2 Yes, those people who did the "I get knocked down, but I get up again" song.

fans, and Rodney even ran a weekly *Star Trek* Role-Playing Game night, which featured several of our regular contributors as players. Occasionally we drew flak from readers for taking humorous digs at various sacred cows or for publishing "Left-Hand Path" material.

In December 1988 we were helped enormously by Caroline Wise. Caroline, then working at *Skoob Two* bookshop in Holborn, London, wrote us a letter saying she couldn't be bothered processing the invoices we were sending to Skoob for small amounts of money, and why didn't we just invoice her for a year's worth of *Pagan News* orders? Caroline's offer gave us a much-needed cash boost, but then of course we realised that we'd just committed ourselves to another year's worth of issues!

Over the next year or so, we refined the format of *Pagan News*, designing simple headers for the various regular columns and standardising the format – news, followed by events & meetings listings, more regular features, humour, reviews, and a short editorial comment beside the classified ads on the back page. In January '89 we started a new feature – *The British Directory of Occult Groups* (B-DOG) and invited various esoteric groups then active in the UK to send in a brief outline of their history, perspectives, and membership requirements. Other new feature columns included Stephen Mace's *Letter from America* (the *Letter from* column was eventually expanded to cover other parts of the world), *All-In Vayne,* for columnist Julian Vayne to comment on whatever took his fancy, *Skywatcher* – a column on esoteric astrology written by Anthony Roe, and *Crafty Talk* – a witchcraft-oriented feature penned by Mike Howard, editor of the long-running Wiccan 'zine, *The Cauldron.*

Flying Solo

By 1990 Rodney was more or less permanently living in Germany, as a result of his band taking off in Europe. Janet Cliff & I carried on *Pagan News*, with Janet helping with editorial planning and curries, whilst I took care of everything else – production, distribution, etc. But not long afterwards, the person who had loaned us the Apple Laserwriter printer took it back and I lost the use of it. This was a major setback – without a laser printer, there could be no *Pagan News*. I sent a letter to subscribers and advertisers informing them that due to these problems, there would be a delay in production.

Another problem is that by this time, the popularity of the Atari ST as a personal computer in the UK was beginning to wane, and it was harder to find support services that catered for it. Eventually, I found a small business in Nottingham – the *ST Club* – which could take Atari-formatted disks and run out hard copy from them to a laser printer.

I also found a new printing company. AGIT Press, who had printed both *NPLN* and *Pagan News*, were restricted insofar as they could only produce double-sided A4 sheets – which we then had to staple manually. This new printer – *Northern Arts Publishing* (based just outside Sheffield) could do A3 printing on recycled paper. But given the difficulties of using a laser-printing bureau in Nottingham and a Sheffield-based printing company, it meant that *Pagan News* could no longer keep to a monthly schedule. 1990 saw only six issues produced, rather than the usual twelve.

In October 1990, *ST Format*, a magazine catering for users of the Atari ST, ran a feature on desktop publishing, and invited 'zine editors using Atari computers to submit their productions for a competition, offering a prize for the best 'zine. I sent some copies of *Pagan News* in, and in December learned that *Pagan News* had won first prize! The runner-up was a 'zine for trainee Anglican priests.

By the beginning of 1991, it was clear that *Pagan News* had to "officially" become a bi-monthly publication. After the Jan/Feb issue, I was joined by Elizia Volkmann, a Leeds-based artist and writer, as co-editor, for the next two issues. I also changed the format, moving *Pagan News* to more of a magazine look – with front cover artwork. I also shifted to yet another new print company – New World Images, run by Gareth Hewitson-May (author of *Dark Doorway of the Beast*). I only managed to get three issues out however, the last of these, May/ June 91, being severely delayed. I sent a letter out to all and sundry, saying that due to my present circumstances, I was unable to continue to produce *Pagan News*.

In July 1991 I received a letter from Vivianne Crowley of the Pagan Federation. She expressed her sympathies regarding the demise of *Pagan News* and made me an interesting offer. For the past twenty years or so, the Pagan Federation's magazine had been titled *The Wiccan* – as the PF was a predominantly Wicca-oriented organisation. As the organisation had changed, with so many of their members following paths other than Wicca, they were considering a name change, and offered to "buy" the name *Pagan News* from me for £100. They also offered to honour any outstanding *PN* subscriptions, my own page in the new magazine, and full membership of the Pagan Federation! This was a good offer – and an accolade of sorts – but I politely turned it down. I wanted to keep *Pagan News* alive, although I wasn't sure how that could be done.

London Calling

In late 1991 I moved to London, and quickly became involved in London's busy alternative and occult scenes. Caroline Wise and her then partner, the late Steve Wilson, generously gave me some money with which to restart *Pagan News*, and

The Atlantis Bookshop held a relaunch party in February 1992. This would be the last incarnation of *Pagan News*. In theory, I had by this time a large editorial team to help me – friends I already knew or who I had met through the London occult scene. But gathering everyone together for editorial & planning meetings proved to be much harder than when it was just myself and one other person, as most of the other people involved had multiple commitments on their time. Also by this time, I was working full-time at The Atlantis Bookshop. Although my living situation had changed enormously and for the better, I found it harder and harder to keep to the schedule I had set for producing *Pagan News* – which is why the last two issues were numbered, rather than dated. Also, changing the format was a mistake – it had become too unmanageable. I did (briefly) add new features to the existing format – *Ecognosis* – a column on ecological issues written by Andrew Clifton, and *Wicca's World* (a replacement for Crafty Talk) written by Nigel Bourne and Seldiy Bate. There were occasional frustrating IT problems too. All combined to make me realise that my heart just wasn't in it any more. *Pagan News* didn't really end, it just stopped there.

How We Did This Book

So here it is in all its glory – the Best of *Pagan News* from its 5-year run. This book doesn't cover everything, but it contains roughly half of what we originally published. If we had published the whole damn thing this book would have become even more ridiculously hefty than it already is, so we went back to our original editorial ways and started cutting. In some cases this wasn't too difficult a choice: some of the original news material was a bit parochial and unimportant in the greater scheme of things, so no longer seemed at all relevant even as a historical document. Some of the articles (a very small minority) hadn't been that great originally, and the passage of time showed their flaws even more glaringly, so they got cut too. Most of the reviews felt really out-of-date, so those we have cut as well. Our *Letters* pages often featured warring sides arguing with each other (frequently egged on by us, it must be admitted) and were always fun as hell at the time, but a lot of what was written then just comes over as vaguely sad and embarrassing today, so most of those got cut too (a lesson to all of us on social media these days we suppose). We did keep a couple of the best examples of each of these so you can get a flavour of them and the environment we inhabited.

The rest of the material we kept, and much of it still reads surprisingly well and feels highly relevant. After a lot of messing around with layout and chapter themes, we ended up simply deciding to keep everything in chronological order

BRITISH DIRECTORY OF OCCULT GROUPS

CENSORED!

B-DOG

VIEW POINT

THINGS TO DO...

...AND THINGS TO READ

A regular series on Practical Magick

Original *Pagan News* header clipart

so you can read it as a history of the period, as well as being able to see how the magazine developed and evolved over time.

In the original issues of *Pagan News* we often didn't have room to cite our sources properly and expand on some of the themes we were dealing with. With this book we've been able to take the time to repair this omission, and you'll find *copious* footnotes on just about every page, not only containing citations, but also providing historical context on many of the topics dealt with in news items and articles. However, since we find most academic footnotes really really *boring*, we've also tried to ensure that the footnotes are humorous and engaging as well, so they should be well worth reading. We hope so, since they ended up being about ¼ of the book!

So now get comfortable in your chair, grab a nice mug of your favourite hot beverage, and come with us on a trip back to the occult world we inhabited in 1988...

PAGAN NEWS

NORTHERN PAGANLINK NEWS

The free monthly newsletter of the national PaganLink network

May '88 issue

BURN THE WITCHES!

Following the item in the last issue concerning pagans being obstructed by Christian Fundamentalists, we received word of a group of pagans in the South of England being persecuted by a small but vociferous group of Christians. They had whipped up a hysterical situation which had become so bad that the pagans at the centre of it were being refused service in local shops, abused in the street by other residents, and had their property defaced by the fundamentalists. Understandably, the people at the centre of this felt very scared and upset. We all know that people are still persecuted because their beliefs are different to others, but until it's our turn to be on the receiving end, it's hard to realise how shocking it is!

The pagans who were the targets of all the hysteria generated by the bigots sought advice and support from people in the North, and within a couple of days, a mass-ritual/meditation to "give support and energy" to them was organised. A few of the PaganLink coordinators acted promptly, asking local pagans to "link up" to direct energy towards the Southern group upon a specific day and time. A few days after this, the group sent a letter to say how they felt much better after receiving the "boost" from this working, and that some other residents are becoming more friendly to them. They would like to thank everyone who helped them in this way, and point out that incidents of this nature show very well how PaganLink can be effective: that "no one ever need feel isolated from their kin again".

The lesson here is clear - that whilst we feel isolated and split up into factions, cut off from each other by dogma and elitism, it is easy for us to be attacked by groups of bigots who, whilst they are small and by no means representative of *all* Christians, can play upon people's fears and media-images (All pagans are Satanists etc.) so that a hysterical reaction is created. Cries of "Burn the Witch/Jew/Darkie" are never far from some people's lips (see Third Eye this issue). Sooner or later the Inquisition will come to *your* town, and by then it could be too late for us to pull together. Pagans and occultists seem to expend a great deal of energy slagging each other off in various journals. But if this energy could be turned towards pulling together, if only to prevent ourselves being cut down one by one, wouldn't that be more effective? Unless of course you delight in seeing people have their lives destroyed just because they have a different approach to paganism that you do? It's not merely a case of "us versus them", but a whole way of thinking which is the problem. We need to not only support each other, but also act to educate society at large - to counter the popular images upheld about pagans, before we find ourselves the subject of a new governmental clause - banning pagan publications, meetings, etc. So if you have any ideas or suggestions, write and tell us about them, but don't wait for someone else to do it for you!

In this issue:

GEOFFREY DICKENS - WITCHFINDER GENERAL

Coming soon to a coven near you!

May 1988

NEWS

Mary Gets a Job?

The recent reports that Mary Whitehouse[1] is being considered for a post on the BBC Board of Governors[2] will have sent a tremor through the hearts and minds of freethinking occultists everywhere.

Lest there be one or two misguided souls out there who might seriously believe that her censorship campaign is a good thing, may I point out that this is the person who believes that all pop music is inherently evil and should be banned, since it leads young people to masturbation; who wants to see a return to "decent Christian values"; and no doubt would not be exactly happy about the magazine you are now holding in your hands either.

If Whitehouse does become a Governor of the Beeb, we can expect to see the end of any sympathetic programmes about the occult on both BBC television channels, on all the local and national BBC radio services, and probably on ITV and Channel 4 as well, due to the knock-on effect of such a person becoming officially recognised.

Spanish Voodoo Housewives in AIDS Panic![3]

Housewives in Spain are becoming bored with the traditional pastimes of reading tea-leaves and newspaper horoscopes, and are moving into Voodoo sorcery for recreation. One of the fastest growing industries is reported to be that of the Shamanic Priestesses, who are making a mint out of selling love potions to ageing glamour girls to make them more attractive to the husbands of other women, while also selling impotence potions to the wives of unfaithful

1 Mary Whitehouse (1910 – 2001) was a hardline Christian conservative media critic who vociferously opposed depictions of homosexuality, sexual permissiveness, and documentary footage of war being shown on television, ostensibly to "protect the children". Ironically her campaign gave an award for moral uprightness in broadcasting to Jimmy Savile, who was later notoriously found to be a paedophile.

2 The Board of Governors was at that time the governing body of the British Broadcasting Corporation. It consisted of twelve people who together regulated the BBC and represented the interests of the public. It existed from 1927 until it was replaced by the BBC Trust on 1 January 2007.

3 Although it was first identified as early as 1981, it wasn't until several years later that most people understood the full extent of how HIV functioned and was transmitted. In 1987 a British AIDS victim who had died of the disease was entombed in concrete at a cemetery in North Yorkshire as a precaution "in case we ever opened up the coffin again," according to a spokesman for the county's health department. See https://www.salon.com/2011/06/05/aids_hysteria/

husbands. One philandering husband was recently admitted to hospital suffering the effects of such a potion administered to him by his wife; when the potion was analysed it was found to consist mainly of arsenic – well, that would certainly make him impotent for sure.

The Spanish Church and various right-wing bodies are now calling for the banning of witchcraft completely – among the reasons given is that witchcraft is responsible for AIDS. The argument is that witchcraft leads people away from the Christian faith; the Christian faith teaches people morality; a lapse in morals leads to promiscuity; promiscuous sex helps to spread AIDS; therefore witchcraft causes AIDS. Despite the fact that this logic has holes in it that Ian Botham[4] could walk an elephant through, it is apparently becoming widely accepted in Spain. It couldn't happen here, right?

What the Dickens?

Wrong! It is happening here. On April 14th Conservative MP Geoffrey Dickens[5] stood up in the House of Commons and called for an emergency debate on the dangers of witchcraft. Mr. Dickens stated that witchcraft was "sweeping the country",[6] and made the astonishing claim that the increase in child abuse in this country was mainly caused by witches! He said that it was well-known that many child-abusers took part in "witchcraft initiation ceremonies", and suggested that witchcraft should be totally banned by the government. (Save our children from Satan!)

This whole speech is so blatantly untrue that it almost confounds belief. Mr. Dickens has got his facts wrong in two ways. First the assumption that child abuse is on the increase in this country is probably way off the mark. The incidence of reported sexual abuse has increased dramatically over the last few years, but this doesn't mean that the abuse itself is on the increase, it simply means that it is now easier to report these things than it was in the past. It is no exaggeration to say

4 Ian Botham (1955 –) is widely considered one of the greatest all-round cricket players of all time. He was famously suspended for 63 days in 1986 by the England and Wales Cricket Board after publicly admitting that he had smoked cannabis. American readers may wish to substitute a baseball metaphor instead of our classically British cricket-based reference.

5 Geoffrey Dickens (1931 – 1995) was a London-born Conservative MP based in the North of England who campaigned for the return of hanging, the re-criminalising of homosexuality, and the banning of teddy bears. His wife famously found out he was having an extra-marital affair only after he held a press conference to announce it. He rapidly became a favourite subject of many articles in *Pagan News*, as will be seen in succeeding pages of this book.

6 This is our first mention of what would become the defining factor in the life of *Pagan News* and our work over the next five years: the Satanic Ritual Abuse myth. At this stage we still had no idea of the scope of what was happening and just how huge this insanity would grow. It wouldn't take long for this to change.

that sexual abuse occurred (and still occurs) in nearly every street in this country – approximately one in ten women in the UK are estimated to have suffered some form of sexual abuse as a child.[7]

Second, Mr. Dickens' contention that witches practice child abuse. We know of only one recorded case of child abuse in connection with occult practices, and this took place in California in the late 1960s (the so-called Solar Lodge of the O.T.O. – no connection with any organisation of the same name currently in existence).[8] What is a fact, is that in an FBI report on mass murderers and multiple sexual killers in 1986, it was found that over 80% of those studied were born-again Christians, and the most common job occupation among them was that of Sunday school teacher! No mention of this from Mr. Dickens, or indeed in any of the other reports on sexual abuse ordered by the government. Banning Christianity would be too inconvenient, no doubt – all those dissatisfied voters to consider, after all.

I must confess that I find it strange that no-one has called for an investigation into the incidence of Christian clergymen cavorting with choirboys – surely a much greater source of child abuse cases for Her Majesty's courts to deal with;[9] perhaps that too might be a little inconvenient for a government dedicated to a "return to Victorian values". All we can be sure of is that a "return to Victorian values" will mean a return to sweeping the evils of sexual abuse under the carpet yet again, with Pagans acting as the scapegoats of the "New Morality".

STOP PRESS – Dickens now calling for return of the Witchcraft Act![10] debate expected in Parliament sometime this month! Aaaargh! More news next issue.

7 At the time of writing, the most recent figures from the UK Office of National Statistics Crime Survey for England and Wales (CSEW) estimate that 7.5% of adults aged 18 to 74 years experienced sexual abuse before the age of 16 years (3.1 million people); this includes both adult and child perpetrators.https://www.ons.gov.uk/peoplepopulationandcommunity/crimeandjustice/articles/childsexualabuseinenglandandwales/yearendingmarch2019

8 The Solar Lodge existed from 1965 to 1972 in California with a syllabus loosely based on the work of Aleister Crowley's A∴A∴ magical order. The notorious "boy in a box" case where a child of one of the members was found chained up in a small hut, and for which one of the leaders received a probationary sentence, now seems to have been significantly exaggerated in some reports. In any case, no sexual abuse was ever alleged or found to have occurred.

9 At the time this news item was written the huge scale of child sexual abuse being perpetrated by Christian clergy was unknown and rarely spoken about publicly (if at all); although both *PN* editors were aware of multiple anecdotal accounts from our own acquaintances. This was our first statement of what would become a running theme in *PN* – that the Satanic Panic was being used as a cover story to conceal the real scope of what was going on inside Christianity itself. The true enormity of what was actually going on is only now beginning to emerge. https://religionmediacentre.org.uk/factsheets/sex-abuse-in-christian-churches-in-the-uk/

10 The Witchcraft Act was passed in the UK in 1735 and made it a crime to claim that any human being had magical powers or was guilty of practising witchcraft. The maximum penalty set out by the Act was a year's imprisonment. It was not repealed until 1951.

THIRD EYE

The Education Bill

Rodney Orpheus

The government's new Education Bill recently received its first reading in the House of Lords, where it was the subject of less than heated debate. However, an amendment to the Bill was made, with the agreement of all three (four?) of the major parties, adding the provision for compulsory "enforceable" religious education in all schools. Although some cosmetic attempt was made by the more left-wing Lords to ensure that "minority" religious belief was catered for, this new amendment is a grave setback for Pagans, and indeed for all non-Christians. School religious education teachers are often Christians of one shade or another, and/or woefully ignorant of any non-mainstream belief. In practice, a great deal of prejudice is applied in choosing Religious Education teachers, and the chances of a known Pagan getting a post as an R.E. teacher are slim at best.

This all adds up to a situation where all children must, by law, attend classes where they have little chance of being taught anything about Paganism, or more likely, where they will be taught the "facts" about the Devil-worshipping, child-beating, virgin-rapers that we know all Pagans to be. The terrible example of Northern Ireland, where one group of children are taught compulsory Protestantism in school, and another group are taught compulsory Catholicism in other schools just down the road, should have been enough to stop this amendment in its tracks, but I'm afraid that it's too late to do much about it now.

Pagan parents are advised to make their views known at their children's schools, and make sure that their children are not being taught the usual crap in R.E. I know that many Pagans will shy away from wanting to make their beliefs public in this manner, but as yet we have no other plan of action. Anyone with any ideas or other information, please let us know at the editorial address.

We leave you with the words of Henry Fielding,[11] actually quoted during the education debate in the House of Lords: *"When I say religion, I mean of course the Christian religion; and when I say the Christian religion, I mean of course the Protestant religion; and when I say the Protestant religion, I mean of course the Church of England."*

Need I say more?

11 Henry Fielding (1707 – 1754), satirist, magistrate, founder of London's first police force, and the man who more or less invented the English novel.

VIEW POINT

"Older Than The Stars and Younger Than The Moon"

an anecdotal essay by *Colin Millard*[12]

Whilst the ink flows from this pen, I hold in my left hand a piece of rock which was probably first formed over three thousand million years ago. Its age is almost as staggering as its beauty and the combined effect of both is sufficient to make you keel over at the knees. Three thousand million years is a long time and the thought of it engulfs me in a sense of wonder. Magick, I believe, is the healthiest consequence of having a strong sense of wonder.

When I was a fresh child in the world, green and content in my ignorance, it occurred to me that something strange happens to people when they get old – they die. This occurrence puzzled me greatly at the time, but as a child I was guarded by the notion of having a possible seventy years lifespan. At that time seventy years seemed like an eternity and death seemed a very faint and distant threat. But now having experienced the years tick carelessly and rapidly by, I have realised that death, far from being a distant threat, looms around every corner.

But to return to the days when I was first being bamboozled and bewildered by the occurrence of death. At that time I developed a friendship with a person who had an amazing facility to make his eyeballs dance around in an unusual,

12 Colin Millard has the notable distinction of being the person who introduced Phil and Rodney to each other all the way back in 1987 (see introductory article in this book). He is now a medical anthropologist working with traditional Tibetan medicine among many other wonderful things.

erratic and crazy manner. On being asked how he did this, he demanded of someone that they move their arm – which they did. He then asked them to explain how they did it – which they couldn't. This little episode has stuck with me ever since and probably will be with me for the rest of my living days. Evidently, it would seem, at the core of all human action is a mysterious inconceivable element known as "the will". The combined mysteries of the power of the will and the apparent oblivion of death make the human lot a very strange one indeed.

As a child these sort of ideas did not bother me because adults always seemed to have an answer for everything. Even if an answer wasn't forthcoming I was led to believe, as did the adults themselves, that science could explain everything, it just needed time, that's all. This led me to believe that wisdom was something that comes with age. Now, so to speak, I have entered into the adult world and sadly it would seem that although most people act with the authority of people who know what they are doing. However this is only a veneer, their world has no real substance to it. It is possible to occasionally come across a truly wise person but they are few and far between. Of course there is a kind of wisdom that comes from being battered about by life, but that is the wisdom of becoming hardened to life and being able to easily adjust to

a new set of bad conditions. It is not the wisdom of understanding life. The wisdom of understanding life can only come about by taking everything into consideration. To this extent present day science fails in that such things as the power of the human will, death, the infinite and other things which are not so immediately apparent do not have any place in its formulas.

The problem is that in many societies this type of scientific outlook has become the prevailing worldview. This conditions people's behaviour. For example, let us take the business man whose sole ambition in life is to own many businesses and accumulate vast wealth. After having accomplished this he dies of a chronic heart-attack only to find he has achieved nothing of real worth. It could be argued that this fellow was the victim of his own ignorance of the finer qualities of life. Fair enough, we are all ignorant and foolish to a certain extent. But it can also be argued that when ignorance is on every level damaging, and alternative paths are present, ignorance then becomes stupidity.

Fortunately, unlike the self-made human world which is solely based on appearances, the real world does have substance. So true wisdom can be attained if your vision bites beneath the surface of things and is truly all-encompassing. It must be a vision that relates the finite conditions of human beings to the ultimate conditions

of their existence. If you like, that bit of people which is younger than the moon should be thoroughly connected with that bit which is older than the stars. To be quite frank I have met so many different types of people who regard themselves as Pagans that I really don't know what a Pagan is. But I would regard myself as a Pagan if a Pagan is a person who seeks wisdom, certainty and fulfilment within the above encompassing framework.

conditions of their existence, rests upon their own intuitions. However, what is important is that these forces are contacted and that there is some continuity and interconnectedness between the people who are doing it. These forces are everywhere present and for them to have full expression in the world, people who are aware of these forces must unite and allow it to be so. The social implications of magick would be phenomenal, but what does

> *"true wisdom can be attained if your vision bites beneath the surface of things and is truly all-encompassing. It must be a vision that relates the finite conditions of human beings to the ultimate conditions of their existence."*

In the present day and age, as far as all-encompassing visions go, there is the slight problem of their abundance. In the past great consideration has been given to the way in which people relate to the wider universe and fragments of this knowledge is in most places readily accessible. Common to them all is the presence of certain forces, contact with which, by necessity, transform an individual's fixed and restrictive notions of life into greater and more far-reaching ones. As to how each person sees and approaches these forces, the forces which lend them an understanding of the ultimate

the Goddess of infinite space have to offer those individuals who would try and unravel her mysteries?

I give unimaginable joys on earth: certainty not faith, while in life, upon death: peace unutterable rest, ecstasy, nor do I demand aught in sacrifice.
Liber AL vel Legis I,58.[13]

Personally, I wouldn't settle for anything less. So I shall keep a good hold on the rock which inflames my sense of wonder and move on…

13 *Liber Legis*, or *The Book of the Law*, was written by occultist Aleister Crowley in 1904 and has been enormously influential on modern occultism. It is the foundational text of the religion of Thelema. See https://lib.oto-usa.org/libri/liber0220.html

NORTHERN PAGANLINK NEWS

The free monthly newsletter of the national PaganLink network

June '88 issue

Dickens Declares War on Witches!

In a special House of Commons Debate last month, MP Geoffrey Dickens called upon all Christians to: *"unite in prayer, word and deed to condemn Satanism and to provide kind and special support for those possessed by the Devil and who turn to the church for help"*. Don't forget that by *Satanism*, Dickens is referring to Wicca and the occult in general, and so incidents of the kind reported in last month's issue could well be likely to happen with increasing regularity. In his Commons speech, Dickens mentioned the Leeds-based occult suppliers, **The Sorceror's Apprentice**. He warned against the growth of businesses catering for public interest in the occult and warned that: *"we could soon follow the path of the USA"* where there have been several incidents of pagans being shot or having their property burnt down by over-zealous defenders of "the one true faith." The Home Office Minister, John Patten has been quoted as blaming "unemployment" as one of the causes of the rise of interest in the occult. Perhaps it is more worrying for the government that people are questioning the "traditional values" that they are so keen to promote through legislation? It is said that the government is "very aware" of the need to consider changing the law to protect people. As yet we may only speculate as to what form such changes (if any) might take.

Gay Occult Magazine censured

Ganymede magazine, an "open forum" for Gay and Bisexual occultists has recently been a target for Mr.Dickens's ire. It was pounced on in a fit of prurient glee, by *The Sunday Sport*, and its editor denounced as a danger to society. Of course, anything that combines homosexuality *and* the occult is too much for the gutter press to ignore! Regardless of one's moral convictions, it remains that the basic right of Freedom of Speech is the underlying issue. It is also significant that **Ganymede's** editor has since remarked that "at the first sign of trouble, most occultists seem to disappear like mice" and no doubt, as this sort of incident increases, our "Pagan Community" will resound to cries of "It's not us that's at fault, it's those........over there who're to blame." Which is the last thing that's needed.

O.T.O. implicated in Sex 'n' Drugs Scandal!!

The Home Secretary Douglas Hurd is being urged to launch an investigation into the activities of *a secret organisation*, the O.T.O.! An article in *The Sunday Express* (15/5/88) named the Ordo Templis Orientis as an organisation which has *"brought misery and degradation for hundreds of children"* . Geoffrey Dickens and Dianne Core (the coordinator of Childwatch) are to hand Mr.Hurd a dossier containing the details. A TV documentary exposing these *evil cults* is also in the pipeline. The dossier is reputedly *a catalogue of child abuse involving Devil worship*. Among the allegations are stories of children being threatened with sacrifice, raped during rituals, given hallucinogenic drugs and then videoed in sex acts.

The report does not state *which* O.T.O. has been implicated in all this, but whether it is the Caliphate or the Typhonian O.T.O. isn't really important. Dickens is obviously gathering fuel for the pyre upon which he intends to heap *anyone* whom he believes to be a threat. All this shows very clearly that Gay or Straight, Witch or Magician or whatever label you want to use, no one is safe from Dickens!!

June 1988

NEWS

Dickens Declares War on Witches!

In a special House of Commons debate last month, MP Geoffrey Dickens called upon all Christians to "unite in prayer, word and deed to condemn Satanism and to provide kind and special support for those possessed by the Devil and who turn to the Church for help."

Don't forget that by Satanism, Dickens is referring to Wicca and the occult in general, and so incidents of the kind reported in last month's issue could well be likely to happen with increasing regularity. In his Commons speech, Dickens mentioned the Leeds-based occult suppliers, The Sorcerer's Apprentice.[1] He warned against the growth of businesses catering for public interest in the occult and warned that "we could soon follow the path of the USA" where there have been several incidents of Pagans being shot or having their property burnt down by over-zealous defenders of "the one true faith."

The Home Office Minister, John Patten, has been quoted as blaming "unemployment" as one of the causes of the rise of interest in the occult. Perhaps it is more worrying for the government that people are questioning the "traditional values" that they are so keen to promote through legislation? It is said that the government is "very aware" of the need to consider changing the law to protect people. As yet we may only speculate as to what form such changes (if any) might take.

O.T.O. Implicated in Sex 'n' Drugs Scandal!!

The Home Secretary Douglas Hurd is being urged to launch an investigation into the activities of a secret organisation, the O.T.O.![2] An article in the *Sunday*

1 At the time The Sorcerer's Apprentice occult store in Leeds was the biggest of its kind in the world, with 20,000 mail order customers from all over the globe. Its owner Chris Bray had become something of a media personality, appearing frequently on UK radio and TV shows. This led to the store becoming a frontline target for fundamentalist Christian extremists. When Rodney worked there, one of his jobs was opening the hate mail and death threats that the store received on a weekly basis.

2 Ordo Templi Orientis is one of the largest initiatory magical Orders in the world. It was founded in Germany at the beginning of the 20th century by Theodor Reuss, who was later succeeded as Outer Head of the Order by Aleister Crowley. During the 1970s-1980s there was a considerable amount of dissension between various different groups each claiming to be the "real" O.T.O., a problem eventually solved via a string of court cases in the USA and UK. The victorious group currently has around 4,000 members internationally.

Express[3] (15/5/88) named the Ordo Templi Orientis as an organisation which has "brought misery and degradation for hundreds of children". Geoffrey Dickens and Dianne Core (the coordinator of Childwatch)[4] are to hand Mr. Hurd a dossier containing the details.[5] A TV documentary exposing these evil cults is also in the pipeline. The dossier is reputedly a catalogue of child abuse involving Devil worship. Among the allegations are stories of children being threatened with sacrifice, raped during rituals, given hallucinogenic drugs and then videoed in sex acts. The report does not state which O.T.O. has been implicated in all this, but whether it's the Caliphate or Typhonian O.T.O. isn't really important. Dickens is obviously gathering fuel for the pyre upon which he intends to heap anyone whom he believes to be a threat. All this shows very clearly that gay or straight, witch or magician, or whatever label you want to use, no one is safe from Dickens!!

3 The *Sunday Express* was the weekend edition of the *Daily Express*, a populist right-wing newspaper founded in the UK in 1900. Over the years the *Express* has become notorious for being on the wrong side of history: in the 1930s it was friendly towards Mussolini, Hitler, and Mosley; in the 1950s it supported fraudster and serial killer John Bodkin Adams, suspected of murdering 400 people; and more recently it has promulgated conspiracy theories around the death of Princess Diana of the UK.

4 Childwatch was founded in Hull, Yorkshire in 1985 by Dianne Core, who rapidly became one of the major proponents of the Satanic Ritual Abuse hoax in the UK. Over the succeeding few years she would be featured widely in UK media stories, despite not a single ritual abuse case ever being brought to court due to her work. In 1991 she published the book *Chasing Satan: Investigation into Satanic Crimes Against Children*, whose synopsis was: "This work provides a documented account of ritual crimes by a British child-care worker. These crimes are now attracting major attention as a new issue in criminology and social policy. Dianne Core, the founder of Childwatch, draws on case histories to illuminate a social tragedy in the making. She relates the secret rituals of satanists to crimes against children. This book exposes attempts to deny the existence of satanic crimes. The authors examine the view that satanic crime is now a political issue that must be confronted as a cultural threat. This work should prove to be of use to professionals involved in child care, social policy and law enforcement. It provides an assessment of the psychological and behavioural indicators that enable community workers like teachers, as well as parents, to identify ritual crime."

5 Dickens would become notorious for his "dossiers", most of which never existed, and even if they did, might consist of 1 or 2 pages with little more than a list of names and a couple of paragraphs of vague accusations. But calling them "dossiers" made them sound very big and authoritative.

THIRD EYE

After Dark - Bemused or Bewitched?
Phil Hine

On April 30th, Tony Wilson's[6] late night discussion show *After Dark* looked at the phenomena of witchcraft. Prompted by the revelations of Witch Finder Dickens, Wilson assembled a group of "experts" to ask the question "What is witchcraft about?", and bring up all the hoary old questions about nudity, sex, and sacrificing babies!

The assembled guests comprised of a worried-looking psychiatrist, a Church Exorcist[7] (who spoke movingly about distraught souls in discos), a woman who had been a Satanist but who had since turned to Christ[8] and on the home team; Olivia Durdin-Robertson[9] of the Fellowship Of Isis, occult author Jack Shackleford,[10] journalist Margot Adler[11] (author of *Drawing Down the Moon*), and

6 Tony Wilson (1950 – 2007) was a TV presenter who also became famous for co-founding Manchester's Factory Records. His life is portrayed in the movie *24 Hour Party People*.

7 Reverend Jack Dover Wellman (1917 – 1989), Vicar of the Parish of Hampstead in London, and author of notable tomes *A Priest's Psychic Diary* and *A Priest and the Paranormal*. He acted as an Exorcist for the Church of England for 40 years.

8 Audrey Harper, author of the supposedly autobiographical *Dance with the Devil*, was a co-director of the Reachout Trust (who we would go on to feature in many subsequent issues of *Pagan News*). Harper had carved out a career on the Christian lecture circuit as an "ex-witch and Satanist High Priestess who had discovered Christ". When she lectured on this at a local Leeds University Campus for Christ meeting (attended by about 500 people, plus *Pagan News* staff), she claimed to have been made Queen of the Witches by showing them that she could kill a bird in flight by the power of her thought alone. She also claimed that in order to show their obedience to Satan, witches had to cut off one hand and toss it in a fire as a sacrifice. When Rodney pointed out to her that she herself appeared to have two hands, therefore couldn't actually have been a witch according to her own testimony, she retorted that she had in fact cut her own hand off, but that "Satan had the power to grow her a new one". The other 500 people in the room actually believed this.

9 Olivia Robertson (1917 – 2013) was an author and artist who co-founded the Fellowship of Isis in 1976, based in Huntington Castle in Ireland. The Fellowship devotes itself to the worship of the Divine Feminine and currently has around 24,000 members worldwide.

10 Jack D. Shackleford (1938 – ?) was a writer of somewhat lurid occult-oriented fiction during the 1970s, inc. *Tanith*, *The Eve of Midsummer*, *The Strickland Demon*, and *The House of the Magus*.

11 Margot Adler (1946 – 2014), whose 1979 book *Drawing Down the Moon* did much to popularise Wicca throughout the 1980s. Rodney once spent a memorable evening with her at a live concert in a New York cafe where they enthusiastically sang along to songs played by occult author Lon Milo DuQuette.

Moira Woods, who belonged to Maxine Sanders'[12] coven. The ensuing debate ranged around all the obvious questions (sex, nudity, evil, etc.) with Olivia Durdin-Robertson giving a winning performance as a lovable eccentric and Margot Adler being patiently reasonable in the face of ingrained attitudes. The debate gained most ground when dealing with Paganism as a personal ethic, rather than being a doctrine-ridden cult. The psychiatrist[13] seemed to come off worst as he seemed to be suspicious of anyone who wasn't a rational scientist – Church included. Interestingly enough, the ex-Satanist still thought that the assembled witches were misguided, but conceded their right to choose their own beliefs. There was a general air of polite conviviality which made the programme all the more accessible, although I don't suppose it would sway anyone's views to being more tolerant of other people's beliefs. Still, it was good to see the media being, if not sympathetic, then at least willing to lend an ear to the views of Pagans. Especially when my file of anti-Pagan newspaper clippings grows greater with each passing week.

Mad, Sad or Just Plain Bad?

The hysteria whipped up by Geoffrey Dickens & co, over "a plague of witches" shows just how entrenched superstition and fear of anything magical or Pagan-oriented there is in our society. While Pagans have spent the last few years talking about the "New Age" and waving Article 9 of the European Convention on Human Rights[14] (refers to freedom of religious practice), the international psychiatric community has been busy sewing up the loopholes. The result of their labours is a manual known as DSM-III – the Diagnostic and Statistical Manual of Mental Disorders.[15] This jolly little tome has been translated into 18 different languages and is very much a standard guide to

12 Maxine Sanders (1946 –) is a seminal figure in the development of modern witchcraft. Based in London, she has been representing and initiating witches since 1965 and continues to do so at the time of writing. Maxine has appeared in innumerable interviews and documentaries, most notably the 1970 movie *Legend of the Witches*.

13 Trevor Turner, who until recently was a Clinical Director in the East London and City University Mental Health NHS Trust. His special interests include "the management of schizophrenia, the 'comings and goings of community care' and the history of psychiatry".

14 Article 9 of the ECHR provides a right to freedom of thought, conscience and religion. This includes the freedom to change a religion or belief, and to manifest a religion or belief in worship, teaching, practice and observance.

15 The Diagnostic and Statistical Manual of Mental Disorders (latest edition: DSM-5, publ. 2013) is a publication by the American Psychiatric Association (APA) for the classification of mental disorders using a common language and standard criteria. Over the years it has been extensively revised, though it has come under increasing criticism for cultural bias in its diagnoses and for its writers' extensive links to pharmaceutical companies.

the diagnosis of "mental disorders". No doubt readers will be pleased to hear that in DSM-lll, the criteria for mental disorders include unusual perceptual experiences, clairvoyance, telepathy, sixth sense, magical thinking and the sense of someone being there who isn't actually physically present. The manual generously allows you to sense the presence of a dead relative for up to three weeks following their death. After which, I'm afraid, it becomes a symptom of "mental disorder."[16] What this amounts to is a manual which classifies many, if not all of the "magical" experiences that we may have from time to time, as being a sign of mental disorder! Translating "mental disorder" from legal gobbledygook reveals that it refers to any undesirable mental state, attitude, or behaviour. That word undesirable certainly covers a lot of ground, doesn't it? It means that virtually anyone who is deemed a nuisance can be sectioned, given a tap with the chemical cosh and put through enough therapy to normalise them back into line. Of course if you've got loadsa money then you don't need to worry. Shirley MacLaine can get herself any number of spirit guides. But any ordinary person who gets messages from inner space better keep them pretty quiet – first come the psychiatrists and then the gutter press. A neat little equation is being cooked up: witchcraft = mental disorder = child abuse = decline of moral values. Pagans are the perfect scapegoat yet again.

Protesting that Wicca is a religion won't help either, as in the USA the Moral Majority are trying to put a bill through congress that says effectively, that any religious organisation that isn't based upon the monotheistic worship of you-know-who isn't a proper religion. DSM-III backs this up by asserting that Pagan beliefs and experiences are signs of mental instability, and Geoffrey Dickens says that witchcraft leads to child abuse. So effectively, you are guilty until proven innocent. Who said the 'Burning Times' were over? "...feelings of persecution. Sees conspiracy around every corner... thinks that certain people are out to get him... subject obviously suffering from paranoid delusions ...prescribe mood stabilising drugs..." Of course, it could never happen to you could it?

16 The most recent version of the Diagnostic and Statistical Manual, DSM-5, changes this criterion somewhat: persistent complex bereavement disorder is diagnosed only if at least 12 months (6 months in children) have elapsed since the death of someone with whom the bereaved had a close relationship.

NORTHERN PAGANLINK NEWS

The free monthly newsletter of the national PaganLink network

July '88 issue

HUMAN SACRIFICE

- the truth?

The latest blow in the current "Burn the witches" campaign was struck by The Star newspaper of June 3rd, which devoted its front page and two inner pages to the revelations of "one of Britain's former top witches", Marion Unsworth. The headline was the phrase "HUMAN SACRIFICE" in letters two and a half inches high, and the main gist of the story was that Ms Unsworth participated in the ritual killing of a thirteen year old girl in the 1970s. The peculiar thing is that there was no mention made of why the police are not going to arrest Ms Unsworth on a charge of conspiracy to murder. Could it possibly be because of the fact that the entire episode is a pack of lies cooked up to fill three pages of the paper? Let's face it, if the story *was* true the cops would be at her door faster than you could say "Here's ten thousand pounds, Marion, thanks for helping us put back the cause of Wicca by about twenty years". Ms Unsworth says her life has been completely changed by reading the Bible - no doubt she has closely studied the part about the thirty pieces of silver.

Devil priest in sinister group

The Star went on to rope in Canon Dominic Walker, described as the Church of England's "Witchfinder General", who is head of the Christian Deliverance Study Group, the section of the Anglican Church devoted to suppressing occultism and "devil-worship". This so-called expert described how initiation rites of occult groups are photographed so that recruits can be blackmailed, and that in "all rites there tends to be a sexual prominence. *These always include homosexual and paedophile acts.*" Now you know and I know that this "expert" is talking through his fundamental passage, and that the product of his labours is *excrement*, but this is someone who is believed by thousands - hundreds of thousands - of people all over this country. This is the man whom our politicians consult when they need some advice on the "problem" of Witchcraft. We have come a long way from the trials of the 16th century, but for these people it's only a short way back. Astonishing as it may seem, the Church of England, the established spiritual authority of this country, really does think that all occultists are drug-taking paedophiliacs who sacrifice naked virgins in churchyards. God knows how we'll ever change their minds.

Green by name, Yellow by nature!

PaganLink has recently come up against bigotry from a rather unexpected quarter - Greenpeace! This came about over the recent Green Fair held in Harrogate, organised by Harrogate Friends of the Earth and Greenpeace. A stall for PaganLink had been booked and organised, so that local members could sell products and answer people's questions. Problems started when some members of Greenpeace started to get worried about a possible hostile reaction from *local bigots*. Members of the Harrogate PaganLink group went along to a meeting to explain what Paganism was all about. It appears that a *local bigot* was already present as a Greenpeace representative, and that this person swayed the meeting so that PaganLink was asked to withdraw from the Fair.

News of this has shocked and dismayed local Pagans, and local PaganLink members who are also members of Greenpeace have written letters of protest stating their disgust over this action. So far, Greenpeace have not yet commented - but it bodes ill for their credibility if local groups are worried about upsetting people. Or maybe they think Pagans aren't an important group to consider. What do *you* think, and why not contact your local Greenpeace group and let them know about it!

NEWS

Human Sacrifice – The Truth?

The latest blow in the current "Burn the witches" campaign was struck by *The Star* newspaper of June 3rd, which devoted its front page and two inner pages to the revelations of "one of Britain's former top witches", Marion Unsworth.[1] The headline was the phrase HUMAN SACRIFICE in letters two and a half inches high, and the main gist of the story was that Ms Unsworth participated in the ritual killing of a thirteen year old girl in the 1970s. The peculiar thing is that there was no mention made of why the police are not going to arrest Ms Unsworth on a charge of conspiracy to murder. Could it possibly be because of the fact that the entire episode is a pack of lies cooked up to fill three pages of the paper? Let's face it, if the story was true the cops would be at her door faster than you could say "Here's ten thousand pounds, Marion, thanks for helping us put back the cause of Wicca by about twenty years". Ms Unsworth says her life has been completely changed by reading the Bible – no doubt she has closely studied the part about the thirty pieces of silver.

 The Star went on to rope in Canon Dominic Walker,[2] described as the Church of England's "Witchfinder General", who is head of the Christian Deliverance Study Group,[3] the section of the Anglican Church devoted to suppressing occultism and "Devil worship". This so-called expert described how initiation rites of occult groups are photographed so that recruits can be blackmailed, and that in "all rites there tends to be a sexual prominence. These always include homosexual and paedophile acts."

 Now you know and I know that this "expert" is talking through his fundamental passage, and that the product of his labours is excrement, but this is someone who

1 Marion Unsworth was an aging glamorous blonde mother of three from Kempstead, UK. She was yet another self-styled "Queen of the Witches" who had turned to Jesus and gave lectures to Christian audiences on the evils of witchcraft and the occult. During the 1980s this became something of a classic scam, reaching its apotheosis in the case of Derry Mainwaring Knight. See later issues of *PN*.

2 Edward William Murray "Dominic" Walker (1948 –) is now a retired Anglican bishop. He was the Bishop of Reading from 1997 to 2002 and Bishop of Monmouth from 2003 to 2013. He is quoted as saying: "In the 35 years that I've been involved in deliverance ministry I've probably carried out six exorcisms and they've always been as a last resort and they've always been with psychiatric care."

3 A report by the co-founder of this group describes the following event: "In 1974, media attention followed a tragic outcome of an attempted all-night exorcism of a man who went home and murdered his wife and was found to be mentally ill and then committed to a Secure Hospital. "The group then revised their internal guidelines to include" ...the ministry of deliverance should always be conducted ...with no publicity" (!) That's right, as far as they were concerned the problem wasn't the fact that the exorcised person went on to murder someone, the problem was that the media found out about it. See: 'The Role of the Psychiatric Advisor in the Ministry of Deliverance' by Dr. David McDonald (Royal College of Psychiatrists, 2012).

is believed by thousands – hundreds of thousands – of people all over this country. This is the man whom our politicians consult when they need some advice on the "problem" of witchcraft. We have come a long way from the trials of the 16th century, but for these people it's only a short way back. Astonishing as it may seem, the Church of England, the established spiritual authority of this country, really does think that all occultists are drug-taking paedophiles who sacrifice naked virgins in churchyards. God knows how we'll ever change their minds.

Green by Name, Yellow by Nature!

PaganLink has recently come up against bigotry from a rather unexpected quarter – Greenpeace![4] This came about over the recent Green Fair held in Harrogate, organised by Harrogate Friends of the Earth[5] and Greenpeace. A stall for PaganLink had been booked and organised, so that local members could sell products and answer people's questions. Problems started when some members of Greenpeace started to get worried about a possible hostile reaction from local bigots. Members of the Harrogate PaganLink group went along to a meeting to explain what Paganism was all about. It appears that a local bigot was already present as a Greenpeace representative, and that this person swayed the meeting so that PaganLink was asked to withdraw from the Fair.

News of this has shocked and dismayed local Pagans, and local PaganLink members who are also members of Greenpeace have written letters of protest stating their disgust over this action. So far Greenpeace have not yet commented – but it bodes ill for their credibility if local groups are worried about upsetting people. Or maybe they think Pagans aren't an important group to consider. What do you think, and why not contact your local Greenpeace group and let them know about it!

O.T.O. Attacked Again

The Ordo Templi Orientis has again been named as an evil Devil-worshipping cult, again by *The Star*. It is claimed that there are 10,000 members in Britain, who "preach their evil gospel at bizarre ceremonies shrouded in secrecy" and "claim to draw their power from blood drunk after animal sacrifices". *NPLN* contacted members of both branches of the O.T.O.[6] but was unable to get any comment except a stunned silence

4 For the three people reading this who don't already know about Greenpeace, it's a high profile and highly effective international environmental organisation that has been fighting to improve the world since 1972. It is entirely funded by its individual supporters, which included *PN* staff.

5 Another long-term environmental pressure group mainly focused within the UK.

6 During this period there were various competing O.T.O. groups, including the so-called "Caliphate" O.T.O. under Grady McMurtry and the considerably smaller Typhonian O.T.O. under

from one, and hysterical laughter from the other. It is understood by *NPLN* that the quoted membership figure of 10,000 is more than slightly exaggerated.

U.S Army Sanctions Satanist!![7]

Michael Aquino, head of the San Francisco-based Temple of Set[8] has recently been accused of molesting children. What makes the case unusual is that Aquino is a Lt. Col. in the U.S Army Reserve![9] The scandal began when incidents of child molestation were uncovered at Aquino's army base.[10] Aquino was accused, but a civilian day care worker – a Southern Baptist minister – has since been arrested. Aquino insists that he was innocent all along and since no evidence has been brought to light, his claims that he is being victimised because of his beliefs seem valid. He makes no secret of his leadership of the Temple of Set, and is forthright about his views. The army has known about his religion since 1981. An army spokesman has been quoted as saying: "Aquino has an absolute constitutional right to his beliefs, unless there is illegal behaviour associated with it." And Aquino says "I suppose I can look pretty demonic."

Love Thy Neighbour?

The Rev. Christopher Horton, vicar of St. Hilda's Church in Grangetown, Cleveland, is showing traditional Christian tolerance to a member of his flock who also happens to be a witch. He has banned Wiccan Sharon McPherson from attending Sunday services at St. Hilda's "until she finishes with the Devil". According to Ms. McPherson: "I explained to the vicar that I perform certain ceremonies in the nude. He gave me a blessing and then said I was banned." Ain't that always the way... The only thing puzzling us here at *NPLN* is why she wants to go to church in the first place.

the leadership of Kenneth Grant. Far from having a membership of 10,000, a later court case saw the Typhonians admitting that their membership was less than two dozen! For more details on this see Rodney's extensive history on the subject *A Timeline of O.T.O. Succession After Crowley's Death* http://rodneyorpheus.com/writings/occult/a-timeline-of-o-t-o-succession-after-crowleys-death/

7 The use of multiple exclamation marks was pretty much mandatory for headlines about Satanism in popular newspapers of the era. We deliberately and relentlessly parodied it at every opportunity.

8 The Temple of Set is an occult initiatory order founded in 1975 by ex-members of the more infamous Church of Satan. Whereas the Church of Satan does not actually believe in the existence of a literal Satan as an entity, the Temple of Set bases its work on a sacred text written by Michael Aquino, 'The Book of Coming Forth by Night', which reveals that Satan is real and identifies with the ancient Egyptian god Set. The ToS currently has a few hundred members internationally.

9 Aquino held a leading role in US military psychological warfare operations, which has led to him becoming a central focus of numerous conspiracy theories over subsequent years.

10 The Presidio in San Francisco, California.

THINGS TO DO...
and THINGS TO READ[11]

Chaos Magick
by *Frater Impecunious*[12]

When obtaining any magical result (including "failure") always think of several explanations for it. These explanations should contain at least one of each of the following types:

 i) an explanation in terms of the belief-system of the magical operation
 ii) strict materialism
 iii) something exceptionally silly

When you have become reasonably adept at switching beliefs, try contemplating two which appear to be mutually exclusive such as Christianity and Tantra, Islam and Radical Feminism, or Celtic mythology and Marxism. In this way you may develop new and bizarre belief-systems/healthy cynicism.

Meditations in Menzies.[13] Read specialist magazines that you have no particular interest in, especially those written by enthusiastic amateurs. Also read publications with opposing views in quick succession, e.g. *Playboy* and *Spare Rib*.

11 As described in the introduction, when we first started publishing articles we wanted to make them short and to the point. And moreover practical. So we decided to start a regular column called 'Things to Do ... And Things to Read' each of which would consist of a short, focused piece on a particular magical practice with a specific action that the reader could perform to get experience with it, plus a reading list so they could go on and study it further if they liked it. We consider it one of the best ideas we ever had, and are amazed that no-one has since ~~ripped this idea off~~ followed up on it.

12 Frater Impecunious (Latin for Brother No-Money) was a friend of ours from the Leeds University Occult Society. He is currently a lecturer at a well-known university where he teaches about *Lord of the Rings* and *The Matrix*, among other things. And they pay him for it. Now that's a great job.

13 John Menzies was founded in 1833 and became a leading chain of newsagents in the UK in the 1980s. A few years later it sold off its retail outlets to WH Smith.

Note also how magazines are classified and, whenever possible, put them back in a different section, so that *Spare Rib* is placed under "Male Interest" for example.

Practice assiduously the exercises for liberation in Pete Carroll's book *Liber Null*. Then bum or sell your copy.

Do not put live toads in your mouth.

Further Reading

Angerford & Lea (aka Lionel Snell): *Thundersqueak*
Aleister Crowley: *Magick/The Book of Lies*
Pete Carroll: *Liber Null/Psychonaut*
Lewis Carroll: *The Hunting of the Snark*
Malaclypse the Younger: *Principia Discordia*
Robert Anton Wilson: *Illuminatus! & Cosmic Trigger*
Fritjof Capra: *The Tao of Physics*
Ray Sherwin: *Theatre of Magick*
Austin Osman Spare: *The Book of Pleasure*
Lao Tzu: *Dao De Jing*

For further information consult your pineal gland. *Fnord.*

NORTHERN PAGANLINK NEWS

The free monthly
newsletter of the national
PaganLink network

August '88 issue

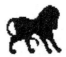

NORTHERN PAGANLINK CONFERENCE

The first Northern PaganLink Conference (organised by ye editors of this august publication) was held on July 9th, and was a storming success - well, stormy, anyway. Much to everyone's surprise, except for the gifted few clairvoyants among us, about 60-odd people turned up, and very odd they were indeed *[ah, the Old Ones are still the best - Ed.]*. The venue, Fat Freddy's cafe in Leeds, was only designed to hold a comfortable 30, which made for an intimate atmosphere to say the least. PaganLink members turned up from as far afield as Newcastle, Hull, Leicester, Stoke-on-Trent, and even the mists of Birmingham, as well as the hardcore Northern coterie from the Leeds, Manchester, and Sheffield areas. In the words of T.V. news reporting "full and frank exchanges of view" occurred on several issues, the main ones centering on the vexed question of how this PaganLink network of ours should be organised (or not) in the future, and whether or not there should be some form of national PaganLink council. Ye editors are very much in favour of this, and presented a possible model for how it could be set up, but good arguments against were voiced by members of the Sheffield and Leicester contingents. It was eventually decided that a full day conference to discuss future organisation of PaganLink would be held in Sheffield next month, giving everyone plenty of time to think about the problem and suggest possible alternative solutions (see PaganLink Update in this issue).

The other main topics discussed were dealing with the media and the issuing of some form of PaganLink manifesto. There was an overwhelming feeling that we do need some form of system of interfacing with the "real" media; although the T.V., radio, and especially newspapers don't tend to be too sympathetic to pagans in general, we think it is possible to get our point of view across if we have the right contacts to do it (again see PaganLink Update for more on this).

As regards a PaganLink manifesto, Rich Westwood brought a draft version up from Brum with him, which seemed fairly o.k. to most people, but did cause a certain amount of controversy in stating that pagans do not worship Satan. Although it is undoubtedly true that most pagans do not even believe in Satan, much less worship him, many of the people at the conference felt that it was wrong to stipulate that members of PaganLink should or should not worship only certain "approved" Gods (here it must be stated that **Northern PaganLink News** clings tightly to the concept that all people have the right to worship whomever they please, be it Diana, Satan, or Bugs Bunny - ye editors are freely prepared to worship all three, and still call themselves pagans. Anyone out there who thinks that they have a monopoly on the truth is not welcome in our company). Admittedly it is true that Satanism is often used as a cover for warped individuals to practice various illegal activities, but then again, so is Christianity, and there are some nice Christians around too (or so we're told).

All in all, the Northern PaganLink Conference was great. There was an astonishing feeling of camaraderie and energy generated throughout the evening, and just seeing so many pagans from so many paths and backgrounds getting together and working out ideas for the future was success in itself. In the past, many occultists have spent a great deal of time bitching about each other instead of devoting their martial energy to attacking our real enemies, and building up new ways of living for the future. At last we may be seeing the end of that mode of thinking, and the creation of a true pagan community at large. Let's keep it up.

NSPCC[1] Slam Bradford Psychics!!

A psychic fair planned recently in Bradford was cancelled at the last minute because the charity which the fair was in aid of refused to have anything to do with it. The NSPCC regional organiser for Bradford, Mr. Bernard Davies, condemned the fair as "the work of the Devil." The fair was organised by a Mrs. Karen Marriott, of Bradford, who had invited spiritualists from all over the country to the event. The NSPCC later apologised to Mrs. Marriott.

Scorpio Rising?

If you've started to think that the current media witch-hunt is beginning to die down, then think again! This could well be the lull before the storm. A group known as Scorpio, who have been named in the press as a "Satanic order", and linked to the O.T.O., may be due to hit the headlines again. We have recently received information which alleges that Scorpio members are being investigated and that a crown prosecution for sexual offences could be brought against them soon. We have no further details, and no one seems to have run across any Scorpio members/publications – which would tend to suggest that they are not a "legitimate" occult group. However, if there is a big exposé on the way, we had better prepare ourselves from being tarred with the same brush as Scorpio, who seem to be the major source for the allegations of Dickens and Dianne Core.

If anyone has any information about this so-called occult organisation, can they please let us know as soon as possible. If this organisation does exist, and is responsible for illegal sexual acts, then we need to make it clear that they are by no means representative of authentic Pagans.[2]

1 The National Society for the Prevention of Cruelty to Children is a charity set up in 1884 which works for child protection in the United Kingdom and the Channel Islands. Although it has done much extremely good and important work since then, it has not been without controversy.

2 Despite numerous mentions of Scorpio in the press and in publications by Christian pressure groups, it now appears that this was a complete hoax all along. There was no group by this name, and obviously thus no connection to O.T.O..

Northern PaganLink Conference

The first Northern PaganLink Conference (organised by ye editors of this august publication) was held on July 9th, and was a storming success – well, stormy, anyway. Much to everyone's surprise, except for the gifted few clairvoyants among us, about 60-odd people turned up, and very odd they were indeed [ah, the Old Ones are still the best – Ed.]. The venue, Fat Freddy's cafe in Leeds, was only designed to hold a comfortable 30, which made for an intimate atmosphere to say the least. PaganLink members turned up from as far afield as Newcastle, Hull, Leicester, Stoke-on-Trent, and even the mists of Birmingham, as well as the hardcore Northern coterie from the Leeds, Manchester, and Sheffield areas. In the words of TV news reporting, "full and frank exchanges of view" occurred on several issues, the main ones centering on the vexed question of how this PaganLink network of ours should be organised (or not) in the future, and whether or not there should be some form of national PaganLink council. Ye editors are very much in favour of this, and presented a possible model for how it could be set up, but good arguments against were voiced by members of the Sheffield and Leicester contingents. It was eventually decided that a full day conference to discuss the future organisation of PaganLink would be held in Sheffield next month, giving everyone plenty of time to think about the problem and suggest possible alternative solutions.

The other main topics discussed were dealing with the media and the issuing of some form of PaganLink manifesto. There was an overwhelming feeling that we do need some form of system of interfacing with the "real" media; although the TV, radio, and especially newspapers don't tend to be too sympathetic to Pagans in general, we think it is possible to get our point of view across if we have the right contacts to do it.

As regards a PaganLink manifesto, Rich Westwood brought a draft version up from Brum with him, which seemed fairly OK to most people, but did cause a certain amount of controversy in stating that Pagans do not worship Satan. Although it is undoubtedly true that most Pagans do not even believe in Satan, much less worship him, many of the people at the conference felt that it was wrong to stipulate that members of PaganLink should or should not worship only certain "approved" Gods. Here it must be stated that Northern PaganLink News clings tightly to the concept that all people have the right to worship whomever they please, be it Diana, Satan, or Bugs Bunny – ye editors are freely prepared to worship all three, and still call themselves Pagans. Anyone out there who thinks that they have a monopoly on the truth is not welcome in our company. Admittedly it is true that Satanism is often used as a cover for warped individuals to practice various illegal activities, but then again so is Christianity, and there are some nice Christians around too (or so we're told).

All in all, the Northern PaganLink Conference was great. There was an astonishing feeling of camaraderie and energy generated throughout the evening, and just seeing so many Pagans from so many paths and backgrounds getting together and working out ideas for the future was success in itself. In the past, many occultists have spent a great deal of time bitching about each other instead of devoting their martial energy to attacking our real enemies, and building up new ways of living for the future. At last we may be seeing the end of that mode of thinking, and the creation of a true Pagan community at large. Let's keep it up.

VIEW POINT

The Great Game of Life

by *Vishvanath*[3]

Humans are not so different from the other animals, plants and microorganisms that throng the earth. Like their lives, ours seem to revolve around a constant series of yes or no decisions. We may see someone who attracts us. We may say hello and according to their reaction we can either say yes or no to the new situation of which we are the co-authors. Sometimes we lie to fit in or to attain covert aims. Whatever we do, we are cocksure that our actions will yield fruit whether full and ripe or diseased. These experiences habituate us to the idea that there are certainties in life beyond the inevitability of death and this attitude pervades everyone who comes to explore the occult for the first time.

In the westernised view of culture which is creeping all over the globe, the inherent dualities of Judeo-Christianity which underlie it reinforce this view. The emphasis in our education is in stuffing the frontal lobes of the brain with facts and creating an arena in which we can compare things and create a corresponding duality. This is a power which has borne humanity much fruit, particularly in the area of science and technology, but it is also a demon which even now threatens to ride it, blind to other types of reality, into oblivion. These other types of reality are not mystical or occult except in the sense that they are hidden from the vast bulk of western educated people. Concepts of superiority and inferiority have no place here except from the point of view of the western conditioned mind. The occult seeker often comes to magick with a desire to create a new niche or situation for themselves. They approach the

3 Vishvanath is the magical name of a long-standing member of AMOOKOS, the Arcane and Mystical Order of the Knights of Shambala. More on this magical Order later in the book.

occult with preconceptions and a belief that they are certain to get something out of it. But if we look at religion we see a similar situation! A man frightened by his own mortality might enter a belief system which offers the illusion of certainty. But this "certainty" carries with it a package of other requirements such as the "Ten Commandments". Authority passes from the man to the system. For the man this is fine because it offers him the opportunity to transgress the enforced code of ethics and still be welcomed into heaven with

is any better than running away from it! Since the deification of the intellect with its attendant dualisms, hierarchies and value judgements, underpins our cultures, we must be aware of the ways in which it englamours us. The illusion of certainty. The illusion of the one right way. The illusion of knowing where we are going. The factionalism in occultism saddens me because it implies that the ghost of Christianity still acts within the region of the free! The intellect is one of the many benefits of being human but its hold over us, to the exclusion

> *"The brain is to be visualised intently as a ripe watermelon. The spine should be visualised as the barrel of a shotgun pressed tight against the belly of the fruit. Pull the trigger and see what happens."*

the formulation of the correct religious observances. Given this kind of buffer between himself and the consequences of his actions, he may never experience any event openly, deeply, honestly. He has no reason to grow out of his neuroses.

For the occult seeker, like everyone else who is honest with themselves, there can be no certainties in life beyond the assurance of death's embrace. Occult practices may be a waste of time but then if we are alive to this possibility they may become a quest for a total and uninhibited experience of life. It is up to each of us to make an honest inquiry into our motive for coming into occultism. There is no certainty that facing life

of almost everything else, has become dangerously fixed. An apt meditation might be that of a variant of Kundalini yoga. The brain is to be visualised intently as a ripe watermelon. The spine should be visualised as the barrel of a shotgun pressed tight against the belly of the fruit. Pull the trigger and see what happens.

Aleister Crowley wrote in *Magick in Theory and Practice* that magick is the union of the microcosm (man) with the macrocosm (universe). If this theory is accurate then this union can only be affected by individuals transcending their own preconceptions about the macrocosm and their own conditioning by society. In this monumental work the

by Ray Nadeau

only reliable starting point can be our own minds, emotions and bodies. Since we ourselves are the obstacles to an open experience of the great outside, we must be able to let go of everything that usually gives us definition, comfort and pleasure. We must be prepared to see the vision of Pan!

If we accept that occultism has no fixed belief system, that it represents a genuine desire to open up to the great outside, then it follows that it can acknowledge no external authority, its only law can be Do What Thou Wilt. Without the buffer of passing the buck the hard knocks become harder but they also provide a greater opportunity to learn. This path was established in Asia as far back as 7000 BC. It was called the Svecchacharya

or "the path of doing according to one's will." This path was influential in the formation of the Tantric schools and has continued in related and spontaneous manifestations ever since. At first sight it is hard to reconcile the idea of having a guru with an acknowledgement that there can be no authority figure outside oneself. In fact the role of guru should always have been to introduce one to a passage of experience and to act as a mirror for good and bad qualities. If we are working on ourselves we need to see an objective reflection in order to choose how we are. Any teacher who imposes an idea upon us should be distrusted. The process of opening is also important here, since it is often easier to open up to a person than to a situation. Opening up

to the guru can be the first step towards the vision of Pan.

It is a testament to the tenacity of the intellect that at almost every turn we find its mechanisms for keeping consciousness or awareness safely locked up. Our culture conditions us to think of thought as a great commodity and since ego is composed of thought we tend to revere it. Tantric texts treat thought as a by-product of metabolism. If we remember that it is an excrescence like faeces and urine there is less likelihood of worshipping it. Thought has its uses and so does manure, but both can harbour disease-bearing organisms as well as hallucinogenic fungi! If we can remember this and remain objective about everything that happens to us without inhibiting bodily and emotional feelings, then we can do a lot.

This article has been written for those who are new to practical occultism. If we approach magick in a hard-nosed and realistic way we are more likely to benefit than adopting a belief crutch! Sri Mahendranath (the Adi-guru of the Adinatha and Kaula Tantric lineages which inform the East-West group AMOOKOS).[4]

Do not mistake religion for spiritual life.
Do not mistake scriptures for divine wisdom.
Do not mistake civilisation for progress.
Do not mistake endurance for happiness.
Do not mistake submission for acceptance.
Do not mistake obedience for freedom.

Sinistroversus Sothis-Wierdglow Publ.
The Magick Starts With You

4 Shri Gurudev Mahendranath (1911 – 1991) was a guru and writer. Born Lawrence Miles in London, in his early years he met Aleister Crowley who suggested that he study meditation and the I Ching, and who eventually advised him to go to India if he wanted to study yoga more deeply. In 1953 he was given initiation as a sannyasin into the Adi-Nath Sampradaya by Shri Sadguru Lokanath and given the initiation name Mahendranath. In 1963 he was given Tantric initiation by Shri Pagala Baba of Ranchi into the Uttara Kaula sect of Northern Tantrics and became his successor.

THINGS TO DO... and THINGS TO READ

Yoga for Lazy Sods
by *Rodney Orpheus*[5]

"It is by freeing the mind from external influences, whether casual or emotional, that it obtains power to see somewhat of the truth of things." (Aleister Crowley).[6]

ASANA (Control of Posture)

The God Posture: Sit in a firm, straight-backed chair, hands resting lightly on the upper thighs. This is the posture that the ancient Gods of Egypt are often depicted in. It is one of the simplest and most effective of all yoga asanas.

The Dragon Posture: Kneel, bum resting on your heels, hands resting on the thighs.

The Lotus Posture: The best known of all yoga postures. Sit with your legs extended; place your right foot on your left thigh so that the right heel presses gently into the groin. Now place your left heel on your right thigh in a similar manner. The hands should now rest on the knees, palm upwards. This posture is difficult, but is the "king of asanas." For most purposes, however, each of these three asanas is as good as any other.

5 We had an editorial policy from the beginning that News articles should not be bylined to any individual contributor but simply presented as by "the editors of Pagan News". In 99% of cases this meant they were written by either Phil or Rodney, or often by both in collaboration. However, longform articles that we individually wrote, we credited to our actual names, although these articles would still receive the same kind of rigorous editing process that we gave to external contributors (and continued in this book).

6 *Magick*, Part 1.

In performing asanas it is vitally important that the back is kept straight, and the body be kept reasonably warm and free from disturbance. It is best to wear something loose and comfortable, such as a dressing gown. It is a good idea to try each of these asanas on different occasions, then choose which one you prefer and stick to it. For maximum effectiveness, asana should be practised for at least ten minutes daily. Regular practice will reduce stress and improve relaxation and concentration.

PRANAYAMA (Control of Breath)
As you become practised in asana, you will find that your breathing patterns change, tending to become slower and fuller. You should now attempt to control the breath. Concentrate on the breath flowing in and out of your body, mentally repeating the words "The breath flows in" and "The breath flows out," at the appropriate times. Your breathing should become deep and relaxed.

When this has been practised for a while, try to steady your breathing so that your exhalation is twice as long as inhalation. If you have reached the stage where you can do this without difficulty, change to holding the breath for the same time as inhalation, so that you are breathing in the sequence: In (1), Hold (1), Out (2) – i.e. a four phase breath pattern.

The next step is alternate nostril breathing. This is accomplished by placing the thumb of the right hand on the side of the right nostril, and placing the middle finger of the same hand on the side of the left nostril. In this position it becomes possible to close the right nostril and breathe in through the left nostril only. Do this, then close both nostrils while holding the breath. Now open the right nostril and breathe out. Breathe in again through the same nostril, thus completing an entire cycle. All of this should be done using the breathing pattern shown above.

Further Reading

'Liber E vel Exercitorum & Liber Ru vel Spiritus' in Aleister Crowley's *Magick*
Eight Lectures on Yoga Aleister Crowley
Sexual Secrets Nik Douglas & Penny Slinger
Light on Yoga B.K.S. Iyengar

Humour [7]

7 This was the first issue with a specific humour section, although obviously we had been trying to be funny from the beginning (with varying degrees of success). Barry Hairbrush was the pseudonym of another friend of ours met via the Leeds University Occult Society. While in person he was relatively quiet and reserved, behind his somewhat nondescript exterior beat a heart of surrealist genius with an eye for absurdity that was second to none. He would go on to produce comedy gold for us every month over the next few years. Barry Hairbrush in many ways became the mascot of the *Pagan News* irreverent house style. Despite a huge number of requests we never revealed his true identity. And no, he definitely was not either Phil or Rodney – we wish we were that funny.

Pagan *News*

CHRISTIANITY IN SUBURBIA

A Shock Expose!

Warning: This article contains Taphthartharath (E174), Asmodial (E208), and artificial elementals (E102, E103).

BARRY HAIRBRUSH *spent three weeks undercover in a so-called Christian "Church". This is his report.*

My first meeting with a so-called "Christian" was with Mike, a young vicar. After much negotiation, I was allowed into his church to see what went on. I was led up a path through a piece of land I later learned was full of decaying corpses, some barely six feet under the ground. Upon opening the door, I saw a large room arranged in a deliberate and warped parody of the black mass. The cross on the wall was pointing upwards, not downwards, Jesus and not the Devil stood on the altar and high above us, white candles burned instead of black.

SEX

Mike often visits his "parishioners" (other people who dabble in Christianity) on his so-called "bicycle". I was not allowed to be present during these visits, but I am reliably informed that in broad daylight and often with young children watching, he sips tea, nibbles biscuits and says, "Splendid, splendid!". I also heard rumours of their strange sexual practices, such as doing it "in private" and other suspect behaviour.

CRANKS

Now, all this may seem just the work of a few cranks. But recent evidence has shown that Christianity can have an adverse effect on the mind, leading to mental breakdown. We visited one clinic in Morpeth to speak to "Neddie", who was part of a so-called "Congregation" for several years.

"**I thought it was just a bit of fun at first... the hymns, the collection plate, the stained-glass windows... but gradually, it takes you over and I am now convinced that the nuclear holocaust is God's will, and the only way forward for mankind. And who am I, Saint Jerome, to be contradicted?**"

BLESS

Can Christians be helped? I spoke to Ravenhawk, Son of Dragonslayer, head of the local Nordic warrior cult.

"**It's very difficult. I keep dropping into their church and leaving leaflets about the importance of blood sacrifice to Loki and Odin's message for modern man. But they just keep throwing them back, and one vicar has threatened on national TV to "bless" me if I didn't mind my own business.**"

QUEEN INVOLVED

It is difficult to say just how widespread Christianity really is. New churches seem to be springing up all over the place. Members are suspected of occupying high positions in the government and police, and even the Queen herself has often been accused of leading the notorious "Church of England". In conclusion, I would remind you that Christians are everywhere – neither you, nor your children, nor your money are safe. You have been warned.

Since this article was written, Mike has become a born-again Thelemite. "Neddie" has been released from hospital and has found work taking people's telephones to bits and scattering the pieces along the M62.

Letters [8]

URGENTLY REQUIRED:
BODYGUARD

Well here I am but a delicate flower, full of charm, manners and gentleness, sat at my humble Tarot table at craft fairs and on Scarborough front[9] (apologies for the plug) would you believe it, harassed, exorcised, sworn at, bricks heaved at me, obscene phone calls – could you credit it from... "Jesus".

I was receiving a lecture from an alien life form (well he certainly looked it, all he needed were the bolts in the neck and obviously had not been in contact with soap and water for a very long time – what happened to cleanliness is next to Godliness? Oh, well back to the saga, me precious). He was trying to convince me to join the Lord, "Hallelujah!" so in my posh telephone voice (we've all got one, so don't deny it!) I pointed out that he should not be so myopic; the alien answered "Der, what does my (mumble) mean?" Therefore, my darlings, I rest my case. Unfortunately – for me – on the same day there was a lecture of Inner Healing (whatever that entails) above the craft fair done by some Monsignor Whatsisface. Yes, you've guessed it, this alien thing was one of them, along with 250 others! I swallowed hard I can tell you. I felt, to say the least, undoubtedly outnumbered. I did, however, consider doing the most logical thing, which was faint, when they all descended into the fair like stampeding rhinos after hearing that there was a Satanic, Devil-worshipping, murderous witch downstairs. They looked like they were prepared to burn me, with a very unpleasant glint in their eyes, and a happy little pixie I was not.

However, I did not faint, but did quite a few readings for some of this Monsignor thingy's groupies (so knickers to him). I did have the Bible throwing stunt, which I have to admit they do have off to a fine art these days – back in the 14th century the plebs missed you by a mile – and of course the inevitable crossing themselves as they walked past me, however the worst was yet to come.

They were actually turning my customers away. Yes, you read it right, my customers! Well, that was the flaming pits I can tell you, fortunately the organiser

8 We got a lot of mail at Pagan News. A lot. And much of it was very complimentary. Those were nice to get, but boring. What we wanted were letters that were spicy, threatening, bitchy, and generally fun to read, because that made them entertaining and we could publish those.
9 Scarborough is a very popular seaside resort in Yorkshire dating back to Roman times, and made famous by the song 'Scarborough Fair.'

realised what was happening and asked them to leave me alone, which they did – after a fashion. The next time I will duff them with my broomstick!

But my conclusion to all this is that their bark is far worse than their bite, though I have to admit that I have never been bitten by one... not yet.

But... just in case there are any tall, handsome, strong males (with nice thighs) out there who like rescuing maidens in distress among you Pagan chaps, then do chenter my amber!

Blessed be, peeps!
Bryn "Hotlegs" Ormsford[10]

Ed's note: What do you think this is, darling, the occult version of Forum"? Anyway, everyone knows that ye editors have the best thighs in PaganLink. Not difficult, really.

P.S. Bryn has also offered to run an Agony Aunt page in future issues of NPLN, so send in all your agonies forthwith to: Bryn Ormsford, A∴A∴ c/o the MATRIX address. Please mark your envelopes: "I have a personal problem".[11]

10 Bryn Ormsford was a Yorkshire-based Tarot card reader and palmist – and an extremely effective one too. Her willowy nubile charms and charisma made her a popular figure at conventions and on local television shows.

11 We think we meant this as a joke, but looking back we still aren't entirely sure.

PAGAN NEWS

The monthly newspaper of
Magick & the Occult

September ' 88

Price 30p

Yorkshire PaganLink Forms Regional Caucus

Following the Sheffield DayCon, (see below for a report) a Regional Caucus has been set up to co-ordinate **PaganLink** within Yorkshire. The Caucus, made up up of both area co-ordinators and members who wish to work on specific projects, will act to promote and manage **PaganLink** activity throughout the region - from general administration (such as answering new enquiries), to fund-raising and promoting specific projects such as The Pagan Funeral Trust (more on this in October's *Pagan News*). The Caucus will meet on a monthly basis, rotating around the local moots held throughout the region.

As **PaganLink** has grown and developed, the task of regional co-ordination has grown too large for any one person to manage. Phil Hine, who originally volunteered to act as Regional Co-ordinator when the network was formed, has decided to pass on responsibility for regional management to the Caucus, so he can devote more time to *Pagan News*. He will, however, still be active in the region as part of the Caucus.

The Caucus will help to forge links with other networks so that we can give each other support, despite our differences - *infinite diversity in infinite combination*. This is not a network *model* that any one individual or faction is trying to impose onto everyone else, but a group of Pagans who have chosen to manifest the awesome potential which **PaganLink** offers in one particular way. When it comes down to it, you can only decide for *yourself* how you will act - to paraphrase the Charge of the Goddess - if you can't find what you seek within yourself, then you'll never find it outside yourself. Full details on the Caucus next issue.

Playschool Paganism

On Saturday, 3rd September, Sheffield PaganLink held a day-long conference on the future structure of the PaganLink network. Rodney Orpheus brought along the Pagan News portable computer. This is what he brought back. Turn to Page 3 for the full report.

S.O.S

As you are no doubt aware, the virus which is threatening the seals has recently been identified. The previous evening, a mass power-raising exercise was organised to direct energy towards aiding the seals, and in which a good number of people (regardless of path or beliefs) took part. Skeptics will cry "coincidence" - which actually means two events ocurring in harmony with each other. Sounds good enough to me! Thanks to Gordon (PL Manchester) for letting us know.

Hot Metal

As exclusively forecast in last issue, the tabloid press have been out in force all last month trying to denigrate our beliefs (again). The Sunday Sport, currently top of our reading list here at the PN office, with such masterful pieces of investigative journalism as "World War II Bomber Found on the Moon", and "Hitler Was a Woman!", launched a sister paper on Wednesday, August 17th, named, with awesome simplicity, "The Sport". Pride of place in this first issue was a two page spread entitled "Please Save my Baby from Satan", which was a further expose on the Scorpio cult (see last ish), who are accused of perversion and blood sacrifice. The Sport's

NEWS

Hot Metal

As exclusively forecast in last issue, the tabloid press have been out in force all last month trying to denigrate our beliefs (again). The *Sunday Sport*,[1] currently top of our reading list here at the *PN* office, with such masterful pieces of investigative journalism as "World War II Bomber Found on the Moon", and "Hitler Was a Woman!", launched a sister paper on Wednesday, August 17th, named, with awesome simplicity, *The Sport*. Pride of place in this first issue was a two page spread entitled Please Save my Baby from Satan, which was a further exposé on the Scorpio cult (see last ish), who are accused of perversion and blood sacrifice. The Sport's informant on the cult was named as a Mr. Alan Blunden, former member, who has been peddling his story all over the media and seemingly used as the basis of the recent claims made by Childwatch and Geoffrey Dickens MP We can now reveal that Blunden is in fact currently on remand in Norwich prison on a charge of criminal damage, and he will very probably end up in a mental hospital. So much for his reliability as a witness.

Mrs. Dianne Core of Childwatch is now concentrating her attention on the O.T.O., who are accused of being "a sinister Satanic sect who procure children and teenagers, and kill all who interfere with their dark desires for lust, power, and magic". She doesn't seem to realise that if this nonsense were actually true, she'd have been dead long ago. It transpires that the source of her allegations is a Mark Burdman of the really sinister *Executive Intelligence Review*.[2] Dianne Core is now advising parents to watch out for people who wear Scorpio medallions, as they are obviously child molesters (1 in 12 of the population condemned!).

Not to be outdone, Newcastle's Sunday Sun of August 28th ran a feature describing how occultism is an infectious disease, which young people can catch by hanging around "those who have been contaminated by the powers of

1 Founded in the UK in 1986, the *Sunday Sport* is amazingly still going strong, despite being full of the most ridiculous stories known to humankind. Recent masterpieces include: Aliens Turned My Son Into A Fish Finger and Gordon Ramsey Sex Dwarf Eaten by Badger.

2 Executive Intelligence Review is a weekly magazine founded in 1974 by legendary American political nutcase and conspiracy theorist Lyndon LaRouche (1922 – 2019). Three months after we originally wrote this article LaRouche would be convicted of multiple fraud charges and sentenced to 15 years in federal prison. The LaRouche movement also owned many other pseudo-political front organisations, such as the Schiller Institute in Germany, and was in many ways the forerunner of modern American political extremist movements such as QAnon. *EIR* is still being published at the time of writing, with a circulation of several thousand copies per week. And it's still full of insane conspiracy theories dressed up as serious political discourse.

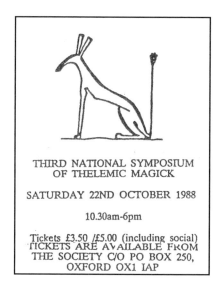

THIRD NATIONAL SYMPOSIUM
OF THELEMIC MAGICK

SATURDAY 22ND OCTOBER 1988

10.30am-6pm

Tickets £3.50 /£5.00 (including social)
TICKETS ARE AVAILABLE FROM
THE SOCIETY C/O PO BOX 250,
OXFORD OX1 IAP

darkness". Treatment on the NHS soon perhaps? Or how about *The People* on the same day, which revealed a Black Mass Horror on Top Tory's Estate – so that's how Ian Gilmour[3] got his seat! We at *Pagan News* were also proud to see our feature on the Green Fair in Harrogate (see June issue) repeated in the *Sunday Telegraph*, no less! Only three months late chaps, must try harder.

And finally, we finish with *The Sport* again. On August 31st it revealed that Fergie's[4] baby, of which the nation is so proud, has been cursed. Guess who by? Yes, none other than our old friend Alan Blunden again, who liked them so much he sent them a painting. Aaaaah…

3 Ian Hedworth John Little Gilmour, Baron Gilmour of Craigmillar (1926 – 2007) was a prominent Conservative politician during the 1970s and 1980s, back when there were actually intelligent Conservatives. He was most notable for his long-term dislike of, and opposition to, his some-time boss Margaret Thatcher.

4 Sarah Ferguson, Duchess of York (1959 –) was the wife of the UK's Prince Andrew. In March 1988 their trip to Los Angeles was described by British newspapers as a "brash, vulgar, excessive, weak-humoured exhibition". After her divorce she reportedly ran up millions of pounds in debts, and has admitted receiving financial assistance from Andrew's close friend, the financier Jeffrey Epstein. We look forward to someday finding out exactly why.

VIEW POINT

Ancient Sites and Moronic Interference
by *Dave Lee* [5]

The study of earth mysteries has come a long way since Alfred Watkins[6] coined the term "leys" for alignments of ancient sites back in the 1920s. Interest boomed again during the 60s dawn of the present occult revival, prompted by new writers like John Michell,[7] and gave us *The Ley Hunter* magazine, which still leads the field. Earth mysteries now covers Pagan sacred sites (and some of their earlier Christian overlays), ley lines, UFOs, and the links between these phenomena and dowsing, crystals and other kinds of subtle energies. Naturally, this all overlaps with areas of interest to Pagans, both from the angle of ritual magic and from that of Pagan religion and Gaia-consciousness. Sacred sites are used by a variety of occultists for various reasons. Since it is almost a truism that occultists can't agree, it tends to come down largely to your opinion of the effects of other people's rites on a given site. However, some more permanent and irresponsible interference with sites is coming to light.

5 Dave was another acquaintance of ours from the Leeds University Occult Society, and former resident of the legendary occult communal house at 4 Ashville Avenue in Leeds 6 (where Rodney had also lived). Dave played a prominent role in the early chaos magic movement, being a member of both the Circle of Chaos and the Illuminates of Thanateros (IOT). He has since written several books on magick such as *Chaotopia!*, *The Wealth Magic Workbook*, *Bright From the Well*, *Connect Your Breath* and *Magical Incenses*.

6 Alfred Watkins (1855 – 1935) was an English author and antiquarian. He discovered the highly influential, if still controversial, concept of "ley lines" in 1921. These ley lines were supposedly straight lines running across the landscape which ancient Britons followed when building their constructions.

7 John Frederick Carden Michell (1933 – 2009) was an English author who published over forty books mainly on occult subjects such as UFOs and earth mysteries. In 1976 he also published *The Hip Pocket Hitler*, a book of "humorous or insightful" quotations from Adolf Hitler. [No, this is not a misprint.] He became a prominent figure in the counterculture movement during the 60s and 70s, despite apparently being a neo-fascist.

Some letters in *The Ley Hunter* and other mags have pointed out that there is a boom in placing crystals at sacred sites across the UK. Apparently, this took off after the "Harmonic Convergence"[8] of last August. Coach and plane loads of New Age tourists were hauled everywhere from the Dagon cliffs to Callanish stones to get us ready for the Big Zap that will cure the world's ills. All based on the usual Theosophical space-waffle, and all terribly compassionate and well-meaning. For sheer moronic behaviour, the report of stones being removed from an ancient enclosure wall at Callanish by some of these tourists is staggering, but the results of the ill-informed good intentions of the crystal-planting crew

> *"There is a boom in placing crystals at sacred sites across the UK. Apparently, this took off after the "Harmonic Convergence" of last August. Coach and plane loads of New Age tourists were hauled everywhere from the Dagon cliffs to Callanish stones to get us ready for the Big Zap that will cure the world's ills."*

may well be more widespread. As there seems no evidence that marvellous new energies have been brought to these islands, it seems reasonable to ask if such ignorant interference might be more likely to have led to some of our continuing train of disasters.

The arrogance of these package tour magicians is exemplified by a letter in the magazine *Lamp of Thoth*[9] concerning the two American women who decided that the British "spiritual shamanic soul" being lost, they would do rituals and plant crystals at numerous major sites last year, in order to teach us the Native American way. I've nothing against anybody's "way", and what's more I believe it's quite possible for some people to work more than one ancestral current without ill effects (it just takes cosmopolitan ancestors). My complaint is twofold:

I don't believe they know what they're doing, and
if they do, it still stinks of holier-than-thou arrogance.

8 The Harmonic Convergence was the world's first synchronized global peace meditation, which occurred on August 16–17, 1987, coinciding with an alignment of planets in an unusual Grand Trine formation. It was organised by José Argüelles and Lloydine Burris Argüelles via the Planet Art Network (PAN), a peace movement they founded in 1983.

9 *The Lamp of Thoth* was an eclectic occult magazine published by The Sorcerer's Apprentice which was the first magazine to publish articles by many authors who would go on to further fame (including your *PN* editors). See Phil's article *Remembering the Lamp of Thoth*, p. 594.

The ley network is a subtle and powerful heritage of our ancestors' love for their environment, for Gaia. Dowsers, often at cost to their health, discovered some while ago that it isn't all sweetness and light, that the ancient sites hold immense power. Is this an ancient technology of survival, community celebration, devotion and magic or just a jumble of wishful thinking, into which you can throw any other component? I'm not getting at people going to sites, psyching them out, doing their own rituals and research. Seeking to alter the function of the sites on a long-term basis sounds like any other form of official vandalism to me; the lack of the crystal planters' explanations of what basis they are doing these things on is insulting to genuine researchers and trivialising towards the stone circles/ sacred sites themselves.

As Paul Devereux has stated: "More questions must be asked about the ancient mind and how it perceived its landscape... rather than further indulgence... with yet more "New Age " projections."

As for the results of the Harmonic Convergence, exactly one year later the British race mind was treated to a brand-new gutter newspaper which reports spurious ET encounters. Sound familiar?

THE COMPUTER RIDES OUT
by *Barry Hairbrush-Wheatley*[10]

Chapter One

The slight drizzle had just started to fall on the little country station as Sir Guy Suit's Rolls pulled up to collect me.

"Jump in, Barry," called Sir Guy, a steely look on his handsomely-bearded face. As the Rolls drew out of the station, the stately towers of Suit Hall were already visible beyond the rainswept hills.

"I got your telegram last night, Guy."

"I trust its contents did not alarm you. As you know, I have, shall we say, a sense of the theatrical." Sir Guy lit a hand-rolled Turkish cigarette.

"No – rather I was intrigued. I recognised that it was from you – the family bloodstains on the paper. So tell me – what's this about?"

"Charlie."

The single name shocked me into attention. Sir Guy, Charlie Richbastard and I had been bosom pals since we'd met in the army, teaching Johnny Chink not to steal white

10 After the success of his previous one-off humour article, Barry turned up one day at the *PN* office with a full pastiche of the highly popular occult novels by English author and "Traditionalist" right-wing political nutcase Dennis Wheatley (1897 – 1977). Wheatley had worked for the London Controlling Section (LCS), a secret British military intelligence department which coordinated Allied strategic military deception during World War II. Many of his books were turned into popular (and awesome!) Hammer horror films, including *The Devil Rides Out* (known as *The Devil's Bride* in the USA apparently), starring Christopher Lee and directed by the fabulous Terence Fisher. We highly recommend that all readers stream this movie as soon as humanly possible, it is unintentionally hilarious. This parody by Barry is obviously very heavily indebted to it.

men's houses. We'd always looked out for one another. Charlie and Sir Guy had been jolly decent after my international arms-smuggling racket got found out by Johnny Taxman, and I'd joined forces with Charlie to cover up that nasty business about Sir Guy and... and the young lads.

Now it seemed that Charlie was in need of our aid.

"Tell me, Barry," said Sir Guy, now ensconced in his favourite armchair at Suit Hall, "what do you know about computers?"

"Load of rubbish really, any sane person'll tell you that. Johnny Nip makes a lot of 'em – enough said."

"If only it were true, my friend." said Sir Guy, watching the firelight play through his brandy glass, while scratching his balls with that aristocratic ease I've always found it hard not to envy. "You see, computers are a reality in our modern world. If I told you how many people actually believe in them, you'd be horrified. There is a working computer in practically every school in the land. Thousands – maybe millions – of ordinary young people are being tempted to dabble in the mysteries of data processing."

"Oh come, Guy! You're a rational Satanist! Surely you don't believe in all this... this scientific claptrap?"

"On the contrary..." and Sir Guy's eyes blazed with an intensity I've rarely seen outside his favourite "gentlemen's club", "I've made a very careful study of the 'computernatural' as some people like to call it – and I'm pretty sure that young Charlie has been initiated into a... User Group."[11]

"No – not level-headed Charlie! Why I've summoned Bartzabel and his attendants many a time with young Charlie... he's a perfectly devil-fearing occultist." Sir Guy shook his head sadly at my ejaculation.

"I'd been noticing strange things about Charlie. His 'Apple User' T-shirt, the twitching joystick-finger, the constant smell of Diet Coke on his breath...[12] Believe me, Barry, Charlie has fallen in with some highly scientific company. Last week I went to see him. He wasn't in, but while I was waiting, the phone rang."

At this point, Sir Guy turned on an elegant Louis Quatorze tape deck, one of the many priceless antiques in his collection. An ugly, evil roar began to fill the room, a screeching redolent of anguished souls in torment.

"I say! What is that fiendish noise, Sir Guy?"

"Data being transferred at the 2400 Baud rate over a modem. I taped it at Charlie's house."

11 For the benefit of our younger readers, back in the 1980s computers were still weird, very expensive things that very few people owned. And we didn't have the Internet. So computer owners would get together in hobbyist User Groups to exchange information and software (on floppy disks!). So yeah, this joke made a lot more sense back then :-)

12 On the other hand, some things haven't changed at all.

"Guy, we've got to do something at once!"

"Yes – let's visit Charlie this evening. We'll take the Bentley."

A number of cars were already parked outside Richbastard Villas as Sir Guy's Bentley trundled smoothly up the drive and hit a servant.

"Looks like Charlie's got company already," I commented.

"We'd better watch our step," Sir Guy agreed.

"Aaaahh, aaahhh, aahhhh," came from under the wheels.

Charlie came bounding up to meet us; I saw no real change in the fresh-faced lad whose father had campaigned so tirelessly to make being black illegal. He seemed full of the usual sense of fun and high spirits. But Sir Guy drew me aside and pointed out the tell-tale signs – the four-coloured pens in his pocket, the Epson posters on the wall.

We were led into a room of people talking of strange and hidden things, of processors, bytes, the latest mouse-driven software. Some, in hushed and reverent whispers, spoke of the 'Great Old Ones' – the ZX81[13] and the Oric.

"You'd better come clean, Charlie. You're into computers, aren't you?" Sir Guy confronted Charlie with a cold, determined glare on his lips.

"I... well it's only a hobby. A pastime, a bit of fun, that's all," Charlie stammered, lost for words.

"A pastime? Meddling with that sort of thing? Believe me, Charlie, I've made a very careful study of these things and I know the danger you're letting yourself in for." Sir Guy pointed to Charlie's bookcase, where brightly-coloured technical manuals clashed with the sedate mahogany. Here, beyond any doubt, was proof of Charlie's obsession. Evil, banned, shunned books: the BBC Master Series circuit diagrams in the full, unexpurgated edition, the *Manual of the Apple Macintosh*, and there, in the middle of them all, the most evil, horrifying book on computers ever written – the notorious *Electronomicon* of Sanjit Patel, the infamous 16th-century magus some call 'The Mad Pakistani'.

At that point, a cold shiver ran down my spine. It was as if my very astral being were being forced to eat an ABBA album.

The entire User Group had turned to look at us, cold malevolent hatred on their faces. I watched in horror as they moved slowly towards us...

The editors would like to emphasise that this is a work of fiction and is not intended in any way to encourage a belief in the computernatural. All characters, events and places depicted herein are entirely imaginary, and the descriptions of computers are taken from common books on folklore. Sanjit Patel is not a historical character, Pakistan is not a real place and there is no genuine edition of the Electronomicon.

13 The Sinclair ZX81 was the first affordable mass-market computer, containing a grand total of 4 silicon chips and 1 kb of RAM! From its inception in 1981 it sold 1.5 million units and changed the lives of a generation. Its inventor was the classic British eccentric Sir Clive Sinclair, who died recently and is sadly missed.

Letters

From, "a Hammered Hack", Manchester

NPLN has gone in for a good deal of Hack Hammering in the last few issues, but to what purpose?

Certainly, full marks for drawing attention to the Commons outburst of Tory MP Geoffrey Dickens, concerning witchcraft and child sex abuse, which the papers loved (enough said); and for the *NPLN's* recent "horrific" headlining article, "Human Sacrifice – The Truth?" which resulted from the original copy in one of the nation's more cosmic newspapers (*The Star*, I believe) which does indeed have an awesome fascination for the occult.

But does the blame lie with them? I think not. The "ordinary" person in the street has very little knowledge of, or access to Pagans (or should I say Satanists!) never mind the media. But what do we do about it apart from draw a veil of secrecy over our activities, rituals etc., often short-sightedly preferring the sanctuary of our homes, countryside, craft shops and sympathetic bookshops.

Contact your local newspaper/radio station/freesheet and let them know what you're doing for, and in, the community. Take a leaf out of the York Folklore Society's book, whose members dared hold a dragon procession in the city in which St. George was felled by the dragon, and the local radio and press lapped it up...

We're still working on stamping out sexism and racism in the media... so it will take time, but then, that's something that Pagans know all about.

From Susan Class, Market Weighton:

Readers will know, and be concerned about, Mr. G. Dickens MP and the amount of publicity he has received recently in his campaign to "prevent child sacrifice and sexual abuse by witches." He alleges that he has a dossier of proof provided by Mrs. Dianne Core of Childwatch. No facts have been made public or given to the police for investigation.

This campaign has done much to damage the cause of sane Paganism. The old sensational myths are once again being aired in the national press and mud sticks. It is ironic that in this area several members of the Christian Church have been prosecuted recently for child molesting. Only one, who hanged himself in prison, was given national attention. There was no "all vicars are perverts," headlines and quite right too. Yet it seems all Pagans can be tarred with the same brush and the allegations not even questioned. However disgusting the accusation apparently it will be believed because it is about witches, if you are Pagan but not a witch don't sit back and let this go because it isn't aimed specifically at you. Next time it might be.

Perverts use many covers for their activities, not just wicca. I suspect the old jokes about scout leaders and choir masters are just as unfair. Childwatch has many volunteers who are doing good work counselling the abused. Publicity seems more important to their leader Mrs. D. Core who seems to spend much of her time in London with Mr. Dickens or talking to the media.

The new witch-hunt seems to be losing steam but it will reappear, with more fantastic allegations and perhaps with enough strength to reintroduce the Witchcraft Acts. Mrs. D. Core is the organ grinder this time and Mr. Dickens her monkey. Mrs. Core's address is 60 Beck Rd, Everthorpe, N. Cave, Humberside. Please write to her to put forward the case of sane Paganism.[14]

Star Letter! [15]
From Cynthia Dickinson, Wakefield

I must admit to being rather disappointed with the tone of the August issue, particularly the mockery of Christianity by "Barry Hairbrush". I believe in tolerance of and respect for alternative opinions, attitudes and beliefs, whether I agree with them or not. I would much prefer a newsletter that promotes Pagan ideals, opinions, attitudes and beliefs without petty mud-slinging. I'm sure we can have fun and express a sense of humour without such articles. I don't even agree with the sentiments of page one, that we should devote our energy "to attacking our real enemies." To me, that is a waste of energy which could be used in a constructive rather than defensive or destructive way. But that is just my opinion.

Our intention in publishing Barry's piece was to lampoon the way in which the tabloid press consistently misrepresent and ridicule Pagan beliefs and practices. And personally, I'd rather attack my enemies than attack my allies. Love & kisses, R. O.

14 Needless to say, please don't do this now. That was over 30 years ago.

15 Right from the beginning we would receive letters of criticism every month, often including the line "I know you won't print this, but…" Given our contrarian natures, that meant we would usually give them pride of place in our Letters column with the heading 'Star Letter' surrounded by starry graphics and anything else we could do to make them stand out. This often infuriated the writer even more, and we would frequently get a follow-up letter more strident than the first. Which always gave us a good laugh. And something else hilarious to print in the next issue.

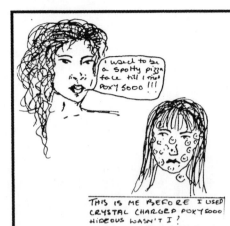

PAGAN NEWS

The monthly newspaper of
Magick & the Occult

October ' 88

Price 30p

AUTUMN LINK-UP : REPORT FROM THE BACK

Autumn Link-Up, a two-day event organised by Leicester PaganLink and the Green Magic Collective, was held on the 17-18th September, in Queen's Hall, Leicester University. It combined a psychic/magical festival & national PaganLink conference, and featured a multitude of talks, workshops, music, drama, dancing, bands and art exhibition. It cost over £5000 to run, and was funded in part by a City Council Grant - surely a first for an event of this nature! It was hoped that Autumn Link-Up would be a focal point to enable pagans from all paths and persuasions to meet and enjoy each other's company, which judging from the spontaenous dancing and drumming in the bar on Saturday night, certainly happened.

Many came to Autumn Link-Up with ideas and projects to set up, and there was much discussion and exchange of addresses. People who'd been corresponding for months met up for the first time, which was a joy to behold. There was too much to take in, too much going on to describe except to say that we need more events like this. The organisers did a fantastic job and still found time to organise lifts and accomodation. What marred the proceedings was the news that a cashbox and bag of silverwork had been stolen from one of the stalls. Hopefully, this won't deter people from setting up similar events, but it is a grim reminder that the "perfect love and perfect trust" in which the festival was brought together, is still a long way off for some people. The perennial problem of stallholders making a loss was still present. Many struggling businesses on the festival scene are happy to turn up for the social benefit, but money is still a problem at the end of the day. In this, Leicester was no different than any similar event of this kind. It'd be easy to pass over this as unimportant - as a whole event Autumn Link-Up was a huge success in terms of bringing people together - but without the support of the stallholders, most of whom are pagans, we'd be hard pressed to run events like this.

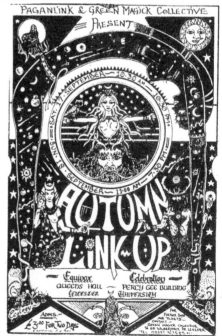

INSIDE:

FEATURE ON WOMEN'S SPIRITUALITY

NEWS

God-Squad Bash Bradford Pagan!

A female worker at The Body and Soul Occult Emporium in Bradford was last month threatened by a group of Christians outside Bradford Job Centre. She had approached them to complain about the noise they were making, and challenged them with a simple banner. She was grabbed by the arms and told to leave in a very hostile fashion. She refused, saying that she was exercising her right of free protest (as were the Christians), and was then set upon and pushed around. The police arrived, and despite protestations from passers-by, she was the one who was arrested!

Lies of a SHE-Devil!

Anyone who thinks that the Dickens anti-witchcraft campaign is running out of steam should take a look at the October issue of *SHE* magazine.[1] A long article "The Devil Hides Out" has been cooked up by "experts" such as Geoffrey Dickens, Dianne Core, and the Rev. Kevin Logan[2] – the man who wanted to erect a huge crucifix on the top of Pendle Hill![3] *SHE* is launching a campaign "against these evil practices". We urge all *PN* readers to write in and let them know your views. Write to: Joyce Hopkirk (Editor), *SHE* magazine, National Magazine House, 72 Broadwick St, London W1V 2BP.

1 *SHE* was a British women's monthly magazine that ran from 1955 to 2011.

2 The Reverend Kevin Logan was the Church of England Vicar of Accrington in the North of England, and writer of multiple books, including a trilogy covering "Paganism and the Occult". He became notorious for his objections to such diverse subjects as evolution, homosexuality, and Harry Potter. He now appears to devote his time to writing about Accrington Stanley Football Club on Facebook. No, really, we are not making this up.

3 Pendle Hill is a famous landmark in Lancashire, England, described as an area "fabled for its theft, violence and sexual laxity". In 1612 it was the focus of the notorious Pendle Witch Trial. Nine women and two men were accused of murder by witchcraft, with nine being found guilty and hanged. Fun fact: the novel *Good Omens* by Terry Pratchett & Neil Gaiman includes several characters named after the original Pendle witches, including Alice Nutter and Elizabeth Device. The local X34 bus route which runs near Pendle Hill today is now called The Witch Way, with some of the vehicles operating on it named after the witches in the trial. Pendle Hill is also famous for being the location of the vision of George Fox in 1652, which led to the foundation of the Religious Society of Friends (Quaker) movement.

Witchcraft Museum For Sale?

The Boscastle Witchcraft Museum[4] in Cornwall may very soon be sold off to rich collectors in the USA. Thus a very important part of our Pagan heritage – the magical regalia of both Wiccans and members of The Golden Dawn, will be lost. The collection of regalia at Boscastle is unique, having taken 50 years to assemble. A campaign has been launched to try and keep the Museum's collection within the British Isles. For further details write to Lynn Brown, 18 Levisham St. York.

Sacred Sites Threatened

Two Pagan sacred sites on the Isle of Arran are being threatened by forestry development. The sites, Torr Righ Mor and The Doon, are of potential archaeological value. Efforts to preserve the sites are being directed by Steve Blamircs, Ivy Cottage, Whiting Bay, Isle of Arran.[5] Any offers of help would be appreciated (write enclosing an SAE).

4 The Museum of Witchcraft and Magic is located in the village of Boscastle in Cornwall, south-west England. The museum was founded by Cecil Williamson in 1951 in the town of Castletown on the Isle of Man, employing seminal Wiccan Gerald Gardner as "resident witch". Gardner purchased it from Williamson in 1954, renaming it the Museum of Magic and Witchcraft. After several changes and moves, Williamson eventually set up the current museum in Boscastle in 1960. As it turned out, he did not in fact manage to sell the museum until 1996. The museum continues to operate at the time of writing and is an essential part of the itinerary for Wiccan tourists to the British Isles.

5 It is important to note here that these News items each ended with a call to action, and details on how to contact the people involved. We considered this to be a vital part of our mission – *PN* didn't just exist to inform readers of things happening elsewhere, it was there to encourage people to get involved directly and bring about actual real change.

REVIEW

CRISIS

Created by Pat Mills & Illustrated by Carlos Ezquerra
A 2000AD production. 65p. On sale fortnightly.
Review by Phil Hine

If you are into comics, then *CRISIS* will blow you away! Hard on the heels of the realpolitick iconoblasts delivered by *Watchmen* and *V for Vendetta* it rams you hard into the all-too-near future of "Third World War" – a not all that distant world where Big Macs are served up with a smile and a bullet. A squad of draftee hipsters sent in to "Free the Third World from Poverty", only that red stuff isn't always ketchup. And one of them's a witch too!

"New Statesmen" has a slower pace, but is definitely another nail in the coffin of the myth of the squeaky-clean superhero.

CRISIS is compelling reading. If you think you're too old for comics then think again. This is real people, real events. Someone out there is being given the hard sell. Read "Third World War" – it's already begun and the stakes are high!

THE COMPUTER RIDES OUT
by *Barry Hairbrush-Wheatley*

Chapter Two

"The history of empires is the history of men in smart trousers. One only needs to count the number of broken teapots in the world to see the truth of this."
The Bene Gesserit (Surrealist Squad)[6]

I shall never until my dying day forget the way Sir Guy Suit got out of Charlie Richbastard's study. Seizing two candlesticks from the fireside he held them up in the dreaded V for Virus sign. The computer freaks backed away in terror.

"Hairbrush! The window!" he roared, his eyes ablaze with fury. Remembering my military training, I made a leap for the window. Trailing shards of flying glass, I plummeted to the ground below. Just before the pig trough broke my fall, I heard the frantic stabbing of computer keys above, and metallic voices clacking out, "Systems crash… systems crash…" A wail of fear came from above, and Sir Guy fell out. Just in time, I managed to call a servant to break his fall.

"Good Gods, Suit!" I exclaimed, "What happened?"

"Dammit," Suit snarled, picking himself up from the luckless retainer, "I was fitting

6 Thanks to Denis Villeneuve's mammoth two-part film adaptation of *Dune*, the Bene Gesserit will probably need no introduction to most readers. At *Pagan News* we were huge science fiction nerds, and if there was one thing we all agreed on it was that the *Dune* books were the greatest SF series ever. You should read them too. Just remember to finish with *God-Emperor of Dune*, the ones after that are… not great.

together some D2-706 patch cables to make an escape rope, but none of the couplings matched and the whole thing came apart when I put my weight on it."

We limped over to the car, just as two vicious-looking attack dogs sailed towards us out of the darkness.

"Drive!" yelled Suit, reaching into the glove compartment for his trusty mini rocket launcher. The car bucked slightly as the rockets kebabbed the snarling beasts, but the Bentley is a sturdy British machine, and can take such punishment without complaint. We swerved off back to Suit Hall.

* * *

Firelight glinted through my brandy as my wounds were dressed by one of the young Arab boys that always seemed to be hanging around Suit Hall. Suit surveyed himself in the scrying mirror, his beard combed back into its usual immaculacy, his velvet smoking jacket smouldering merrily on his back.

"So what now?" I asked. Sir Guy pursed his lips.

"I'm not sure. For so many of them to be in the one place... there must be some great event in the near future, some digitised nightmare which beckons to them all."

"Do you know of any such event?"

"Well, as you know I have made a very careful study of these things. I subscribe – anonymously, of course – to an evil publication from a Leeds mail-order firm. Here it is." He opened a locked drawer and took out a copy of *MacUser*. Monocle clenched in his eye, he pored through the glossy arcade reviews and printer bench tests that had cost so many innocents their credit cards. At last, a cry of triumph and he slammed the paper down. "How could I have been so stupid as to forget? Look – tomorrow night! It's the annual Microfair at the exhibition centre – the biggest festival of the Silicon year, when the great Mainframe himself will be logged into! If Charlie is to be going there, why, it'll be the end of him. Nobody leaves the Microfair without becoming a total computer freak."

"Suit – something must be done."

"True, my friend. And it is we who are going to do it."

"But what can we do against such forces?"

"Tonight we will work the invocation of the Nephilim with due sacrifice and meditation. And then we must contact my head-gardener."

"The gardener? Why?"

"He's a Vietnam veteran, and when he left the army, he kept all his weapons. Always a useful chap in a pinch, if a bit mentally unbalanced from the war – Johnny Nip, you know, torture camp. Now, let's to the ritual."

Suit unsheathed his athame, and the candles glinted on its blade like a kiss of sweet lightning from the titan shadows of forgotten aeons.

We were in for a pretty wizard evening.

PAGAN NEWS

The monthly newspaper of
Magick & the Occult

November ' 88
Price 30p

Whale meets Whale!

Those readers who live in the North-East will probably be familiar with D.J. James Whale, whose phone-in radio show is enormously popular. Now all of the country can catch his irreverent (some would say awesomely irritating) style, courtesy of ITV's "Night Network". The first national James Whale show was broadcast on the morning of 8th October, the subject was - "black magic!" - and the star was Pagan News' favourite M.P. Geoffrey Dickens (is there no avoiding this man?). Oddly enough, rumour has it that Geoffey's nickname around the House of Commons is "The Great White Whale", which is not surprising, as he really is enormously fat. Accompanying him was some doddery old priest, whose name is instantly forgettable, as were his comments - the usual "Well, James, the thing is, that Paganism isn't really a religious belief, it's just inspired by the Devil...." etc. The programme had a couple of filmed items - again the usual stuff - Barbara Brandolani's front room in Manchester, stuffed with occult paraphenalia, a bit over the top, perhaps, but it always makes good television; and Chris Bray at The Sorceror's Apprentice, who has been on TV so many times that he made it look all too easy. Then it was back to the studio, where Geoffrey went on and on about how evil it all was. We also had The Rev. Kevin Logan (he's the nut who is campaigning for the erection of a twenty-foot high concrete cross on Pendle Hill) pushing his new book about all the thousands of young children who are being destroyed by the powers of witchcraft - we will be asking for a review copy, you can be sure!

In the studio later we had the well-respected witch Patricia Crowther to add a sprinkling of grace and sanity to the proceedings. It's a pity she had to go and spoil it by trying to perform a Wiccan rite in the lobby of the TV company live on the air - the Pagan News team were cringing on the floor by this stage. Interspersed with all this nonsense we had phone calls from interested viewers - usually along the lines of "Do you believe people can contact the dead then, Father?" Full marks to Chris Bray, who called in and made mincemeat of Dickens and his ridiculous anti-pagan allegations with a few well-chosen sentences. Dickens ended up stating that he had nothing against pagans (he just wants to bring back the Witchcraft Act is all!) but that this was a Christian country and that he had no sympathy with anyone who did not share his Christian beliefs. I wonder how the Hindus, Buddhists, and Moslems who live in his constituency feel about this?

So what lessons can we draw from all this? That we should stay away from the "Big Media"? No! Just the opposite. Dickens and co. got their point across to millions of listeners. Some of them - many of them - will believe the lies. Dickens has started a war - an information war - and we must fight back with all the weapons at our disposal. We have got to learn how to get our views across successfully, and not just sit around bitching about how bad it all is.

One last note - it was nice to see a copy of Pagan News lying on James Whale's desk during the show - wonder what Geoffrey thought of it?

Whale Meets Whale!

Those readers who live in the North-East will probably be familiar with DJ James Whale,[1] whose phone-in radio show is enormously popular. Now all of the country can catch his irreverent (some would say awesomely irritating) style, courtesy of ITV's *Night Network*. The first national James Whale show was broadcast on the morning of 8th October, the subject was black magic!, and the star was Pagan News' favourite MP Geoffrey Dickens (is there no avoiding this man?). Oddly enough, rumour has it that Geoffrey's nickname around the House of Commons is "The Great White Whale", which is not surprising, as he really is enormously fat. Accompanying him was some doddery old priest, whose name is instantly forgettable, as were his comments – the usual "Well, James, the thing is, that Paganism isn't really a religious belief, it's just inspired by the Devil..." etc. The programme had a couple of filmed items – again the usual stuff – Barbara Brandolani's[2] front room in Manchester, stuffed with occult paraphernalia, a bit over the top, perhaps, but it always makes good television; and Chris Bray at The Sorcerer's Apprentice, who has been on TV so many times that he made it look all too easy. Then it was back to the studio, where Geoffrey went on and on about how evil it all was. We also had the Rev. Kevin Logan (he's the nut who is campaigning for the erection of a twenty-foot high concrete cross on Pendle Hill) pushing his new book about all the thousands of young children who are being destroyed by the powers of witchcraft – we will be asking for a review copy, you can be sure![3]

In the studio later, adding a sprinkling of grace and sanity to the proceedings, we had the well-respected witch Patricia Crowther.[4] It's a pity she had to go

1 James Whale (1951 –) is a long-serving English talk show host. He originally began broadcasting on Radio Aire in Leeds (based just a stone's throw from where Phil & Rodney lived in Leeds 6) as a typical early morning phone-in host. However on November 18, 1988 he launched a late-night show heavily influenced by the new generation of American "shock jocks". The show quickly became a major success across the UK.

2 Barbara Brandolani (? – 2015) was the High Priestess of the Hermetic Order of the Silver Blade. Phil, along with several other Pagan luminaries, was once kicked out of the aforementioned house in Manchester – for the full scurrilous details of that episode you will have to buy him a drink sometime.

3 Sadly, we never got one.

4 Patricia Crowther (1927 –) author and (for a change, genuine) Wiccan High Priestess. She was initiated into Wicca by Gerald Gardner in 1960, and founded a coven in Sheffield in 1961 along with her husband Arnold. Fun fact: it was Arnold Crowther who had originally introduced Gardner to Aleister Crowley in 1947, which would lead to Gardner later joining the O.T.O. and would heavily

and spoil it by trying to perform a Wiccan rite in the lobby of the TV company live on the air – the *Pagan News* team were cringing on the floor by this stage. Interspersed with all this nonsense we had phone calls from interested viewers – usually along the lines of "Do you believe people can contact the dead then, Father?" Full marks to Chris Bray, who called in and made mincemeat of Dickens and his ridiculous anti-Pagan allegations with a few well-chosen sentences. Dickens ended up stating that he had nothing against Pagans (he just wants to bring back the Witchcraft Act is all!) but that this was a Christian country and that he had no sympathy with anyone who did not share his Christian beliefs. I wonder how the Hindus, Buddhists, and Moslems who live in his constituency feel about this?

So what lessons can we draw from all this? That we should stay away from the "Big Media"? No! Just the opposite. Dickens and co. got their point across to millions of listeners. Some of them – many of them – will believe the lies. Dickens has started a war – an information war – and we must fight back with all the weapons at our disposal. We have to learn how to get our views across successfully, and not just sit around bitching about how bad it all is.

One last note – it was nice to see a copy of *Pagan News* lying on James Whale's desk during the show – wonder what Geoffrey thought of it?[5]

Bray Bites Back!

More on Chris Bray... On Wednesday 21st September Chris had been due to appear on Radio Leeds to talk to Geoffrey Dickens, but on this occasion the conversation never took place, since Dickens, in Chris' words, "chickened out". His place on the show was taken by Bill Williams, who will be known to observant readers of *Pagan News* as the Assistant Editor of *SHE* magazine, and the man responsible for last month's witch-hunting feature. Chris took no time in demolishing all Williams' statements, and generally came out the clear winner in what was a rather heated exchange.

It's extremely encouraging to see that we Pagans can get our views across if we try hard enough. Chris Bray is now organising a national Occult Census, see p.84. (Thanks to Chris for sending us a tape of the show.)

influence Gardner's creation of the Wiccan system. See Rodney's article on the subject: 'A New and Greater Pagan Cult: Gerald Gardner & Ordo Templi Orientis' http://rodneyorpheus.com/writings/occult/a-new-and-greater-Pagan-cult-gerald-gardner-ordo-templi-orientis/

5 In succeeding years we would find that there would be a copy of *Pagan News* on the desks of pretty much every media personality involved in the Satanic Ritual Abuse myth. It's amazing how far our little back room zine managed to penetrate the corridors of power.

Hallowe'en Howler

Did you enjoy Samhain? Did you know that Hallowe'en images & icons spread fear amongst children and old people, encourage vandalism, and suggest that evil is fun and goodness boring? Such is the view of the Association of Christian Teachers. They argue that Hallowe'en is not part of any "mainstream faith" (oh yeah?) and that it lowers children's resistance to the growing interest in the occult. Want to know more? For 40p + SAE you can get a pamphlet entitled Hallowe'en in the Classroom, from Association of Christian Teachers, 2 Romeland Hill, St. Albans, Herts AL3 4ET.[6]

Bradford Row Continues

The fracas between a group of Christians and a lone Pagan last month in Bradford (see Oct issue) continues to have its effect. Zoe Simpson of The Body & Soul Shop says she was bruised by a member of the "Abundant Life Church",[7] a "fringe" Christian group. Bradford's *Telegraph & Argus* newspaper has printed a series of protest letters from members of the local Christian community, but letters sent in by local Pagans on the subject appear to have been passed over. Curious, eh?

STOP PRESS!!

SHE magazine are intending to print a retraction of their article on witchcraft last month! It seems that one of the more together Pagan organisations, the Pagan Anti-Defamation League[8] put their solicitors onto the case, and *SHE* has been "asked" to give Pagans space to reply in a future issue, possibly two months.

Childwatch are concerned that Dianne Core's ravings are doing more harm than good, and are reportedly asking Pagans to write in and put the record straight. Sounds like too good an opportunity to miss!

6 Many years later Rodney would spend some time as a college lecturer. Imagine his surprise when a similar campaign was launched at his college to get rid of Hallowe'en celebrations! Imagine the even greater surprise for the college when he and several other lecturers threatened to sue the college for religious discrimination against Pagans (and won).

7 The Abundant Life Church based in Bradford, Yorkshire, was founded in 1971 as part of the burgeoning charismatic movement. It would grow to become a modern megachurch and under its new name of LIFE Church UK it currently also generates income creating Christian records and TV shows. There's a sucker born every minute.

8 The Pagan Anti-Defamation League ran from around 1985 to 1990 under the leadership of Prudence Jones and Nigel Pennick (of whom more later).

Word has it that St. Esther[9] herself may be approached to give airtime to defend Pagan views. Sounds a bit like the lamb lying down with the lion – watch those teeth![10]

Sorcerer's Census

The increasing flood of anti-Pagan propaganda coming our way over the past few months has been thriving on the ignorance that most people have about occultism – the half-truths (and downright lies) of Dickens, Core, et al go largely unchallenged in the media, since in the eyes of most these idiots are "experts", and so they must be right. To counter this, Chris Bray has put the large resources of The Sorcerer's Apprentice behind a project which will attempt to garner some real facts about the Pagan world today. The Occult Census is being distributed widely throughout Britain, and within a few months enough data should be collated for the first proper survey of what exactly goes on in the minds of us "weirdos".

No survey can ever be exactly representative, and given the inherent secrecy of most occultists, this one will surely be no exception – but if you want to see your point of view put forward, this is one way to do it. We here at *PN* are supporting the Census by sending out copies to as many of our readers as we can. If you have not received a census form yet, simply send an SAE to The Sorcerer's Apprentice, The Crescent, Hyde Park Corner, Leeds LS6 2NW and ask for one (or several, pass 'em around).[11]

Editorial note: we feel we must advise those filling in Occult Census forms to take very great care. Information about occultists is considered valuable by the internal security forces in this country (Goddess alone knows why), and thus it may be wise not to put your full name and address on the form – your postcode is sufficient. We also advise you to put the form inside a sealed envelope, and do not write the words "Occult Census" anywhere on the outside of the envelope. OK, so we're paranoid...

9 Dame Esther Louise Rantzen DBE (1940 -) is an English television presenter, who was a household name in 1980s Britain due to her astonishingly popular (and irredeemably awful) TV show That's Life. She is also a famous celebrity face fronting various charities dealing with child abuse, despite being a friend of serial rapist Jimmy Savile, and the ex-lover of accused serial child abuser MP Nicholas Fairbairn. She has been criticised for failing to act on allegations about Saville.

10 Ms Rantzen was also famous for her overly large teeth.

11 More on the results of this in succeeding pages. A booklet with the results of this census is apparently still available from the Sorcerer's Apprentice.

SPOTLIGHT

The Secret Life of Rodney Orpheus [12]

In the odd hours when he isn't editing Pagan News, *Rodney Orpheus sneaks off to tour Europe with his band, The Cassandra Complex. Though relatively unknown in the UK, The Cassandra Complex has a huge following in Europe, and the forthcoming tour will take them through at least half a dozen countries. The last record,* Theomania *sold over 20,000 copies and* Pagan News *caught Rodney between studio sessions for this interview.*

PN: How did you get involved in magick?

RO: One day in the library I picked up David Conway's *Magic: An Occult Primer,* (a true classic), which opened up a new world to me. This was what I'd been waiting for – the first thing in my life which made spiritual sense. Pretty soon, my local library had one of the best collections of occult books outside the British Museum.

PN: What kind of magick are you interested in?

RO: All kinds. My primary interest is Thelema, and 20th-century manifestations of ancient magicks. I'm quite willing to adopt any belief system that happens to be useful at the time.

PN: What was the first practical act of magick you did?

RO: I wondered if I could make a talisman to invoke a planetary spirit, and lo and behold, Wham! the planetary spirit was suddenly in the room with me. And I thought "Oh shit – what have I done?" This brought it home to me very fast just how powerful magick was, and also just

12 OK, so we used our magazine to give Rodney and his band some free PR. In our defence it wasn't our idea, people kept asking Rodney about his background so we thought we'd kill two birds with one stone. Rodney says that 30 years later he reserves the right to have changed some of his opinions since we did this interview, but probably surprisingly few. Note that at the time of writing Rodney is also finishing off yet another new album by The Cassandra Complex. Go get that one too.

MAGICAL MUSIC

Rodney Orpheus, vocalist with The Cassandra Complex, talks about the magick in his music.

how dangerous it was; that you really had to be careful what you were doing, but also how useful it was, and how brilliant it was, that these things happened. But you had to know what you were doing. I was really scared, panicking, but I read the book and figured out what to do. After that, I made sure that I had some idea what I was doing before I tried anything again. That was well over ten years ago, and I'm still figuring some things out. Magick is a very long and lonely business.

PN: How far has your magical development influenced your music?

RO: My magical development influences everything I do, it has to, otherwise there wouldn't be any point in doing it.

PN: You don't seem to make obvious references to magical themes in your lyrics, like other "magically" influenced bands do.

RO: When I write a lyric, I often get embarrassed because the subject of the lyric seems so obvious. It's only just now that I'm starting to realise that people don't find my lyrics obvious. To my mind, most groups which use magical

themes don't have an understanding of how magick really works in the modern world. Singing about television has got as much magical validity as singing about athames – it's just as strong a magical weapon.

PN: How do the fans react?

RO: Pretty well, I think. I think that most young people today are very interested in magick, if they have the opportunity to experience it and discuss it. At concerts, people quite often ask me about things, and I always talk to them about it.

PN: What do you think is your most overtly magical song?

RO: That's a really difficult question – because I can see the meanings in them all, but it depends what people listening think. The new single, 'Gunship' is very magical, but it's very well hidden. It's inspired by the Vietnam war, although the original idea came from something I read about a woman who'd been raped. She said that right at the moment of being raped, she saw the fear in the rapist's eyes, and realised that no matter what happened, she had won.

Even though she was the victim, at that moment of absolute conquest, she became the winner, because she found a strong centre within herself, where nothing could touch her. This made me think of Vietnam, where the Americans barged in, very strong, and raped the whole country. The Vietnamese people took all this shit, but won. In 'Gunship' a Vietnamese guy

finished until people hear it and respond to it, because their response completes the picture.

PN: There's a song you've just finished called "E.O.D." What's that about?
RO: "E.O.D." is inspired by the Esoteric Order of Dagon – a magical order who work with the Cthulhu

> *"Everything is political, because politics is all about the way you want to live your life. It's about who controls what you want to do. The way you do anything must therefore be political, because you're expressing something about yourself. Most importantly, politics is about what you do. All the songs are political, no matter what they express."*

is shot down by a helicopter pilot, and when he dies, his soul possesses the pilot, driving the American's spirit out, so that he becomes the helicopter pilot and goes back to America and changes their way of life. So 'Gunship' is about the magical use of power against someone who uses it against you. People might not understand what the song's about intellectually, but that's not important as long as people can feel what the emotions are. People often ask me what a song is all about, and I always say – "What does it mean to you?" Again, this comes back to magick because when I write a song I tap into a magical current that that song expresses, like you're acting as a medium to that. Of course I am an imperfect mirror in that I don't reflect exactly what's going on, but I reflect my perspective on it. A song's never

Mythos transmitted by H.P. Lovecraft, and the song's an expression of their magical cosmology. In a way, the whole song is an invocation of Cthulhu.

PN: Couldn't that be dangerous?
RO: Yes, of course it's dangerous. All rock music is dangerous, because it breaks down the barriers – it produces "anti-social tendencies". It breaks down primal conditioning, bringing forth feelings, emotional and spiritual, that are normally repressed in industrial society. That's why it's important.

PN: Do you use The Cassandra Complex to express any political opinions?
RO: Everything is political, because politics is all about the way you want to

live your life. It's about who controls what you want to do. The way you do anything must therefore be political, because you're expressing something about yourself. Most importantly, politics is about what you do. All the songs are political, no matter what they express.

PN: What are you hoping to achieve with The Cassandra Complex?

RO: Taking it from a magical perspective, to most people today, rock'n'roll stars are shamans, in that they provide a gateway to another world, and provide the raising of emotions and magical energy. As someone who is a magician, and wants to be a professional magician, then being a rock star is one of the easiest and quickest ways of going about it in the modern world.

PN: The Cassandra Complex have a very high-tech approach to music, in both the lyrics and production. Do you see this as part of modern magick?

RO: Yes, it's Rosicrucian. One of the statements of the Rosicrucian manifesto is that anyone who was a Rosicrucian had to clothe themselves in the garb of the country in which they resided. In other words, if you want to be an effective magician working within your environment, you must use that environment to its fullest extent. Our environment is completely created by modern technology. Anyone who calls themselves a modern magician, living in western society, and doesn't use technology is not a very good magician.

PN: How do you see magick developing?

RO: It's becoming much more widespread, which is why we're getting the anti-Pagan campaign. We're big enough now to be a threat to the status quo. We arc a threat to society. This means that we will run into a lot of trouble, but once we get that trouble sorted out, then magick will become a liberating force. Magical methodology and training allows you to be very adaptive – dealing very much with the realm of the imagination – artificially created universes. This helps when coming into contact with modern technology.

PN: What would you say to anyone who's becoming interested in magick through listening to your records?

RO: Don't just adopt one viewpoint and assume that it's right. Be very wary of great revelations in a blinding flash of light, because the first things you always come across are things that either attack, or bolster up the ego. Take as many different viewpoints as possible, but don't accept any of them as being absolutely true. Read *Pagan News* and buy my records!

VIEW POINT

The Rite to a Decent Funeral[13]
by *Katon Shual*[14]

"Man has the right to die when and how he will"
Liber Oz[15]

Have you ever worried about what will happen to you after you die? No, this is not another attempt to sell insurance or a pension plan. As Pagans I assume you are already taking steps to safeguard your spiritual future, but what will happen to your body when you have no further use for it yourself? One idea that has been kicking around for a number of years is that of some sort of Pagan funeral organisation or trust. Progress on this score has been painfully slow and now seems to be the time to give the initiative an added push.

There are a number of things a Pagan Funeral Trust could do: the first and most obvious is the execution of instructions contained in the last wills of Pagans. This may be trickier than it seems. The funeral business is very conservative,

13 We were delighted when we received this article since it hit all of our major targets: it was brief, it was Pagan-oriented, and it covered a very real and practical issue that 100% of our readers would someday face, and which most of them had probably never considered beforehand. And it needed action.

14 Katon Shual is the nom-de-plume of author Mogg Morgan, who founded occult publishing house Mandrake of Oxford. Mogg has written several very good books on subjects as diverse as Tantra, Egyptian magic, and Thelema.

15 *Liber OZ* is a one page manifesto published by Aleister Crowley in 1941. Crowley intended it to convey the "O.T.O. plan in words of one syllable" and in "five sections: moral, bodily, mental, sexual, and the safeguard, tyrannicide."

and trying to get some authenticity injected into the conventional funeral service would take a great deal of push from the surviving relatives. I'm sure most of us in our time have attended those uninspiring services at the local funeral parlour, and heard things said by the piece-rate vicar that bear little or no relation to the life of the deceased. However, if there were an organisation ready and primed, there is no reason

and with a new long barrow in the centre. My body would be cremated and the ashes left in the long barrow for a year after which they would be scattered on the site. This site would be open for ritual use by appointment, and one might expect friends and relatives to return at Samhain for the appropriate ritual. Another possibility is excarnation, i.e. one's skeleton would be "fleshed" and the bones returned

> *"At the beginning of this century groups like the Theosophical Society were involved in attempts to legalise cremation. It is incredible to think that cremation was once banned."*

why elements of Pagan ritual, or even a "designer" ritual should not be incorporated into the service.

This raises a second problem. What do you do if the relatives don't know that the deceased was a Pagan? This is a common enough experience for gay people, who often come out only on their death-beds. If the relative's first revelation of this is during the reading of the Hymn To Pan, there would be a few raised eyebrows. One solution might be to have a two-stage service, a conventional one followed by a Pagan one. Some kind of bereavement counselling is also going to be desirable.

Over and on top of this is the question of Pagan burial grounds. I have a vision in my mind of a circular or elliptical site surrounded by trees,

to friends for ritual use. If this makes you shudder then you are probably suffering from cultural atrophy: this practice has been current in Tibet and Nepal for centuries. There is a demand for human bones for ritual purposes in this country, i.e. for the construction of thigh-bone trumpets and other shamanic tools. These objects would have far greater magical authenticity and power if they were bequeathed by a willing Pagan, rather than at present, imported from Tibet.

All of these points raise issues of a moral and legal kind. It is obvious that it will be a long hard struggle to get everything we want, and the above is only an outline of the possibilities. A funeral trust would have to have some legal, possibly charitable status, like the Humanist Funeral Trust

and others. This would also serve to establish Paganism with some legal presence with which to combat the growing witch-hunt in this country. At the beginning of this century groups like the Theosophical Society[16] were involved in attempts to legalise cremation. It is incredible to think that cremation was once banned. Then as now the legal milestone came when a member of the lobbying group died, having specified a desire for cremation. A similar scenario is likely here; we are talking several years of legal battles until one of us dies having made a will specifying Pagan burial.

On the legal front there is something to be learned from earlier attempts to start a Pagan Funeral Trust, which as of August 1987 was still stumbling along. I was once involved with this group and offered to be a trustee. As far as I knew I was the only Thelemite candidate for this post. The issue then was obtaining charitable status, and a solicitor had been engaged to draw up the relevant paperwork. However the Charity Commissioners rejected the application on the basis that Paganism was not a religion! At this time I alerted some friends at the Secular Society, who seemed confident that they could overturn this decision through the courts – even the European Court of Human Rights if necessary. However the other trustees preferred a "softly, softly" approach and so the issue has remained. The Secular Society would have been a good ally for this cause, as their avowed aim is total religious freedom, which includes the right to have no religion. The Pagan Funeral Trust can still be contacted at BM Box 9290, London WCI 3XX.

There is room for a second trust with similar aims but perhaps stemming more from the revitalised occult community. The existence of a second organisation need not undermine the work already achieved by the original group, and eventually they could cooperate where possible. If anyone is interested, please contact me through the Pagan News address, enclosing an SAE.[17]

16 The Theosophical Society was founded in 1875 by Madame Blavatsky and is arguably the most successful occult organisation in history. The term "theosophy" comes from the Greek theosophia, which is composed of two words: theos ("god," "gods," or "divine") and sophia ("wisdom"). Theosophia, therefore, may be translated as "wisdom of the gods", "wisdom in things divine", or "divine wisdom". The Three Objects of the Theosophical Society are: To form a nucleus of the universal brotherhood of humanity without distinction of race, creed, sex, caste, or colour.
To encourage the study of comparative religion, philosophy, and science.
To investigate the unexplained laws of nature and the powers latent in man.

17 The Pagan Hospice and Funeral Trust was eventually granted charitable status in the UK in 1995, but after a great deal of hostility only managed to struggle on to 1998. As of this writing, there doesn't appear to be any similar organisation currently operating in the UK. However in the meantime Pagan funerals have now become relatively normalised with several leading funeral directors able and willing to facilitate Pagan rites on request. So it's arguable that we don't really need such an organisation in the UK any more.

THINGS TO DO...
and THINGS TO READ

Devotional Magick
by *Phil Hine*

Devotional Magick, or as it is sometimes known, Bhakti yoga, is the practice of drawing upon the power and qualities of a particular mythic figure by a process of prolonged devotion to the chosen subject – usually (though not exclusively) a god or goddess. Over time, the practitioner identifies so entirely with the subject of devotion, that the powers and qualities of that figure can be accessed. Thus this operation is a type of invocation.

First choose your subject, being mindful of the associated qualities upon which you wish to draw. Research the image, myths and symbolism surrounding that figure.

Obtain, or make, by whatever art within your capacity, an image of that figure. The collection of a small shrine or altar, whereon is placed the objects/substances associated with the figure, is desirable. This is the outer manifestation of one's devotion.

As many sensory stimuli as possible should be found that assist in the focusing of awareness upon the subject of one's devotion. For example: colour, perfume, plants, gems, ritual objects, musical instruments and gestures.

The devotion should be performed daily, with as much ceremony, pomp, and dignity as can be mustered. Daily meditation, prayer and mantra should ever be directed towards the subject of devotion.

The invocation should comprise three parts:

> The deeds of the figure expressed in the third person.
> The qualities of the figure expressed in the second person.
> The powers of the figure expressed in the first person.

Thus the invocation progressively unites self and subject of adoration. You become that figure, and so manifest the requisite qualities. You should live, as much as possible, in a manner which, given the nature of the subject, would be pleasing to it. You should continually strive to be inflamed with the passion of devotion, so that the process becomes an inner alchemy of transformation.

All works, acts and sensations should be felt to proceed from the chosen figure. "Every breath, every word, every thought, is an act of love with thee" – *Liber VII*.[18] The value of this practice is the ecstatic union between subject and object (samadhi) and the insights gained concerning the nature of self, and of the subject of adoration.

The major obstacle to success is that you may become obsessed with the subject of adoration, to the extent that it becomes the sole power in the universe. Dogmatic cults spring from such obsessions.

Further Reading

Liber Astarte Aleister Crowley[19]
Advanced Yoga Philosophy Ramacharaka[20]
Liber Null Pete Carroll[21]

18 Or to give it its full title: *Liber Liberi vel Lapidis Lazuli Adumbratio Kabbalæ Ægyptiorum sub figurâ VII*, one of a series of short "Holy Books" published by Aleister Crowley around 1909/1910. See https://lib.oto-usa.org/libri/liber0007.html

19 *Liber Astarte vel Liber Berylli—On uniting oneself to a Deity*, first published in Volume I, Number 7, of *The Equinox* in 1912. See https://www.sacred-texts.com/oto/lib175.htm

20 *Advanced Course in Yoga Philosophy and Oriental Occultism* by Yogi Ramacharaka was first published in 1904 by the Yogi Publication Society of Chicago, Illinois. Ramacharaka is believed to be one of the many pseudonyms of William Walker Atkinson (1862 – 1932) publisher, author, and pioneer of the New Thought movement. The astonishingly prolific Atkinson is estimated to have written over 100 books, as well as authoring innumerable magazine articles, all during the last 30 years of his life. See http://www.yogebooks.com/english/atkinson/1905-09advancedcourse.pdf

21 Peter J. Carroll's (1953 –) first book *Liber Null*, published in 1978 by The Sorcerer's Apprentice. This book was a revelation when it came out and changed the lives of many young occultists of the period, including your two Editors. Its tightly written pages emphasised practical sorcery over theory, the modern over the ancient, and simplicity over complexity; and launched the chaos magic movement. It is now available in an anthology with his follow-up book, as *Liber Null & Psychonaut*, and is compulsory reading for any budding magician. Unfortunately Carroll's later works do not display a similar amount of original genius and should probably best be avoided.

THE COMPUTER RIDES OUT
by *Barry Hairbrush-Wheatley*

Chapter Three

I looked through the window of Sir Guy Suit's car as rain crashed in torrents around us. From time to time lightning ripped the sky, showing up the road and the evil, domed shape of the Civic Exhibition and Conference centre. Sir Guy sat in the back with me, his mentally ill gardener, Sylvestenegger, at the wheel.

He polished his silver revolver and slid it into his pocket. The car ground to a halt.

"OK Move out!" grunted the gardener. We left the car and splashed through the mud to flatten ourselves against the wall of the building. Sir Guy gave me a leg-up and I peered through a window. What I saw chilled me to the very bone.

A huge, brightly-lit room lay before me, full of people walking around. Everywhere, computer terminals and other hideous machines formed a deadly forest of metal and plastic. Huge sigils – the holy apple of Mac, the immortal owl of Beeb, the terrifying trident of Atari – covered the walls. And there, in the middle of it all, young Charlie Richbastard, being shown through an expensive-looking set of peripheral hardware. I told Suit.

Strange sounds behind us told of Sylvestenegger setting up some pretty strange equipment, but Suit pulled me into the shadows and set to work picking a lock. Once inside, we padded quietly down a corridor, and gently eased open a door. There was the evil room I had seen before, but with something far worse added to it – a terrible, ozoney, WH Smithy[22] smell ... the fetid breath of computers!

22 WHSmith is a classic British chain retailer, selling books, stationery, magazines, and newspapers since 1792. In the 1980s it became a favourite haunt of technology enthusiasts looking

An astonished, gruff cry came from behind us, and we were looking into the face of a nasty-looking security guard. Before the fellow had time to react, Suit leapt up and kicked his yang essences into next week. He dragged the whimpering guard off, but I called him back in horror.

"He's buying one!" I whispered. "The entire Richbastard fortune down the drain."

"Hang the fortune! What about Charlie's soul?"

We went in, disguised as computer freaks. Snatching a couple of magazines, we buried our faces in them and sidled over to where Charlie was getting his cheque book out. A slimy, bespectacled figure leapt in front of us.

"Can I interest you in an Epson[23] sir? Latest models, wide range of software… ulp…" Sir Guy had quietly moved forward to stick his revolver in the odious salesman's side.

"Stop talking. Move forward slowly. One false move…"

Whimpering, the man obeyed. I saw that Charlie had started writing the cheque, he had already put down the date and amount.

"Now!" yelled Suit, and we both pounced, knocking Charlie to the ground. A chorus of gasps went up from the computer freaks around us.

"I'm sorry, Charlie. This is for your own good."

"Suit! Dammit, I know what I'm doing!"

"No, Charlie… I've made a very careful study of these things, and I know how evil they can be. You're coming with us."

We started pulling him, protesting, across the floor. At that moment, the door flew open and the irate guard came in.

"Where are they? Where are the sods?"

The nasty little salesman jumped, pointing to us. "There they are!"

The hall went completely quiet.

A sea of bandaid-mended NHS spectacles[24] turned to look at us. A wall of faces, pitted with the acne of a thousand Mars bars, began to snarl menacingly, as the computer freaks realised who we were.

"What now?" I asked.

for publications dealing with their specialist interests (since we didn't have the Internet back then).

23 Did you know that Epson is an abbreviation for Son of Electronic Printer? No, we didn't either until we started doing the research for this book. It's true though.

24 From 1948 to 1986 the wonderful British National Health Service offered a range of free spectacles to all children in the UK who needed them. These were designed to be highly functional at a cheap price, and eventually became an object of some scorn, marking the wearer as being both nerdy and poor. Ironically many of them are now seen as design classics, particularly the 422 model as worn by John Lennon and Harry Potter (and often by Rodney too). However the somewhat less stylish 524 model was notorious for breaking over the nosepiece and having to be repaired by the judicious application of a band-aid. This look became the ultimate in nerdiness for us kids back then, and was later adopted by Morrissey, a leading poseur who has lent his support to anti-Islam activism and called the Chinese a "subspecies". Yet another thing he ruined for us.

"We'll have to wait until Sylvestenegger gets here." I surveyed the approaching mob with little enthusiasm. "But we're going to die!"

Sir Guy pinned the struggling Charlie to the ground as the crowd shambled nearer. He seemed to think for a moment.

"There is one thing… the ancient litany against Computer Freaks. But…no, I daren't use it. It's too terrible."

"Suit!" I screamed, closer to hitting him than I had ever been. "For God's sake, use it, man." Suit looked round as the throng of worshippers began wrenching off microdrives to use as makeshift weapons. His eyes blazed again, and he stood up, shouting in a thundering voice:

"I AM HE! THE BORNLESS ONE! THE COLLECTOR OF TELEPHONE BILLS, FOR YOUR MODEMS AND DATABASES! I AM HE WHO CUTS YOU OFF WITH AN OVERDUE BILL AND A £27 RECONNECTION FEE!"

The crowd panicked, running here and there as the threat to their precious lifeblood sank in. In the melee, we dragged Charlie to safety, as an enormous explosion rocked the building. I just had time to see Sylvestenegger's helicopter gunship crash through the roof, cannons blazing, before I passed out.

When I awoke, it was morning. The birds were singing, and only a burnt-out hulk remained of the Exhibition Centre. Charlie was sitting on the grass, rubbing his head, the nightmare mercifully forgotten. Sylvestenegger was on top of the town hall, in an unproductive dialogue with some armed police officers. Suit was smashing the last of the computer terminals. He turned to me.

"Well, Barry, it's done. We've ridden this town of the evil of computers."

"But when will the work ever truly be done?" I asked.

"That's not up to us alone. It's up to every devil-fearing occultist to fight this evil menace, wherever they may find it. But for now, I think we can rest."

A hail of gunfire erupted from the town hall.

"Pity about Sylvestenegger," said Sir Guy, "He was, it's true, a terrible gardener. But as a warrior, he was impeccable."

THE END

Star Letter!

From Kat, Hastings

What was printed in this "fanzine" [i.e. Pagan News - Ed.] was in short, nothing, save the wild ravings of feminists and anarchists. Of course, you'll never print this letter,[25] I doubt if you'd dare to show the feelings of those of us who have real work to do concerning the religious side of things. Nevertheless, this is the really important thing – perhaps the self-titled "Council of Elders" in Oxford may have originally thought so, but, I for one, knew nothing at all about them until I saw the "bit" in the Pagan News. When are the real Wise Ones going to get together, talk, listen, teach and learn? At the dawn of the New Age, there are massive powers and surges at work of which those who are truly attuned are aware; and those people are far too busy developing themselves and gently spreading the Truth to be concerned or mixed up with all the weird, strange, anti-establishment or downright unpleasant groups and ideas found inside Pagan News.[26] In fact, in reality, those who seek for the Truth are not "Pagans" at all, but priests and priestesses of the Way.

When are all these folk who are full of opinions and themselves going to realise that feminism is a man-created illusion? One doesn't need all these fancy words, every aware woman knows with every fibre of her being that men and women are equal in importance, and that segregation and "women only" groups are missing the point; men and women need to work together in all areas. What women don't have, men do and vice versa. Likewise the anarchists: the spiritual movement and the development of the Truth and the Way will get nowhere whilst people such as these are campaigning, shouting, demonstrating and generally "complaining about society and the establishment." Ok, so it's all wrong, but there are other, more successful ways of changing things.

As for Satanists: who? Satan is a Christian concept, so those who claim to worship same are being mere "religious anarchists" moving toward the degradation and non-acceptance of the Way – they have no place in the New Age. Please, clear your minds a little and think again of the aims of the Link, and of all those who would be pleased to join and lend their knowledge, their spirits and their love to the Cause, but are put off by the overwhelming presence of minority, misinformed and sadly, angry factions now present.

Since receiving this letter we have both been illuminated by the light of "the Truth" and have seen the error of our ways. We intend to cease publication of Pagan News immediately. Honest. – Eds.

25 Writing "Of course, you'll never print this letter" was the proverbial waving a red flag to a bull when it came to your Editors. It pretty much guaranteed we would print it. Strangely, nobody ever seemed to catch on to this. We are now considering taking it one step even further and using this quote on the back cover of this book. Thanks Kat. You'll never know how much you did for us.

26 We considered this then, and still do to this day, one of the best compliments we have ever received. We took it as encouragement to not only keep on doing what we were doing, but to take it even further.

PAGAN NEWS

The monthly newspaper of
Magick & the Occult

December ' 88
Price 30p

LUCIFER RISING?

For Hallowe'en, the BBC Six'o'clock news decided to run a special feature. Instead of the usual tales of wart charming or witch-hunting at Alderley Edge, we got Dianne Core and the Rev.Kevin Logan starring in what was undoubtedly a masterpiece of inflammatory reporting. We were informed that Tarot cards and Ouija boards are "the commonest way for children to get hooked", and a film clip of robed "witches" performing an outdoor ceremony was accompanied by a voice-over to the effect that "children are enticed into the shadowy world of witches covens and mystic ceremonies". Well, *Pagan News* can now reveal that the alleged "witches" in the film clip were a group of West Yorkshire magicians performing a ritual for the BBC documentary, **Lucifer over Lancashire**. Naturally, they are apalled at being used in such a way, and one particpant spoke of organising legal action against the BBC. The original intent of the rite was to raise energy towards environmental issues, but that fact was conveniently passed over by the BBC.

The Reverend Kevin Logan spoke movingly about "the broken lives of teenagers and adults - after Hallowe'en we have·to pick up the pieces". His own study found that of 300 children, 9 out of 10 had had some "experience of the occult" (whatever that means). If this is supposed to be representative of general trends, then it implies that there are more occultists around than Christians! The report ended with the warning of children being drawn into a world of "cult-like obedience".

Funny, I thought that that was what religions were all about. Occult study requires people to think for themselves - which is probably the real reason that people like Logan are worried about us!

A week later, the Daily Mirror came up with the headline "Victims of the Satanists". Yet more evidence of a ring of devil-worshipping child-abusers. The Mirror "had access to reports of these practices" but went on to admit "that they were too horrific to be published". Shame. Doubtless when any 'evidence' is brought to light, it will be seized on and made all the more credible because of the months of hysterical reporting by the press.

Save Our Stones

The islanders of Jersey are trying to recover a prehistoric monument moved to England two hundred years ago. The monument, a four-thousand year old tomb, was moved to Berkshire in 1788 by the governor of Jersey, Marshall Conway, to his estate near Henley-on-Thames. The estate, Park Place, is now up for sale, and Jersey residents, led by the island's Historical Association, hope to raise several thousand pounds to buy the stones back.

The stones were first 'discovered' in 1785, near St. Helier, and two years later, they were offered as a gift to Marshall Conway. Conway was encouraged to buy them by his cousin, Horace Walpole, who, on later visiting visiting them, wrote: *"I have been to Park Place on a pilgrimage, to little master Stonehenge. Every morsel of stone that formed the circle originally is placed to an inch in its primitive position, and although the whole is very diminuitive, yet being seen as the horizon it looks very High Priestly."*

A spokesman for Jersey's Historical Association said that they were hoping to buy the stones, and that estate agents acting on behalf of the owners were considering an offer. The tomb forms a circle eight meters in diameter, composed of stones three meters high. It is the largest single monument brought to England from overseas.

Lucifer Rising?[1]

For Hallowe'en, the BBC *Six O'clock News* decided to run a special feature. Instead of the usual tales of wort charming or witch-hunting at Alderley Edge, we got Dianne Core and the Rev. Kevin Logan starring in what was undoubtedly a masterpiece of inflammatory reporting. We were informed that Tarot cards and Ouija boards are "the commonest way for children to get hooked", and a film clip of robed "witches" performing an outdoor ceremony was accompanied by a voice-over to the effect that "children are enticed into the shadowy world of witches' covens and mystic ceremonies".

Well, *Pagan News* can now reveal that the alleged "witches" in the film clip were a group of West Yorkshire magicians performing a ritual for the BBC documentary *Lucifer over Lancashire*. Naturally, they are appalled at being used in such a way, and one participant spoke of organising legal action against the BBC. The original intent of the rite was to raise energy towards environmental issues, but this fact was conveniently passed over by the BBC.

The Reverend Kevin Logan spoke movingly about "the broken lives of teenagers and adults – after Hallowe'en we have to pick up the pieces". His own study found that of 300 children, 9 out of 10 had had some "experience of the occult" (whatever that means). If this is supposed to be representative of general trends, then it implies that there are more occultists around than Christians! The report ended with the warning of children being drawn into a world of "cult-like obedience". Funny, I thought that that was what religions were all about. Occult study requires people to think for themselves – which is probably the real reason that people like Logan are worried about us!

A week later, the *Daily Mirror*[2] came up with the headline Victims of the Satanists. Yet more evidence of a ring of Devil-worshipping child-abusers, the

1 Also the title of one of our favourite occult movies, the legendary *Lucifer Rising* by the equally legendary director Kenneth Anger (1927 – 2024). This influential 1972 movie starred Marianne Faithfull, Chris Jagger (brother of Mick Jagger of The Rolling Stones) and Jimmy Page of Led Zeppelin, with music by the very talented Bobby Beausoleil.

2 The *Daily Mirror* is a British tabloid newspaper founded in 1903. During the late 1980s it was owned by Robert Maxwell (1923 – 1991). Since he had been born in Czechoslovakia and was well-known as a fraudster, Maxwell's nickname was the rather appropriate "The Bouncing Czech". After his mysterious death at sea it was found he had stolen millions of pounds from his employees' pension fund in order to fund his lavish lifestyle. He is also suspected of having been an agent for the KGB and Israel's Mossad.

Mirror "had access to reports of these practices" but went on to admit "that they were too horrific to be published". Shame. Doubtless when any "evidence" is brought to light, it will be seized on and made all the more credible because of the months of hysterical reporting by the press.

Whale Meet Again

Last issue we reported the appearance of Dickens & co. on Yorkshire TV's *James Whale Radio Show*. Two weeks later, Whaley did a follow-up, presenting a more sympathetic view of the occult, with guests Chris Bray, and *Pagan News'* resident Rune Master, Bryn Ormsford. Whaley asked all the standard questions about sex, drugs and perversion, but was disarmed by Bryn's charm and Chris Bray's calm answering of stupid questions with intelligent replies. A video clip showed Bryn demonstrating the use of the Thoth deck to a bemused Whale, who admitted that he was superstitious and didn't want to shuffle the cards. The studio guests were interested and sympathetic, and Chris stressed that occultists only want freedom to follow their own belief, rather than proselytising. A caller rang in, babbling about "White and Black" magic and the dangers of being taken over by "evil" forces. Chris replied that evil resides in the hearts of people, not in any outside agencies.

Since the TV appearance, Bryn has been a guest several times on James Whale's Radio Aire late night show, and has taken every opportunity to dispel the myths and lies being propagated against Pagans. And how did she get on in the first place? Well one of our readers sent James Whale a copy of *Pagan News*, where he saw her ad. Radio Aire now receives *Pagan News* regularly, but alas, we are still "too controversial" to get on the air ourselves. But we're working on it![3]

3 Since that was written Phil & Rodney have gone on to feature in so many TV, radio, and podcast interviews that we have literally lost count. So we got there in the end :-)

CHOOSING YOUR FIRST TAROT DECK

by *Steve Jones*

I am often asked, as a Tarot reader, which decks I'd recommend to someone who is just starting to get interested in Tarot. Traditionally, your Tarot deck should be bought for you, however considering most cost nowadays between £10-15 you need to have good friends for this to work!

The first point to bear in mind when choosing a deck is that while all Tarot decks contain at least 78 cards, they can be divided into two types: those decks which follow a traditional pattern and do not have pictures on all 78 cards, and those intended for use as a magical or fortune-telling deck, which have pictures on all the cards relating to their meanings. The Tarot of Marseilles[4] is probably the best-known of the former type and the Rider-Waite[5] the best known of the latter. You are better choosing a pack based on the Rider-Waite deck if you intend to use your deck for readings, because each of the Minor Arcana cards has a picture relating to its meaning, whereas traditional decks only use patterns – which are harder to remember.

There are some decks which are sold specifically for "beginners" which are not very good. The Starter Tarot, for instance, only contains the 22 Major Arcana cards, so is useless for doing full readings. The Prediction Tarot deck has no pictures on the Minor Arcana cards, thus making learning harder. The 1JJ deck,[6] which is commonly sold in stores such as WH Smiths not only has no pictures for the Minor Arcana, but replaces the traditional Pope & Papess found in traditional packs with Jupiter and Juno, which newcomers to the Tarot can often find confusing.

Personally I use the Aquarian Tarot[7] which is based on the Rider-Waite deck but is better executed. I find the Rider-Waite useful, but the pictures could be better. Decks based on the Rider-Waite (though in my opinion, better drawn)

4 The Tarot of Marseilles is one of the earliest known Tarot decks, dating from 1650.

5 More accurately known as the Smith – Waite deck, this was produced in 1909 by artist Pamela Colman Smith and author Arthur Edward Waite, and has become the most widely-known Tarot deck in the world. Both were original members of the Order of the Golden Dawn and their Tarot is derived largely from the teachings of that Order.

6 A 19th century derivation of the Tarot of Marseilles. The "JJ" in the title refers to the addition of the Juno and Jupiter cards.

7 First published in 1970, the Aquarian Tarot features mock Art Deco and Art Nouveau illustrations. Personally we think it's horrible hippy junk, but your mileage may vary.

are the Morgan-Greer,[8] Royal Fez Morroccan,[9] and the Hanson-Roberts[10] (a very fairylike deck).

I would not recommend aspiring readers to buy the Crowley-Harris Thoth Tarot,[11] as it has very complex symbolism and requires a good knowledge of Crowley's background and magick to use properly. The Witches Tarot[12] by the way is something no self-respecting Wiccan would be seen dead with. It is actually the James Bond 007 deck from *Live and Let Die* under a new name and is really only of use to Bond fans![13] There is no Wiccan Tarot as such at the moment (Eds note – the late Arnold Crowther produced a Witches Tarot, but alas it was never published).

There are a number of decks which are aimed at those with specific interests. The Ukiyoe Tarot[14] is done in traditional Japanese style with all the figures in period costumes. The Masonic Tarot[15] is for those of us who enjoy rolling our trouser legs up! Feminists should look out for the Motherpeace Tarot,[16] which is an excellent deck, using circular cards. Some might find its price a bit exorbitant though. Cat lovers will adore the Tarot of the Cat People, unfortunately dog lovers are not catered for at present. Those of a broad-minded magical persuasion should look out for the Initiate's Tarot (also known as the Sexual Tarot)[17] which is soon to be reprinted by the Sorcerer's Apprentice. It is a very good deck for those who know how to use it.

Finally, a word about non-standard decks. Beware buying any deck called a Tarock deck. This is intended for the game of Tarock and will only contain 56 cards. The Fantasy Showcase Tarot has each card illustrated by a different artist,

8 More horrible hippy junk.

9 Actually quite nice.

10 And yes, even more horrible hippy junk. All of these are based on the Smith-Waite deck, but without a quarter of Waite's occult knowledge, or a tenth of Smith's artistic talent.

11 Painted by Frieda, Lady Harris based on designs by Aleister Crowley and published in 1944, despite Steve's un-recommendation the Thoth Tarot now rivals the Smith – Waite deck in popularity. It's a fabulous deck and I wouldn't use anything else – Rodney.

12 Not to be confused with a more modern deck with the same name.

13 This deck was designed for the movie by artist Fergus Hall. It's actually quite interesting artistically, but useless for any magical purposes. Fun fact: in the Bond movie the cards were read by the character Solitaire, played by the lovely Jane Seymour. Many years later Rodney would spend a fabulous evening with Jane and she really is every bit as lovely as she appears on film.

14 Koji Furuta, 1982. Quite beautiful.

15 There are a couple of Tarot decks with this name. We believe Steve is here referring to the 1987 deck produced in Paris by Jean Beauchard.

16 Created in the late 70s by Karen Vogel and Vicki Noble, this deck became quite influential in the feminist movement during the 80s.

17 By friend and mentor of the Editors, the late Richard Bartle-Bitelli.

Seven *of* Cups

thus making it very difficult to use for readings, and it also has a couple of extra cards. It is a good collector's item. Qabalists should check out the Tree of Life deck, each card of which just gives its position on the Tree of Life. Those interested in Meditation should look out for the Yeager Tarot of Meditation, of which the Major Arcana is specifically designed as aids for meditation/pathworkings.[18]

Those of you with artistic talents might like to design your own cards. This is good if you can do it, since the cards will relate directly to yourself and your ideas. I personally like the idea of a photographic deck, though none are available at present to my knowledge.

I hope this article has been helpful and I will be glad to answer any queries. I can be contacted c/o the *Pagan News* address. Please enclose an SAE when writing.

(Eds note: the illustration for this article – Seven of Cups from the Initiate's Tarot appears by kind permission of the artist and publisher.)

18 Don't do it, it's also hippy junk.

VIEW
POINT

The Way of the Left-Hand Path
by *Magda Graham*[19]

Compare the achievement of Adepthood to the climbing of a great mountain. Everyone who commences a study of the occult has reached base camp. Some will remain there, in their comfortable armchairs, reading about others' exploits. A few will make it all the way. Most occultists have the wisdom to perceive when to stop, when they have acquired as much knowledge and power that they can cope with. Some take on more than they can handle.

The terms "Left-Hand Path" and "Right Hand Path" are merely convenient labels to distinguish the alternative methods of getting as far as the Abyss. They have nothing to do with crossing the Abyss; one either crosses it or does not cross it. And, having crossed, the Adept has access to everything, so labels are no longer relevant.

Balance is the key to everything. In the early stages, one tries to equate balance with what one feels is the right thing to do. But "the right thing" is a subjective judgement. A world from which suffering has been eradicated would be as unbalanced as a world ruled by one mad dictator. It is emotionally difficult to accept that. And emotions must not be suppressed; they must be recognised and understood, so that, whilst they continue to exist, they cease to have influence.

When religion comes along, people suspend all logic. They expect a new set of rules to obtain in that situation. In fact, there is only one rule that upholds the universe and everything in it. Trying to use occult power to solve a non-occult problem is like trying to transmit electricity through a water-main. Developing one's occult skills without simultaneously developing the competence to deal effectively with mundane life leads to imbalance and therefore inhibits further progress in any direction.

19 Magda Graham was the editor of Satanic magazine *Dark Lily*, the official publication of the Anglican Satanic Church. *Dark Lily* has now disappeared into the mists of history, but was quite influential in its time, although by our reckoning at least 95% of the stuff in it was aspirational fantasy and bore little relation to anything in the real world. Despite multiple reports of mass initiations into their Church, we only ever knew two members. Not much is known about Ms. Graham apart from that she apparently suffered from severe multiple sclerosis and disappeared in the 90s.

The mechanical functions of the brain are awesomely complex, but it encompasses far more than the disciplines of neurology and psychiatry have yet realised. However, modern science has presented us with a relatively simple means of explaining the concept. Think of your own mind as a terminal, connected to the mainframe computer which is the universe. So everything that has ever been and will be is inside your own head and is available to you when you know what keys to press. Access to this capacity exists inside your subconscious mind. It is and always has been a part of you, and successfully invoking it activates a hitherto unexplored part of your subconscious which is able to do what is required.

First Steps to Adepthood, revealed in Print. Quite safe to do this, because it is not exactly inviting. Occultism has its own system of elitism which has nothing to do with snobbery. There is no need for self-appointed Guardians of the Secrets because the secrets guard themselves much more effectively. We can spell it out in the pages of *Dark Lily*, and we have done so, but less than one percent of readers have realised that, much less comprehended what it is all about.

It is so much easier to put on the robes, light the candles and incense, and summon up a monster from the Infernal regions; he can be banished, probably without too much trouble. But you will fare otherwise when you stand alone, without the ceremonial trappings,

> *"There is no need for self-appointed Guardians of the Secrets because the secrets guard themselves much more effectively."*

The subconscious is often misunderstood and misrepresented as an almost automatic gateway to enlightenment. In fact, the uncontrolled subconscious is a fraud, a phoney which will give you false information. The management of the subconscious is, like the management of the ego, not a task to be accomplished in one effort, but is a continuing endeavour throughout one's occult development. Start by recognising it; evaluate its communications and realise how much of a disadvantage to the host body the subconscious in its present form is. Whatever material success the unawakened person gains, he is never truly in charge of his life though he probably never realises this.

and realise that this monster is actually within your own mind and it would be harder to banish him than to amputate your own arm. You also have to accept that this monster is as necessary as your arm. He must be assimilated and understood, because removing him would create an imbalance which could impede your work.

You see, the Secrets do not need to be guarded, their best defence is the seekers themselves. You will protect yourself from the truth until you are ready for it, and from then on you are on your own. The only people who will take any notice of you are the few, very few, who have set out or who are about to set out on that long, lonely and dangerous trek towards the Abyss.

Pagan *News*

DELINQUENT ELEMENTALS

Is Society to Blame?

by BARRY HAIRBRUSH

This month, we look at what is becoming a major occult problem in society today – astral delinquents.

These elemental beings, many unemployed and without qualifications, can often be found slouching round the lower regions of the qliphoth. They come from many different backgrounds – Western elementals, Wiccan familiars, Chaos servitors – but all are united by their cynical, contemptuous sneer and bored, glassy-eyed slouch.

What can be done for these poor outcasts? I spoke to sociologist Kay O'Chambers.

"Of course, you know they're all victims of society. They get conjured up in bright, breezy rituals and then, when they've been used and extorted, they're tossed on the scrapheap. It's a no-hope situation for them, and the government doesn't seem to be doing anything about it. That's why we set up the 'Off the Planes' youth club for them. Like the name suggests, it keeps them off the astral planes and out of trouble, and a place where they can come in, talk to someone about their problems, and play table tennis."

Tight

On the other hand, some are not so sympathetic to delinquent elementals. We visited Hercules Wobble in Shrewsbury, a magus well known for his forthright views on keeping to tradition.

"Well I blame the angelic forces meself, for not keeping a tight enough rein on these hooligans. It was different back in the old days when they were all kept busy searching for treasure at crossroads or divining the fate of kings, but there's no call for skilled labour

any more. And they had a lot less free time, elementals did – when they weren't out on the job, they had to sweep the magician's house, cook all his food... but these young buggers nowadays, they've all got hoovers and microwaves, so their elementals are left with too much time on their claws. A good dose of national service, that'd do them all some good. You see them all hanging round the town centre on a Saturday, drinking, fighting, shop-lifting astral energy from people... we need to bring back stiffer sentences, that's what I say. In the old days, they had to answer to Lucifer Rofocale himself if they went out of line, and woe betide them if they did! But it's the ones on motorbikes I really can't stand. Roaring round the aetheric plane at five o'clock on a Sunday morning, you can't even hear yourself think."

Unemployed

And what do these typhonian tearaways think themselves? After a long and tiresome ritual, I managed to get in touch with Kevin. Kevin was constructed to break up someone's marriage in 1982, and has been unemployed ever since.

"Well, it's you know, like, really demoralising. There's nothing to do, no money to spend or nowt. We cluster together round the 49th pit of lesser darkness, usually on a Tuesday night, and pass around a plastic bag full of Geburah." (This is another problem associated with delinquent elementals – Sephiroth abuse.)

Priest Came

Did he see any prospects for the future?

"Well, we get handed round leaflets about these job schemes – getting a place in one of Dr. Svengali's moneymaking spell-bags. But there's no guarantee of a steady job in the spirit world afterwards. It's hard to find a fixed address. A couple of my mates set up a squat in somebody's house, but a Roman Catholic Priest came and moved them on."

Cases like Kevin's are indeed heart-rending. Yet the blame lies neither with society, nor with the angelic hierarchy. It is up to the individual to make sure his or her elementals are brought up in a disciplined and moral way.

IS YOUR FAMILIAR A POSSIBLE DELINQUENT? TRY OUR SUPER SOARAWAY QUIZ!

Does it materialise on demand:
1) often
2) sometimes
3) never

Does it keep its bottle/crystal/ring/wand tidy or do you have to do the job yourself?

Does it smoke strange-looking cigarettes? Does it keep magazines hidden under its bed?

Do you regularly give it a time to be back home by at night?

What is its name?
1) Hieronymus
2) Ozymandias
3) Dave

Does it announce its arrival by:
1) a distinct tapping sound
2) an eerie glow round the room
3) aerosolling its name on the walls?

Think about the answers carefully! It could mean the difference between a successful magical operation and your elemental ending up on the scrapheap.

Star Letter!

From Diane, Wakefield

Personally I do not receive this so-called Pagan News, but having this issue thrust at me, I glanced at a few pages. I was surprised to see that you had even printed Kat's letter (see last issue – Ed). As a personal friend of Kat's, I find your small comment very insulting, pathetic, and downright rude; but that's not surprising when this rag is run by a bunch of black, chaos minded, egotistic, immature people (Eds – that's us). One day, some of you may be privileged to see the truth of the New Age, but I doubt it very much. Instead, carry on spreading the blinkered ideas of the black side to young, impressionable people (Eds – that's you, readers). It is clear from your paper that it truly has no aim in the Neo-Pagan age. Only to mock people who speak against the Craft. The same as Christians who speak against Wicca, you lower yourselves to their level. Also, I do not like the way you preach the so-called left-hand path.
Make a sarcastic comment at the bottom of this letter. As no doubt, with your dirt filled pathetic minds you probably will. An apology to all true Craft people maybe more in line, don't you think.

Would any other readers care to comment on this subject? I'm off to whirl through the slimy cesspits of depravity – Phil Hine.[20]

20 We were, of course, delighted that we seemed to be raising so much ire with each issue. It was very encouraging. Hence why we then asked more people to join in.

The Black Lodge

LEEDS UNIVERSITY UNION OCCULT SOCIETY aka "THE BLACK LODGE"

L.U.U.O.S has been a feature of the Leeds Occult scene for many a year, and now as "The Black Lodge", in addition to the more usual lectures and forums, the Society holds popular "alternative discos" (ok if you like Goth music). Planned events this term include:

Sunday 6th March

"THE FORGOTTEN ANGEL" a talk by Phil turner of the Typhonian O.T.O. In the O.S.A lounge, 6.30pm.

Sunday 13th March

"THE MAGICK LANTERN" cycle of films by KENNETH ANGER (includes LUCIFER RISING). Rupert Beckett Theatre 6.30pm, (provisional).

For further details write to LUUOS, c/o the NPLN editorial adress.

PAGAN NEWS

The monthly newspaper of
Magick & the Occult

January ' 89
Price 30p

YULE FOOLS!

It was to be an eventful morning at the Twelve Apostles stone circle (Ilkley) for many pagan folk - or at least that's what the Bradford *Telegraph & Argus* newspaper was telling everyone less than a week before the Winter Solstice. So, in anticipation of the hundreds of pagans, druids, witches and hermits who were to be gathering at the site (as was told) an intrepid band of four local pagans gathered at the home of that well-known example of *domesticus hippius*, Dr.Paulus Benneticus, to partake of the wild revelry among the heather. Apart from the host, our other three were Brian Hughes (fruitcake extraordinaire), Mick Nolan (a distant relation to the fab five sisters?) and a certain co-editor of this very organ.

In the wee hours before dawn, when most sensible people were still slumbering, this intrepid group *staggered* into Ilkley, to be greeted by four reporters from the **T&A**. With a great deal of groaning, we made our way up to the stones, and were welcomed by all the others present ...well, er not quite. Where were you all then? With just about one remaining brain cell between the whole group, we entreated the Goddess to give birth to the sun - not that it could be seen thro' the fog, but it's the thought that counts isn't it?

After one of the fastest Solstice celebrations yet seen at the stones, we *squelched* back into Ilkley, our hearts touched with wonder at what utter morons we were! Still, it was good to get away from all the Christmas capitalist crap for a while. See you at the Summer Solstice perhaps..?

The T&A subsequently ran two articles on the morning's weirdnesses. Despite referring to Phil Hine as Paul Bennett (they all look the same, these occultists) and coining the most cringe worthy word of 1989 so far

(paganists) the tone was suprisingly sympathetic. The smaller piece was a completely straight report about the "Old Religion", which only queried why so few had braved the cold, whereas the second carried in-depth and largely unedited interviews with the participants. The stress was on the pagan idea of respect for the planet, so topical today, and the failure of the established churches to meet the spiritual needs of the Modern Green on the street. Of course, the Christian(ists) were given a right of reply, and tried rather lamely to claim the cause of ecology as their own, before trotting out the hoary old chestnut about having to pick up the pieces of ruined young lives - not very original and about as convincing as a chain store Santa. It is good to start the year with an intelligent centre spread about paganism in the mainstream media (as well as a huge colour photograph of Phil Hine!) and may herald, in the light of these de-ozoned days, a move away from manic scare stories to a serious consideration of what Paganism can offer the people and the planet. The only question is - why weren't YOU there??

Who Banned Rodney's Record?

The news that all Europe is talking about! Rodney Orpheus telexed the PN office from Geneva to say that the new Cassandra Complex album (provisionally entitled *Satan, Bugs Bunny and Me*) would not now be pressed by CBS as previously agreed, due to their concern over "the pagan content of the lyrics". After much negotiation it was decided that Belgium was sufficiently amoral to cope with the threat of corruption, and the album will now be pressed there, but will be banned in the USA. This is a rare honour indeed, and is already stirring American Cassandroids, as well as supporters of religious freedom, to vocal protest. It makes me wonder what the C in CBS stands for; maybe Christian, perhaps Censoring, but certainly not Civilised!

NEWS

Yule Fools!

It was to be an eventful morning at the Twelve Apostles stone circle (Ilkley)[1] for many Pagan folk – or at least that's what the Bradford *Telegraph & Argus* newspaper was telling everyone less than a week before the Winter Solstice. So, in anticipation of the hundreds of Pagans, druids, witches and hermits who were to be gathering at the site (as was told) an intrepid band of four local Pagans gathered at the home of that well-known example of domesticus hippius, Dr. Paulus Bennedictus, to partake of the wild revelry among the heather. Apart from the host, our other three were Brian Hughes (fruitcake extraordinaire), Mick Nolan (a distant relation to the fab five sisters?)[2] and a certain co-editor of this very organ.[3] In the wee hours before dawn, when most sensible people were still slumbering, this intrepid group staggered into Ilkley, to be greeted by four reporters from the *T&A*. With a great deal of groaning, we made our way up to the stones, and were welcomed by all the others present... well, er not quite. Where were you all then? With just about one remaining brain cell between the whole group, we entreated the Goddess to give birth to the sun – not that it could be seen thro' the fog, but it's the thought that counts isn't it?

After one of the fastest Solstice celebrations yet seen at the stones, we squelched back into Ilkley, our hearts touched with wonder at what utter morons we were! Still, it was good to get away from all the Christmas capitalist crap for a while. See you at the Summer Solstice perhaps?

The *T&A* subsequently ran two articles on the morning's weirdnesses. Despite referring to Phil Hine as Paul Bennett (they all look the same, these occultists) and coining the most cringe worthy word of 1989 so far (Paganists) the tone was surprisingly sympathetic. The smaller piece was a completely straight report about the "Old Religion", which only queried why so few had braved the cold, whereas the second carried in-depth and largely unedited interviews with the participants. The stress was on the Pagan idea of respect for the planet, so topical today, and the failure of the established churches to meet the spiritual needs of the Modern Green on the street. Of course, the Christian(ists) were given a right of reply, and tried rather lamely to claim the cause of ecology as their own, before

1 The Twelve Apostles, despite their name, were originally neither 12 nor Apostles. It's the remains of a 15 metre wide prehistoric circle in Yorkshire which originally may have been composed of up to 20 stones.

2 An obscure reference to the (at the time) popular Irish singing group The Nolan Sisters.

3 That was Phil. I'm not that dumb – Rodney.

trotting out the hoary old chestnut about having to pick up the pieces of ruined young lives – not very original and about as convincing as a chain store Santa. It is good to start the year with an intelligent centre spread about Paganism in the mainstream media (as well as a huge colour photograph of Phil Hine!) and may herald, in the light of these de-ozoned days, a move away from manic scare stories to a serious consideration of what Paganism can offer the people and the planet. The only question is – why weren't YOU there??

Who Banned Rodney's Record?

The news that all Europe is talking about! Rodney Orpheus telexed[4] the *PN* office from Geneva[5] to say that the new The Cassandra Complex album (provisionally entitled *Satan, Bugs Bunny and Me*) would not now be pressed by CBS as previously agreed, due to their concern over "the Pagan content of the lyrics". After much negotiation it was decided that Belgium was sufficiently amoral to cope with the threat of corruption, and the album will now be pressed there, but will be banned in the USA.[6] This is a rare honour indeed, and is already stirring American Cassandroids, as well as supporters of religious freedom, to vocal protest. It makes us wonder what the C in CBS stands for; maybe Christian, perhaps Censoring, but certainly not Civilised!

4 Telex was a crude precursor to email, a network of huge hulking teleprinters using telegraph-grade connecting circuits for text-based messages. Telex messages were typed on to special paper tape and then the machine would convert that into electrical signals and send it to another Telex machine somewhere else in the world where it would be printed out. It was insanely slow and cumbersome. It was later surpassed by the fax machine, which was a slightly less stupid way to send messages over a telephone line. But still horrible. You kids today don't know how lucky you are.

5 By this stage Rodney's musical career had really started to take off and he was spending many weeks at a time on tour across Europe.

6 The album would come out in America on the Wax Trax label. That rare version is something of a collector's item now.

VIEW POINT

Pagan Animal Rights

By Tina Pye[7]

Pagan Animal Rights was set up in August '83 and has members throughout Britain together with a few abroad. We also have local groups based in Wirral, Sheffield, Oxford, Dorset and Middlesborough with new ones forming all the time. PAR was set up primarily for two reasons. Firstly to bring together those Pagans already involved in animal rights and also to encourage other Pagans who have never considered animal issues to take stock of their lives. It is, after all, hypocritical to claim to live close to nature and then to eat factory farmed animals or buy animal tested cosmetics and toiletries. Secondly, the group was hoping to inform members of the animal rights movement on Paganism – its existence and ideals. Judging by the amount of mail I receive it has met with some success on both levels.

As members are spread from Aberdeen to Cornwall we obviously cannot get together as a group very often so members are kept in touch by a quarterly magazine written by and for PAR members. We try to get together psychically and achieve our ends by joining in a weekly pathworking aimed at one or other aspect of animal abuse, which has met with a significant number of "coincidences" over the years. Local groups, which are entirely autonomous, often perform rituals for specific ends, for example to prevent the Waterloo cup, an annual hare-coursing event.[8] (Three hares round the sun is one of our logos.)

7 Tina Fox (Pye) ran Pagan Animal Rights until 1995. She went on to become CEO of the Vegetarian Society of the UK, and drew up the Animal Rights Policy for the Green Party. In 2001 she organized the World Vegetarian Congress in Edinburgh, and in 2007, founded Vegetarians for Life, which aims to help older vegetarians (particularly those in care homes).

8 Hare-coursing is a bloodsport wherein two fast dogs that hunt by sight rather than scent (sight-hounds) are set to chase a hare, and the result bet on. Despite being a fairly appalling use of animals for "sporting" purposes it is still legal in many countries, and widely practised undercover in the countries where it has been made illegal (such as the UK). Some people really need to get a new hobby.

About 90-95% of PAR members are Vegetarian/Vegan and this is where I feel we get most opposition – many Pagans are content to dress up, celebrate the festivals and maybe attend the odd demo, but they don't want to change their lifestyles too drastically. Many say our ancestors ate meat so it's okay for us to do the same – I disagree strongly with this simplistic analysis. We live in a vastly changing world and although there may not have been a Pagan argument for vegetarianism in the past there certainly is today. Firstly, factory farming is an abomination and an insult to the Earth Mother and no-one who calls themself Pagan should support such systems even by their silence. Even free range animals suffer when it comes to transport and slaughter, modern abattoirs are far from respectful of the wonder of life.

Gone are the days when the farmer killed his own stock or the Native American hunted the buffalo. With other protein sources so easily available should we demand the untimely death of an animal merely for the pleasure of our taste buds? In addition meat production is extremely wasteful of the planet's finite resources. The grain that feeds such prisoners is taken from our Third World Pagan brothers

> *"We live in a vastly changing world and although there may not have been a Pagan argument for vegetarianism in the past there certainly is today."*

and sisters, great amounts of power are used for the lighting, ventilation, automated feeding systems etc,. chemicals are produced and used in great quantities to combat the diseases caused by the systems themselves, and the end product is so many units of meat and profit and a large amount of pollution and slurry for the earth to deal with. Can we in all conscience claim to care about our mother and do nothing to combat the waste and perversion of her precious resources? Rearing one's own meat or hunting (without snares or other cruel practices) would appear to be the only honourable solution for a Pagan who needs the taste of meat.

PAR also advocates the abolition of vivisection, bloodsports, fur, performing animals, whaling etc. and although we know many of our aims are a long time off, our effort and energy brings them that bit closer. We work quite closely with, and try to promote, PaganLink, many members belonging to both groups. Members are given every encouragement to get in touch with one another and work closely. Our paths and methods may differ but we are united by our love for the mother and all her creatures and that unity is strength.

If anyone would like a leaflet on PAR please contact me; subscription to the mag/membership is £2 per annum, cheque to Pagan Animal Rights.[9]

9 As mentioned above, this organisation is now defunct, but has been replaced by a great many other excellent animal rights organisations. Give your donations to them.

THINGS TO DO...
and THINGS TO READ

The Nusphere Ritual [10]

by *Rodney Orpheus*

The following is an example of a banishing ritual – as used to open and close any kind of magical activity.

Stand facing East and form the Cross of Light in the following manner:

Visualise a sphere of white brilliance above your head.
Draw down a stream of light, touching your forehead with your finger, and say:
My God is above me
Draw the light down through your body, touch your genitals and say:
My God is below me
Touching your right shoulder say:
My God is to the right of me
Touch your left shoulder and say:
My God is to the left of me
Cross your arms over your breast and say:
My God is within me
Raise your hands above your head in a V shape (sign of Apophis) and say:
There is no God where I am [11]

This forms the Cross of Light.

10 This was the first publication of this ritual. It would later become the focus of one of the chapters of Rodney's first book *Abrahadabra* – and is now a very well-known and widely practiced ritual by many Thelemites around the world.

11 This is not a nihilistic statement – the invocation serves to unite the individual with their chosen source of inspiration, or godhead. [Original note by Rodney]

Advance to the East and draw a pentagram before you, starting at the bottom left-hand point and moving up towards the apex; energising it with the word:

I.A.O.[12]

Repeat this for South, West and North. Return to the centre and, facing east, stretch out your arms to each side and visualise the arched body of the Goddess Nuit; feet in the North, hands in the South, covering the circle. Invoke with the words:

Every man and every woman is a star.[13]

Repeat the Cross of Light (first part).

Comments

This rite follows the same basic procedure of most standard banishing rituals:

setting up a "sacred space", the centre of which is the Axis Mundi or crossroads, where the magician stands, balancing all the elements

an act of unification with one's chosen form of inspiration – drawing this power from within and without. The general principle is that the more intense the magical activity, the more thorough the banishing (especially afterwards) should be.

12 This is the formula of creation (Isis), destruction (Apophis) and rebirth (Osiris). [Original note by Rodney]

13 See *The Book of the Law* Ch. I, v3 by Aleister Crowley [Original note by Rodney]

B-DOG

the British Directory of Occult Groups[14]

B-DOG – the British Directory of Occult Groups is a new Pagan News feature. Each instalment will feature one occult/Pagan group or organisation, looking at its aims, praxis, and orientation. Any group interested in appearing in this feature should get in touch with us at the editorial address.

To open the series, we begin with a cautionary piece on approaching groups by Val Dobson, editor of Brigantia Beacon *and* Noname.

Groups:
Some Danger Signals to Watch Out For

Many "new" Pagans, isolated and alone, search desperately for a group or coven to guide them. There are quite a few perfectly good groups around, but unfortunately there are also some bad ones, run by people who seek to fulfil their own egomaniac fantasies and exploit others. Even more unfortunately, these "bad" groups are usually much easier to find than the other sort – they seek out converts and court publicity, while the genuine groups and covens wait for the seeker to be guided to them. Here is a checklist of signs to watch out if you are looking over a group, or even if you have already joined one:

14 B-DOG was another of those ideas which in hindsight seem obvious, but at the time was fairly revolutionary and even quite controversial. Although the UK and other countries were experiencing an unprecedented growth of people interested in occultism, most of the magical groups were, at best, wary of each other, and at worst, openly competitive and hostile. Also there was almost no crossover between different "paths": you were either a Wiccan, a Thelemite, a Satanist, a "ceremonial magician" (which apparently was supposed to be something different to all of the preceding, which we could never figure out), or some other weird-ass thing, but you were never allowed to be involved in more than one of these. This of course was utter bullshit – especially when you consider that Gerald Gardner, who invented Wicca in the first place, was a member of O.T.O. So for us to offer a forum for any magical group to set out their practices and aims was considered outrageous by some people. As we will see in succeeding issues...

- Is the group dominated by one or two powerful people who insist on doing things their way?

- Do most of the members strike you as being weak, passive, dependent personalities? Does this apply to you?

- Does the group work entirely from a book/set of writings that are "interpreted" by the leader(s) and must not be deviated from?

- Do they demand that you observe a number of rigid rules (more demanding than everyday social rules) concerning dress/behaviour etc?

- Do they insist that they have all the answers and "rubbish" other groups?

- Do they promise or imply that they have the power to cure all your ills and give you more power?

- Do they try to control your life outside the group, e.g. interfering in personal relationships, telling you not to read certain books, talk to certain people etc?

- Do they encourage members to demonstrate commitment to the group by giving large amounts of cash/goods or devoting most of their spare time in unpaid work for the group? (This is not the same as "tithing" – the regular donation of a small set % of your income to the group).

- Do they constantly draw a distinction between themselves and "the outside world", depicting the outside as ignorant/evil and themselves as elite Guardians of the Truth?

- Do they actively seek out converts?

- Is there a complex hierarchy, with the leaders giving themselves long and impressive titles?

- Do they strongly discourage the expression of dissident opinions in meetings, and label dissidents as "immature" or "stuck at a low spiritual level"?

- Do they make it difficult for members to leave the group?

All of the above are danger signals which indicate that a group is being run for the benefits of its leader(s) rather than its members, and can be applied to any group, whether religious, political, etc. If two or three of the above points apply to the group you are looking at, tread warily; if six or more apply – AVOID!

It is also useful to question your own motives for joining a group. Here are some sage words of advice from Frater Impecunius:

Ask yourself the following questions before advancing further along the path – remember, it could save you your intellectual credibility, your credit rating and even your sexual integrity:

• How much am I influenced by reading fantasy novels and playing Dungeons & Dragons? Will I be disappointed if I can't learn to blast my enemies with fireballs?

• Am I choosing a set of occult beliefs because they appeal to my political beliefs? This isn't necessarily a bad thing, but can lead to some remarkably sterile magical backwaters.

• How useful do I expect magick to be in everyday life? Do I, for instance, expect it to help me get a job as a sales consultant? If so, why only a sales consultant and not Managing Director of ICI?[15] If I learn to bend spoons, will it affect the quality of my life, or even my cutlery?

• How do I see it all ending? Am I after some kind of ultimate mystical orgasm, or would I be content with charming warts? Do I see myself as an awesomely powerful sorcerer, or wise old recluse?

We'd also be interested in hearing from anyone who's had a run-in with dodgy "Gurus/Spiritual Masters" or experienced problems with a particular group. All correspondence will be treated in strictest confidence – Eds.

15 Imperial Chemical Industries (ICI) was a British chemical company formed in 1926. At this point in time it was an iconic company, being the largest manufacturer in the UK; but a few years later it would be sold off and broken up. And now it's just a footnote in the history of an obscure Pagan magazine. How the mighty are fallen.

T'AI CHI CH'UAN

a Brief Introduction by *Frater Impecunious*

T'ai chi ch'uan (taijiquan) is a Chinese system of self-development involving health, self-defence and spiritual practices. It is classed as an internal martial art, in that it emphasises relaxation, mental calm and the utilisation of the body's vital energy, as opposed to external arts (such as Shaolin, kung fu or karate), which place more emphasis on strength and athletic ability. The core of t'ai chi practice is a long series of moves known as the Form. This takes between ten and thirty minutes to perform, depending on the style of t'ai chi practiced. Although the movements are based on fighting techniques, they are performed slowly and smoothly. Advanced students sometimes practice with sword and spear forms as well.

Breathing exercises known as ch'i kung (qigong) are used to stimulate the internal organs and develop the ch'i (qi), a subtle energy associated with the breath (similar to prana in yoga). Some exercises are done in pairs, notably pushing hands (t'ui shou/tuishou). This is a system of pushing, following, and deflecting movements, which increases sensitivity and internal strength.

Benefits Of T'ai Chi

T'ai chi is a relatively gentle form of exercise which can be taken up by women and men of all ages and in all states of health. T'ai chi improves health in three main ways:

- Relaxation. All movements are performed in a relaxed manner, leading to a general feeling of well-being, reduced stress, and improved blood-circulation, digestion and toxin elimination.
- Body-use. Many ailments are caused by bad posture, which places stress not only on the spine but also on the internal organs. T'ai chi corrects this by straightening the spine. Practice also improves coordination and develops suppleness, grace and efficiency of movement.
- Breathing. T'ai chi emphasises slow, deep breathing. This has immediate cardio-pulmonary (heart-lung) benefits. However, the main purpose is to mobilise the ch'i. Ch'i flows throughout the body, though it is concentrated in the tan t'ien (dan tian) below the navel and in the acupuncture meridians. Improving the flow of ch'i, like

acupuncture, increases vitality and strengthens the body's resistance to disease. Eventually it can even be projected outside the body and used to heal others.

There are also pronounced psychological benefits to be gained. The ability to "lose yourself" in the t'ai chi movements is a good antidote to anxiety, nervousness and obsession. As an invigorating exercise it helps combat depression, while in contrast its calming effect neutralises anger, frustration and irritability. A further consideration is that psychological problems often manifest as muscular tensions and postural defects ("character armour").[16] By gradually correcting the physical side, the psychological side often sorts itself out without the need for conscious intervention. The stilling of the mind involved in t'ai chi is also a preparation for more advanced spiritual cultivation. On a more practical note, attitudes formed by t'ai chi are useful in everyday life.

Self-Defence

All martial arts have a latency period before they can be used "on the street". In the case of t'ai chi this is often several years, varying according to different styles, teachers and students. The development of the "internal strength" which is the essence of t'ai chi, is always a slow process.

If t'ai chi is looked on as a long-term investment the benefits become apparent. In middle age, when most people become less "fighting fit", the t'ai chi player is coming into his or her full power, which will continue into old age. This is because chin (jin) or internal strength derives from the ch'i rather than the muscles. It can be used defensively to protect the body from injury or projected to give power to a push or punch. Nobody knows exactly what chin is, but its reality has been demonstrated repeatedly against orthodox fighters.

The History Of T'ai Chi Ch'uan

T'ai chi is attributed to the Taoist saint Chang San Feng, who probably lived in the Yuan dynasty (1279-1368). However, Chang was a legendary character about whom little is known for certain. The earliest t'ai chi player we know much about is Ch'en Wang Ting (1597-1664) who founded the Ch'en style of t'ai chi, though this is still a matter of some debate. Ch'en style uses snappier movements than

16 The concept of character armour was first identified by unorthodox (but fascinating) psychologist Wilhelm Reich. His conception was that children would tense their muscles to armour themselves against emotional or physical trauma, and this tension would become internalised and automatic, leading to semi-permanent muscular blocks later in life.

modern t'ai chi and similarities to Shaolin kung fu are apparent. This style was passed down through the Ch'en family, but also branched off to create other styles.

Wu style is characterised by gentle swaying movements of the spine and small, precise hand-movements. Yang Lu Chuan (1799-1872) also modified the Ch'en style to create Yang style, the most popular of the t'ai chi styles. Unlike Wu style, the spine is kept erect and more expansive moves are used.

The main Yang forms practiced today are those of Yang Chengfu and Cheng Man-ch'ing. Yang Chengfu was the grandson of Yang Lu Chuan and was known as "invincible Yang". Yang was undefeated in challenge matches, which in those days were frequent and decidedly rough, and there are many stories about his extraordinary abilities. One relates how he was bitten on the leg by a pair of guard dogs. Yang strolled on nonchalantly but that evening the dogs were noticed to be off their food. Closer inspection revealed that they had broken all their teeth!

In addition to the main styles of Ch'en, Wu and Yang, there are a large number of lesser-known styles, as well as a simplified composite form devised by the Chinese government. In choosing a class the quality of teaching is more important than what style is being taught – someone who has been taught well in one style will find it easy to assimilate others if they so choose. However, charlatans and incompetents abound, so it is worth checking the lineage and reputation of a prospective teacher.

The name "t'ai chi ch'uan" is usually shortened to "t'ai chi", but strictly speaking "t'ai chi" (literally "supreme ultimate") refers to the philosophical principle described by the "yin-yang" or "two fishes" diagram (more properly known as the T'ai chi t'u).

The black fish-shape represents the yin principle, which is dark, receptive, yielding and enduring. The white half represents the yang principle, which is bright, expansive, strong and explosive. Each principle contains the seed of its opposite, as shown by the two dots in the diagram.

Ch'uan means fist, and by extension any martial art, so t'ai chi ch'uan could be translated in full as "the martial art which utilises the harmony of yin and yang" (Chinese is wonderfully concise!). This use of yin and yang is seen in the t'ai chi form. At the simplest level, outward-going striking or pushing movements are yang, while inward-moving defensive movements are yin. Yin and yang give rise to each other throughout the form.

Although t'ai chi is rooted in Taoism, it is not necessary to be a Taoist to appreciate the principles of harmony and naturalness on which this philosophy is based. T'ai chi is an excellent supplement to mystical practices such as meditation and ritual and its uncompromising physicality is a good antidote to the spiritual constipation that results from spending too much time in your own head!

REVIEW

Oxford Thelemic Symposium
by Dave Lee

The third national Symposium of Thelemic Magick was held at Oxford's Town Hall, on Saturday the 22nd of October. The event took place in the council chamber, which is ringed with the signs of the zodiac.

Ken Cox of the Typhonian O.T.O. took the podium first, giving an excellent talk on the magick of Surrealism. Ken presented a wide overview of Surrealist ideas, and demonstrated the "random" method of decalcomania (ink or gouache on folded paper) as a means of constructing sigils and obsessional images.

Lionel Snell[17] completed the morning's events with one of his extraordinary, intricate talks. Taking as a starting point the astrology of Uranus in the change of Aeons, he traced the assimilation of the ideas of both Aleister Crowley and Austin Osman Spare (along with those of Einstein for more general comparison) from 1904 to the complete Uranian cycle to 1988. This pathway spawned more ideas than there's space to mention. For more of Lionel's thoughts have a look at his new book *Words Made Flesh*.

In order to fit in lunch I had to miss the next item on the day's agenda. Andrew Collins, author of *The Black Alchemist* gave a talk on his "psychic quest", which involved the channeling of Crowley. I returned to catch a workshop on Kali by Mike Magee and Andrew Stenson (both members of the tantrik order, AMOOKOS). They provided a whole host of Kali attributes and ideas, which led to the day's liveliest discussion.

The final sit-down event was Mike Goss's showing of the 'Magic Lantern' cycle of films by Kenneth Anger. Unfortunately, the video quality was rather poor.[18] Mike also ran an excellent disco (with slides) at the evening social.

My overall impression of the Symposium was lots of energy but virtually no arguments. It was certainly an improvement on the near-drongoism of last year's afternoon session. Perhaps a little more discussion might have been fruitful. Still, an excellent event, with a great opportunity to make contacts.

17 Lionel Snell (1945 –) is probably the most influential British magician of the late 20th century that no-one has ever heard of. His works have been published under a variety of pseudonyms including Ramsey Dukes, Lemuel Johnston, Angerford & Lea, and The Hon. Hugo C StJ l'Estrange. His book *Thundersqueak* is essential reading, though all of his works are well worth picking up.

18 Happily the entire Magick Lantern cycle has since been made available on high quality Blu-ray from the British Film Institute. The films in the cycle include: *Fireworks* (1947), *Puce Moment* (1949), *Rabbit's Moon* (1950/1971, the rarely seen 16mins version), *Eaux d'Artifice* (1953), *Inauguration of the Pleasure Dome* (1954), *Scorpio Rising* (1964), *Kustom Kar Kommandos* (1965), *Invocation of My Demon Brother* (1969), *Rabbit's Moon* (1979 version), *Lucifer Rising* (1981).

PAGAN NEWS

The monthly newspaper of
Magick & the Occult

February ' 89

Price 30p

WAS JESUS A WOMAN?

No, we haven't been reading *The Sunday Sport* again,
this is the opinion of Anthony Harris, a British
biochemist. He claims that Jesus - who he calls Yeshu (a
variation on the Hebrew) was a woman suffering from
Turner's Syndrome. Women with this condition are short
(according to the Jewish historian Josephus, Jesus was
only 5' tall), have wide chests and underdeveloped
breasts, and overgrowths of blood vessels in the skin.
Another symptom is the abscence of menstrual bleeding.
Harris also explains Jesus' agony in the garden of
Gethsemane as literally sweating blood - as Yeshu knew
that she was about to be arrested, her capillaries burst
under the intense blood pressure. Harris says that when
Yeshu was born, Mary knew that no female redeemer
would be taken seriously, and further, that the Jewish
priesthood was so misogynistic that Yeshu had to live as
a man to enter the teaching area of the synagogue.

Harris believes that the Turin Shroud is, of course, a
fake, but asserts that pieces of a female skull, once owned
by the Cathars (who claimed to possess Christ's relics),
would support his thesis. Unfortunately, the skull was
stolen and, says Harris, has "since vanished from history
and today probably lies in the Vatican." A spokesperson
of the Mormon faith, when asked how she felt about the
idea that Jesus was a woman stated *"I know in my heart
that Jesus was a man".*

The Tell-Tale Heart!

Leeds Tarot & Rune reader Bryn Ormsford received an
unusual (and early) Valentine the other day - a
gift-wrapped sheep's heart through the post! Written on
the box in gold marker pen was the following dire curse
"From a woman of the red, to a woman who will soon be

THIS ISSUE

Temple Ov Psychick Youth

Special Feature on Mind Control

Magick & the Modern Age

Shamanic states of Ecstasy!

dead Woman to woman,

blood to blood,

heart to heart".

This awe-inspiring legend was followed by some silly
runes. A bemused Bryn told *Pagan News* "Since
receiving this, I've been offered a permanent post at the
place where I'm working, promotion, been asked to do
lectures, and appear on local radio." We later spoke to
local sorceror Ragnor Blacktrousers who said "This is
obviously the work of amateurs who've read a few books
and think that everyone is as gullible and petty-minded as
they are. This sort of thing should be left to the
professionals, like me."

Seriously though, it's this kind of silly behaviour that the
gutter press love. It confirms their suspicions that pagans
& occultists are both silly & cranky. Far from being
struck down with terror, we all had a good laugh at this
pathetic attempt to frighten Bryn - the ineptitude of the
sender(s) is only matched by their overblown sense of
self-importance. Of course, we'd dearly love to point the
finger at the *Body* in question, but being responsible
pagans we won't - unless, that is, the sheep's hearts
continue to appear on Bryn's doorstep. 'Woman of the
Red', search your own heart & *Soul* before your actions
catch up with you.

Was Jesus a Woman?

No, we haven't been reading *The Sunday Sport* again, this is the opinion of Anthony Harris, a British biochemist. He claims that Jesus – who he calls Yeshu (a variation on the Hebrew) was a woman suffering from Turner's Syndrome.[1] Women with this condition are short (according to the Jewish historian Josephus, Jesus was only 5' tall), have wide chests and underdeveloped breasts, and overgrowths of blood vessels in the skin. Another symptom is the absence of menstrual bleeding. Harris also explains Jesus' agony in the garden of Gethsemane as literally sweating blood – as Yeshu knew that she was about to be arrested, her capillaries burst under the intense blood pressure. Harris says that when Yeshu was born, Mary knew that no female redeemer would be taken seriously, and further, that the Jewish priesthood was so misogynistic that Yeshu had to live as a man to enter the teaching area of the synagogue. Harris believes that the Turin Shroud is, of course, a fake, but asserts that pieces of a female skull, once owned by the Cathars (who claimed to possess Christ's relics), would support his thesis. Unfortunately, the skull was stolen and, says Harris, has "since vanished from history and today probably lies in the Vatican."[2] A spokesperson of the Mormon faith, when asked how she felt about the idea that Jesus was a woman stated "I know in my heart that Jesus was a man".

The Tell-Tale Heart!

Leeds Tarot & Rune reader Bryn Ormsford received an unusual (and early) Valentine the other day – a gift-wrapped sheep's heart through the post! Written on the box in gold marker pen was the following dire curse:

"From a woman of the red, to a woman who will soon be dead
Woman to woman, blood to blood, heart to heart"

1 *The Sacred Virgin and the Holy Whore* by Anthony J. Harris, Sphere Books, 1988.

2 This would have been the legendary Head 58m: "A great head of gilded silver, most beautiful, and constituting the image of a woman. Inside were two head bones, wrapped in a cloth of white linen, with another red cloth around it. A label was attached, on which was written the legend CAPUT LVIIIm. The bones inside were those of a rather small woman." – Oursel, Le Procés des Templiers.

This awe-inspiring legend was followed by some silly runes. A bemused Bryn told *Pagan News* "Since receiving this, I've been offered a permanent post at the place where I'm working, promotion, been asked to do lectures, and appeared on local radio." We later spoke to local sorcerer Ragnor Blacktrousers who said "This is obviously the work of amateurs who've read a few books and think that everyone is as gullible and petty-minded as they are. This sort of thing should be left to the professionals, like me."

Seriously though, it's this kind of silly behaviour that the gutter press love. It confirms their suspicions that Pagans & occultists are both silly & cranky. Far from being struck down with terror, we all had a good laugh at this pathetic attempt to frighten Bryn – the ineptitude of the sender(s) is only matched by their overblown sense of self-importance. Of course, we'd dearly love to point the finger at the body in question, but being responsible Pagans we won't – unless, that is, the sheep's hearts continue to appear on Bryn's doorstep. 'Woman of the Red', search your own heart & soul before your actions catch up with you.

VIEW POINT

Blow Up the Future[3]
by *Phil Hine*

"Every man and every woman is a star".[4] And everybody wants to be a star. Or so the story goes. We live in a magical universe, where nothing is true, and everything is possible. Or so they say. Through magick we may bring about change, in accordance with will. Turn ideas into reality using a body of techniques and concepts that have changed very little since the dawn of our species. Or so we'd like to think. But the times they are a changin'.[5]

Magick, as we have been told often enough, is concerned with the quest for individual power. Sorry, that should read empowerment, the word on everyone's lips from "rad" journalists to yuppie channelers. Problem with magick is that it takes time to implement. Nor is it particularly user-friendly. The siddhis are only won at the risk of insanity, angst and becoming lost in the tortuous ramblings of generations of half-starved hermits who have committed their insights to paper. All this is too slow, way too slow for the children of the Horus Aeon,[6] who want their glory now. The promises of future incarnations, Heaven, and good karma in

3 This is a line from one of Rodney's songs: 'Presents' by The Cassandra Complex. The first of several song lyrics that Phil quotes in this article. The article is notable for introducing something that would later become essential to our personal magical practices, the updating and repurposing of traditional magical concepts with modern symbols.

4 Another line from Crowley's *Book of the Law*. Yeah, we read a lot of Crowley back then.

5 Bob Dylan.

6 In Crowley's Thelemic cosmology, human civilisation can be broken into different Aeons, or major social-political eras. The first being the Aeon of Isis, ruled by feminine energy, when humans first banded together in tribal societies as hunter-gathers; the second being the Aeon of Osiris, when masculine energy dominated – the age of city dwelling and nation building; and the third being the modern Aeon of Horus, the age of the child, with the creation of post-industrial society.

numbered Swiss accounts isn't where it's at. Live fast, die young, and leave a good corpse, is the only manifesto needed. Liber Oz for minimalists.

"Wealth is good, but fame is eternal"
an Indonesian tribal woodcarver, quoted on *Wide World* (BBC, 09/03/88)

The World Wars of the 20th century effectively inaugurated the Aeon of Horus. Hiroshima was the final seal of authenticity that a New Age was about to dawn. Even as the dust cloud

that they are material symbols for bringing about change on the inner levels of reality. The "traditional" magician is more or less happy with orchestrating the occasional fortuitous coincidence. But what about the direct manipulation of reality. Like now, this minute...?

Changes in culture and the rapid advance of technology have produced a magical universe. We are individuals, spawned from a fragmented society where pluralism is running riot. No

"The IRA are condemned as 'animals' for using nailbombs, while the Americans change from metal to plastic flechettes so that they're harder to dig out from torn flesh. Gun-culture brings its own contradictions: when they kill our civilians it's an atrocity; when we kill their civilians it's tough retaliation."

settled, the new era was being planned. Reality was to become magical again. Malleable, that is, by those with the secret keys to the temple. How so?

The "traditional" magician works through a set of four magical tools, or weapons. The Wand (Fire), The Dagger (Air), The Chalice (Water) and the Pentacle (Earth). These correspond, respectively, to the qualities of motivation, analysis, intuition and synthesis. All are instruments for controlling reality. Some would say

longer part of a clan, tribe, community (or even nation), we have gained a great deal of freedom of movement to shop around for a lifestyle that fits our personal ethics. The future is breathing down our necks, and we conjure up "traditions" to assure ourselves that the past we never had is still there, waiting to be rewritten. Our magical reality has its own magical weapons. If you dare, you can take them up and realise your divine potential – we can be heroes, just for one day.[7] Nowadays we have the Gun (Fire), the Microphone (Air),

7 David Bowie, 'Heroes'. Bowie was also very interested in occultism. In an interview with BBC 6Music in 2016 he talked about how important spirituality was to him, particularly "Qabalah,

Television (Water), and the Computer (Earth). Four ways to become a star: Kill, make a record, get yourself on television, or get hacking. Simple enough, yes? Let's have a look...

The Gun is the wand, of course. Or if you prefer, the phallus, pumping bullets into the fabric of order. What a way to impose your will upon the world. ...I don't like Mondays.[8] Conversation overheard at a psychic festival:

"This talisman will protect you from psychic attack."
"Yes, but will it jam a Kalashnikov?"

In our magical reality, any nonentity with a gun can suddenly be immortalised. We remember our dead culture heroes, and usually the people who gunned them down as well. The death of one person sparks an outrage, while politicians blithely talk about "collateral damage" (i.e. civilian megadeaths) during limited nuclear wars. The IRA are condemned as "animals" for using nailbombs, while the Americans change from metal to plastic flechettes so that they're harder to dig out from torn flesh. Gun-culture brings its own contradictions: when they kill our civilians it's an atrocity; when we kill their civilians it's tough retaliation.

For millennia, war has been the major route of initiation into manhood. War initiated the planet into the Aeon of Horus; each successive melting-pot has bred further changes, further fragmentations. Vietnam is an initiation ceremony misfired. Its returning illuminati couldn't be plugged back into the American Dream. The "revolution" of the 60s revealed in full technicolour the dream turning putrid. No coincidence that this was the first televised war either.

The rock star is the 20th century equivalent to the tribal Shaman. The idol who mediates between our dreams and fantasies, and the crushing ponderous weight of everyday reality. Someone who's done it all, and made it back again. The sinner-saint who tells it like it is. And ultimately, is sacrificed on the altar of fame. Pulled down by the same people that put them up there. Dead pop stars become gods – Joplin, Hendrix, Lennon, while live stars are occasionally sacrificed if the crops are failing. rock stars are people who've made it. So even as we idolise them, the seed of jealousy can be sown, and so the stories of catching them with their pants down are even sweeter than hearing of their success. Rock 'n' Roll is the Devil's work in any case. In a recent TV debate on witchcraft, a Church exorcist spoke of the distraught souls in discos which were sources of moral pollution. Born-Again Christians in the USA banned

magick, Tibetan Buddhism, and the writings of Madame Blavatsky".
8 The Boomtown Rats.

records by Bill Nelson[9] because his LP's back cover showed photographs of magical implements.

The Microphone is the weapon of air that the Rock Star wields. If you have a message to get across, go out and make a record or tape. Words and music carry images to the target subculture. The airwaves are full; radio stations, citizens band, pirate transmissions. These are not just neutral technological tools, but means of reaching out to others, of engagement. The intent to which they are used is your own, but the microphone confers its own magical power – anyone can grab one, and so grab our attention, if only momentarily.

"TV is everything"
The Cassandra Complex,
Prairie Bitch.

Television is probably the most complex of our modern magical weapons. It is the birth channel, the universal mother, the gateway to magical reality. So far, human beings are the only species to artificially extend and augment their nervous systems.

Television extends our channel of perception, always reminding us that we very often do not see things as they are, but in accordance with our expectations. Television replicates our images and symbols and feeds them back to us in an elevated and amplified form. Televisualised reality is magical – larger-than-life. And the debate as to who manipulates who continues to rage on. As a commentator on the television violence issue said, it's a case of: "television makes everyone more violent, except me." Matters of truth and fiction, morality and fantasy become magical, which is to say, malleable. Home video and pirate TV are possible routes of access.

And so to the weapon of earth (the pentacle) – the computer. This article is being written using a computer, and a computer will typeset and lay out this newspaper. The sheer power of the things to translate ideas into reality is awe-inspiring, as is the power of people to subvert them to their own ends. One of my favourite tales is the guy in the States whose mother gave all her money to Jerry Falwell's[10] evangelical crusade. The guy was

9 This was the US release of the album *Getting The Holy Ghost Across* in 1986 which featured the classic picture *The Annunciation with St. Emidius* (1486, by Carlo Crivelli) as well as the title in the Enochian language. Bill Nelson (1948 –) is from Wakefield, Yorkshire, not far from Leeds where we were based. He is one of the true idiosyncratic geniuses of British music, first with his band Be Bop Deluxe, and later with his own solo albums (which he released at a rate of about 4 each year!). Many of his albums feature his interest in Gnostic and mystical themes, and the influence of magician Austin Osman Spare. Well worth tracking down.

10 Jerry Lamon Falwell Sr. (1933 – 2007), founder of the American right-wing political action group the Moral Majority, and of the whites-only Liberty Christian Academy. He opposed the civil rights movement, was against homosexuality, and supported the apartheid regime in South Africa. He also opposed British kids TV show *Teletubbies* because the character of Tinky Winky was supposedly promoting a gay lifestyle. He said about the 9/11 attack: "I really believe that the

A New occult & information magazine.

A5, 50-60 pages. Vol. 1 available now. £3.00 incl. postage from M. Calpin, Nethermoor Lane, Killamarsh Sheffield, S31 8BZ.

understandably pissed off, and so he used his computer to get his own back. Falwell had started up a dial-a-rant service where he paid for the calls – using comms software, the hacker used his computer to ring Falwell every thirty seconds, and had several friends do the same. Six months of this gave Falwell an eight-million dollar phone bill![11] The hacker is next year's culture hero. Anyone who's into *Neuromancer/Count Zero*[12] is already hooked. Teenagers in West Germany hacked into the US defence mainframe – a seventeen-year old whizz kid "the Syscruncher" ran rings around the top brains at M.I.T.'s computer dept. Certain models of IBM mainframes can have their memories filled with the word RABIT if you know the codeword. "...the street finds its uses for everything."

Grab the moment... do it now... think/decide/act! What more magick do you need?

Pagans, and the abortionists, and the feminists, and the gays and the lesbians who are actively trying to make that an alternative lifestyle, the ACLU, People For the American Way, all of them who have tried to secularize America. I point the finger in their face and say 'you helped this happen.'" An all-round asshole of a human being. Not to be confused with his son Jerry Falwell Jr. whose wife admitted she was fucked by a pool boy who himself claims that Jerry Jr left him out of a promised business venture.

11 Turns out this story was indeed true, but the figure was considerably exaggerated – in reality it was only $750,000. But that's still a decent amount of money and it was still a great hack, and so our hats are off to this unknown gentleman from Atlanta. Well done sir!

12 Two seminal books by William Gibson (1948 –) that launched the cyberpunk SF movement.

B-DOG

the British Directory of Occult Groups

Message From The Temple

This month, B-DOG features the
Temple of Psychick Youth[13]

What are the aims of the Temple of Psychick Youth?
Involvement with the Temple ov Psychick Youth requires an active individual, dedicated towards thee establishment of a functional system of magick and a modern Pagan philosophy without recourse to mystification, gods or demons; but recognising thee implicit powers of thee human brain (neuromancy) linked with guiltless sexuality focused through will structure (sigils). Magick empowers thee individual to embrace and realise their dreams and maximise their natural potential. It is for those with thee courage to touch themselves. It integrates all levels of thought in the first steps towards final negation of the control and fear. TOPY is to instigate individual focus and development, through promoting a personalised system of magick and self investigation technique, and to parallel this individual project with the advancement of a "neo-tribe" network of collaboration and communication.

How did TOPY come to be?
TOPY arose thru the increasing dissatisfaction with the pedantic and hierarchical structure of the already established magical groups. Along with the desire to expand magick into every aspect of an individual's life and employing it at all times.

How widespread is the organisation?
TOPY now has access points throughout the Western world, as well as increasing numbers of correspondents and allies in Japan and Eastern Europe.

13 Thee Temple ov Psychick Youth was founded in 1981 by members of the band Psychic TV, most notably the late Genesis P-Orridge (1950 – 2020), who would later become a close friend of Rodney. It was very successful in introducing occult teachings to a new generation of young people around the world and encouraging them to experiment.

Is TOPY distinct from Psychic TV?

TOPY is distinct from PTV. Should PTV cease to exist, the Temple would be in no way diminished – it is not a PTV fan club.

What is the significance of the Psychick Cross?

The single vertical line represents the individual & the struggle to manifest one's own destiny. The bottom horizontal line represents the individual's past – both personal and collective genetic. This time mode can be used to learn from one's past mistakes. The middle line represents present time – one's temporary state of existence at any given moment. It is constantly subject to change, although when an individual is involved in this time frame it may seem to be inescapable and most important. The top line represents the future. The will. What one should always be striving to attain. The legend in your own mind. Many times it may appear to be unattainable, but it is your only real choice to be made. This is not a fixed meaning, it can also stand for the dictionary of TOPY. The disenchanted individual, yet the individual who recognises the necessity to transmute disenchantment into positive action.

Why do you use a peculiar form of English – "thee, coum", etc?

As in all things, individuals allied to TOPY choose whichever form of expression works best for themselves. The use of such words is purely a matter of choice, although such words have organically become the most common form of writing in TOPY.

Why do Temple members use the prefixes "Kali", "Eden", etc?

The prefixes "Kali" and "Eden" have no special meaning but are primarily for filing purposes and to promote security. They are also used to avoid any hierarchical notions.

Are TOPY members Pagan – in their own view?

In the sense that Pagan means having no belief in god(s) or any other superior being or intelligence to woman/man, then allies of TOPY are Pagan. However, each individual associated with TOPY will have differing views and so it is impossible to be other than general in answering this question.

How do you see TOPY developing?

Personal development, of necessity leads to development of the whole... and as individuals constantly develop, so their input causes the Temple to evolve in relation to themselves. Thee Temple's main weapon in overcouming thee insidious hand ov control is our internal exchange of information, and the external expansion of propaganda in thee information war. It is selfish to keep things to ourselves. By exchanging ideas within the Temple Network we can each develop faster, making thee necessary connections to remove all unwanted obstacles. All is contingent on the individual input. Together we will rise.

Shamanism and Atavistic Resurgence
By Eden 230

Shamanism is thought to be the earliest form of religion, possibly dating back 100,000 years or more. The term "shaman" comes to us through Russian, from the Siberian Tungusic term "saman", meaning, "one who is excited, moved, raised." In most cultures, the shaman, like other types of religious specialists, is concerned with the ultimate problems of life and their solutions. Shamans are distinguished from priests in that their authority rests on their own personal experiences with nature and supernature, whereas priests are liturgical officiants presiding at rituals and over congregations without the necessity of a personal direct experience with the deity.

Like the Yogi or meditator, the shaman experiences altered states of consciousness as part of a definite discipline. There is also a guru-disciple relationship, and a system of techniques and prescribed types of altered states of consciousness the goal of which is the transformation of the individual. The shaman's trance is outwardly-oriented. It is not autonomous but directed toward the community so that the trance serves as a medium of communication between the supernatural or non-ordinary reality, and the everyday mortal world.

Unobtrusive inner observation requires some training. This training amounts to developing an attitude of mindfulness. The meditator is instructed to notice effects and thoughts as soon as they arise in consciousness, and to observe them in a contemplative way, until they disappear. The essential objective of the shaman's training is to allow them to control their own trances.

Trance can be induced using a number of techniques which have the effect of transforming consciousness from the outer, sensory world to the inner,

contemplative one. It can be brought about, for example, by sensory deprivation in which a lack of external stimuli results in an inner compensatory release of energy in the form of images. This state can be achieved by combining sleeplessness, fatigue, fasting and suspended breathing techniques, and through the use of hallucinogens.

The key to the shaman's activity is the capacity to retain control of visions. The trance techniques are undoubtedly integrative and not self-destructive.

consciousness to the visionary world of symbols through an act of willed imagination. The shaman may conjure specific images to mind, but at the same time, allows the body to relax, restricting the outer vision. In the course of being initiated, the future shaman has to learn the secret language that will be used to communicate with spirits. This language is either learnt through a teacher, or by a personal method. All over the world, learning the language of animals, especially that of birds, is equivalent to knowing the secrets of Nature, and hence to be able to prophesy. Bird language is

> *"All over the world, learning the language of animals, especially that of birds, is equivalent to knowing the secrets of Nature, and hence to be able to prophesy."*

In modern magick the meditative techniques and the ritual repetition of sacred mantra-like god names have essentially the same effect as the sensory deprivation methods of the shaman. The magician within the circle enters a sacred space and perceptually encounters the mythic images being invoked. Such chanting of divine names and concentration on the images and symbols of the gods have a profound emphasis on the creative imagination, stimulating the archetypes of the unconscious mind.

Essentially the trance meditation technique involves a transfer of

usually learned by eating snake skin, or some other reputedly magical animal. The animals can learn the secrets of the future because they are thought to be receptacles for the souls of the dead or epiphanies of the gods. Learning their language, imitating their voice is equivalent to being able to communicate with the beyond. The shaman's instruction often takes place in dreams. It is in dreams that the pure sacred life is entered. It is always in dreams that historical time is abolished and mythical time regained – which allows the shaman to witness the beginnings of the world.

Austin Osman Spare[14] produced a cosmology which was totally shamanic in its structure and technique. He postulated a primal and universal source of being, "Kia", arguing that the human body, "Zos" was an appropriate vehicle through which to manifest the spiritual and occult energies of the unconscious. Spare regarded that this level of mind was an epitome of all experience and wisdom, past incarnations as men, animals, birds, vegetable life... everything that exists, has ever and will exist. His technique of arousing these primal images is called 'Atavistic resurgence', and involved focusing the will on sigils which he developed to instruct the unconscious. Spare believed that the sigil representing an act of conscious will could be planted like a seed in the unconscious during a state of ecstasy, when the personal ego and the universal spirit blended together.

Ecstasy, inspiration, intuition and dream... each state taps the latent memories and presents them in the imagery of their respective languages. By means of monotony, isolation and intuition, the shaman destroys the fixed patterns of personality, thus opening the way for the visions and the voices.

14 Austin Osman Spare (1886 – 1956), English artist and occultist who created a unique magical system based on automatic writing and drawing, and sigilization. His work languished in relative obscurity until popularised by the work of Kenneth Grant and the rise of the chaos magick movement, and he is now widely seen as a seminal figure in the development of modern magical techniques. Phil Baker's biography of Spare was published by Strange Attractor in 2011.

Famous Occult Stereotypes[15]

Elvira Pressington-Bagley (Mrs)

by *Barry Hairbrush*

"Well, dear, you know the nature spirits are such playful things, I'm regularly in touch with one, he makes my begonias come up so nicely in the summer. I'm sure that the inner light would come to us all, if we only sat around on hilltops a little bit more. I was sitting on a hilltop only last week when a saucer from 'Friends from Space' touched down beside me. They all had such a kindly look in their eyes. I gave them a tea cosy I'd knitted the week before and they seemed pleased with it. In fact, when Trouser the Trouserian beamed down at our last meeting with his words of light, I'm sure one of his retinue was wearing it, you know, the little blue ones who always stand at the back.

Would you like another cup of herbal tea? I get it from a little shop in the village where we leave our leaflets. You really could do with some more, you know, your aura's gone quite green, and that's not a good sign in a Sagittarian, you are a Sagittarian aren't you? Oh well I wasn't far wrong. You can take a book with you, if you want, I've got all of Madame Blavatsky's works, so inspirational, they're just under the Von Daniken collection. Did you know that spacemen taught the Incas everything they know? As a matter of fact, I'm making a chilli for Norman's tea tonight! Synchronicity!"

15 This would become a regular monthly feature in *PN*, and every time Barry delivered a new one it never failed to make us roll on the floor with laughter, they were so acutely observed. Elvira Pressington-Bagley (Mrs) accurately nailed a classic, if now dying, breed of middle-class British weirdo who was completely normal on the outside but inside was a muddle of post-Theosophical cosmology coupled with a belief in aliens and fairies. Psychic Fairs were full of them back then.

PAGAN NEWS

The monthly newspaper of
Magick & the Occult

March ' 89

Price 30p

Not On Sunday?

On thursday, 16th February, Channel 4's Not on Sunday programmme decided to take alook at Witchcraft. The cameras first visit was to Nigel and Seldiy Bate's Streatham coven as they celebrated Imbolc; then onto Felicity Wombwell and her group who do not work in a 'set, traditional structure', and who made the point that Christianity has incorporated pagan elements and has built on sacred sites. In answer to the old good/evil argument, Felicity noted that whereas Christianity is dualistic, pagans integrate light and dark and take responsibility for their actions; morality comes from within, not imposed by or onto others.

In the studio were Dr David Burnett (Worldwide Evangelisation for Christ) and Leonora James, President of the Pagan Federation. Predictably, the old black/white witch stereotypes formed the premise of Burnett's attack; Witchcraft is by definition evil, against God and the Bible, a mish-mash of modern ideas which lead the innocent victim from yoga to Tantra, Crowley, DRUG ADDICTION, and other depravities too gruesome to name. This was neatly blocked by Ms James who stressed the historic global and cultural currents involved - it merely felt like a new religion because it has touched people to the core, and what the Bible said was irrelevant. Burnett then rambled on at length about African Witchcraft being the province of women and therefore evil, and people had to go to the male Witchdoctor to be cured! Somewhat bemused, Leonora explained that the 1920s definition of Witchcraft in this context was a mis-translation of a local dialect and had long since been discredited by serious anthropologists. There were more mumblings about depravity and addiction until Leonora had the last word, that Christianity can breed a very authoritarian personality which can pave the way for

dictators. Burnetts whole argument was that Paganism was modern, addictive,the province of women, and therefore evil, and his liberal sprinkling of the word 'drugs' throughout was calculated to feed peoples fears by llnking one folk devil with another. Using his arguments, perhaps the Pope should be dried out as he's obviously addicted to Christianity; we should be attacking Christianity for not doing exactly as it did in AD34; and what about the Queen, horrors, an evil woman as head of the Church of England ! As for the black/white thing, it is tedious and wastes valuable media time - why does no-one ever say "Are you a good or an evil vicar" in response to show its irrelevance. Full marks to Leonora James who remained cool and reasoning throughout and undermined Burnetts outdated ramblings. Strange how his eyes glittered whenever depravity was mentioned - but then the Church is an old hand there isn't it - the curates and choirboys, Jim and Tammy Bakker, the Borgias, Torquemanda, Jimmy Jones and all those massacres of heretics...

Bury Vicar Bans Beltane!

A Bury Vicar has banned his area's May Queen celebrations because, he says, the tradition of the May Rose Queen is "firmly rooted in pagan fertility rites, like dancing round the maypole." In the latest edition of his parish magazine, the Rev. Ben Turner, of St. Stephen's, Elton, said that "To continue the practice, outwardly harmless & entertaining though it may be, shows poor theological understanding. And it is not in the best interest of good Christian education." Some parishoners,

March 1989

NEWS

Not On Sunday?

On Thursday, 16th February, Channel 4's *Not on Sunday*[1] programme decided to take a look at witchcraft. The camera's first visit was to Seldiy Bate & Nigel Bourne's[2] Streatham coven as they celebrated Imbolc;[3] then onto Felicity Wombwell[4] and her group who do not work in a set, traditional structure, and who made the point that Christianity has incorporated Pagan elements and has built on sacred sites. In answer to the old good/evil argument, Felicity noted that whereas Christianity is dualistic, Pagans integrate light and dark and take responsibility for their actions; morality comes from within, not imposed by or onto others.

In the studio were Dr. David Burnett (Worldwide Evangelisation for Christ)[5] and Leonora James,[6] President of the Pagan Federation.[7] Predictably, the old black/while witch stereotypes formed the premise of Burnett's attack; witchcraft is by definition evil, against God and the Bible, a mish-mash of modern ideas which lead the innocent victim from yoga to Tantra, Crowley, DRUG ADDICTION, and other depravities too gruesome to name. This was neatly blocked by Ms James who stressed the historic global and cultural currents involved – it merely

1 *Not on Sunday* was an attempt at an "alternative" religious TV programme. It didn't last long and sank without trace.

2 Seldiy Bate & Nigel Bourne were well-known Wiccans who would appear frequently on various media over the years (including Nigel appearing as a contestant on classic British game show *Countdown*!). In 1987 they had released an album of their music *Pagan Easter: Ritual Music For The Spring Equinox* on Temple Records (run by Genesis P-Orridge and TOPY), somewhat of a collector's item these days.

3 Imbolc is one of the four Gaelic seasonal festivals, along with Bealtaine, Lughnasadh and Samhain. Traditionally held on February 1st – halfway between Winter solstice and Spring equinox.

4 Felicity Wombwell is a creative arts therapist and author of *The Goddess Changes* (1992). She is a co-founder of the Foundation For Inspirational and Oracular Studies.

5 Worldwide Evangelisation for Christ, now known by the snappier, more media-friendly abbreviation of WEC International, was founded in 1913 by English cricketer Charles Studd after he saw an advert stating that "Cannibals need missionaries". Which is about as colonialist a statement as it's possible to get in three words. Dr. David Burnett would rise to the post of Academic Dean of All Nations Christian College.

6 Leonora James was a founder of The Pagan Front and a former editor of *The Wiccan*. She also played an instrumental role in the Pagan Anti-Defamation League – a body that had the specific purpose of addressing misinformation regarding contemporary Paganism.

7 Founded in the UK in 1971 to "support all Pagans to ensure they have the same rights as the followers of other beliefs and religions. It aims to promote a positive profile for Pagans and Paganism and to provide information on Pagan beliefs to the media, official bodies and the greater community." It regularly publishes the magazine *Pagan Dawn*. It can be contacted at https://www.Paganfed.org/

felt like a new religion because it has touched people to the core, and what the Bible said was irrelevant.

Burnett then rambled on at length about African witchcraft being the province of women and therefore evil, and people had to go to the male witchdoctor to be cured! Somewhat bemused, Leonora explained that the 1920s definition of witchcraft in this context was a mistranslation of a local dialect and had long since been discredited by serious anthropologists. There were more mumblings about depravity and addiction until Leonora had the last word, that Christianity can breed a very authoritarian personality which can pave the way for dictators.

Burnett's whole argument was that Paganism was modern, addictive, the province of women, and therefore evil, and his liberal sprinkling of the word "drugs" throughout was calculated to feed people's fears by linking one folk devil with another. Using his arguments, perhaps the Pope should be dried out as he's obviously addicted to Christianity; we should be attacking Christianity for not doing exactly as it did in AD34; and what about the Queen, horrors, an evil woman is head of the Church of England ! As for the black/white thing, it is tedious and wastes valuable media time – why does no-one ever say "Are you a good or an evil vicar" in response to show its irrelevance? Full marks to Leonora James who remained cool and reasoning throughout and undermined Burnett's outdated ramblings. Strange how his eyes glittered whenever depravity was mentioned – but then the Church is an old hand there, isn't it – the curates and choirboys, Jim and Tammy Bakker, the Borgias, Torquemada, Jimmy Jones and all those massacres of heretics...

Bury Vicar Bans Beltane!

A Bury Vicar has banned his area's May Queen celebrations because, he says, the tradition of the May Rose Queen is "firmly rooted in Pagan fertility rites, like dancing round the maypole." In the latest edition of his parish magazine, the Rev. Ben Turner, of St. Stephen's, Elton, said that "To continue the practice, outwardly harmless & entertaining though it may be, shows poor theological understanding. And it is not in the best interest of good Christian education." Some parishioners, who regard the tradition as a harmless celebration giving little girls a chance to dress up, are not happy. One mother said: "We'll be banning Christmas next. That was a Pagan festival until the church took it over."[8]

8 Bury, Lancashire, in common with many towns in the region, continues to hold its traditional annual May Rose Queen celebration. This Vicar's zeal may have been somewhat misplaced, since modern research now holds that these "ancient" festivals were invented in Victorian times. See *The English Year: A Month-By-Month Guide to the Nation's Customs and Festivals, from May-Day to Mischief Night* by Steve Roud (2008).

Pagans I-Dentified!

I-D, the fashion trends magazine,[9] last month published an article on "Earth Magic & Paganism". Their researchers did an outstanding job, with an A-Z guide to some of the funny words bandied around the Pagan scene, and a very comprehensive guide to shops, organisations, & magazines, including of course, *Pagan News*. It's good to see that not all journalists are suckered into the flimsy tissue of lies thrown up by the anti-occult lobby and their tabloid mouthpieces.

NF Goes Native British?

We have been recently receiving reports that extreme right-wing groups such as the National Front[10] & the British Movement[11] have taken to using Celtic symbols on their propaganda – doubtless they are trying to appeal to the current resurgence of "native British Paganism."[12]

9 *i-D* was founded by designer Terry Jones in 1980 to document and celebrate street style and youth culture.

10 The National Front (NF) is a far-right political party in the UK. Founded in 1967 by A.K. Chesterton, formerly of the British Union of Fascists, it grew to become the UK's fourth-largest party in the 1970s. Although by 1989 it was well past its peak, it was still of considerable concern to young people like us.

11 The British Movement was a full-on hardcore Nazi party founded by Colin Jordan in 1968 which drew a lot of its membership from thugs in the skinhead movement. It was successfully infiltrated by anti-Nazi Ray Hill from 1980–1984, who ran for leadership of the organisation and almost completely demolished it from the inside. See his book *The Other Face of Terror* (1988). Thanks to his efforts the organisation is largely moribund today.

12 This was just the first hint of what would become a huge problem in years to come. Today it is commonplace for right-wing groups to co-opt Pagan (particularly Norse) symbology and use it to further their own ends. It's worth remembering that back in the day this came as a huge shock to us and many other Pagans, although given that the Nazis had been doing it since the 1930s we shouldn't really have been surprised.

VIEW
POINT

New Age Soap Washes Whiter!
by *Tanith Livingston*[13]

I am deeply concerned at the way that certain branches of Paganism are willing to ape the duality inherent in such religions as Christianity or Islam. To me the great advantage of what I practice is the lack of a dualistic division into good and evil, or light and dark. Such categories are at best arbitrary, at worst the greatest stumbling block to achieving any real change in consciousness.

The first concept of a moral universe divided into good and evil did not appear until about 1000 BC in the teachings of Zarathustra the prophet of Zoroastrianism. This was the first religion to postulate a war between good and evil, Ahura Mazda being the good god and Ahriman being his adversary, and a Last Judgement where the good are rewarded and the evil cast into hell. It seems likely that Judaism and the Bible were influenced by these concepts, since at the time the Bible was written the Jews were in exile in Babylon, part of the Persian Empire whose official religion was Zoroastrianism.

The development of Jehovah is interesting with respect to a dualistic view, since it is the one which has had the most profound effect on Western thought. The god Jehovah was originally seen as being both good and evil, as well as male and female. It is the female form of the Shekinah which are represented as winged forms on top of the Ark of the Covenant. Gradually though, Jehovah became split. Samael or Satan became a separate entity to Jehovah, rather than his left

13 Tanith Livingston (1962 – 1996) was a long-standing Pagan and environmental activist. A founding member of the Greenham Common Peace Camp, she was later involved in the Road Protest Movement in the mid-90s.

(punishing) hand. The Shekinah was seen as leaving Israel, ascending to the highest heaven, leaving the throne to Lilith, the dark female principle. This duality was further developed in Christianity, and the body itself became sinful – leading to a concept of spirituality which was regarded as being in opposition to the body and its needs; thus the accent on chastity for priests in the Roman Catholic Church. This concept of Spirituality as being divorced from the world of matter is the source of most of our problems today. If spirituality is set apart and over the body it is permissible to destroy and punish the body, i.e. the earth and still exist, since even after the earth is destroyed, an external agency, in this case God, will descend and save those sufficiently spiritual. The question is, to what extent do many New Age philosophies question these dualities which threaten to end our evolution?

For example, the leaflet advertising the 'Harmonic Convergence' is typical. I counted the word "light" over a dozen times, but not one mention of the word "dark." Do these people not realise that light unbalanced by dark would create a desert of desolation? A wasteland where nothing could live. The Limitless Light needs to be balanced by the boundless void. In pre-monotheistic cultures, gods and goddesses were thought of as both light and dark. For example, in Sumerian mythology, the Queen of Heaven, Inanna, is not seen as complete until she has entered the underworld and made her peace with the dark sister-self Erishkigal. The human too mirrors this journey with Dumuzzi, the human consort of Inanna becoming a god, not through his sacred marriage to Inanna (this only makes him a king), but by his enforced descent into the underworld where the situation is resolved by him becoming the husband of Erishkigal for half the year. Only when he knows the dark goddess is he reborn. The sharing of a husband made it quite clear that the initiated priesthood regarded Inanna and Erishkigal as one goddess, rather than totally separate entities.

The subject of opposites being united is also a feature of Tantra. In Tantra the male Shiva and female Shakti are divided so that they may know union. The purpose of Tantric practice is to know god or the whole universe. This is done by the experience of the all, which becomes the void which is beyond time and death. This experience is called 'Sadakara' or the thousand-petalled lotus. To retrace the emanations of the yoni of the goddess back to the primal void outside of time and space, which is the womb of Shakti. This is also the meaning of the Thelemic concept of the union of Nuit and Hadit, the two into one which is none. The union of opposites is infinitely more than can be achieved by pursuing any separate path which divides any one thing from another.

The manifest world, by definition, must be both a duality and a

multiplicity, however, it is best not to allow this to obscure one's understanding of the oneness and the void. Then is the manifest world divided into the two and the many. "For I am divided for love's sake, for the chance of union."[14] Our separation allows us to be conscious of our union when it occurs – to actively participate in it, and assimilate the experience. The whole is divided so that it may know itself. We are a multiplicity of paths and ways which make the

Paganism seem to actively welcome this regression. They want to return to some ideal Golden Age, be it Celtic, Egyptian or Atlantean, where some paternal god or maternal goddess will take care of them. This is seemingly inherent in technological New Age ideas, except that the role of protecting parent is taken over by extra-terrestrials or returning Atlantean Adepts with an advanced civilisation. How far this fantasy is removed from the father god returning is questionable. It does

> *"This imaginary perfect New Age is the false grail castle of Klingsor, made of candy-floss. It conceals the wasteland without transforming it. This New Age vision in many ways apes the heaven of Christian sects such as Jehovah's Witnesses – all is sweetness and light, the lions don't bite and the thorns don't scratch."*

whole by mirroring the eternal lovers embracing. In terms of modern Paganism, it is totally impossible to achieve anything of importance without achieving an integration of the whole self. In the system I practice, we see the integration of primal urges such as sexuality and violence as being vital, since these urges which we refer to as 'The Forgotten Ones', fuel our evolutionary growth via our survival instincts. To repress these instincts is effectively to deny yourself the power to evolve and transform. Without this power you are doomed to stagnate, or worse still, regress. Many forms of

not indicate the level of consciousness where we know our will and, like adults, take responsibility for our own evolution and actions by creating the best conditions for their further development. Life is dynamic and changing. This imaginary perfect New Age is the false grail castle of Klingsor, made of candy-floss. It conceals the wasteland without transforming it. This New Age vision in many ways apes the heaven of Christian sects such as Jehovah's Witnesses – all is sweetness and light, the lions don't bite and the thorns don't scratch. This misses one vital point. They seem unable

14 Yet another quote from Crowley's *Book of the Law*. It really is a very influential book.

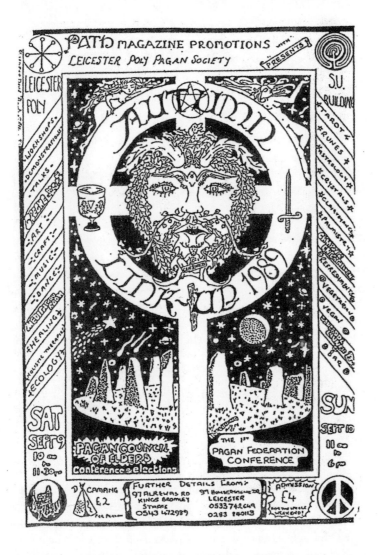

to comprehend that many precious insights come from the darkness. We need a world with challenges in it – so that we have the will to overcome the challenges. We need pain to grow. I welcome more challenges, to pass beyond the centre into infinity and to recreate myself and return to the finite, not only to be necessary, but as a pleasure. I thrive upon the challenge of the future, and do not intend to hide behind an aping of the sterile dualities of religions which at the same time I claim to reject. I am free to will and choose my destiny from all possibilities.

B-DOG
the British Directory of Occult Groups

AMOOKOS

How did AMOOKOS come about?

The South East of Asia is rich in occult and spiritual life. Between the Mahayana Buddhism of Butan, Sikkim and Tibet and the Theravada Buddhism of Ceylon, Burma and Thailand lies the diverse patterns of Hinduism with, on one hand, the orthodox Vedas and their schools, and on the other hand the freedom and divine madness of the sadhus and sannyasins.

Sir John Woodroffe (Arthur Avalon) in his time had passing contact with some of these sadhu sects, and pointed out in his book *Shakti and Shakta* that there still remained a rich field for research. Europeans travelling in the subcontinent brought back tales of their strangeness and the respect in which they were held by the native population. But it is still little known that some of these cults were the source and inspiration of the yogas and tantras that have excited interest in the West in recent years.

It fell to an Englishman to penetrate some of these mysteries. Sri Gurudev Mahendranath (Dadaji to his disciples) was born in London in 1911.[15] From his early youth he had a deep interest in the occult and spiritual patterns of the world, when in his early twenties he chanced to meet the infamous Aleister Crowley, whose hyperbole stirred and outraged Fleet Street in the 20s and 30s. Crowley had himself travelled in South East Asia, and had an inkling of the vast potential of the occult world of the tantras and yogas of India. Crowley's advice to the young Dadaji was simple – go to the East to learn more of the occult

15 Sri Gurudev Mahendranath (1911 – 1991), original name Lawrence Amos Miles. He served in the International Brigade, fighting against Franco's fascists in Spain. Returning to the UK in 1938, he became a communist activist and leader of the National Unemployed Workers Movement. He was arrested during a demonstration in Brighton and rare archive footage (http://screenarchive.brighton. ac.uk/detail/699/) shows people demonstrating for his release. During the Second World War, he served as a physiotherapist, stationed in Cairo. He arrived in Mumbai in 1953, and shortly afterwards was initiated into the Adinath Sampradaya – a subset of the Nāth yogis.

and wisdom patterns, which had flourished there since pre-Christian times. However, the second World War intervened, and it was 1949 before Dadaji left the shores of Britain.

When he arrived, penniless, in Bombay, he was introduced by a mutual friend to a sadhu of the Adinath sect. The Nathas were at one time very numerous in India; there are nine sub-sects, one of which is the Adinath cult. "Nath" is Sanskrit for "Master" or "Mistress", and is used as an epithet of the often bizarre Lord of Yoga, Shiva. Initiates of the Nath tradition have names that end with "-nath". It was one of the legendary Nath initiates, Gorakhnath, who had devised or reintroduced Hatha yoga in the 11th century. The Nath cult was responsible for such works as the *Hatha Yoga Pradipika* and the *Gorakhsa Samhita* which have become in recent times standard textbooks on yoga.[16]

The Nath tradition has a very ancient lineage. There is some evidence to suppose that the cult dates from the pre-Vedic days, before the Aryan gods were introduced to India.[17]

Be that as it may, the sadhu introduced to Dadaji was the last remaining Adinath Yogi in all India, and was the Adiguru, or holder of the sacred line of tradition. Unlike some of their brother and sister Naths, the Adinaths were interested first and foremost in the yoga of liberation from the restraining conditioning of life, and to become free from the wheel of samsara. Dadaji was initiated as an Adinath by Adiguru Lokanath. Many adventures followed.

In the last few years the Mahatma has lived in a small village in Gujurat State, India, sustained by many thousands of Indian disciples. When in 1978, Mr. Michael Magee (co-editor of the 70s occult magazine, *SOThIS*) visited him there, Dadaji expressed his wish that the Adinath become a more expansive cult, suitable not only for Sannyasins and hermits but also for people who live an ordinary household life. As Adiguru of the Adinath line, Dadaji initiated Mr. Magee and nominated him as his successor.[18] There are now Adinaths all over the world and their in-group is called AMOOKOS.

The aims of AMOOKOS

Because the root of AMOOKOS is the Indian occult Adinath tradition, an initiate's main aim must be to realise herself or himself as a master – the meaning

16 Recent scholarship has shown that this is not the case.

17 There is no evidence whatsoever to support this claim.

18 Mike Magee (1949 – 2024) was a tech journalist and founder of websites *The Register*, *The Inquirer*, and *TechEye*, as well as the excellent Tantric website *Shiva Shakti Mandalam* www.shivashakti.com. His most recent work is the excellent *Kali Magic*, edited by our very own Phil Hine.

of the word "Nath". The first three phases of AMOOKOS prepare fertile ground for this work. To do or achieve this aim we harness many methods.

We start from the viewpoint that the ordinary person has a concept or idea of self which falls short of the reality. For example, we are fitted with 5 sense organs capable of a huge diversity of perception. Yet observation shows that most people cease to be aware of what their senses tell them from an early age. This may be due to either conditioning by birth patterns or conditioning and hypnosis (this word used in its widest context) in later life. The 3 phases of our First Order provide a course which allows an individual to begin to realise just what is possible.

AMOOKOS contains within its papers, methods which are aimed at the practical realisation of all a person's energies or Shaktis. As an Order with Tantrika roots, we cover most Tantrik concepts in a way easily accessible to people without requiring knowledge of Sanskrit or Tibetan.

Kaula Naths divided people into three broad bands, each having a different disposition: Beasts, Heroines & Heroes, and Spiritually Attained:

- A "beast" is one fettered by the 5 obstacles of ego, ignorance, attachment, aversion and clinging to life; one who has made no real effort to free herself or himself from conditioning; one fettered by the chains of time.
- A Heroine or Hero is one who makes genuinely heroic efforts to free themself from their fetters. In such a battle one may easily fail, so wholeheartedness is a prerequisite.
- The Spiritually Attained are those who have realised these goals. They are accountable to none but themselves.

Our Methods

One major key is access to the Kala Chakra pattern of the Kaula Naths which allows for an extensive investigation into any time-bound thing. The next key is knowledge of inner and subtle physiology, which allows the potential of different centres to be realised, and balances a human being. The third key is the inner tradition of freedom and tolerance peculiar to the Kaula Naths, and the development of spontaneity, perfect assimilation, and equipoise.

We have to add and stress that initiation into AMOOKOS implies no exoteric or cultural elements peculiar to India. The same fountain that inspired the Naths also flowed Westward, Northward to Tibet, eastwards to China and Japan, and South to India and Sri Lanka. Therefore any cultural elements attached to the inner tradition are completely superfluous and we discourage them.

Our methods are not against life or the material world, which, to us, is a suitable and excellent matrix for development. Membership is open irrespective of sex or race to anyone over 18 years of age who is sincere.

Letter from America[19]

The Blatant Occult
by *Stephen Mace*[20]

In the last letter I got from Phil Hine, he suggested that I write something for *Pagan News* on the occult scene in the States. Of course, "occult scene" is a contradiction in terms, but the U. S. of A. is full of contradictions, so we'll give it a look.

Sticking up highest in the landscape and waving its arms to catch everyone's attention is the elves-and-strawberries crowd of the New Age Movement. Yes folks, you too can make big bucks if you'll only swallow your self-respect and train yourselves to say "Holistic Personal Development" with unaffected sincerity. You'll also need a good line of credit to stock your shop with crystals, Amerindian art, psychobabble books, and a rack full of cassette recordings of virtually indistinguishable, and entirely forgettable, electrodrone music. Decorator occultism, harmless as surface gloss, but with no real depth and a dead end to anyone who expects it to have any.

Just as conspicuous, but with a middle finger stuck in the air instead of waving a hand, is exoteric Satanism. (We'll mention the esoteric next letter.) It's most visible manifestation is heavy metal rock, but you might say that's just the initiatory sacrament for neophytes. Of course much of a Satanist's power comes as a product of Notorious Rebellion, so they can tend to be conspicuous, but

19 Now that we had successfully conquered the occult scene in the UK, we figured it was time to spread our wings internationally, and roped in Phil's friend, author Stephen Mace, to write a regular column about magick in the USA. Unfortunately we had few other links in America at this time, so we never managed to actually get the magazine distributed there, which was a great pity.

20 We can think of no better introduction to Stephen Mace that this author blurb: "Stephen Mace was introduced to the study of sorcery in 1970, when a Tarot reading predicted an imminent disaster in his life. Three days later the State Police raided his apartment, confiscated his stock and trade, bound him with handcuffs, and locked him in their tomb/womb for six weeks. In the 35 years since he has dedicated himself to the discovery of the fundamental dynamics of the art, the better to empower individuals to defy the oppression of the State Apparatus. To this end he has written several books." We highly recommend all of them.

even so the media here don't really make much of them, only giving them any notice when they do something stupid that gets them onto the police blotter. Geraldo Rivera[21] – famous American TV personality – did an hour special on psychopathic killers who affect Satanic lifestyles and was roundly panned by establishment critics for being sensationalist. And then a few weeks later, when he caught a chair in the face during a brawl on his talk-show, broken-nosy Geraldo became a national joke.

> *"A few years ago Senator Jesse Helms introduced a bill to deprive groups of Pagans, witches and magicians of eligibility for non-profit tax and franking status, but it raised such a stink that his colleagues ran for cover and it never got out of committee."*

On the Southern Connecticut local level, the only time Satanism really hit the news was at the end of 1987, when a "Satanic Temple" was discovered in an empty warehouse in West Haven. The police found an altar with candles, a discarded robe, a jar of animal remains, and on the floor in front of the altar was a circle which police said included "Satanic markings." The notable feature of the official reaction was its tolerance. The West Haven Chief of Detectives was reported to have said "...that it is not a crime to worship the devil. He said, however, that anyone caught in the warehouse would be charged with criminal trespassing. The Connecticut Humane Society is also investigating." (*New Haven Register*, Oct 31. '87).

There were later articles concerning the discovery of a second temple in West Haven's abandoned incinerator, the area clergy's reaction (Bible-thumpers and Roman Catholics aghast, liberal Protestants and Jews stressing tolerance), and an amusing feature wherein New Haven's most publicity-seeking Satanist, Paul Douglas Valentine,[22] gave his "expert" opinion that the symbols were carefully drawn, but lacked accuracy; said his own motives for allegiance to Satan were

21 Geraldo Rivera (1943 –) was one of the originators of "Trash TV" with his show *Geraldo* which had started in 1987, and would continue for another 11 years. At the time of writing he is still a frequently featured guest on the notoriously right-wing "news" channel Fox News.

22 Paul Douglas Valentine (1956 –) was best known for his leading appearance in the documentary *Scream Greats 2: Satanism and Witchcraft* (1986), currently available on YouTube if you want a good laugh. On his Twitter page, Valentine describes himself as "Founder and director of the Worldwide Church of Satanic Liberation, international Satanic superstar, bonafide cultural icon." Despite this, he still has only 46 Followers at the time of writing. So yeah, a lot of work still to do there on the "cultural icon" front Paul.

sex, power, and notoriety; and claimed to have 1,000 followers world-wide. The West Haven Chief of Detectives said the information Valentine had given them on local occultists was worthless, and a local stale legislator remarked that he was capable of violence. "He hangs out in public places and recruits very young girls into his cult."[23]

All this pretty much summarises the public relations of occultists in America. If you stand up and call attention to yourself and the media haven't covered you before, they will glance in your direction and you will get your brief mention in the infinite volumes of the public record. But if you keep a low profile and stay out of handcuffs, no one cares. Nothing Satanic or magical or even Shirley MacLaine has received a fraction of the ink that the hypocrite evangelists Jim and Tammy Bakker[24] and Jimmy Swaggart[25] have gotten. A few years ago Senator Jesse Helms[26] introduced a bill to deprive groups of Pagans, witches and magicians of eligibility for non-profit tax and franking status, but it raised such a stink that his colleagues ran for cover and it never got out of committee. The reason for this blessed state is surely the First Amendment to the United States Constitution, guaranteeing a free press and no establishment of religion. The free press means that the media can vent its hostility on the government instead of those who hold minority beliefs, and since religion is free the police stay strictly away from it. Any legislator that tried to act on the supposition that this was a Christian country would be ripped to shreds by the Jewish lobby, a big supporter of almost everyone's campaign. Laws against religious discrimination in employment are strict, and civil penalties are enough to bankrupt a small company.

Of course some might say that this will be the case only until Pagans get a significant following, and once that happens we'll be attacked, but I'm not worried. Barring a breakdown in public order, unless we show such incredibly

23 We have no evidence that this police report is accurate.

24 James Orsen Bakker (1940 –) is an American televangelist and fraudster (aren't so many of them?). He and then-wife Tammy Faye hosted the television programme *The PTL Club* from 1974 to 1989, and apparently used the money they earned to buy a private jet, two Rolls Royces, a Mercedes Benz, expensive clothes, and an air-conditioned doghouse. He was convicted of fraud and sentenced to 45 years in prison (eventually reduced to 5); as well as accused of sexual abuse by his 21-year old secretary Jessica Hahn. Astonishingly at the time of writing he is back and now peddling survival remedies for the apocalypse. Blessed are the poor.

25 Jimmy Lee Swaggart (1935 –) is yet another American TV evangelist. His weekly shows are broadcast to over a hundred countries. In 1988 he was implicated in a scandal when he was found with a prostitute (and he would be caught again in 1991). Fun fact: that's Swaggert's voice shouting "Hey Poor!" at the beginning of the classic "Welcome to Paradise " by Front 242 (1988).

26 Jesse Alexander Helms Jr. (1921 – 2008) was an American journalist, politician, racist, bigot, and enormous asshole. During his 30 year tenure on the US Senate he opposed civil rights, disability rights, feminism, gay rights, affirmative action, access to abortions, and pretty much anything else in any way important or fun.

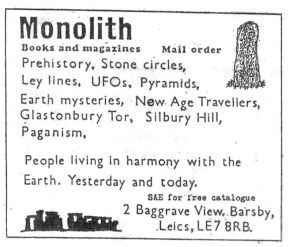
bad taste that we try to preach to people who don't want to hear it, I think we'll be safe. If we were subtle enough, the Pagan community could even become a majority before it was even noticed. There's so much information available (the cable system I get has 45 channels)[27] and people are so habituated to tuning it out, not being noticed is a snap.

In my next letter I'll talk about some of the groups that do so well at this, staying out of the media even as they sue specific mediums for libel. It all has to do with knowing how to play the game.

27 This was actually something to boast about back in 1989.

Famous Occult Stereotypes

Cliff Othick – Chaos Gothic
By *Barry Hairbrush*

Erm, well I got into Chaos magic about three years ago, cos I was really made up with that bit says everything is permitted – especially smoking dope in bedsits, which I tend to do a lot – and nothing is real, which is what I find especially when I've been in my bedsit smoking dope.

No I don't think Chaos is dead, just people get pissed off with it, usually after their minds get zapped when the rituals go wrong. I went drumming on the moors last Tuesday, it was great, we really entered a shamanistic state of consciousness, I attained to the primal atavistic me and suddenly the cosmic chaos of the universe poured through my being. Then this old lady started hitting me over the head with her umbrella and telling me to put my clothes back on.

I've got a whole wardrobe of black gear – I like this long trench coat the best. I go to a goth club in the evening, well it's my mate's cellar actually but it's good we get some great bands in and just this sixty watt bulb in the corner. Sorry, I can't talk anymore, I've got this Civil Engineering essay to hand in and it's already three weeks late.

PAGAN NEWS

The monthly newspaper of
Magick & the Occult

April ' 89

Price 30p

THIS ISSUE

United We Stand? - *Rosetta Stone* looks at factions in the Craft

Pendle Gathering Report - turn to page two

Dickens Discredited - It's Official!

Most readers will be aware that Geoffrey Dickens MP has for the past year been conducting a witchhunt against "Devil-worshipping child-abusers". He has frequently stated in the press that the Home Office has received proof of offences of this kind, and he has called for a return of the Witchcraft Act. During his media-orientated rants, Dickens named The Sorceror's Apprentice shop in Leeds as a focal point of such activities, despite having no evidence whatever to back up these claims. Accordingly Chris Bray of The Sorceror's Apprentice wrote to the Home Office last December, asking them to clarify their position. He received a reply on 7th March, which contained the following statement:

"...according to press reports, Mr. Geoffrey Dickens MP has sent the Home Secretary a dossier of child abuse cases allegedly connected with witchcraft. However, this has not been received and the Home Office has no other evidence that there is a problem of the kind Mr. Dickens describes. The Government is satisfied that the existing law on child abuse would be sufficient to deal with any offences against children which might be connected with witchcraft."

This letter *proves* once and for all that Dickens' campaign is nothing more than the fantasy of a publicity-seeking politician. His allegations have no basis in truth whatsoever. Despite the combined efforts of Dickens, Diane Core, Kevin Logan, and most of the main newspapers in Britain in the past year, the sum total of "Devil-worshipping child abusers" reported to the Home Office adds up to *zero*. This letter is also important in that it shows that pagans can get fair treatment from the

"establishment" if we try. How many other pagans wrote to the Home Office, or to their MP, stating our case? Not many, I'll bet. We must fight for our freedom on all fronts, and regardless of whatever our political opinions are, we must try to ensure that the Government fights for us, rather than against us. It may well be very satisfying to our egos to feel that we are the victims of some sort of capitalist, patriarchal oppression, but "dropping out" of the political process gets us nowhere. So *make your voice heard!*

Notts S.S. To Hold Conference ?

We have recently been given information that Mrs. Judith Dawson, principal officer for child protection with Nottinghamshire Social Services is intending to hold a conference to investigate the "ritualistic abuse of children". She bases her concern on reports from abused children who "told of being penetrated orally and anally by adults in strange costumes and made to sit in circles around candles". According to her *"experts"*, this means that they were involved in devil-worship. But according to Detective Sergeant Alan Brecton, who investigated the case: "We have not found any evidence to support that it took place". And what about the strange costumes, the circle, and the candles? Sergeant Brecton says: "On at least one occasion family members dressed up in witches' costumes for a Hallowe'en party"!

This whole episode shows once again, only too clearly, that most of our problems stem from the ignorant bleatings of a small group of influential people, not from

Dickens Discredited – It's Official!

Most readers will be aware that Geoffrey Dickens MP has for the past year been conducting a witch-hunt against "Devil-worshipping child-abusers". He has frequently stated in the press that the Home Office has received proof of offences of this kind, and he has called for a return of the Witchcraft Act.

During his media-orientated rants, Dickens named The Sorcerer's Apprentice shop in Leeds as a focal point of such activities, despite having no evidence whatsoever to back up these claims. Accordingly Chris Bray of The Sorcerer's Apprentice wrote to the Home Office last December, asking them to clarify their position. He received a reply on 7th March, which contained the following statement:

> "... according to press reports, Mr. Geoffrey Dickens MP has sent the Home Secretary a dossier of child abuse cases allegedly connected with witchcraft. However, this has not been received, and the Home Office has no other evidence that there is a problem of the kind Mr. Dickens describes. The Government is satisfied that the existing law on child abuse would be sufficient to deal with any offences against children which might be connected with witchcraft."

This letter proves once and for all that Dickens' campaign is nothing more than the fantasy of a publicity-seeking politician. His allegations have no basis in truth whatsoever. Despite the combined efforts of Dickens, Dianne Core, Kevin Logan, and most of the main newspapers in Britain in the past year, the sum total of "Devil-worshipping child abusers" reported to the Home Office adds up to zero.

This letter is also important in that it shows that Pagans can get fair treatment from the "establishment" if we try. How many other Pagans wrote to the Home Office, or to their MP, stating our case? Not many, I'll bet. We must fight for our freedom on all fronts, and regardless of whatever our political opinions are, we must try to ensure that the government fights for us, rather than against us. It may well be very satisfying to our egos to feel that we are the victims of some sort of capitalist, patriarchal oppression, but "dropping out" of the political process gets us nowhere. So make your voice heard!

Notts S.S. To Hold Conference?

We have recently been given information that Mrs. Judith Dawson,[1] principal officer for child protection with Nottinghamshire Social Services, is intending to hold a conference to investigate the "ritualistic abuse of children". She bases her concern on reports from abused children who "told of being penetrated orally and anally by adults in strange costumes and being made to sit in circles around candles."

According to her "experts", this means that they were involved in Devil-worship. But according to Detective Sgt. Alan Breeton, who investigated the case: "We have not found any evidence to support that it took place". And what about the strange costumes, the circle, and the candles? Sgt. Breeton says: "On at least one occasion family members dressed up in witches' costumes for a Hallowe'en party"!

This whole episode shows once again, only too clearly, that most of our problems stem from the ignorant bleatings of a small group of influential people, not from some imaginary group of Satanic baby-eaters hiding in our midst. It is up to us to educate people like Mrs. Judith Dawson, who obviously has no idea what Paganism is all about.

If you wish to make your views about this planned conference known, please write to: Mr. David White, Director of Social Services, Nottinghamshire County Council, County Hall, West Bridgford, Nottingham, NG2 7QP.[2] If this conference goes ahead, it will be used by those who have an axe to grind, such as Dickens and Core, to once again have a platform to make their bigoted views known to the media. We have little chance of a fair hearing, no matter what the "evidence". So write now and object.

1 We will be hearing much more about Judith Dawson (or Judith Jones as she would later be known). She wrote 'When the Truth Hurts' in the March 1989 edition of *Community Care* magazine where she and co-author Chris Johnston specifically endorsed the idea of abuse for the sake of religion. "Children were fodder for the gratification of those not interested in sex itself," they wrote, "but in its use as a tool for the promotion of ritualistic acts that could only be described as satanic." She went on to preside over the first Satanic Ritual Abuse case in the UK, now widely derided as a literal witch-hunt. After the massive mess of her first case, she later moved to Newcastle, where she would be embroiled in yet another false accusation scandal: "The judge said that the team, whose report for Newcastle city council led to Dawn Reed and Christopher Lillie fleeing their homes in fear of their lives, had acted "maliciously" and deliberately misrepresented the evidence in a ruling which has also left the council with a £4 million legal bill." *The Telegraph*, 4 August 2002.

2 As always, don't do this now, since this problem is long gone. We leave it in for historical purposes only.

Wagner's Wotan Blacked – A Thor Point for Odinists?

Oxford Odinists are outraged by the casting of a black actor in the role of Wotan in Wagner's *Das Rheingold*. They handed out leaflets to the audience at Oxford's Apollo theatre. The leaflet attacked the production as "offensive" and "sacrilegious". Their leaflet also stated that their religion "...is a mystical and spiritual awareness of nature that underpins a wholesome and noble lifestyle..." Though obviously, not an especially tolerant one. Perhaps religious intolerance is the order of the day at the moment, as the ripples from the Salman Rushdie affair[3] spread outwards. Perhaps the cast will have to go into hiding from hordes of axe-wielding berserkers![4]

3 Ahmed Salman Rushdie (1947 –) is a British Indian novelist. His fourth novel, *The Satanic Verses* (1988), provoked huge protests from Muslims in several countries. A fatwā calling for his assassination was issued by Ayatollah Ruhollah Khomeini, the Supreme Leader of Iran, on 14 February 1989. At this point he was under police protection and would remain so for many years to come.

4 As we go to press with this book, some people (who claim they aren't racists) are up in arms about the decision to cast a black woman in the role of Death in the TV series of Neil Gaiman's seminal comic book series *The Sandman*. That the author himself approves of the change is neither here nor there. Apparently Death has to be a white person. Some things never change.

VIEW POINT

United We Stand, Divided We Fall
by *Rosetta Stone*[5]

In his book *Paganism and the Occult*, the Rev. Kevin Logan says, in chapter 16, that "backbiting and bitchiness have reached epidemic proportions in some areas of the occult, especially witchcraft..."

A statement such as this in a book that is full of distortions, misrepresentations and scare-mongering is easy to overlook, or, even if specifically noticed, could be dismissed as yet another wild exaggeration from a man who is simply out to arbitrarily discredit anything remotely connected with the occult. However, it could be that this statement merits more careful consideration. Could there in fact be an element of truth in it? If we are totally honest with ourselves and try to view the matter dispassionately, I think that we have to admit that there is more than an element of truth in it.

The last year has seen one of the biggest, most concerted and well orchestrated attacks on the occult in general and witchcraft in particular for many years, a backlash to the fact that since the 1960s more and more people have become interested and/or involved. Matters which were once kept strictly under wraps have been made public and available to all who seek them. Magical orders and even covens advertise their services, and to a large extent the veil of secrecy that has surrounded the occult for so many years has been pulled away.

Faced with this "coming out" and the accompanying air of respectability and acceptability, the response of the more fanatical sections of the Christian Church has been to seize upon the campaign of the decade, namely the fight against child abuse, and to use it as a means of stirring up public emotion and hysteria, not to say hatred,

5 Neither of your esteemed Editors can remember for the life of us who "Rosetta Stone" actually was. We assume it's either a pseudonym or someone whose parents had an odd sense of humour.

against anything remotely connected with the occult, but especially against Wicca. This has been a very clever move. No-one, but no-one, could possibly have any objection to a campaign against child abuse, and if it can be "shown" through the press, Members of Parliament, members of the clergy, and child care groups that wicked, evil people are using children in witchcraft ceremonies then anyone involved in such activities deserves everything they get, and if on the way you happen to accuse everyone by implication then hard luck; no decent, honest, upright Christian can possibly tolerate witches and suchlike anyway.

Now to come back to Kevin Logan's statement. What has the response of the occult world been to this attack? Has it been to make people close ranks and present a united front? Has it been to make the various groups and organisations get together to discuss a united, concerted plan of action? NO, IT HAS NOT! Far from it. We have all simply continued to meander along our own individual, blinkered paths, seemingly oblivious to what is going on around us, having adopted the attitude that as long as it doesn't affect me personally then I'm all right, Jack. It is true that a few organisations have attempted to get people together. A few brave individuals have stood up and spoken out against the lies and slander. But a great many more have said and done precisely nothing at all. They have clambered hurriedly back into their cauldrons and, worst of all, there are those who have decried the efforts of others to speak out.

Why is it that there are those among us today who are so blinded by their own particular ideas that they cannot see the good in others? Why is it that there are those among us who are elitist to the point that anyone who is not following their "path" or is not of their "tradition" is worthy only of being treated with contempt and derision? Faced with a united enemy, why cannot we be united ourselves? We are after all all on the same basic path, or at least all our different paths are heading in the same direction. And yet "traditionalists" still look down their noses at Gardnerians who cannot always bring themselves to see eye to eye with Alexandrians. Everyone sneers at the Seax-Wicca. Hereditaries want nothing to do with anyone else. Those "in" the Craft treat the uninitiated neo-Pagans as outsiders and consequently and understandably are regarded with considerable suspicion

In turn New Agers are treated as nothing more than a laughable hangover from the late 1960s and some of the exponents of high magic see themselves as being way above any of us.

Dion Fortune once said "All the Gods are one God and all the Goddesses are one Goddess". Many of us know that she said it but a great many of us have forgotten, possibly by choice, what she meant by it. My own interpretation is that it doesn't matter whether you call your deities Isis, Diana, Freya, Cerridwen or Heme, Jupiter, Zeus, Odin or Osiris, they are all basically the same entities. It does not matter whether you place your altar to the north, south, east, or west, or hang

it from the ceiling. It does not matter what your tradition calls itself or even whether you have a tradition at all (yes, shock horror, the self-initiated). It does not matter whether your magic is high or low. None of this matters because, on the bottom line, it all boils down to the same thing; different sides of the same cube, different ways of looking at the same thing.

The occult world in general, and the Craft in particular, is in danger of going the same way as the Christian Church, into schism and split (it could be argued that it already has done). However, despite all their various differences, the numerous Christian sects have got one advantage over us – they are at least united in their opposition to us. We, on the other hand, cannot agree among ourselves at the best of times, let alone when under attack. It is time that we all climbed down from our respective, self-erected pedestals and rediscovered our mutual middle ground and stood together on it. Of late, a small group of people proclaimed themselves to be a Craft "Council of Elders" and, instead of at least being listened to for what they had to say, were treated with hoots of derision by many, "Bloody cheek – what gives them the right, never heard of them" etc. etc. Whatever the rights and wrongs of this attempt, it has at least shown a possible way forward. The occult in Britain DOES need a Council of Elders. Not a rule-making governing body, not a panel of people who will try to lord (or lady) it over everyone, but a group of accepted representatives from each of the major Craft "traditions" (I hate that word) and the high magic lodges who can form a focal point, who can discuss and agree suggested courses of action at times such as now. Who can coordinate reaction and who can at least arbitrate disagreements. If you like, a sort of occult ACAS.[6]

Whatever we do we must at least do one thing, and that is to stop all the backbiting and infighting that Kevin Logan makes so much of, for it is here that our greatest weakness lies. Paganism is one of the fastest growing "religions" in this country today and through it many people are being led into the Craft or onto the path of high magic. We have the potential to be a real religious force in this country if only we can settle our differences. Failure to realise this potential could, very easily, lead to us all being forced back underground. There are already moves afoot to reintroduce anti-witchcraft laws under the guise of child protection. Are we really so stupid, really so bigoted against one another, that we will carry on squabbling and allow this to happen?

We are all (hopefully) walking the same Path. Just because we are not all members of the same rambling club does not mean that the end is any less worth reaching.

6 Advisory, Conciliation and Arbitration Service, an independent public body in the UK that handles employment disputes.

Letter from America

Stephen Mace

L ast month I closed by remarking that the more sophisticated magical groups can stay out of the public eye even as they sue elements of the media for libel. What I was specifically referring to was the O.T.O. Last year Dolphin/Doubleday published Maury Terry's *The Ultimate Evil*, a book that tried to tie the Son of Sam murders of David Berkowitz to a nationwide Satanic conspiracy. According to the *Gnosis* magazine (Autumn 1988) review of the book (Lord knows I'd never buy it), "Terry drags in the Process Church of the Final Judgement, hypothetical O.T.O. offshoots, drug dealers, neo-Nazis, and kinky sex fiends in a rather weak attempt to place it in the real world." And also, "It's not that the possibility of such a group is out of the question... It's simply that Terry offers little real evidence beyond word associations and hearsay to bolster his case." So the O.T.O. sued for libel and, according to my O.T.O. informant, recently won. I have to rely on informants here because the whole affair has been ignored by the mainstream media – for two reasons. The first is that 95% of the American people had no idea there was a trial (or even a book), and so the outcome was no news. The second is that Dolphin/Doubleday can be confident that their reputation will be best served if they make no further fuss and simply pay the judgement, call in the copies from the bookstores, and then bring out a new edition that doesn't mention the O.T.O., or just take it out of print. The only mention made will be in the publishers' trade press, which is enough for the Order, for it will scare off other publishers who might want to profit from irresponsible exposés. Such legal pugnacity is surely an appropriate role for an organisation that traces its spiritual ancestry back to the Knights Templar.

The O.T.O. is the most magically hardcore American order that is open to anyone who wishes to join it. All an interested party needs to do is write to them and ask after the chapter nearest his or her home. But of course that just lets one in at the bottom. Policy changes since Grady McMurtry's death have had the effect of increasing the distance between those in the outer "Man of Earth" triad and those above, giving the higher grades a chance to do their work in peace.

The new Caliph, Hymenaeus Beta X, remains anonymous, hidden behind his ritual name.[7]

Now though he was forbidden to give any precise figures, my source told me that the Order now has well over a thousand members, surely the largest it's been since Philip the Fair had Jacques de Molay burned at the stake.

And yet it is dwarfed by the other "open" magical order based in America, the Builders of the Adytum, or B.O.T.A., which claims over 100,000 members worldwide. Of course it works further back from the edge of things than the O.T.O., eschewing both sexual alchemy and the Enochian system, but it does teach ceremonial magic and astral travel in the Golden Dawn style. It was begun by Paul Foster Case, who got a charter from Moina Mathers to teach correspondence students in America, this on the premise that people were too widely scattered to do lodge work. Case was succeeded by Ann Davis, and on

> *"At the other end of the doctrinal spectrum are those organisations with a primarily Satanist orientation, including Michael Aquino's Temple of Set and the Witches of Endor in California, and also the Prometheans, who are active in New England and up through Canada."*

her death in 1975 control was taken by an inner council filled by rotation among the upper grades. As in the original Golden Dawn, there is also guidance from hidden masters, a "Master R" being quite influential. In the last decades B.O.T.A. has grown so much that there are local study groups as well as correspondence instruction, and once one has studied for a few years one may be initiated into a local inner circle for doing ritual working. This growth has also brought in a good deal of fresh blood. Whilst once the average age of members was about 60, there are now a great many in their 30s and 40s – the fruit, I would presume, of the magical revival of the 1970s.

At the other end of the doctrinal spectrum are those organisations with a primarily Satanist orientation, including Michael Aquino's Temple of Set and the Witches of Endor in California, and also the Prometheans, who are active in New England and up through Canada. In general these take a Manichaean view of existence, the idea that the creator of this universe is small potatoes compared

7 This anonymity was comprehensively demolished in 2012 by the publication of the late James Wasserman's autobiographical account of his involvement in the modern O.T.O. *In the Center of the Fire: A Memoir of the Occult 1966–1989.*

to the Light within us and beyond it, and it must be worked through and defied for liberation to occur. Michael Aquino was one of the two law-abiding Satanists whom Geraldo Rivera had on his exposé (see letter last issue) to give it "balance", and he came off as an intelligent, articulate spokesman. The other one was Anton LaVey's[8] daughter,[9] who did as well at facing down The Nosy One. LaVey himself, at one time the great showman of the Satanist movement, has in recent years been keeping very much out of sight.

To close this letter on organisations I should mention Michael Bertiaux,[10] who operates out of Chicago as leader of a half-dozen or more organisations – some as straight as Theosophy, others more along the lines of Voudou. I write this with no irony intended. Voudou and Santeria are important ingredients in the American occult mix, and I'll be getting to them in my next letter.

8 Anton Szandor LaVey (1930 – 1997) was the founder of the Church of Satan and author of several notable works, including *The Satanic Bible*, *The Satanic Rituals*, and *The Satanic Witch* (although we have it on good authority that several of the rituals in his books were actually written by others, including Michael Aquino).

9 Zeena Schreck (1963 –) was a spokesperson for the Church of Satan during the 80s, before changing her allegiance to its rival the Temple of Set. She currently lives in Berlin where she teaches Tibetan Tantric Buddhism.

10 Michael Paul Bertiaux (1935 –) is best known for his *Voudon Gnostic Workbook* (1988), a monumental compendium of his idiosyncratic personal occult system. It's a mind-shattering work, which your Editors highly recommend. Just don't take it too seriously. Really.

Famous Occult Stereotypes

Grevington Gore – Crowley Bore

by *Barry Hairbrush*

Now listen, you're quite wrong on this point. It says quite clearly here, "How far is the lowest high point of its verticulations, and the stumbling thereon dissimulating to the distant kiss of Kephra..." Now that seems perfectly self explanatory to me.

Lots of people have quite the wrong idea about Crowley. When he was talking about the Will as perceived by the Khabs, he was developing the theory listed on page 925 of Liber XVCDLIVVII where he definitively states that perception of the perceived universe depends on introversion of the eternal consciousness. Well no, it's not actually in this book. This is the poem he wrote about wiping his bum on a kitten.

But he was a great chap, really. Never went senile, you know, he was still churning out reams of this stuff on his death bed. I've got a couple of volumes of it here if you promise to wear rubber gloves and not breathe too heavily when you're reading them. And I'll want a five pound deposit.[11]

11 Any relationship between this and various lectures on Thelema given by Rodney is, we are certain, completely coincidental.

Star Letter!

From Jan Frey, Ruislip

As a practical occultist I am disquieted by the paucity of active, creative work done by other practitioners – it seems that they are content to sit around and talk, but do little else. Where are the innovative "magicians" who can point to operations done, and results achieved?

My roots are in traditional witchcraft, and I was always taught that the lessons of yesterday were learnt in order to give life and form to what will be done tomorrow. I see little evidence of this – from the long-winded and smug verbal posturings of those who speak at the frequently asinine conferences and kaffeeklatsch-type gatherings, it appears that active occultism died with Aleister and poor old Austin Spare.

The most immediate concern, however, is that there is no magical Priestess extant who was born after – as an estimate – 1945. Or so it seems: women have gained much in "identity", "equality", and "status" (whatever such ephemeral things are) but in the process lost in grace, power, and comprehension of the supernal potential of their sexuality:

I am privileged to work with two superbly qualified Priestesses, but other aspirants to the status of Celebrant are less fortunate. Is there, then, a woman born after 1945 who will value the amber cord more highly than material possessions in order to tread the diamond path of pleasure to real power?

I fear not. If there is – and she alone will know if she is qualified – I have it in mind to meet her. I will bring one of my Priestesses; and perhaps the editor of this magazine would like to come along? I suggest as the venue the bar of a good London hotel. I'll provide the wine! Now, I expect to be called a male chauvinist something-or-other. That is one of the sillinesses – and sadnesses – of our time. I am not, I think, and in self-defence will point only to a paraphrase of the late John F. Kennedy's words: "lass sie nach die Priestessen kommen...". I expect also to be assailed by the knee-jerk reactions of those wondrously daft women who have no idea at all of what Priestess-hood really means, and assume that the status is accessible to almost any energetic nymphomaniac. I would like to think not, but modern women being what they are...

Or is it possible that a genuine candidate will emerge through the pages of this journal?

Editor: Highly unlikely. Our readership are quite intelligent, and they recognise a dirty old man looking for a bonk when they see one. And let us not forget that John F. Kennedy also said: "Ich bin ein Berliner". (A Berliner is a German doughnut – European Ed.)[12]

12 Looking back on this letter now, we are still struck by how utterly cringeworthy it is. But back then a lot of people thought this kind of thing was OK. We didn't. We didn't know whether to laugh or cry. Or punch this asshole in the face. So we settled for giving it the Star Letter treatment so everyone could see what an asshole he actually was.

PAGAN NEWS

The monthly newspaper of
Magick & the Occult

May '89
Price 30p

Canterbury Trails

On the 15th-17th of September, Canterbury will be hosting what is promised to be "the largest celebration ever" of religion and ecology. The World Wide Fund For Nature has organised the 'Festival of Faith and the Environment', which is being billed as a combined festival of pilgrimage, music, art, conferences, workshops, and vigils. *All the faiths and environmental organisations of the UK are invited to use the spaces for exhibitions, workshops, displays, art, drama, music - or whatever medium they choose to express their concern for nature. Throughout the festival, Buddhists, Muslims, Christians, Baha'is, Jews, Sikhs and Hindus will celebrate, each in their own way, their care for nature through special acts of worship taking place throughout Canterbury. Everyone is welcome to attend the various acts of worship and prayer and to participate to the extent they feel able.*

This sounds like an excellent opportunity for pagans to get involved in a multi-denominational event. Since the flyers advertising the event are specifically stating that any group interested in participating is invited to contact the organisers, it would be hardly in the spirit of the festival for them to try and exclude pagan groups. The **Pagan Federation** are planning a simple harvest ritual and would welcome support, so that a united pagan event can take place. It is likely that our presence at the festival will raise some eyebrows, but this is all the more reason for us to be there and be noticed! If you are interested in supporting **The Pagan Federation**, then get in contact with Gordon McLellan, c/o Mersey Valley Visitor Centre, Sale Water Park, Cheshire (Tel: 061-905-1100).

Suster Sussed

On April 16th, the News of the World "newspaper" exposed the sickening story of a Sussex schoolmaster who is secretly a member of a sexy sect. His name - Gerald Suster. The "vile occult sect" that he belongs to is the O.T.O. (Ordo Templi Orientis, as most of our readers already know). The News of the World states that "parents of children at the £2,460-a-term school will be horrified to learn about the sickening practices of Devil-worshipper Gerald Suster and his sinister friends". What they fail to mention is that Gerald Suster can hardly be "exposed" when he has made little attempt to hide his magickal beliefs and practices. For the past few years he has been one of Britain's best-known occult authors, having written "Hitler and the Age of Horus" and "Legacy of the Beast", among others (highly recommended, for those who haven't read them already).

The News of the World describes the Headmaster of Suster's school as "shocked", which seems rather unlikely, since he was already well aware of Suster's books before the "expose". He quite rightly refused to speak to the News of the World hacks about Gerald Suster and his work. In desperation, the paper was reduced to that perennial favourite "Anonymous Source", who said that there was "talk of him getting the sack now". Let's hope not. If ridiculous stories like this actually end up destroying this man's career, than none of us are safe, no matter how innocent.

INSIDE: INTERVIEW WITH PAT MILLS OF 2000AD ON COMICS AND THE OCCULT

Suster Sussed

On April 16th, the *News of the World*[1] "newspaper" exposed the sickening story of a Sussex schoolmaster who is currently a member of a sexy sect. His name – Gerald Suster.[2] The "vile occult sect" that he belongs to is the O.T.O. (Ordo Templi Orientis, as most of our readers already know). The News of the World states that "parents of children at the £2,460-a term school will be horrified to learn about the sickening practices of Devil worshipper Gerald Suster and his sinister friends". What they fail to mention is that Gerald Suster can hardly be "exposed" when he has made little attempt to hide his occult beliefs and practices. For the past few years he has been one of Britain's best-known occult authors, having written *Hitler and the Age of Horus* and *Legacy of the Beast*, among others (highly recommended, for those who haven't read them already).

The *News of the World* describes the Headmaster of Suster's school as "shocked", which seems rather unlikely, since he was well aware of Suster's books before the "exposé". He quite rightly refused to speak to the *News of the World* hacks about Gerald Suster and his work. In desperation, the paper was reduced to the perennial favourite "Anonymous Source" who said there was "talk of him getting the sack now". Let's hope not. If ridiculous stories like this actually end up destroying this man's career, then none of us are safe, no matter how innocent.

Social Services Conference Cancelled

One of our familiars has recently reported that the "conference" on "ritualistic abuse of children" that we reported on last issue has been cancelled. This is despite a pathetic attempt by the "holy trinity" of Doreen Irvine, Dianne Core, and Geoffrey Dickens to drum up hysteria in the pages of woman's magazine *Bella* recently. *Pagan News'* other favourite ladies' journal, *SHE*, which last year featured the rantings of the aforementioned trinity, has recently been running features on

1 The *News of the World* was founded in 1843 and was at one time the world's highest-selling English-language newspaper. During the 80s it was owned by Rupert Murdoch's News International and became renowned for publishing lurid celebrity sex and drug scandals. The *News of the World* concentrated in particular on celebrity scoops, gossip and populist news. To get stories it would frequently use video or photographic surveillance and covert phone hacking, which would prove its downfall in later years when several of its staff were arrested on related offences.

2 Gerald Suster (1951 – 2001) was a well-known figure on the London occult scene at the time. He authored several very readable books on occult subjects..

Reincarnation, Spirit Guides, and Telepathy. Obviously the editors realised that there was more money to be made in selling the occult than in criticising it.

Canterbury Trails

On the 15th-17th of September, Canterbury will be hosting what is promised to be "the largest celebration ever" of religion and ecology. The World Wide Fund For Nature[3] has organised the 'Festival of Faith and the Environment', which is being billed as a combined festival of pilgrimage, music, art, conferences, workshops, and vigils.

All the faiths and environmental organisations of the UK are invited to use the spaces for exhibitions, workshops, displays, art, drama, music or whatever medium they choose to express their concern for nature. Throughout the festival, Buddhists, Muslims, Christians, Baha'is, Jews, Sikhs and Hindus will celebrate, each in their own way, their care for nature through special acts of worship taking place throughout Canterbury. Everyone is welcome to attend the various acts of worship and prayer and to participate to the extent they feel able.

This sounds like an excellent opportunity for Pagans to get involved in a multi-denominational event. Since the flyers advertising the event are specifically stating that any group interested in participating is invited to contact the organisers, it would be hardly in the spirit of the festival for them to try and exclude Pagan groups. The Pagan Federation are planning a simple harvest ritual and would welcome support, so that a united Pagan event can take place. It is likely that our presence at the festival will raise some eyebrows, but this is all the more reason for us to be there and be noticed!

York Dragon Fights Back!

On Saturday, 22nd April, shoppers and tourists in York were surprised to see a large dragon loose on the streets, apparently in pursuit of a certain gentleman-at-arms. This was York Folklore Society's second 'Dragon Procession', a lively and entertaining reclamation of St. George's Day as a Pagan festival day. In this version of the myth though, the dragon gets to humiliate St. George, and show him up as a tin-plated prat! St. George retreats, and the dragon returns to her lair, voluntarily offering her blood to Hilda the Hag who, with knife and bowl, offers it to the land. The procession attracted a lot of attention, and the Folklore

3 The World Wide Fund for Nature (originally named the World Wildlife Fund) was founded in 1961 and is the world's largest environmental conservation organization. Its panda emblem has become an iconic international symbol.

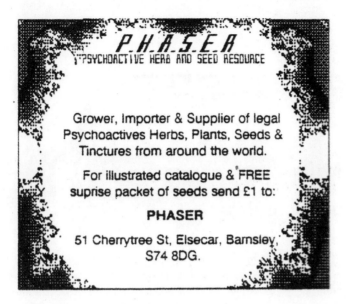
Society hope to make it an annual event. The procession started at the point where the rivers Foss and Ouse join (reputedly the position of a ley line) and ended at the Minster, and the players were accompanied by a ten-piece band. It just goes to show what you can accomplish with a bit of ingenuity, organisation, and perseverance! We hope that other Pagan groups can be equally creative throughout the year. If you want to get in contact with the YFS, write c/o the *Pagan News* editorial address.

SPOTLIGHT

Pat Mills – Cults & Comics

2000AD[4] is a weekly comic read by people from all walks of life and ages. Over the years, it has featured stories which contain Pagan themes, displayed with a subtlety and degree of insight which is unparalleled elsewhere. The man largely responsible for this is Pat Mills, the creator of 2000AD *itself, and the originator of characters such as Slaine, The ABC Warriors, and Nemesis the Warlock. Pat is currently working on* CRISIS,[5] *a fortnightly comic, on the strip* Third World War. Pagan News *caught up with Pat following a lecture at Leeds University.*

PN: How influential do you think your treatment of Pagan themes in comics is?

PM: I like to think that the stuff I'm doing in *Slaine* is arguably more profound than *Nemesis*, since I only have a relatively superficial knowledge of chaos magic. With *Slaine*, I think there's an educational factor – many people are finding things in *Slaine* that they're not going to find anywhere else, for example the Glastonbury Zodiac. Whether it actually exists or not, to my mind, is irrelevant – the thing that's really important is that it reclaims our mythology. The mythology I was taught as a kid was Greek mythology, but we have here in our own country our own artifacts, our own culture, and I think that the reason that that isn't admired and pushed forward is because of the whole Oxford & Cambridge establishment. At another level, it may not be maturing anyone else, but I think it has matured

4 First published in 1977 and still going strong at the time of writing, *2000AD* has now become a legend in the world of comics, with great British comic creators such as Grant Morrison, Alan Moore, Bryan Talbot, and many others getting their start in its pages.

5 *CRISIS* ran from September 1988 to October 1991, Over its lifetime it would run into considerable controversy for the cutting-edge themes it dealt with. As well as Pat Mills, other creators who were featured in its pages include Garth Ennis, Grant Morrison, Steve Yeowell, Peter Milligan, and Brendan McCarthy – all well worth looking up. Rodney still has a complete collection of *CRISIS* in his bookshelf, where he can see it as he types this footnote.

me – it's my own quest for spirituality, it's just that I'm getting someone to pay me for writing it down at the same time.

PN: Do you see yourself as someone who is bringing these myths forward, and making them more accessible to people?

PM: Yes, at the moment these myths are very much in the province of the middle classes, and are presented in such a way that they're difficult to relate to. The original Celtic sagas, like the original Norse Sagas, are very earthy, and in crude terms, some of them read like *Dallas*.[6] They're very enjoyable, and I think these things should be reclaimed by street-level culture. What I admire, is maybe the kind of Paganism you'd find if you could be bothered to wade through *The Golden Bough*,[7] is the native culture. It's best expressed by the folk customs that remain, such as the hobby horse, the maypole – religion as fun! I grew up with a Catholic background, and religion was bloody boring! I had to be dragged screaming to church, whereas running round the maypole, running off into the woods and fucking sounds like a lot of fun to me! A point I make particularly

> *"The original Celtic sagas, like the original Norse Sagas, are very earthy, and in crude terms, some of them read like Dallas. They're very enjoyable, and I think these things should be reclaimed by street-level culture."*

in the next *Slaine* story, *The Horned God* is when Slaine's spiritual education advances. He makes the point that what he's discovered is not some inner secret held by some bunch of holy Druids, but that everybody knew it, but they've just forgotten it. When I read up about Paganism, I feel that this is something I've already half-known, and I've just forgotten it. I think that most people feel that. I don't feel that you have to spend ten years reading secret Necronomicons and all the bullshit – I think that's just pretentious crap.

PN: One of the episodes of Slaine that impressed us the most, and incidentally, was one of the "closest to the edge" depictions of sex in 2000AD, was Slaine's marriage to the Earth Goddess.

6 At that time TV soap opera *Dallas* had been running since 1978 and was the biggest TV show in the world. It would continue to run over 357 episodes until its merciful cancellation in 1991. Don't go looking it up, it was awful.

7 *The Golden Bough: A Study in Comparative Religion* by Scottish anthropologist Sir James George Frazer was first published in 1890 and became enormously influential in the fields of both anthropology and occultism. Which was unfortunate, because it was largely made-up nonsense. Don't waste your time slogging through it, it really is rubbish.

PM: We go much further in the next series *The Horned God*, which features The Lord Weird Slough Feg – based on a cave drawing of probably the oldest male shaman dancing, with this massive phallus. Simon Bisley, the artist on *The Horned God*, as I understand it, has actually drawn this phallus hanging down like an animal's, but he's done it in such a way so it could look like part of the costume. The whole thing is about virility, and the idea that you've got the old Horned God (Slough Feg) and Slaine, who aspires to be the new Horned God. Another aspect to the story is the idea of role models. I came across a book called *The Horned God*[8] which was very influential to the story. What he's saying is that you can be hardy but not hard. I think that the problems men have are linked to our role models. Male role models are pop stars, film stars, and successful men, who do we have? Rambo? Richard Branson? Young American men died in Vietnam because they were imitating John Wayne. There seem to be few distinct male role models where you can look at someone and say "I want to be them". A lot of the stories I write are about role models. For Slaine to become the Horned God for example, he has to lose some of that macho bullshit. The new story provides a visual synthesis of some of these ideas in *The Horned God*.

PN: Your treatment of the "Dark Gods" theme in Slaine must have taken you into some interesting areas.

PM: I wanted to do something to move Slaine out of its primitive background, to grasp a sort of Lovecraftian[9] wide scale scene. I read books like *The Dark Gods*[10] which is a nice book to read late at night. Total paranoia, but very good in its time. It was just a passing phase of the story. You have to have Dark Gods, but I was more interested in Light Gods. I'd seen Graves' *The White Goddess*[11] and found it too heavy. Perhaps most *PN* readers are familiar with *The White Goddess*, but for anyone approaching it for the first time, it's a hellish book to get into. He has accounts of women pursuing men, which I was astonished by. Then I went on to read Monica

8 *The Horned God: Feminism and Men as Wounding and Healing* by John Rowan (1987).

9 Howard Phillips Lovecraft (1890 – 1937) was an American writer and racist who created the Cthulhu Mythos, which has become one of the most significant inspirations for horror fiction in the late 20th century and beyond.

10 *Dark Gods* by Anthony Roberts & Geoff Gilbertson (1980). "Malevolent forces from another dimension have long been plotting against humanity. Throughout history these forces have manifested as demons, angels, spirits, fairies, vampires, dragons, aliens and Men in Black. They have convinced some humans to create secret societies that unwittingly aim to bring about the downfall of humanity. Lovecraft's tales are not mere fiction. Nyarlathotep and Cthulhu are very real, and they're patiently waiting for misguided humans to call them forth so that they can lead us into an era of blasphemous anarchy and interdimensional terror." That's the marketing blurb, and you have to admit it's a pretty good one.

11 *The White Goddess: a Historical Grammar of Poetic Myth* by author and poet Robert Graves (1948). Like *The Golden Bough* it was enormously influential on modern Paganism, and also like it, was pretty much rubbish from start to finish. Read his novel *I, Claudius* instead, that one is a masterpiece.

Sjoo's *The Great Cosmic Mother*[12] which is full of anger and power, and explained the Sheila-Na-Gigs in Celtic churches. These two books showed me an entirely different view of women's sexuality to the one I'd been conditioned to believe in. I had a sense of being cheated, of anger that so much had been hidden away.

PN: You stress very much the idea of Matriarchy. How important do you see this to be?

PM: Obviously, it's a glib thing to talk about a matriarchal golden age, but surely it can't be worse than the present fuck-up. One idea that I'm pursuing in *Slaine* is the fall of the neolithic, matriarchal society. Celtic society has both elements of the new values, with the dark neolithic era underneath. The new *Slaine* story features the Druids, who represent Sun God values and are only paying lip service to the Goddess. Slaine wants to become the Horned God, and then there's this Druid who is kind of based on Sir Humphrey in *Yes, Prime Minister*[13] saying "Well yes of course sire, we worship the Goddess, but…" and Slaine is trying to hearken back to an earlier era. As a wanderer, he can see the insularity of his society.

PN: Turning to CRISIS, the character that immediately springs to mind is Paul, the eco-terrorist. Can you say a few words about how he was developed?

PM: He's two characters combined together. One is an ex-Northern Ireland veteran who's now a kind of eco-hippy. The other is a local witch who's been feeding me material. There's no compromise in his stuff – Stewart Farrar[14] he is not. He's a very hard witch. Paul is turned on, for example, by the idea of taking risks. He's outrageous, which makes him a good character. He's very much a Dark Green person. Paul gives voice to the idea, which is both central to Paganism and Third World Politics, that the answer to the problems lies not so much in bringing in a new fertiliser or socialism, but in present women reclaiming the earth. The most important episode in *Third World War* was the "Made of Maize" story. There's a very pervasive idea that we're not meant to admire "savage" society, and the more I read about "savage" society the more I admire it. We're still basically a Roman culture, and our own culture is undervalued to a large extent.

12 *The Great Cosmic Mother: Rediscovering the Religion of the Earth* by Monica Sjoo & Barbara Mor (1987) was a massive influence on the feminist Goddess movement. We will have more from Monica later in this book.

13 *Yes Minister* (later *Yes, Prime Minister*) is one of the greatest British comedy TV shows of all time. Written by Antony Jay and Jonathan Lynn, it was a political satire which ran from 1980 to 1988. It was so accurate that it became compulsory viewing even by the politicians it satirised.

14 Frank Stewart Farrar (1916 – 2000) was a prominent figure in the Wiccan movement. In early life he was a committed communist and worked as a reporter for the *Soviet Weekly* and the *Daily Worker*, but in later years would go on to success as a TV and radio scriptwriter, winning a Writer's Guild Award. His book *What Witches Do* (1971) was a major influence on early Wicca, and would be followed by collaborations with his wife Janet: *Eight Sabbats for Witches* (1981) and *The Witches' Way* (1984).

PN: **Do you think it's easier to introduce Pagan themes into a story than political issues?**

PM: I think it would be hard to legitimate an occult comic; there would be a backlash. A witch in *CRISIS* isn't central to the story, it's just part of the character. Take Slaine for example. When we did the role-playing Diceman series of Slaine, I got an irate letter from a vicar saying that he found these role-playing games very questionable, particularly *Slaine the Berserker*.[15] Apparently the vicar played this game, and says that he "woke up in the middle of the night, screaming with fear."

When *Third World War* comes back to Britain, and we start showing direct action which takes place in our own backyard, then we'll probably be in for trouble.[16] There's a lot of "Green Terrorism" going on in America, such as spiking trees. You drive a nail into a tree, which screws up chainsaws and lumber mills, and American lumberjacks won't touch a forest if they think it's been spiked. This gives people ideas, but you have to do it in a way that's socially responsible, so that it's done in such a way that it won't kill the person with the chainsaw. There's a book out called The Eco-Defence Manual[17] which is a complete guide to ecological terrorism, though I wouldn't call it terrorism, when it's non-violent protection of the earth. That kind of stuff is literally promoting green vigilantes, but these are the issues of the 80s and 90s. It's no longer about Batman beating up muggers.[18]

PN: **Pat Mills, thank you very much.**

15 Collected in *The Slaine Gaming Book: You Are The Hero: You Are Slaine* (1986), and now almost impossible to find, unfortunately. Not to be confused with the also excellent *Sláine: The Roleplaying Game of Celtic Heroes* by Ian Sturrock (2002).

16 He was right.

17 *Ecodefense: A Field Guide to Monkeywrenching* by Dave Foreman (1985).

18 Ironically of course, several of the *CRISIS* team would go on to work on *Batman*, most notably Grant Morrison. Capitalism, eh?

VIEW
POINT

The Green Party – Not Just a Bunch of Old Hippies[19]
by *Feorag*[20]

"Green" is a bit of a buzzword at the moment – the mainstream political parties are all clamouring for votes by climbing on to the ecological platform. Unfortunately, the green tinge is little more than mould. The major parties seem completely unaware of what Green is all about, including some Pagan folk who still regard us as a bunch of ageing hippies intent on saving the whale and legalising cannabis.

One of the foundations of Green thought is the belief that we cannot continue to exploit Earth's finite resources indefinitely, and that the past (and present) policies requiring economic growth and vast consumption have brought humankind to the edge of an unprecedented disaster. As a result, the Green Party[21] advocates a sustainable, steady-state economy "of stock rather than flow". The *Manifesto for a Sustainable Society* (MFSS)[22] gives the Earth as an example of such a system and states that a sustainable economy would probably be based

19 Another article that shows how important political activism was to us. We have never seen any distinction between the spiritual and the political, believing that they should go hand-in-hand, as reading this book should make very clear.

20 Feorag is an activist of the PaganLink network. They produced and ran *The Pagan Prattle* – a PaganLink newsletter from Manchester, which had the distinction of being typeset on Quark Xpress, in the days when most Pagan zines were hand-written or run out on dot-matrix printers. Feorag later established the first PaganLink website which is still present at: http://www.Paganlink.org/

21 The UK Green Party was established as the PEOPLE Party in 1973. In 1990 it reorganised to emphasise more local activism and the Southern branch became The Green Party of England and Wales. It has hundreds of councillors at the local government level, plus four MPs. Scotland and Northern Ireland have their own independent Green party.

22 First published in 1973 and amended and expanded several times since then, this formed the foundation of Green Party policy from its inception.

on nature, rather than by trying to infinitely increase production as in traditional economics.

But Green politics are not just about protecting the countryside, another common misconception. In New Age speak, to be truly Green you need to adopt a holistic viewpoint – the whole environment is vitally important, and its health affects us all. And I don't

hardship. The most common objection to this scheme is its supposed cost. The money to run it would come from several sources: in the first case, it would be far cheaper to run than the present "benefits" system; Income Tax personal allowances would be lowered (so you'd pay tax on more of your other, earned, income); Community Ground Rent (see below); tax on the

> *"One of the foundations of Green thought is the belief that we cannot continue to exploit Earth's finite resources indefinitely, and that the past (and present) policies requiring economic growth and vast consumption have brought humankind to the edge of an unprecedented disaster."*

mean just the pretty bits with trees and flowers and birds, but the urban cityscape as well, and all stops in between. As it says in the introduction to the 1987 General Election Manifesto: "Like all other forms of life, we depend for our survival and well-being upon a fragile network of physical, social, and spiritual links with the rest of Creation. Green Politics is an acknowledgement of the complexity of that web."

Although opposed to materialism, the Greens recognise the need to ensure a basic level of material security for everyone. This has led to the much misunderstood Basic Income Scheme – automatically paying everybody a weekly sum free of tax, the amount varying with age. Supplements would be payable to those who still suffered

use of resources, with high charges to those who pollute; increases in indirect Consumption Taxes; and higher Company Tax on large firms. Land would be "owned" by the local community and those using it would pay Community Ground Rent, the amount rising the further the land is from its natural state.

Cultural values are respected by Greens; all cultures, not just the White Christian establishment, or the selected "ethnic minorities" focused on by the Opposition.

"We need to rediscover our roots and our histories, and to learn from those cultures which are more in harmony with their environment than we are. We must stop imposing our values on native peoples as though we had all the

answers for them – we don't. Through our imperial efforts we have forced people to abandon ways of life which were often far more satisfying than we can ever imagine." (General Election Manifesto, 1987). It is a process which is still going on – it is not only the rainforests which are cleared to rear the cattle for your Big Mac, it is the inhabitants of that area as well.

The Green Party recognises and respects the place of the spiritual in the scheme of things, without imposing any approved "religion", yet there is much of the philosophy which is totally Pagan. The following is another extract from the 1987 manifesto:

"Whatever our religious beliefs, a vital part of Green politics is our love and respect for the Earth and for each other... The power to take responsibility for our own lives and futures... lies only within ourselves."

Of more specific interest is a resolution to be found on page 100 of the current MFSS, part of which states:

"To recognise the right of all people to enjoy our common heritage, and to accord the right of freedom of religious expression to Pagans (capital P) and to all who regard Stonehenge as a temple." (MFSS p.100 E27 Stonehenge).

No other party specifically mentions Pagan rights, and despite my otherwise holistic tendencies, I would cite the above as the sole reason, above all others, why Pagan folk should vote Green... On June 15th, you will have the opportunity to vote Green as the party are fielding a full slate of candidates in the forthcoming Euro-elections. If your vision of the world is one of integration, of working together and playing an important part in building a truly sustainable society, then I think you've guessed where your "X" should go...[23]

23 As it turned out, in these 1989 elections the Green Party polled 15% of the vote with 2.3 million votes, making it the third biggest party in the UK; though because of the UK's first-past-the-post Parliamentary voting system, it failed to win a single seat. The UK still hasn't reformed its absurd electoral system.

THINGS TO DO... and THINGS TO READ

Colourful Clothes
by *Julian S. Vayne*[24]

Some of the best occult exercises may seem trivial, or at least the essence behind them may not be initially apparent. The following exercise is subtle (no flashes of divine lightning here!) but is well worth trying.

1. According to the doctrine of correspondences there is a relationship between colours, days of the week, and the seven ancient planets. One of the most frequently used systems of colour/planet/day correspondence is as follows:

DAY	PLANET	COLOUR
Sunday	Sun	Yellow
Monday	Moon	Purple
Tuesday	Mars	Red
Wednesday	Mercury	Orange
Thursday	Jupiter	Blue
Friday	Venus	Green
Saturday	Saturn	Black

2. Select at least one item of clothing of each planetary colour to wear over the course of one week. Perhaps a yellow jumper on Sunday, a purple scarf on Monday, and so on. Wear appropriate colours on each day of the week.

24 Julian Vayne is an occultist and writer. He is a Chaos magician, an initiated Wiccan, member of the Kaula Nath lineage, and Master Mason. His interests include drugs and magick, permaculture and the politics of sustainability, teaching and graphic art. He is the author of the celebrated *Getting Higher: The Manual of Psychedelic Ceremony* among many other works. Julian is a co-organizer of Breaking Convention, a co-director of The Psychedelic Museum, a trustee of The Psychedelic Museum Project, and of The Friends of the Boscastle Museum of Witchcraft.

3. After your "planetary week" has elapsed, record the results in your magical diary. Compare the results to those of a "normal" week. Did you feel any different? Did wearing the colours of the Sun on Sunday make you more attuned to the solar aspects of your personality? Were other people affected by the colours you wore?

4. Experiment with other variations of this idea, wearing appropriately corresponding jewelry (e.g. a silver or moonstone brooch on Monday). You could also try wearing planetary corresponding perfumes on each day (e.g. sandalwood on Friday).

Further Reading

Colour Psychology and Colour Therapy Faber Birren (Citadel Press)
Liber 777 Aleister Crowley (Weiser)
Art and Visual Perception Rudolf Arnheim (University of California Press)
Colour and the Kabbalah D. & J. Sturzaker

Letter from America

Stephen Mace

O ne problem with working magick in a secular society is that of supply. There are lots of things you can make, of course, and that's better than buying anyway, but you can't make incense – you either buy it or grow it. Since communication with my Holy Guardian Angel is crucial to my magickal work, I have a constant need for cedar, storax, and frankincense. I harvest the cedar from the local high places, but frankincense and storax are tropical and must be bought. Of course I could take the train to New York, but that adds a lot to the overhead. The New Age shops sell frankincense at exorbitant prices, but have no storax at all. I could order it from England, which is what I do for the more obscure herbs and resins, but I use too much incense of Abramelin to make that feasible, and changing the money is a bitch.

To which it may be asked, where did I get the solid stuff to begin with? The same place I still do, and my frankincense too; the Botanica Chango, which is the local Santeria supply shop. The Botanica is just a storefront and from the outside what you see are the painted statues in the window – some of them saints, others animals, and human figures that are clearly not saints. Inside the first thing that hits you is the smell of too-sweet perfume, the source being the shelves on the right wall, all full of seven-day scented candles and canisters of incenses and bath powders with names like "Stop Evil", "Lucky in Love", "Money Come Here", and "Do As I Say". On the left are more statues, ranging from pious saints to naked women and black idols. On a high shelf in the back is a statue of Chango, the orisha who is patron of the store. A black man seated in the lotus position, his demeanor is hardly contemplative – arrogant, haughty, a gold crown on his head, his bare chest and arms adorned with gold chains and bracelets. He is the Yoruba god of war and lightning, and he is attributed to Saint Barbara. The proprietor is a light skinned Cuban gentleman of late middle age. His frankincense and storax cost about 75 cents an ounce, and he also sells bags of myrrh, mandrake, and tabonuco. Most everything else is the prepared scents – even the sandalwood and dragon's blood are heavily perfumed and otherwise adulterated.

The reason he carries the frankincense, myrrh, storax and tabonuco in bulk is that once ground together in equal measure, they make a useful incense for Santeria ceremonies. Tabonuco is the resin of a tree known as candlewood, *Dacryodes excelsa*. It has a sweet smell and is clear, amber, and brittle rather than gummy like frankincense. If one takes a piece of about one cubic centimetre in size, puts it on a spoon, and holds the spoon over a burning candle, it will readily melt and then boil. If one then breathes the vapors, a strong feeling of drowsiness will soon follow. Even the next day one will notice a significant lack of precision in thought and movement. Thus the bag I bought is still almost full, for I have no idea how it would help my magick; it is, for instance, absolute death on the ability to visualize. But I can see how the Santeros could use it, for theirs is a possessive technique, and anything that knocks the ego down will help the

> *"The Santeros believe we are each linked to one of the seven orishas before birth, and that if we are to flourish in life, we must work with that god instead of against it."*

orishas take over. I suspect that to be sent towards sleep by the incense, even as the drums urge one's feet on to greater exertions, would put one into a perfect state for possession. There are seven orishas in Santeria, with various attributes and powers, each matched with a Catholic saint. In the same way, there are the various loa in Vodou and the gods of Macumba in Brazil. All three are varieties of African sorcery brought over by black slaves who hid their religion from the whites by covering it with a veneer of Roman Catholicism. Ironically enough, Eleggua, the Santeria trickster, is attributed to the Christ child.

Now though the Santeros believes that the orishas were created by the supreme God Olodumare, he is so aloof that he is largely irrelevant; the orishas are the ones who manage human affairs. The Santeros believe we are each linked to one of the seven orishas before birth, and that if we are to flourish in life, we must work with that god instead of against it. The climax of this cooperation is a rite called *asiento*, where the deity is "seated" in the initiate, and he or she is for a time taken in a full possession. At this point the Santero becomes a balalawo, the equivalent of a houngan or mambo in Voudou.

Asientos are expensive, costing up to 5,000 dollars, this due to the need to hire drummers for the nine-day ritual and also for buying the dozens of goats, rams, chickens and other animals that must be sacrificed on this occasion. This is the crux. The orishas help you if you feed them, and the Santeros relationship with

them is exactly what we would call a pact. Pacts are frowned upon in Western magick, where the spirit is seen as less than the wizard and must be bound to his or her will, but in Santeria they are the gods and must be placated. One's personal orisha is intrinsic to one's soul, however, so there's no question of selling that. What one is doing is feeding them, and while blood is the most energetic food, they also like honey, tobacco, rum, and the appropriate perfume and candles. If one gives the gods this food, they help one's life go the way one wants it. Otherwise they turn away, and bad fortune follows. The gods' will is learned through direct communication and, for those who have not yet "made the saint", through divination by a priest. The orishas fill specific requests after one gives the appropriate gifts, followed by taking baths, potions, wearing charms and the like. And supplying the necessary ingredients is what the Botanicas are for.

I should emphasise that this sketch of Santeria is merely an outsider's superficial view, but it is an important movement and a growing one. It has no hierarchy except that of competence; when one has power, one gets a clientele who pay for one's skills. Thus its governance is by the culture itself, perhaps a worthy model should we Pagans ever create something sufficiently unified and enduring that it can be called a culture.[25]

25 We were very happy to get this *Letter* from Stephen, as up until this point we considered that we had a significant lack of diversity in *Pagan News*. Western European/American occultism at that time, and still even today, was very much a white, middle-class pastime, with little connection to magical practices of people with different skin tones and cultures, except via the relics of Victorian colonialism (e.g. the Egyptian pretensions of the Golden Dawn). Rodney would later go on to travel to New York and New Orleans to participate in Santeria and Vodou rituals and still considers them highlights of his occult career. He also made an album dealing with his experiences: *Sun God*. It's very good, look it up on Spotify.

Classified Ads

PAGAN NEWS

The monthly newspaper of
Magick & the Occult

June '89
Price 30p

SUSTER SACKED!

Following last month's leader concerning the 'expose' of Gerald Suster by *The News of The World*, we now have to report that he has indeed, been sacked from his teaching post, and will probably find it very difficult to get another job in the teaching profession. The incident was explored in Channel 4's **Hard News** programme, during which Gerald was interviewed, along with his publisher, and Lionel Snell, another respected occult author, and fellow-member of the Caliphate O.T.O. Apparently Suster had been approached in a London pub by a stranger who, following a literary meeting, began to ask him questions about the occult. This person was, in fact, a freelance journalist, and the discussion was being secretly taped. The freelancer sold the tape to *The News of The World*, who dispatched an interview team round to the school where Suster taught as a housemaster. The *NoW* hacks accused Gerald of worshipping devils, drinking blood, and sacrificing children - all the usual lies, in fact. Although the school headmaster considered Suster to be a "first-rate teacher", he asked Gerald to resign, "for the good of the school." Suster is now taking his complaint to the press council, and is considering taking further legal action against the *NoW*. The Hard News reporter wound up the story by revealing that one of the "sick books of evil" that the *NoW* team drooled over - The Law is for All, by Israel Regardie, is published by Thorsons, who, in turn, are a subsidiary of Collins - owned, ultimately, by Rupert Murdoch, the owner of *The News of the World.*

The implications of this tale are quite frightening, especially for anyone who is a regular attender of public pagan & occult meetings, such as the many pagan moots springing up around the country. Let's hope that it won't serve to raise levels of paranoia amongst pagans and deter people from declaring themselves "out" as following their chosen path. Doubtless it is phase two of the campaign to drive us back underground - by threatening those people who have a 'high profile', and work in sensitive professions.

And Aquino Attacked!

Michael Aquino, head of the American Temple of Set, has also been pilloried by the press recently. Dianne Core backed a story in *The Daily Star*, whilst the Rev. Kevin Logan did his bit in *The Daily Mirror*. Not to be outdone, *The News of the World* took up the cry as well. All three reported that Aquino was currently being investigated in relation to a child sex-abuse scandal. In fact, Aquino has been cleared of the accusation by both the U.S Army (he is a Lt. Colonel in the Army Reserve) and the San Fransisco Police Deprtment. The source of the accusations, an army chaplain, is currently being court-martialled for making false and slanderous accusations. The gutter-press also fawned over the fact that Aquino was interviewed for the forthcoming Cook report on Witchraft (*he* was spotted hanging around outside The Sorceror's Apprentice in Leeds recently). Aquino says that he agreed to this in order to try and clear up the confusion surrounding contemporary Satanism. Aquino contacted *Pagan News*, sending copies of letters to the editors of *the newspapers,* in which he strikes back at the rantings of Logan & co, saying that *"..the legacy of Christianity is awash in the blood of tortured and murdered innocents - from the massacres of the middle ages to the religious wars in recent history to the*

NEWS

SUSTER SACKED!

Following last month's leader concerning the "exposé" of Gerald Suster by the *News of the World*, we now have to report that he has indeed been sacked from his teaching post, and will probably find it very difficult to get another job in the teaching profession.

The incident was explored in Channel 4's *Hard News* programme, during which Gerald was interviewed along with his publisher and Lionel Snell, another respected occult author and fellow-member of the O.T.O. Apparently Suster had been approached in a London pub by a stranger who, following a literary meeting, began to ask him questions about the occult. This person was, in fact, a freelance journalist, and the discussion was being secretly taped. The freelancer sold the tape to the *News of the World*, who dispatched an interview team round to the school where Suster taught as a housemaster. The *NoW* hacks accused Gerald of worshipping devils, drinking blood, and sacrificing children – all the usual lies, in fact.

Although the school headmaster considered Suster to be a "first-rate teacher", he asked Gerald to resign, "for the good of the school." Suster is now taking his complaint to the press council, and is considering taking further legal action against the *NoW*. The *Hard News* reporter wound up the story by revealing that one of the "sick books of evil" that the *NoW* team drooled over – *The Law is for All*, by Israel Regardie, is published by Thorsons, who, in turn, are a subsidiary of Collins – owned, ultimately, by Rupert Murdoch, the owner of the *News of the World*.

The implications of this tale are quite frightening, especially for anyone who is a regular attender of public Pagan & occult meetings, such as the many Pagan moots springing up around the country. Let's hope that it won't serve to raise levels of paranoia amongst Pagans and deter people from declaring themselves "out" as following their chosen path. Doubtless it is phase two of the campaign to drive us back underground – by threatening those people who have a "high profile", and work in sensitive professions.

And Aquino Attacked!

Michael Aquino, head of the American Temple of Set, has also been pilloried by the press recently. Dianne Core backed a story in the *Daily Star*, whilst the Rev. Kevin Logan did his bit in the *Daily Mirror*. Not to be outdone, the *News of the World* took up the cry as well. All three reported that Aquino was currently being investigated in relation to a child sex-abuse scandal. In fact, Aquino has been cleared of the accusation by both the U.S Army (he is a Lt. Colonel in the Army Reserve) and the San Francisco Police Department. The source of the accusations, an army chaplain, is currently being court-martialled for making false and slanderous accusations. The gutter press also fawned over the fact that Aquino was interviewed for the forthcoming *Cook Report on Witchcraft* (he was spotted hanging around outside The Sorcerer's Apprentice in Leeds recently). Aquino says that he agreed to this in order to try and clear up the confusion surrounding contemporary Satanism.

Aquino contacted *Pagan News*, sending copies of letters to the editors of the newspapers, in which he strikes back at the rantings of Logan & co., saying that, *"...the legacy of Christianity is awash in the blood of tortured and murdered innocents – from the massacres of the middle ages to the religious wars in recent history to the Catholic/Protestant violence in Northern Ireland. It is not Satanism which has wreaked such violence on society. It is not Satanism which preaches intolerance, torture, and death to other religious persuasions. It is not Satanism which terrifies small children into religious slavery with twisted, perverse, and sexually-obsessed nightmares."*

Green Light for Harrogate Pagans!

Those of you who can remember back to the June '88 edition of *Northern PaganLink News* may remember our report concerning a group of Pagans being banned from appearing at Harrogate Green Fair – as local greens were worried about what people might think. Not surprisingly, this provoked an angry response from Pagans involved with Greenpeace and Friends of the Earth, many of whom wrote to express their dissatisfaction and anger at being treated in such an offhand way. The incident was widely reported and eventually made its way into the national press. This year, another Green Fair is being planned for Harrogate, and the organisers have apparently had a change of heart. A Pagan ecology stand will be present at the fair this year.[1] If you want to know more details, write c/o the editorial address and we'll forward letters to the group concerned.

1 Yeah, direct action works; proven time and again throughout the *Pagan News* time period.

Tarot Teacher in School Censure Storm!

A primary school in Bedfordshire has just been subject to a change in its May Day events. For many years both parents and teachers had liked the idea of a school-fund-raising fortune teller, and planned to have one at this year's fayre. However the idea was rejected at the last minute.

Why? An objection was raised on "religious grounds", by members of the PTA who had previously played no part in organising the fete. Obviously we cannot mention names as the people involved are school governors and our source has a child at the school. Despite explaining the Tarot to the assembled PTA, those who raised these stupid objections remained firm (surprise!). More importantly, the rest of the committee heeded them, voted for a quiet life, and thus did a simple day out for the kids fall foul of the reactionary face of Christianity. Still, it's a good thing that the objectors are bottom of the class at Pagan symbology, or they would have noticed that maypole dancing was still on the programme of events! Whatever next!

Sorcerer's Census Speaks

The Occult Census conceived by Chris Bray and carried out by the Sorcerer's Apprentice has been collated, analysed and the results published in the form of a booklet. The Census was instituted in order to present an accurate picture of the vast spectrum encompassed by occult activities; to provide a positive image of today's occultist, (backed up by evidence) enabling us to counter the stereotypes being dragged up by the media. Census forms were widely distributed, showing that, for once, occultists can co-operate without too much bitchcraft. The Census shows what we might have expected; that occultists tend to be intelligent, open-minded, supporters of green issues, and that we are kind to animals and our next-door neighbours.

Whether this information will have any effect on how we are portrayed in the media remains to be seen – it's hard to keep a good stereotype down, after all. Still, thanks to Chris and company, we at least have some ammunition to work with. The Census revealed, for example, that a good proportion of occultists favour Channel 4 as their TV station of choice. Perhaps if enough people wrote in and pointed this out to C4's executives, then we might see some serious programmes being made about occult issues. The census booklet also provides some interesting comments on the subject of satanism. This will be one of the hardest stereotypes to chip away at, since a good many Pagans and occultists

have swallowed the moral panic glamours concerning this particular subject. The Census report argues for open-mindedness and freedom of belief. It could well become a key weapon in the war against "flat" thinking, depending of course, how much use we make of it!

Pandaemonium in Hull?

This month's occult-Drongo award goes to the anonymous persons who have chosen to pester Pandaemonium Books of Hull with threatening phone calls and the posting of a "curse object" through the shop doorway. The matter has been brought to the attention of the local police who are proceeding with enquiries.

THIRD EYE[2]

TVs from Space... ?

Rumour has it that tele-evangelists in the USA are developing an unbreakable TV set. Made of plastic and styrofoam, solar-powered and pre-set to receive a specific satellite channel, it can be dropped from aircraft to spread the word to the most remote regions of the planet. Oh yes, and there isn't an off-switch![3]

Albion Arising...

The current trendiness amongst Pagans of adopting a native British glamour is stirring up some of the more muddier elements in society. Amidst all the Celtic shamans, punk druids and Arthurian adepts, we are beginning to hear the crunching of jackboots marching under the New Age banner. Take for example, "The Brotherhood of Albion", a group which aims, amongst other things,
"...to defend our people and preserve our country, our religion and our national identity." The "religion", in this instance, is Paganism.

The Brotherhood point out "Minority religions such as the various Pagan followings are fiercely attacked by the established Church, the press, the people at large and elements of the government, while at the same time, the country is being swamped by foreigners who are taking over large areas of our towns and cities... yet we cannot even express an opinion against foreigners publicly without breaking some legislation which offends the Race Relations Board." I think you get the drift of their argument, yes?

Underneath all this "native British spirituality" stuff there lurks an undercurrent of nationalistic fervour, and The Brotherhood of Albion exhort their followers to

2 Third Eye was our semi-regular media watch section. Although clearly some of our news was about the media's treatment of the Satanic Ritual Abuse myth, in general we tried to make news articles about actual real people doing actual real things, not just talking about it. So we created the Third Eye column as a more meta commentary on news media itself.

3 We have no information as to whether this initiative ever came to fruition, but we do know that since then several Christian groups have been sending wind-up radios to remote African tribes so they can preach to them. Ironically, the wind-up radio was invented by Englishman Trevor Baylis (1937 – 2018) as a way of spreading information about AIDS, and Baylis himself had been sexually abused by a Christian clergyman at the age of 5 years old, as reported in his autobiography *Clock This* (1999).

"march into the bright new dawn" under their banner. Trouble is with new ages, they tend to get ushered in with fire and steel. After all, wasn't Hitler elected on a New Age ticket?[4]

Christians faced with Uncomfortable Truths

Christian Family magazine have recently published the results of a reader survey on child sex abuse, the results of which have appalled them. The magazine was flooded with hundreds of grim personal accounts of abuse at the hands of close family friends and relatives. This of course, fits the general pattern, but what the magazine found most disturbing was that many of the abusers were described by their victims as outwardly respectable churchgoers, and many of them appear to have been church workers or leaders. The situation is further complicated by the admission that a large majority of Christian parents and church social workers believe that sexual abuse could not possibly take place within a Christian family.

These revelations (though hardly surprising really) shed new light on the campaign by some zealous Christians to put the blame for child sexual abuse onto "witches". Since a good Christian cannot possibly do such evil things, the only answer is to find an outside agency as a scapegoat. Since a good many Christians, it appears, cannot even acknowledge the possibility of such abuse of power existing, the potential for it to arise within a family set-up where women must submit to the will of men, and children must submit to the will of adults must be enormous. The recent revelations concerning the behaviour of tele-evangelist Jim Bakker in the States is another example of this process of denial. The accusations against Pagans & Wiccans concerning child sexual abuse, ritual murder etc. aren't that particularly original either – the same charges were levelled against the Jews in medieval Europe.

Robber Barons go Radio-active

RTZ (Rio Tinto Zinc)[5] is a British-owned company dealing in uranium and aluminium mining. Some of the richest deposits of uranium have been found on sacred lands belonging to the Aborigines and that of the North American Indians. RTZ have laid waste thousands of miles of Aboriginal land,[6] with a

4 The Brotherhood of Albion seem to have vanished into history. Where fascist groups belong.

5 Now known as the Rio Tinto Group, this company was founded in 1873 and is currently the second largest metals and mining corporation in the world.

6 And they are still doing it at the time of writing this book! In May 2020, Rio Tinto demolished

devastating effect on the local population, as the radioactive waste products cause irreparable genetic damage. Some waste-products from the mining have even been used as building materials! They are also one of the largest producers of CFC's, and naturally, have persistently denied any connection between CFC's and the destruction of the ozone layer.[7]

PARTIZANS (People Against Rio Tinto Zinc And Its Subsidiaries) is a pressure group which exists to give a voice to the people who suffer the consequences of their activities. They can be contacted at 218 Liverpool Rd, London N1 ILE, Tel: 01-609-1852.[8]

a sacred cave in Juukan Gorge, Western Australia, which had evidence of 46,000 years of continual human occupation, and was the only inland site in Australia to show signs of continual human occupation since the last Ice Age.

7 Rio Tinto is still one of the top 100 industrial greenhouse gas producers in the world, accounting for 0.75 percent of global industrial greenhouse gas emissions between 1988 and 2015.

8 For more, see Roger Moody, *PLUNDER!: The Story of Rio Tinto Zinc* (Partizans, 1992).

VIEW POINT

Conservation
by *Norman Clinton*

As Pagans we are expected to be concerned about the environment, and so we should be, as we all call upon the aid of the elements. I will be asking why they should come to our aid, but first let's look at what we are conserving and why.

I became interested in survivalism whilst serving in the forces, and noticed, when I later became a Pagan, that the writers of survival manuals know more about nature, flora and fauna than most Pagans do. This set me thinking about the guys I served with, some of whom run survival schools today. We may not like what they do, but remember that they are conditioned by the society in which they live, as I once was. And they have learned the lesson the hard way, that some Pagans never learn, that without our mother earth and her gifts, mankind will not survive. You may say "Why do you think we call upon the elements then?", which I will answer later, but first let me pose another question. If you were caught in the wild, ill or injured, could you survive? Know which plants healed what? What to eat? How to build a shelter? There is more plant and herb lore in a survival manual than any book on the craft, and though you may criticise the survivalist's beliefs, don't criticise their knowledge. We need to look at our motives for supporting conservation, and perhaps admit that one of our main reasons is self preservation, individually and as a species; we live on the planet, as will our children and grandchildren. According to my (admittedly cheap) dictionary, conservation comes from the word conserve: to preserve and keep from decay. Decay is a natural phenomenon, but most of the decay that exists today is unnatural and caused by man. So, back to my point about why the elements should help those Pagans who call for their aid. The problem is that while we understand the magical uses of earth, air, fire and water, we don't look closely enough at them, respect them or try to understand them.

AIR

Whatever your branch of Paganism, in ritual the power of air is called upon. Air is essential, we need it to breathe to live, and magicians can visualise the blowing of a gentle breeze. But as any sailor will tell you, a breeze can turn into a gale, and a gale into a hurricane. Air can both sustain and take life, positive and negative, and should command respect. If you were air, would you answer the call of those who polluted you with everything from lead to radioactivity? Can we ask for the aid of air if we use aerosols and leaded petrol? OK, so it's impossible to avoid causing at least some pollution in today's society, and we shouldn't do away with scientific advances. But we can, as individuals, think about what we do, respect the air, and minimise the damage that we personally cause.

FIRE

We often see fire in a negative way, as a destroyer, but this is due to man's misuse of the element to sate his own greed – via atomics, weaponry, napalm, even the burning of the ground in order to grow the basics on which to live. But fire also warms and nurtures, as in the warmth felt by both parties in healing, and without it none of us would be. Whatever our persuasion, we should oppose the use of any element for destruction rather than benefit.

WATER

What can I say about water? So many books on magic and Wicca say that only pure water should be used, but where do you find it? There may be the odd brook, stream or well, but they ain't in the city, where even the tap water can be polluted. If you look at major rivers and canals, you find that life cannot survive in them; factories pump chemical waste into them, local authorities pump sewage into them. Animals, fish and plants are all dying off. Even rain water collected for ritual purposes and distilled, is full of pollution, from acid to sand from the Sahara. Can we really ask for the help of water if we are not prepared to come to its aid?

EARTH

Again, I could write a book; the earth is our mother, it gives us our food, our air, and provides for all our needs. Just look at the way we repay it. Would you poison your own mother? Force her to give more than she can? Exploit her to gain more power? Stand by and watch others do these things? Of course you will say *no*.

But we put so many pesticides, insecticides, and poisons into the ground so that yet more produce can be grown. We buy products that can never be recycled, that can not be reclaimed by the earth itself. I have a theory that factory farming came about not to supply a growing demand for food, but so that land which would otherwise be used for natural farming could be used for the building of industrial estates, factories and big houses in which the exploiters could spend their ill gotten gains. To me, it's not a question of do you respect the earth, but do you respect our mother?

Observations

We often forget the interdependence of the elements. Air needs the earth to provide the plants that utilise the gasses that we can't use. Fire gets its fuel from the earth, and will not burn without air. Earth needs the fire of the sun and water to feed its plants and creatures. Water is made up of parts of air, hydrogen and oxygen. We ourselves consist of many of the elements, being mostly water. So, if you take the elements for granted, you might just find that they won't work for you.

THINGS TO DO...
and THINGS TO READ

Touch Exercises
by *Phil Hine*

Our sense of touch is something which we tend to take for granted, only realising how much we rely on it when it is lost from some part of the body. Touch is important in both survival and communication, particularly intimate communication. Speech is more of a social mode of communication, whereas touch belongs more to the personal and intimate. A single touch can carry more meaning than a thousand words. When we combine gentle words and touch, we can be transported to other worlds – of relaxation, sleep, visions, or the illumined darkness of lovers. Enhancing our ability to sense through touch is an important skill in developing psychic abilities such as healing, psychometry, and trance techniques.

Sensitising the Hands This exercise can be used as a warm-up prior to doing any exploratory work with your hands, such as massage, healing, or attuning crystals. Begin by rubbing your hands together briskly and then "feeling" an energy field between them, rather like a ball. Try stretching and compressing the ball, and bringing your hands together, so that you can feel the resistance of the field. Then try drawing your hands further apart until you can no longer feel the ball. This exercise should be performed for about five minutes. It focuses awareness into the hands.

Colour Sensing Cut out squares of coloured paper and have someone else arrange them on a table so that you do not know the sequence. Then devise some kind of covering over the table, under which you can slip your hands. Try and feel with your hands for the colour of the paper – call out the colour you feel, and see if the square you pull out is that colour. This exercise can take a great deal of practice, but you will learn to be aware of the different feelings in your hands and learn to associate those feelings with different colours. It involves relaxing, so that you can be aware of the fleeting thoughts and images that arise in your mind.

REVIEW

2000AD

Price 35p, published weekly.
Review by Frater Impecunious

2000AD is a peculiar creature; it was one of the first of the new generation of adult oriented comics, yet its format and editorial style still give the impression that it's definitely "for kids". This, combined with the multi-story approach means that stories range from the puerile to the sublime. Currently *2000AD* is witnessing the return of two excellent stories of particular interest to Pagans; *Slaine* and *Zenith*.

Slaine is the creation of Pat Mills (see last month's *PN* interview), a Celtic hero who serves as a vehicle for Pat's magical and political ideas – the thinking Pagan's Conan. The new adventure, *The Horned God* is the most overtly Pagan so far – the title speaks for itself, as does Simon Bisley's superb (and risque) artwork.

Grant Morrison's *Zenith* draws more from Lovecraft and Chaos magick. Previous stories have lifted both text and artwork from *Psychonaut*.[9] Set in an alternate present where superheroes exist (but aren't up to much), Richard Branson (well someone very like him) steals nuclear missiles, and showbiz counts far more than saving the world, *Zenith* is an enjoyably cynical social satire, with some informal magical content as a bonus. Zenith himself is a superhero who prefers being a popstar which makes a refreshing change from popstars who want to be superheroes. Get down and buy your progs[10] before the talent dries up and we are reduced once more to old Judge Dredd reprints or the space-soap opera of *Moonrunners*.

9 *Psychonaut* (1982) was the second book by Peter Carroll, the follow-up to his enormously influential *Liber Null*. The illustrations were by yet another member of the Leeds University Occult Society, the very talented (and very odd, even by our standards) Brian Ward. His incredibly intricate and evocative pointillist renderings of alien entities were arguably as influential as Carroll's text, as evidenced by Morrison & Yeowell's use of them in this comic book.

10 Both of these *2000AD* strips have now been collected into graphic novels: *Slaine – The Horned God* (1993) and *Zenith – Phase Two* (2014). Though we highly recommend that you read all of *Zenith*, starting with *Phase One*. It will make a lot more sense that way.

Famous Occult Stereotypes

Kevin Crookes – He's Read a Few Books

by *Barry Hairbrush*

Yeah, well I bin in the, er, you know, the occult (people who're into it spell it OCKULT, did you know?) a few years now. Initiated? Yeah, a long time ago, well, I did it myself in the attic after the pub one night.

Of course, the greatest of them was that Aleister Crawford. He wrote the Neckrocromnicon, it's this book you can contact demons with if you read it. It's so powerful I buried my one in the woods. And that Dennis Wheatley guy, he wrote these true-life stories about what they, er we, get up to. All the orgies and that. Yes, there was one last Wednesday, it was brill.

You get given this special knife called an athmaymee and you have to plunge it into the breast of a naked virgin. It's amazing what you get up to once you're in a convent – that's what you call a group of witches. Although they do hate being called witches; their real name's Winkles.

You want another drink? I'm loaded this week. Some priest who's writing a book on the occult paid me a grand to tell him all about it.

PAGAN NEWS

The monthly newspaper of
Magick & the Occult

July '89
Price 30p

PLAIN CRAZY!

Stonehenge '89: the news reports came over like some twisted parody of the Falklands War - a four mile exclusion zone; helicopters strafing the ground with their searchlights, and six police forces on standby waiting to move in, should the 800 police around the stones require assistance. And for what? Most people, it seems, were content to remain at Glastonbury holding a free festival. There were no outbreaks of mass violence, and people were arrested after they outwitted the police cordons in the exclusion zone and reached the stones. People moving towards the stones from the small town of Amesbury were moved back to the town centre by police using riot gear. Local residents complained that the police tactics were too heavy-handed, and one householder said *"if they want to go to Stonehenge, why should they be stopped?"* while another resident described the police tactics as "unneccesary". Riot tactics may be 'acceptable' in inner-city streets, but not in the country towns of the sourthern counties! English Heritage, no doubt embarrased over the debacle, released a statement saying *"we hope for a situation in which we can allow druids and others in limited numbers to carry out their ceremonies"*.

Such a move is unlikely to be welcomed by the hawks in the police force, who want to destroy the tradition of a free festival associated with Stonehenge. For these, the means, being a large police presence for several years, justifies the end, which has wider implications than the Solstice festival itself. The tactical deployment of the police at Stonehenge reflects the desire of some senior police officers to switch from so-called 'community' policing to a more paramilitary style. Of course, a massive confrontation at the stones would have resulted in a lot of support for this arguement. As it is, the whole operation has not cast the police in a very good light, their image having already been seriously damaged by the Hillsborough disaster earlier in the year. Perhaps this year's events at Stonehenge will defuse the tensions on both sides of the wire and allow solutions to be approached rationally. Less fist-waving from both the authorities and those who want to visit the stones would be welcomed. While each sees the other as "the enemy", little progress will be made. In the meantime, hopefully the Festival Campaign will organise a "bust fund" for the 260 people who were arrested in the exclusion zone.

Moral Majority Bows Out

Good news for pagans on both sides of the Atlantic is that Jerry Falwell's Moral Majority organisation is being closed down, ostensibly "because it has achieved its aims". This is somewhat perplexing as these aims include banning abortion, homosexuality, withdrawing sanctions on South Africa and compulsory Christian prayer in schools. What it has done, in the words of an opponent, is *"moved republicans so far to the Right they've fallen off the flat earth in which they now believe."* The Moral Majority have taken their fair share of batterings in the series of scandals which have shaken the power of the evangelical movement in the states. Perhaps this heralds a more liberal atmosphere in the states as we move into the 'nineties, as America's national psyche finally shrugs off the 'Cold War' mentality.

Plain Crazy!

Stonehenge '89: the news reports came over like some twisted parody of the Falklands War – a four mile exclusion zone; helicopters strafing the ground with their searchlights; and six police forces on standby waiting to move in, should the 800 police around the stones require assistance. And for what? Most people, it seems, were content to remain at Glastonbury holding a free festival. There were no outbreaks of mass violence, and people were arrested after they outwitted the police cordons in the exclusion zone and reached the stones. People moving towards the stones from the small town of Amesbury were moved back to the town centre by police using riot gear. Local residents complained that the police tactics were too heavy-handed, and one householder said "if they want to go to Stonehenge, why should they be stopped?" while another resident described the police tactics as "unnecessary". Riot tactics may be "acceptable" in inner-city streets, but not in the country towns of the southern counties! English Heritage,[1] no doubt embarrassed over the debacle, released a statement saying "we hope for a situation in which we can allow druids and others in limited numbers to carry out their ceremonies".

Such a move is unlikely to be welcomed by the hawks in the police force, who want to destroy the tradition of a free festival associated with Stonehenge. For these, the means, being a large police presence for several years, justify the end, which has wider implications than the Solstice festival itself. The tactical deployment of the police at Stonehenge reflects the desire of some senior police officers to switch from so-called "community" policing to a more paramilitary style. Of course, a massive confrontation at the stones would have resulted in a lot of support for this argument. As it is, the whole operation has not cast the police in a very good light, their image having been seriously damaged by the Hillsborough disaster earlier in the year.[2] Perhaps this year's events at Stonehenge will defuse the tensions on both sides of the wire and allow solutions to be approached rationally. Less fist-

1 English Heritage was set up in 1985 as the British government body tasked with overseeing many of England's ancient monuments in public ownership, such as Stonehenge and Hadrian's Wall. After considerable controversy during its history, in 2015 it was turned into an independent charitable trust.

2 The Hillsborough disaster occurred on 15 April 1989 during a football match at Hillsborough Stadium in Sheffield. 96 people lost their lives in a crush, with another 766 seriously injured. Police and the media blamed hooligan fans for the deaths, but the families of the dead refused to accept their story. After decades of legal battles, they were finally vindicated in 2016, when a second coroner's report showed that the true cause was a combination of police negligence and poor stadium design. Despite this, and years of police cover-ups, still not one of the guilty parties has been jailed.

waving from both the authorities and those who want to visit the stones would be welcomed. While each sees the other as "the enemy" little progress will be made. In the meantime, hopefully the Festival Campaign will organise a "bust fund" for the 260 people who were arrested in the exclusion zone.

Moral Majority Bows Out

Good news for Pagans on both sides of the Atlantic is that Jerry Falwell's Moral Majority organization is being closed down, ostensibly "because it has achieved its aims". This is somewhat perplexing as these aims include banning abortion, homosexuality, withdrawing sanctions on South Africa and compulsory Christian prayer in schools. What it has done, in the words of an opponent, is "Moved Republicans so far to the Right they've fallen off the flat earth in which they now believe". The Moral Majority have taken their fair share of batterings in the series of scandals which have shaken the power of the evangelical movement in the States. Perhaps this heralds a more liberal atmosphere in the States as we move into the 90s, as America's national psyche finally shrugs off the "Cold War" mentality.

Ayatollah – Rest in Pieces!

Iran has seen the passage of the Ayatollah Khomeini[3] and the emergence of a new government. The West has performed the usual trick of offering its condolences to the Iranians who supported the Ayatollah's regime of terror which still holds one of Britain's leading writers in hiding. Ironically, during the funeral, the body of Khomeini was abused at the hands of mourners, an act which the Islamic faith considers abominable (dead bodies being considered "unclean"). The fanatical spirit which Khomeini evoked led to a jihad against Iraq, in which over one million Iranians died, and the execution of an estimated 200,000 political opponents. From a Pagan perspective, we should remember that the face of religious intolerance is still very much visible in the modern world. The Ayatollah may have been just an impersonal "news" item to most of us but the *Satanic Verses* case[4] has shown the long arm of fanaticism is far stronger than many of us may think.

3 Supreme Leader Sayyid Ruhollah Musavi Khomeini (1900 – 1989) was the fanatical puritan Islamic religious leader who set the previously liberal country of Iran back about 100 years. Admittedly the American government had already set that process in motion when they previously overthrew the democratically elected government of Mohammad Mosaddegh in 1951. Dumb American foreign policy has a lot to answer for.

4 In 1989 Ayatollah Khomeini of Iran issued a fatwa ordering Muslims to kill British writer Salman Rushdie after the publication of his book *The Satanic Verses*. This fatwa remains in place to this day, and even as late as 2016 Iranian media companies were still raising money to pay for his assassination. We believe that this bounty currently stands at somewhere around $600,000. You'd think there would be a lot more useful things they could be doing with this money.

THINGS TO DO...
and THINGS TO READ

Light Breathing

by *Julian S. Vayne*

Light Breathing is intended to fill the practitioner with magickal energy; it can be used as an exercise in visualisation or to re-energise the body in times of stress. It balances unharmonious energies, breaks down energy blockages, and brings about a state of relaxation and vitalisation, thus promoting the health of mind and body. Regular practise stimulates creative, intuitive and intellectual functions, creating flashes of inspiration ("inspiration" literally means "to breathe in").

* Choose a warm, well ventilated room (weather permitting, Light Breathing is particularly effective performed outdoors). Wearing loose fitting clothes, sit or lie in a comfortable position, with spine straight, and eyes closed if you prefer.
* Start a regular breathing pattern, i.e. breathe in through the nose for a mental count of four, then deeply exhale through the mouth for a further count of four. Establish a regular, relaxed pattern then move on.
* Breathing rhythmically, listen to sounds in the distance, then move your attention to sounds in the room, and finally focus on the sound of your own breathing, regular and calm.
* Imagine that your body is surrounded by a brilliant white light. As you inhale the light circulates throughout your body, permeating every fibre of your being. As you visualise this, feel the clear, vitalising power of the light.
* As you exhale, visualise all your cares, worries, problems and illness departing to be vapourised by the clear radiance of the white light.
* Repeat the visualisation, breathing in the light and exhaling detrimental forces from your mind and body. Continue for between five and fifteen minutes.
* Concentrate once more on your breathing alone, forgetting the visualisation of light. Listen again to the sounds of the room, then in the distance as you become aware of the world around you. Open your eyes and return to the "everyday" level.

If you performed the exercise correctly, you should feel an inner glow and be both relaxed and full of energy. Record your experiences in your diary.

Further Reading

Magick Aleister Crowley (RKP – 1983)
The Complete Yoga Book James Hewitt (Rider – 1983)
Dreambody Arnold Mindell (RKP – 1984)

B-DOG

the British Directory of Occult Groups

THE SEAX-WICCA

The Seax-Wicca, or Saxon "tradition" of witchcraft, was begun by Raymond Buckland in 1974 with his book *The Tree*.[5] Buckland did not claim that *The Tree* was a reconstruction of the original Saxon religion, but called it rather a new "tradition" hung on an old peg.

Like other types of Wicca, the Seax-Wicca is a religion of initiation, worshipping the God and Goddess in their Anglo-Saxon forms of Woden and Freya, and celebrating the turning Wheel of the Year with its eight Sabbats. In a number of respects however, the Seax-Wicca differs from other traditions; these points of difference have proved attractive to many would-be followers of the Old Gods.

Firstly, the God and Goddess enjoy equal devotion from the worshippers, and the Priest and Priestess of the coven have equal roles to play, neither more important than the other. This is in contrast to Gardnerian and Alexandrian practice, where the Goddess is accorded the dominant role and so, accordingly, is the High Priestess. Secondly, the Seax-Wicca is far less hierarchical than other traditions. A Ceorl, or neophyte, may attend the Rites, with the unanimous approval of the Coven, but may not take part in them within the Circle. An Initiate is referred to as a Gesith, an Old English word for companion. Gesith-hood is, in fact, the only level of initiation, for the Priest and Priestess are elected yearly by all initiates of the Coven. "High Priest" and "High Priestess" are honorific titles conferred on those who have held the post twice, not necessarily in consecutive years.

5 *The Tree: The Complete Book of Saxon Witchcraft* by Raymond Buckland. Weiser Books, 1974.

The third, and most controversial, point of departure is the possibility of Self-Dedication by those who wish to worship the Gods as Seax-Wiccans, but have no contact with an established Coven. Initiation into an established Coven remains the preferred path, but the Saxons recognise the difficulties – even today – of the individual seeker, and the psychological importance of the act of Self-Dedication in such circumstances. Whether a Self-Dedicated Gesith will, in practice, be accepted as such by other Gesiths depends on the level of maturity and good intentions of all concerned; fools and scoundrels remain fools and scoundrels whatever titles they adopt or have conferred upon them by others. Perhaps recognition of this fact by other traditions would lead to less bickering and ego tripping, and more healthy pragmatism. The Rites themselves have a simple beauty which has to be experienced to be appreciated. They lend themselves easily, by adaptation, to solo ritual. For matters of practical magick, the rites tend to err on the side of too much simplicity, and at least one Seax-Wicca Coven has embellished the Rite of Erecting the Temple to provide greater security and power.

What does the future hold for the Seax-Wicca? This will, of course, depend on the growing number of adherents and the effort they put into forging a distinct character for their tradition. It has many good things to its advantage – dynamism, flexibility, and pragmatism to name but three – but I feel that the impetus must come from the continued development of its peculiarly English character. Other traditions lean heavily on Celtic or even Graeco-Roman mythology for their inspiration; a genuinely English tradition may well flower in the Seax-Wicca. Those interested in further research along these lines should read *Rites and Religions of the Anglo-Saxons* by Gale R. Owen, chapters 1-4.

Raymond Buckland's *The Tree* has provided the roots and branches; active Seax-Wiccans must now ensure that those roots strike deep into the fertile soil of English folklore to provide the nourishment for a multitude of healthy leaves.

All-In Vayne [6]

GOING TO THE DEVIL

L et's face it, Satan has had a bit of a bad press over the past couple of thousand years. As a godform, even amongst the "enlightened" Pagan community, he's not exactly "Top of the Pops". However Satanism seems to be undergoing something of a revival at the moment. Satan is beginning to receive the attention that this exceptionally interesting deity warrants. The time is ripe to put things into perspective.

The word Satan is of Hebrew derivation. He (or more correctly "it") was an archangel in the same manner as Gabriel or Michael. Etymologically the word Satan is closely related to Saturn and to the god names Shaitan and Set. In Hebrew myth Satan is God's "agent provocateur", he is the face of god who tests the resolve of the mortal Christ in the wilderness. In this aspect Satan is the force of the "trial", he brings about the crisis point, such as that experienced in initiation. Being "just another angelic being" Satan is no less a viable occult force than Raphael or the rest. Even so this being occupies a rather odd space in the mentality of many Pagans. For a start Satan is not, even by Qabalistic Hebrew standards, the adversary of god. Those who see Satan as an integral part of Christian ethos are missing the point. We might as well jettison concepts such as karma (which Hinduism uses) or the whole of the Qabalah (of Judaistic theory). Just because Satan has been the literal scapegoat of orthodox Christianity should not mean that Pagans should be loath to use this force if the need arises. Why reject a perfectly effective deity just because someone else has a warped understanding of it? Another problem with Satan is that he is a "dark god". Any reader who has

6 We enjoyed Julian's work so much that we decided to give him his own monthly column. The title (which I believe came from Julian himself) was a bad pun on the phrase "all in vain". But also carried the connotation of "all-in wrestling" where there were no rules for the contestants.

faced a spiritual crisis will know that such events are not comfortable ones. Yet they are an integral part of life, of development – "Suffer to Learn" if you like. Those who seek out only the "sweetness and light" in occultism are fearful of these forces. The ego death which Satan presides over is not "nice", and so these forces are labelled "evil", "detrimental", or simply "dangerous". The deeper aspects of "Satanic Philosophy" are little known. This is odd considering that it is here that Satanists really do differ from many of their Pagan brothers and sisters. The essence of Satanist philosophy is what may be termed "Sacred Blasphemy". The basic idea is that the spark of internal godhead is much more important than any "divine" force. The rationale is rather like that of Buddhism taken to its natural conclusion. Even if there is a creating force (god) we have been created with independent minds, or Wills. Therefore we should not seek union with any other entity or being (such as the "Great Mother"). In fact, even if such a being exists the highest "praise" we may render it is to rebel – to become independent gods in our own right, rather as a child must break away from its mother if it is to become whole in its own right.

This philosophy is expounded by Dr. Michael A. Aquino of the Temple of Set in his use of the term "Xeper" (pronounced "Kheffer", from the ancient Egyptian "to become" or "come into being"). This doctrine emphasises the need to seek for awareness of self and to fan the flames of consciousness into a fire of godhood.

This is not to say that Satanism advocates gratification of the mundane ego any more than does the dictum "Do What Thou Wilt". The very flames of godhood are also the pyre of the "Slave Self". Absolute awareness necessitates absolute responsibility; just as the martial arts master may deal death with a gentle touch, but has no wish to use his/her abilities for gratuitous ends.

In Qabalistic terms, Satan is the figure who traverses the desert (as his Egyptian predecessor Set did). He is the "long dark night of the soul" where the layers of the personality and social conditioning are stripped away from the Self, which emerges into progressively "higher" (or, in the way of occult paradox, lower) spheres.

The forms of Set, Satan, Shaitan, and others are also symbols of the individual who plumbs the dark realms of the cosmos without loss of identity. To the Satanist we are not "drops of rain flowing to the ocean"; rather we are energised particles, rising from the water, streaming off into whatever universes we wish to create.

Yes, there are important differences between the Satanic and general Pagan world views. But in the end we are all bound by the same basic credo – that the Will is central to existence, and that to "do thy Will" is the greatest human challenge. We may go about it in different ways, but in any case all serious students of the occult must "go to the Devil" sooner or later.

THE OCCULT CENSUS

This issue we take a special look at The Occult Census, recently published by
The Sorcerer's Apprentice.

It is estimated that there are over 250,000 Pagans & occultists in the UK, and interest in subjects as diverse as astrology and Zen meditation seems to be ever-growing, yet the popular stereotypes of witches and Satanists, who do "unspeakable" things behind closed doors, retains a great deal of power. That this is so, despite acceptance of many "alternative" ideas concerning health, living and religion, was demonstrated powerfully by the great media campaign against "Satanists" (a sort of catch-all under which anyone remotely connected with the occult could be lumped) which began last year. A moral panic was instigated, with us at the receiving end.

The reaction of occultists to the attention of the ever-vigilant tabloids and media pundits ranged from stark incredulity to the passing the buck gambit of "It's not us, but those nasty people over there who're to blame". Somewhere in the middle fortunately, were a few people who actually tried to do something about the situation. One of these people was Chris Bray, and The Occult Census is his counter to the tissue of lies served up by the press – a survey of occultists which throws up some interesting facts about how we behave and act.

The Occult Census data was sifted from just over 1,000 returns, from all over the country. The average age, for example, of occultists was 27, and interest in the occult seems to predominantly begin in the mid-teen years. Occultists in the sample were predominantly male (62%), and 50% of the sample considered themselves to be "single" in terms of family bonds. Witchcraft & Paganism proved to be the most popular paths that people expressed a "committed" belief in, whereas only 4% of the sample expressed a "committed belief" in Satanism. Curiously, there is no figure for Thelemites, and committed Chaosists only accounted for 8% of the sample. Only 25% of the sample expressed committed belief in Astrology, which may indicate that whilst credible, occultists are not necessarily gullible in the way that the media portray us. As for general interests, the Census reveals that reading is top of the list of interests, with politics at the bottom. Nearly half the sample were home-owners, and also nearly half the sample owned cars. The Census shows that occultists prefer to read *The Guardian* and watch Channel Four. The most popular political platform was that of the Green Party, and the least, anarchism. A good few anarcho-Pagans, at the time of the Census, refused to fill in the forms for all the usual reasons, so that may account for the low figure. More than half the sample felt that the relationship between science and the occult was underrated, and 71% of respondents felt that being

involved in the occult did enhance their social life. Community spirit between people of a like mind was the most popular reason for this, so there must be a genuine thread of communality underneath all the bitchcraft and curse-slinging that one hears about. This is a good sign for those of us who have been worn down by gossip and apathy. On the subject of religious education, 72% disagreed with the idea of compulsory religious education, although 85% reported that they would accept it if alternative & Pagan beliefs were included.

As for ecology, 94% of occultists in the Census expressed positive interest in environmental issues, and 49% of those affiliated to different groups were members of Greenpeace. Even the Satanists were members of ecology and animal rights groups, perhaps showing that all this Green stuff comes from Satan & the Commies really! Only one person in the whole Census admitted having killed an animal or bird as a magical act, and 60% said that they would, upon hearing of such activities, report the perpetrators to the authorities. Do babies count as birds or animals though? When it comes to killing, the major world religions beat us hands down.

Overall then, this points to a basic picture of occultists as being nice young middle-class people, rather than horrible perverts who do unspeakable things. One would have thought that rather than trying to use us as a scapegoat, the powers that be would have a vested interest in seeing us as a market to be exploited through offering incentives – perhaps shares in Green technology, for example. Certainly, the Occult Census reveals just how vast the gulf is between media stereotypes and reality.

So what happens now? Chris recommends that everyone get hold of a copy of the Census if you're interested in countering the disinformation generally at large. Interestingly enough, the Census, and Chris's commentary, come out against the "official" recognition of Paganism as a religion – something which has been discussed at great length in various Pagan camps. Instead, the call is for a Bill of Rights, which would enable a greater level of individual freedom for all.

Coming soon from **Pagan News**, a *very careful* study of the paranormal.

THE UNBELIEVABLE

Series editor: Barry Hairbrush graphic design by Mibrashet Sha'ir
research by Barrie Brosse a Chevaux

Each month **The Unbelievable** brings you a look at the brain-wrenchingly terrifying mysteries which science has yet to explain. Month by month, **The Unbelievable** builds into a multi-volume encyclopaedia illustrated with hundreds of well-dodgy black and white photographs.

TESCO'S IN BARNSLEY
Was it the original Camelot?

THE BERMUDA TYPHONGLE
Why do dozens of people mysteriously leave the Typhonian O.T.O. every year, never to return?

THE GREAT SIBERIAN EXPLOSION
We reveal why the commies can't be trusted with their own Nukes.

< Artist's impression of the mysterious explosion which has baffled western scientists.

Plus: Witches!

What do they *really* do?
We've got the nude photos to all your questions in issue 18!

STONEHENGE
Every year vast crowds battle with the authorities to get to the sacred stones – but no one knows how the druids smuggled the megaliths through the police cordon, or indeed why they chose to build it on a National Trust site in the first place.

MYSTERY BEASTS
Does this blurred photograph show actual evidence of the notorious 'Sheffield Hamster'? For three weeks in the winter of 1986, local people made many sightings of a mysterious "hamster-like" creature roaming the hills round Sheffield. Claimed by some witnesses to be in excess of four inches long, the beast was staked out by an army sniper team, who failed to catch it. Local farmer Ted Shelf remarked, "Stop scarin' my sheep with that bloody camera!"

MYSTERIES OF NATURE
According to scientists the bumble bee should not be able to fly, let alone find its way back from the pub after a hard night's drinking. Sometimes truth is stranger than fiction!

MYSTERIES OF THE MIND
Ever since being hit on the head with a Philips Ladyshave thrown during a domestic argument, Gerard Bluetack of Caernarvon has been able to recall perfectly every combination of shirt and tie worn by weatherman Michael Fish on TV since 1981.

FREE WITH ISSUE ONE!
A unique souvenir! Cut-out-'n'-bury-in-the-garden talisman! And look out for our realistic designer-grimoire human-skin binder offer! Just the thing to impress your friends with your occult erudition as a student of the Mysteries! Only from The Unbelievable!

PAGAN

NEWS

The monthly newspaper of
Magick & the Occult

August '89

Price 30p

THE CROOKED
REPORT!

Monday, 17th July; the long-promised Roger Cook report on Satanism and child-abuse was revealed to a salivating audience. It was, as we might have expected, a masterpiece of hysterical TV 'Journalism'. Viewers were given the impression of a massive Satanic, child-abusing conspiracy, "somewhere, out there, lurking around every corner" and being supported by books like The Omen and heavy metal supremos such as Ozzy Osbourne, who, while being interviewed, admitted that he felt Aleister Crowley to be a "bizarre person" - not bad coming from the man who reputedly bites the heads off bats! The reporters took the 'victims' words as complete truth, for example, that paragon of credibility, career ex-satanist Audrey Harper; whilst scorning the explanations of Temple of Set leader Michael Aquino, and archive film of Chris Bray. The report didn't give any conclusive evidence to support claims of a 'Satanic Conspiracy', just hints and amorphous accusations. Take Audrey Harper, for instance. She claims to have been a recruiting agent for a coven that practised human sacrifice and child abuse. Why then, has she not been prosecuted, if she has the proof as she claims? The Nottingham child-abuse case was also examined, and the report alleged that the investigation of 'Satanic elements' was being re-opened, thanks to new evidence - this was news to the police however. The report interviewed an ex-satanist youth who appears to have been afflicted by the Dennis Wheatley Syndrome. You know, wearing black, desecrating churches, living in a tent, that sort of thing.

Of course, if all Satanists are into this sort of perversion. then no doubt all Christians are, deep down, just like Peter Sutcliffe, who was told directly by God himself to go out and kill women! That's the kind of twisted logic on which the report was based. Michael Aquino was filmed (with permission) in the act of initiating a Mr. David Austen as British head of his organisation. Aquino told *PN* that he allowed the ceremony to be filmed to try to dispel some of the disinformation about his activities - probably not successful. More charges against him followed, but then anyone can make an accusation, can't they? Even children have been known to tell lies sometimes - just who is manipulating whom, here? The report ended with the Rev. Kevin Logan 'blessing' a poor victim of the Devil's work.

Can we expect a new wave of persecution following this report? It's highly likely, although a quick perusal of the right-wing tabloid press reviews the following day showed a surprising degree of scepticism, accusing Cook of damaging his reputation by trotting out a bunch of social inadequates and no evidence; you can't fool all of the people all of the time! However, we do know that the scale and scope of child-abuse in this country is bigger than many people care to admit. Most of the perpetrators are family members, and the rot runs across all professions and social groups. How convenient it will be then, if a scapegoat can be found. Past witch-hunts were all targeted at a discrete group in the community; blacks, Jews, women. This is more subtle, *anybody* could be a Satanist - they don't all run around wearing black and smelling of sheep's blood. Also, it's a good opportunity for a 'moral panic'. Christianity has lost it's high moral ground, with the advent of (gasp!) women priests and gay vicars. Despite all the revelations about child-abuse by Christians, no one is calling for investigations - perhaps there is a conspiracy here too?

It'll also be interesting to see how the occult/pagan community responds to all this. Some pagans seem to hold at arms length anything which might threaten the

1

NEWS

The Crooked Report

Monday, 17th July; the long-promised Roger Cook[1] report on Satanism and child abuse was revealed to a salivating audience. It was, as we might have expected, a masterpiece of hysterical TV "journalism". Viewers were given the impression of a massive Satanic, child-abusing conspiracy, "...somewhere, out there, lurking around every corner" and being supported by books like *The Omen* and heavy metal supremos such as Ozzy Osbourne,[2] who, while being interviewed, admitted that he felt Aleister Crowley to be a "bizarre person" – not bad coming from the man who reputedly bites the heads off bats![3]

The reporters took the "victims" words as complete truth, for example that paragon of credibility, career ex-satanist Audrey Harper; whilst scorning the explanations of Temple of Set leader Michael Aquino, and archive film of Chris Bray. The report didn't give any conclusive evidence to support claims of a "Satanic Conspiracy", just hints and amorphous accusations.

Take Audrey Harper, for instance. She claims to have been a recruiting agent for a coven that practised human sacrifice and child abuse. Why then, has she not been prosecuted, if she has the proof as she claims? The Nottingham child-abuse case was also examined, and the report alleged that the investigation of "Satanic elements" was being reopened, thanks to new evidence – this was news to the police however. The report interviewed an ex-Satanist who appears to have been afflicted by the Dennis Wheatley Syndrome. You know, wearing black, desecrating churches, living in a tent, that sort of thing.

Of course if all Satanists are into this sort of perversion, then no doubt all Christians are, deep down, just like Peter Sutcliffe,[4] who was told directly by God himself to go out and kill women! That's the kind of twisted logic on which the report was based.

1 Roger Cook (1943 –) was an investigative journalist who was frequently on British TV back in the 80s and 90s. His show *The Cook Report* had incredibly high ratings for a current affairs programme, with 12 million viewers.

2 Ozzy Osbourne (1948 –), lead singer of British heavy metal band Black Sabbath, who would go on to infamy by parodying himself in the TV show *The Osbournes*. His song "Mr. Crowley" has meant he is often associated with the occult, even though, in common with many other things, he hasn't a faintest clue about it.

3 He did indeed try to bite the head off a bat, on 20 January 1982, while performing at the Veterans Memorial Auditorium in Des Moines, Iowa. Unfortunately for Ozzy, the bat decided to bite back and he had to get treatment for rabies. Poetic justice.

4 Peter William Sutcliffe (1946 – 2020), an English serial killer who was dubbed the Yorkshire Ripper. He murdered 13 women across the North of England between 1975 and 1980.

Michael Aquino was filmed (with permission) in the act of initiating a Mr. David Austen[5] as British head of his organisation. Aquino told *PN* that he allowed the ceremony to be filmed to try to dispel some of the disinformation about his activities – probably not successfully. More charges against him followed, but then anyone can make an accusation, can't they? Even children have been known to tell lies sometimes – just who is manipulating whom, here? The report ended with the Rev. Kevin Logan "blessing" a poor victim of the Devil's work.

Can we expect a new wave of persecution following this report? It's highly likely, although a quick perusal of the right-wing tabloid press reviews the following day showed a surprising degree of scepticism, accusing Cook of damaging his reputation by trotting out a bunch of social inadequates and no evidence; you can't fool all of the people all of the time!

However, we do know that the scale and scope of child abuse in this country is bigger than many people care to admit. Most of the perpetrators are family members, and the rot runs across all professions and social groups. How convenient it will be then, if a scapegoat can be found. Past witch-hunts were all targeted at a discrete group in the community: blacks, Jews, women. This is more subtle, anybody could be a Satanist – they don't all run around wearing black and smelling of sheep's blood. Also, it's a good opportunity for a "moral panic". Christianity has lost its high moral ground with the advent of (gasp) women priests and gay vicars. Despite all the revelations about child-abuse by Christians, no one is calling for investigations – perhaps there is a conspiracy here too?

It'll also be interesting to see how the occult/Pagan community responds to all this. Some Pagans seem to hold at arm's length anything which might threaten the squeaky clean image of Paganism that they are so keen to promote. We must stand up for what we believe in rather than just disown everyone who gets crapped on by the press. We must acknowledge our differences, not sweep them under the carpet and pretend that everything is ginger-peachy, because it's not. Likewise, we must be prepared to condemn the obvious drongo elements in occultism who go around defacing property, and also deal with the instances of people who do use occult images and trappings whilst physically or mentally abusing others. Is the occult/Pagan community strong enough to deal with these issues without falling into the same trap as Logan & co? We hope so.

5 After a brief flurry of media nO.T.O.riety Mr. Austen seems to have disappeared into the mists of time. He did manage to co-edit one issue of a magazine called *The Diabolist* published in the Isle of Man in 1994. That's about as far as we have been able to track him.

SPOTLIGHT

Gerald Suster

The name of Gerald Suster has been well known in the occult community for some years. Gerald is a Thelemite, member of the O.T.O. and author of numerous occult books including Hitler and the Age of Horus *and* The Legacy of the Beast. *However, as reported in the May & June editions of* Pagan News, *Gerald has become the subject of the anti-occult ravings of the gutter press in the form of the* News of the World *newspaper. The* NoW *article accused him of the usual nonsense of "Devil-worship" and "sickening practices" So how has this sorry business affected Gerald both as a writer and a Thelemite?*

PN: Gerald, can you explain the events leading up to the *News of the World* story?

GS: Firstly let me say that the *Pagan News* report of the whole incident was perfectly correct. I was approached by a chap at the Plough Inn who seemed genuinely interested. We hold meetings in the pub of 'The Society' (a sort of occult discussion group). I think that must have put him on the scent. Really the next thing I knew was when I read the story.

PN: The *NoW* story resulted in you losing your job as a teacher; can you tell us about that?

GS: Well the reason was that the school really wanted a quiet life. It's not a "Christian" school by any means. We've got kids from Islamic, Hindu, and Shinto backgrounds. I was asked to leave so they could avoid any direct bad publicity.

PN: How much do you think that being a Thelemic writer has contributed to this series of events?

GS: Well it's quite safe to be a writer, although I could foresee an occult Salman Rushdie affair. You advocate Thelema publicly and you're in a position to be hit.

At present it seems that you will be hit. Well I can't say it's been easy, I've lost my job and my house, but I'm still alive and well and pressing charges. I'm going to nobble them and make them see that we cannot be forced down.

PN: What has this incident taught you about the way the media and the establishment view the occult?

GS: It's taught me that the enemy is out in the alley and dirtier than ever, and it's shown me just how low they can be. Perhaps I was a little naive, I didn't think people could stoop to such low acts. If I'd been getting drunk in class or making passes at my female students it would be a different matter. But no. I am a totally innocent man. This whole business is a deliberate attempt to assassinate Thelema and to terrify anybody involved in the occult into cowardly submission. But there is no way I'm submitting to these people – this time I've got them by the balls.

PN: As a Thelemite writing on the occult from that perspective, how do you react to the allegations levelled against the Thelemic system by other occultists – for instance, that Thelema is just a cult based on the personality of Crowley?

GS: Well Crowley was the Prophet of the New Aeon. He was the greatest mountaineer of his age, a fine poet, a chess master, an explorer, and a natural magician. He was greater as a man than any other Prophet before him. Also was any Prophet so honest as Crowley? His diaries are open to all to read, lines like "feeling bad today, thin diarrhoea". How many of today's wonderful occultists would have the guts to put that in a book that their adherents could read? Yes Crowley was a great man but Thelema is not about being like him or slavishly repeating his work. "Do what thou wilt shall be the whole of the Law", thy will, not Crowley's will; not mine, but thy will. You can still be a Thelemite and be nice and sweet and gentle, you don't have to be like Crowley the personality at all.

Today we have a basic synthesis of classical magick through the Golden Dawn. Crowley went further. Austin Spare trained in Crowley's system and evolved his own techniques. I welcome new developments in occultism, the best of Chaos magick for example. The problem is that today too many people plunge in without knowing what they are doing. Thelema provides a basic, non-oppressive, framework. Like the paintings of Picasso, the rule is to learn the basic techniques first; then go wild.

PN: Many people in the occult perceive Thelema as a very male oriented system. How do you react to that?

GS: Again the *Book of the Law* says "Every man and every woman is a star". Thelema is about equality. If you look at Thelema you see that all acts are ultimately directed toward our Goddess Nuit, infinite Goddess of the stars. But before you find the ecstasy of Nuit you must understand Hadit, the atomic core

of infinite potential. Thelema is about balance and equality. Some women do get abused at the hands of so-called Thelemites – it's horrible. They get turned into second class citizens. Vivien Jones gave an excellent talk at the last Thelemic symposium about this subject. Don't be mistaken, Thelema advocates excellent ideals but you can not prevent people adopting the label Thelemite and then abusing those ideals.

I think I have the right to make a pass at any woman and she has the right to accept or turn me down. Problems arise if a man gets abusive about being turned down, or he uses an occult facade to conceal the fact that he has had a life of repressed sexuality. Thelema is about love under will. It teaches men that women are their sisters, equal in all respects.

> *"This whole business is a deliberate attempt to assassinate Thelema and to terrify anybody involved in the occult into cowardly submission. But there is no way I'm submitting to these people – this time I've got them by the balls."*

PN: How do you see Thelema developing in the next ten years?

GS: Well I think we are going to see the most extraordinary events. We're coming into the 90s now. In the *Book of the Law* it says "I am the warrior lord of the forties, the eighties cower before me and are abased". Many people in the past took that as being there was going to be a nuclear war in the 80s, thank heavens there hasn't been one. The 80s have been the most disgusting, cowardly and abased decade. I think Ra-Hoor-Khut is coming in the 90s and the 80s will be looked upon as the most despicable decade of humanity in the 20th century. The 80s have been a time of no real values at all.[6] In this decade we have seen what the Hindus call the 'Kali Yuga', the dark age in which mediocrity has been exalted and greatness put down. We will turn upon the 80s and spit upon them. Now what convulsions that will involve I do not know. But I think that is what the *Book of the Law* means.

PN: Gerald Suster, thank you very much, and you have our best wishes for your legal action against the *News of the World*.

6 It did produce some awesome music though. Your editor is currently listening to the Simple Minds' 1980 classic *Empires and Dance* as I write this.

VIEW POINT

The Burning Times
by *Mike Howard*

Recently I have seen several references in articles and media interviews to the so-called "Burning Times", a term used by Crafters and Pagans to describe mediaeval witch-hunts in relation to modem harassment. The emotive slogan "Never again the Burnings", coined by an American neo-Pagan in the 1970s, has also been evoked. Unfortunately, when practitioners of the Craft and orthodox historians write about the witch-hunting mania, they often present a distorted and sensational picture of the subject which has little relevance to historical fact. The raison d'etre offered by historians for the persecution of alleged witches in the Middle Ages and later can be categorised into three main theories called the Hysterical Syndrome, the Diabolic Scenario, and the Fertility Cultus Idea.

The first theory proposes that the witch-hunts were the artificial product of a patriarchal and misogynistic Church, fed by the xenophobia, ignorance, and religious bigotry of the masses. Witches were a useful scapegoat for natural disasters, social upheavals, plagues etc., and witch-hunts were used by the Church as a control mechanism to consolidate its political power and exterminate its rivals. This theory is supported by evidence that the majority of witch-hunt victims were innocent people who suffered the religious intolerance and organised malice of popular society.

The Diabolic theory is a spin off from the previous hypothesis, and is widely accepted in the outside world, with adherents in the Vatican and among both

the new breed of Christian Evangelists and the alcoholic hacks of Wapping.[7] It claims that mediaeval witchcraft (and by association the modem Craft) was a Satanic conspiracy organised by depraved sex perverts who worshipped evil, practised human sacrifice, and plotted the overthrow of civilised society. It is not surprising that there were social deviants who were attracted by this negative concept and created the "Satanism" which the Church had said always existed.

Lastly, there is the Fertility Cultus, originating in the 18th century, popularised first by Dr. Margaret Murray[8] in the 1920s, and later in a more practical form by Gerald Gardner in the 1950s. This theory explains the medieval witch cult as a

"Witches were a useful scapegoat for natural disasters, social upheavals, plagues etc., and witch-hunts were used by the Church as a control mechanism to consolidate its political power and exterminate its rivals. This theory is supported by evidence that the majority of witch-hunt victims were innocent people who suffered the religious intolerance and organised malice of popular society."

descendent of a pre-Christian fertility religion. In recent years, Murray's rather simplistic ideas have been attacked for their academic sloppiness, but she was broadly correct in alleging that some aspects of mediaeval witchcraft were Pagan in origin. Gardner relied on Murray's theories (perhaps too heavily) when he was desperately formulating his own theory about the origins of the Craft to provide a historical background for modern Wicca.

Supporters of these theories have a tendency to offer their favourite one as the unique answer to account for the deaths of thousands of alleged witches from the end of the fifteenth to the end of the seventeenth centuries, when witch-hunting was at a height in Christian Europe. In the study of such a complex subject it is very tempting to produce an all-embracing theory which explains this bizarre

7　An area in East London which contains the print works of Rupert Murdoch's News International media empire.

8　Margaret Alice Murray (1863 – 1963) archaeologist, anthropologist, historian, folklorist, and early feminist. She lectured at University College London (UCL) from 1898 to 1935, and served as President of the Folklore Society from 1953 to 1955. Her classic 1921 book *The Witch-Cult in Western Europe* promulgated the witch-cult hypothesis, a theory that witch trials were an attempt to destroy the pre-Christian Pagan religion of the Horned God. This theory formed the backbone of the narrative around the development of the early Wiccan movement, despite being very controversial academically. Murray would go on to write the foreword to Gerald Gardner's 1954 seminal book *Witchcraft Today*.

social phenomenon. However, the truth probably lies in a combination of all three theories to provide a more convincing socio-political overview of the historical situation. An unbiased evaluation of the available evidence, for instance, suggests that the victims of the witch-hunts cannot be classified into a single category, as some Crafters attempt to do in their perpetuation of the myth of the "Burning Times". These victims included innocent scapegoats persecuted as social outcasts, followers of heretical sects opposed to Christianity, freethinkers defying the system, misguided people who worshipped evil in the Satanic image created by the Church, village wise women peddling herbal remedies who could curse or cure, ceremonial magicians conjuring up spirits, and even the odd Pagan who venerated the old Nature gods!

Such diversity in victim profile illustrates the problem the would-be historian faces in attempting to analyse the persecutions or trace the development of the Craft in that period. It is a time many modern Crafters would prefer to forget, hence the present trend towards neo-Pagan romanticism, drawing its inspiration from some mythical pre-Christian golden age. Such a retreat from reality is understandable, for the witch persecutions represent a dark age when the Old Ways went underground to become fragmented and debased. The last thirty years, in contrast, can be presented as a bright period, with the gradual re-discovery of our Pagan heritage in its myriad forms, and the Church being forced to face the karma of its crime against Pagandom. A new approach to the history of the witch-hunts is required but it needs to be non-sensational and, if possible under the grim circumstances, non-emotional, facing the facts and not attempting to project modern concepts of the Craft back into the past to create new myths. The modern folklore of the "Burning Times" and the exaggerated claim that nine million witches died in the persecutions – a figure that seems to have been borrowed from the 20th century extermination of the Jews by Nazis – needs to be exorcised from popular consciousness. In fact, the term "Burning Times", while very evocative and punchy, is a misnomer in England and Wales, where witchcraft was treated as a criminal offence, not a heresy as on the Continent. Those found guilty of maleficia under English law were either imprisoned or hanged.

The myth of the "Burning Times" is a dangerous one on a psychological level for it not only perpetuates untruths but also feeds the paranoia of modem Crafters and Pagans facing very real persecution from present day witch-hunters because of their beliefs. Many thousands of men, women and children were tortured, imprisoned, hanged or burnt as witches. In all honesty we need to ask ourselves one very important question – just how many of these "witches" were actually Pagans or members of the Craft?

B-DOG

the British Directory
of Occult Groups

The Caliphate O.T.O.[9]
a Brief History

The O.T.O. (Ordo Templi Orientis – Order of Eastern Templars) was founded at the beginning of this century by Carl Kellner, a wealthy German industrialist and high-ranking freemason. In doing so, he united Tantric teachings which he had encountered in India, with Freemasonry and Western occultism. In the 1920s, Aleister Crowley became the head of the Order, using the name 'Baphomet', this being the name of the idol said to have been worshipped by the Knights Templar.

Under Crowley the O.T.O. changed, "accepting the Law of Thelema" – meaning that it aligned itself with the magickal force which inspired *Liber Al vel Legis, The Book of The Law*, received by Crowley in 1904. Thelema is a Greek word meaning "will" In Thelema there are no priests, rabbis, or imans to tell others what to believe. The Thelemic magical force is initiating humanity into a new Aeon of spiritual growth and freedom; The Aeon of Horus.

Organisation

The Caliphate O.T.O. is organised along the lines of a degree system. Progression through the degrees requires both increasing commitment to the Order and to Thelema. The basic symbolism of the lower degrees is this: 0° (Minerval) = Conception; I° = birth; II° = life; III° = death; IV° = resurrection. The initiation rituals operate to open the chakras, and the initial degrees are a complete system.

9 As mentioned previously, at this point in time there were several competing organisations all claiming to be the "real" O.T.O.. The largest (by far) of these was commonly known as the "Caliphate O.T.O.". It is now known simply as the O.T.O., after winning several court cases to retain exclusive use of the name and trademarks.

The higher degrees explore different forms of sexual magick: VIII° – autosexual; IX° – heterosexual;. XI° – homosexual. The X° is an administrative grade.

While the initiation rituals are private for obvious reasons, Crowley wrote the Gnostic Mass as the public ritual of the O.T.O.. Study of this ritual can elucidate much about the nature of the O.T.O.. For example, the rite centres around a Priestess who is exalted upon an altar. She says little, yet in practice is the most important of the celebrants, since it is she who brings the power through. Though the Gnostic Mass may seem a bit "alien" to many Pagans, it should be remembered that sections have been incorporated into the Great Rite, the third and highest Wiccan Initiation.

The degree system of the O.T.O. forms a system of initiation which, given aspiration, endeavour and work, can help candidates to change themselves and their universe in accordance with their Will. Guidance is given in the form of suitable ritual work given to help one explore the system but this is not compulsory. No one can tell another how best to experience their initiations. Possession of a high grade within the Order does not mean that one has high spiritual attainments or power over another.

Occasionally it is sometimes necessary to accept limited authority in order to move more effectively towards freedom. The Order is headed by the Caliph,[10] who is chosen by senior Order members. The Caliph charters the heads of national and local bodies, the mistress or master of which is responsible for its actions. This authority extends to Order business and no further. The activities of groups varies greatly, both in the UK and internationally. These activities include study groups, group ritual work and Gnostic Masses, meetings and parties. Groups may explore different facets of the O.T.O. and Thelemic Magical Current.

The Caliphate O.T.O. is the continuation of Crowley's O.T.O.. In his time and since, parts of the Order have split off and some continue to use the title O.T.O.. Some of these offshoots do useful work. The tales one hears of arguments between different O.T.O.'s are greatly exaggerated.[11]

To become a member of the Order you must be over 18 years old, and are required to be sponsored by two existing O.T.O. members. But this should not discourage those who do not know anyone in The Order, as applicants can be put in contact with potential sponsors.[12]

10 As far as we know this title is no longer used by the modern O.T.O., who instead use the title *Frater Superior and Outer Head of the Order.*

11 The stories were not exaggerated. They hated each other with a passion.

12 Note that, as with all of these historical articles, some of the information given may now be out of date. For current information, see the O.T.O. International HQ website at http://O.T.O..org/

Barry Hairbrush and the Tentacles of Naughtiness
by *H.P. Saucecraft*[13]

Part One: A Mystery and a Member

The distant chimes of Big Ben striking ten were barely audible in the lounge of the Senior Satanists' club. The older members lay snoozing in their leather armchairs, their faces covered by copies of *Nuit-Isis* magazine,[14] while in the corner the committee leafed through a selection of New Age books in search of drivel bad enough to win this year's Blavatsky prize.

As for me, I stared out of the window at the headlights cutting through the London fog. It had been a boring summer, no excitement since Lord Rochester de Savile's pack of demons got loose and blew up a local poultry farm. But at that moment I heard a thunder of feet up the stairs, and the door flew open.

"Barry!" I turned to see my old friend Sir Guy Suit standing in the doorway, an elated look on his face, his trousers at their usual jaunty angle.

"A most interesting case has come up. Can we talk in private?" We slipped into the Bray rooms. A number of people were gathered round the table. Sir Guy introduced me to the only one I didn't know.

13 A classic Hairbrush pun. HP Sauce is a British institution, invented by Frederick Gibson Garton, a grocer from Nottingham in 1895. He later sold the recipe and HP brand to Edwin Samson Moore for the sum of £150. In April 2006 it was acquired by Heinz for £440 million, who moved its production to the Netherlands. The sad story of the decline of Britain's manufacturing infrastructure... Now the UK doesn't even produce its own legendary sauce any more.

14 *NUIT ISIS: A JournAL Of the NU EquiNOX* was a h igh-quality Thelemic magazine that came out around this period, featuring in-depth articles by notable occult authors such as R.A. Gilbert, Katon Shual, Ray Sherwin, Gerald Suster, Stephen Mace et al. For some bizarre reason, every issue featured the same cover image, just in a different colour, which we could never understand.

"This is the Right Honourable Norris Grott, the local MP for Crowley Bay."

"The seaside resort?" I asked.

"Precisely. Pray tell your story sir."

Grott began: "Ever since the summer season ended, something unnatural has been happening in Crowley Bay. On dark nights, a strange, eerie mist rolls in from the beach, terrible screams are heard out at sea... people disappear mysteriously, snatched away into the darkness, never to be seen again."

This strange tale intrigued me. "Any clues so far?" I asked.

"Only a strange sticky slime everywhere after the disappearances occur. And..." here he bent towards me, a terrified look on his face "...on the beach are the trails of some enormous, tentacled beast!"

"I say!" I exclaimed, looking up at Suit, "sounds just the sort of case for a couple of game British chaps after a bit of wholesome adventure, eh?"

"Exactly Barry, but this time I have arranged for some outside assistance. I believe you know our other guests." He gestured around the table. Sir Guy had certainly assembled an admirable team; Professor Raymond Bogey of the Gebludengeblutz Institute, Vienna, whose daring theories on the uses of the human brain had been published in a good many tabloid newspapers; from America came the famous lady detective Dio Durant, who curved sensuously round the end of the table, and, of course, Sylvestenegger, Suit's thrice-lobotomised gardener, glowering at us from beneath the folds of his green beret.

"So you'll help?" asked Grott.

"You can depend on us!" said Suit. "Now, in the meantime, I suggest we adjourn for dinner before setting off for Crowley Bay. This being Tuesday, the club will be serving its excellent Blanquette de Veau. Ring for Igor, would you Barry?"

Two hours later, having thrown a few necessities into my overnight bag and had my servant carry it down to the station for me, I was on the night train to Crowley Bay, with Suit and his companions.

"Any thoughts yet, Guy-baby?" asked Dio Durant, curving sensuously round her British Rail[15] Travellers Fare cheese and tomato roll. "Not yet" Suit smiled politely; however I noticed that he was reading a copy of Schitzky's *Very Naughty Cults Indeed* and had marked several pages.

Sylvestenegger had taken up a defensive position on the luggage rack and was busy assembling a blowpipe missile launcher. Suddenly his ears pricked up as the train began to slow down.

15 British Rail was another great British institution formed in 1948 when the Labour government nationalised the previously private rail services across the UK. It lasted until the mid-90s, when the Conservative Party privatised it and pretty much destroyed it as a viable transport system. Conservative financial policies suck. And in beautifully timed irony, as I write this the British Conservative government has just announced its intention to re-nationalise the whole thing, only this time it will be called Great British Railways.

"Looks like ve haf arrived." said Professor Bogey, nervously rubbing the radiation burns on his wrist. A strange fog began to whip round the windows, and a silent, dead cold wafted through the compartment, chilling us all to the very bone. The train lurched as its brakes came on, and a murky, lonely station platform could just be seen through the windows.

We stepped out onto the chill platform, and the train chugged off. We could hear nothing but the whisper of the cold sea wind, and the creak of the station sign as it swung slowly backwards and forwards. We huddled together as the silent, noisome fog enveloped us. There wasn't a soul about; no stationmaster, no ticket collector, no porters...

"Suit!" I cried. "Do you know what this means?" He turned to me, a look of bitter resolution on his face. "Yes Barry. I'm afraid we're all going to have to carry our own cases down to the hotel!"

Famous Occult Stereotypes

Meredith Muir – His Cult's Quite Obscure

by *Mibreshet Sha'ir*

I first got into the Caballah of Tibetan Yogic Shamanism about two years ago. I've not really found anyone else who practises it though I'm hoping to set up a group one day.

I wrote to the Pagan Council of Elders about it, and they said they'd never heard of Tibetan Yogic Shamanism.

I've got my sister-in-law quite interested in it, and Mr. Purvis the milkman borrowed my book on it, the one I found in a junk shop. It'll be brilliant if they join, 'cos that'll mean the membership will have tripled overnight! Just think, the Caballah of Tibetan Yogic Shamanism will be the fastest-growing religion in the world! With me as its High Priest, of course...

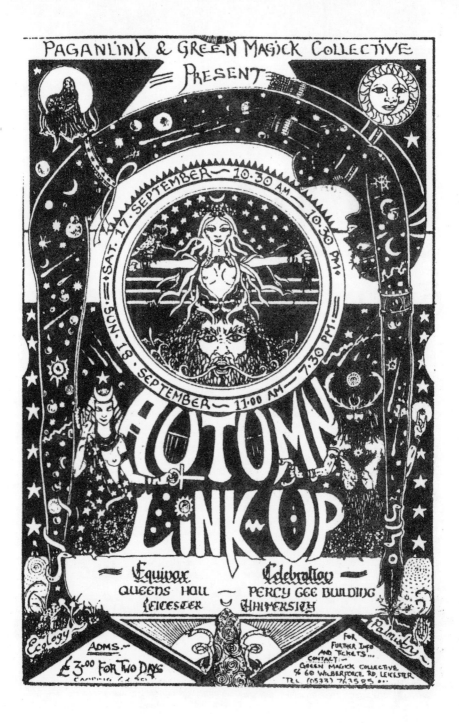

PAGAN NEWS

The monthly newspaper of Magick & the Occult

September '89

Price 40p

1ST BIRTHDAY ISSUE!

SORCERORS SCORCHED!!

In the early hours of Saturday, 13th August, Astonishing Books, the retail shop of **The Sorceror's Apprentice** occult suppliers, was broken into. The security glass on the front door was broken, and bolt cutters used to gain entry into the shop. Wooden bookshelves containing books by Aleister Crowley and on the subject of witchcraft, were broken down, the books piled in the centre of the shop floor, and ignited. The resulting conflagration caused serious damage to the retail premises, but fortunately, the fire was spotted by a local client who happened to be passing, and alerted the fire brigade. The mail-order division was saved, and the S. A. is able to continue in business.

West Yorkshire Police are investigating the attack, and Chris Bray feels that the most likely culprits are Christian Fundamentalists acting in misguided response to the recent Cook Report and the allegations made about the S. A.'s involvement in the Satanist sex-abuse scare. It is interesting that although the S. A. stocks a huge variety of books on all kinds of 'alternative' and religious creeds, only the ritual magick and witchcraft books were burnt. Perhaps this is meant as a warning of things to come? Although The Cook Report was universally slated in the media, it has obviously reached the right people - the Fundamentalists who wish to attack everything that threatens their closed world-view. They have for years used firebombing tactics against abortion clinics, gay bars and other 'centres of pestilence' in the U.S.A. - now the campaign could be beginning over here too. Don't be misled into thinking that the attack on the S. A. was an isolated incident carried out by a 'lunatic fringe'. Although the Fundamentalists are a minority, they are an extremely vocal and well-organised one, and the growth of groups such as The Jesus Army and The Reachout Trust shows that someone, somewhere behind the scenes, is organising a self-appointed church militant. So what can *we* do about it? Well, now is the time to realise that if we don't do anything, both collectively and individually, then things will only get worse. The rooms above Astonishing Books are unoccupied, but at one time they were flats. Do you want a couple of deaths before you'll wake up to what's happening here?

All Cooked Up?

Following last month's leader on the scabrous **Cook Report**, more light has been shed on the 'behind-the-scenes' activities of Cook & co. While the gutter press were drooling over the fact that the programme was shelved on the order of IBA head George Russell, what they omitted to mention was the reason why - this being that the so-called report was a complete fabrication from beginning to end. Not only was it known that Michael Aquino was innocent of the accusations levelled against him, but several other people featured in the programme

1

Sorcerer's Scorched

In the early hours of Saturday, 13th August, Astonishing Books, the retail shop of The Sorcerer's Apprentice occult suppliers, was broken into. The security glass on the front door was broken and bolt cutters used to gain entry into the shop. Wooden bookshelves containing books by Aleister Crowley and on the subject of witchcraft were broken down, the books piled in the centre of the shop floor, and ignited. The resulting conflagration caused serious damage to the retail premises, but fortunately the fire was spotted by a local client who happened to be passing who alerted the fire brigade. The mail-order division was saved, and the S.A. is able to continue in business.

West Yorkshire Police are investigating the attack, and Chris Bray feels that the most likely culprits are Christian fundamentalists acting in misguided response to the recent *Cook Report* and the allegations made about the S.A.'s involvement in the Satanist sex abuse scare. It is interesting that although the S.A. stocks a huge variety of books on all kinds of "alternative" and religious creeds, only the ritual magick and witchcraft books were burnt. Perhaps this is meant as a warning of things to come?

Although *The Cook Report* was universally slated in the media, it has obviously reached the right people – the fundamentalists who wish to attack everything that threatens their closed world-view. They have for years used firebombing tactics against abortion clinics, gay bars and other "centres of pestilence" in the USA. – now the campaign could be beginning over here too. Don't be misled into thinking that the attack on the S.A. was an isolated incident carried out by a "lunatic fringe". Although the fundamentalists are a minority, they are an extremely vocal and well-organised one, and the growth of groups such as The Jesus Army[1] and

1 The Jesus Army was founded in 1987 as the outreach arm of "charismatic" Christian church The Jesus Fellowship, led by Noel Stanton (1926 – 2009). At the time we published this article they were a common sight at various events around the country, wearing army surplus clothing dyed in bright colours and attempting to "lead sinners to the righteous path of the Lord and away from sinful sex". They preached that their members should live together, and that the leadership should be celibate. It will probably come as no surprise to those who have read this far, that we now know that within The Jesus Army sexual abuse of children and women was rampant. At the time of writing 43 men have been accused of historic sexual and physical abuse with ten already convicted of sex offences, with as many as 800 victims. It also turns out that Jesus Army leaders were fully aware of these offences happening over a period of many years and tried to cover them up. We would love to make some kind of sarcastic joke about them here, but after doing the research for this footnote we don't feel like laughing. The survivor accounts are horrific.

The Reachout Trust[2] shows that someone, somewhere behind the scenes, is organising a self-appointed church militant.

So what can we do about it? Well, now is the time to realise that if we don't do anything, both collectively and individually, then things will only get worse. The rooms above Astonishing Books are unoccupied, but at one time they were flats. Do you want a couple of deaths before you'll wake up to what's happening here?

All Cooked Up?

Following last month's leader on the scabrous *Cook Report*, more light has been shed on the "behind-the-scenes" activities of Cook & co. While the gutter press were drooling over the fact that the programme was shelved on the order of IBA[3] head George Russell, what they omitted to mention was the reason why – this being that the so-called report was a complete fabrication from beginning to end. Not only was it known that Michael Aquino was innocent of the accusations levelled against him, but several other people featured in the programme were innocent too. Roger Cook also managed to upset some of the child welfare agencies that he went to for information. Dianne Core for one, was annoyed about Cook's decision to fly the Aquinos over from the USA. Without him though, the programme would not have had any "genuine" Satanists, despite attempts to "scare" various occult suppliers and magazine editors into parting with information.

So why then, was the programme – universally condemned by the media as the most unprovable investigation that Cook has put together – shown in the first place? We can thank IBA supremo Russell for this. He backed down under pressure from Cook and his gutter-press cohorts, ignoring the real facts behind the report and the complaints he had received from Chris Bray and others concerning Cook's activities. Russell has yet to explain (to the broadcasting department of the Home Office among others) why he saw fit to allow the programme to be aired, and what purpose it served.

2 Founded in 1982 in Twickenham, England by Doug Harris as an organisation to help people leave the Jehovah's Witnesses "cult", it rapidly extended its reach to encompass other "cults" such as Mormonism, Freemasonry, and of course, the occult – under which term it includes astrology, yoga, Transcendental Meditation, Zoroastrianism, and even Buddhism. They hold an annual weekend conference in the UK attended by over a hundred delegates, and from there send people out to "educate" churches all over the UK.

3 Independent Broadcasting Authority (IBA), the regulatory body for commercial television in the UK up until 1990. It didn't do a very good job and has now been superseded by Ofcom. Who also don't do a very good job. So it goes.

German Church Commissions Witchcraft Memorial

Yes, you did read that right! A group of women based in Gelnhausen, near Frankfurt, have demanded, successfully, that the churches own up for their persecution of women during the 'Burning Times', and that they make public amends for this by commissioning works of art to commemorate the memory of those who were tortured. A statue by sculptress Eva-Gesine Wegner now stands in the garden of the 'Hexenturm', or Witches Tower in Gelnhausen, where many women and men were tortured before being burnt at the stake. Sculpture by Eva-Gesine will also be featured in the exhibition *The Goddess Reawakening* in Glastonbury this month.

SPOTLIGHT

Richard Carpenter:
Behind the Hooded Man

I'm sure all Pagans remember the fabulous ITV series Robin of Sherwood.[4] *Music by Clannad and one of the most accurate representations of Paganism to hit the small screen in recent years. The credit for writing it and a number of other ITV series goes to one Richard Carpenter.*[5]

Looking out from Mr. Carpenter's beautiful cottage garden we could see the summer sun glinting off the corn in the rolling Hertfordshire countryside. Maybe not Robin Hood country, but as Pagan as you can get...

PN: Most of our readers will know you as the writer of *Robin of Sherwood*, can you tell us what else you have written?

RC:*Catweazle*[6] was the first thing I wrote. After that I did *Black Beauty*[7] and then *The Ghosts of Motley Hall*.[8] *The Ghosts...* was written as a result of having an experience in Liverpool when I saw my first and last ghost in a theatrical digs. The first night I was there I woke in the middle of the night and there was

4 Well, Pagans *of a certain age* will remember it, since it only ran from 1984 to 1986. However those of a younger generation can (and absolutely should) discover it for themselves by doing a search on TV streaming services where it is now once more available.

5 Richard Michael "Kip" Carpenter (1929 – 2012).

6 *Catweazle* was a kids fantasy show on British TV from 1970-1971, which portrayed the adventures of an 11th century wizard accidentally transported to the present day.

7 An extremely popular kids show that ran from 1972-1974, whose 104 episodes have often been repeated since.

8 An imaginative premise for a kids show featuring a British stately home haunted by several eccentric ghosts of its past who can never leave. It ran from 1976-1978.

this figure beside the bed. I always felt that I wouldn't be frightened of spirits or anything but I was absolutely terrified! I got this curious tingling all over and I looked away, and when the pins-and-needles feeling stopped I knew it had gone. Fifteen years later I met a man and his wife who were psychic investigators and it turned out that the guest house was supposed to be one of the most famous hauntings in Liverpool. After *The Ghosts...* I then wrote *Dick Turpin*[9], but I didn't write anything connected with magick or the occult until *Robin...* I wanted to set that in a mythological, magical background because I felt that most myths have magick in them and this one didn't, so I thought I'd put it in.

PN: The occult elements in *Robin...* were very accurate, what resource material did you use?

RC: Well, it's a subject I've studied to a fair degree, I've read a lot on the occult, and other things I've made up and then found that what I've made up actually exists in some form. I remember one of the first books that I asked for as a child was *The Age of Fable & the Beauties of Mythology* by Thomas Bulfinch.[10] It was full of the most marvellous pictures, of classical statues, renaissance paintings. The book is still available and is something of a classic of its kind, collating Greek, Roman, Egyptian, and Norse myths.

PN: You have plans for a full-length film of *Robin of Sherwood*, how is that project progressing?

RC: The money is more or less in place, but we can't start issuing contracts until we've absolutely got it all there. At present it looks like we may start work about mid-September. The film will be made in Hungary because they have marvellous facilities and everything is much cheaper to shoot there.[11] I'm also working on a new satirical series for *Spitting Image*,[12] and a thing which I really shouldn't talk about with Ridley Scott who made *Alien* and *Blade Runner*. We have a project that we're working on together which will certainly have an occult background to it – very much.[13] I'm also working on a series called *Tristram Snail*, the main character of which invokes this creature through a computer which is called Tritone. And Tritone teaches the hero about music, we're trying to break down the barriers between styles of music, we're saying there's only two

9 1979-1982, based on the adventures of legendary 18th century English highwayman Dick Turpin.

10 Thomas Bulfinch (1796 – 1867). His mythological works are available in a collected edition as *Bulfinch's Mythology* (1881).

11 Alas, just after doing this interview Richard's production company found out that two other Robin Hood movies were already in production, and so the *Robin of Sherwood* movie never got made. We got that embarrassment with Kevin Costner instead. What a let-down.

12 Tremendously popular UK TV political parody show which used caricature puppets to great effect and which ran from 1984-1996. It has just been revived (poorly) for a new series at the time of writing.

13 This doesn't seem to have ever happened.

sorts of music: that's good music and bad music. I'm also working on some stuff with my wife Annie for New Zealand TV, one of the projects is a thing called *Monster Mountain*, which again is about space intelligences, ESP, time travel, and the possibility of immortality.

PN: I know many Pagans who were impressed by the depth of understanding which *Robin...* **revealed. How do you react to some of the interpretations which have been put on your work?**

RC: Well, the end of the first series, when Robin sacrificed himself, was shown around Easter. Now my model for that was not anything Pagan or Christian. It was a film called *For Whom The Bell Tolls*[14] which was my inspiration. Obviously if you are writing mythic, legendary stuff everything is so sharp and archetypal

> *"There's nothing wrong with any form of occultism, provided it doesn't harm anybody. We all need magick in our lives, even if it's just playing computer games, and pretending to be inside the game, but it's the balance that is important. Balance is everything."*

that it tends to have so many echoes of various cultures. I think there can be a bit of a danger in this... It's very interesting if you read Crowley, in his book *Magick* he takes "Humpty Dumpty" and interprets it mystically, and I think the humour and the wisdom in that is that he is saying be careful that you don't read too much into some of these things. I think that because the occult has been so misrepresented in the past, Hammer Horror and all that, because *Robin* treated the Paganism so sympathetically, there has been a rush to read into it every possible known bit of magical stuff that I wasn't conscious of writing.

It's interesting to go to America, where there's a lot of Pagans, many of whom attend conventions because Pagans tend to be fanatics or imaginative people. They would ask me questions: "You know when so-and-so says so-and-so? Were you referring to the Osiris legend..." And I'd say, "No, not at all actually, that was Little John ticking off Will Scarlet!" Obviously, for any writer, once you get latched on to a theme which runs through you, you may be writing stuff fairly unconsciously. It just comes through and falls into the right sort of patterns, but I think a lot of what people write into *Robin* was slightly wishful thinking.

PN: Did the occult content of *Robin* **evoke any hostile reactions?**

14 *For Whom the Bell Tolls* (1943) directed by Sam Wood, starring Gary Cooper and Ingrid Bergman, based on the novel of the same name by Ernest Hemingway.

RC: Well, I did a panel with Mary Whitehouse on Tyne-Tees television, and among the people there was a little man called Teddy Taylor, who was a sort of "Bring back hanging" character.[15] He came up to me and said *Robin of Sherwood* would be much nicer just told straight, without any "Satanism". And I said that there was no "Satanism" in *Robin*, with the exception of some of the villains who were shown calling on "The Dark Forces"; but they are destroyed by "The Powers of Good", in the form of Robin and his band, and good triumphs. I did have a letter from "Disgusted of Cheltenham", who accused me of anti-Semitism. Now I wrote an episode called *The Children of Israel*, with the *Sepher Yetzirah*[16] and the Tree of Life.[17] The central character was a Jewish mystic, and what this fool in Cheltenham didn't know was that we had a letter from the Chief Rabbi's office thanking us for the accurate way we had portrayed medieval Judaism, and saying that they were using a video of the programme to teach in Jewish schools!

The Mary Whitehouse thing was, in fact, her old cry of anti-violence. Yes, there was a certain amount of violence in *Robin*. We tried not to make it too violent, but obviously people died hideously and horribly in those days, and a lot of them. What we did was to show people wounded and in pain, so what we were saying was that violence hurts, we didn't want to brush the whole issue away with "bang, bang, you're dead", but tried to show the consequences of violence.

We had very few complaints on a religious basis. The whole point of *Robin* was that it wasn't in any way anti-Christian, but it was pro-humanity.

PN: Why do you think there has been such a resurgence of interest in magick and the occult?

RC: I think that people want something more than the very materialistic world that has developed since the industrial revolution. They want to go back to a bit of magick, which is why science fiction took off in the early part of the 20th century, because it has a magical element. People need an element of "what lies beyond" in their lives. I think this is also part of the reason for the growth in the Pagan movement, allied to the fact that everybody feels the need to get back to the roots of things, and to get out of the car and walk along the country lane. I think that it's the human imagination crying out to be fed.

PN: What are your personal feelings about occultism?

RC: Well I come from Norfolk and the sheep shearers' motto from that part of the country is "live and let live". I believe very strongly in "Do what thou Wilt and

15 We assume this to be a reference to Sir Edward MacMillan Taylor (1937 – 2017) Conservative MP, hardline right-winger, and all-round bumbling oaf. He did indeed introduce a parliamentary bill to bring back hanging in 1974, which was roundly defeated.

16 *Sefer Yetzirah* (Book of Formation), the earliest extant book on Jewish mysticism and Qabalah.

17 The central diagram of the Qabalah, formed of Spheres and the Paths between them.

no harm", and it's not all that easy to live by that because it implies responsibility. As much responsibility as the Christian message of "Love thy neighbour as thyself".

I see no wrong in any form of the occult provided it isn't active in stirring up forces that you might not be able to control. I think also it can, and certainly Crowley's life suggests, it can attract a lot of neurotics. I think if the occult goes bad on you it's like anything else. You can be a connoisseur of fine wine, or you can be an alcoholic. The occult is very powerful, and if that power is misused it will ultimately destroy the person who misuses it. I do believe very strongly in Karmic Law, that if you put out bad vibes they will bounce back on you. You see, being an ex-actor, I understand about ritual, because the theatre started as ritual. The whole idea about being another person is obviously a magickal act, such as mask improvisation, for example, when the mask is invested with a certain magical power. There's nothing wrong with any form of occultism, provided it doesn't harm anybody. We all need magick in our lives, even if it's just playing computer games, and pretending to be inside the game, but it's the balance that is important. Balance is everything.

I would recommend any occultist to read the chapter in *The Wind in the Willows* by Kenneth Grahame[18] entitled "The Piper at the Gates of Dawn." [19] OK it's a bit Victorian,[20] but in it he captures the wonder of a group of little animals seeing Pan in the English woodlands. That, to me, is magick.

PN: Well, we look forward to seeing more of your work very soon. Until then, Richard Carpenter, thank you very much.

18 British writer Kenneth Grahame (1859 – 1932) first published children's classic *The Wind in the Willows* in 1908, later to be released as a very fine Disney animation of the same name.

19 This name was also used as the title of the first album by Pink Floyd, released in 1967, and which your editor is listening to while writing this footnote.

20 It's actually Edwardian, since Queen Victoria died in 1901, seven years before the book was published. Yes, this may well be the most pedantic footnote ever.

VIEW POINT

God's Warriors

by *Phil Hine*

These, in case you didn't know, are the last days – the final years of battle between good and evil before the end of the world. The Day of Judgement, the Rapture, the Second Coming – it's just a few short years away. At least, that's according to the Christian fundamentalists who are currently stirring the anti-occult campaign that has steadily grown for the last two years. They are fighting the forces of Satan, however he appears, whether it's in abortion clinics, gay bars, yoga schools, alternative medicine, and of course, Pagan and occult suppliers and groups. "We" are all doing the Devil's work, and so will all go to Hell unless we repent.

In the meantime, of course, we have to be prevented from "corrupting" others. Some of God's Warriors are content just to pray for us, while others are prepared to "fight the good fight" in more physical ways. How do I know this? 'Cause I spoke to some fundamentalists a few weeks ago, and I've read enough of their literature recently to get the general idea. They're not open to intellectual debate – they believe all this stuff utterly and totally. Anything we say is lies "...the Devil quotes scripture for his own ends...", and you can't argue with someone who's emotionally committed the way they are.

Nor does it matter that they are a relative minority, since they are a minority who have the ears of the press, and are skillful in manipulating events and providing misinformation for the maximum effect. The press campaign we've seen developing didn't just appear because Dickens, Logan and Core thought

it up. No, we have to thank Sandi Gallant[21] of the Intelligence Division of San Francisco Police Department for providing the original hype about "Ritual Child Sexual Abuse". Gallant used her position to conduct numerous lectures at professional conferences concerning the imagined threat of "Satanic Cult Sexual Exploitation of Children", and it is from many of her statements that the legends about Satanic Child Abuse have grown. Gallant's statements, although vague and unprovable, were of course NEWS, especially since the source was a member of the San Francisco Police Department. As with any hyperbole, what begins as vague rumours becomes allegations, and then becomes accepted fact.

Gallant used her police experience to compile "Activist Packs" so that "investigators" could identify "Satanic" activities. These packs are now available in the UK from Maureen Davies of The Reachout Trust, who is distributing them amongst sympathisers. The Packs include a 20-page checklist designed to indicate the likelihood of occult/Satanic activity such as:

- Punk rock music
- Heavy Metal music
- jewelry OR THE ABSENCE OF JEWELRY
- graph paper for fantasy games
- dice
- metal figurines of a mythological nature
- posters of mythological beings
- posters of Heavy Metal or Punk rock stars

Get the general idea? The Pack goes on to list "Symptoms Specific to Ritual or Satanic Abuse" which include:

- discussion of urine or faeces at the dinner table
- asking if they (the child) will die
- numbers or letters written backwards
- fear of ants or insects

The Pack is just a modern version of the Medieval witch-hunter's kit. It is presented so that it looks authentic and somehow "official". Gallant was introduced to the British press as "Satan's Cop" in January '88, just as Dickens, Logan and Dianne Core were beginning to crank up their campaign.

21 After a brief flurry of fame in the late 80s and early 90s as a police "Satanic Ritual Abuse Expert" Sandi Gallant Daly now seems to have vanished. And who can blame her? Your editors can find no trace of her today.

And of course, the rest we know – or do we? Anyone who has been compiling media reports on the campaign should, surely, be able to see the pattern emerging – that "God's Warriors" are working hand in hand with sympathetic media people. The *Hull Daily Mail*, for example, has run 34 sympathetic articles about Dianne Core, and is currently giving her a regular slot as an agony aunt, specialising in – you've guessed it – Satanic child abuse. So what's to be done? Well, the inanities of the recent *Cook Report* have given occultists and Pagans an unprecedented opportunity for us to put our views across in a positive manner. This calls for action – at the very least writing letters to any group or organisation

> *"Now is the time to be standing up for your own beliefs, rather than hiding in the closet, waiting till it all dies down, or blaming someone else. The Sorcerer's Apprentice in Leeds has been firebombed."*

– from the Home Office to the NCCL, about what has been going on, and asking for help and advice. Now is the time to be standing up for your own beliefs, rather than hiding in the closet, waiting till it all dies down, or blaming someone else. The Sorcerer's Apprentice in Leeds has been firebombed. One of the British members of the Temple of Set, "exposed" in the tabloids, received a letter-bomb through the post. Several schools up and down the country have withdrawn Hallowe'en celebrations, because they have been convinced of its harmful effect on younger children. Have you noticed that there are fewer psychic fairs about? Trust House Forte,[22] who own the largest chain of hotels and exhibition halls in the UK have made a corporate decision to ban any exhibition which has "occult" overtones, because of fundamentalist pressure. Do you want this to go on? If not, then communicate, organise, and act. Let's see some of that grassroots support that people are always going on about – or are you waiting to hear that *Pagan News* is late 'cause one of the editorial team has had their hand blown off by a parcel bomb? Or would that be our own fault for sticking our necks out?

22 Back then, Forte were another great British institution, having bought London landmark Cafe Royal in 1954, opening the world's first motorway service station in 1960 (in Newport Pagnell of all places), and running several well-known fast food and hotel chains such as Little Chef, Happy Eater, Travelodge etc. So this ban was something of a big deal at the time. The company was taken over in 1996 and is now effectively defunct. While we are still here. So screw them.

THINGS TO DO... and THINGS TO READ

Elemental Consecration
by *Julian S. Vayne*

Consecration is the act of deliberately charging an object with power. It also serves to banish the object of unwanted influences so that it may be a fit receptacle for magickal energies (much as one would physically clean a metal chalice before filling it with wine and drinking from it). The following is a general rite of consecration which serves both to purify and empower the designated object.

1. To begin the purification part of the rite, take the object (let us assume that it is a ring) and leave it outside in sunlight. The ring should be left to lie on the earth, and in the light for a day.
2. Take the ring to the room in which you intend to work. A single lighted candle, a receptacle containing water and a little salt, and an incense burner should be set out on your altar. An ideal consecration incense may be composed of: frankincense, myrrh, storax and white sandalwood.
3. Place the ring on the altar and draw over it the banishing pentagram of earth. Visualise the pentagram shining with a brilliant white light. Say: **By my will, I command this ring to be purified and banished of all restrictions. So Mote It Be.**
4. Sprinkle the ring with water and say: **By the element of water let this ring be consecrated unto my will.**
5. Pass the ring through the incense smoke and say: **By the element of air let this ring be consecrated unto my will.**
6. Pass the ring over the candle flame and say: **By the element of fire let this ring be consecrated unto my will.**
7. Place the ring back on the altar and draw the invoking hexagram of earth over it. Visualise the hexagram as being composed of radiant black flames.
8. Say: **By my will, I command this ring to be consecrated by the balance that is in spirit, that it may serve as a fit channel for the powers of magick. So Mote It Be.**
9. Remove the now consecrated ring to a safe location (such as under your pillow).

Letter from America

Sateria and Voudou
by *Stephen Mace*

Santeria is a recent phenomenon in the United States, arriving in the 1940s with the first Puerto-Rican immigrants and then blossoming with successive waves of refugees out of Castro's Cuba. Thus it hasn't really had time to penetrate mainstream American culture, especially considering its penchant for secrecy and also the language barrier. But Santeria is only one of the African traditions in the New World; far more notorious is Voudou, which arrived in America during the Haitian Revolution of 1791-1803. Thousands of French and mulatto refugees came to New Orleans and Galveston, bringing with them what slaves they could hold and also Voudou to seed among the American blacks.

Voudou and Santeria are very similar, like two houses with identical floorplans but different interior decoration. Both are complete religious systems that offer a ritual program for the salvation of the soul; beginning in childhood and continuing after death, each stage is marked with magickal operations that manipulate the components of the believer's spirit so it may attain an optimum state both during and after the believer's life. This magick requires contact with the gods or spirits – the orishas of Santeria or the loa of Voudou – and this contact can also be used for more mundane workings, from gaining wealth, love, protection, or revenge, to precognition, healing, and great strength in a crisis.

The usual method of a god's manifestation is through a full possession. The "horse" (the person possessed) suffers a complete amnesia of the event, and during it has the power of the god in question and is invulnerable – tales of plunging hands into fire and boiling water without harm are common. In her book *The Santeria Experience*, Migene Gonzalez-Wippler suggests that the orishas are personified archetypes out of the collective unconscious. "When an orisha descends to take possession of a santero... that particular archetype's overpowering energies are temporarily unleashed within the conscious personality. That person then displays strange powers... the natural attributes of an archetype formed of pure psychic energy directed into a specific channel." Which to me sounds a lot like Kenneth Grant's account of Austin Space's atavistic resurgence.

In his book *The Invisibles: Voodoo Gods in Haiti*, Francis Huxley gives an idea of the method the drummers use to induce possession. The drummers lead the dancers into a trance-like state, then break them out by shifting the beat so they have to pick it up on the wrong foot. Then they lead them into trance again, then break trance again, continuing until they see one of the dancers "emptied of the feeling of himself and his efforts ... aware only of the drums sounding him out." The drummers then "shift their rhythms so that he loses himself in a place that is nowhere: out of his bewilderment the loa is hatched, taking charge of the empty body and riding it down the open road of the ceremony."

And yet there are significant differences between Santeria and Voudou. Voudou is more fearful; there is a long tradition of evil magicians stealing the souls of

> *"Voudou and Santeria are very similar, like two houses with identical floorplans but different interior decoration. Both are complete religious systems that offer a ritual program for the salvation of the soul; beginning in childhood and continuing after death"*

the living and the recently dead to serve as their slaves. In Santeria the concern is more over unhappy ghosts. Also, deceased relatives are fed with candles and perfumes so they will gain coherence and self-awareness on the spiritual plane, and so be able to use the power there to help the living. Another big difference is that as a Santeria rite can be done in a city apartment, Santeria can prosper in cities like Harlem or New Haven, while Voudou is better suited to rural areas, as the layout of the oum'phor, or temple, is crucial – a physical representation of the spiritual organization of the planes.

In each temple the public rites are conducted under a circular-roofed peristyle with a dirt floor, on which is drawn the veve, or characteristic sigil, of the loa invoked, its crossed arms meeting at the centerpost. The centerpost itself is sacred to Legba, god of the crossroads and opener of the way between the worlds, the one who makes contact with the loa possible at all. The post is painted with two colored spirals for the two serpents Danbhala and Aida Wedo. Danbhala is phallic and a lot like Kundalini, for he represents the force which energises all things. Aida Wedo is Erzulie, the goddess of love, the rainbow. Voudouists say that this pole with the two snakes is identical to the Caduceus of Mercury, who, as messenger, may be attributed to Legba; they explain the identity by saying that Voudou and classical myth have a common source in Africa, and the centerpost may also, with profit, be equated with the Middle Pillar of the Tree of Life.

Barry Hairbrush and the Tentacles of Naughtiness
by *H.P. Saucecraft*

Part Two: Drunken Sailor, Devil's Spawn

I watched the grey waves crash onto the deserted seafront of Crowley Bay. Even here in the snug bar of The Rude Policeman (the only hotel still open) an air of gloom had descended. Sir Guy Suit and his MP friend Grott gazed thoughtfully into their beer. Dio Durant curved sensuously around the bar, while Professor Bogey experimented on an unlucky dog that had come in to warm itself. From the lounge bar came the sound of sporadic gunfire as Sylvestenegger gave the Space Invaders a real run for their money.

"The first thing to do," said Suit, falling off his chair (this was not his first drink of the day) "is hire a boat to take us round the bay."

"But where from?" Bogey asked, wiping bits of dog from his white coat. Dio Durant curved sensuously round her fourteenth Manhattan and said,

"We could ask around." She beckoned the barman with a sultry finger and whispered to him for a moment. He replied,

"If you're looking for a good sea captain, there's none better than old Gardner Saunders over there." He pointed to a dishevelled figure asleep at the other end of the bar. Suit, with years of experience in introducing himself to sailors, was volunteered to approach him. He strode over and dealt the fellow a smart blow with his cane.

"Hey! Oh... hey... you, Jimmy... oh, you, hey, Jimmy... eh, pal... eh..." I looked on with some suspicion. The last time I had encountered this combination of accent, breath and stubble it had been asking for the price of a cup of tea. I felt uneasy about not having brought my revolver downstairs.

"I'm told you have a boat," said Suit, with an insouciant pick of his nose. "What's it tae you pal?" squinted the man, lurching to his feet. Suit dropped two hundred-pound notes into his hand.

"We wish to hire it. I'm afraid this is all the cash I have with me, but you're welcome to join us for a drink." Saunders took the money, brushed his jacket down, and was suddenly sick all over the bar. Then he fell over.

"Do you think he iss ze right fellow?" Bogey asked.

"Oh there won't be too much of a problem," Suit replied. "We'll get Sylvestenegger to drag him up and down the seafront on a rope. That ought to sober him up."

We all trooped out to the seafront to watch the fun, but I noticed that Suit was staring at a small metal plaque on the pub wall. It was covered in strange inscriptions and marks.

"I won't be a moment Barry." he said, taking from his jacket one of his priceless antiques, a genuine Albanian kitten-upsetting mallet. "I'm just going to nab this off the wall."

...

Gardner Saunder's trawler chugged around the moonlit bay, as I stood with him and Grott in the wheelhouse. Grott just stared nervously out to sea, but Saunders was well into his third whisky bottle, and ranting away. Ahead of us, a yellow glow lit up the sky.

"Yon's the Crowley Rock Lighthouse. Back in 1893, the crew were cut off for three months and had tae eat their own legs tae survive."

"Were they rescued?" I asked.

"Aye, but it took them a long time tae walk doon all those steps. Then in 1923, the whole crew disappeared. The rescuers found the fire burning, food on the table, the tea still hot, but nobody there. And worst of all, the floor was covered in hundreds of small bakelite model weasels!" His tale finished, he wiped the bits off the mouth of the bottle and offered me a swig. I made my excuses and left.

"Ah, Barry!" Suit cried, as I came into the cabin, "Look what we've found here." He and his friends were gathered round the plaque I'd seen at The Rude Policeman. Bogey lifted it up and announced:

"I haff translated some of ze inscription." In a loud voice he intoned: "THAT IS NOT DEAD THAT IN OLD PAPERBACKS CAN LIE AND WITH STRANGE CLICHES EVEN DEATH MAY DIE!"

Suit showed me a page of *Very Naughty Cults Indeed* – there was the very same inscription.

"This was one of the Great Old Cliches used by the Esoteric Order of Dralon,[23] an evil sect of flares-wearers who were around in the 17th century. I think they died out, or else rejoined the mainstream Baptist movement." I was wondering whether this could be the cause of the strange disappearances, when Dio, who'd been curving sensuously round a fish weight, asked, "Hey... has anybody noticed that the engine's stopped running since Bogey read that inscription?" She was right! A deathly silence reigned; but only

23 The brand name of an acrylic fiber developed by German chemical company Bayer AG in 1954, and still unfortunately in production to this day. It produces an enormous amount of microplastics with horrendous environmental impacts.

for a moment. Then, the night exploded into an inhuman, hate-filled roaring, the like of which I had not heard since my father sat on a Chaosphere by accident. I ran onto the deck with Sylvestenegger, who opened up with his M16, armour-piercing rounds blazing out into the night. And there, by the light of his throbbing weapon, I saw a huge, greyish tentacle slither horribly across the deck into the wheelhouse. More screams followed, this time human. Suit joined us, and we dashed to the wheelhouse to help Saunders and Grott. But it was too late. Our seaman splattered the walls, while Sir Guy's Member lay limply in my hands...

Famous Occult Stereotypes

by *Barry Hairbrush*

Sheena Fry – She Wouldn't Hurt a Fly

...Of course, my cat's vegan. Well it was, it's dead now. This stupid vet said its stomach had evolved for meat not lentils but that's rubbish - everyone knows the cat is an embodiment of the goddess.

I think it's terrible how occult magazines go on and on about people working magic, never mentioning the work done by animals - so I've set up this Pagan Animal Magazine, just for animals to contribute to. Well no, I've not had any contributions yet. I bet someone's intercepting my mail!

Yes, it's high time we did something about the terrible plight of animals in today's society. My group liberated 300 mink from a fur factory last month. Funny how all the otters and swans in the area disappeared afterwards... must be the pollution. Animals have as much right to the world as we have, and... CHRIST! That bastard dog from next door's crapping on my garden again. Hang on a minute, I'm going out to kick its arse.

PAGAN NEWS...

...refreshes the parts other magazines do not reach!

PAGAN NEWS

The monthly newspaper of
Magick & the Occult

October '89

Price 40p

The Fall and Rise of Autumn Link-Up!

Autumn Link-Up was eagerly looked forward to as the pagan gathering of the year. Imagine then, the surprise and disappointment of those who arrived at Leicester Polytechnic on Saturday, 9th September, only to be told that the event had been cancelled! What happened was that the Leicester Mercury, (a particularly pro-Christian Newspaper) published a defamatory article concerning Autumn Link-Up on Thursday, 7th September. The resulting furore in the press alarmed local Christians, and the Polytechnic Board of Governors, after seeking legal advice, withdrew permission for the event to be held at the Polytechnic. The deputy director of the Polytechnic issued a statement saying that the college believed that the event was "a small exhibition on folk history" and not a pagan gathering.

Left without an indoor venue, we moved to the festival campsite at Groby, just outside the city centre. Autumn Link-Up went ahead, and overall, it was a highly successful event, despite the adverse beginnings. The site staff and locals around Groby were extremely supportive and sympathetic. The police were cooperative and actually turned up to say that they would protect *us* from any incursions of the local 'Jesus Army', who, it was rumoured, would be attempting to trash the festival. The traders who had arrived set their stalls up from the backs of vans or on blankets (fortunately the weather held up for most of the festival), and a couple of large tents were found where lectures could be held. As I recall, there was no unpleasantness, or incidents that could justify the hysteria that the Mercury and the Fundamentalist rabble-rousers had raised. Early on Sunday morning, a man was

found suffering from **asthma** and hypothermia - he was a local who had wandered onto the site. An ambulance arrived to take him to hospital, and by mid-morning, the facts of the incident had been broadcast round the site, and a short healing ritual was enacted. Representatives from the festival later visited the man in hospital.

The fabled **Pagan Federation** and **Council Of Elders** conferences did not take place. There was however, an energetic **PaganLink** Moot on Sunday morning, proving that despite what you might have heard from other sources, **PaganLink** is very much alive and active. Members of the **Pagan Federation**, and notable Wiccans Janet & Stewart Farrar were on site, as well as a less-expected face, the Rev. Kevin Logan *(See this issue's Spotlight feature - Ed)!* The atmosphere of the gathering was one of hope and humour, and more events of this nature will very much help the building of a truly energetic pagan community. The owner of the Groby campsite was reported as saying that as far as he was concerned, the event was a private party on his lands, and that we were welcome anytime to hold another event. Plans are now being discussed to hold an outdoor festival in May, depending on response and enthusiasm.

Leonora James of **The Pagan Federation** was interviewed on Radio Leicester about her views on the media hysteria. A local representative of the Christian community made it very clear that it was things like "the

CRO Cranks Up Anti-Occult Campaign!

Christian Response to the Occult (CRO)[1] are a fundamentalist group sponsored by an Evangelical charity, the Deo Gloria Trust (reg charity no. 243305).[2] They state their objectives are to alert and inform both the public and Christians of the dangers of occult involvement, the reality of the Devil, and of the greater power of Jesus to give deliverance, peace and fulfilment. They wish to accomplish this through a planned campaign of attack against all manifestations of what they see as "occult", via the press and by researching (and infiltrating) various groups and organisations. Part of their programme is to create a network of "experienced and dedicated Christian men and women" who will be trained so they can provide the necessary response. Part of their campaign will be a "media blitz" of local newspapers, radio and TV They are creating a body of "experts" who will be able to spread the ideas that they want to propagate.

The spurious "symptoms" of satanic abuse quoted in last month's Viewpoint? Well, some of them recently turned up in Croydon's free paper, *The Advertiser*, as "Symptoms children show as a result of ritual abuse". Make no mistake, this is not just a passing phase, as the CRO material talks of engaging in "Spiritual Warfare". The Croydon paper also printed a Help-Line Number open to anyone who needs to talk about their involvement in the occult: 0745-343360. CRO can be contacted by writing to; 7 London Rd, Bromley, Kent BR2 1BY. They want to hear from people who are prepared to counsel people with occult-related problems, write for magazines/newspapers, and act as media consultants. Any takers?[3]

Sorcerer's Apprentice Occult Society Forms

Since the recent firebombing of Astonishing Books in Leeds (see last month's leader – Ed), numerous rumours concerning the ultimate fate of the Sorcerer's Apprentice have circulated. Chris Bray's latest move is that in future all clients

1 This was an initiative set up in 1982 and which operated until 1996 when its work was folded into the work of The Reachout Trust (see previous issues of *Pagan News*).

2 Still very much alive and kicking, this is a mysterious charity operating out of a suburban semi-detached house on the south coast of England, and offering financial grants to other organisations "promoting the Gospel of the Lord Jesus Christ".

3 Their current contact details can be found at https://www.deo-gloria.co.uk/contact.php. Yes, unbelievably, they are still going.

will be asked to sign a declaration of intent, and must be willing to register their name and address. The Sorcerer's Apprentice Occult Society is a formalisation of the recognition of established customers, since Astonishing Books will no longer be open to the general public. S.A.O.S. members will receive special discounts and be able to purchase items and equipment which could not be openly advertised in the current climate. Since the attack, letters of sympathy and support have flooded in towards Astonishing Books, and even the Rev. Kevin Logan has written in to say that he was "sorry" to hear of the incident!

Furore at the Festival of Faith?

Regular readers will know about the Pagan Federation presence which had been planned for the Canterbury Festival of Faith & the Environment. Apparently fundamentalist Christians are reportedly "incensed" at the decision to allow acts of celebration by non-Christian faiths, including Pagans, Muslims, Jews, Sikhs and Hindus. A spokesman for Dr. Runcie[4] has been quoted as saying: "...the created order is a gift to us all, whether Christians or not, and that all must cooperate in its stewardship." The conservative Church Society[5] plans to protest during the festival, and is calling for Dr. Runcie to forbid any "Pagan" elements appearing in the festival.

4 Robert Alexander Kennedy Runcie (1921 – 2000) was the Archbishop of Canterbury from 1980 to 1991.

5 Formed in 1950, the Church Society has as its aim: "To maintain the doctrine and worship of the Church of England as set forth in the 39 Articles of Religion, and the Book of Common Prayer, as reviewed and adopted in 1662, and to uphold the supreme and exclusive sufficiency and authority of Holy Scripture as containing all things necessary for salvation." This also includes opposing homosexuality and the ordination of women. Because back in 1662 there were no gays or women apparently. Or some other completely spurious and ridiculous reasoning.

SPOTLIGHT

Kevin Logan
Behold the Man!

Whilst wandering around the Groby campsite at Autumn Link-Up, members of the Pagan News *team were delighted to find that one of the most-featured media personalities of the current witch-hunt was here among us – the Reverend Kevin Logan! Renowned for his guest appearances on* The Cook Report *and numerous other TV programmes, as well as his many newspaper & magazine interviews on the subject of the "dangers" of witchcraft & Paganism, he agreed to an exclusive interview with* Pagan News, *in what must be an unparalleled opportunity to put his viewpoint across to the Pagan community.*

PN: **Why do you think people are here today, at this gathering?**

KL: I believe that people here believe that they are in touch with a power which they can manipulate and use for their own needs, they find it a great comfort. But I do believe that the power they are in touch with is not a benign power, that sometimes they lose control of, and they have so many different names for it, and so many different identities for it, that they don't know what they are dabbling with.

PN: **Do you think this is a Satanic power?**

KL: In my own world-view, I have a God, who is the supreme power, and there is Lucifer, who is out to destroy mankind.[6] You have to be awfully careful, that when dealing with a spiritual power source, you have to be 100% satisfied that it is God, or whether it is a counterfeit.

6 This is a remarkably common belief among many Christians, even though it has no actual basis in the Bible. The name Lucifer is Latin and refers to the morning star. Guess who claims to be the morning star in the Bible... Revelation 22:16, KJV: *I Jesus have sent mine angel to testify unto you these things in the churches. I am the root and the offspring of David, and the bright and morning star.*

PN: Would you accept, though, that a lot of other religious groups have different names for God – such as Allah, Jehovah, Yahweh, and other major religions who perceive God as an idea in slightly different ways? Would you accept the Islamic view of God, generally speaking, as a Christian?

KL: No I wouldn't. One of the difficulties is the question of what do you make of Jesus – he said that I am the Way, the Truth and the Light, and he then went on to say that there is no other way to the Father except by me. Jesus Christ was either a fanatical idiot, he was mad or bad, or he was who he said he was – he was God.[7]

> *"The Pagan movement I believe, has taught Christians to remember that once again, that we are stewards of the earth, that God made us stewards of the earth, and I will say for one thing, that Pagans should be thanked for their ecology, and for reminding the world that if we don't do something very soon, then it's actually going to be too late."*

PN: Can there be no middle ground between those two poles?

KL: If you take the words of Jesus, it's a very black & white issue. Within the occult, people will recognise Jesus and take his teachings, and will mark him out as a master, but will not accept him as the son of God or God become flesh. Now that's the distinction.

PN: Some Pagans might argue that we are all the sons & daughters of God, and that though Christ was the son of God, he is not an exclusive avatar. Also, that you can work with the teachings of Christ, and of Christianity as a whole, without being a Christian?

KL: The problem that we're getting confused with here, is the folklore type of approach to Christianity, which says that Christianity is a way you act, that it has behaviours, and morals – don't do this and don't do that. Christianity, in fact, is a relationship with Jesus Christ, and the power of Christ. Now that is what the scriptures say is a Christian – someone who has Jesus Christ as Lord and Saviour, which is a whole lot different from the traditional view of Christianity.

PN: You must have heard about the recent firebombing of The Sorcerer's Apprentice. Have you got any comments on that?

7 We suspect that these choices were given as some kind of elimination strategy based on the notion that since the first two choices are absurd, the only one left to logically choose is the third one. That's not the conclusion we come to, Kevin.

KL: I wrote to Chris Bray, and I said that I was sorry to hear about that firebombing. I tried to point out to him that for a Christian to actually do that, goes totally against everything that Jesus Christ stands for. You cannot love your enemies, as Jesus said, and then firebomb them.

PN: Could it not have been, in some roundabout way, God's will?

KL: I really don't know God's Will in that subject. I would say that a true follower of Christ, who let Jesus Christ into his heart, would not firebomb the Sorcerer's Apprentice.

PN: The problem here is extremism, of any sort. Surely as a Christian you cannot condone extremism that forces other people to be harassed?

KL: No. When I wrote the book (*Paganism and The Occult* – Ed.) it was simply to say that Paganism, witchcraft, ecology, nature-loving religion & peoples are on a tremendous increase, and that Christians need to be aware of this. But I was saying, within that book, that you need to love them.

PN: You must understand that since the recent press interest, that a lot of Pagans and occultists do feel very antagonistic to Christians, but we recognise that we need to listen to each other, not to further extremist attacks.

KL: I think at the end of the day as we listen, there are certain things which we will understand about each other, and if we come to the point where we say that we do fundamentally disagree, which is where I think we will end up, that is acceptable, as long as we don't bring back the ducking stool.

PN: Do you think that there is anything that Christianity as a whole in this country could learn from the Pagan movement?

KL: The Pagan movement I believe, has taught Christians to remember that once again, that we are stewards of the earth, that God made us stewards of the earth, and I will say for one thing, that Pagans should be thanked for their ecology, and for reminding the world that if we don't do something very soon, then it's actually going to be too late.

PN: The Christian world-view is based predominantly on the teachings of the Bible, and certainly a lot of Pagans will agree that the Bible is a very important document, but surely it's been shown, on many occasions, that there are many mistranslations in the Bible. The famous one for us, of course, is "Thou shalt not suffer a witch to live". Now this has been shown to be a mistranslation, and yet resulted in millions of deaths. Now this is the whole problem. How can your argument fall back on using a book which has been shown to be full of mistranslations? Although it may be the revealed word of God in essence, I think you'd agree that it has on many occasions been politically manipulated.

KL: Politically, very much manipulated, and the Bible has been ill-used and misused by politicians, by statesmen, and by people who've got into Christianity. You can look back on the Inquisition, and the way it was used in a political,

hammer-type of way. Now as far as the Bible is concerned, that particular passage is not really a misinterpretation. There was the stipulation that witches should not be allowed to live within the community of the people of God, of the Israelites at that time. I think that that still stands for the Israelites. That God was saying that if you allow a witchcraft-type of mentality, or a Pagan mentality, which is a short-sighted spiritualness, as far as I'm concerned, which sees the nature, and yes, acknowledges a certain life-force, but stops short of seeing almighty God as he really is.

PN: But "They" shall not be allowed to live?.

KL: I think God saw that there could be corruption from the pure word, or the book of the law as Moses was giving it. It stood throughout the time; it was a law for that nation. Today, we are governed by the Sermon on the Mount which says that you love your enemy, that you go out and speak to him about the love of Jesus Christ and what it's done in your own life, and I think that's where Christians stand today, not going back to that old law, which was for a special nation.

PN: What do you think of the links which have been provisionally made between child abuse and Paganism?

KL: Whenever I've spoken to journalists about this, I say that as far as I can tell, paedophiles have been using Satanism as a cover, and that there are people using the darker aspects of witchcraft as a cover for abuse.

PN: Presumably people also come into Christianity too, and use it as a "cover"?

KL: Well, yes; the Christian Church, or maybe "churchianity" as opposed to Christianity, you get vicars having it off with choirboys and that sort of thing. Where I come to criticism with the occult, is that sex is so much built into it, and the abuse of sex.

PN: In what way abuse?

KL: Abuse in the sense that you use sex for the generation of power, for initiations, and various rituals. Now if you are using sex in that way; that I feel is an abuse. It is such a beautiful act, between a man and a woman, and there we might come to a disagreement (mmm, what can he mean? – Ed), but it is something which God has given, which he delights in, when it's used within the context of expressing love for each other.

PN: I think that's a view of sex which Pagans would share. Sex is the supreme sacrament for us.

KL: Many of the people I have spoken to in this respect assure me that they use sex in a loving way. The problem is that when it is such an integral part of the Craft; because of man's innate rottenness, or human nature being what it is, it is open to such abuse.

PN: Would you not accept that in the Christian Church, a lot of the symbolism that's used is very sexual in content as shown by many psychologists, analysing

it from both a Freudian or Jungian point of view. Surely the only difference is that Pagans do it with their bodies, rather than pieces of metal?

KL: Psychologists certainly have worked hard on this, but I would think in real Christianity, in a loving relationship with Jesus Christ, there is a tremendous, intimate, deep relationship. Sexual? I don't know, I wouldn't go as far as to say that, though I understand what psychologists are getting at.

PN: The media coverage seems to suggest that there is nothing right with the occult or Paganism as a whole. That we're exclusively a band of evil, satanic paedophiles. Do you think that that coverage is unbalanced?

KL: Very, very unbalanced. When we were dealing with *The Cook Report*, what we were trying to do was to uncover a form of Satanism being used by paedophiles.

PN: You must be aware that if people are found to be using occultism and Paganism as a cover for any kind of abuse of others, then most Pagans in this country would be as much concerned with bringing those people to justice as would anyone else.

KL: May I say that part of the support I have had has come from people within witchcraft, and it was someone who has been in touch with me through Wicca, who has brought me here today. So I understand that a lot of people within the Wicca, and within the occult as a whole, stand a million miles away from child abuse.

PN: **Any last words, Mr. Logan?**

KL: No, I think I've said enough.

PN: **Reverend Logan, thank you very much.**

That was Phil Hine and Julian S. Vayne, on location, at Autumn Link-Up. Now back to the studio...

VIEW POINT

The Chilling Fields
by *Janet Cliff*

"Let's Glam-up for Link-Up" said Phil, chains clanking, leather agleam, sparkly bits dancing in the breeze. Well, why not? After all, hasn't it been organised down to the last detail, and isn't it being held in a moderately comfortable building with all amenities, as befits such an important event? Creature comforts catered for, let's get down to the real business – socialising, trading, arguing, voting, strengthening links, looking beautiful. Well, aren't I the naive one! Sorry my dears, but the event will now be held in the newly refurbished "Field", and Pagan Glam 89 will comprise the essential gumboots, the radical waterproof hat, and the *de rigueur* large woolly blanket, preferably multi-coloured, to hide the mud and blood of clashes with the Jesus Army perhaps. And it's so now!

So off we went, and as fields go this one was quite agreeable, with a sympathetic owner, grass and hedges, a view of sorts, and even a little stream, but it just wasn't appropriate for the purpose. Now I know that Pagans are in touch with their environment, and love sitting in the mud, but it was bloody cold! Which is fine if you're into a bracing walk, but not really conducive to conferencey things; a field on a blustery day is for landing a helicopter in. Were our Pagan ancestors not a tiny bit enlightened when they struck on the idea of shelter? And heating systems? I am not keen on having my lungs, eyes, hair and clothes polluted by woodsmoke just to keep at least one side of my body moderately warm. And if you call me a wimp, what about the non-existent disabled access, and lack of basic facilities like telephones in case of emergencies? What price equality when to go to a Pagan conference you need to be a Ramboesque model of Health and Efficiency?

What really annoyed me was that we should be beyond expecting to have to rough it all the time when we're evicted from a legitimate venue on some pretext. I may be city-soft, but it's very difficult to have to try to hold any kind of constructive event when you have to be worrying about incidentals, like will all your merchandise get ruined if it rains, and can your fingers possibly get any bluer. The first thing you ensure if you want positive results

veterans when the common enemy and the pressure is taken away. The adrenalin buzz of having to react and improvise under attack shouldn't be allowed to gild the dull reality of a cold bum in a field in the middle of nowhere.

What the Christian fundamentalists want is to force women back into the kitchen, gays back into the closet, and Pagans out of mainstream society. They did quite well with the last one

> *"All I warn against is that we don't get addicted to the stress of being under siege to the extent that we're unable to claim our place in what is our society too; I don't want to see Pagans wandering around lost and alienated like Vietnam veterans when the common enemy and the pressure is taken away."*

is an appropriate environment, so as to free your faculties for the task to hand. What happened here was rather like the old management trick of rendering an executive functionally impotent by making him count paperclips all day.

Ah, but you say, the Pagan spirit rallied, a good time was had by all, and things were done, so what am I complaining about? Yes, this time it worked, and it was wonderful to see the flexibility, determination, and ingenuity of all involved. All I warn against is that we don't get addicted to the stress of being under siege to the extent that we're unable to claim our place in what is our society too; I don't want to see Pagans wandering around lost and alienated like Vietnam

didn't they? Partly, it's the traditional Pagan niceness, flexibility and practical preparation for the worst that makes it so easy for others to exclude us, marginalise us, and divert our purpose by forcing us to retreat; if we expect the worst, that's what we'll get. Wrapping the event in a nostalgic glow of "how well we coped with adversity, so let's do it in a field again" will only serve the fundamentalists; we'll remove ourselves from society and save them the trouble, not to mention confirming the worst fears of a public that wonders what we've got to hide. Remember we were pushed out, we lost, they won, however much fun you had.

Today in Leeds the National Front had a meeting and rally in a plush city

centre hotel. How could that possibly take place, given the NF's questionable sentience, and after all that happened to us? Are we missing something? How did the debacle that was Link-Up happen, and who is responsible for it? The college authorities said they were misled as to just exactly what type of event was being planned, which gave them their excuse to pull out. OK, let's make sure they do know in future, in writing, and get a signed copy from them to prove it. We must learn exactly what our legal position is if such an event is cancelled again at such short notice, and be prepared to take action such as suing for breach of contract, with adequate compensation for all wasted journeys and loss of earnings. If appalling press lies are the cause (and local coverage plumbed new depths) then we must have trained and skilled media manipulators of our own to go in and respond. Let's get professional about this!

Most of all, let's stop being prepared to take the crap; leave the woollies and the wellies at home, expect our rightful comforts, and leave the fields to the sheep!

B-DOG

the British Directory of Occult Groups

The Order of Bards, Ovates and Druids

The Order is not a cult or religion – it simply represents a particular way of working with, and understanding the Self and the natural world – it speaks to that level of our soul and our nature which is in tune with the elements and the stars, the sun and the stones. Through the work of the Druids we are able to unite our natural, earthly selves with our spiritual selves while working, in however small a way, for the safeguarding of our planet.

Like all esoteric orders, the Druid Order has passed through phases of outer activity followed by periods of dormancy. The last active period began in 1717, when John Toland assembled delegates from many Druidic and Bardic circles at the Apple Tree Tavern in Covent Garden. Their formation of the Druid Order was announced traditionally on Primrose Hill at the Autumn Equinox of that year. The Order of Bards, Ovates & Druids moved into a period of dormancy after the death of the chief Druid, Philip Ross Nichols in 1975. In 1984 instructions were given to begin a new cycle of activity, and for four years preparatory work was undertaken until the new cycle of the Order was officially inaugurated on St. Valentine's Day 1988.

Druids believe in the interconnectedness and sacredness of all life. The work consists in the applying and living of a system of teaching which has evolved over many generations. The heart of this system is the observance of eight particular times during the year, through which deep connections are built between the individual, God, and the world of nature. At these times during the year, we either individually or collectively celebrate the eight festivals: the solstices and equinoxes and the four fire festivals.

In between these eight festivals we meet together to work, study, meditate and enjoy each other's company as often as is practical. These meetings are called Groves and are usually held fortnightly. For those who cannot attend the Groves, the teachings have been prepared in a series of discourses which are mailed directly to the member's home.

The teachings of the Order are given in three grades: those of the Bards, Ovates and Druids. The Bardic Grade is the first grade that the student enters. Each grade has its own initiation which can be performed by the student alone, or with others in a Grove. Once the Druid has completed her/his training, s/he is able to continue with further work, and with the approval of the Order, is able to open his own Grove.

The Work of the Grades

During the first year of training in the Grove of the Bards, the student is first provided with an Introductory Discourse in which the Chosen Chief introduces the aims and work of the Order. These are followed by brief and concise discourses which cover the subjects of basic Druidry: the four elements, the circle of nature and man's life, the Sun, the Earth, the eightfold observance calendar, and a study of poetry and the development of the artistic self. In addition to these discourses, the student receives copies of the eight festival ceremonies, together with a workbook of the Grade.

Initiation into the Ovate Grade commences with work on the healing and divinatory skills, a study of sacred trees and plants, sacred sites and ley lines. Study of the Arthurian cycle is begun and further work is undertaken on the development of the inner self of the student.

Entry into the Druid Grade marks one of the high points in the student's work. Every effort is made to assist the aspirant in the task of becoming a worker for the Light. The teachings continue the study of the Arthurian and Grail myths and are particularly concerned with the development and direction of energy. The Workbook for the Grade concerns the Triple Knot of the Druids and the mysteries of the Serpent's Egg. The Druid is shown how to open and lead a Grove, and when felt ready, is given every assistance to build a successful working group.

At any time the student may suspend his studies, either completely or for a time, if he feels this is appropriate. If he is unable to attend meetings, he is welcome to correspond with the Order to obtain clarification on his studies as he progresses. If you feel you might like to undertake this work, you can receive the first month's package on a trial basis. If after studying the material you feel it is not right for you, you may return it undamaged and the Order will return your payment in full. If, however, you find it answers an inner call, then you will be most welcome to keep the package and begin a journey that we hope will be exciting and rewarding.

The Order is a non-profit making organisation and has applied for charitable status. Surplus funds are used for the Order's "Campaign for Individual Ecological Responsibility" & the Tree Planting Programme.[8]

8 The Order of Bards, Ovates, and Druids currently has over 20,000 members in 50 countries. It can be contacted at https://druidry.org/

Letter from America

Stephen Mace

HOODOO

One thing about Santeria and Voudou that needs to be emphasised is their mainstream character. Though they hid from its censure, they never put themselves in opposition to Roman Catholicism. Instead their devotees just saw it as the whites' way of looking at the same spiritual reality. They attributed each orisha or loa to a saint, and they never mention Satan. A believer could be ridden by Erzulie on Saturday night, then burn a candle to the Virgin on Sunday morning, and both times be dealing with the same spiritual current. It's bizarre, but both cults have thus had no trouble diffusing through all strata of Haitian and Hispanic society.

But the United States is not a Catholic country, and in 1803 it was less one than it is now. Except in New Orleans itself, in the American South the big denominations were Baptist, Methodist and Presbyterian – Bible-oriented sects that saw all decoration as popery and all magic (including lighting a candle to the Virgin) as the Devil's work. They recognised neither saints nor any feminine component in divinity, and on this barren ground Voudou could not take hold. The initial effect of this was to burn the Christian elements out of the African, except for the acceptance of Satan as a master conjurer. The secondary effect was one of degeneration, a general withering of the religious aspects, especially the careful cultivation of the believer's soul. This left a great deal of what we might call "low magick", and not much else. A third effect was to separate Voudou from the mainstream, even the black mainstream, pushing it into the backwaters of the South where it mingled with the magick of the Indians and also the European witchcraft still practiced by the hill-dwelling whites. Though the result is often called Voudou, it isn't really, and to distinguish it we can call it Hoodoo.

For the most part, Hoodoo is a collection of sympathetic magick spells. Dolls are courted and punished, charms are buried at the house of love interests and enemies, spells are done for self-protection and the attraction of cash. Possession

by the loa is not often required, lavish ritual generally being replaced with solitary chanting accompanied by the burning of incense and anointed candles. But the relationship between believer and loa is the same; if they are fed, they help the one that feeds them. And even if Legba is not there as centerpost, his veve will still be drawn on parchment, or worn as a talisman, and the operator will still call him to open wide the gate so that the spell cast can reach the powers that can accomplish it. As props for conjuring, modern Hoodoo makes use of the same collection of powders, perfumes, soaps and incenses as Santeria, from Removing Powder as a precaution against hexes to Ylang Ylang Oil for love spells, from Rama Dream Incense for psychic powers to a Wealthy Way candle for money. Graveyard dust is an important item, as are a wide selection of botanicals, from Aaron's Rod Tea to restore youth to Zedoary burned as an incense for love magick. It appears that all these serve the same functions as the symbols of Western systems, calling the powers through learned association of smells, names, and psychic effects rather than images. That they are often arbitrary is shown by the disclaimers of those writing the handbooks, declaring that attributes vary with locale, and that local custom is always best.

To become a priest in Hoodoo, more elaborate spells are required. When she was initiated into a Hoodoo cult in New Orleans, the black American anthropologist Zora Neale Hurston had to lie for 69 hours naked on a couch, all the while with a snakeskin on her navel. When the 70th hour struck, five men carried her to a ritual which left a streak of lightning painted on her back and the taste of blood in her mouth, this from a sacred chalice containing blood from all the participants.

The use of the charm bag is not conspicuous in Voudou or Santeria, but it is in Hoodoo, where it is also called a mojo. Any sort of power object, from crystal to black cat bone, may be placed in it, and it serves as a much more inconspicuous repository than the necklaces and amulets of Voudou. To keep a charm bag active, it should be "fed" regularly, perhaps by anointing it with an appropriate oil or passing it through the proper incense while chanting a call to the loa whose powers match its intent, and to Legba also to open the way. Another tradition that makes much use of charm bags is the Native American, where they have come to be called medicine bags (the French called all Indian magick "medicine"). The dictionary says the Hoodoo word mojo comes from "moco", an African word meaning witchcraft or sorcery, but one has to wonder if the blacks' contact with the Indians didn't give them the idea of it and also make them choose that particular name, for the use of the two bags is the same – a portable container within which charged objects can reinforce one another's power.

All-In Vayne

THE KARMA BEFORE THE STORM

The word karma is a panacea for all ills. Just drop it in at the appropriate point in a book, lecture, discussion or whatever, utter some stuff about the 'Three Fold Law' and your esoteric street cred will soar. karma is seen as being some complex system of "fair play" intrinsic in the universe. Moreover it is managed by the mysterious 'Lords of karma' who seem to play the part of cosmic bank managers; awarding brownie points to those of us who are "good", and black marks to those of us who aren't. But is it all that simple?

The word karma is of Sanskrit derivation and is usually translated as "action" or "the law of cosmic cause and effect". One can see a simple analogy of this in Newton's law that for every action there is an equal and opposite reaction. My point is that karma is an impersonal force, much as electricity or heat. To see it as "divine retribution/grace" or to apportion its action to any entity is a religious rather than magical attitude. Also, like any impersonal law, karma cannot be seen as rewarding "good" and reprimanding "evil". Such concepts are frail attitudes of human morality. For instance, healing is seen by many to be an inherently "good" act, which can only provoke a positive Karmic response. Yet if granny is dying peacefully at the age of 90 and one attempts a healing spell, are you really doing her a favour?

Karma is simply the principle that energy tends to return to its source, much as ripples from a stone dropped in a pool will bounce back from the sides to the point where the stone first fell. The banker's vision of Karmic debt and credit is unrealistic.

One of the modern additions to the all-singing-all-dancing principle of karma is the "three-fold law" so beloved of some Wiccans. My only criticism of this little "law" is that there is not a single shred of evidence that it exists! To say that 1=3 in terms of Karmic action would have the Indian originators of the concept (not

to mention Isaac Newton) throw a fit! The notion that if I give little Johnny one sweet he'll give me three back can only be the product of someone who looks at the universe through a rose-tinted brain.

The law of karma and indeed the universe as a whole cares very little just how "good" or "bad" an individual is by the social standards of his or her culture. The

> *"Karma is simply the principle that energy tends to return to its source, much as ripples from a stone dropped in a pool will bounce back from the sides to the point where the stone first fell. The banker's vision of Karmic debt and credit is unrealistic."*

perception that the mighty forces of the universe, which cause stars to be born and oceans to flow, should be concerned with human morality is perhaps just a bit egocentric. Karma cannot be understood fully in the human sphere without relating it to the concept of the True Will. If you can imagine the True Will as a vertical line composed of units of experience, rather like beads on a string, then whilst some are fairly unavoidable (birth, death etc.), others can be avoided or actively sought – these are developmental and self-evolutionary experiences. Karma is a kind of pressure which acts by forcing the individual onto the path of the True Will. The further that the individual deviates from the course of the True Will, the greater the "kick-back" effect produced. Conversely, the closer the person adheres to his or her True Will the less pressure is exerted.

That is not to say that the individual following the course of the Will lives a trouble-free life. Rather, that such a person is more able to comprehend life experiences and integrate them into the gradual growth of self. If people spent more time in discovering their True Will rather than worrying about incurring Karmic debts and overdrafts, then perhaps more would be accomplished. Leave the belief in grace and guilt to religions – they are past masters in such things. But the magickal universe has no need of divinely-imposed morality and much less of fallacious divine retribution.

Barry Hairbrush and the Tentacles of Naughtiness
by *H.P. Saucecraft*

Part Three: Slime and Punishment

I peered down from the kitchen of the Crowley Rock lighthouse at the wrecked trawler on the rocks below. Sir Guy had managed to steer the crippled craft onto the rocks, and we had dragged the unconscious Norris Grott up to the lighthouse with us.

"I've put him to bed and given him a little executive relief," purred Dio Durant, coming in, "he should sleep for hours."

Professor Bogey was downstairs analysing a piece of the monster's tentacle which poor Gardner Saunders had bitten off before he died. Sylvestenegger was in the cellar laying a defensive perimeter and eating some fish he'd clubbed to death while swimming ashore. Suit had been busy inscribing pentagrams on the wall, and a large circle of protection covered the floor. Outside, flickers of lightning skittered round the clouds; ever since Bogey's incantation had caused the boat to be attacked by some hideous apparition of the depths, a storm had struck up, and was growing by the minute. What awful fate had befallen the crew of the lighthouse in 1923 could only be guessed at, but now as then, we had found a small model weasel sitting on the floor – the totem of what obscene cult?

I checked through the pages of *Very Naughty Cults Indeed*, and to my abject horror, discovered a reference to small model weasels on the same page as the Esoteric Order of Dralon!

"Suit! Come and look at this!" There was the sudden splintering crash of some huge object falling down the stairs, followed by Sylvestenegger's voice yelling "...kin' HELL!" as he tumbled downwards. We all jumped to our feet, and Norris Grott walked in, a revolver in his hand. With a twinge of terror I noticed he was wearing a pair of Dralon Flares.

"The Esoteric Order of Dralon!" Suit hissed.

"Precisely, my dear sir. Alive and well in the 20th century. Now, hands up please, and stand against the wall."

"What's the meaning of this?" I asked. He gave an evil smile.

"You'll find out when our friend from the sea comes back. And none of you try any heroics. We're cut off from the outside world, and your friend Sylvestenegger is far too busy with the sideboard I've just dropped on him to help you."

Bogey came rushing in. "Suit, I haff analysed zer tentacle, und, er..." He took in the gun. Suit smiled at him.

"I think you'll find it's latex, Professor."

"What?" I asked, "You mean, as in 'Johnnies'?"

"I'm afraid so Barry."

"How did you guess?" asked Bogey.

"It was simple really," replied Suit, "Every summer the tourists wash thousands of condoms down the drains into the bay. Over the years, this huge undersea mountain of rubber has taken on a life of its own, thanks to our friend Grott here, who's been using the Rites of the Order of Dralon to control the monster. I became suspicious when it didn't attack him on the boat".

"How very clever," Grott sneered, "but I'm afraid it won't help you. Even as we speak, the time comes to make sacrifice again, to Him Who Slumbers in The Deeps!"

"And we're the sacrifice!" gasped Dio Durant.

"Precisely..." He turned to the balcony, and began a barbarous invocation. "Bggr 'Oph! Bggr'Oph!" – a great roar came from the sky – "Wooloomooloo Ftang!" A bolt of lightning struck the lighthouse, thunder shook its very foundations, and the sea glowed blue with the charge. I felt the most excruciating, maddening terror pass over me so that I began to doubt my very sanity. A quivering, slimy, cyclopean mountain of rubber, tentacles waving, single red eye glaring balefully at us, emerged from the boiling sea.

"God's armpits!" gasped Suit, "It's Great C'thontraceptive himself!" Grott yelled more incantations into the storm, and I felt the floor lurch as, with a shuddering roar, the monster condom slid onto the rocks, and began unrolling itself down the lighthouse. Professor Bogey fell to the floor, gibbering and foaming, his sanity destroyed. Grott took no notice. I whispered,

"Suit, his attention's distracted. There must be something we can do." Dio pulled out a hatpin.

"There's only one way to render a condom useless. Stick a pin through the top!"

"Of course!" I shouted. "I'll distract Grott!" I ran over and dealt him a sound British punch to the jaw. He staggered backwards and I recoiled in terror; his face was transformed into the likeness of a "french tickler". Behind me, Dio Durant – jolly plucky for a female – climbed sensuously onto the roof of the lighthouse. I gave Grott a sound British knee in the nuts and turfed him over the balcony. With an eldritch wail, he plunged into the mass of tentacles and slime below. Above me, Dio plunged a well-aimed hatpin into the

top of the giant rubber monster. The creature screamed as its life energies began to spew out into the storm. Dio fell off the roof, but I pulled out Professor Bogey and used him as a makeshift safety net to catch her. The vile, noisome monstrosity gave one last convulsive heave, and began to glow a tasteless shade of green. A deep rumbling began. Suit whirled round in surprise.

"Hell's teeth! It's going to explode!"

"Hurrah!" yelled Sylvestenegger from below.

There was a very loud noise, and everything went black. I felt myself being hurled through the air, and when I opened my eyes, found that I had landed on the roof of The Rude Policeman. Suit was trying to dislodge his head from a chimney pot while Dio Durant curved sensuously round the tree she'd landed in. Nothing remained of the distant lighthouse except a smoking crater, in the middle of which sat Sylvestenegger, sewing his legs back on. Bogey was lying on the beach, gibbering senselessly to himself, his eyes staring and blank. Whatever mysteries he had experienced he would surely take to the grave.

It was a sombre party which caught the train back to London the next morning. We had all watched Bogey being loaded into the yellow van, laughing hysterically. Suit, still wearing the chimney pot on his head, settled back to read the *Times*.

"I say Guy, don't you feel sorry for the poor chap?" I asked, as the train pulled away.

"Not in the least, Barry – why?"

"He'll probably spend his life in an asylum."

"Certainly not!" Suit replied, a merry twinkle creeping back into his eye, "He'll simply be transferred to work in the Housing Benefits Office. After all, it doesn't do to let that sort of talent go to waste!"

Famous Occult Stereotypes

by *Barry Hairbrush*

Derek Drew – He's Been on BBC2!

...Well, Barry, this is one of the main misconceptions about occultists, that we sacrifice children and animals, hold orgies and desecrate churches, no honestly, it doesn't happen; well it does, but not by us; not by real occultists, as I hope to prove by the ritual I'm about to do in the studio here. Black magic? Well you see, we don't use those terms, we have what we call the right and left hand paths, which are functionally different approaches to occultism, defined by the magician's own perception of self and development, and... what do you mean, that's all we've got time for?

PAGAN NEWS

The monthly newspaper of Magick & the Occult

November '89

Price 40p

Link-Up goes to European Court!

The organisers of this year's Autumn Link-Up festival, turfed out of Leicester Poly by nervous governors after hysterical attacks on the event in the Leicester Mercury newspaper, are taking their case to the European Court of Human Rights. They are taking legal action on behalf of the festival traders, based on loss of earnings, and against the Mercury, which contravened several articles of the Human Rights charter in its reporting on the festival, reaching new heights (or should that be plumbing new depths?) of intolerance, and entirely forgetting that last year's Link-Up had been aided by a grant from the city council. One of the festival organisers, whose name and address the Mercury helpfully printed, has since received several death threats. Complaints concerning the Mercury's reporting of the event have also been directed to the Press Council.

On a happier note, remember last month's leader concerning the events over the festival weekend? Well the local man who was carted off the site in the early hours of Sunday morning suffering from asthma & hypothermia, has since been in touch with *Pagan News* and has asked us to print the following message:

To all the people at the Autumn Link-Up in Groby, Leicestershire. I wish to thank the following people for your thoughts when I was taken ill - thanks to all pagans, witches, Aldred and Graham from New Mills, and the lady who came to see me in hospital, from Mark J. Van Der Willik.

The festival organisers are now planning an open-air Link-Up to be held next May, probably at the campsite in Groby.

S.A. starts up Fighting Fund!

Chris Bray's latest move to counter the anti-occult campaign is the founding of the SORCEROR'S APPRENTICE FIGHTING FUND, which is to be a certified trust, for the purpose of conducting legal defence against newspapers, television companies and other news media who defame occultists and pagans. This isn't just about occultists, but about individual freedoms, which are slowly but surely being eroded in this country, though of course we don't tend to realise how bad it gets, until it affects us *personally*. Pagans and occultists are fast becoming yet another of society's scapegoats; with the Fundamentalists stoking the fire, the press fanning it and blowing it up out of all proportion (Sex and Satanism sells newspapers, after all), and some people get hysterical enough so that someone is going to get hurt!

The main purpose of the Fighting Fund is for us all to pool affordable amounts which will, in turn, help us protect our interests by fighting test cases against those who are out to get us. This is a matter of survival - we either fight for the society which we want to create, or we go under. This means looking at ways of countering what is happening *now*. If everyone gave a pound or two, then

November 1989

NEWS

S.A. starts up Fighting Fund!

Chris Bray's latest move to counter the anti-occult campaign is the founding of the SORCERER'S APPRENTICE FIGHTING FUND, which is to be a certified trust, for the purpose of conducting legal defence against newspapers, television companies, and other news media who defame occultists and Pagans. This isn't just about occultists, but about individual freedoms, which are slowly but surely being eroded in this country; though of course we don't tend to realise how bad it gets, until it affects us personally. Pagans and occultists are fast becoming yet another of society's scapegoats; with the fundamentalists stoking the fire, the press fanning it and blowing it up out of all proportion (Sex and Satanism sells newspapers, after all), and some people get hysterical enough so that someone is going to get hurt!

The main purpose of the Fighting Fund is for us all to pool affordable amounts which will, in turn, help us protect our interests by fighting test cases against those who are out to get us. This is a matter of survival – we either fight for the society we want to create, or we go under. This means looking at ways of countering what is happening now. If everyone gave a pound or two, then we'd be in a lot better position to start sticking up for ourselves. What price can you put on freedom of belief & expression?

More on Christian Response to the Occult

As we reported last issue, the Christian Response to the Occult are stepping up their campaign to combat "dark forces" (that's us). The advantages that CRO have over Pagans is that their members & recruits are not given to individual interpretations of religion etc., and will undoubtedly swallow the "evidence" which CRO are producing and will be united in their struggle – while Pagans & occultists are notorious for disagreeing on all kinds of things, once a decent-size roomful are gathered together. Undoubtedly though, the biggest asset CRO has is financial backing, which is in part provided by the Deo Gloria Trust, who are also involved in backing the notorious 'Campus Crusade for Christ'[1] and other

1 Campus Crusade for Christ was founded in 1951 at the University of California, Los Angeles. It is now known by the marketing-friendly name of Cru (because the word "crusade" has unfortunate implications), although it still retains its focus on horrible 50s style "family values" i.e. that gay people are bad and women should be subservient to men. And of course it supports the Republican Party and all of the other usual right-wing American talking points as well. At the time of writing Cru has 19,000 staff members in 190 countries. Organisations like this are really scary.

"charitable" projects. Thanks to a combination of owned & leased property, shares etc., the Deo Gloria Trust is worth several hundred thousand pounds. Also, by using the Christian Computer Bulletin Board Network,[2] CRO have access to an already efficient and speedy information network. Some of the *PN* techno-Pagans have been sneaking a peek at these Bulletin Boards, and we'll be bringing you a report in due course. Meanwhile, any information about fundamentalist groups would be much appreciated.

Cook Report Bubbling Under

We have started to receive feedback from readers who have been writing to various bodies to express their feelings about the recent *Cook Report*. One of our London subscribers was recently verbally harassed by a crowd of people because she was seen to be wearing an "occult pendant". Apparently the Senior Television Programme Officer of the IBA holds the view that "the programme offered a proper investigation into the occurrence of Satanism in this country and some of the horrific and criminal practices associated with it."

So there you have it, but don't let this put you off from writing in and giving them your views on it. Don't forget that the original premise of the programme was to "expose" a network of criminal satanists who were allegedly active in large numbers, perpertrating child-abuse, ritual murder etc. – in no way did any of the so-called "facts" the *Cook Report* dug up corroborate these allegations, nor has any hard evidence appeared yet to give credence to the statements. If you have complained to the BCC and other organisations, we would urge you to write again, stressing the nature of your complaint.

Role-Players – Rabid Satanists?

Those of you into Fantasy Role-Playing games will be aware of the recent debate in the Role-playing press between Christians (mostly the Reachout Trust and the Evangelical Alliance) who say that such games lead to Devil worship etc., and the gamers who quite rightly ridicule this farcical argument. Gaming giants Games

2 Children of the Internet Age will be wondering what the hell a Bulletin Board Network is… Back before the World Wide Web was invented people would set up little text-based messaging software on their home computers, where others could log in and leave messages to each other. These were called bulletin boards. When the Internet came along it became possible for these individual boards to form ad hoc networks to exchange posts more widely. They became increasingly popular until they were killed off by the development of the first proper web browser, NTSC Mosaic, in 1993. Yes, people couldn't actually use the web until 1993… which was four years after this article was originally written. Hard to comprehend, I know.

Workshop[3] have even labelled some of their gaming material with a disclaimer to the effect that none of their products are intended to offend religious sensibilities. Most gamers, it seems from the letters pages of *White Dwarf*[4] and *G.M.* magazine,[5] have a healthily sceptical attitude to yer actual occult. However, in the last issue of *G.M.*, Hull Pagan/role-player Penny Hill decided to put over an alternative viewpoint. She points out that elements of magick within a game are a great deal different than the real thing, and that if anything, the games tend to reinforce the accepted occult stereotypes; real magick and real witchcraft would make for very boring roleplay. Much more fun in real life, although requiring a commitment and dedication that many would be reluctant to offer.

3 Founded in 1975 in a small apartment in London, Games Workshop have since risen to become a gaming behemoth. Back in the 80s though they were still a fairly small chain of retail stores carrying all sorts of RPGs. Your editors spent way too much time in there as young men. We still to this day own and play some of the games we bought there back then, including Steve Jackson's classic *Illuminati* and GW's own *Talisman*.

4 The first issue of *White Dwarf* came out in 1977, covering all sorts of tabletop wargames and Role-Playing Games and it rapidly became a must-read for nerds like us. Phil's first paid writing job was actually for *White Dwarf*!

5 *G.M. – The Independent Fantasy Roleplaying Magazine* was a monthly high quality eclectic gaming magazine that ran from September 1988 until its demise in March 1990, another victim of the Games Workshop colossus. Which is a pity, because it ran some excellent content over its 19 issues, including fiction from authors such as Michael Moorcock, Terry Pratchett, and Storm Constantine.

SPOTLIGHT

Sorcerer Under Siege

Chris Bray, owner of The Sorcerer's Apprentice Occult Suppliers based in Leeds, is probably one of the most well-known of British occult personalities. The Sorcerer's Apprentice, recently the subject of an arson attack, has featured prominently in the publicity around the rising wave of witch-hunting. Chris has, since the trouble started, been at the forefront of the occult response, and has recently produced an Occult Census, and set up a legal aid fund. We asked Chris his views on the current situation.

PN: Chris, you've been at the forefront of the persecution of occultists & Pagans in this country. Why, do you think, it began in the way that it did?

CB: It is too early in the game to gain any true perspective and it would be trite and misleading to conclude that persecution has erupted again due to some particular immediate circumstances. We know how the campaign was applied and by whom. We know of the fundamentalist groups in the USA beavering away along with their UK branches. We know of the handful who have spearheaded and orchestrated the campaign. It is really frightening that a handful of twisted people like this can cause so much trouble and mobilise millions of people into hate and aggression.

When you hear of people like Hitler or Churchill or Charlemagne you fall into the same psychology and assume that just because they had such a powerful effect on millions of people that they were in fact powerful people. Nothing could be further from the truth; to me most were pernicious, insecure little bastards with nowhere to go who spotted that 98% of the populace were zombie-brained and could be led like sheep. These fuckers cause us all trouble because we allow them to manipulate us.

Prejudice is humankind's ever present testimony to the stupidity of our species. Persecution is a continuous thread in the history of mankind; it has always been with us in various forms and never disappears. Persecution (or the willingness to victimise) is constantly re-directed by culture, education, and politics into various arenas, and crescendos at various times in various guises. The occult was always made for scapegoating of course, because by definition an occultist is an outcast; and being disparate and without any of the usual power structures of a society,

occultists make ideal victims. It is far easier for the disgruntled masses to pick on a victim and rid themselves of their frustrations by beating them to a pulp or setting fire to them.

It is important to realise that people who are prepared to do such things are not the exception within humanity. Indeed we can only free our species from this syndrome if we understand that we ourselves are ready to become just as extreme given a motivation in which we believe. The sad fact is that within any large social structure (civilisation) an individual human has no control over their destiny and whilst suffering from the inequities of that society, is denied the systems and devices necessary to change this... regardless of any illusory devices which have been created to convince the people that they have freedoms and rights (such as democracy and law). The real evil lies in the astonishing willingness of people to adhere to this system as though it is of some value considering that breaking the subconscious conspiracy is so easily accomplished on an individual basis.

PN: In the aftermath of your shop being firebombed, what do you think the trend will be in the near future? Do you envisage more attacks on Pagans and occultists happening?

CB: Oh yes, absolutely. The cycle of events is very predictable. The question is, what do we do about it? The true nature of all religions and philosophies demands wisdom, from hence follows tolerance and understanding. fundamentalists by definition are those who do not understand their own religion and become insecure because of that. Being veiled from the initiation which could bring them wisdom they will attempt to prove the validity of their own belief by embattling those whom they consider to be their enemies and who by continually existing make the fundamentalists even more insecure. The enemy therefore is irrelevant to the purpose, and before long that insecurity will turn into hysteria, and this will push their judgement beyond normal bounds and criminal acts are bound to occur. The danger when Christianity and occultism are linked in this way is simply that those who would, under normal circumstances, call a halt to the hysteria (government, police, alternative political lobbies, trade associations and pressure groups etc.) simply refuse to take any action and therefore the persecution gains in momentum by leaps and bounds. Furthermore, any political activist will confirm that pressure of this kind produces successful results so that the scene is set for continual action.

Within the hundreds of thousands of fundamentalists in the born-again movement perhaps only a handful will be psychologically ready to be incited to commit criminal acts, burnings, beatings and murders, but the rest of the fundamentalists give them the justification for doing so. Now that the S.A. has been firebombed there is no doubt in my mind that other bookshops will follow. In the absence of help from the authorities, Pagans and

occultists are left to provide their own defence and any such defensive action will have to be very carefully applied so as not to inflame the situation. Unfortunately my experience over the last two years has shown that most rank and file Pagans and occultists are ill-equipped to deal with things of this nature and are likely to exacerbate a situation which will lead to someone else's death.

PN: Some people seem to have the attitude of "It'll all blow over." What do you say to this?

as an escape hatch from society into an astral free-for-all where any fool can grab the spotlight and overcome their deficiencies by imagining all manner of psychic experiences they are highly unlikely to consider something which is going to spoil their little game, even if that does mean profaning the Craft. It is doubly unfortunate that often popularity and fame are so important to many of these so-called leaders that they allow it to replace any genuine magickal work they may have at one time accomplished, and being bereft

> *"It is doubly unfortunate that often popularity and fame are so important to many of these so-called leaders that they allow it to replace any genuine magickal work they may have at one time accomplished, and being bereft of the current are willing to beguile whatever followers they have by allowing them to indulge in any old crap and call it magick."*

CB: We can only overcome this kind of silliness by being ruthlessly honest and it has to be said that the calibre of occultists in this country is sadly lacking. Newcomers are so ready to become followers that they have elevated to positions of influence people who are totally devoid of the wisdom and common sense needed to cope with this kind of situation. Most of these people are not initiates at all and have an airy-fairy romantic image of Paganism or occultism totally out of context to its true meaning and power. They are stuck in Yesod. Accordingly if they, and it has to be admitted that there are a majority of them, are using Paganism/occultism

of the current are willing to beguile whatever followers they have by allowing them to indulge in any old crap and call it magick. A great man of wisdom once said that you can gauge the accomplishments of a person by counting their enemies and in this there is great truth, for most people don't like forthrightness if it becomes uncomfortable.

PN: What level of support have you had from other Pagans & occultists during the "Occult Census" and other steps you've taken?

CB: This situation has polarised all those occultists who have become involved into three categories. Those who are willing to fight for their

beliefs; those who don't want their apple-cart upset; and those who don't give a sod. Many of the latter are simply not aware of the fuller ramifications of the situation. Despite the anti-occult campaign being two years old and the extensive publicity both nationally and within the occult, ignorance is still being met with. This is not helped by category two occultists, some of whom insist that there is no campaign but who also influence the minds of their followers/acquaintances to the same end. In fact it is heartbreaking to see in hindsight that by fighting amongst ourselves and arguing about whether we were indeed under concerted attack or not, we have materially abetted the fundamentalists in their campaign. Many occultists still refuse point blank to see the reality of the situation and are still acting like ostriches in order not to lose face whilst occultism is being suppressed further and further into oblivion.

Many of the people who were prepared to stand up and fight for beliefs put themselves at great risk and went to great lengths and effort to counteract the anti-occult campaign. Most heartening was the way in which complete strangers "did the right thing" and took up the banner themselves. To mention all the people who helped (and are still helping) would be impossible, but I'd like to give a special mention to Jo Logan of *Prediction*; Keith Morgan of *Deosil Dance*; Magda Graham; David North; Patricia Crowther; Susan Class; Melanie Gomersall; RBB; Mark Spooner; Steve Blamires; Stewart & Janet Farrar; Mark Winter; Adrian Hodges; John Morgan; T. Morgan; Karen Graham; Stuart Gregory; and Peter Elliott (there were more). Note that the majority of people on this list are unknown on the "circuit". Contrast this to the following people who refused to involve themselves in my campaign or even acknowledge a need for action: Zach Cox of *Aquarian Arrow*;[6] Leonora James of the Pagan Federation; Doreen Valiente;[7] Nigel Pennick[8] (Pagan Anti-Defamation League); Mike Howard of *The Cauldron*; Karen of *Pagan Prattle* and the editor of *Chaos International*

6 Zachary Cox (1928 – 2019) was editor of the excellent *Aquarian Arrow* magazine from 1978 to the early 1990s. He and Jean M. Williams continued running Gerald Gardner's original Bricket Wood coven after Gardner's death in the 1950s, as well as putting on regular performances of Aleister Crowley's O.T.O. Gnostic Mass in London for a great many years. They are the authors of *The Gods Within: The Pagan Pathfinders Book of God and Goddess Invocations.*

7 Doreen Edith Dominy Valiente (1922 – 1999), English Wiccan author. She was High Priestess of Gerald Gardner's Bricket Wood coven, and edited many of his early witch cult ritual texts (purging or changing a lot of material that Gardner had originally taken from Crowley's works). Her books on Wicca are classics of the genre and are a must-read for anyone interested in the subject. Unfortunately her legacy is somewhat tarnished by the uncomfortable fact that for a time she was also a member of British neo-Nazi groups the National Front and the Northern League.

8 Nigel Campbell Pennick (1946 –) is an English marine biologist and author who has written an astonishing number of books on a wide range of occult topics.

(these mentions will upset friends of *PN* editors; it will be interesting to see if they are "adjusted" in any way) [as if we would – Ed.][9]

Of over 100 magazines and magical orders mailed out to, many did not respond in any way at all. However, it is most important for those who haven't either given support or taken any action to realise that they must do so sooner or later because of the deteriorating situation; and the quicker they get down off the fence the better things will be. We must act to secure the freedom to follow our own beliefs and philosophies. And by addressing the problems inherent within prejudice we may find a route to freedom from it ourselves.

PN: Thanks to the gutter press, Roger Cook and others, occultists tend to see the media as a general "enemy". Do you think that it is possible to work with the media in a constructive way?

CB: It is absolutely not possible to work with the media at any level. I and many others thought that a new spirit of co-operation and sensibility had begun to spread through the media and that new journalists were more "Aquarian", and so more willing to get across the truth. During the 70s and early 80s I, along with many other occultists, did my best to put over the positive aspects of occultism, and by and large the result was slightly in our favour, perhaps. The misapprehension we laboured under was that the media would report the truth if they had access to it. In fact a newspaper has nothing whatsoever to do with the truth, it is primarily a political vehicle and is padded out with bigotries designed to increase the manipulation of its readership. A journalist is not promoted for his ability to detect and report on the truth, but to increase the sales of the newspaper. Those in a position of influence will always be those willing to subjugate principles of truth and justice in order to further their "career". I have recently refused five interviews with the press and one with BBC Radio 4. I suppose it is too much to hope that others will continue to refuse journalists, no matter how pleasant, honest or beguiling they may be, as a protest at the system itself.

9 We didn't adjust them then, and we still aren't adjusting them now. But as it happens, we barely knew most of the people mentioned.

THINGS TO DO...
and THINGS TO READ

Strutting Your Stuff
by *Digambranath*

Walking, as everyone knows, is a wonderful form of exercise, and like most wonderful forms of exercise is something most people avoid as much as possible. This is a shame, since walking also provides a good opportunity for practicing occult exercises. Here is a sample you can try on your way to the supermarket.

Posture. Examine the way your posture makes you feel. Do you habitually slouch, stoop, swagger? Try different ways of walking: cocky, casual, manic, sexy. Apply the knowledge you gain to your magical practice.

Body-centres. Once you're familiar with different postures, keep your posture upright and relaxed (not easy: try t'ai chi or the Alexander Technique if you have problems). Then try leading with different parts of the body: Don't stick them out, just imagine you are being gently pulled along by the part in question. Good ones to try are groin, belly, chest and forehead. Forget everything you've read about chakras and examine your own feelings.

Rooting. Imagine that each time you plant your foot on the ground it sends down roots. Energy comes up through these roots, rises up your spine like sap, and shoots out of your head and hands.

Sense expansion. While pursuing that elusive sixth sense we usually make a fairly pathetic use of the other five. One way to increase awareness is to concentrate on one sense only, and on a very limited range of impressions. For example, with sight stick to noticing the colour red in all its different shades. As before, always examine your physical and emotional reactions – and be careful not to walk under a bus while concentrating on your sense of smell!

Sense expansion. This is the opposite of the previous exercise. Again take one sense, but try to be aware of as much as possible simultaneously. For instance, with sight, take in your entire field of vision as one pattern; with touch feel all of your body at once. When you've been doing this for a while, try combining two senses, then three, and so on. This kind of diffused, relaxed attention is surprisingly hard to cultivate, but just a few seconds with all five senses aware and awake is enough to reveal what an impoverished simulation our normal consciousness is.

B-DOG

the British Directory of Occult Groups

The Fellowship of Isis

by *Rev. Steve Wilson, Priest Hierophant F.O.I.*

Since early childhood, Olivia Robertson has heard the call of the Goddess Isis. Her early experiences led both her and her brother Lawrence into a lifelong exploration of religion, leading in 1985 to the formation of the Fellowship of Isis. A multi-faith, non-hierarchical organisation, it has around 9,000 members in more than 60 countries. Membership simply involves accepting the Fellowship manifesto and applying; there are no fees of any sort.

As a multi-faith grouping we have no strict theology, and the Fellowship Centres (Iseums) each organise according to the wishes of their members. To give some idea of the variety involved, the forty or so Iseums in the UK include covens, feminist circles, ritual magick and ecological groups; a new Iseum in London is primarily concerned with Celtic and Arthurian traditions. In Nigeria, a single Church of Isis organises throughout Yorubaland and has thousands of members. As a third of the Fellowship's 9,000 members come from Nigeria and have difficulty in obtaining books and "Isian News" due to currency restrictions so the F.O.I. has a charitable trust to alleviate the situation. Arch Priest the Rt. Rev. Michael Okoru topped the Nigerian bestsellers list with his book *The Aour*, and his healing ceremonies are so popular they have to be held in football stadia! Some centres attempt new syntheses, such as the Church of Isis, while recently a group of Egyptians whose forebears have been practising the ancient Isian faith in secret since time immemorial joined us.

Members may be ordained into the priesthood of Isis to serve the Goddess of their choice. For instance, among the members of the Iseum I serve we have priestesses of Sekmet and Hecate, and a priest of Nuit. The title of Priest and Priestess Hierophant is given to those who have taken on a teaching duty within the Fellowship:

While the activities of each Iseum is their own concern, a series of initiations and other rituals are available. Written through Olivia, they constitute a complete liturgy and are practised in an increasing number of Iseums. It is perhaps through these that the flavour of the Fellowship is best experienced. Each ritual is magical, mystical, and religious; there is no attempt to reduce our Deities to "archetypes" or other such psychobabble. Each involves the invocation of Goddesses and Gods from different Pantheons. Working with the deities of many systems magnifies rather than dilutes the forces of each one, and I can only say that I have never felt such powerful energies in any of the many systems I have explored as those achieved in the Fellowship liturgy. The coming age is of a world culture and its essence can only be experienced through direct involvement in the world's Pagan religions.

The liturgy comprises several series of rituals. The Sophia series consists of twelve Zodiacal rituals aimed at achieving consciousness of the cosmos. The Urania series are ceremonial magical rituals for the planets, time and space, and the elements. Panthea gives eight seasonal rituals and four initiations, including a Pagan equivalent of a christening and a funeral ceremony, while Dea gives morning and evening rites and still more festivals (we like festivals). In addition, there are rites for initiation into the Fellowship, ordination as a Priestess or Priest, and the Isis wedding rite. While many centres were working groups before joining, more and more Iseums are being founded to specifically work the liturgy. Readers may be interested to know that leading members of SOL, the Green Circle, and O.T.O. are long-time members.

Since my own ordination five years ago, I have at last found what I felt was lacking in the western mysteries. What I see in the development of the F.O.I. is the emergence of a Pagan life, embracing all aspects of existence just as it does in countries where Paganism has been relatively uninterrupted, such as India or Nigeria. In the F.O.I., one can follow whatever path one chooses; there are no demands that only "our" heritage or tradition is followed. The nonsensical games that plague the "scene" are difficult to play in the context of the FOI; there are no ranks to achieve; as Initiates, Priestesses, Priests, and new members are all equal, and such positions as do exist are duties that do not bestow any special privileges. The manifesto and nature of the liturgy, and the multi-faith, multicultural, international basis of the FOI make racism and intolerance of other cultures ridiculous, and the feminine emphasis melts not reinforces the ego.

The dedication and modesty of Olivia and Lawrence and the forces that work through them put most of the scene-leaders and publicity seekers to shame. And above all, the F.O.I. delivers what it promises. Members of the Iseum I serve will attest to the peace, power, energy, and above all the reality of the F.O.I. liturgy, both during and after the actual performance of the rites.

Letter from America

Stephen Mace

HOODOO AND THE BLUES

As I mentioned last month, Voudou never really prospered in the United States due to the hostility of Protestant America to the very idea of it, and when I say Protestant America, I mean black America as much as white. From the start Hoodoo was equated with Devil worship, even by those who practised it. The pre-Haitian American blacks had been thoroughly indoctrinated with fear of the Devil, and the idea of making pacts with him was surely common. This meshes nicely with the practice of feeding the loa, and so with Hoodoo Satan became the master conjurer, one whose favour should be sought. But if Satan was on your side, you couldn't expect much help from Jesus or his Dad, and since these were the white man's gods, and the white man was the source of the misery, it was an easy choice to make if you were sufficiently up against it.

Which is to say, when blacks were well enough off to approach respectability, they gathered in Baptist and Methodist congregations to praise the Lord and thus spawn the tradition of gospel music, out of which came soul. The poorest blacks living in sharecroppers' shacks in the Mississippi Delta were the ones who took to Hoodoo, and the music they invented was the blues.

Now I don't want to suggest here that there was any direct line of descent from Voudou drumming to blues, but they were brewing in the same pot, and one could argue that blues fills many of the spiritual needs the drumming once met. Voudou has stayed most pure in New Orleans, it being sufficiently Catholic and cosmopolitan to provide a cultural armour against the rest of the Protestant south; there are even pre-Civil War accounts of public Voudou dances on St. John's Eve. Blues developed in the surrounding countryside, in the delta lands of East Texas, Louisiana and Mississippi, most directly as an Africanisation of traditional Anglo-Irish ballads and work songs. Itinerant bluesmen would travel from juke joint to barbecue, playing for dances that lasted far into the night, and from their lyrics, it is clear that they were familiar with the existence

of Hoodoo – there being frequent references to mojos, black cat bone and other implements of sympathetic magick.

One early ballad tells of Aaron Harris, "a bad, bad man" who "got out of jail every time he would make a kill, he had a Hoodoo woman, all he had to do was pay the bill." Or, in Lightnin' Hopkins' "Mojo Hand": "I'm going to Louisiana, and get me a mojo hand, I'm gonna fix my woman so she can't have no other man." In Grant and Wood's charming "Keep Your Hands Off My Mojo", the woman insists that for as long as she lives, her man better keep his hands off her lucky mojo, for as long as he does she "won't never be broke." But if he touches it she could fall in love with him, and he doesn't have "one thin dime". Finally, in "Little Queen of Spades", Robert Johnson extols the virtues of a gambling woman with a mojo, with whom he will "make our money green".

Robert Johnson was the most conspicuously magical of the old bluesmen. Born in 1914 near Robinsonville, Mississippi, he was just a child and already a competent harmonica player when he asked Son House and Willie Brown if he could sit in with them to learn guitar. House and Brown moved on before they could start teaching him, but on their return six months later, they found that Johnson had not only taught himself, but had become a local star. His career was short lived however, for he was murdered in 1938, and local legend has it that it was the Devil collecting his soul, which he had sold to obtain his skill in playing. "I went to the crossroads", his song tells us, "fell down on my knees". Since the crossroads is the sacred place of Legba, we needn't suspect that Jesus Christ was the Lord he was asking for mercy. As it was, he had to "keep movin', keep movin', blues fallin' down like hail" because he had a "hellhound on my trail"..

Another Johnson, named Tommy, who first learned the blues with Willie Brown and Charlie Patton, also took a trip down to the crossroads to deal with the Devil. He recounted the procedure to his brother Ledell, explaining that you should get there just before midnight, sit yourself down and start playing a song. "A big black man will walk up there and take your guitar, and he'll tune it, and then he'll play a piece and hand it back to you. That's the way I learned to play anything I want."

All-In Vayne

WOT, NO RIGHT HAND PATH?

Can someone please explain to me just what all this "Right Hand Path" nonsense is about? I have repeatedly read in esoteric literature about the horror with which the "Left-Hand Path" is greeted, and self styled white witches and RHP groups are forever sounding off about the evils of LHP magick. However, I've yet to find out just what the RHP adepts get up to.

I am told by various people that I'm a follower of the LHP, and from some I think this label is in fact meant as an insult? The reason for their accusation is that I traffic with non-human entities, am willing to use sexual magick, and don't run a mile when someone mentions the words Dark/Kali/Crowley/Goetia etc.

As I understand it, the whole formula of magick, expressed as accurately and briefly as I can manage, is this:

Energy is liberated by whatever is the most appropriate and effective means. At this point it is chaotic – "without form and void"[10] – if you will. This energy is then captured in some way – such as in a symbol, a mental image, or simply a powerful desire. It is then directed and released, as one might loose an arrow at a target.

This simplistic explanation serves to illustrate that in order to do any type of magick from healing, to gaining spiritual illumination, to cursing, one must know how to go about obtaining the chaotic energy. Generating and capturing this unstable power is the prerequisite for all occult work; how can you throw a pot without the unformed clay at your disposal? It is here that, I assume, my knowledge is lacking. If the LHP is such because it deals directly with these chaotic currents, then just how does RHP magick work? Indeed, is there such a thing?

10 Genesis 1,2: *And the earth was without form, and void; and darkness was upon the face of the deep. And the Spirit of God moved upon the face of the waters.*

I've been informed on more than one occasion by occultists that Crowley and Kenneth Grant, among others, were devotees of the LHP, while Marian Green and Gareth Knight et al are respectable RHP adepts. Yet doesn't Crowley refer to astral projection just like dear ol' Marion, and both Kenneth Grant and Mr. Knight talk about the use of the magick circle. So just what are the secrets of the RHP? Is it true that they indulge in obscene rites such as the "Wiccan five-fold kiss", and that they wear their pentagrams, perversely, one point uppermost?

Seriously, I think it's about time that people realised that the RHP is just an excuse for armchair magick. The "follower of the light" simply sits back, decrying the very dark forces that gave him or her their birth! The only difference between any two magical systems is the duration of the path taken. Hatha yoga and "orthodox" Wicca, for example, are methods that lead the aspirant slowly and gently to understanding. Sexual magick and Goetia are more direct and dangerous, but that is the decision of those who take these roads. We must all come to the same abysses of the Self sooner or later, and in my estimation the adept who has deliberately and systematically plumbed the depths of these caverns will be better prepared. In ignoring the dark powers on which all magick is based, the untrained, biased minds of RHP followers see them not as the Black Flames of power but the monsters of the suppressed soul.

Such an attitude smacks of Christian repression: "Ignore your sexual urges. They may be natural but they're not nice!" The RHP seem intent on building a pantheon of gods without substance, based on superficial so-called "light" imagery – a real perversity! Go into the dark regions of reality and you will find the symbol of the raven and the rainbow, the child and the corpse, the fire snake and the flower. There is no division between light and dark; the dark is the blackness of the womb from which all comes, the subconscious, the well-spring of all manifestation. Why is the word occult used for our studies? The answer is because these things are hidden: Magick is formless in the shadows of self until we call it forth. Occultism is the science and art of discovering the mysteries of these regions.

I am not, of course, saying that there is no light/dark symbolism in magick; the Qabalah, for example, is based on the interaction of negative and positive forces. But it is from the deep mind, subconscious or dark, that magickal power flows, and all methods of magick are intended to tap into these cthonian regions. Be it candle magick or Voudou spellcraft, all operations are driven by the same fuel.

In any event, from what I can see, devotees of the Right Hand Path are just cutting themselves off from the very source of magickal power. They will have only themselves to blame when, in the manner of these things, their sterile creed becomes just another dogmatic religion, self-destroying, denying its own dark heritage, and, ultimately, impotent.

Pagan *News*

PRIVATISING THE OCCULT!

A shock Report by City Editor Barry Hairbrush

The occult is in uproar after last night's controversial announcement by a government spokesman that the paranormal is to be privatised. Magic, witchcraft and the psychic world are all to be sold off and floated on the stock market.

The Minister for the Occult, Mr. Peter Tarmac, explained, "it's about time that the astral planes and their inhabitants were made to conform to market forces, and justify themselves in terms of cost-effectiveness." Included in the new reforms, I learned, was the Faustian Pact; instead of the demon being guaranteed a man's soul when he dies, the pact is now to be a "freely negotiated bargain between the parties concerned." Naturally this has upset many demons who fear for their livelihoods.

Militant

It's very worrying," admitted Arithbolorax 444 when I spoke to him yesterday, "all the big guys like Vassago and Beelzebub, the blasting and treasure finding crowd who pull in all the big contracts, they'll be fine. But the little demons who offer minority interest services (Arithbolorax paints a neighbour's front door blue every alternate Tuesday) will go under very quickly." Some demons take a more militant line. Saribaxor, a mighty duke, great of prowess, fair of appearance and head of the Cleckheaton branch of the National Union of Demons, said; "If they're not careful they'll have a national demons' strike on their hands. No more work done, no fortunes told, The entire apparatus will grind to a halt."

Shrewsbury

However some occultists are unconcerned about Saribaxor's threats. Hercules Wobble,

104, of Shrewsbury, now head of the Hermetic Order of the Nine Blades (PLC) told me, "It's high time all these buggers were made to do a fair day's manifesting for a fair day's sacrifice. When I was a lad, familiar spirits knew their place, even archangels would tip their hats to you, but no-ones' got any respect these days, they've had it all far too easy far too long! Now if you'll excuse me, I'm off out to buy a Filofax and a mobile phone before my shares drop too far." Privatisation is also affecting New Agers in America, where intelligences are refusing to offload any more information to Channellers, or transmit healing power to crystals. I spoke to "Angelflower" at her shop in California.

"Well of course a lot of us are expressing very negative emotions over this, and we're trying to find a less, you know, less confrontational approach. Some of us are anyway. Most people haven't noticed that their crystals aren't working."

Scabs

But how successful would an occult strike be? Tough new laws on-demonic protest are on the way, which would stop so-called "secondary manifesting", where demons picket covens which haven't invoked them. Also, it's likely that Chaos magicians would be able to import "scab labour" from the Greek and Hindu pantheons quite easily. Nevertheless, the government scheme seems to have run into trouble already. Nobody knows how to stop clairvoyants from using their scrying bowls for insider trading, and one sorcerer has been struck off the register for making multiple share applications for both himself and his astral body. Despite an expensive media campaign, promoting the slogan, "British Occult – Invoking for Britain", the Britoc share price seems to be very low.

Financial expert Dominic Mortgage, of merchant bank Barclays de Bleck Barsterd, said: "It's a very dodgy share. I can't see full return dividends being paid out until well into the Maat Aeon. Allied Lyons is looking much sexier if you've a few thou to spare."

So there you have it. Is privatising the occult a good idea? Are we seeing the dawn of a new era of Yuppie Occultism? Whatever the answer, one thing is certain; at least one group of people stand to make a profit either way.

This is Barry Hairbrush for Pagan News, *inside Daddy's stockbroking office.*

Famous Occult Stereotypes
by *Barry Hairbrush*

Leslie Lard – Pagan Bard

I like coming out here to sit among the trees, and watch the marvellous procession of nature's colours around me. It's at this sort of time that I write my best poetry. This is one I started last week:

Twas in the evening I did go, tra la the merry-oh,
To love the trees so tall and green, tra la the merry-een,
Round and round the gods do dance, as we Pagan folk do prance
Like the fishes in the seas, like the rabbits in the trees.

Well, I know they don't live in trees, but that's poetic license to support the metaphor. I try to make my poetry express the wonderment of being at one with nature. Come up here for Samhain? No I can't, I've got this flu you see, and the nights are too cold and rainy at this time of the year. And you won't catch me trampling through the mud and getting my sandals dirty, these were thirty quid from Next!

PAGAN NEWS

The monthly newspaper of Magick & the Occult is publication info masthead.

The monthly newspaper of
Magick & the Occult

December '89

Price 40p

O.T.O Raided!

A special report by Stephen Mace. Mea culpa, mea culpa, mea maxima culpa, and may the Lord have mercy on my soul. Back in my first "Letter from America" I assured the world that here in the U S of A the police left anything religious strictly alone. Fat chance! On 29th September 1989 the Berkeley, California police raided three O.T.O houses in Berkeley and Oakland on the most minimal cause, trashed temple rooms, arrested twelve people, and claimed to find two syringes when there were none before they came. And after the raid, over $800 in members' funds were found to be missing. Though ostensibly a drug raid, the subsequent behaviour of the police made it clear that they were out busting "Devil Worshippers".

Residing as I do in Connecticut, my information is based on communication with a friend who was one of those arrested. According to the affidavit for the warrant, the police first took an interest in the O.T.O when they were contacted by a disgruntled ex-affiliate of the Order, who informed them that the residents of the three houses belonged to the Ordo Templis Orientis, "which is involved in the worship of Satan." They were also informed that the residents were involved in the trafficking of psychedelics, narcotics, and methamphetamines. This latter drug, incidently, is the current bugaboo on the American West Coast, having replaced crack cocaine as the Prime Threat to the Social Fabric - which is to say, it's what you accuse people of having when you want a judge to grant you a search warrant. No methamphetamine was found during the raid. What was found were some hash pipes (as common in Berkeley as bluejeans), rolling papers, the two mysterious syringes, and an eighth of an ounce of marijuana. Also, a guest was charged with possession of LSD and marijuana, both found in his wallet. On the basis of this twelve people were told they had to provide urine samples or receive an automatic 90 days in jail, and then arrested for suspected narcotics intoxication and being in a place where paraphernalia is kept. Thus all the residents were gotten out of the way so the cops could do their real work - busting Satan.

As is well-known, Satan has no real place in the O.T.O.'s Thelemic system, but during the raid the temple rooms were trashed, ritual knives confiscated, and all other ritual implements spread out so they could be videotaped. The police also confiscated the papers of one member who is also a member of Michael Aquino's Temple of Set, confiscated the guest book for the Gnostic Mass, and photographed everyone's address books!

Once the arrestees reached the jail, they were given the special treatment that through the ages has distinguished heretics from mere criminals. According to Bill Heidrick (one of the arrestees) *When the six arrested at Thelema Lodge were brought with the six from Merkabah House over to the Berkeley Jail, it became immediately apparent that religious persecution was the name of the game. Our members were called 'Devil Worshippers' consistently by the jailers...Ordinary requests made by prisoners were honored by the jailers, but not identical humanitarian requests made by our folk. One of our people had*

1

O.T.O. Raided!

A special report by Stephen Mace

Mea culpa, mea culpa, mea maxima culpa, and may the Lord have mercy on my soul. Back in my first Letter from America I assured the world that here in the U S of A the police left anything religious strictly alone. Fat chance! On 29th September 1989 the Berkeley, California police raided three O.T.O. houses in Berkeley and Oakland on the most minimal cause, trashed temple rooms, arrested twelve people, and claimed to find two syringes when there were none before they came. And after the raid, over $1,800 in members' funds were found to be missing. Though ostensibly a drug raid, the subsequent behaviour of the police made it clear that they were out busting "Devil Worshippers".

Residing as I do in Connecticut, my information is based on communication with a friend who was one of those arrested. According to the affidavit for the warrant, the police first took an interest in the O.T.O. when they were contacted by a disgruntled ex-affiliate of the Order, who informed them that the residents of the three houses belonged to the Ordo Templi Orientis, "which is involved in the worship of Satan." They were also informed that the residents were involved in the trafficking of psychedelics, narcotics, and methamphetamines. This latter drug, incidentally, is the current bugaboo on the American West Coast, having replaced crack cocaine as the Prime Threat to the Social Fabric – which is to say, it's what you accuse people of having when you want a judge to grant you a search warrant. No methamphetamine was found during the raid. What was found were some hash pipes (as common in Berkeley as bluejeans), rolling papers, the two mysterious syringes, and an eighth of an ounce of marijuana. Also, a guest was charged with possession of LSD and marijuana, both found in his wallet. On the basis of this twelve people were told they had to provide urine samples or receive an automatic 90 days in jail, and then arrested for suspected narcotics intoxication and being in a place where paraphernalia is kept. Thus all the residents were gotten out of the way so the cops could do their real work – busting Satan.

As is well-known, Satan has no real place in the O.T.O.'s Thelemic system, but during the raid the temple rooms were trashed, ritual knives confiscated, and all other ritual implements spread out so they could be videotaped. The police also confiscated the papers of one member who is also a member of Michael Aquino's Temple of Set, confiscated the guest book for the Gnostic Mass, and photographed everyone's address books!

Once the arrestees reached the jail, they were given the special treatment that through the ages has distinguished heretics from mere criminals. According to Bill Heidrick (one of the arrestees), when the six arrested at Thelema Lodge were brought with the six from Merkabah House over to the Berkeley Jail, it became immediately apparent that religious persecution was the name of the game.

"Our members were called 'Devil Worshippers' consistently by the jailers... Ordinary requests made by prisoners were honored by the jailers, but not identical humanitarian requests made by our folk. One of our people had suffered an injury when he was allowed to tumble downstairs during the raid. His requests for medical examination were refused to his face. With persistence he was finally heard by an officer from another part of the building, and later released on his own recognizance. This was on the third day of his incarceration, and he had been denied his first phone call for about 60 hours."

Of the twelve who were arrested, four have had all charges dropped, whilst the rest await trial. The Order does plan a civil rights suit, but it will not be filed until all the criminal charges are disposed of – probably within six months.[1]

The clear lesson in this is that Constitutional protections only come into effect after the police have had their way, and all they need is a raving malcontent to get them started. In England the magic words appear to be Child Abuse. In the USA the word is methamphetamine. If these can be somehow intoned together with Devil worship, the spell will cause the ignorant to see only evil, even if all that is there is their own bigotry projected onto a tissue of lies.

Gallant backtracks over Ritual Abuse Statements

Sandi Gallant, the San Franciscan policewoman from whose statements and work on so-called "Ritual Child Abuse" many fundamentalist campaigners, both here and in the USA, are drawing their material, appears to have modified her views somewhat. In a letter in the Witchcraft, Satanism & Ritual Crime information manual produced by *Green Egg* magazine (Journal of the Church of All Worlds) she says:

"In approximately 1981, I began to see investigations involving perverse interpretations of occult belief systems. As this was a new field of study for myself and many others dealing with this area, I found that many of us, including myself, tended to categorize all occult beliefs in the same way... The majority of criminal acts of a ritual nature appear, at this time, to be conducted by dabblers or adolescents who don't understand the basic differences in the belief

1 O.T.O. did sue eventually, won their case, and got awarded damages. The rest of the Pagan movement could take good lessons from their example.

systems or the symbols (i.e. of Pagan/occult systems – Eds.) and only use them to satisfy their own desires or needs. To my knowledge, no evidence currently exists establishing that organised Pagan or satanic groups have been involved in criminal activity. This is not to say that certain individuals associated with such groups have not committed crimes. Certainly, within my own Christian faith, there have been many individuals who have perversely interpreted their belief in God and used it to justify criminal behaviour; however, no theory of criminal conspiracy in this area has been proven."

Sandi Gallant however, is still sure that ritual crimes exist. Over in the States, Pagans have responded to the fundamentalist campaign by coming forward and holding meetings with Law Enforcement agencies and other professional bodies. Of which, more in the January issue.

Dragon Crafts Opens to Press Barrage

A new occult suppliers (and stockists of *Pagan News*) Dragon Crafts, of Walpole Road, Boscombe, Bournemouth, has recently opened with a flurry of articles debating its existence in the local press. An article explaining what the shop was about was met by a surge of complaints from letter-writing residents, about whether the shop should be allowed to exist at all. The debate quickly turned into a subtle witch-hunt, with arguments going from the usual occult = evil to a ridiculous conspiracy theory which linked witchcraft to the Russians and the Book of Revelations. We await further developments with interest.

THIRD EYE

The Perils of Yoga!

Last issue we mentioned the numerous Christian Bulletin Boards which are being used to further the extreme views of Christian Response to the Occult, and similar organisations. One of our resident techno-Pagans, known only by his handle "Jacques de Molay" has been looking at the Christian BBS network, and after browsing through some of the information he found there, sent us this report.

Basically, a Bulletin Board is a computer-generated "noticeboard" on which messages can be posted, and most Bulletin Boards have different sections, where you can download information (files & programs), enter into real-time discussions with other users, or leave messages that can be read by other users later. There is a vast range of BBSes set up, catering for all possible tastes, including a growing network of Christian Boards such as Computers for Christ. I logged onto this board one night out of curiosity, and wandered around looking for items of interest, and found the dangers of yoga revealed in full...

In the wake of the intrusion of eastern mysticism into western culture during the last two decades, a whole spate of eastern spinoffs have caught the fancy of the western mind. From vegetarianism and Zen macrobiotics to yoga exercises and martial arts, all share a common focus: the development of the powers of the body. Some of the practices are relatively innocent; others have definite cultic overtones. The goal of yoga is the same as the goal of Hinduism – Hindu God realisation, i.e. for the yoga devotee to realise that he is one with Brahman, the highest impersonal Hindu god. The physical exercises of yoga are designed to prepare the body for the psychospiritual change vital to inculcating this idea into the consciousness and being of the person. Hence talk of separating yoga practice from theory is meaningless. From a Christian perspective, whether the two can be safely divided is doubtful. "I do yoga, but Hinduism isn't involved" is an incorrect statement. Those who do "yoga exercises" alone run the risk of spiritual pollution entering their lives.

The warnings go on to quote various "authorities" on the subject, to demonstrate the dangers of Hatha Yoga to the unwary. Among these are recognised scholars such as Arthur Avalon and Patanjali.

H. Rieker warns: "Yoga is not a trifling jest if we consider that any misunderstanding in the practise of yoga can mean death or insanity", and

that in Kundalini (hatha) yoga, if the breath is "prematurely exhausted, there is immediate danger of death for the yogi".

The basic message is that yoga is innately related to magick, the acquisition of supernatural powers, and the "false" experience of "oneness". The writers also discuss Kundalini in wholly negative terms:

Both TM and kundalini have produced the following: sexual arousal to the point of free prostitution, blackouts, surges of power, past-lives experiences, demonic and insane states, temporary respiration stoppage, astral projection, the development of "soma" occult powers including an opening to the astral world, use of the akashic records, spirit contact, and extreme paranoia. There is a similarity in claims and in description of mental states attained through the practice of both TM and Kundalini arousal (bliss, merging or unity, enhanced perception, ego dissolution, mystical contemplation, union in Brahman etc.) There are also similar practices used (mantra meditation, sensory withdrawal, nostril breathing), and finally, both involve an identity change...

The "report" suggests that Kundalini may well be a guise for demonic activity, and notes, (again quoting writers such as Avalon) that Kundalini arousal is the basis of all yogic practice and as such, yoga is a trap for the unwary that can lead into the slippery slopes of black magick! Yoga, TM and the like, are all the more dangerous because of their insidious effect on the unwary and ignorant. So don't say you haven't been warned!

A name that seems to crop up time and time again is a Dr. Kurt Koch,[2] who appears to be a Christian authority on the subject of occultism, demons and Satanism in general. We couldn't find a suitable quote of Dr. Koch's views on yoga, but here he is on homosexuality – it should give you a taste of his leanings:

"A distinction is drawn between those people who have been born homosexual and those who have been perverted. From a medical point of view, the hereditary form is not curable. Perversion, on the other hand, can be overcome. Many believers will say, "God can do miracles". I believe so too. But I have never yet met anyone who has been delivered from congenital homosexuality... Those who become homosexual in early years as a result of being led astray by others can be set free. The perversion which they have developed disappears when they are truly converted and born again."

Get the picture? But remember folks, any eastern meditation technique leads you inevitably into the ways of Satan, so anyone practising and promoting them is an enemy of fundamentalism... See you at the burning...

2 Kurt E. Koch (1913 – 1987) was a German Protestant theologian who wrote numerous (terrible) books on occultism both under his own name and a variety of pseudonyms, including *Occult Bondage and Deliverance*, which is not half as exciting as the title might suggest.

SPOTLIGHT

The Art of Magick

Una Woodruff has been described as one of the greatest artists working in the medium of watercolour alive today. She studied at art college in Newport, South Wales, and now lives in a rosy wee village in Wiltshire. As an occultist her work is as magical as that of Austin Osman Spare but far more "Pagan" in flavour. She has exhibited her work on numerous occasions, the last exhibition to date being held at the Francis Kyle Gallery in London. However most Pagans will have encountered her work in a series of books published in the Paper Tiger series by Dragons World Ltd. Her books include Inventorum Natura *(1979),* Amerant *(1981), and* Witches *(1981) with text by Colin Wilson. Her most recent work was a children's story* Catwitch *published in 1983. Naturally as a famous witch she has appeared on numerous TV shows and is something of a local legend. We sent our intrepid reporter Julian S. Vayne down to the leafy pastures of Wiltshire to find out more...*

Those who have seen the work of an artist like Una cannot help but feel they know her. Her work is a perfect marriage of the most cerebral magick and the most earthly elements. Arriving in the evening at her cottage I was not disappointed; I found Una sitting on the floor of her living room picking the grains from a rather motley looking crop of wheat. "I'm just winnowing the sacred crop," she informed me. "I grew this lot from a single ear and now it has been harvested!"

To the untrained eye the living room was as ordinary and free from esoteric clutter as one could hope, yet Una's magick was still in evidence. A copy of *Starfire*[3] lay on top of a glass case, above this hung a painting by Austin Spare, and in the case itself stood a rather strange artifact.

3 *Starfire, a Journal of the New Aeon* was a Thelemic magazine published from 1986 onwards, focused mainly on the works of Kenneth Grant and his followers. At the time of writing they are currently reprinting Grant's books, which for some bizarre reason are still popular despite being pretty rubbish.

"It's a copy of Roget's Thesaurus," she explained, "I opened it on the pages with all the words about magick and witchcraft and sowed it with bird-seed." As I looked closer I could just see the printed text; 'Witchcraft', 'Magic', 'Occultism', 'Arcane Wisdom' and spiralling between each word the fine dry stems of vegetable growth.

An important part of Una's work is attention to detail. Even the paintings published in her books ("I hate them now, they're so old!") contain minute images. Like magick as a whole; the surface of the image is bold and simple but beneath the facade are unending details, webs of complexity and half-hidden figures.

We talked not just about art but about occultism too, discussing the age-old problem of finding other (sane) Pagans to work with. Una has worked with certain Druidic groups based in the South West but does most of her magick alone.

"Sometimes I'm just like a hermit. I shut myself up to work and don't really see anybody for weeks".

This is hardly surprising as the precision in each painting means long hours of work. Una showed me her current project; a still life composition of enchantment lilies – gilded on the paper with real gold!

"This one is going to be a rich man's painting, it'll probably take about six hundred hours to finish," she said.

I asked her how important detail was to her in the magick she weaves outside of painting and drawing.

"Visualisation is vital, both in magick and to my work. I've got to be able to hold a mental picture between the object I'm painting and the paper. I also take great care with the details of my magical work". She smiled a secret cat-like grin and this precipitated a conversation about the importance of pronunciation in magick. Is it 'Sephiroth', as in "sphere-of" or as in "sef-ear-off"? And just how do you pronounce all that Hebrew stuff?

As an artist much of Una's practical magick is inextricably linked to her painting, just as Spare linked his passion with the geometry of form with his sigil system. I was led to the studio, a converted bedroom and sort of artistic variant on the Woodruff 'Witches Kitchen motif'. The room was full of boxes of photographs, drawers containing rough sketches (drawings which I would feel proud to think of as the finished article), brushes, paints, an African shaman's spear on the wall and myriad other curiosities.

"Here are my astral doorways" said Una pointing to the south and north walls respectively. On one hung a painting of criss-cross lines in tones ranging from burnt umber to crimson; the doorway of fire. The north wall displayed a far more "solid" design, a grid of squares in green and brownish yellows. Hebrew letters and occult squiggles showed plainly that this was the gateway to the realm of the earth spirits.

Many of Una's paintings, even the ones without an obviously "witchy"

content are acts of magick. She explained how she puts spells into her work.

"This was a healing spell for some friends of mine," she began, showing me a painting of a jester figure playing a pipe. The painting was a slide from her last exhibition, the whole body of the figure being composed of seed pods, grasses and astonishingly detailed flowers. "I drew the figure and then painted their names onto it and

Una sat down and pulled out an Ordnance Survey map to explain the geography of Salisbury Plain: "It's like a desert. A huge mass of chalk with hardly any free water on the surface. It all gets channelled away at the edges. "She then pointed out hundreds of barrows, mounds, and dew ponds with child-like glee. The plain was as described. The dry, chalky soil was covered with grasses dyed yellow-gold in the hot sun. The

> *"When I was a child, somebody asked me what I wanted to be when I grew up. I said I wanted to be a witch. But they said that I couldn't make money at just being a witch so I said, 'I'll be a writer then.'"*

then painted the body over the letters." So the spell is hidden from the view of both the artist and the buyer, just like the deliberate destruction of a sigil to let it implant in the subconscious of the magickian.

My time in Wiltshire was pleasantly punctuated by an interesting excursion to a place called 'Imber'. Never been there? Well that's hardly surprising. Imber is situated on Salisbury Plain; right in the middle of the 'Danger Area'. The village was very kindly appropriated by the MOD in 1939 and, like much of our past in that neck of the woods, has never been returned. However, during a brief period each year the squaddies stop playing and the public are permitted to visit the town and the many sacred sites on the plain.

open expanse, uncluttered by houses or farm buildings, made the sky seem as vast as that on the open sea. Imber itself consisted of a number of pathetic breeze-block buildings, with only a few brick dwellings still standing. In the centre of the village, on a curious mound, stood the church, still consecrated but ringed with barbed wire.

We walked around the village with a few of Una's friends, investigating the wild plants, the curious array of pottery fragments, stones and spent cartridges on the ground. Una called to us from behind an old barn building. "I found some old plough shares, very significant!" she mused. For Una this odd day-trip took on a strange significance when she met a long lost friend.

"The whole place is to do with the past. People who used to live here come back each year, united by the past. I've come here today and met someone from years ago...". I could see her train of thought and tucked one of the plough shares under my arm as a souvenir.

Later that evening we talked about the film. Following a long copyright battle *Catwitch* is to be made into a feature film in the USA.[4] For Una this is another manifestation of her art magick. It should be a great success despite the fact that in one part of the U.S. *Catwitch* has been taken off bookshelves following protests by Religious fundamentalists! Naturally *Catwitch*, with its fable about magick and faery land, must be corrupting young minds!

"When I was a child, somebody asked me what I wanted to be when I grew up." Una told me. "I said I wanted to be a witch. But they said that I couldn't make money at just being a witch so I said, 'I'll be a writer then. Or a painter'. And that's just what I've done!"

Now that's magick!

4 We don't have any record of this ever coming to pass, unfortunately.

VIEW POINT

Impressionable Worriers

by *Digambranath*

Any generation produces its ideal types, and this is as true of spirituality as of pop music. The Pagan glamour of the moment is that of "warrior." We have Inner Warriors, Chaos Warriors, Impeccable Warriors, and Rainbow Warriors – in fact with so many warriors around it is a wonder that the New Age isn't swimming in blood already. It is ironic during a period of relative peace, that such a combat-driven mentality should become popular, particularly with liberal New Agers who are often vociferous in their anti-militarism. Times of war produce collective insecurity and demands for self-sacrifice for the common good, whilst times of peace tend to produce individual insecurity and a tendency to dramatise one's own conflicts. Adopting the persona of a warrior can be a method of coping with the lack of a definable collective enemy. The ideal of the warrior is essentially individualistic; it is personal whereas that of the soldier is collective.

Those who adopt the warrior role often draw their inspiration from warrior-based societies such as the Celts. Celtic society was based on caste with power concentrated in a warrior elite and many minor wars were fought to provide slaves, plunder and entertainment. A strange object of admiration when the admirers are, or claim to be, egalitarian and peace-loving.

Native Americans are also a source of inspiration for many "warriors". For the Plains Indians, warriorhood was a matter of violence between consenting adults, where heroism was more important than victory. This enabled warfare to be a socially cohesive rather than disruptive activity, although even before the arrival of the white settlers it was already beginning to get out of hand.

Societies that no longer exist (or idealised societies that never existed) exert a great deal of fascination on the modern mind. Usually the appeal is personal heroism, which serves as a model for less dramatic conflicts. If identifying with Sir Lancelot[5] or Frodo Baggins[6] makes it easier to deal with bureaucracy or poverty then it can be a valid technique – providing the results are forthcoming. However, the idolisation of warrior-cultures tends to require a selective blindness that amounts to intellectual suicide.

An alternative source for latter-day warriors is the work of Carlos Castaneda.[7] The Don Juan novels appealed to the spirit of the 70s with their psychedelic fantasies, but the warrior element speaks directly to our paranoid present. Warriorhood in this "shamanic" system is again a personal affair, though without the usual mayhem. The ideal is to be an impeccable warrior which unfortunately is not defined very clearly, but appears to be a person whose actions are all aware and considered. This sounds laudable, but I suspect that it frequently leads merely to an increase in self-consciousness.

A common catchphrase of those enamoured of this glamour is "Warriors not victims!". I find this declaration somewhat confusing. Victims, by definition, do not choose their fate; if a bomb drops on me I am a victim whether I want to be or not. The fashionable "New Age" argument that victims create their own misfortunes (from being raped to being born in poverty) can be dismissed as moral cowardice.

I would speculate that the Warrior/Victim dichotomy is at the heart of the matter. A society where life is relatively secure engenders a passivity which then leads to an exaggerated sensitivity to threats which are either rare (such as mugging) or hard to influence (the Greenhouse Effect). That personal security depends upon impersonal forces produces a horror of becoming a victim. This in turn creates a nostalgia for the warrior who could rely on the strength of his (or her) sword arm. The Greek hero, the Medieval knight, the samurai and the gunfighter provide such models for different people. The Pagan who sneers at the machismo of Dirty Harry[8] yet glorifies some Celtic thug

5 One of the traditional great heroes of the Arthurian legends. See the movie *Excalibur* for a magnificent treatment of these myths (and ignore all of the other movies about them).

6 If you don't know Frodo Baggins by now, there is really no hope for you.

7 Carlos Castaneda (1925 – 1998) American author and charlatan. Possibly the worst writer on occultism to emerge in the second half of the 20th century. And that's a very hotly contested field.

8 The quintessential hard boiled cop hero of 5 Clint Eastwood movies between 1971-88, which the *Pagan News* team universally loved. So much so that Rodney even used a *Dirty Harry* catchphrase to introduce one of the chapters of his first book: "A man's gotta know his limitations". An important motto for magicians to remember.

is guilty not only of hypocrisy but a lack of sympathy for the powerless who derive comfort from such images of personal potency.

Having criticised the warrior glamour so harshly, it may surprise the reader when I now claim that it also has some considerable benefits. The strata of previous societies lie under our own, and are continually unearthed in our common life. To an extent we still live in Arthurian times – not the real hiatus between the Roman withdrawal and the Germanic invasions, but the mythical constructs thrown up by such cultures. Look at *Star Wars*[9] for example. To understand our own society, and hence our own lives, we need to assimilate these and other myths at a personal and emotional level, as well as dissecting them coolly. Without the former approach we risk intellectual sterility, without the latter we risk making idiots of ourselves.

You can play around with your archetypes to good effect so long as you don't take them too seriously. If we realise that we are playing a complicated head-game, we do not need to distort the past in order to idealise it. It's perfectly OK to pretend that you're Luke Skywalker, King Arthur, or The Man With No Name[10] so long as you know you are just pretending. But what about the real world? I would suggest that those enamoured of the warrior ideal – which is not without its virtues – should make a serious study of the martial arts. These deal directly with the paradox of pursuing spiritual development through the study of violence. They can also provide an appreciation of the realities of violence, as opposed to its mythic sublimation. This should result in a more compassionate and less foolhardy attitude. Last but by no means least, they prove useful if a band of warriors decide to prove their impeccability upon your body!

9 Back when this was written *Star Wars* consisted solely of *Episodes IV-VI*. It was a simpler, more innocent time.

10 Another classic Clint Eastwood character who appeared in Sergio Leone's "Dollars Trilogy" of Spaghetti Western films: *A Fistful of Dollars* (1964), *For a Few Dollars More* (1965), and *The Good, the Bad and the Ugly* (1966). All are essential viewing.

THINGS TO DO...
and THINGS TO READ

SCRYING
by *Phil Hine*

Scrying is a basic divinatory technique which helps to develop one's clairvoyant abilities. It can be performed using any reflective surface, such as a mirror, a shiny black surface, or a bowl filled with dark fluid. Gazing into the embers of a fire is another common method. Scrying requires that you be able to enter a light trance state where images arise in your mind, rather like day-dream visions, or the pictures that you see before falling asleep. The "trick" of scrying is to try to relax and let any images appear before you, gazing steadily into the medium that you are using, without staring too hard or intensely concentrating. This only comes with practice. At first it should be enough to let random images well up, and later on to try and answer specific questions.

The area in which you are practicing should be dimly lit, and lights placed so that they do not reflect in the medium you are using (candles are excellent, being less harsh than electric lights). Incense can also be a useful aid, particularly those resins & oils which act as relaxants. You may find it useful to perform a meditation or relaxation exercise prior to attempting to scry. A grounding ritual, performed before and after scrying, is also recommended.

Pathworkings designed to relax and stimulate the Deep (subconscious) Mind to throw up images can be used. Scrying can lead to drowsiness, and it is a good idea not to make your initial practice sessions go on for too long. Divinatory techniques such as these help develop the intuitive and psychic faculties, and the trick of relaxing and letting images arise in your mind is also a key to other talents such as psychometry and aura reading. Once you have tried the basic method, then regular practice will help you develop it.

The above is an extract from Two Worlds & Inbetween, *the second volume in Phil Hine's series on Modern Shamanic Techniques. This book will soon be available from Pagan News Publications.*[11]

11 You can find a scan of this original publication on the Internet if you look hard enough – feel free to download it, we won't be upset. Phil is currently working on a new, revised edition of the

B-DOG

the British Directory of Occult Groups

THE MAGICAL PACT OF
THE ILLUMINATES OF THANATEROS
by *Ian Read*

The IOT was originally a loosely connected group of individuals who were experimenting with the newly created discipline of chaos magic. A lot of readers may wonder at my use of the word "discipline"; suffice to say that much nonsense has been written about the Chaos Current, but the fact remains that Chaos is not entropy, and chaos magic is not an excuse to be sloppy about magical technique – quite the reverse.

A few years back, however, selected persons within the Chaos corpus received a letter from Pete Carroll (author of *Liber Null* and *Psychonaut*) inviting them to assist in the creation of a rather more structured chaos magic order by forming a temple in their surrounding area. An article by Pete, laying out the basic ideas behind this proposed order, appeared in *Chaos International III*. Since these early days the Pact has blossomed and now has a healthy membership in the UK, Germany, Austria, Switzerland, Italy, Australia, the USA and even the Philippines.[12]

Organisation

The basic aim of the Pact is to bring individual chaos magicians together to experiment with existing, and develop new, magical techniques, and to work hard at their own development as magicians. Hierarchy is played down, and the various grades within the Pact are only there to signify an individual's commitment to the Pact, their magical ability and organisational flair. Certainly the grades are not to be taken as a sign of supposed "advanced spirituality" etc. Senior members are each given their own personal critic who is referred to as their "Insubordinate". Each Insubordinate is responsible for making sure that the

Modern Shamanic Techniques trilogy, so keep an eye out for that.

12 From this peak it appears that the IOT has somewhat declined and at time of writing currently seems to operate only in the UK & USA.

person's teachings are understandable, that they are not remiss with their own magical work, and that their ego does not become too inflated; in short, to guard against bullshit!

Each Pact Temple is completely autonomous. We have found in practice that the individual temples have varying interests, and our computer mailbox is used as a centre for the distribution of the results of each temple's work in whatever disciplines they favour. We also have various special interest groups within the Pact, and I am currently the editor of *Chaos International*.[13]

New members are encouraged to contribute as much as possible from Day One, with no attempt being made to restrict certain teachings for certain members or suchlike. The accent is firmly upon good solid magical work, although we do like to have a lot of fun and laughter as well, magic being about improving the way we interface with this world that we have all created for ourselves.

The Pact is completely eclectic and will borrow anything from any system, providing that it proves to be efficacious. We do however lean slightly towards the more simple techniques that were pioneered in this country by Austin Osman Spare. Experience has shown that overly complicated rituals do not necessarily lead to better magical results.

We hold an international meeting every year, to which all our members are welcome, which has an equal mix of theory and practical magical workings.

13 As far as we are aware the last issue of *Chaos International* appeared in 1993. It was a fine publication, which now fetches ridiculous prices in the second-hand market.

Letter from America

Stephen Mace

BLUES, ROCK AND KUNDALINI

Our story so far: Voudou, faced with the strict dualism of Protestant Christianity, broke off from the mainstream of black American culture to become Hoodoo, the religion of those blacks most completely alienated from the white man's world. This Pagan underclass produced a characteristic music, the blues, which speaks plainly of the Hoodoo elements in the lyricist's experience. We cannot say that this music is directly descended from Voudou drumming, notorious for its ability to induce possession, but for eighty or so years after the Civil War there was a pretty clear division of black culture, and Voudou, Hoodoo and the blues were always on the same side.

At the present time in America, Hoodoo is not much seen, and I would speculate that at least in the Northern cities, those blacks drawn to this path are moving towards Santeria – whose sacred language, incidentally, is not Spanish but Yoruba. And blues is no longer the popular music with blacks; the infernal cacophony of rap[14] has taken that place. White people are the ones keeping the blues alive, keeping it alive and transforming it into that NEW THING, rock and roll.

The connection of blues to rock is well known. Early rock was a blend of blues, tin-pan-alley pop, and white hill music. Later rock of the acid variety was as often as not just a straight electrification of the blues: Cream, the Rolling Stones, Led Zeppelin, Jefferson Airplane and – with the greatest perseverance and success – the Grateful Dead, all did just what Robert Johnson would have done, had he been equipped with wah wah pedal and fuzz box. But it is intriguing that those who favoured the LSD experience chose this music to enhance it. They could have picked Beethoven or Bartok or fucking Schoenberg for that matter.

14 Note: this isn't necessarily to diss rap – your editor is listening to Public Enemy while writing this footnote. Its "infernal cacophony" is one of the things we love about it.

And Mahler is so majestic – why not Mahler on a Moog? But instead they chose electrified blues. Is there something to the music itself that makes it useful in "sacramental" situations?

We can hardly say the blues has the psychic punch of Voudou drumming; it just doesn't have the rhythmic complexity. Even so, the sonic variety gives much more than drums can, and though not so devastating to conscious control, the emotional range is greater. This sense of emotion is what distinguishes the blues lyrically from the ballads it grew out of – the intense involvement of the singer as participant instead of mere storyteller.

Robert Johnson was the first to carry this emotion into his approach to the guitar – he really was an acoustic Hendrix. But the blues form itself carries a spiritual charge even when the guitarist just strums chords, this from the way it creates and resolves strain. To exaggerate, from Robert Johnson's "Love in Vain":

When the trAAINN, it lEft the STAAtioNN, with two lights onn be-HIIND,
When the trAIN, it LEFT the STAAtion, with two lights on behind,
Weill the BLUE light was my BLUUes, and the RED light was my miIIInd.

What the music gives us is a reliable creation and release of stress, pulsating back and forth without need of lengthy development, and easily expansible so long as eventual resolution is reached – as long as the long runs are caught up sharply enough, as long as great tension is followed by greater release. In dance, this results in an irresistible urge to exaggerate pelvic motion, to move THIS way and then THAT way, and then BACK and then DOWN, and how can any Snake sleep through that? Once the Snake awakes, how far it rises is up to the individual listener/dancer, but the music's ongoing impetus is always up. And it is predictable music. Everyone knows exactly where it is going; the delight is in seeing how it gets there. And because it is predictable, it is easy to jump on and ride along. If enough people do so a group rapport is created, a free flow of energy from the musicians to the crowd and back again, the whole thing amplified to the extent that there is no limit to the amount of enthusiasm that may be generated.

We all have similar psychic anatomies. Certain types of music affect certain centers. With the Snake awakened, our task now is to pull it all the way up and crack it through the top of the skull to let fall the Light Fantastic. Then must the old time be finally swept away, and the Crowned and Conquering Child enthroned.[15]

15 Yet another reference to Crowley's *Book of the Law*. That thing manages to worm its way into everything.

...And now, brought to you exclusively from the House of Hairbrush

THE BARRY HAIRBRUSH YULETIDE GIFTS COLLECTION

Inflatable Archangels

For people who can't visualise very well. Inflate at suitable points during the ritual. From the same line as our ever-popular Blow-up Baal and Lilith Li-Lo.

£5.99each.

"Be a Cult Shaman" kit.

Includes bodypaint, fungal hallucinogens and a dead animal on a stick.

£4.99.

Golden Dawn Action Figures!

Perfect for the kiddies this Yuletide. All your favourite characters from the popular magical order in 8 inch high fully poseable figures. Will A.E. Waite win the eternal battle of good and evil? Can Aleister Crowley rescue the beautiful princess Leah from theevil Count Macgregor? Only you can decide - with Golden Dawn Action Figures!

Action figures £1.99

Castle Boleskin £14.99

"Possessed by the Devil" make-up set - Fool your vicar this Christmas!

£1.99

"ADANATH" T-shirt

Shows who's been raising *your* kundalini!

£3.99

Barry Hairbrush's controversial book "The Turin Underpants"

Just how was Crowley's face imprinted on them? A fascinating piece of historical research.

£5.99

Orgone-permeable Condoms

For those "tantric" moments in your life. Lets the *real* juices flow! *Not for sale in U.S.A.*

99p for three.

Wicker Man Barbecue

Perfect for those pagan picnics, our uniquely styled outdoor stove fries or grills burgers, sausages, steaks and police inspectors. And at our special price, you don't have to make sacrifices with the cooking budget!

£14.95

note: planning permission may be required before use

His 'n' Hers Magical Robes

Each one embroidered with your name. Choose from plain/wiccan/cabalistic)egyptian print patterns.

Washable terylene.

£9.99 each £15.99 matching pair.

Crowley Cosmetics

Aleister's famous "Perfume of Immortality" in a chic new aftershave for men. Also available in toilet soap, shampoo, hair gel, body lotion, talc, shower gel and an ozone-friendly underarm deodorant!

We're "perplexed" that we didn't think of it sooner - get some for the *Beast* in your life.

From £2.99.

SWORD OF DAMOCLES HOME SECURITY KIT!

ARE YOU

Worried by burglars/Religious Loonies/ Investigative Reporters? Afraid to leave your home? Well The Sword of Damocles will *Banish* all your fears. Just set it up andleave it to guard your home.

MY LITTLE KALI

Fully bendable Kali, complete with skulls, swords & realistic entrails and *REAL, GROWING HAIR!!*

Available seperately, ACTION SHIVA comes with trident, glow-in-the-dark third eye, and sacred herbs.

£4.99 each.

SWISS ARMY ATHAME

As used by Olive Twitch, famous "trad" Witch! Its thousands of useful features include:

- Built-in corkscrew
- Fully-extendable wand
- Compass (*end those 'which way's North?' moments*)
- Dual-purpose laser beam (*for impressive Watchtower invocation & silencing noisy neophytes*)
- Beeps when dropped in the ground
- hook for prising self-appointed spokespersons apart from reporters' microphones
- a snip at £22.50

MEDICINE WHEELS

Cough Sweets for those Winter Sniffles. With added peyote for that "get up and fly" feeling!

New Age Personal Organiser

...Sorry we couldn't find one that worked.

PAGAN NEWS

The monthly newspaper of
Magick & The Occult

March \ April '90
Price 40p

Bare Faced Lies!!

Just when you thought the 'Satan ate my baby' fuss had died down, back it comes into the headlines, and this time it's the NSPCC as the mouthpiece, talking about *ceremomies in which children wore masks, were given alcohol and made to inject adults with drugs* - in other words, all the usual hype from the fundamentalists concerning 'ritualistic child abuse'. As if this wasn't enough, on the 13th March, Dianne Core was given a five-minute slot on Radio 4's, "Today" programme (incidently, this is our dear P.M's favourite radio programme) According to Ms Core, "*thousands* of children *all over the world*....as young as 2-3 years old...babies born into covens, not registered & then sacrificed...children forced to watch little animals sacrificed...children kept in cages and fed soft drugs." In other words, a clever tirade of emotive buzzwords. When asked what proof Ms. Core had for all of this, she actually admitted that there wasn't any, but "if it happens in other countries it's bound to happen here!" Also, she said, they have 'evidence' of children's drawings of sacrifices." The whole thing could be laughed off if it wasn't so frighteningly well done. The Yorkshire Evening Post for example, on the day of the NSPCC press release ran the cryptic headline **Children and Satans of Sex - Bizarre Rites Revealed** The 'report' consisted of the usual veiled references to drugs, pornography and children being forced to drink blood and urine - as usual there was no solid evidence. Thanks to the good offices of Chris Bray and the S.A Legal Fighting Fund, the NSPCC are fully aware that there is no proof of the claimed links between Satanism and child abuse. They have also been sent a definitive FBI report which categorically states that

Satanic Crime does not exist and is the result of hysterical scaremongering by extremist fundamentalist groups. All the NSPCC has managed to do is reinforce the growing tide of ignorance and fear, and given the right-wing fundamentalist groups further ammunition.

Diane Core in Link to U.S. Right?

An interesting piece of news has come our way via our American correspondent, Stephen Mace. Apparently one of the more vociferous of American anti-occultists is Lyndon LaRouche. LaRouche has many strange beliefs, including the idea that the F.B.I is a "front organisation" for the O.T.O, and that Queen Elisabeth is the head of an international drugs ring. LaRouche has a front organisation based in California called the Schiller Foundation, whose newspaper, *The New Federalist* has been running attacks on the O.T.O, Temple of Set and other groups for some issues. As a test, the Californian branch of the O.T.O fed the Schiller Organisation some inaccurate addresses for an O.T.O lodge - addresses which subsequently turned up in one of Diane Core's harangue's against satanic groups such as the 'O.T.O'. *The new Federalist* also believes that the O.T.O is under "*high-level protection from Soviet intelligence.*"

More evidence for a definite link between Dianne Core and Lyndon LaRouche is emerging. Last spring she attended the Rome conference on Child Abuse, which was organised by LaRouche. The text of her speech (see the current copy of *ORCRO* magazine) makes it clear that she, and others, clearly see themselves as waging 'Holy

March/April 1990[1]

NEWS

Bare Faced Lies!!

Just when you thought the "Satan ate my baby" fuss had died down, back it comes into the headlines, and this time It's the NSPCC as the mouthpiece, talking about ceremonies in which children wore masks, were given alcohol, and made to inject adults with drugs – in other words, all the usual hype from the fundamentalists concerning "ritualistic child abuse". As if this wasn't enough, on the 13th March, Dianne Core was given a five-minute slot on Radio 4's *Today* programme (incidentally, this is our dear P.M's favourite radio programme).

According to Ms Core, "thousands of children all over the world... as young as 2-3 years old... babies born into covens, not registered & then sacrificed... children forced to watch little animals sacrificed... children kept in cages and fed soft drugs." In other words, a clever tirade of emotive buzzwords. When asked what proof Ms. Core had for all of this, she actually admitted that there wasn't any, but "if it happens in other countries It's bound to happen here!" Also, she said, they have "evidence" of children's drawings of sacrifices. The whole thing could be laughed off if it wasn't so frighteningly well done. For example, on the day of the NSPCC press release the *Yorkshire Evening Post*[2] ran the cryptic headline **Children and Satans of Sex – Bizarre Rites Revealed.** The "report" consisted of the usual veiled references to drugs, pornography and children being forced to drink blood and urine – as usual there was no solid evidence. Thanks to the good offices of Chris Bray and the S.A. Legal Fighting Fund, the NSPCC are fully aware that there is no proof of the claimed links between Satanism and child abuse. They have also been sent a definitive FBI report which categorically states that Satanic Crime does not exist and is the result of hysterical scaremongering by extremist fundamentalist groups. All the NSPCC has managed to do is reinforce the growing tide of ignorance and fear, and given the right-wing fundamentalist groups further ammunition.

1. Yes, there are two months missing. By this stage Rodney was almost continually on tour with The Cassandra Complex and spending most of his time in Germany, so Phil was shouldering most of the editorial burden himself. Getting *Pagan News* out on our regular monthly schedule was becoming increasingly difficult and by later in 1990 we had to go to a bi-monthly schedule, unfortunately.
2 The *Yorkshire Evening Post* was founded in 1890 as a local daily newspaper serving the Leeds area. At its height in the 60s to 80s period it had a circulation of well over quarter of a million readers. That's now been reduced to barely 10,000, thanks to the Internet.

Dianne Core in Link to U.S. Right?

An interesting piece of news has come our way via our American correspondent, Stephen Mace. Apparently one of the more vociferous of American anti-occultists is Lyndon LaRouche. LaRouche has many strange beliefs, including the idea that the FBI is a "front organisation" for the O.T.O., and that Queen Elizabeth is the head of an international drugs ring. LaRouche has a front organisation based in California called the Schiller Foundation, whose newspaper, *The New Federalist* has been running attacks on the O.T.O., Temple of Set, and other groups for some time. As a test, the Californian branch of the O.T.O. fed the Schiller Organisation some inaccurate addresses for an O.T.O. lodge – addresses which subsequently turned up in one of Dianne Core's harangue's against satanic groups such as the "O.T.O.". *The New Federalist* also believes that the O.T.O. is under "high-level protection from Soviet intelligence."

More evidence for a definite link between Dianne Core and Lyndon LaRouche is emerging. Last spring she attended the Rome Conference on Child Abuse, which was organised by LaRouche. The text of her speech (see the current copy of *ORCRO* magazine) makes it clear that she, and others, clearly see themselves as waging "Holy War" against Pagans, players of fantasy role-playing games, alternative medicine practitioners, etc. etc.

Further to the great O.T.O. raid we reported in the December issue, it is expected that the drugs charges laid against O.T.O. members will be dropped. It is expected that a civil case on behalf of those arrested will follow.

LHP Sauce?

Ace of Rods, the long-running Pagan contacts magazine has recently been taken over by Nigel Bourne & Seldiy Bate, who also run *O Fortuna*. A letter with the current edition informs us that the editors will no longer accept advertisements which contain "certain wordings", which include "Satanist", and LHP. This, they say, is not a judgement on anyone's path or beliefs, but a means of making sure that *Ace* does not come under criticism by "fanatics" and "the press". In other words, It's not us, It's them over there who"re to blame" all over again. The whole RHP/LHP distinction in the first place came from Mme Blavatsky & Co. who, when bringing Asian wisdom to the west, thought that the Bhakti-oriented cults of the Indian RHP were morally superior to those of the LHP who, rather than having degenerated into a priest caste, still practised the ancient tantric arts of liberation through involvement with the world, rather than asceticism. In other words, they were still exploring magick rather than pursuing devotional rites. Modern

exponents of the LHP relate the current to the survival of stellar & draconian lore, Voodoo, Tantra, and women's mysteries.

As far as *Pagan News* is concerned, anyone can place a contact ad – it will be treated as a classified advert and letters sent c/o *PN* will be forwarded on. Your "path" is your own affair, but people who can still divide other occultists into those in white hats and those in black hats have more in common with the fundamentalists than they may care to admit.

Occult to Go I.T.?

Good news for techno-Pagans is the plans under way to set up at least one electronic Bulletin Board node specifically for the use of occultists. Ironically enough, this idea was enthused by your *Pagan News* editors a couple of years ago, but it largely fell on ears that were deaf, or who suffered from techno-fear. That of course, was before the "summer of hate" in '89 which netted over 300 anti-occult articles in the press. Now there is a much more realistic perception of the need for email systems. After all, the fundamentalists have a very well-organised approach to email, which has a worldwide scope.

The S.A.F.F. is currently exploring the possibility of setting up a bulletin board system open only to registered users. The possibilities offered by such a set-up not only relate to constantly updating information on anti-occult activity, but also a chance to open a central magical research archive, a "safe" place for contacts, specialised interests etc. There is a very high proportion of Information Technology professionals who are also keen on the possibilities offered by computer mail, such as the fact that It's cheaper & quicker than the post, and no one can intercept it.[3]

A second proposal comes from the editors of *ORCRO* magazine. They are looking into the possibilities of setting up a node for MAGICKNET, which is a large occult-oriented network that links magicians & Pagans across the USA. Recent contacts between MAGICKNET and UK techno-Pagans had led to unfolding of the Dianne Core – Lyndon LaRouche connection discussed above.

A Warning!

It has come to our attention that fundamentalists who are engaged in direct action to suppress Pagan/occult activity are infiltrating local moots, public events and also harassing Pagans by "nuisance dialling". They are getting information by

3 Oh, how naive we were… as we should all know now, email is trivially easy to intercept and these days is done on a daily basis by most governments.

the simple expedient of buying newsletters and magazines, and looking through columns such as our "Events" listings.

Now we are not going to stop listing events & meetings – this would only further the fundamentalists' cause. However we would advise people to exercise a little caution when approached by "interested strangers" at moots and so forth. This is how Gerald Suster *(PN passim)* was "exposed" by The *News of the World*. If you're not sure about "seekers", try asking them what they think about Christ as a spiritual teacher. Similarly, paranoia isn't the answer – developing a sense of *discrimination* when dealing with people is. See it as a time to put your "psychic senses" to the test.

Student Pagans Get Going!

Over the last year or so we have seen a growth in the number of university/ polytechnic Pagan Societies, indicative perhaps, of a healthy growth of interest in Pagan values and esoteric wisdom. A group at Lancaster University recently held, in conjunction with the Pagan Federation, an "Earth Healing Day" presided over by Vivianne Crowley. The event began with a short talk by Dr.. Crowley concerning The Craft, followed by a series of guided meditations and chants, culminating in a performance of the Farrars' *Ritual of the 13 Megaliths* – a very impressive performance by Dr.. Crowley, who led the proceedings without being overly dominating, nor forgetting her sense of humour. Afterwards, there was general socialising and conviviality. All in all, an excellent event – hopefully the Lancaster group will be spurred on to further heights of excellence!

Incidentally, Cambridge University Pagan Society are proposing a network of Pagan Societies in establishments for further education. Such cooperation and exchange of ideas can only be welcomed, although doubtless the paranoiac Reachout Trust will cry that Devil worshippers are taking over the universities.

Pagan Federation Joins Festival of Faith

A late report held over from last year. The Pagan Federation presence at the Canterbury Festival of Faith & the Environment was a quiet success. Despite threatening rumblings from the extremist Church Society, the PF event, discreetly tucked away in a car park, had no problems, with the "Earth Healing" ritual taking place before an audience, including some no doubt bemused Japanese tourists. That the PF were given a place on the programme shows that tolerance between Church & Pagans can be a reality. The Pagan Federation has also produced an information pack for liaison with local press and other groups. Mainly covering Paganism & Wicca, it is available from The Pagan Federation.

S.A.F.F. Update

The latest news from the Sorcerer's Apprentice Fighting Fund is that contributions to the Legal Fund are growing steadily and several small successes have been won. These include correspondence with the Oxford English Dictionary over the usage of various occult terms; overturning some of the rubbish written about Samhain which was posted on a large bulletin board on Microlink,[4] and the beginnings of an indemnity plan to pursue claims of unfair dismissal which may arise from fundamentalist activity.

We'd recommend that *all* our readers donate a couple of quid every so often to the S.A.F.F.. If you send in a large SAE and a couple of 20p stamps you'll get the S.A.F.F. newsletter. An "Action Pack" is also available, giving suggestions about how *you* can get involved with countering the fundamentalists at whatever level you feel able.[5]

We're Back!!

If you've been wondering where *Pagan News* has been this past two months, then read on. Over the Yule period the computer system used to typeset *Pagan News* had to be replaced, and seeing that these machines don't just fall off trees, alternative arrangements had to be made. Also, Janet "Madame Guillotine" Cliff has retired from the editorial armchair, the strain of working in a high-pressure job and coming home to a high-pressure newspaper meant that something had to go. Also, due to a variety of changed circumstances, some of our other regular contributors will be taking a well-earned rest.

Also, we're still having problems with laser-setting & production, which is why the March & April issues have been run together. There's no doubt that *PN* will continue, but things may be a little shaky for a while. Normal service will be resumed as soon as possible. In the meantime we'd like to thank everyone out there in readerland for the messages of support, continued subscription, and patience while we've been getting sorted out.

4 Microlink was an early pre-World Wide Web online information service.

5 We are fairly sure that the S.A.F.F. no longer ships these out, but if you browse through their rather lurid and confusing website you can probably find all sorts of interesting stuff. http://www.saff.ukhq.co.uk/

EDITORIAL

Ritual Child Abuse – The Convenient Heresy
Phil Hine

"Painful to live in fear, isn't it?" That's what it means to be, in the eyes of society, a heretic; an outsider. There's a lot of us about, and in case you had any doubts about the subject, there's a recruitment drive on. Not satisfied with the old standards: women, black people, those of us who go "against nature" by not being heterosexual, or not settling down into a family unit – well they're still there, but the latest ones are these so-called Pagans and occultists. Corrupters of children and disciples of the Devil, the lot of them. And some of them are women, and some of them are gay – polluting souls as well as bodies. The recent revelations concerning the physical & sexual abuse of children have rocked the country. Look at the two groups who have actively sought to pin the blame on Pagans – the fundamentalists and the Press. Ever wondered why this might be?

The fundamentalist lobby have long been calling for a return to "Christian/ Victorian values". These are the people who continually point out that Britain is a "Christian" nation – where It's being revealed that 1 in 10 children suffer some kind of abuse. Now surely, society can't be at fault can it? So a moral scapegoat must be found. The Press too, have leapt to seek out the Satanic conspiracy – that way they don't have to face the bitter truth that our society is falling apart, and that the constant diet of lip-licking prurience that they've served up hasn't just been harmless fun. Despite the mammoth wave of hysteria on both sides of the Atlantic, hard evidence to support the "conspiracy" of child eating/raping Satanists is decidedly flimsy.

So where did the notion of a "satanic conspiracy" come from? In a 1985 interview, Sandi Gallant proclaimed that "Satanism is the cult of the 80s..." A fateful comment, to say the least, but the Satan-cult scare-stories go back much further. The first eruption of rumours came with the publication of Ed Sanders" *The Family* (1971), which explored the events surrounding Charles Manson, and described several "sleazo inputs" – groups which practised ritual murder & orgiastic rites. In particular, The Process Church of the Final Judgement and the O.T.O. were implicated. The Process went to court over the allegations, but the damage had been done. More recently, the O.T.O. won an out-of-court settlement with the publishers of Maury Terry's *The Ultimate Evil*, in which the O.T.O. and an offshoot of The Process are implicated in the Manson killings, the Son of Sam slayings, and others.

PN regulars will recall the Gerald Suster case – Suster is a member of the O.T.O., and they were the subject of some of Geoffrey Dickens' more ridiculous

pronouncements. Kevin Logan, in his *Paganism and the Occult* (1988) says that charts in his possession reveal that the O.T.O. is "a worldwide network of undercover occultism", adding that "The O.T.O., founded by freemasons, has much to answer for in the last eighty years." It seems ironic that the addiction that some occult groups and cults have to giving themselves long historical antecedents is beginning to backfire, as fundamentalists are using these (often dubious) histories to demonstrate evidence of satanic conspiracy. The image being put across, by journalists such as Tim Tate in Britain and Ted Gunderson in the States, is that of a worldwide network of Satanic practitioners that the

> *"It seems ironic that the addiction that some occult groups and cults have to giving themselves long historical antecedents is beginning to backfire, as fundamentalists are using these (often dubious) histories to demonstrate evidence of satanic conspiracy."*

police, courts and social services are powerless to do much about. There are also the numerous "Survivors of Satanic Abuse" to consider – I'll be taking an in-depth look at this issue another time.

It's also important to consider the language of the reporting – the alleged rituals are only vaguely described, often in terms of being "unspeakable", "bizarre", or "horrific", to distinguish them from "ordinary abuse", as though any other kind of child abuse is somehow not as important, or that only Devil worshippers are capable of such offences. Alas, there's no real evidence to support this, but It's easier for people to think that evil Satanists are to blame, rather than members of our own families or friends. Studies of child sex rings in Leeds for example, reveal that in some cases, the children's parents knew what was happening to them, and that children were recruited into the rings by men acting as unofficial baby-sitters, or through the children of friends and neighbours. Where one draws the line at "bizarre" acts is also difficult to see. I remember as a student therapist coming across the case of a man who, as a way of punishing his three-year old son, placed him in a hot oven! Very often, the so-called "Satanic" rites cannot be revealed because there is nothing concrete to reveal that would stand up to cross-examination. It's easier to shift the guilt by using "outsider" terms like Satanist or paedophile – by doing this we don't have to look at the unpleasant idea that the problem lies in the roots of our social structure, not in the hands of some "evil" conspiracy.

In researching Satanism as a historical phenomenon, what becomes clear, time and time again, is that the people responsible for spreading the most information

about the subject are the churches and the press, from the *Malleus Maleficarum*,[6] which made it a heresy not to believe in Satanism and witchcraft, to the *Sunday Sport*, which has fearlessly "exposed" Satanists, whilst carrying adverts for pornographic videos with "Satanic" themes. This isn't just an example of media doublethink, but again demonstrates the complexity of "organised" child abuse. A recent study of child abuse cases from Canada concludes that, though there is little evidence to support allegations of "Satanic cults", there is evidence to indicate that children were being exploited by pornographers using Satanism as a theme. Moreover, some of the testimonials of so-called "child victims" of ritual abuse have been revealed to have been worked up from watching horror films. Indeed, some of the common themes that crop up in media stories: girls being used as "breeders" for covens, whole families of satanists, and wide networks of abusers, are all themes which crop up in the 1968 production *Rosemary's Baby* (in which the part of the Devil was played by Anton LaVey),[7] and numerous B-movies.

Hence another factor. On the one hand there is the credulity of the self-appointed "experts" concerning children's knowledge of "black magick" – which is hardly surprising given the vast amount of literature and films devoted to the subject. And on the other, the possibility that there are both individuals and groups who are drawing upon the vast pool of information for inspiration in perpetrating criminal acts. Arthur Lyons, an American researcher into Satanism, describes what he calls adolescent Satanists, whose acts – graveyard desecrations and the like – are concerned more with rebellion and thrill-seeking, rather than acts of ritual worship. Heavy metal music is another strand that figures in the fundamentalists" arguments, and the conviction that the music industry is controlled by satanists has been circulating in Christian circles for decades. In a debate between Leeds University Occult Society and the Campus Crusade for Christ, a spokesman for the Crusade stressed that not all rock music was Satanic – only that which had direct references to black magic. To which a certain Rodney Orpheus replied "What about Cliff Richard's 'Devil Woman' then?"[8]

6 The *Malleus Maleficarum* or *Hammer of Witches* was written by Heinrich Kramer and first published in Germany in 1486. Although even in its own time it was condemned by other leading theologians, its lurid descriptions of Pagan and Satanic practices, and its endorsement of torturing and executing witches, made it a popular book for centuries after, and it has influenced popular views of witchcraft up until the present day.

7 *Rosemary's Baby* (1968) written and directed by Roman Polanski, starring Mia Farrow & John Cassavetes, based on the novel by Ira Levin. Now regarded as one of the greatest horror movies ever made, it was also in many ways responsible for the creation of the Satanic Baby Breeder myth in popular consciousness. It's definitely a movie that every horror fan should see. However the story that Anton LaVey played the Devil has turned out to be an urban legend – LaVey said he did, but modern evidence shows this was an untrue claim.

8 "Devil Woman" was released in 1976 by renowned British born-again Christian singer Cliff Richard. It sold 2 million copies worldwide. Someday Rodney will record a cover version.

Another group may well be called the D.I.Y. diabolists – people who, isolated from the mainstream occult and Pagan subculture, construct their own belief systems out of the media-given information pool, and enact what they *believe* to be "Satanic" rites. Which is not to say that everyone who watches a video of *The Devil Rides Out* is in danger of indulging in orgiastic ceremonies. Since the whole anti-occult trend started, various factions have complained that It's not "real" witches, etc., that are responsible for the bad publicity, but people appropriating the symbols, language, and the concepts of occult and Pagan beliefs, often using them as a justification, or framework, for acts of control and abuse over other people. It's easy to absolve yourself of personal responsibility by shifting the onus onto a "higher" authority; be it Satan, God, or for that matter, the government. However, such is a prerogative for anyone in our society, given its structure, not just the fundamentalist or divinely-inspired killer.

Perhaps on this point we are approaching the root of the fundamentalists" (and their allies") fears – the erosion of social control. At the core of Pagan and occult philosophy is the concept of self-determination; that morality comes from within the individual, rather than being imposed by external agencies. This is a huge issue which requires close attention, so having made the point, I'll move on.

At this point, it should be clear that the whole issue of "ritual child abuse" is much more complicated than it first seems. There's the appalling reality of the scale of child sexual and physical abuse in our society – for which the increasing evidence is being stifled by mechanisms for denial and shifting the blame to "outsiders". There are the individuals who are making political and religious weight out of the issue and, no doubt, lining their pockets too. Then there the people caught in the cross-fire; one section of whom are the Pagans & occultists who are a part of the slide in moral values towards self-determination and the "right" to question the rule of God and state, seek alternatives, and most damning of all, strive to enjoy our sexuality, unencumbered by guilt, prurience, and prejudice. Kevin Logan has stated on many occasions that he is worried about the role of sex in Pagan/occult beliefs. The alternative appears to be a set-up where the people with the power can fuck over the people without the power. Look not to devils to explain evil, but to the society which breeds them.

So where does this leave us heretics? We can seek escape routes, go underground, or pretend that It's none of our concern. Or, we might begin to use our visions, knowledge, magick – call it what you like – in trying to do something about it. Or is the posturing of masters, adepts, initiates and shamans so much hype after all? There are no easy solutions – but this doesn't mean that there aren't any solutions at all.

THINGS TO DO...
and THINGS TO READ

Pentagram Meditation
by *Andy Morris*

Draw a pentagram on a piece of paper. Look at it, relax and see what comes into your mind. Consider the following:

The uppermost point represents human awareness.

The other four points symbolise the four elements.

The connecting line is the energy of life itself, unifying and connecting all things.

The pentagram symbolises your desire to be in harmony with the forces of nature, to be able to express your spirit through whichever element you choose. Try imagining yourself at the top point of the pentagram, connected to all the elements by a universal thread. Now spend a little while thinking about each element in turn as an aspect of your personality.

When you think of fire, think of all the things that get you excited or enthusiastic. Think about your own power as a human being.

When you think of air, think about yourself thinking. Notice the way you can detach yourself and see life from an analytical, intellectual perspective.

When you think of water, think of all your emotions. Sadness, joy, yearning and your intuition, those unspoken shades of feeling.

When you think about earth, think about your physical body. The qualities of determination and discipline that you must develop also.

Consider the way the pentagram connects these facets of your being. Your Will (fire) with your intellect (air), your emotions (water) all manifesting through you (earth), to form a whole (spirit).

Further Reading

An Introduction to the Mystical Qabalah Alan Richardson[9]
The Book of Celestial Images A.C. Highfield

9 This is a short (less than 100 pages) basic intro to the subject, which like most of Richardson's work is heavily indebted to much better authors. Try the introductory books by Dion Fortune, Gareth Knight, or Frater Achad instead.

B-DOG
the British Directory of Occult Groups

The Order of The Cubic Stone

1988 saw the 25th anniversary of the OCS; during the accompanying celebrations the Order's head and co-founder, Robert Turner, was not too modest to make comparison with the much-documented Order of the Golden Dawn which lasted for only 14 years.

The OCS grew as a teaching order, evolving its own style and store of wisdom. Beyond this, however, the Order has always been dedicated to practical research into ritual magic, and it is here that its main strength lies. While a large number of students have passed slowly through introductory programmes, a smaller number remain to form a slowly-changing core membership. Most of the Order's current key members have been with the OCS for more than 10 years.

While the basic Hermetic/Qabalistic teachings have not altered much over the years, there have been a number of upheavals in the way the group has been organised internally. Before the advent of so-called chaos magic, the OCS underwent a period of "total democracy": there were no grades nor hierarchies, all information was equally accessible to all members, and there was no further attempt at structured teaching or assessment. This was a heady period, but suddenly, nothing happened. Members became bored with the almost total lack of developments. Thus, in the early 80s there was a unanimous vote to restore a degree of structure, one with three grades of membership, following which the Order regained its creativity and dynamism.

The OCS regards itself primarily as a research order, but students are required to complete a structured training programme before acquiring access to the inner resources of the Order. This has the practical advantage that all members are versed in the same ritual techniques, essential when performing work in a new, untested or dangerous area. It also gives tutors the ability to assess students'

319

progress by contrast with years of accumulated wisdom, enabling them to offer down-to-earth advice. The second grade – which usually lasts from 2 to 4 years – leads the student through Planetary and Zodiacal Magic, Geomancy, the Shemhamphorasch, the Qlippoth, Spiritual Alchemy and a complex ritual based on John Dee's Enochian magic. Students who have completed the first two grades are encouraged to establish their own research projects and to share their results with the Order. Recent projects have included innovative work on the lunar mansions, runes, magic squares, and a Hebrew planetary-metallic system known as Aesch Mezareph. Four members recently spent a week in a remote Elizabethan manor practising an entirely new ritual system based on the Nahua ("Aztec") pantheon.

For many years the Order communicated its thoughts and findings to the outside world through its regular journal *The Monolith*. The last issue was published in 1983, but an internal magazine *Labrys* continues to be produced and we hope shortly to publish a volume of recent papers by members of the Order. Meanwhile the literary and artistic efforts of several members have been taken up in producing *The Heptarchia Mystica of John Dee* and *Elizabethan Magic* (the latter, by Robert Turner et al, is published by Element Books, whilst the former is due for reprinting by Element Books – Ed). These two titles indicate the area for which the OCS is probably best-known: the Angelic magic of the Elizabethan John Dee. This difficult and obscure field has long been the speciality of Robert Turner, though even he admits that the remaining manuscripts contain many enigmas yet to be resolved.

The OCS has a notional maximum size of 25 members and has continued to tread its rather idiosyncratic path for nearly 27 years now. It is a small, select, supportive group of women and men who share a remarkable capacity for drinking red wine and an unswerving commitment to ritual magic as a means to spiritual fulfilment; though within this prevailing ethos a wide range of views is encompassed. Generally the Order sticks to the Western Esoteric tradition, avoiding world-hating mysticism and "psychological" interpretations of magic, treating both angels and our emotions as aspects of reality. We don't evangelise or mix much in occult circles, and we don't set out to create any particular sort of image. We work hard, compare results, and seek to commune with higher intelligences.[10]

10 From what information we can gather, Robert Turner was attacked and severely injured in the early 1990s, and has now passed away. The OCS appears to have become effectively defunct since then.

LISTEN TO THE EARTH

One of the **LISTEN TO THE EARTH** projects will take place on **April 9th 1990, (Full Moon Rising) between 9pm and 11pm.** *Pagan News* will be co-ordinating a mass raising of energy, with the intention of increasing awareness of Ecological issues, and how we can promote change in accordance with our ideals. Power may be raised by meditation, dancing, chanting, music, prayer, ritual or any kind of celebration, so choose your favourite way of raising power and join in! THE ACE OF CUPS IS THE SYMBOL CHOSEN TO ALLOW EVERYONE PARTICIPATING TO FOCUS THEIR ENERGIES INTO THE FLOW.

The Ace of Cups symbolises the power of Love, Inspiration, Creativity, Ideals and Nurturing Growth.

9 APRIL, 9-11PM, FULL MOON RISING

FULL MOON 10 APRIL, 4.20am.

Moon 20⁰ Libra

Under Heaven nothing is more soft and yielding than water,

Yet for attacking the solid and strong, nothing is better.

It has no equal.

Lao-Tzu, Tao Te Ching

Please help our endeavour by adding your energy to the flow. Thoughts are like water - a few drops may pass unnoticed, but enough of them flowing together becomes a river. In celebrating together, we can focus our energie so that we create a great wave of power, reaching out across the world. Our aim is to raise awareness of Ecological issues, and so promote the changes neccesary to ensure the survival and recovery of our world.

9pm

Live your beliefs and act. Knowing that what you do will make a difference. This will turn the world around.

11pm

PLEASE HELP BY DISPLAYING, PASSING ON, OR COPYING THIS POSTER

Ace of Cups image by *Sheila Broun*

PAGAN NEWS

The monthly newspaper of
Magick & The Occult

May '90

Price 50p

Malleus Maleficarum: The Sequel?

While the gutter press continue to salivate over continued scare stories of 'satanic child abuse', a more sinister level of the fundamentalist campaign of attacks on occultists has been playing itself out in the corridors of Whitehall. The S.A.F.F. have recently revealed the existence of a 'parliamentary committee' being chaired by Dame Jill Knight MP (Conservative, natch') who were being fed information by a researcher for the Cook Report. This committee is both unoffical and private, and will accept any biased information it wants to in order to produce a report which can be then used to press for an 'offical' investigation of the subject. This could well lead to fundamentalist-inspired pressure to ban Psychic Fayres, restrict the sale of occult books and equipment and even bring back the Witchcraft act. Paranoia? I don't think so. Occult suppliers could easily be brought under similar restrictions to those of sex shops, while Prediction could disappear from the magazine racks and occultists subjected to some form of prohibitive legislation - Clause 666 perhaps?

So what to do? Dame Knight's committee will very soon begin to deliberate on the 'link' between occultism and child abuse. Give her *your* views on your beliefs and the fundamentalist/gutter press claims by writing to her at her constituency address which is: *Dame Jill Knight MP,*

DBE, Conservative Office, 16 Greenfield Crescent, Edgbaston, Birmingham B15 3AU.

Following in the wake of the recent NSPCC comments on the ritual child abuse issue, this organisation has been summoned to the Department of Health to address the allegations. Despite the complete lack of evidence, apparently, they are being taken seriously. West Yorkshire police have begun an investigation into satanic child abuse in Yorkshire, again largely thanks to both the NSPCC and fundamentalist pressure. Fortunately, the Leeds-based SAFF have been invited to attend meetings. Since the NSPCC's comments there has been at least one case of a pagan family being harassed by police and Social Services, following an anonymous tip-off that they were 'devil worshippers'. The reliability of the source was, of course, never called into question. This sort of incident will be on the increase. The child-care organisations are out to protect *your* children from *you.*

Pagan Credo issued

The SAFF has recently begun to distribute a *Pagan Credo.* Compiled by Stewart & Janet Farrar, with help from members of the Pagan Federation, SAFF, and other pagans, it is designed *not* to represent any pagan doctrine to which we should all adhere, but to be used as an introductory explanation for outsiders. As an exposition of the common threads of pagan philosophy, it is well-constructed and is a distinct improvement over some of the other attempts at this which have appeared in recent years. One of the key statements is:

It is not rigid or dogmatic in form; its exact expression depends on the individual Pagan, or willingly cooperating group of Pagans. This Credo is therefore itself not

Malleus Maleficarum: The Sequel?

While the gutter press continue to salivate over continued scare stories of "Satanic child abuse", a more sinister level of the fundamentalist campaign of attacks on occultists has been playing itself out in the corridors of Whitehall. The S.A.F.F. have recently revealed the existence of a "parliamentary committee" being chaired by Dame Jill Knight MP[1] (Conservative, natch) who were being fed information by a researcher for the *Cook Report*. This committee is both unofficial and private, and will accept any biased information it wants to in order to produce a report which can be then used to press for an "official" investigation of the subject. This could well lead to fundamentalist-inspired pressure to ban Psychic Fayres, restrict the sale of occult books and equipment and even bring back the Witchcraft Act. Paranoia? I don't think so. Occult suppliers could easily be brought under similar restrictions to those of sex shops, whilst *Prediction* could disappear from the magazine racks and occultists subjected to some form of prohibitive legislation – Clause 666 perhaps?

So what to do? Dame Knight's committee will very soon begin to deliberate on the "link" between occultism and child abuse. Give her your views on your beliefs and the fundamentalist/gutter press claims by writing to her at her constituency address.

NSPCC Allegations

Following in the wake of the recent NSPCC comments on the ritual child abuse issue, this organisation has been summoned to the Department of Health to address the allegations. Despite the complete lack of evidence, apparently they are being taken seriously. West Yorkshire police have begun an investigation into Satanic child abuse in Yorkshire, again, largely thanks to the NSPCC and fundamentalist pressure. Fortunately the Leeds-based S.A.F.F. have been invited

1 Joan Christabel Jill Knight, Baroness Knight of Collingtree, DBE (1923 – 2022) English Conservative Member of Parliament. She began her career in politics by lying about her age, and it was all downhill from there. She is one of those right-wing politicians who is invariably on the wrong side of history, whether about racism, homosexuality, or pretty much anything else. She was widely blamed for motivating racists to set alight a building housing young black people having a party in New Cross in London in 1981, leading to the death of 13 people. She was also responsible for the reprehensible "Section 28" Act of Parliament in 1988 which outlawed "promotion of the homosexual lifestyle".

to attend meetings. Since the NSPCC's comments there has been at least one case of a Pagan family being harassed by police and social services, following an anonymous tip-off that they were "Devil worshippers". The reliability of the source was, of course, never called into question. This sort of incident will be on the increase. The child-care organisations are out to protect your children from you.

Werewolf Wilting!

Regarding last issue's "Third Eye" comments regarding the organisation known as Radio Werewolf,[2] one of our American correspondents has supplied some information, including a tape of one of their so-called attempts at sonic propaganda. If you've encountered the worst excesses of "New Age" music, then this stuff is definitely "dark age" – producing the effect of wanting to leave the room It's being played in – or hurl the tape out of the nearest window! Their frontman, Nikolas Schrek, apparently makes a living from selling Nazi regalia. Perhaps then, the whole thing is merely a money-making scam directed at the kind of pocket megalomaniacs and bedsit Maguses that abound, unfortunately, everywhere.

From Chris Sempers & Graham Raven, Humberside.

On 28th March 1990, just after tea, we were subjected to a flying visit from the social services and the local CID![3] There had, it seems, been a complaint made to the NSPCC that our little boy was being abused during certain occult rituals that we held, involving people who cavorted naked. "Devil worship" was also mentioned! What a wonderful thing to accuse someone of! The SS were most concerned that my son Christopher (his name isn't Christopher, but Michael!) was in "moral danger". When we asked just what this term meant, we were told by the CID officer that it could actually mean just about anything you'd care to choose! We spent over an hour explaining to SS and police that this was completely untrue, but how do you prove you're innocent? Yes, we're Pagan, but no we don't have groups of naked people cavorting about, we work alone; our child is the most precious thing we have and we are more likely to turn christian than ever consider abusing him.

2 Radio Werewolf was a band formed in Los Angeles in 1984 by Nikolas Schreck, and later featuring his wife Zeena, daughter of Anton LaVey. They rapidly became notorious for their blatant Satanic themes, neo-nazi overtones, and overblown, poor quality goth music. Take it from me, they were third-rate Third Reich.

3 Criminal Investigation Department (of the police). The section that most plain clothes detectives in the UK have worked for since 1842.

"So just how many people are there in your coven and what are their names and addresses?" we were asked. "We don't work with anyone else!" we said. "Oh, pity," said the CID officer. "If you'd tell us about your contacts, they could help to establish your character."

They didn't seem to want to believe that we really didn't work with other people and couldn't give them any names and addresses. Can you imagine what my little boy may have been subjected to? In the "investigation" to prove our innocence, even the policewoman described the physical examination as being "horrific" for a child. And just who do you imagine would do such a thing to report this allegation? A Christian fundamentalist group perhaps? No – it was a "fellow" CRAFT member. We know damn well who did this and that the police also interviewed them. Naturally the culprit denied everything but said (according to the police officer) that they ought to question us about pornography and the Great Rite! So back came the CID and the SS official.

"Did we ever perform the Great Rite?" and "Did anything funny go on in our circles?" we were asked grimly. If these people weren't threatening to take our son away into care, you'd laugh in their faces, so idiotic are their questions. Did they understand what they were asking? Whenever any man and woman make love they are performing the Great Rite! Do we perform sexual antics in the circle? No we didn't! We have performed the Great Rite only once in the circle (yes we were alone, and no we didn't have video cameras). That was seven years ago and was to ask that we may be blessed with a child – Michael was the result! Then the house was searched – with our permission (were we really going to refuse, did we want to keep our son?).[4]

We were both upset and angry. Do readers realise that anyone can ring up the SS, NSPCC, police, or any of the child-based charities and make allegations about your children? All of these charities have their own axes to grind and are all in competition for money from you, and therefore need to be something worthwhile and preferably newsworthy. The mentality of the person who makes these allegations will not be questioned, neither will their motives, and they are allowed to remain anonymous no matter how badly they defame your character.

So what do we do now? This is a clear case of religious defamation. We need your help. Please don't get angry, do something. Write to us, your MP and also

4 Note to any reader who may be subject to something similar: never, ever, EVER allow the police to search your home without a warrant! In fact, as soon as you realise that you may be under investigation, immediately insist that the police leave your home and that you will only answer further questions at a police station with a lawyer present. It doesn't matter how innocent you are, It's important for your own safety and security, and that of your family, to establish proper legal procedures right away.

the Sorcerer's Apprentice Fighting Fund. Remember, next time it could be your child.

Editor's Note: Anyone who wishes to help Chris & Graham is advised to get in contact with the S.A.F.F., who have taken up the case on their behalf, and have been writing to the CID officer and social services official mentioned in the above letter. This case brings to light not only the "eagerness" of police and social services to follow up accusations of Satanic child abuse after all the media hype, but also the sad fact that persecution can come not only from people outside the Pagan community, but from within it. Last year's raid on the Californian O.T.O. was prompted by a disaffected ex-member, and in the UK there have been numerous instances of in-fighting between people of different occult persuasions reaching dangerous proportions, including the posting of "curse objects", the "shopping" of people to the gutter press, and death-threats over the phone! The story related above has a distinctly "burning times" flavour to it – someone pointing the finger of accusation at someone else, for reasons as yet unknown? If anyone can shed light on this affair, we would like to hear about it, and all communications will, of course, be treated in strictest confidence. Sadly, it could be the first of many such occurrences, as the grey forces, unless they turn up any real Devil worshippers, will start picking on the nearest substitutes. All it takes is for a newspaper to pick up on the story and, well, I'm sure you can imagine the resulting headlines. Don't write to *Pagan News* if you want to help Chris & Graham, write to the S.A.F.F. But if you know of similar cases happening, do let us know about them. So far, Pagans & occultists have got off lightly, despite the gutter press barrage – things could get a lot worse, and the tendency to not get involved 'cause you don't like a particular individual or group, or because the people being attacked aren't on your path is long past!

SPOTLIGHT

The Reachout Report
by *Phil Hine*

Two years ago, the anti-occult campaign inspired by fundamentalist groups started the press hysteria, led by "have a go" MP Geoffrey Dickens and the gutter press. It hasn't stopped since and shows every sign of getting worse. Groups like The Reachout Trust and Christian Response to the Occult have orchestrated a countrywide campaign to "inform" national and local press alike about the "dangers" of the occult, using powerful emotive hooks – the family, and children "in danger".

People have tried to dismiss them as a few cranks and extremists, but It's not that simple. It's not just Pagans & occultists who are under fire. The last few years have seen a steady erosion of civil liberties in the UK. Britain has its own "Moral Majority" – a collection of peers, knights, ministers, academics, journalists and other professionals. They have influence on industry, the government, and the ear of the press. Bodies like Family and Youth Concern,[5] The Conservative Family Campaign,[6] Family Forum, and The National Family Trust[7] all believe that the family must be central to all "political thinking." They are the people who inspired Section 28 and have successfully applied pressure on central government to abandon its AIDS campaign. Dame Jill Knight, whose "unofficial" parliamentary committee on "Satanic child abuse" is presently gathering information, is one

5 Founded in 1971 and now known as the Family Education Trust, this is yet another conservative pressure group that acts as a front for anti-gay, anti-divorce ideology. The group's leadership praised Hungarian Prime Minister Viktor Orbán and in 2022, the group promoted the anti-Drag Queen Story Hour campaign.

6 Yet another right-wing Conservative pressure group. This one was created in 1986 and advocated that Christians in the UK needed both to work and pray for the re-election of Margaret Thatcher. In *The Daily Telegraph* in 1991 its chairman Dr.. Adrian Rogers described homosexuality as "a sterile, disease-ridden and God-forsaken relationship".

7 According to the UK Charity Commission this group is now defunct. We have been unable to find any other information about them. Like many of these "concerned moral majority" pressure groups it was probably one guy and his dog in a basement in the middle of nowhere.

of the people who helped promote Family and Youth Concern's video *The truth about AIDS*, which they tried to force every school in Britain to take. The Campaign for Real Education[8] submitted detailed proposals to the Secretary of Education, some of which have ended up in the new syllabus. This should give you an idea of how much influence these groups have – and how much they can achieve.

Groups such as Reachout are now instructing their members to campaign to try and get *Prediction* magazine[9] removed from the shelves of chain distributors like WH Smith & Sons, and Menzies. They have at least learnt that scripture-quoting and banner-waving tends to put people off. Instead, they are going for the approach of being "concerned parents". With rank-and-file members complaining to local shops, and the Evangelical Alliance[10] applying pressure at director level, this approach suddenly doesn't sound so ludicrous, does it? Reachout are now claiming that they have managed to pressure WH Smiths into issuing an internal directive ordering that *Prediction* be stacked on the top shelves, where pornographic magazines are usually placed. They are also complaining to the Director of Education about subjects which have "occult elements" and have harassed teachers that they have discovered to have a Pagan background. They are well-versed in the art of manipulating the press through complaints to TV stations and newspapers. In a tape entitled *How to deal with the occult in your area*,[11] Maureen Davies boasts of how she has picketed Transcendental Meditation[12] meetings, and even presented a case to hospital management about why TM is dangerous to health. TM and similar techniques are widely used in the National Health Service as part of relaxation training for people with a wide variety of problems – but as far as the fundamentalists are concerned, It's

8 And yet another limited right-wing pressure group run. This one was founded in 1987 by Nick Seaton and attempts to bring back "traditional" education, which some might see as teaching the history of great men fighting wars and how wonderful Christianity is.

9 *Prediction magazine* was the UK's first esoteric, astrological and horoscope magazine, launched in 1936. Back in the 80s it was a common sight in newsagents. It has been effectively defunct since 1991.

10 In contrast to the other groups mentioned, the Evangelical Alliance is a huge pressure group. Formed way back in 1846, it currently has over 3,000 churches and 750 other groups under its purview. According to latest accounts with the Charity Commission it has 48 employees and banks nearly £3 million a year.

11 Unfortunately we don't have a copy of this, otherwise we would certainly be putting it up on Soundcloud for readers to hear. If anyone finds a copy of this, we would love to have it.

12 A form of yoga invented by the Maharishi Mahesh Yogi and successfully popularised by him during the 60s and 70s. It is estimated that millions of people have gone through the training programme. The Beatles song "Sexy Sadie" is about the Maharishi and his alleged sexual advances to fellow student Mia Farrow (original lyrics: 'Maharishi, you little twat/Who the fuck do you think you are?/Who the fuck do you think you are?/Oh, you cunt.')

a doorway to Satan. Anyone who teaches it, therefore, is suspect. Now as we all know, TM is a fairly innocuous practice, so one wonders what chance more in-depth approaches have of surviving the fundamentalist onslaught?

Maureen Davies tells her followers to go "right to the top" when complaining – that's to senior management – who are usually very concerned with the threat of bad press and will cancel an event or meeting, or take other action in line with fundamentalist demands. Apart from a few notable exceptions, the major response that the Pagan community has managed to come up with is along the lines of "It's not us who's to blame – It's someone else" – which is not very convincing or helpful.

I'll keep on repeating it till it gets through – they are out to suppress all minority beliefs and practices which they see as being a threat to their conception of how society should be. We need to be building bridges with other minorities that

> *"We need to be building bridges with other minorities that are at risk, not trying to hide behind barriers, hoping that they'll go and bother someone else."*

are at risk, not trying to hide behind barriers, hoping that they'll go and bother someone else. They won't; and they've got the resources for a long, and escalating campaign. As was reported last issue, they are buying magazines like *Pagan News* to find out names, addresses, and phone numbers of local contacts. In their newsletter, Reachout recently asked subscribers to "pray" for the "enlightenment" of misguided people like myself and the editors of *ORCRO* (Occult Response to Christian Response to the Occult) magazine – a form of cursing, perhaps?

Assessing the success of the anti-occult campaign so far is difficult. While it remains true that the general public tend not to be concerned one way or the other, the fundamentalists have been successful in that they have created a press barrage and the appropriate hysteria that allows them to bring pressure on to government bodies – where they already have a great many allies; people of influence who have the ear of ministers and Whitehall mandarins. The implication is that right-wing and fundamentalist pressure groups are "steering" the policy making of central government, and officers within the Department of Health are already complaining that they cannot control the influence of fundamentalist-motivated groups. They are so highly-connected however, that they cannot be ignored. The proof of their power, in the case of Pagans, will be the appearance of fundamentalist inspired legislation against us. Are we going to sit back and wait for it to roll over our heads? Probably. A recent letter to *Pagan News* gave the view that "any good magician has nothing to fear" – so much for

"community spirit", eh? It's not just a question of "Pagan rights", but the whole erosion of human rights. How easy is it to have an outdoor gathering these days? How many psychic fairs have been subject to last-minute cancellations? Let's face it – so far Pagans & occultists have been a soft target for the fundamentalists; good copy for the gutter press, a nice carrot to rope in respected groups like the National Society for the Prevention of Cruelty to Children, easily divided against each other, no ability to lobby or organise counter-information as a whole, plus an innate tendency to ignore "material" affairs and politics. They don't see us as individuals – just a homogenous group of evildoers masquerading under a variety of guises. A couple of years ago, some U.S senators tried to sneak a bill through Congress which "defined" witchcraft, in order to pass anti-occult legislation. Thanks to the Bill of Rights, and well-organised lobbying, it was thrown out, but there is no such safety net here. Our government recognises only Christianity as a legitimate religion, and individual "rights" have no protection whatsoever.

So where do we go from here? Keep quiet and hope it all goes away? Some of us don't have that option, and in writing this article I've probably added a few lines to a file on some shadowy fascist database. So far, the only organised response is via the Sorcerer's Apprentice Fighting Fund and the Pagan Federation who are actively involved in countering and lobbying against the fundamentalist aims. Making links with other groups who are having their freedom constrained would also be helpful–the fundamentalist ethic wants women chained to the sink, lesbians & gays back in the closet, and anyone who aspires to "alternative" lifestyles suppressed. If anyone's got any good ideas – I'd like to hear them. A basic tenet of Pagan philosophy is that morality and ethical responsibility comes from within – if we're not careful and attentive to what's happening, we will very soon find ourselves hamstrung by an imposed definition of what we are in the eyes of those who make policy. Sure, they cannot take our beliefs and values away from us, but they can make it more difficult for us to live. Life could be made very difficult for anyone who is running a small business related to the occult; some Pagan families are already having problems from people who've reported them to social services and police; our freedom to gather together is being restricted; how worse does it have to get? It's easy to become apathetic or frustrated, but we must persevere; use your magical skills not to lash out, but to ground yourselves so that you can act – with calmness and persistence. Adversity such as this could be a great opportunity for us to reach out to each other (despite differences in path or lifestyle) and give support where It's needed. If the only thing which unites us in action is the desire to preserve our freedom to live as we wish, without interference, then let this be our clarion call!

VIEW POINT

Pride, Paranoia & Prejudice
by *Barry the Pedant*

One Friday evening in the Catford Ram, a local and regular meeting place for the Pagan folk in my area, somebody told me that they didn't know how I could call myself a Pagan because I made reference to a Mahayana Buddhist concept. For me this highlights a certain element of xenophobia that I have experienced regularly over the past couple of years, about the East meets West thing. I won't mention right-wing politics.

There are a lot of people around these days talking about the "Western Tradition" or the "Native British Tradition" or "Celtic Shamanic Craft" or whatever, as if everyone knew exactly what they meant and as if there was some kind of long running historical precedent for these terms. Most of these people are practising magic as it was taught by the Golden Dawn, Wicked Uncle Aleister, Gerald, or Alex (to my mind there isn't much difference) but how can this be called Western? Most of it is based on conceptual structures and symbol systems that have been imported from all over the place – mainly the Classical, Judaic, and Islamic worlds. Even Kaledon Naddir, in his excellent work on Celtic folk and fairy tales, feels it necessary to go into modern Qabalah to describe the Otherworlds. It's not even as if what we call Qabalah has much to do with what the Rabbis keep under lock and key; since it has been sanitised by the European intellectuals of the ill-dubbed Renaissance. Then the people working these systems make a point of criticising "Westerners" for turning to Vedic, Buddhist, Tantric, or

Taoist teachings or practices. The fact of the matter is that my list of famous people above got a lot of ideas from those traditions; they just made up new names for them.

Why, then, you might say, do you bother to call yourself a Pagan? After all the distinction as most of us understand it is something to do with that very much remains of Native British heathenism in practice. I am suspicious of most of the people who have set themselves up as authorities on this subject by cobbling together a bit of folklore and medieval literature because they seem to have changed from Hermeticians into Shamans overnight. I wonder why? I think It's

> *"I call myself a Pagan because I am deeply concerned with these issues. I just don't believe that very much remains of Native British heathenism in practice. I am suspicious of most of the people who have set themselves up as authorities on this subject by cobbling together a bit of folklore and medieval literature because they seem to have changed from Hermeticians into Shamans overnight."*

the place, the "Land" in which we are living. Also, you could argue, I spend just as much time reading Tolstoy,[13] Marion Zimmer Bradley,[14] the Matthewses, and the *Mabinogion*[15] as I do poring over my copy of *777*, so I am very concerned about the "Matter of Prydein".[16] Well, I reply, I call myself a Pagan because I am deeply concerned with these issues. I just don't believe

time that a lot of Pagans came out of the Summerlands and looked into the anthropology, archaeology and natural history of Northern Eurasia. It's incredible, and in one or two places, It's still alive. It's not always romantic, often a bit bloodthirsty and tends to be hooked into bio survival for the individual or clan more than any broader issues.

13 Count Lev Nikolayevich Tolstoy (1828 – 1910), Russian Christian anarchist who wrote *War and Peace* and *Anna Karenina*, and who despite receiving nominations for the Nobel Prize in Literature every year from 1902 to 1906 and for the Nobel Peace Prize in 1901, 1902, and 1909, never actually won once.

14 Marion Eleanor Zimmer Bradley (1930 – 1999) American author of fantasy and SF. She is best known for her shitty rewrite of the Arthurian myth cycle *The Mists of Avalon*, and for being a shitty person who assisted her husband in the rape and sexual abuse of multiple children.

15 The *Mabinogion* is a collection of eleven stories written in Middle Welsh in the 12th–13th centuries from earlier Celtic roots, including some of the very earliest Arthurian legends..

16 A phrase referring to the early history of Britain.

So where to turn? To the places where it was allowed to evolve! There is both linguistic and other evidence to show that many Asian traditions have a relationship with the folklore upon which we so heavily rely. This connects with Native American traditions, equally likely to be labelled as "foreign". I've been a son of Buddhism as long as I've been a Pagan and the form of Buddhism to which I personally was drawn is that of Tibet where it absorbed a lot from the primal shamanic current. What I have learned from that is that state of consciousness is everything in this game. Most of the practices mentioned here and elsewhere, from visualisation to ritual theatre, banging the drum, incanting the *galdr*[17] or drawing the pentagram and vibrating a Hebrew god-name are concerned with this principle but are secondary to it.

I believe that it doesn't matter what tradition you belong to or whether you belong to a tradition of not, whatever you choose to call yourself. You don't need to invent or discover one either. You are Pagan if you have a Pagan attitude – reverence for your environment in all its dimensions. Recognition that all levels of activity and being are interconnected and that you can be a conscious participant. This is the Buddhist concept which prompted my friend in the pub to say that he didn't know how I could call myself a Pagan.

17 The Old Norse *galdr* are a collection of magical incantations to be sung during ritual.

THINGS TO DO...
and THINGS TO READ

SPIRAL PENTAGRAMS
by *Phil Hine*

The traditional form of the pentagram as used in most forms of magick for invoking/banishing is a solid, pythagorean figure which can be seen as suggesting a barrier, or a containment of energy. A couple of years ago I began experimenting with figures constructed from curves and spirals, using them in meditation and ritual.

The "Spiral" pentagram shown above has a more "dynamic" effect than that of the classical pentagram, showing forms expanding into space with maximum harmony. It is formed from five vesica piscis. It is not really a spiral, but when tracing them, I visualise the outer figure rotating clockwise, and the inner figure rotating anti-clockwise, thus forming a vortex or tunnel which spirals into infinite space. I have found these pentagrams to be very effective as gateways for

stellar/Da'athian energy in solo and group ritual. The shape has also appeared in dreams, moving from a 2-dimensional figure to a 3-dimensional tunnel. When used as part of a goetic evocation, tracing the pentagram at the 4 quarters created a windstorm (which dropped immediately the figures were "closed") but at the same time, seemed to impede the manifestation of the spirit. However, the spiral pentagrams have worked well when used in ritual and trance work with entities such as Eris, Arachne, & Ma'at. I trace them by beginning at the apex and tracing the left arc.

A standard Banishing Pentagram of Earth appears to be sufficient to close the vortex at the culmination of the working – at the same time reversing the visualisation of the rotating figures so that the 3-dimensional effect becomes a 2-d figure.

I don't regard this idea as unique to myself, but I have not heard of anyone else using it. If any groups or individuals have, or would be interested in experimenting with the applications of figures such as this, I would be very interested in corresponding.[18]

18 Phil would later expand on this idea in the pages of his bestselling book *Condensed Chaos*, which we obviously highly recommend that all readers pick up.

This issue, we welcome a new column by PN's resident astrologer, Anthony Roe. In future issues, Anthony will be examining the application of different aspects of astrology, beginning with a look at astrological timing for rituals & other events.

It is all very well to read up on the signs and planets, their strengths and weaknesses, in any of the myriad books on astrology, but how is this information applied in everyday life, and used in daily ritual?[19] To invoke a planetary influence, or perform a rite under the auspices of a planet is powerful. That is, when it is in its own Domicile,[20] Exaltation,[21] or Triplicity;[22] in that order of priority.

An angular planet is most powerful, i.e. when at the East, South, North, or West point of the sky. The East or ascendant is pre-eminent. This is because astrology is all about beginnings: the Sun rises and the day commences.

19 We were very happy to publish these in-depth articles from Anthony, because unlike most works about astrology they weren't just about *interpreting* astrological data, but about using astrology *actively* as a magical practice. However Anthony's articles were quite complex and dense, and took considerable previous study of astrology to really get the most out of them. Happily, for this republication we now have the space to explain in more detail some of the background to Anthony's work.

20 A planet's Domicile is the zodiac sign over which it has rulership.

21 Each planet has its Exaltation in a sign of the zodiac:
 Sun: 19th degree of Aries
 Moon: 3rd degree of Taurus
 Mercury: 15th degree of Virgo
 Venus: 27th degree of Pisces
 Mars: 28th degree of Capricorn
 Jupiter: 15th degree of Cancer
 Saturn: 21st degree of Libra

22 The Triplicities are essentially the 4 classical elements:
 Fire — Aries, Leo, Sagittarius – hot, dry
 Earth — Taurus, Virgo, Capricorn – cold, dry
 Air — Gemini, Libra, Aquarius – hot, wet
 Water — Cancer, Scorpio, Pisces – cold, wet

The Zodiac is the path of the Sun, and any sign is empowered by the Sun's presence. This is a good time to invoke the virtue of a sign. Similarly, the Moon in a sign gives access to the latent force of the sign, or its planetary ruler, as the Moon is the intermediary, releasing power to the sublunar world. Herein lies the revelation of the full Moon, which reflects the glory of the Sun, the deity of physical power, and itself becomes the potent plenilune,[23] translating the power of the Sun from daylight time into the realm of nightdark. An appropriate rite at this time can "draw down the Moon".

Amulets and talismans are consecrated when relevant signs or planets are in the ascendant, though one school of thought prefers the time when they are overhead at their zenith. The use of planetary hours is common in this constellatory practice, as also in the gathering of herbs, and all manner of divinations and star spells, echoing the days of the week to the planets.[24]

Strict adherence means that a work commenced in a particular hour must resume in a similar hour later on if the work remains incomplete in the first hour chosen.

Emphasis on a particular hour may be achieved by undertaking a vigil from the start of the day until the particular hour arrives. Less realised is the fact that the planets, from the ruling hour of inception, also govern the nights in turn, as Sunday night under Jupiter, Monday under Venus; Tuesday, Saturn; Wednesday, the Sun; Thursday, the Moon; Friday, Mars; and Saturday, Mercury. This makes prolonged ritual a practicable affair when commenced under the aegis of the planet ruling the night or day. The Ancients invoked the celestial gods at dawn, or in open day, and called upon the infernal deities at dusk, or in the depths of night.

There is a key here for the theurge who would understand the different shades of magick. Those who wish to invoke their own familiar spirits may do so when the Lord of the Ascendant of their Nativity (the planet ruling the rising sign) is powerful, or when the Moon at least is in the ascendant sign of their birth. A

23 Plenilune is an archaic (and rather wonderful) term for the full moon.

24 The planetary hours describe which of the seven classical planets is given rulership over each day and the parts of the day. The sequence is the "Chaldean Order": from slowest- to fastest-moving as they appear in the sky i.e. Saturn, Jupiter, Mars, the Sun, Venus, Mercury and the Moon. The first hour of a day is ruled by the planet three places after the planet ruling the first hour of the previous day, and It's how the conventional European days of the week have been derived in various languages i.e. Sunday has its first hour ruled by the Sun (Sunday/Dimanche), and is followed by a day with its first hour ruled by the planet three places later in the Chaldean Order, the Moon (Monday/Lundi), followed by the next planet three places later, Mars (Tuesday/Tew's Day/Mardi), then Mercury (Wednesday/Woden's Day/Mercredi), Jupiter (Thursday/Thor's Day/Jeudi), Venus (Friday/Freya's Day/Vendredi) and Saturn (Saturday/Samedi).

fortunate aspect, as conjunction or trine between the Lord of the Ascendant and one of the benefics, such as Jupiter or Venus, is also to be looked for.[25]

For enchantments the Moon itself should otherwise be in one of the human signs, of Earth or Air, and the opus should be undertaken in the day and hour of Mercury or the Moon. Positive works should be done when the Moon is increasing in light, and negative operations when it is waning. Things to be kept

> *"In considering when to undertake any ritual procedure, the first need is to classify the nature of the rite according to its astrological correspondences."*

hidden or secret should be done in the dark time of the New Moon, though some say that all things fail at this time. The Full Moon is reserved for works of great might. Operations when the age of the Moon is an equal number of days as two, four, etc. are generally considered propitious.

In considering when to undertake any ritual procedure, the first need is to classify the nature of the rite according to its astrological correspondences. It has then to be worked out when the planets or signs that characterise the desired result are auspiciously located. When deciding the opportune time to act, it must be borne in mind that any effect that is attracted will stem from the moment of commencement

A most apt time for the performance of any ritual is thus when the choice of planetary day and hour coincides with powerful natural positions of the planets in the sky. In that thesaurus of lore contained within the cover-title *Bible* we read that "to every thing there is a season, and a time for every purpose under heaven".[26] The choice of a "becoming" time cannot but enhance individual ritual efforts.

25 In classical astrology, the Benefic (good-natured) planets are: Jupiter, Venus, Mercury, and the Moon. The Malefics (bad-natured) are: Saturn, Mars, and the Sun.
26 Ecclesiastes 3

EXCHANGE MAGAZINES

Gates of Annwn Contacts & news magazine. Sample issue £1 from BM Gates of Annwn, London WC1N 3XX.

Greenleaf Quarterly 'zine of info on sites, festivals, & travellers. 30p plus stamp from George Firsoff, 96 Church Rd, Redfield, Bristol 5.

Meyn Mamvro Earth Mysteries in Cornwall. sample copy £1.60 incl. postage from 51 Carn Bosavern, St. Just, Penzance, Cornwall TR19 7QX.

Moonshine Quarterly pagan zine of community development. Sample issue £1 + 40p postage from Kate Westwood, 498 Bristol Rd, Selly Oak, Birmingham.

Pandora's Jar Pagan Eco-living 'zine, sample copy £1.50 + sae from Blaenberem, Mynyddcerrig, Llanelli, Dyfed, Cymru SA15 5BL.

Silvermoon Pagan views 'n' news magazine. Sample issue £1.25 from Gareth J. Medway, 300 Old Brompton Rd, London SW5.

The Ley Hunter £7 for 4 issues from Empress Ltd, PO Box 92, Penzance, Cornwall, TR18 2XL.

Aquarian Arrow Journal of the Neopantheist Society, £1.50/issue from BCM Opal, London WC1N 3XX.

UFO Brigantia Quarterly irreverent UFO Journal details from Andy Roberts, 84 Elland Rd, Brighouse, W.Yorks, HD6 2QR.

EVENTS

Bradford Earth Mysteries Group holds regular meetings. Contact Paul Bennett on 0274/613763.

Darwen Moot meets at the Millstone, on the first Tuesday of the month. from 8pm. Wear a daisy!

Hull pagan group holds regular meetings. Contact Samantha on 0482/448679.

Leeds Pagan Moot restarting at Fat Freddies' on Call Lane (next door to Leeds Other Paper) on the first thursday of the month. Note: Fat Freddies only has a restaurant license at the moment. though this may change in the future.

London North London PaganLink moot is held at The White Lion of Mortimer pub at Stroud Green Rd. London N4. on alternate Thursday evenings. Contact Ray on 01-263-5066 for details.

London "Talking Stick" - informal talks on esoterica held upstairs at The Plough. Museum St. London W1. . For further info phone Caroline on 01-738-7950.

London 'House of the Goddess' has started up again. & Shan tells us she is organising a series of gatherings. The events will include talks. workshops. & music. For further details tel: 01-673-6370.

Manchester University Occult Society Contact Chris on 061-225-9148.

Oxford Pagan Fellowship contact Anne on (Oxford) 714796 for information.

Preston Pagan Moot. Ring Val or Brian. 0772-34696 for details.

Wakefield Pagan Moot meets on the first Wednesday in the month at The Beer Engine. Westgate. from 7.30pm.

SUMMER EVENTS

June 15th-26th Stonehenge People's Free Soistice Gathering

June 16-17 Leamington Peace Festival

June 21st SUMMER SOLSTICE

June 22-24 Glastonbury Festival. Info from 0898-400888.

June 23 Norwich Green Fair

June 30 Gay Pride March. London

July 6-15 Lichfield Arts Festival

July 13-15 22nd Recar Folk Festival

July 14 - Aug 19 'Tree of Life' ecological art at MacLaurin Art Gallery. Ayr.

July 21-Sept 2nd 'Out of the Wood' eco-art at Derby Museum & Art Gallery

Aug 3 'Torpedo Town' Free festival. Info from Friends of T'Town, Box B. 167 Fawcett Rd. Portsmouth. Hants.

Aug 3 Cantlin Town Free Festival. Lower Short Ditch (on the border of Shropshire & Wales).

Aug 10 - 12 Trecastle Free Festival (Wales).

London Dialling Code Changes

Would the organisers of London Moots & similar regular events please send us revised details of their telephone numbers.

NEWS & EVENTS cont: p14

REVIEW

The Life and Letters of Tofu Roshi
By Susan Ichi Su Moon, Shambala Publications, £5.50

Dear Tofu Roshi,
I'm trying to save all sentient beings. I thought it would be easier to start with the small ones, so I need to know if this includes bacteria.
A Sincere Student.

Dear Sincere,
A moot point. Start with something that is at least visible to the naked eye, like a housefly. It is difficult to tell when a staphylococcus, even a large one, is in a proper zazen posture.

This is a typical exchange in Susan Moon's hilarious and instructive collection of the fictitious Zen master's writings. These are interspersed with recollections of her days with Tofu Roshi, whose detractors make the claim that he became a Zen master because It's the only profession open to someone who can't read, write, or tie his own shoelaces. Also included is the essay *How to give up Self-Improvement.* A wonderful book, and not just for Zen students. – Fra. Impecunious

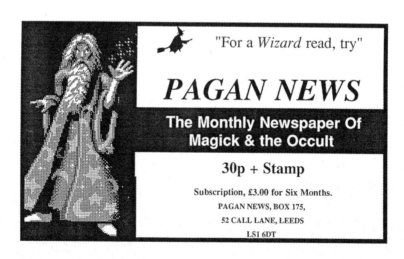

PAGAN NEWS

The monthly news magazine
of Magick & The Occult

June '90
Price 50p

Nottingham Witch–Hunt Exploded!

A recent report into allegations of 'ritual child abuse' in the Nottingham area has exploded fundamentalist hype about the evidence for such activity. Fundamentalists such as Dianne Core, Maureen Davies and Kevin Logan have for months been insisting that there was 'solid' evidence for ritual crimes against children in the Nottinghamshire case, which resulted in nine people being jailed for a total of 43 years, and 23 children being taken into care. As accusations of 'satanic rites' grew, an inquiry was set up. The report, which was leaked to Central TV, accuses social workers into leading children into making unfounded allegations. It states that there is no evidence of 'ritual abuse', and that much of the 'evidence' was merely a product of 'suggestive questioning' until answers were provided that the social workers wanted to hear – they were using deliberate psychological ploys to induce a confession. One child, after three months of 'therapy', for example, claimed to have witnessed several murders and participated in acts of cannibalism, but has since admitted fabricating the story as a result of pressure.

This report is a serious blow to fundamentalist claims about ritual abuse in the UK. It could mark the turning of the tide against their efforts to scapegoat occultists & pagans, although October may well bring a new scree of media hype to back up Audrey Harper's new book about 'satanic child abuse'. The report criticising the Nottinghamshire social workers who produced the falsified reports of ritual abuse could well lead to a full enquiry into the allegations of those who suborn their professional judgement to serve the ends of religious bigotry. Social Workers have been placed in an increasingly precarious position over child abuse cases ever since the Cleveland Affair, and the current spate of 'vigilantes' posing as social workers isn't helping. There are also reports that the police are becoming increasingly irritated over fundamentalist claims of satanic child abuse. *The Manchester Evening News* last month carried a brief speech by the head of the Greater Manchester Police child abuse unit who implied that he wouldn't rule out the possibility of 'satanic abuse'. A report in the same paper a couple of weeks later told of four children taken into care *amid fears that they were victims of black magic rituals.* The children's parents are protesting their innocence and say that the social workers are mistaken, but the tone of the report indicates that someone is awfully keen to have their allegations proved. Apparently the only 'evidence' to back up the black magic claim is a small wooden cross found at the house! The saddest part of this whole affair is that while the fundamentalists go around causing trouble for everyone, the heart of the problem – the magnitude of child abuse in this country, becomes harder and harder to deal with, as the problem is being continually obsfucated.

Nottingham Witch-Hunt Exploded!

A recent report into allegations of "ritual child abuse" in the Nottingham area has exploded fundamentalist hype about the evidence for such activity. Fundamentalists such as Dianne Core, Maureen Davies and Kevin Logan have for months been insisting that there was "solid" evidence for ritual crimes against children in the Nottinghamshire case, which resulted in nine people being jailed for a total of 43 years, and 23 children being taken into care. As accusations of "Satanic rites" grew, an inquiry was set up. The report, which was leaked to Central TV, accuses social workers of leading children into making unfounded allegations. It states that there is no evidence of "ritual abuse", and that much of the "evidence" was merely a product of "suggestive questioning" until answers were provided that the social workers wanted to hear – they were using deliberate psychological ploys to induce a confession. One child after three months of "therapy", for example, claimed to have witnessed several murders and participated in acts of cannibalism, but has since admitted fabricating the story as a result of pressure.

This report is a serious blow to fundamentalist claims about ritual abuse in the UK. It could mark the turning of the tide against their efforts to scapegoat occultists & Pagans, although October may well bring a new scree of media hype to back up Audrey Harper's new book about "Satanic child abuse". The report criticising the Nottinghamshire social workers who produced the falsified reports of ritual abuse could well lead to a full enquiry into the allegations of those who suborn their professional judgement to serve the ends of religious bigotry. Social workers have been placed in an increasingly precarious position over child abuse cases ever since the Cleveland Affair, and the current spate of "vigilantes" posing as social workers isn't helping. There are also reports that the police are becoming increasingly irritated over fundamentalist claims of Satanic child abuse.

The *Manchester Evening News* last month carried a brief speech by the head of the Greater Manchester Police child abuse unit who implied that he wouldn't rule out the possibility of "Satanic abuse". A report in the same paper a couple of weeks later told of four children taken into care amid fears that they were victims of black magic rituals.

The children's parents are protesting their innocence and say that the social workers are mistaken, but the tone of the report indicates that someone is awfully keen to have their allegations proved. Apparently the only "evidence"

to back up the black magic claim is a small wooden cross found at the house! The saddest part of this whole affair is that while the fundamentalists go around causing trouble for everyone, the heart of the problem – the magnitude of child abuse in this country, becomes harder and harder to deal with, as the problem is being continually obfuscated.

The case of the Sempers, reported in last issue's News Extra, has also been wound up satisfactorily, thanks to the S.A.F.F .and the Pagan Federation. After a case hearing at which both parents were present, they were offered a written apology. Both the S.A.F.F. and the Pagan Federation are liaising with child-care organisations in order to educate them about Pagan values.

The Bishops Ride Out?

PN is occasionally criticised for being anti-Christian. We're not, and have tried to make it clear that It's fundamentalists (who come in all shapes and creeds) that we're reporting on. They, after all, don't regard the majority of Christians in this country as true members of the faith, and the Church as a body has largely ignored their ravings. Recently however, both the Bishop of Oxford and the Bishop of Armagh have made public statements condemning the rise of Pagan values in Europe and the need to oppose it. Moreover, the *Church Times*[1] has also recently provided us with a fascinating "rationale" for ritual child abuse – if you believe that psychic forces which help your ego to develop are released by persons under trauma, then your ritual will tend to involve those who are sexually abused. Their trauma and terror release psychic energy and once you are into that you are into some fairly beastly stuff.

It shouldn't be surprising to Pagans that one of the "experts" involved in writing the piece was Kevin Logan. The *Church Times* can be contacted at: 33 Upper Street, London N1 0PN.

Bronze Age Site Under Threat

A plan to develop a new coal mine in Wales is threatening five Bronze Age pillow mounds on Machen Mountain. Local pressure has so far managed to delay the planners, but protestors are desperately seeking evidence that would help them convince the developers of the need to preserve such sites until we can fully understand their value.[2]

1 The *Church Times* is a magazine focused on the Church of England and has been running continuously since it was founded on 7 February 1863.
2 This site was saved in the end, only to be badly damaged by vandalism in 2020. Sigh.

S.A.F.F. Update

Latest news from the Sorcerer's Apprentice Fighting Fund is that the Broadcasting Standards Council have recognised the possible value of trying to educate programme makers about modern Pagan & occult values. The BSC has therefore requested that the S.A.F.F. construct a Teaching Pack to introduce media people to the pitfalls of religious prejudice, and so would welcome any input from individuals and groups – but quickly, please.

Chris Bray's long struggle to complain about *The Cook Report* has also been upheld by the Broadcasting Complaints Committee. This is the first time that a complaint made against Roger Cook and his "investigative" programme has been upheld.

O.T.O. Raid Update

from Stephen Mace, our American correspondent

News on the police raid on houses belonging to the Caliphate O.T.O. in the USA (as reported in the December issue) is that the Order have filed for damages against the City of Berkeley. Such litigation has little chance of a quick resolution, and could go all the way to the Supreme Court. On the bright side, all drug charges against members of the Order have been nullified, and it has been deemed that the original "disgruntled ex-affiliate" who caused the raid is "conspicuously unreliable": that the warrant to enter the Order's premises was illegally obtained, and the initial surveillance conducted was both illegal and inadequate.

Also damning are the police's own videotapes, which are almost exclusively devoted to occult paraphernalia, which should have been of no interest to them, considering the raid was supposedly concerning "drug trafficking". Also, Lyndon LaRouche's *New Federalist* paper has quietly ceased its attacks on the O.T.O., apparently in response to the Order's threat of legal action.

SPOTLIGHT

What *do* Witches do?

Janet and Stewart Farrar are probably Europe's best-known witches. With a string of books to their credit and a new volume just published, Spells: And How They Work, *they are continuing to promote a simple yet effective (and ethical) magickal system. A PN interview team met up with them in Leeds last month and posed a few stumpers...*

PN: How do you think the modern Pagan movement is developing?

Janet: I'd like to see a few more people getting their act together: less of the great "I Am" and a lot more acceptance of people just as people. As Gerald Gardner once said to Doreen Valiente "There's too many bloody chiefs and not enough Indians. The great Queens and Kings and self-proclaimed Magi are in for a big surprise when they die 'cos the gods will kick them so hard up the arse they won't know what's hit them." It's very difficult to assess the situation of the current Pagan movement, as there are a lot of bandwagon jumpers and dabblers, but generally we believe that the mainstream bulk of the movement is healthy.

PN: You must get sick of all the in-fighting and ego-stroking that goes on?

Janet: One of the best Priestesses I know in this country is a perfect replica of the Venus of Willendorf statuette. She was initiated by us in between '71 and '72, and is very sincere and down to earth. Sometimes her words of wisdom put half the Craft to shame. But a coven would not accept her as a Second Degree (which she was) until she'd brought her weight down! They tried to demote her to First degree and humiliate her.

PN: How have other members of the Craft reacted to your books?

Stewart: Some people accuse Janet & I of giving away secrets. But we've never published material that hasn't previously been published in other documents before us, often in badly distorted form. All we did, with the help of Doreen

Valiente, was to correct distortions by going back to the source. A criticism made about *Eight Sabbats for Witches* was that the rites were "so secret" that they should never have been given out. But we designed those rituals from research, as we felt that Gardner's original sabbat rites were too skimpy and unworkable, so we expanded them. Doreen Valiente helped by eliminating the Crowley material present or by rewriting it in simpler terms. People who want to keep Gardner's rites secret are simply not living in the modern world. There are a large number of people looking for a simple and effective ritual system.

PN: Speaking of Crowley, what are your views on him as an occultist?

Janet: We don't think that Aleister Crowley was ever initiated as a witch.[3] He was a brilliant poet but couldn't suffer fools gladly, and seems to have regarded most of the people around him as fools. He did much useful research for the modern occult movement, but tended to make matters overly complicated. Towards the end of his life though, he seems to have realised that a simple approach to occult development was the way to go forwards.

PN: Last year saw an attempt to spawn a Pagan "Council of Elders". What do you feel about this sort of move?

Janet: Different groups are of course entitled to their own councils of "Elders" but we never want to see an overall council of Elders arising out of the Craft. Institutionalisation is something which the Craft needs to avoid.

PN: In *The Witches' Way* you went into some detail about Dorothy Clutterbuck and the New Forest Coven with whom Gerald Gardner made contact. Has any new evidence about this link emerged?

Janet: When we started work on *The Witches' Way* Doreen Valiente was researching information about Dorothy Clutterbuck and the New Forest coven. Ginny, our coven maiden, suggested that we search the records of the British Army in India. Sure enough, the birth of Dorothy Clutterbuck was recorded, along with a place called Highfield House, which is where Gerald Gardner claimed that he'd been first introduced to her. Within a year of *The Witches' Way* being published Doreen Valiente sent us a very interesting news clipping from a Brighton paper. The clipping referred to a firm of solicitors who had discovered a diary which told of life in Brighton during the Second World War (the period in which Gardner met Dorothy Clutterbuck). The diary contained letters from a lady friend who had illustrated the diary for the authoress. The diary belonged to one Dorothy Clutterbuck of Highfield House and subsequently appeared on

3 Hardly possible when modern Wicca didn't even start until just before Crowley's death (and much of early Wiccan initiation was based on Crowley's works in the first place). See Rodney's article on the subject: *A New and Greater Pagan Cult: Gerald Gardner & Ordo Templi Orientis* http://rodney-orpheus.com/writings/occult/a-new-and-greater-Pagan-cult-gerald-gardner-ordo-templi-orientis/

public exhibition. Both Doreen and ourselves wrote to the firm of solicitors concerning the significance of the diary as an item of Craft history. We never received a reply, and the diary was subsequently withdrawn from public view. One Wiccan priestess that we know (not Doreen Valiente) has in her possession correspondence between Dorothy Clutterbuck and Gerald Gardner but will not allow anyone access to them.

PN: **There's been a debate recently in some quarters over the number of lesbian and gay people becoming involved in the Craft.**

Janet: It entirely depends on the persons concerned. Witches who are afraid of people who are gay are afraid of their own sexuality.

PN: **What are your views on the presence of children during ritual?**

Janet: Most responsible people only let children into the post-ritual feast, and we feel that people who talk publicly about having children present in full rituals are asking for trouble. When making magick It's unfair to have children present as they are very susceptible to energy and cannot protect themselves. As one of our Priestesses says, children should be taught about religion, rather than simply taught religion.

PN: **How about another subject loved by the press – the role of psychoactives as a ritual aid?**

Janet: Various psychoactives belong to different parts of the world. A Native American shaman for example can work well with Peyotl, but introduce them to whisky and you'll destroy them. I have an American friend who's spent most of her life in Nepal. She works teaching English in the Nepalese villages. Pure opium has the same effect on her that cigarettes have on me. Offering her a cigarette would be like offering me pure opium.

As most people know, Cannabis and Datura are extremely beneficial for bronchial and asthma sufferers and we hope someday to see it legalised here and all over Europe.

Stewart: Cannabis in our culture can be compared with alcohol in that when used in moderation it can be relaxing, but can lead to a lot of problems if over-indulged in.

Janet: I think for young students coming into the occult for the first time, during their initial training period, whether It's alcohol, tobacco, or anything else, either cut them out for 18 months or cut down on them. Give your psyche the potential it had when you were younger.

Stewart: Anything "harder" than cannabis is utterly destructive and must be avoided. Not only that its use supports a widespread, vicious organisation who are not above selling it to children. Within our own coven and home we ban all psychoactive substances, including cannabis because we are much happier training people's psychic faculties without potentially dangerous aids.

Janet: I've come across cases of so-called shamans and New Age Pagans publicly stating (on TV) that they disagree with psychoactives if they are chemically produced and then proceeding to reel off a number of naturally-occurring psychoactives that can be picked up in any hedgerow in the UK, and give these plants their blessing, saying "Our groups use them" not considering bright young

> *"Witches who are afraid of people who are gay are afraid of their own sexuality."*

minds who without too much effort and very little knowledge could identify these plants from any botanical handbook with dangerous and possibly fatal results. For example, the Lesser and Greater Celand: neither of which are hallucinogenic, the Lesser being an excellent cure for piles and the Greater which can be fatal if taken internally.

PN: **What do you think about the number of shamans who are popping up everywhere?**

Janet: Shamanism has become the fashionable trend of the moment (as "chaos magic" was a couple of years ago), but few people who claim to practice it realise how much work and long training it requires.

PN: **Do you think It's possible for Pagans to have any dialogue with the authorities?**

Janet: You can get to a stage when you become over-paranoid. Sure, we're all on file as active Pagans and occultists, but "they" will leave us alone, as long as we're totally honest and open about what we do.[4] The police in Ireland for example, have from time to time consulted us over various allegations concerning witchcraft, and by helping each other we have been able to avoid things getting blown up out of all proportion.

PN: **Any last words for your readers?**

Janet: We sometimes find ourselves set up to be god-like figures, but I'm 39, still have spots, PMT and thinning hair, and don't give a damn.

Stewart: I'm 73, half-deaf, and waiting to have a cataract in my good eye removed, and also have a slipped disc. We've been together for 16 years and wouldn't have it otherwise, and we worry about the electricity bill like anyone else. We could probably be making more money if I were a bus driver and Janet was working in a shop. The only good thing about being a writer is that you never retire.

Janet & Stewart Farrar, thank you very much.

4 Editorial note: as you will have already noted in your reading of this book, there is a multitude of evidence that contradicts this opinion.

THINGS TO DO...
and THINGS TO READ

Approaching the I Ching

by *Frater Impecunious*

Most occultists are familiar with the *I Ching* and talk casually about "throwing the Ching" as though they perform divination by hurling the book across the room (not a good method, as it falls open at some pages more than others). To the uninitiated this may seem confusing. Why is it, for example, that Tarot is supposed to require years of meditation on the symbolism of the cards, but people often make major life decisions on the basis of a book they may not have even read in its entirety just by throwing a few coins?

One answer is that the *I Ching* is not just any old book. It's an incredibly old book: chock full of archetypes, primal symbols and what have you. This is a nice idea, although the *I Ching* isn't actually as old as people make out – about 800 BCE at the earliest. Then there are the commentaries, which are the result of several authors working at different dates. Texts have been altered for both philosophical and political reasons. Then of course, there's the problem of translation.

Richard Wilhelm's translation of the *I Ching* has come to be regarded as the "authorised version"... and is certainly one of the best. Nevertheless it is sometimes over-literal and has an uncritical attitude towards the mythology surrounding the text. One approach is to compare different editions. Some of the better ones are listed below. This lessens the problems of translating such an ambiguous language as classical Chinese and can also give a variety of views. Off-beat editions, such as Crowley's non-translation and rewritings from a particular viewpoint (i.e. feminism) provide interesting contrasts, but should be taken with a pinch of salt. Ultimately, It's your own knowledge of the hexagrams which is important, and this requires study; which needs to be both intellectual and contemplative. In both cases it is best to start from the bottom up.

The concept of Yin and Yang may well be later in origin than the text of the *I Ching* but they still provide the best key to it. Practising a related physical

discipline such as Tai Chi Chuan helps to absorb these ideas. The eight trigrams can be comprehended next, and Steve Moore's book *The Trigrams of Han* is invaluable here. The *Shuo Kua* printed in the Wilhelm edition is also useful, although not historically accurate. Contrary to popular belief (both Chinese and English) the hexagrams probably originated before the trigrams rather than afterwards, but It's still best to approach them as combinations of trigrams.

Given this complexity, It's a wonder anyone actually uses the *I Ching* as an oracle. In fact the vast majority of the Chinese don't, they either pay someone else to do it or use a simpler system. Those who read the *I Ching* do so as a work of Philosophy, as a way of understanding natural processes. But if I haven't put you off, then part two will look at methods of consulting the oracle.

Further Reading

The I Ching or Book of Changes (RKP), Richard Wilhelm
I Ching – the Book of Change (Allen & Unwin), John Blofeld
The Trigrams of Han (Aquarian Press), Steve Moore

Crafty Talk
by *Mike Howard*

Y our editor has bravely suggested that I write a bimonthly column in *PN* exploring various aspects of the Craft, which in its revivalist form is commonly known as Wicca. Always ready for a challenge, I agreed! However, readers should note that the views expressed will be my own and not those of an "official" spokesperson for any branch of the Craft whether it be Revivalist, Traditional, or Hereditary.[5]

In this issue I would like to set the scene by reflecting on the development of the Wiccan revival over the past 25 years and speculating on its progress in the 90s. When Gardner wrote *Witchcraft Today* in the 1950s he feared the Craft would not survive the modern age. Obviously he had not foreseen the dramatic change in social consciousness which was just around the corner. The 60s was a time when the first stirrings of the Aquarian spirit began to manifest in straight society. This great change in cultural awareness and its aftermath were to provide a fertile breeding ground for the neo-Pagan revival and the Wiccan resurgence.

In the mid-1960s, following Gardner's passing to the Summerland, the branch of the Craft he had founded was suffering a crisis of confidence. His death left a vacuum which his chosen replacements, Monique and Scottie Wilson, were unable to fill – probably because they did not have the support of the covens Gardner had established. A pirated version of the Gardnerian Book of Shadows had been published and several Hereditary witches had emerged to claim the Wicca promoted by Gardner bore little resemblance to the "true" Old Faith. In addition the cosy, sherry-sipping, middle-aged, middle class image of the Gardnerians was hardly the right stuff to create a popular revival of Paganism in the so-called "permissive society", even if their practices of religious nudity and ritual sex had been considered pretty risque in the puritan 50s!

Two new influences were to transform this stagnant situation. One of these was the advent of the charismatic personality of Alex Sanders. His flair for sensational self-publicity and blending ceremonial magic with Gardnerian Wicca attracted

5 Back when Mike first wrote this, these three terms seemed vitally important distinctions. Whereas today you would be hard pressed to find anyone who cares. Times change.

a large number of people into the Craft who otherwise would never have joined. Some of these converts persisted to form the nucleus for the new Wiccan revival of the 1970s.

The second of these influences was the embryonic Green movement. The spiritual ideas behind it had begun to develop during the heady "Flower Power"

> *"The publication in 1982 of Starhawk's The Spiral Dance and the work of feminist writers like Monica Sjoo helped influence a new generation of neo-Pagan revivalists who either had no access to the Gardnerian Craft or rejected its perceived fuddy-duddy image."*

years with the widespread interest in ley lines, Stonehenge, and the sacred landscape of Albion among the hippies. However Green politics did not establish itself until the early 1970s with the formation of environmental action groups like Friends of the Earth and Greenpeace. In the 60s American groups like the Church of All Worlds[6] had pioneered the promotion of ecological causes and early Gaianism.

This had a spinoff over here albeit unconsciously, and in the early 80s groups like Pagans Against Nukes,[7] the magazine *Wood & Water*,[8] and the Dianic Craft emerged to embrace radical politics and feminism. The publication in 1982 of Starhawk's *The Spiral Dance* and the work of feminist writers like Monica Sjoo helped influence a new generation of neo-Pagan revivalists who either had no access to the Gardnerian Craft or rejected its perceived fuddy-duddy image.

6 The Church of All Worlds (CAW) is a modern Pagan organisation formed in 1962 by Oberon Zell-Ravenheart and Morning Glory Zell-Ravenheart, inspired by a religion portrayed in the Robert A. Heinlein SF novel *Stranger in a Strange Land* (1961). Yeah, It's a bunch of hippies, how did you guess?

7 Pagans Against Nukes (PAN) was founded in 1980 and via its magazine *The Pipes of PAN* organised demonstrations and rituals to protest deployment of American nuclear cruise missiles to the UK. While this article was being written in 1990 the Soviet Union collapsed and most nuclear protests with it, including PAN. In 1987 the USA had already started withdrawing most nuclear weapons under the terms of the Intermediate-Range Nuclear Forces Treaty, though this would not be complete until 2006. The UK still retains its "independent" nuclear submarine fleet, though in reality all of its missiles are effectively still under the control of the USA. So depending on how you look at it, the anti-nuclear weapon movement either succeeded really well, or it didn't succeed at all.

8 *Wood and Water* was founded by Hilary Llewellyn-Williams & Tony Padfield in 1979. Originally starting with a focus on sacred wells, it rapidly became refocused on general Goddess spirituality and ran for an amazing 80 issues until 2003.

So what role does Wicca have in the 90s? As we prepare for the dawning of the Aquarian Age the emphasis on priestly hierarchy, formal initiations, and the ritual structure of elitist power groups like covens which characterises the Gardnerian Craft is bound to be challenged. New Age opinion is that humanity is moving towards a more mystical and individualistic concept of spirituality. Self initiation and solitary working may be the key Craft buzzwords in the new decade. As the 80s saw the Green movement gain a measure of political credibility, so the 1990s are destined to see this support become a spiritual force in the world. After all it is our basic attitude to Mother Earth which has created the present crisis. I believe that the Craft and neo-Paganism have an important role to play in such a scenario, albeit in a subtle way.

I also predict that the 90s will see the Craft returning to basics and an emphasis on more "traditional values".[9] The Craft has, in my opinion, always been a mystery faith for the few rather than a popular myth for the masses. However, in the future the Craft will certainly need to be more flexible than it has been in the past. It also might realise that the attitude of insular superiority is not an answer. Somehow I doubt we will see another Gardner or Sanders because the Pagan movement does not need them now.

Wicca, whatever its flaws, provides one of the many legitimate paths of neo-Paganism but it is, and never was, a path for everyone. In the 90s it will be forced to face up to the challenge of change as we prepare to embark on the magical mystery trip of self discovery leading to the eclectic world of 21st Century Spirituality. How it deals with this challenge will determine whether Gardner's belief it would not survive the modern age was prophetic or merely pessimistic.

9 He couldn't have been more wrong. As it turned out the 90s brought us the movie *The Craft*, Ronald Hutton's *Triumph of the Moon*, and Silver RavenWolf's *To Ride a Silver Broomstick...*

Isis of a Thousand Names

A weekend of Goddess empowerment will take place on the 19th – 21st October at Hawkwood College, Painswick Old Road, Stroud, Gloucester GL6 7QW. This residential weekend offers the chance to revere the Goddess through meditation, ritual, music, dance, and practical workshops. The weekend will be led by: Caitlin & John Matthews, Felicity Wombwell, Vivienne Vernon-Jones, and Jerry & Naomi Ozaniec. For further details contact Caitlin Matthews, BCM Hallowquest, London WC1N 3XX.

Pagan Federation Conference

The Pagan Federation has booked a central London venue for its second annual conference, which will be held on November 24th from 10.30am to 6pm. Speakers include Doreen Valiente, Nigel Pennick, Caitlin Matthews and Philip Carr-Gomm. The event will include stalls and local groups meetings. Tickets will be £8 for the day (£5 to PF members and subscribers to *The Wiccan*). Further details from The Pagan Federation, BM Box 7097, London WC1N 3XX (please enclose an sae).

Phantoms of the Sky

The Independent UFO Network has announced their first annual UFO conference, which will be held in Sheffield Library Theatre, July 14th–15th. Speakers include Jenny Randles, Paul Deveraux, Andy Roberts & Dave Clarke, and it is hoped that the infamous documenter of strange beings, John Keel, will be attending also. For further details of the event ring 0294-444049 or 0484-721993.

EVENTS

Bradford Earth Mysteries Group holds regular meetings. Contact Paul Bennett on 0274/613763.

Darwen Moot meets at the Millstone, on the first Tuesday of the month, from 8pm. Wear a daisy!

Hull pagan group holds regular meetings. Contact Samantha on 0482/448679.

Leeds Pagan Moot restarting at Fat Freddies' on Call Lane (next door to Leeds Other Paper) on the first thursday of the month. Note: Fat Freddies only has a restaurant license at the moment, though this may change in the future.

London North London PaganLink moot is held at The White Lion of Mortimer pub at Stroud Green Rd, London N4, on alternate Thursday evenings. Contact Ray on 01-263-5066 for details.

London "Talking Stick" - informal talks on esoterica held upstairs at The Plough, Museum St, London W1. . For further info phone Caroline on 01-738-7950.

London 'House of the Goddess' has started up again, & Shan tells us she is organising a series of gatherings. The events will include talks, workshops, & music. For further details tel: 01-673-6370.

Manchester University Occult Society Contact Chris on 061-225-9148.

Oxford Pagan Fellowship contact Anne on (Oxford) 714796 for information.

Preston Pagan Moot. Ring Val or Brian, 0772-34696 for details.

Wakefield Pagan Moot meets on the first Wednesday in the month at The Beer Engine, Westgate, from 7.30pm.

SUMMER EVENTS

June 15th–26th Stonehenge People's Free Solstice Gathering

June 16–17 Leamington Peace Festival

June 21st SUMMER SOLSTICE

June 22–24 Glastonbury Festival. Info from 0898-400888.

June 23 Norwich Green Fair

June 30 Gay Pride March, London

July 6–15 Lichfield Arts Festival

July 13–15 22nd Recar Folk Festival

July 14 – Aug 19 'Tree of Life' ecological art at MacLaurin Art Gallery, Ayr.

July 21–Sept 2nd 'Out of the Wood' eco-art at Derby Museum & Art Gallery

Aug 3 'Torpedo Town' Free festival. Info from Friends of T'Town, Box B, 167 Fawcett Rd, Portsmouth, Hants.

Aug 3 Cantlin Town Free Festival, Lower Short Ditch (on the border of Shropshire & Wales).

Aug 10 – 12 Trecastle Free Festival (Wales).

London Dialling Code Changes

Would the organisers of London Moots & similar regular events please send us revised details of their telephone numbers.

NEWS & EVENTS cont: p14

PAGAN NEWS

The bi–monthly news magazine of Magick & The Occult

July/Aug '90
Price 50p

All Quiet on the Stonehenge Front?

This year's Summer Solstice gathering was relatively quiet, compared to last year's military–style police blockade. There was no massive police presence, though the Larkhill track to the Stones was blocked off with a heap of sand to prevent cars moving onto it. Some pagans who visited Stonehenge told *PN* that the police allowed them to walk up to the Hele Stone and carry out a short celebration. Some celebrants were warned that they could go up to the wire, but that if they stopped or tried to tie themselves to the railings they would be arrested. At one point a coachload of people arrived at the Stones and 'unfortunately' broke down – the police directed traffic around it but wouldn't let anyone off the bus. No clashes between police and celebrants has been reported, though we understand that about 23 people were arrested, but the circumstances around these arrests are unclear.

Rumour has it that next year the Ministry of Defence (MoD) have offered land for a site for next year's Solstice, and that the English Heritage are also planning to re-open the Stones. This could be the turning point in the long history of Solstice celebrations at Stonehenge. The lessons of last year's debacle seem to have been understood by all concerned, including English Heritage and the police.

Environmental Theatre Competition

The Sacred Earth Drama Trust are holding an international competition to create a piece of Environmental Theatre based on a sacred story from your own culture or from someone else's. The idea is that you think about the great religious and mythological stories that you know, and choose one which you think says something important about the natural world and how we should live in it. Retell or reshape it as a drama for people of all ages to enjoy, using the theatrical techniques and traditions of your choice. The competition is inspired by the traditions of religious theatre, from the mystery plays of Christianity to the Australian Aborigine Dreamtime Ceremonies. The aim of such sacred drama is to renew and integrate all dimensions of life. The competition will lead to an international festival and broadcast of winning entries. Winners will also be published in an anthology of Sacred Earth Drama, which it is hoped will become a widely–used resource in schools around the world. All profits from the anthology & broadcast will go to the United Nations Environment Programme. For further details write to: Sacred Earth Drama UK, Kilnhurst, Kilnhurst Rd, Todmorden, Lancs, OL14 6AX. Entries must be in before 31st December, 1990. Sounds like an excellent opportunity to present some positive pagan images!

July/August 1990

NEWS

U.S "Satanic" Hysteria Still Rampant

PN informants who have just returned from the USA report that the hysteria over "Satanic" cults is doing just as well as over there. Last month a young stockbroker was hauled in for questioning because he had taken out a library book on Aleister Crowley! This was in connection with the hunt for a serial killer known as "Zodiac" because notes he leaves on victims appear to be governed by astrological patterns.[1] The stockbroker has since been cleared of all suspicion – he was described as white, 22 years old, clean-shaven and weighing under 150 pounds, whilst the Zodiac killer has been described by police as a heavy-set 6' tall man over 30 years old and weighing over 180 pounds. Some discrepancy, huh? It seems the police illegally gained access to library records, a trend which began years ago with intelligence agencies asking libraries to watch out for people with Russian-sounding names taking out books on suspicious topics.

'At the Heart of the Matter' Just Scrapes the Surface

Joan Bakewell's programme on the 22nd of July dealt with "ritual child abuse".[2] All the old favourites were roped in – Audrey Harper, Kevin Logan, etc. Time and time again the fact that there is no evidence whatsoever to support the claims of the fundamentalists and "ritual abuse" professionals was mentioned, yet the programme still managed to put over the familiar tale of a worldwide conspiracy of Satanic baby-killing torturers. Almost the sole voice of sanity, an advisor to the Bishop of Liverpool, gently pointed out that fundamentalists were very good at maintaining fixed beliefs despite all evidence to the contrary, and are likely to twist the truth so that it fits in with their worldview. Horror videos were cited as a source of "Satanic imagery", with the possibility that abusers were using props that they had seen in videos as an "excuse" for perpetrating abuse. Much mention was made of "Satanic cults" but as usual no details could be mentioned because

1 Zodiac started killing in 1968, so it was truly odd to bring someone in for questioning who was literally *born* in that year. Also Zodiac had ceased killing in the early 1970s (as far as we know) and by 1990 the case was decidedly cold, so to even consider pulling in some random young guy on suspicion of it is super weird. We suspect that the reasoning was given after the fact to try to cover over a completely stupid arrest.

2 Baroness Joan Bakewell (1933 –) is a British TV presenter and member of the House of Lords. The programme mentioned would have been *Heart of the Matter* which she presented for 12 years between 1987 and 1999.

they were "too horrific". An NSPCC official interviewed said that he couldn't afford not to believe in the possibility of ritual abuse, which perhaps highlights part of the problem that social workers face. Throughout the 80s the social services have been faced with a series of incidents which have time and time again called their competency into question: faced with criticism from all sides It's easy to see how some professionals fell for the intense barrage of fundamentalist propaganda.

Who Owns Your Body?

The last decade or so has seen a sustained attack on individual freedoms that shows no sign of stopping. There has been a sharp increase in prohibitions relating to what we can read, view, and participate in. The government might not have got around to the occult yet being still occupied with Acid House parties. The latest minority to loom under the judicial hammer is those interested in tattooing and body modification (such as piercing). Proceedings have begun against Britain's most well-known practitioner of bodily modification, Mr. Sebastian,[3] who is being charged for performing body piercings under the laws of assault – despite the fact that he only works on paying clients. If this ruling goes against Mr. Sebastian then it would effectively curtail any individual's domain over their own body.

German Library collects Pagan Mags

One of the more unusual subscribers to *Pagan News* is the "Institut für Grenzgebiete der Psychologie und Psychohygiene" in Frieburg.[4] It is a specialist library which collects all books and journals on parapsychology, spiritualism, witchcraft, astrology, Tarot, UFOs and the like. The library has over 23,000 books and subscribes to more than 200 journals which deal with these subjects. The library can be contacted at Eichalde 12. D-7800 Freiburg. W. Germany.

3 Mr. Sebastian was Alan Oversby (1933 – 1996), a legendary pioneer of modern body modification. Although widely accepted and practiced today, back in the 80s and 90s body piercing, tattooing, and other modifications were still considered very "alternative" and beyond social norms. In 1987 Sebastian was arrested for "assault occasioning actual bodily harm" for performing a genital piercing on a client, and using anaesthetic without a license. He pleaded guilty (he had little choice) and received a sentence of 15 months, suspended for two years. In retrospect this may seem astonishing, but that was life in the UK back then. Mr. Sebastian can be heard on the track " Message from the Temple" on the excellent first album from Psychic TV, *Force the Hand of Chance*.

4 The Institute for Frontier Areas of Psychology and Mental Health (IGPP), founded by the physician and psychologist Hans Bender in 1950. It concentrates on "systematic and interdisciplinary research of so far insufficiently understood phenomena and anomalies at the frontiers of our knowledge. These include conditions of altered states of consciousness, extraordinary human experiences, mind-matter interactions as well as their social, cultural, and historical context in the humane, social, and natural disciplines." https://www.igpp.de/allg/welcome.htm

TOPY UK Anti-Dolphinarium Campaign

Over the past eighteen months the Temple of Psychick Youth UK have been campaigning to close down Brighton's Dolphinarium. The dolphins, Silver and Missie, have spent 12 and 20 years respectively in a bare concrete pool only 23 metres in length and 3 metres in depth that is completely underground with no natural light or ventilation. The water is poorly filtered and is contaminated with the dolphins" waste matter and neat chemicals which are poured directly into the pool in a bid to keep the water clean.

In the wild, dolphins have been recorded as surviving to 40 years. However, Brighton Dolphinarium has had eighteen dolphins die since it opened in 1968 and two calves have been stillborn. The Dolphinarium's breeding record alone provides enough evidence to support the widely held view that these creatures should not be held in captivity under such conditions. The only justifications provided by the owners are, ironically: breeding, education, and research. Well, the Dolphinarium's breeding record is a complete failure that has only resulted in unnecessary suffering and death for the dolphins. As to education: how can seeing a pair of dolphins confined in an underground pool that bears no relation to their natural environment be construed as "educational"? Add to that the spectacle of seeing these dolphins being made to perform tricks designed to entertain, such as leaping through hoops, pulling children around in a rubber boat, and having their teeth cleaned with an oversized toothbrush. What kind of twisted mind considers this explicit placing of sentient creatures in an inferior role as merely our entertainers as educational? As for research, the only research that seems to be going on is economic – how many dolphins can they afford to have die this year without adversely affecting cashflow?

The only acceptable alternative is a rehabilitation programme for the dolphins with their eventual return to the wild. There are spaces for them on a number of rehabilitation programmes, including an institute in Florida. These creatures belong in the wild. TOPY will continue to fight for the closure of the Dolphinarium and the release of the dolphins into an open water facility. Picketing has already been successful in drawing attention and the Temple say they will picket every weekend for five years if necessary.[5]

5 Missie was caught off Biloxi, Texas in 1969 and Silver caught off Taiwan in 1978. They had been in captivity ever since. This campaign to free them succeeded admirably and in September 1991 Missie and Silver were released back into the wild in the Caribbean. Protest works. (More on p.419)

SPOTLIGHT

Meetings with
Remarkable Women

Estelle Seymour meets Monica Sjoo

Monica Sjoo is an acclaimed writer and artist, and is probably most well-known in Pagan circles for her book The Great Cosmic Mother. *She has been actively involved in the Women's Movement since the 60s and regularly lectures about her approach to Women's Spirituality. She writes regularly for magazines in both America and Europe, and is a vociferous critic of New Age philosophy. Here Estelle Seymour recounts her meeting with Monica Sjoo.*

"Do you fancy interviewing Monica Sjoo?" asks Phil one cold November night. "Yes!" I reply, jumping up and down enthusiastically, trying to remember what little I know about her and having always pretended more knowledge than I actually had so as to appear "right on" to my feminist-lesbian friends, who waxed lyrical about Monica's pictures and book *The Great Cosmic Mother.* After two attempted meetings I finally made it to Monica's Bristol flat. Acutely aware that I was feeling somewhat overawed at the prospect of meeting such a "famous" person, let alone interviewing her for a reputable Pagan mag (? – Ed.), I found the address and was greeted by a friendly Monica who was happy to feed me vegetarian stew and herb tea while we talked. I soon felt at home in the postcard-lined flat and any feelings of trepidation soon vanished (thanks Monica).

Our conversation ranged around politics, women, painting and Monica's forthcoming book which will be an exposé of the New Age movement and is due out in 1991 from the Womens Press.[6]

A quick biographical note: Monica lost both of her sons within three years of each other. One was run over and the other died slowly of cancer. To try and cure the cancer they tried a variety of therapies such as Rebirthing. Whilst

6 *New Age and Armageddon: The Goddess or the Gurus?* (1992) London, Women's Press.

investigating the alternative New Age therapies, Monica became increasingly concerned at the fascist ideology underpinning New Age thought: "Take personal responsibility for everything that happens to you – It's your karma. Never mind the pollution and poverty that surround you – the planet has a lesson to learn. Don't get caught in victim consciousness whether you've been raped or your children have leukaemia because you worked at Sellafield – you chose the lesson."[7]

Monica pointed out that the shining lights in the New Age are invariably men, whether currently incarnate or operating as "secret masters". Christ consciousness is in vogue and we all know the atrocities perpetrated against women by the Christian Church(although there are arguments to dissociate the figurehead from the organisation). What about some female masters (mistresses?). What about following our own wisdom instead of the unchallenged New Age psychobabble that gullible followers choose to base their lives on?

The eternal war against the powers of darkness continues to be waged and the New Age perpetuates the split between good and evil (wot, never heard of transcending opposites, Abraxas or Tao?). Even the concepts of yin and yang have become value-laden and the male still rules supreme, negating the flow and neutrality of the original understanding. These concerns. together with three years of research, have formed the basis for Monica's forthcoming book, and judging by the contents page she showed me it will be a useful reference source.

So much for the New Age and on to the Women's Movement, which Monica has been closely involved with since the late 60s. Monica's painting entitled *God Giving Birth* caused a stir when she painted it in 1968 and there was talk of blasphemy since she depicted God as a woman standing up to give birth.[8] Many distributors of *Peace News*[9] refused to stock the issue that featured the painting on its front cover for that reason. As far as she was aware, for many years she was the only person painting "Goddess pictures" and talking about women's spirituality. At that time feminists had only got as far as political consciousness and the Matriarchy Study Group[10] was barely conceived. Monica has been

7 While writing this footnote during the Covid-19 pandemic, it has become obvious that this nascent neo-fascism has recently become considerably more overt with the right-wing anti-vaccination and anti-mask movements being enthusiastically embraced by various New Age gurus, spearheaded by leading conspiracy theorist and all-purpose asshole David Icke.

8 *God Giving Birth* (1968) depicts a non-white woman giving birth. It was censored multiple times and Monica was reported to the police for blasphemy. We are still not sure whether the blasphemy consisted in portraying god as a woman, or in making her a Person of Colour.

9 *Peace News* was founded by Quaker activist Humphrey Moore in 1936 and continues advocating for pacifism to the present day.

10 The Matriarchy Study Group was founded in 1976 by a group of women in London (including feminist spirituality writer Asphodel P. Long) to examine the assumptions of society under patriarchal religions; and to increase awareness of earlier matriarchal religious systems and how they might encourage modern women to take control of their spirits as well as their bodies.

involved with the group since its inception and has been a regular campaigner at Greenham Common.[11] She has seen women organising, achieving, and now seemingly falling into various factions of in-fighting and suffering from lack of funding. However many of the early radical reforms have been commonly accepted, if not acted upon, for example workplace creches.[12]

Involvement with Paganism came when Monica moved to Wales and linked up with the Oak Dragon Camps.[13] Listening to her I was impressed with her mythological knowledge and her political awareness; two subjects which do not always go hand in hand. We talked about her identification with Celtic mythology in spite of her home being in the north of Sweden where runestones are as common as our roadside crosses, and the adoption of Odin as the chief in the pantheon of deities associated with them. This she sees as unbalanced since it ignores Freja and the fact that Odin gets defeated. She is deeply involved with earth mysteries and has made many journeys to sacred sites. We spoke of Avebury[14] and Callanish stone circle[15] which is a very special place for her where she has spent time tuning into the energies and drawing the stones. Her shared experience of tracing the sacred spiral at Glastonbury Tor[16] has been documented by Geoffrey Ashe[17] who also notes the often far-reaching changes that occurred after the event.

Monica's lecture tours have frequently been to Germany where she has been shown many village squares where women were burned as witches during the Inquisition. Some villages were so decimated that they only had one woman left.

11 Greenham Common Women's Peace Camp began in September 1981 to protest nuclear weapons being placed at RAF Greenham Common in Berkshire, England. By 1983 there were an estimated 70,000 women protesting there. The camp was active until 2000. A memorial now stands in the spot.

12 In 1990 the UK government began offering tax credits for employers who provided child care facilities in the workplace – a significant victory for working mothers.

13 Oak Dragon Camps are an annual set of events that began in 1987 and feature everything you would expect of a 10 day UK Pagan retreat: tents, rain, mud, and a lot of hippies holding hands.

14 Avebury henge and stone circles were built in Wiltshire, England during the Neolithic period between 2850 BC and 2200 BC, and form part of a huge temple complex that originally covered an enormous area including the more famous (but considerably less impressive) Stonehenge. Well worth visiting.

15 The Callanish Stones were erected about 5,000 years ago and were an area of ritual activity for about 1,500 years. They are near the village of Callanish on the west coast of Lewis in the Outer Hebrides, Scotland. Not an easy place to get to, but absolutely worth the effort, they are breathtaking.

16 A beautiful hill near Glastonbury, Somerset, England, also known as the Isle of Avalon, which is associated with many occult legends. Its fame has led to Glastonbury becoming a place of pilgrimage and residence for many modern Pagans since the 70s, and the area holds many Pagan-themed events, not least of which is the annual Glastonbury Festival, one of the biggest rock festivals in the world.

17 Geoffrey Thomas Leslie Ashe (1923 –) is a British historian known for his multiple works on King Arthur and his identification of Cadbury Castle in Somerset as the historical site of Camelot.

German Christian feminists (yes, they do exist!) have demanded an apology from the Church for these deaths during the Inquisition, and plaques and statues are gradually appearing in the squares or on the towers still standing. During one working, women were looking into a pond used previously as a ducking pond for suspected witches. It was as if the reflected faces were those of the drowned women and a strong connection was made with their past. One of the women present had her task revealed as casting bronze statues to commemorate the burning grounds as a result of this powerful experience.

Monica sees her role as that of a teacher. She teaches women to connect with forgotten memories of themselves through her paintings which portray images from many cultures and ages. Her first book *The Great Cosmic Mother* has recently been expanded and reprinted and anyone interested in seeing her earlier work and reading about women's spirituality is advised to read it.

Finally a message to all women: Women need to organise themselves. I see all these Pagan magazines with articles written by men. Where are the women and why aren't they writing? So over to you.[18]

18 Although your editors identify as male, during the run of *Pagan News* we worked hard to get female writers and interview subjects featured as often as we could (as we hope can be seen from this book). It wasn't easy back then, though we happily note that today we see a lot more women writing and webcasting about the occult.

VIEW POINT

Black Magic and Dirty Tricks
by *Choronzon 999*[19]

For some years now certain sections of the media have given regular prominence to lurid accounts which associate occultists with a variety of bestial practices including the abuse of children. The impression that such activities are commonplace has been given some credence by the pontifications of various sensation-seeking clerics and the pronouncements of Geoffrey Dickens MP.

The provenance of such stories has always been a mystery to those of us who have never encountered anything of the sort. A recently published book contains a few clues which fellow "black magicians" may find interesting.

Who Framed Colin Wallace? by Paul Foot[20] is an account of the activities, trials, and tribulations of a former Ministry of Defence (MoD) Information Officer. Colin Wallace's involvement in a "dirty tricks" campaign in Northern Ireland in the 1970s has been confirmed as recently as 30th January this year by the Minister for the Armed Forces, Archie Hamilton MP in a written Parliamentary answer to Michael Marshall, the MP for Arundel.

A section of the book deals with distasteful activities which took place at Kincora Boys" Hostel, Belfast, allegedly with the knowledge/connivance and involvement of various figures within the Ulster establishment as well as the civil and military intelligence communities. In 1981 the head of the hostel and two staff members were tried and convicted on 28 charges. More contentious is the apparently well-supported allegation that the authorities allowed the situation at Kincora to continue for at least six years after it had been brought to their attention, because of the blackmail and other dirty tricks opportunities it provided the intelligence services.

19 Choronzon 999 was the magical name of Charles Brewster (? – 2013). A seminal figure in the early development of chaos magic, he was involved in groups such as the Stoke Newington Sorcerers (along with Peter J. Carroll and Gerald Suster) and the Illuminates of Thanateros.

20 Paul Mackintosh Foot (1937 – 2004) was one of Britain's greatest investigative journalists, most notably for *Private Eye*, the *Daily Mirror*, and the *Socialist Review*. The Paul Foot Award for journalism is awarded every year in his memory.

One aspect of the broader Kincora saga which has received scant attention is the existence of an occult dimension to the business. This is alluded to in a memo apparently written by Colin Wallace in November 1974, which is reproduced in Foot's book, relating specifically to "ritual overtones" in the murder of a 10 year-old boy, Brian McDermott. It seems that Wallace had some motivation to play down the occult aspects of the affair at the time, because one of the more successful disinformation tactics of the MoD "Information Policy" dirty tricks unit, was the manufacture of spurious black magic and witchcraft scenarios.

> *"Detailed accounts are given in Foot's book of intelligence officers buying bundles of black candles, and acquiring chicken's blood and feathers to plant in Republican areas. The purpose being to use these as evidence to assist in defamation exercises being mounted against prominent personalities to scandalise their church-besotted supporters."*

Detailed accounts are given in Foot's book of intelligence officers buying bundles of black candles, and acquiring chicken's blood and feathers to plant in Republican areas. The purpose being to use these as evidence to assist in defamation exercises being mounted against prominent personalities to scandalise their church-besotted supporters.

The last thing Wallace and his cronies in the intelligence community wanted was a real child sex and ritual murder scandal attaching to the people on the other side of the sectarian divide who were caught up in the Kincora business.

Several questions arise. One obvious one concerns the extent to which the current media diatribes and attempts to link occultists to child sexual abuse might be the end product of some Wallace-style disinformation exercise, eagerly lapped up by the gutter press, as were the "Information Policy" stories of the 70s. Other questions concern the whole matter of official enquiry into Wallace's allegations and the ramifications of Kincora, or the lack thereof... There have been two inquiries into Kincora during the 80s, but neither addressed the intelligence aspects of the case. This trend continues, as Mr. David Calcutt QC opens an investigation into Wallace's dismissal from the MoD, which supposedly occurred after his refusal to become further involved with a smear campaign against British politicians. There appears to be no brief for Calcutt to look at the wider aspects of the Kincora affair.

Illustration by Mykel Bates

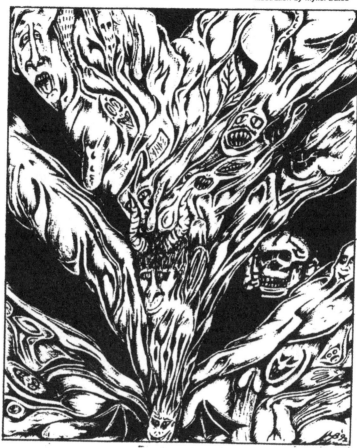

In the meantime Geoffrey Dickens MP raves on, with increasing clerical support, about the threat presented to society by occultists. If he is really as concerned as he likes to pretend, it seems Mr. Dickens should be pressing hard now for a proper inquiry into the death of Brian McDermott. The reasons why that matters and the involvement of high-level figures in the Kincora scandal appear to have been the subject of a systematic cover-up for over 15 years. I bet he flunks the challenge.[21]

21 It will come as no surprise to readers that Dickens did not take up the challenge of investigating real child abuse cases like those at Kincora. An investigation was finally launched in 2016 (yes, it took that long!) by the Northern Ireland Historical Institutional Abuse Inquiry (HIA). Their findings were that the abuse was limited to three staff members. However, many believe that this investigation was yet another cover-up of the real story in order to protect leading politicians and intelligence assets.

THINGS TO DO... and THINGS TO READ

Approaching the I Ching, Part 2

by *Frater Impecunious*

Last issue I looked at some of the problems to do with the text of the I Ching. The problem remains of what to do with the text once you've decided what it means. Although the I Ching is widely read as a purely philosophical work, it is obvious from the text that it has been used as an oracle from the earliest days. Unfortunately we don't know exactly how.

In the Shang dynasty (1766-1122 BCE) divination was performed using animal bones, particularly tortoise shells, but this predates the I Ching as we know it by several centuries. During the Chou dynasty (1122-221 BCE) this was replaced by the use of yarrow stalks, but this was not the method used today. That was invented by the neo-Confucian Chu Hsi (1130-1200 CE) as a possible reconstruction. I won't give instructions here since they can be found in most editions of the I Ching – It's enough to say that It's incredibly long-winded. This probably works to its advantage, since the repeated sorting of piles of stalks can create a light trance into which intuitions may drop. However, its claim to be the oldest method is false.

This title, funnily enough, belongs to the less prestigious three coin method, developed in the Han dynasty (202 BC- 220 CE). Chinese coins were symbols of Heaven and Earth: the square hole in the middle represented the Earth (which they thought was square) while the round rim represented Heaven. Similarly one side was inscribed (Earth/yin) while the other was blank (Heaven/yang). This meant tossing coins wasn't quite so flippant as it is today.

The method's popularity comes from its simplicity: the main objection is that It's hard to see why it should produce one result rather than any other. There's nothing inherently yin or yang about heads and tails, Chinese or English, and coin-tossing is only minimally affected by the caster's state of mind.

It may come as a shock to find that neither of these methods enjoy much popularity in Chinese communities today. The most widely used is the eight coin method. Eight coins of the same kind are used, one of which has been marked in some way. These are shuffled in the hand then placed on a map of the trigrams in the order shown in the diagram below.

When the marked coin comes up, this is read as the lower trigram. The process is repeated for the upper trigram. A similar process is used for the individual lines (starting at the bottom) to give a moving line. This is wonderfully simple, and is similar to geomantic types of divination.

There are other techniques, such as Crowley's stick-throwing, for instance. The point is that there is no "authentic" method. The I Ching is a symbol system. and divination usually consists of combining a pseudo-random process with a suitably familiar set of symbols. It's success depends on how well you know the system, how well you "fix" the randomness, and most of all how your intuition influences the interpretation of your result. So tossing coins with a book is better than just tossing a coin.

Perhaps.

B-DOG

the British Directory of Occult Groups

PaganLink Network

PaganLink Network is alive and kicking, contrary to the assumption that has been made by some that it had sunk without trace. PaganLink is continuing to grow, and carries with it the spirit and intent for which its founder, the late Rich Westwood, originally brought it into being. That intent was to allow Paganism to become accessible to people around the country who wished to meet each other: share, celebrate and learn without being initiated into a closed group or follow an exclusivist path. The central concept of PaganLink is that it acts to link Pagans and people interested in Paganism. Those of us currently active in PaganLink believe that for the Pagan community to develop it should move beyond the cliques, cults, and dogmatic boundaries which exist between people, and which generate interminable disputes and otherwise dissipate energies. There are witches, magicians, shamankas, followers of Asatru, women's mysteries etc. linking into the network, making contact, sharing energies, organising joint projects, learning from each other – surely this is what "Pagan community" means?

The Network consists of individuals who are prepared to chat to or write to inquirers about Paganism and what is going on in their area. PaganLinkers ideally try to develop links with local groups and help people find contacts which suit their needs best. Some areas have open moots on a regular basis. PaganLink is not an organisation as such and there are no rules setting out what a PaganLinker can and cannot do. Anyone who is in sympathy with these ideas becomes a PaganLinker by making contact with other active people. The emphasis is on sharing knowledge and raising energy together, rather than sitting passively waiting for someone else to get things done.

PaganLink does not require a leader-based structure: it is based on the basic Pagan belief that we all have God/dess within us and are responsible for our own reality. The Network acts to link active people together so that we can support each other. Two recent examples of the Network in action have been the Dragon-awakening project to defend KIt's Coty in Kent and the Listen to the Earth mass ritual.

PaganLink has developed through a number of "incarnations", through the ideas and energies of the different people who have been giving energy to the network. Current activists, while rejecting the establishment of any central organiser, encourage individuals to act as "Network Nodes", so that people seeking networking information and those wanting to become active participants themselves can contact them as a start to networking. There are still a number of free newsletters circulating, and many Pagan magazines, including *Pagan News* (which began as a free newsletter – Ed) are only too happy to print information about events, projects, etc. so let them know too. Weave your energy into the web with us, and help the Pagan community to grow.

Bright Blessings.
Anne Barrowcliffe

NB: There will be a Network information stall at the Lammas Link-Up this year, so send or bring any information etc. that you want to network. There will also be an open PaganLink Moot at 2pm on the Sunday afternoon. See you there.

This month Anthony Roe examines the Sun's role in Astrology

Albumasar[22] said: "There is no life in living things beyond God, unless it be through the Sun." Sol is the Lord of Life: his power sustains the orgasm of creation. Astrology charts the vital influence of the Sun through the avenues of time. The Sun's course through the year is delineated by the Zodiac through solstice and equinox, and Sol emerges as the Invincible Light-Lord of Heaven. In his daily course through the sky the Sun's creative activities are codified within the hours. A distinction is made between the day-time presence of the Sun and the hidden power of the Dark Sun at night. With select ritual the solar influences can be invoked effectively at midnight as well as noon.

In the configuration of a horoscope the Sun integrates the other features. The Sun's orientation of space marks the quarters of heaven and the angles of a chart, and its relation to the horizon denotes the coasts of the world. Sol's presence gives light and power, whether in the affairs of humans or the scheme of heaven. Planets in "cazimi", very close conjunction to the "heart of the sun", are immeasurably increased in virtue.[23] The nature and role of the Sun is well conveyed by those things it signifies in horary astrology, which seeks to answer specific questions. The Sun betokens vitality, creativity, the ego, fame, pride, gold, emperors, kings, men, husbands, lovers, and virility.

In natal or genethlialogical astrology, which deals with individuals, the Sun represents waking consciousness. A certain vital awareness of its position is the key to understanding the self-expression of a personality. This is the basis of newspaper horoscopes, which are taken from the Sun's Sign position, easily

22 Abū Ma'šar Ğa'far ibn Muḥammad ibn 'Umar al-Balḫī (787 – 886) was the court astrologer in Baghdad. His many works in Arabic were later translated into Latin and became the foundation of Western astrology.

23 Cazimi is a Latin transliteration of the Arabic term kaṣmīmī, which means "as if in the heart".

found from the day of birth. When the Sun is emphasised in such a chart it prognosticates dignified self-reliance, and shows artistic aptitudes. Ill-placed, it portends over-confidence, egomania, selfishness, and a dictatorial manner.

Spiritual as well as physical energies emanate from the Sun. In everyday concerns a "bad" Sun merely indicates some fear, trouble, or oppression connected with the matter at hand, probably stemming from an overbearing

> *"Astrology is not just passive sufferance of the slings and arrows of outrageous fortune. The whole point of divination is that by discovering more about the ingredients of a situation, or trend in circumstances, the more likely will it be possible to weave the strands of fate into a favourable, desirable, or acceptable pattern."*

person. Solar people are naturally energetic and make their strength available to others. Authority and exertion characterise Sol's protagonists. Successful solar types find senior posts and become executives or at least responsible for executive action. They like grand enterprises, usually have generous personalities, and often appear unmindful of where the gold they spend comes from.

In practical work it is known that the planets are most efficaciously invoked when in their own Signs. Thus a link can readily be made with Sol when the Sun is in Leo. Anciently a Solar Eclipse in the last part of Cancer was believed to occasion sedition in those areas governed by the Sign, which would include Scotland and Holland (particularly Amsterdam), Northern Germany, Venice, Milan, parts of North Africa and Istanbul.

Astrology is not just passive sufferance of the slings and arrows of outrageous fortune. The whole point of divination is that by discovering more about the ingredients of a situation, or trend in circumstances, the more likely will it be possible to weave the strands of fate into a favourable, desirable, or acceptable pattern. Astrology can be a very proactive procedure. Besides division of the Sun's path into 12 Signs, there is also the division of each Sign into 3 sections of 10 degrees each, giving 36 decans.

"Many Happy Returns" refers to the progress of the Sun around the Zodiac back to where it was at birth. The opposite degree in the Circle of the Sun, six months away, can be a time of depleted esteem in a person's life. That is the time to invoke life forces to offset any low tide in personal affairs. In his opus on

making life agree with the heavens Marsilio Ficino[24] quoted Proculus who said that "in the face of the Sun all the powers of the heavens are congregated and gathered into one". The Sun is the lord of elementary virtues, and all things can be fructified by his influence, duly distilled. Those who would work with the Sun might echo that exhortation from the *Stockholm Papyrus*:[25]

Sun. Berbeloch. Chthotho. Miach. Sandum. Echnin. Zaguel: grant thou that I mayest comprehend thee.

Afterwards take a hearty breakfast (more than just Sunflower or Morning Glory seeds) and then step forth into the enchanted world of light and look to receive omens and tangible benefits from illustrious Sol.

Work for invincibility, honour and success in his hours. Anciently sacred to the Sun was the cock, and his sacrifices included white horses and rams, but he was also offered honey. The best incense for morning rites is pure Frankincense.

24 Marsilio Ficino (1433 – 1499) was a humanist philosopher during the early Italian Renaissance who translated Plato's works and the books of the Hermetica from Greek into Latin. His interest in astrology led, unsurprisingly, to him being accused of heresy by the Roman Catholic Church in 1489.

25 *Papyrus Graecus Holmiensis*, compiled in Egypt c. 300 AD. It contains 154 alchemical recipes in Greek; some of which appear to derive from the *Pseudo-Democritus* of Egyptian alchemist Zosimos of Panopolis.

NORSE GODS TO SPLIT?

by Pagan NEWS Pop Correspondent BAZ HAIRSTYLE[1]

Rumours are flying around the astral plane that phenomenally successful pantheon The Nordic Gods are to split up over alleged "Magical differences" between members of the group. Here I am at their luxury Valhalla mansion to ask lead singer Odin if It's all true.

"Well, yeah, in a way. We were asking ourselves just where were we going esoterically, you know? And after Freya and I split, it was hard for us to go around pretending everything was okay; fertilising the crops and all. Then there was Thor and his Coke problem. We'd have gigs set up – Imbolc, Samhain, all the big tour dates, and he'd be locked in the bathroom, out of his mind."

But you must have made a lot of money. Look at the string of hit legends you had back in the Dark Ages.

"Oh yeah, but it never felt that good at the time, man. Most of the audience were drunken berserkers, and hall security was a big problem. And some of the venues we were invoked at were a real bummer. Try dragging your amps and speakers up and down a fjord all week. But it wasn't just the fans" fault. We used to do Moose Juice and go and smash up the circle where we'd been invited. Thor especially saw Stone Circles as a bit of a challenge. We really did get a bit of a rep. Hellraisers, that's what the early Christians called us. I remember one night when Thor took over my hotel room and filled

1 Yet another permutation of the Barry Hairbrush pseudonym. Obviously.

it full of Valkyries. I didn't mind the girls, it was what the horses did to the carpet that got me."

Wasn't this when one of your famous "tiffs" started?

"You bet man, we didn't speak to each other for months."

Didn't the fans mind?

"They didn't notice. Too busy getting cheap day returns to Ancient Britain and kicking the crap out of the place. But they were, like, the children of their age, y"know? We'd had the Roman Empire, with everyone being respectable and middle-class, then along come the barbarians and suddenly gratuitous violence was trendy and cool, right? All the kids were dropping their togas and laurel wreaths and going out thumping people. We were all walking round with little scowly-face badges and "Burn "n" Pillage, Man" biroed on our jeans. Then, like, suddenly the party was over. Not long after that the Goths appeared and everything went downhill."

As I look around the luxurious mansion at all the famous memorabilia – the Platinum Pentacle for One Million Materialisations, The Golden Torc of Montreux, all the purple-sequined armour, and the pink battle-chariot that Loki once drove into the swimming pool, I can hardly believe the Nordic Gods phenomenon might come to an end. Yet such splits are all too common, look at old-time pantheon The Ancient Hebrews, which folded after bass player Jehovah left to pursue a highly successful solo career.

Odin looks at me; a strange glint in his eye, and offers me a bag of tablets.

"Here man, d"you wanna, like... do some runes?"

PAGAN NEWS

The bi-monthly news magazine of Magick & The Occult

Sept/Oct '90
Price 50p

Occult Supplier Under Seige!!

On the morning of Friday, 3rd August, the premises of 'The Something Else Shop' in Dartford, Kent, was raided by police purporting to be acting under a search warrant issued in regard to drugs. Nothing of an incriminating nature was found, and the police consequently looked for evidence of other illegalities. They alleged that the shop's electricity meter had been tampered with and called in the Electricity Board, who subsequently removed it. Shop owner John Male is currently running his power from a portable generator donated by a friend. On the morning of 17 August a PN reporter called at the shop, and as John was describing what had taken place, a representative from from the Electricity Board called in, saying that they'd been informed that 'lights' were on in the shop, so it seems apparent that the shop is being watched. These are the latest developments in what seems to be an orchestrated attempt to put John out of business – the shop has been extensively picketed by Christian Fundamentalists, who are also running round-the-clock pray-ins (i.e. cursing) to ensure the closure of the shop. The Electricity Board are claiming that there was extensive damage to the meter, a claim that John Male is currently disputing through his solicitor.

John would welcome any offers of support or advice, especially from other pagan shop-owners who have run into similar problems. The address of the Something Else Shop can be found on p15. Dartford appears to be a small, conservative town which has not taken kindly to the appearance of a shop which sells occult books, tarot cards,

and 'head' paraphenalia. Someone is already spreading the rumour that John has been busted for drugs.

Satanic hysteria plumbs new depths

It is becoming evident (at least to the non-tabloid media) that the current 'satanic' hysteria is becoming increasingly absurd. Sue Hutchison, director of SAFE has recently been quoted as admitting that there is no concrete evidence for a satanic child-abusing conspiracy, but she's convinced it's going on, so it's only a question of time. Meanwhile in L.A., the trial of Heavy Metal kids Judas Priest in connection with a suicide pact carried out by two teenage boys whilst listening to one of their albums. Lawyers acting for the deceased boy's parents claimed that the album had hidden satanic references and subliminal death messages. Principal prosecution witnesses included a Doctor who claimed that hidden messages on audio tapes had supernatural powers; but his Ph.D was discovered to have come from a mail-order firm, and his evidence dismissed. Also dismissed was a probation officer who had written a handbook on how to 'de-punk' heavy metal fans, and Dr. Wilson Keys, a man who has spotted subliminal sexual messages in Ritz crackers, Rembrandt paintings and Abraham Lincoln's beard on five dollar bills! Defence council argued that the boy's suicide was the result of troubled upbringing, school failure and delinquency, which,

Norse Beliefs Linked to Fascist Attacks

Norse Pagan beliefs have been linked to a rising wave of fascist attacks in the NorthWest, particularly the desecration of Jewish graves with runic symbols. A representative of *Searchlight*, the anti-fascist magazine, has recently claimed that fascist groups such as the BNP all ascribe to Nordic myths. Let's hope that Odinic Pagan groups don't become identified by the media with fascist activities.[1]

And as if by magick, the following letter was sent to the editorial address...
By the sacred Eye of Odin! Has that infidel and varlet by the name of Baz Hairstyle learnt nothing from the Salman Rushdie Affair? Has he not learnt how dangerous it is to deride the religious beliefs of others, and to insult another man's gods? Does he wish to have a thunderbolt directed his way? If not he must apologise immediately for the blasphemous article that appeared in the July/August issue of Pagan NEWS. If such an apology is not forthcoming, and a retraction of the article made, then I must warn Mr. Hairstyle that Pagans of the Nordic Tradition, and followers of Asatru, will be looking to nail his fool head to a tree at some future point. It is not that we lack a sense of humour, but this article was sordid, degrading, and trivialising – it certainly was not funny! We were angry and disappointed to see that you Mr. Hine, as editor, took the decision to include such an offensive article. Sieg Heil!

The letter contained a Nordic illustration bearing the legend "The Order of Valhalla" and "All Solar Salvation To Him Who ls Conscious of Power."[2] Baz Hairstyle is now in hiding along with the creators of *Noggin the Nog*[3] and *Erik the Viking*.[4]

1 Unfortunately this was just the tip of the iceberg and neo-fascist groups across the world have now adopted pseudo-Norse mythology to give their racist bullshit a veneer of spiritual authority. See the research of the wonderful Amy Hale for more information on this subject: *The Pagan and Occult Fascist Connection and How to Fix It* https://medium.com/@amyhale93/the-Pagan-and-occult-fascist-connection-and-how-to-fix-it-d338c32ee4e6

2 Despite extensive research we have still never been able to ascertain what this supposed Order of Valhalla was or its membership. We suspect it was yet another "one man and his dog in a basement" magical order, as so many were back then. And still are, unfortunately.

3 A classic British children's TV series which ran through the late 50s – early 60s and was briefly revived in the 80s. It was based on a surreal version of Norse sagas and the characters were inspired by the famous Lewis chessmen. An absolute treasure for those of us who grew up back then.

4 A 1989 comedy film by the Monty Python team which, alas, is far from their best work. Honestly, you really don't need to know more about it than that.

A Prince Amongst Pagans

Prince Philip[5] has recently attracted attention by making positive statements about Paganism in a speech given to a Washington conference on religion and ecology. He pointed out that monotheistic religions such as Christianity had tried to draw people away from what they have seen as the Pagan worship of natural phenomena, and that it is now apparent that the ecological pragmatism of the so-called Pagan religions, such as that of the American Indians, the Polynesians, and the Australian Aborigines, was a great deal more realistic in terms of conservation ethics than the more intellectual monotheistic philosophies of the revealed religions.

Predictably, these words drew fire from the *Executive Intelligence Review*, a right-wing publication founded by Lyndon LaRouche, whose followers have maintained that the Queen, aided by the Mafia, is the head of an international cocaine smuggling racket.

5 Prince Philip, Duke of Edinburgh (1921 – 2021), late husband of Queen Elizabeth II of the United Kingdom, and self-described "cantankerous old sod". As President of WWF International from 1986 he promoted several large conferences bringing together religious leaders to focus on ecological issues, and in 1995 he co-founded the Alliance of Religions and Conservation (ARC). Unfortunately, despite all of the major religions being represented, and having the backing of the World Bank, these efforts seem to have achieved nothing of any substance since then. Which should tell you a lot about major religions and capitalism. It was a noble effort on paper though.

THINGS TO DO...
and THINGS TO READ

Self Hypnosis

by *Adrian Reynolds*

The technique described here is taken from Bandler and Grinder's[6] work in Neuro-Linguistic Programming (NLP), a form of psychotherapy that has a lot to offer to anyone interested in magick. NLP offers the potential for self development and helping others through easily understood exercises in changing perceptions to maximise use of your personal resources. That practical emphasis sets it apart both from anal-gazing psychotheologians and their counterparts in magical circles... which is an excellent reason to try it if you ask me.

Sit comfortably and find something easy to look at, preferably something that's reflecting light. Fix your gaze on it and make three statements to yourself about what your visual experience is. For example "I see the vase on the shelf... I see the pattern on the vase... I see my fingers twitch."

Repeat this sequence for your auditory experience, eg. "I hear the traffic outside... I hear the television next door... I hear a fly buzzing round."

And then for your kinesthetic experience, e.g. "I feel my hands on my knees... I feel a draught on my ankles... I feel the pulse in my neck."

Then go through the whole feedback process again, making two statements each time and again, making just one statement. Then start again with three.

By the time you are going through the cycle of two statements you'll probably be experiencing tunnel vision, and enter a trance state soon after that. Tell yourself

6 Richard Wayne Bandler (1950 –) and John Thomas Grinder Jr. (1940 –), along with several others, together founded the discipline of Neuro-Linguistic Programming. Although highly influential on many occultists and alternative therapists (including the *Pagan News* team), modern studies have failed to establish any scientific basis for its claims. Self-help "guru" Tony Robbins got his start with NLP and has turned it into a $500 million fortune despite being a "major jerk" (according to *Forbes* magazine). We would say more, but he is renowned for suing anyone who says anything negative about him and he can afford much better lawyers than we can.

beforehand how long you want to be in trance – you'll be surprised how good you are at keeping time. At first use the trance for relaxation, but when you're familiar with it start to use it for visualisation exercises. Moving into further altered states... I'm sure you can all think of applications.

Don't feel you have to do things exactly as I've suggested. If it works better for you to comment internally instead of speaking out loud, then do so. Similarly, some people find that starting with auditory comments works better than visual ones. And if your eyes close at an early point (quite likely!) don't struggle to keep them open, substitute internal visualisation (whether of the room you're in or somewhere you'd like to be). Experiment!

For more about NLP, read Bandler and Grinder's books (don't be put off by the covers, which are the kind of things that used to grace Hawkwind albums),[7] though I'd recommend starting with *Frogs into Princes* (Real People Press).

7 Note: your Editors personally *love* Hawkwind, one of the greatest rock bands of all time. And Strange Attractor Press also publishes the excellent Hawkwind biography *Hawkwind: Days of the Underground – Radical Escapism in the Age Of Paranoia* by Joe Banks which we highly recommend.

B-DOG

the British Directory of Occult Groups

The Pagan Federation

The Pagan Federation was formed in 1970 as the "Pagan Front" by a group of people who would now be seen as being "elders" of what was then a burgeoning growth in interest in the Old Religions of the British Isles and as such is the longest surviving organisation of its kind in this country.

Initially formed to act as a focal point for the disparate groups operating under the loose umbrella of Gardnerian witchcraft, the Federation has expanded over the years to encompass all groups working within the confines of what many people now call the Native British Tradition including Odinism, Druidism, Celtic and Shamanic paths in whatever form they may materialise, and can count amongst its members people from groups such as the Odinist Hof; the Order of Bards, Ovates, and Druids; and of course those who follow one or another of the traditions now collectively known as Wicca. Other groups connected with the PF include the Pagan Funeral Trust and the Pagan Anti-Defamation League. Individual members include such people as Doreen Valiente (a founder member) and Janet and Stewart Farrar.

From this it can be seen that the PF represents a wide spectrum of thought and tradition and as such can justifiably claim to be fairly authoritative (without being authoritarian).

Over the last few years the Federation has not had a very high public profile and has mainly worked in the background to try and improve the image of Paganism and the Craft in the eyes of officialdom in which it has achieved some success. However, with the increase over the last year or so in fundamentalist Christianity the profile has been raised considerably in an increasingly successful attempt to appeal to the growing number of people who have chosen one or another of the native British Pagan Paths, to help people, wherever possible, to find their way, to provide a contact point for worthwhile groups and, very importantly, to bring the truth about Paganism and the craft to the general public.

The Federation is Pagan first and foremost and does not seek to represent or reflect those who work outside that area in the more general field of "The Occult". That is not to say or suggest that ritual magicians, Cabbalists, chaos magicians, and suchlike are no less worthy but simply that many of them come from non-Pagan traditions and therefore fall outside our scope.

The Federation believes in using the media whenever possible to publicise what it stands for and its members have regularly appeared on radio and television to tell the truth about Paganism and the Craft, the latter of which is seen as being an inner mystery path of the former. We feel that it is important to make and maintain the distinction between the two. It is quite possible and acceptable to be a Pagan without being a witch and many people want no more than that. However, it is not possible to be a witch without being a Pagan and without realising that there is far more to Paganism than simply celebrating the seasonal cycle, valid though that may be. The various forms of the Craft, Druidism, or any other mystery disciplines are the more specialised ways for those seeking the inner path of Paganism.

Membership of the Federation is open to anyone working with or believing in the traditions described above. The Federation will also try to help those who are looking for suitable contacts or those who are "in trouble" as a result of their beliefs. We cannot promise or guarantee success but we will try wherever possible. For further information write with an SAE to: The Pagan Federation, BM Box 7097, London WCIN 3XX.[8]

The Pagan Federation also publishes an Information Pack which gives a basic overview of Wiccan philosophy, and answers some of the most commonly-asked questions about witchcraft, gives a useful glossary of terms, and some basic information about the eight sabbats ritual practices, and gives a comprehensive list of periodicals and books.

8 The Pagan Federation is still active and can be contacted via their website at https://www.Paganfed.org/

Crafty Talk
by *Mike Howard*

Your editor has asked me this issue to try and define the differences/similarities between the **Revivalist**, **Traditional**, and **Hereditary** Craft.

By definition the Revivalist Craft covers those traditions which have developed during the last 40 years. These include the Gardnerians, Alexandrians, Dianic, Faerie, Seax-Wicca, Shamanic etc. The Traditionalists are pre-Gardnerian groups and individuals claiming to follow Craft forms which have more in common with historical witchcraft than modern neo-Paganism. Hereditaries, as the term suggests, are those following traditional versions of the Craft and Pagan survivals handed down in family groups or traditions for several generations. Trads and Hereditaries either worship the Lord and Lady equally or individually. In the latter respect they generally differ from accepted Revivalist practice.

In generalised terms, the Trads base their rituals on an improvised format which is often very simplistic. They ignore the suburban sitting rooms of popular Wicca for the outdoors for their workings. For this reason robes are usually worn and there is an emphasis on the magical use of Earth energies and contact with Nature Spirits, Elementals, and Faeries. In fact communion with the spirit world is an important aspect of Trad belief. As one old witch said to me "If you can't summon then you can't be a real witch…!"

Many Trads are solitary workers of the village wisewoman or cunning man type. They claim that in the old days witches always worked alone, although some met together from a local district to celebrate the festivals or the full moon esbats, which were business meetings presided over by the Man in Black who was the "Devil" of the medieval witch trials. It was this practice which led to the historical notion of the coven system.

Both the Traditional and Hereditary versions of the Craft contain important elements which could be characterised as "Shamanic" by Revivalists. These include the employment of natural psychoactive agents such as Fly Agaric for increasing the vision, trance, and mediumship for communicating with the Otherworld, the summoning of spirits, the use of familiars and guides, and wortcunning. Obviously there are neo-Pagans and Wiccans who may also use some of these elements to a greater or lesser extent.

What are the similarities which can be discerned between modern Wicca and the pre-Gardnerian Craft? Again, by definition, the New Forest group into which Gardner was accepted circa 1939 can be classified as "Traditional". Although its membership was a mixture of local country folk and Theosophical occultists it had Trad elements including a knowledge of Fly Agaric and a flying ointment made of bear's grease for skyclad rites.[9] Kenneth Grant has also told me that

> *"Many Trads are solitary workers of the village wisewoman or cunning man type. They claim that in the old days witches always worked alone, although some met together from a local district to celebrate the festivals or the full moon esbats, which were business meetings presided over by the Man in Black who was the 'Devil' of the medieval witch trials."*

from his experience Gardner had "the elemental contacts" which are a sign of the Traditional Craft. On the several occasions that I have seen GBG in spirit he has been accompanied by the good-folk. Whether or not the New Forest group was a surviving remnant of one of George Pickingill's nine covens[10] is debatable and has not been proved.[11] Personally I keep an open, if very skeptical, mind!

While some neo-Pagan purists mock the use of ceremonial magical techniques and the Cabbala by modern Alexandrians, such traditions were not unknown among the Trads. The Staffordshire tradition into which the Anglo-American writer Paul Huson[12] was inducted has these aspects which date from the 16th century. Those *PN* readers which are au fait with his controversial book *Mastering Witchcraft* (Rupert Hart-Davis" 1970) will have seen this indication. It provides

9 Since bears became extinct in Britain in the early medieval period, about 1,500 years ago, this story seems to be apocryphal at best.

10 George Pickingill (1816 – 1909), English farm labourer and cunning man (folk magician), who was widely believed to be a significant figure in 19th century witchcraft. Modern scholarship has effectively now disproved this theory, along with the existence of the "nine covens" he was alleged to lead.

11 Steve Wilson has since argued persuasively in his 1996 article *Woodcrafting the "Art of Magic"* that the New Forest coven was actually derived from the neoPagan, phallicist Order of Woodcraft Chivalry, itself influenced by Greek myths and various other quasi-Masonic and Rosicrucian groups, rather than any actual "traditional witchcraft" group.

12 Paul Huson (1942 –), author and screenwriter. He published the highly influential *Mastering Witchcraft* in 1970 as well as several other works on the occult. He and his late partner William Bast were also the writers of the extremely successful US soap opera *The Colbys* in the 1980s.

snippets of information on the robed (or Traditionalist) groups which he gained from his parent tradition – although they were apparently a little miffed that he revealed them in a mass-market book! Logically it is almost impossible to think that the Craft could have survived the persecutions without absorbing some of the influence of the magico-occult tradition in a pure, uncorrupted form. Any study of historical witchcraft and Pagan survivals since the 12th century must take this factor into serious consideration.

In these comparisons of the differences between the Revivalist, Traditional, and Hereditary Craft I have deliberately avoided any suggestion that one version is better than the other. All branches of the craft can be criticised for their flaws. However they can all learn from each other and I would like to see more contact and exchange of views between the different traditions in the future. Such a development can only be a healthy one for the continued survival of the Old Ways in the modern world.

PAGAN NEWS

The bi—monthly news magazine of Magick & The Occult

Nov/Dec '90

75p!

Yorkshire Goddess Rave!

NOW 20 PAGES!!

Samhain has traditionally always been a time for the media to trot out their cursory occult scare–stories, and this year has been no exception, with a concerted attack from the scribblers on anything that is even vaguely pagan or 'new age'. The tabloids have told us that children are being discouraged to celebrate Hallowe'en, whilst the shops have been as full as ever with plastic pumpkin masks and rubber bendy bats. Doubtless frantically casting his eye out for a target, Bradford's Rev. Howard Astin settled upon a course entitled 'Goddesses & the Wheel of the Year' run by Sheila Broun at Bradford & Ilkley Community College and wrote up his fears in Bradford's *Telegraph & Argus* newspaper. According to the Rev. Astin, attending the course could lead to "suffering confusion, depression or illness at the hands of evil powers." Statements such as this gave rise to a spirited exchange in the T & A, from both supporters of Astin and outraged pagans and free-thinkers. After letting the argument run on for a week, the T & A ran a column which summed up that the problem wasn't so much paganism, but *Far too many vicars getting in a twist.* Perhaps underneath the outrage over the promotion of pagan beliefs was the fact that this was also a course for women, run by a woman. By the following week, *The Sun* had got in on the act with a brief article on the Goddess Course, and trotted out a "very concerned" Rev. Kevin Logan. There really wasn't much they could make of the story, but they did their best. A somewhat bemused Sheila Broun told *PN* that the newspaper coverage had, on the whole, been good publicity for her courses, and that she had received the full backing of the colleges concerned.

Trouble at t'Stones

A stone circle near Bradup, near Keighley has become a dump for plastic & tin waste drums, according to members of Bradford's Earth Mysteries' Group. The circle, aproximately 30' in diameter, usedt o have 18 standing stones around its circumference. Earlier this century, some of the stones were removed to repair the nearby Bradup Bridge. Now, all that is left is a couple of stones near the circle, one of which is being used as a gatepost. Reporters from Bradford's Telegraph & Argus newspaper have approached the farmer on whose land the former circle stands, but so far he has declined to comment.

In Cumbria, police and local farmers have started a stonehenge-style "Hippy Watch" (their words) around Castlerigg Stone Circle. While ordinary visitors will be unaffected, the police say that "appropriate action" will be taken against large convoys.

In Derbyshire, people seem to have recently experienced difficulties in visiting Arbor Low Stone Circle, although I visited Arbor Low twice in July (the first time with 3 other pagans, the second time with 30-odd) and had no

Nov/Dec 1990

NEWS

France Gets New Martyr

The city of Abbeville, in northern France, has rededicated its monument to a martyr who was executed at the request of the Roman Catholic Church. On the 1st July, 1766, a 19-year old youth named Chevalier de la Barre was tortured and beheaded for failing to remove his hat while he walked within 25 yards of a Catholic procession.[1]

Dartford Occult Row Continues

Following last issue's leader concerning the problems of John Male, owner of Dartford's "The Something Else Shop", we have recently been informed that John has now been formally charged with abstracting electricity to the tune of £2,600, and it is up to him to prove his innocence against the evidence of the EGB. The shop is still without an electricity supply, and now the case is being taken to the Crown Court.

1 Here's the actual sentence that the court handed down on 20 February 1766. Note that he was to be put to the Extraordinary Question, which was a nice way of saying he should be tortured; and that he was to be burned to death with a copy of Voltaire's *Philosophical Dictionary* that they had found in his bedroom.

Regarding Jean-Francois Lefebvre, chevalier de La Barre, we declare him convicted of having taught to sing and sung impious, execrable and blasphemous songs against God; of having profaned the sign of the cross in making blessings accompanied by foul words which modesty does not permit repeating; of having knowingly refused the signs of respect to the Holy Sacrament carried in procession by the priory of Saint-Pierre; of having shown these signs of adoration to foul and abominable books that he had in his room; of having profaned the mystery of the consecration of wine, having mocked it, in pronouncing the impure terms mentioned in the trial record over a glass of wine which he held in his hand and then drunken the wine; of having finally proposed to Petignat, who was serving mass with him, to bless the cruets while pronouncing the impure words mentioned in the trial record.

In reparation of which, we condemn him to make honourable amend, in smock, head bare and a rope around his neck, holding in his hands a burning candle of two pounds before the principal door of the royal Churchof Saint-Wulfram, where he will be taken in a tumbrel by the executioner who will attach before and behind him a sign on which will be written, in large letters impious one; and there, being on his knees, will confess his crimes; this done, will have the tongue cut out and will then be taken in the said tumbrel to the public marketplace of this city to have his head cut off on a scaffold; his body and his head will then be thrown on a pyre to be destroyed, burnt, reduced to ashes and these thrown to the wind. We order that before the execution of the said Lefebvre de La Barre the ordinary and the extraordinary question will be applied to have from his mouth the truth of several facts of the trial and revelation about his accomplices. We order that the Philosophical Dictionary be thrown by the executioner on the same pyre as the body of the said Lefebvre de La Barre.

Yorkshire Goddess Rave!

Samhain has traditionally always been a time for the media to trot out their cursory occult scare-stories, and this year has been no exception, with a concerted attack from the scribblers on anything that is vaguely Pagan or "New Age".

The tabloids have told us that children are being discouraged to celebrate Hallowe'en, whilst the shops have been as full as ever with plastic pumpkin masks and rubber bendy bats. Doubtless frantically casting his eye out for a target, Bradford's Rev. Howard Astin[2] settled upon a course entitled *Goddesses & the Wheel of the Yea*r run by Sheila Broun[3] at Bradford & Ilkley Community College[4] and wrote up his fears in Bradford's *Telegraph & Argus* newspaper. According to the Rev. Astin, attending the course could lead to "suffering confusion, depression or illness at the hands of evil powers." Statements such as these gave rise to a spirited exchange in the *T&A*, from both supporters of Astin and outraged Pagans and free-thinkers. After letting the argument run on for a week, the *T&A* ran a column which summed up that the problem wasn't so much Paganism, but far too many vicars getting their knickers in a twist. Perhaps underneath the outrage over the promotion of Pagan beliefs was the fact that this was also a course for women, run by a woman. By the following week, *The Sun* had got in on the act with a brief article on the Goddess course, and trotted out a "very concerned" Rev. Kevin Logan. There really wasn't much they could make of the story, but they did their best. A somewhat bemused Sheila Broun told *PN* that the newspaper coverage had, on the whole, been good publicity for her courses, and that she had received the full backing of the colleges concerned.

Logan Asks Only For
'Freedom to Be Concerned About the Occult'

In a recent letter to *The Independent on Sunday*, the Rev. Kevin Logan, well-known scourge of Pagans, stated that Caring Christianity in no way wishes to launch a witch-hunt. All they want however, is "...freedom to be concerned about

2 Rev. Howard Astin started life as a lawyer and then descended even further into the abyss by becoming the Church of England vicar of St. John's Bowling in Bradford, West Yorkshire; which post he held for 29 years until retiring in 2017. He is the author of *Body and Cell: Making the Transition to Cell Church* (2002) which advocates for smaller Churchgroups. Considering that, according to latest figures as we go to press, less than 1% of the UK population attends Church of England services, they don't really have any other option at this point.

3 Visionary artist, teacher, priestess, and mask-maker, Sheila was also a frequent contributor to *Pagan News*.

4 Founded in 1832 and still going strong, Bradford College currently has approximately 25,000 students, so a problem with a course there was kind of a big deal.

the occult". To support his view, he quoted from an article which appeared in the August '89 *Pagan News* by Julian Vayne, which dealt with the subject of occult fiction written for children, saying that he was only responding to a Pagan campaign to persuade children that the occult is best for them. Well thanks for the mention, Kev, but an article in one small, independent 'zine hardly constitutes a massive campaign now, does it?[5]

Trouble at t'Stones

A stone circle near Bacup, near Keighley has become a dump for plastic & tin waste drums, according to members of Bradford's Earth Mysteries Group. The circle, approximately 30' in diameter, used to have 18 standing stones around its circumference. Earlier this century, some of the stones were removed to repair the nearby Bradup Bridge. Now, all that is left is a couple of stones near the circle, one of which is being used as a gatepost. Reporters from Bradford's *Telegraph & Argus* newspaper have approached the farmer on whose land the former stone circle stands, but so far he has declined to comment.

In Cumbria, police and local farmers have started a Stonehenge-style "Hippy Watch" (their words) around Castlerigg Stone Circle.[6] While ordinary visitors will be unaffected, the police say that "appropriate action" will be taken against larger convoys. In Derbyshire, people seem to have recently experienced difficulties in visiting Arbor Low Stone Circle,[7] although I visited Arbor Low twice in July (the first time with three other Pagans, the second time with 30-odd) and had no problems. Pagans from Sheffield also visited the site at Samhain and reported no problems, remarking on how friendly the farmer (on whose land the site stands) was to them.

The Lost Stone Circle of Ilkley Moor
A report from the West Yorkshire Earth Mysteries Group.

When a local history work briefly mentioned a stone circle present on Ilkley Moor, so far unknown in archaeological circles, we set out to search for this site,

5 It really does amaze us even now what an influence we had on these people – and more importantly how much worse things might have been if we hadn't got to them when we did. We suspect that our research and stories made many of them realise that we were watching them and if they stepped too far over the line they could get into some serious PR (and possibly legal) trouble.

6 Castlerigg, near Keswick in Cumbria, North West England, is one of the earliest stone circles built in the British Isles, erected in about 3000 BCE.

7 Arbor Low is a remarkable Neolithic henge monument in the Midlands of England. Within an earthen bank and ditch, a circle of 50 white limestone slabs surrounds a central stone cove.

with the valuable assistance of Dowser Nigel Mortimer.[8] Eventually, we found an assemblage of standing stones: a double circle in fact, with remnants of an avenue leading westwards towards the Swastika Stone. After several visits to the site, Ilkley Archeological Group were informed, and the site confirmed. It is now included on one of their guides to the prehistoric Moor. Located at SE 12614613 on the west slope above Backstone Beck, the circle is intruded by walling on the south, west and northern sides, with at least one of the stones being incorporated into the base of the south wall. The immediate vicinity has subsequently produced a number of anomalous light phenomena both in and around the circle. Physical energy readings have proved very valuable, giving typically anomalous results. At least two alignments (one visible in the ground), a number of new monoliths and a dried up well relative to the site were later uncovered.

Test Case for Athame Carriers

A case is currently proceeding in Birmingham of a Pagan who has been charged with carrying *without lawful authority, a knife with a blade, the cutting edge of which exceeds three inches*. This followed an altercation in a public house where the landlord objected to the presence of a five-year old boy drinking pop with his father. The landlord had already served the boy, and only afterwards ordered them to leave (this being a quiet afternoon). The landlord subsequently appeared with a policeman & woman, who asked the boy's father (who was wearing "shaman garb") if he would object to being searched. The man volunteered the information that he was carrying an athame underneath his jacket, and the police consequently confiscated it and charged him with possession of the knife, despite the explanation that it was a religious artefact. *PN* understands that the Pagan Federation are giving advice in regard to this case.

Euromancy?

DEF II, the Beeb's six o'clock slot for euro-culture vultures,[9] recently did a feature on "New Age" phenomena across Europe. It revealed that France is gripped in the throes of an exorcism revival – not so much witch-hunts in the press, but people feeling that "the Devil" is responsible for everything from burst water mains to stress. Magick is booming in Italy, however, where professional

8 Author of *Etheric UFO Portals* and many other equally fascinating works.

9 DEF II was produced by "media personality" Janet Street-Porter for BBC2 from 1988 to 1994. And if you think she's annoying on camera, be thankful you have never had to deal with her in real life.

magicians are opening up consultation shops where you can pop in, get your aura read, be counselled and depart, having paid the equivalent of £200 for a love spell. On Italy's Channel 5, a bald, Charles Grey[10] lookalike does regular "magical miracles" live on TV. In Finland, as might be expected, there is a lot of interest in Nordic beliefs. Two groups were shown, one who bopped to a tuneful rock band, whilst the other lot were shown performing a ceremony outdoors. Poland's turn featured Catholicism, but interestingly enough looked at a five-day pilgrimage to visit the shrine of the Black Madonnas. All this was very interesting, since we don't tend to hear much about what's going on Paganwise in Europe, and only occasionally see the odd zine from Germany or France. If anyone has any regular contacts, or visits parts of Europe regularly, can you write and let us know, as we'd like to feature more news & info about what's happening over there. That goes for the rest of the world too!

10 Charles Gray (1928 – 2000), English actor best-known for playing the archetypal villain Ernst Stavro Blofeld in the James Bond film *Diamonds Are Forever* (1971), and of course as the Criminologist in *The Rocky Horror Picture Show* (1975). However, to the *Pagan News* team he will live forever in our hearts for his magnificent performance as Mocata in the classic Hammer Horror movie *The Devil Rides Out*.

THINGS TO DO...
and THINGS TO READ

I See You're Having Trouble Visualising...
by *Adrian Reynolds*

It's happened again. You've got together, done some relaxation exercises to prepare for the main event of the evening – a guided visualisation. It seems straightforward enough, but why are you struggling to get the picture?

Maybe you're not cosmic enough, but more likely, the visualisation failed for you because it is biased to visual experience at the expense of other perceptions. A full experience of the world needs all our senses, including kinesthetic and auditory inputs and, to a lesser extent, taste and smell.

For whatever reasons, we tend to favour one of the three main senses in preference to the others, with profound effects on the way we experience the world. Listen closely to the language you and other people use to work out your dominant reference system. Visual people "see" things getting clearer, get an "overview" and need new "perspectives". Kinesthetic people have to "get to grips" with things to get a "solid" understanding. Auditory people "hear" where you're coming from and are "all ears" to ideas that sound good.

Sounds simplistic?[11] Try it, and then utilise what you learn to communicate with people. I've been in situations with people I normally have trouble communicating with, but after learning what their dominant reference system

11 Unfortunately for the author, not only does it *sound* simplistic, modern research has shown that it really *is* simplistic, and there's no scientific evidence that people have different "learning styles" as described. It appears to be an entirely made-up modern myth within teaching practice.

is and talking back to them in the same terms, got on with them a lot better. I've also known one or two people who essentially agreed about an issue, but because one of them was very visual and the other strongly kinesthetic, they had a lot of difficulty talking and each perceived the other as awkward, obstinate, and at odds with their own point of view. WHAT they were saying was basically the same. HOW they said it was very different. Once I realised what was happening it was almost comical, but communication problems like that are occurring all the time.

How can knowing this help you construct better pathworkings? Well, once you've realised you're not just visualising things, but trying to hear, feel, smell and even taste them, It's quite simple. With a well-structured pathworking, everyone will be fully drawn into the experience and discover that perceptions they are normally weak in become fully as powerful as their primary ones. Next time then, don't just see that doorway – feel the warp in the wood, hear the squeak as it opens, and smell what's on the other side before you see it.

The ideas here are drawn from Bandler and Grinder's works in Neuro-Linguistic Programming.

by *Anthony Roe*

Fable relates that when the angels fell from heaven and copulated with the daughters of men they also revealed the secrets of astrology.[12] There has ever since been ambivalence towards star lore, which is either ridiculed or revered. Certain it is that astrology originated in Mesopotamia, was appropriated by the Egyptians, intellectualised by the Greeks, and commercialised by the Romans. Juvenal chided the women of Rome for the hold it had over them, yet the emperors kept their astrologers. Seminal texts came from these ages, as the works of Ptolemy, which classical knowledge was passed on by the Arabs; and the Hebrews, slaves and heirs of Babylon, were ever proficient in the calculatory arts, and served the courts of the Renaissance.

With the advance of mathematics the art became more and more complicated. Gone were the simple omens of the eclipse looked for by the Chaldeans. Every nuance was pursued, until today there is a choice of over 50 systems of house division, and practitioners need a degree in psychoanalysis to interpret the details of a birth chart.

12 The First Book of Enoch VI-VIII:

VI. 1. "And it came to pass when the children of men had multiplied that in those days were born unto them beautiful and comely daughters. 2. And the angels, the children of heaven, saw and lusted after them, and said to one another: "Come, let us choose us wives from among the children of men and beget us children."

VII. 1. And all the others together with them took unto themselves wives, and each chose for himself one, and they began to go unto them and to defile themselves with them, and they taught them charms and enchantments, and the cutting of roots, and made them acquainted with plants.

VIII. 1. And Azazel taught men to make swords, and knives, and shields, and breastplates, and made known to them the metals (of the earth) and the art of working them, and bracelets, and ornaments, and the use of antimony, and the beautifying of the eyelids, and all kinds of costly stones, and all colouring tinctures. 2. And there arose much godlessness, and they committed fornication, and they were led astray, and became corrupt in all their ways. 3. Semjaza taught enchantments, and root cuttings, Armaros the resolving of enchantments, Baraqijal, (taught) astrology, Kokabel the constellations, Ezeqeel the knowledge of the clouds, Araqiel the signs of the earth, Shamsiel the signs of the sun, and Sariel the course of the moon.

A great error is to think of astrology as the primitive forerunner or sibling of astronomy. It has been cultivated for its own sake and permeates all the occult arts. Astrologers have taught that humanity is a universe. Astrologic technique for probing the psyche and releasing unknown forces is perhaps feared by those who would surround themselves by narrow certainties. Yet the charge of determinism is levelled against the art! The only destiny we carry is in consequence of our tendencies and aspirations.

However, the consequences of pursuing astrological gnosis have often been dire, even to death at the stake. In 1824 the law was still framed against astromancy. The famous Vagrancy Act was passed to punish "incorrigible

> "*A great error is to think of astrology as the primitive forerunner or sibling of astronomy. It has been cultivated for its own sake and permeates all the occult arts. Astrologers have taught that humanity is a universe.*"

rogues" and contained a clause that "every person pretending or professing to tell fortunes" should be included. Francis Copestick advertised his services in his own almanack, and was visited by plain clothes officers who arrested him after they had paid him to do a horoscope![13] By 1930 astrology was respectable enough again to warrant a column in the *Sunday Express*.

In the Dark Ages the curious arts survived in folk ways. Wort-cunning and starcraft were practiced by the followers of those who had built the henge observatories. All occupations were regulated according to the days of the moon, and the course of illnesses. Even life and death was forecast in the mystical Sphere of Petosiris, a numerological procedure equated to the lunar cycle.[14] In the 11th century King Canute forbade the worship of the sun and moon, but all manner of astrological practices continued. Above all, astrology views the regimen of time, and is the classic mode of divination.

Knowledge of astrology in England was common by the Middle Ages, though in a society where books were hand-written and expensive it was still the province

13 Francis David Rees Copestick (1829 – 1902), was arrested for practicing horary astrology in violation of the Vagrant Act, in December of 1851.

14 Petosiris was a High Priest of Thoth who lived in Egypt around 300 BCE. His letters to King Nechepso contain significant magical thought, including a method of foretelling illness via Greek numerology combined with lunar significators applied to a diagram known as the Circle of Petosiris. We don't have space to go into this in detail here, which is a pity, because It's quite fascinating.

of clerics and the learned. Adelard of Bath[15] wrote in the 12th century: "If a man acquire this science, he will obtain knowledge, not only of the present condition of the world, but of the past and future as well." The integrated structure of the medieval cosmos was revered and received mystical devotion. It gave a degree of insight which enabled an understanding with nature to be gained. Like Ariadne's thread[16] it can still lead back to self-realisation and bring a forgotten fullness of life. The dream of the so-called Age of Enlightenment is shattered. The world can no longer be explained merely in terms of physics and mathematics. The Babylonians did prognostications for kings, the Greeks took astrology into every class of society, and the Romans took it on the streets. There is no area of life with which it cannot be called upon to deal.

In categorising astrology of the present day, two methods are distinguishable, the old astrology which works by analogy, and alongside that the experimental method which bases itself on statistical research. In the West the tendency is towards "person centred" astrology, whereas oriental practitioners concern themselves more with events. When a client asks an astrologer to draw up a chart, what is actually meant is "What's going to happen to me?" Charts mirror alternative ways ahead, but it is up to the client which path is taken. Will is for individuals to express: only they can enunciate the name of the spirit within. Astrology may unlock all the potentialities of the spirit.

Would-be astrologers should take first principles and nature as their guide. Their deity is Zurvan Akarana, who represents Boundless Time, who embodies the powers of all the gods.[17] His body is entwined six times by a serpent, typifying the course of the sun through the Zodiac; he has four wings bearing the signs of the seasons; holds a key and a scepter as symbols of authority and power, and the thunderbolt upon his breast hints at his ineffable might. Embrace him, and his symbols of sovereignty will be yours.

15 Adelard of Bath lived in England in the late 11th century/early 12th century and was notable for translating many important Arabic scientific and magical texts into Latin, and particularly for introducing the use of Arabic numerals, which revolutionised mathematics in Europe.

16 In Greek mythology Ariadne was the Cretan princess who helped Theseus escape the Minotaur by laying thread showing the way out of his labyrinth. After which the asshole then abandoned her. She got her revenge by later marrying Dionysus.

17 In Zoroastrianism, Zurvan Akarana is the primordial creator deity who conceives the twins Ahura Mazda and Angra Mainyu. As such Zurvan is considered a neutral god who exists beyond the concepts of good and evil or time and space.

Letters

Denying the Devil's Children?
Name and Address Supplied...

I'm very concerned at your response to the current spate of "Satanic abuse" allegations. I feel you need to be careful not to be panicked into a position where you are denying the accounts of abused children and women. No-one makes the kinds of allegations we are now hearing without having suffered considerably. I have met two professionals involved with two such cases in the North of England. My impression is that they are not fools.

In a recent documentary on BBC2 in the North West, and in the press, the psychiatrist dealing with a victim, now a 26 year old woman, gave a careful account of why he was publicly backing her story. This included evidence from physical examination consistent with rape, the injection of drugs and the dislocation of joints. We can hardly expect to attack psychiatry for its appalling record of denying women's experience, and then proceed to accuse this woman, despite her consultant's stand, of "hysteria". Yet this, by implication, is what your editorial commentary (Sept/Oct issue) is at present doing.

Unhappily there is now a climate in which the terms "coven" and "ritual" are being linked in the public mind with unspeakable abuse and violence. Of course this is worrying. It doesn't however mean that organised "satanic" abuse is not taking place, and that some people who could even justifiably be described as mentally "sick" people have not perverted the meaning of Pagan language and symbolism, just as they have appropriated some of the symbolism of Christianity.

The one thing that is certain in all this, is that there is an enormous amount of healing work to be done! For my money it matters not a lot what the people doing this believe in or call themselves, providing of course what they are doing *is* healing work, and not conversion to some fundamentalist creed, be it Pagan or Christian.

Well, we'd like to see the press account of the case to which you refer, and if you have any knowledge of a genuine case of "Satanic" abuse, again, we'd like to hear about it – if only in strictest confidence. So far though, no "hard" evidence has come forth to support the claims that "organised Satanic abuse of children" is occurring on any scale, and until it does we shall continue to be skeptical about allegations in the press – Ed.

...And this letter, from Michael Charles, London

I was disappointed to read your easy dismissal of children's experiences in your comments about the Nottingham and Rochdale ritual abuse cases. Children do not lie about sexual abuse. In a recent Channel 4 documentary viewers were shown victims" drawings of their abusers. The perverts were depicted wearing weird costumes, adorned with various "occult" symbols.

Until very recently Pagans were persecuted for "coming out" about the nature of their spiritual experiences. Pagans should therefore be able to empathise with children's detail of their sexual experiences. During the "burning times" wimmin were destroyed not only for being witches but also for refusing to be passive rape victims. I wonder how many children shared in their suffering.

It is important that Pagans recognise that there are cynical patriarchal elements hiding under their banner. You only have to look at Aleister Crowley's chapter on sacrifice (in his *Magick*) where he recommends the use of infant male children. Something like 20% of all children are sexually molested at some time, usually by male family members. Perverts come from all backgrounds, just as there are Christian perverts and Atheist perverts. We all bear a responsibility to deal with this situation by listening to children and believing them. Without this I don't think there is any hope for peace and tolerance in this world.

You begin by making a serious and emotive charge, that we're denying "children's experiences", which is not the case. Despite the huge hullabaloo about "ritual sexual abuse" there is not one documented genuine case to prove the claims that it is happening on the scale which is claimed. Children might not lie about sexual abuse, but they have been known to be led into making erroneous statements about the exact nature of the abuse.[18] Child sexual abuse is happening on a huge scale in our society, regardless of class or creed, But if a Christian male is convicted of abuse, people don't start leaping up and down trying to "ban" Christianity – which is what some people are trying to do with Paganism. Finally, Crowley's referral to "male children" was a tongue-in-cheek joke about masturbation – the male child being of course, his own semen. PN has been reporting on the ritual child abuse issue for over two and a half years, during which time there hasn't been one genuine case. If one does appear, we won't shirk from looking at it. – Ed.

18 Since this was written there have been a multitude of studies which clearly show incidences of children lying about sexual abuse. We now know for a fact that during the late 80s and early 90s period of the Satanic Panic many children were coached to lie by Christian social workers with the result being the sending of several innocent people to jail, sometimes for years.

PAGAN NEWS

The bi-monthly
news magazine of
Magick & The
Occult

Jan/Feb '91

75p

Independent Explodes Satanic Survivor Story!

On the 30th December, *The Independent On Sunday* ran a large, three-page feature investigating the death and background of Caroline Marchant, a 23-year old woman who committed suicide by taking an overdose of the anti-depressant drug Amitriptyline, whilst staying at the home of the Reverend Kevin Logan. It was claimed that Caroline had been 'sexually initiated' into a Satanic sect at the age of 13, and that she had subsequently become involved in drug abuse, prostitution, and ritual murder of new-born babies, including Caroline's own son. Details of this were luridly exposed in *The Sunday Mirror* last March, though the paper neglected to mention that the 'Devil's disciple' had taken a fatal overdose whilst staying at Logan's vicarage.

Caroline's life history, and the facts surrounding her death have been thoroughly researched by investigative reporters David Hebditch and Nick Anning. Their work reveals that Caroline Marchant did not begin to recount stories of satanic abuse until she became involved with evangelical Christians. Also, the testimony of friends, social workers and police casts serious doubts on the allegations of Satanic activity. A pathologist who was comissioned to examine Caroline's body for 'physical evidence' of 'satanic marks' has since withdrawn his findings, and the investigation into Caroline's background shows that she had a history of self-mutilation. Blackburn Police say that they have found no evidence to support the allegations of Satanic involvement, indeed, that they found evidence to the contrary. Caroline also left a 'diary' of her alleged 'satanic past', which has been demonstrated to have been plagiarised from Doreen Irvine's *From Witchcraft to Christ.* One of Caroline's friends also asserts that she did not claim to have been involved in Satanism until *after* she had read Irvine's book.

The *Independendent's* report notes that if Caroline Marchant wasn't after all, a victim of Satanic abuse, then she was certainly a victim of something. Solicitor Marshall Ronald, an associate of Maureen Davies (who later commissioned a pathologist to look for 'physical evidence of satanic abuse') claimed (according to the reporters) that Caroline *...had been involved in Satanic rings from the age of 13 to 21. She can tell me information about recruitment, snuff videos, political hierarchy systems, places of rituals, Satanic financing etc...She has also been involved in the arms involving the IRA, Baader-Meinhof, Libyan connection.*

Hebditch and Anning conclude that it may have been the pressure to maintain the fiction of being 'a satanic survivor' that led Caroline to committ suicide. Needless to say, her parents were completely unaware of Caroline's 'past' and her friends have angrily rejected the claims that she was involved in Satanic practices.

This investigation marks a significant turn in the Fundamentalist's claims of Satanic activities. The Reachout Trust has recently announced that Maureen Davies is going to hive off and create her own trust to combat ritual abuse and satanism. In the wake of the Rochdale case, Manchester social services have had their interviewing procedures criticised as well as their compulsive belief in the Satanic Ritual Abuse Myth. Recent media reports concerning the Rochdale case have quietly dropped the subject of 'Satanic Abuse' now that the evidence for it is being shredded in the courts. We await further developments with interest.

INSIDE: ASTRAL ADVERTISING - A SHOCK REPORT!

Independent Explodes Satanic Survivor Story!

On the 30th December *The Independent On Sunday* ran a large, three-page feature investigating the death and background of Caroline Marchant, a 23-year old woman who committed suicide by taking an overdose of the anti-depressant drug Amitriptyline, whilst staying at the home of the Reverend Kevin Logan. It was claimed that Caroline had been "sexually initiated" into a Satanic sect at the age of 13, and that she had subsequently become involved in drug abuse, prostitution, and ritual murder of new-born babies, including Caroline's own son. Details of this were luridly exposed in *The Sunday Mirror* last March, though the paper neglected to mention that the "Devil's disciple" had taken a fatal overdose whilst staying at Logan's vicarage.[1]

Caroline's life history and the facts surrounding her death have been thoroughly researched by investigative reporters David Hebditch and Nick Anning. Their work reveals that Caroline Marchant did not begin to recount stories of Satanic abuse until she became involved with evangelical Christians. Also, the testimony of friends, social workers and police casts serious doubts on the allegations of Satanic activity. A pathologist who was commissioned to examine Caroline's body for "physical evidence of satanic marks" has since withdrawn his findings, and the investigation into Caroline's background shows that she had a history of self-mutilation. Blackburn Police say that they have found no evidence to support the allegations of Satanic involvement. Indeed, they say that they found evidence to the contrary: Caroline also left a "diary" of her alleged "satanic past", which has been demonstrated to have been plagiarised from Doreen Irvine's *From Witchcraft to Christ*. One of Caroline's friends also asserts that she did not claim to have been involved in Satanism until after she had read Irvine's book.

The Independendent's report notes that if Caroline Marchant wasn't, after all, a victim of Satanic abuse, then she was certainly a victim of something. Solicitor Marshall Ronald,[2] an associate of Maureen Davies (who later commissioned a pathologist to look for physical evidence of satanic abuse) claimed (according to the reporters) that Caroline had been involved in Satanic rings from the

1 After 3 years being passed around various Christian "Satanic rescue" groups, Caroline Marchant ended up in the hands of Kevin Logan, at whose house she took a massive dose of 70 x 300mg capsules of Amitriptyline. She then spent 19 days in ICU and eventually died.

2 This gentleman would later reappear in the public eye in 2010 when he was allegedly part of an elaborate scam to extort £4.25 million for the return of the stolen painting Madonna of the Yarnwinder by Leonardo da Vinci. He was acquitted of all charges.

age of 13 to 21. "She can tell me information about recruitment, snuff videos, political hierarchy systems, places of rituals, Satanic financing etc... She has also been involved in the arms trade involving the IRA/Baader-Meinhof/Libyan connection."[3]

Hebditch and Anning conclude that it may have been the pressure to maintain the fiction of being "a Satanic survivor" that led Caroline to commit suicide. Needless to say, her parents were completely unaware of Caroline's past and her friends have angrily rejected the claims that she was involved in Satanic practices.

This investigation marks a significant turn in the fundamentalists" claims of Satanic activities. The Reachout Trust has recently announced that Maureen Davies is going to hive off and create her own trust to combat ritual abuse and Satanism. In the wake of the Rochdale case, Manchester social services have had their interviewing procedures criticised as well as their compulsive belief in the Satanic Ritual Abuse Myth. Recent media reports concerning the Rochdale case have quietly dropped the subject of "Satanic Abuse" now that the evidence for it is being shredded in the courts. We await further developments with interest.

Birmingham Athame Case Proceeds

Last issue's feature concerning the Birmingham Pagan nicked for being in possession of a blade "over three inches long" (his athame) has moved on. The defendant has been fined £200, but we understand that the man's solicitor has put in an appeal. The defendant & family are trying to argue the case that the athame is a necessary part of valid religious regalia, in the same way that Sikhs are allowed to carry their small knives, which relates to national dress as well as religious observance. The defendant is an ordained "Priest of Isis", and it will be interesting to see if this status is legally acknowledged. The underlying issue is whether Pagan beliefs can be compared to organised religions. What do you think?

PN gets Award from Computer Magazine

As is stated on the back cover, *PN* is produced using an Atari 1040 ST. One of the computer magazines dealing with all aspects of the Atari ST, *ST Format,* recently ran a feature on Desktop Publishing and invited zine editors to send in their mags produced using ST software and hardware, offering a prize to the best offering. In the December issue, the results were announced, and your editor was pleased to learn that *Pagan News* was considered to be the best magazine!

3 We still have no idea where he got the notion that this young girl who wasn't even capable of looking after herself was somehow a dastardly international terrorist organiser.

The prize will be put towards further improving the quality of *PN*. The runner-up was a magazine which catered for trainee Anglican Priests.

Q: Who Owns Your Body?
A: H.M. Government!

In the July/Aug issue we reported on the court proceedings being taken against Mr. Sebastian, the renowned tattooist & body piercer. In December, he was charged with "malicious wounding & assault" for performing body piercings on consenting & paying clients, given a 15-month suspended sentence, and ordered to pay legal costs. The court ruled that it is not illegal to have body piercings done if they are purely for decoration, but that piercings which have sexual overtones are illegal. The outcome of this case is worrying for anyone who is interested in body piercing from a shamanic or hedonistic viewpoint.

On an even stranger note, copies of the "Re/Search" publication *Modern Primitives*[4] which takes a cross-cultural look at body modification practices around the world, in both modern and tribal cultures, have been seized by the Obscene Publications Squad in a raid on a Charing Cross bookshop.

4 RE/Search Publications was founded in San Francisco by V. Vale in 1980. It was a huge influence on the development of punk and industrial culture, particularly with *Modern Primitives* which Vale and Andrea Juno published in 1989. That book arguably launched modern tattooing and body modification practices into the alternative subculture, whence it would grow into the phenomenon that it is today. It's amazing to think now that it was considered obscene only 30 years ago and selling it was a criminal offence.

SPOTLIGHT

HOBLink is the Network for Gay, Lesbian &
Bisexual Pagan folk. It has been running for
over two years now[5] and in this issue, PN *talks*
about HOBLink to its central coordinator,
Gordon McLellan.

Q: What gave you the idea of setting up HOBLink in the first place?

GM: At the time, I was aware of the complete lack of support for "out" homosexual or bisexual Pagans, or even any help within any of the networks I was involved in, for people who didn't want to be out, but wanted someone to talk to. In addition, there seemed to be a general lack of awareness of gay issues, so I thought "Why not get stuck in there and cause a bit of trouble?" because I felt that we were ignored; that everything revolved around a heterosexist attitude to the world, which estranges gay people from magick.

Q: Do you find there's a lot of bias against gay or bisexual people in magical or Pagan beliefs?

GM: In some instances, yes. In the circles I've worked in, it depends almost entirely upon the individuals, but at best there's been a passive tolerance and at worst "Oh no, you can't work magick because you can't raise power because you're not natural." With some, It's a case of "Well, It's all right so long as you don't let it come into your magical working" which is probably even more patronising.

Q: Do you think that some "magical theories" of why homosexuality is bad are just prejudice dressed up in occult terms?

GM: Yes, completely. They cannot back that up with anything other than personal feelings – there's no historical precedent that says that people of other sexualities have no place in magick. In fact the historical evidence is more in our favour than against us.

Q: Could you give some examples?

GM: I don't think there's enough real evidence of the nature of Celtic culture to talk about sexuality. What we have mostly is the Irish and Welsh material, most

5 At the time of publication of this book the HOBLink network is now, unfortunately, defunct.

of which was written down well into the Christian era, and has been edited or censored. I read that material, and I think that there's something not being said here. Most warrior societies we do know have a high level of homosexuality, and there's the South American cultures where there are men's spaces and women's spaces; the men and women do meet, but there's also a lot of sexual activity within the individually-sexed houses.

Q: How has HOBLink has been received by the Pagan community in general?

GM: A very mixed response. Some people have been very supportive; magazines like *Moonshine*, *Pagan News*, *Greenleaf*, and various bits of the F.I.N. network.[6] Some others have ignored us completely. We haven't been attacked but we've certainly been ignored.

Q: How do you think HOBLink has developed over the last two years?

GM: Very slowly. It hasn't done much, but then you let a network grow the way it wants to. Within the last 8-10 months It's opened out and started to pick up speed again. Initially, people were quite shy, and now more people are willing to be open contacts for the network, which gives us a chance to do things, like workshops, of which we've just had the first ever. It'd be nice to see other different strands of the web linking across, rather than all the information coming through me.

Q: Do you find that the network includes people from a wide variety of paths?

GM: Yes, very diverse. I think the majority would describe themselves as Wiccans, and then next are those who would call themselves magicians, rather than Pagans. It's still a predominantly male network, although the balance is changing and there are more women coming in, which is nice to see.

Q: Do you think that gay people are alienated by working in heterosexist magical traditions?

GM: I think so. From the people I know in the network, there's a lot of people who have been confused and hurt by Wiccan traditions in particular where they feel they've been taken in because they were physically male or physically female and then expected to behave as a heterosexual. Not necessarily sexually, but within the magical working because that's the only role that a man or a woman could have. We're also seen sometimes as androgynous, which smacks of so much ignorance. gay men for example, are sometimes thought not to be "men" just because they relate sexually to other men – that is still a god-feature, if you want to use those terms, and a very powerful one. Our relationship with a god-figure is still as strong as any heterosexual male's, albeit a different one.

6 The Free Information Network grew out of the Traveller/Free Festival alternative scene in the UK. During the 1980s there were a number of FIN nodes across the country, publishing free community newsletters aimed at minority subcultures. Some examples of FIN newsletters can be found at: https://archive.org/details/sparrowsnestlibrary?&sort=-week&page=2

As I see it, our relationship with the Goddess is an equally strong one, and from conversations with heterosexual Pagans, I feel that our relationship is possibly more intimate than theirs.

Q: One "occult" theory of homosexuality that gets brought up is that gay people are female bodies with male spirits (for lesbians) or vice versa for men.

GM: I don't think so. I am a spirit, and to assume that my sexuality reflects my spirit is a limiting view of the universe. The Universe is not male or female – It's energy. I'm a spirit in a body, and at this time I love men, and in all my explorations of my self and my relationship with the Universe, there has never been any feeling of "Oh you're the wrong spirit in the wrong body." The Universe says, "Love, and go for it."

Q: Do you think a sexually-positive theology might come out of HOBLink?

GM: I think that we're so diverse as a group that the evolution of something like that I would feel would come from a group of people working in a similar tradition. HOBLink is so diverse that all that would evolve is a very general approach. What might come is a way of looking at deities which was much more supportive of the whole range of sexualities.

Also, a changing awareness that divinity doesn't give a damn about your sexuality, and that the biggest thing that we can do, in whatever paths we work in, is to help people, who are perhaps trapped in a heterosexual dream, to see a wider reality. The relationship that deities have with us is to see us live our lives to the fullest; they don't give a damn what your sexuality is, and It's really wrong to impose that upon them.

Q: Do you think that HOBLink could help to uncover any gay-positive myths that have so far been hidden?

GM: I think that It's the sort of thing that a lot of people, both within the network, and outside of it, are looking at already, and it might be that HOBLink could be a vehicle to promote those through publications, etc.

Q: Is there anything that you'd recommend to people in the way of reading?

GM: There's *Living the Spirit*,[7] which is a modern Native American work, looking back on their sexual traditions and looking at them in the modern context and reclaiming them. On the whole there seems to be very little in the way of useful publications. If we can get some money together and somebody to write them, then perhaps we can produce some books. Folk stories and myths are crucial and I'd be supportive of publishing rediscovered collections of myth or folklore, rather than the more academic treatises on our role.

Q: Does HOBLink have an educational role to play then?

GM: Yes, as an agent for raising awareness. Also, I think people have a great tendency to make magick "safe", and this safety is in hiding from things in society

7 *Living the Spirit: A Gay American Indian Anthology* edited by Will Roscoe (1988). "A groundbreaking collection of essays and stories by, about, and selected by gay American Indians from over twenty North American tribes."

which they don't like, which in some cases, is us. Magick, more than anything else, is about honesty, and personal honesty. You cannot be honest with yourself and your community if you hide from it.

Q: One criticism which has been lodged at Wicca, for example, is the rigid adherence to "polarity" within very narrowly-defined terms – forgetting that "male & female" can exist within one individual.

GM: If you are wholly male, with no trace of the goddess in you, then there's something horribly wrong, and you're completely unbalanced. I don't think HOBs are any more balanced than anyone else, but perhaps we are more aware of the presence of both within us.

Q: Would this be due to having had to question one's sexuality in depth?

"For me, being Pagan means working with the Earth, and if I try to sell myself as a nice, sweet, slightly eccentric person who's not a trouble-maker at all, then I'm betraying the Earth, because this society is destroying the Earth."

GM: It sounds almost paranoid, but to be out as gay or whatever and to be out as Pagan means that you've gone through a double process and hopefully accepted the joy of who you are.

Q: Some say there's a parallel between coming out as gay and coming out as a Pagan.

GM: Either one can get you thrown out of your home or job and estranged by the community.

Q: That brings up another point. Do you think that some people in the Pagan community are wary of HOBs due to the current wave of anti-occult press?

GM: Not that I've met. But I can see that as a danger. Some elements of the Pagan community are trying to sell it as nice and safe and essentially middle-class and not at all threatening to society. They might well try to stuff us back into our broom cupboards. I think for Paganism to try and present itself like that is a betrayal of what we stand for. For me, being Pagan means working with the Earth, and if I try to sell myself as a nice, sweet, slightly eccentric person who's not a trouble-maker at all, then I'm betraying the Earth, because this society is destroying the Earth.

THINGS TO DO...
and THINGS TO READ

Vibrating Hebrew Letters
by *Mibreshet Shai'ir*

Anyone interested in the Qabalah or ritual magick often comes across different versions of Hebrew words. This is because Hebrew has been for many centuries a liturgical language, pronounced in the local accents of Jewish communities all over the world. There follows a brief guide to the letters themselves:

Alef is usually silent. It shows where a word begins with a vowel, or where a vowel follows another.

Bet is (generally) B after consonants, V after vowels; sometimes the B version has a dot in the middle.

Gimel is G as in "Good".

Dalet is D.

Heh is H.

Vav is a V (in ancient times, a W). It also represents the vowels "oo" and "oh".

Zayin is Z.

Chet is a husky sound like a forced exhalation. Modern Israelis say it like the "ch" in "loch".

Tet – a T-sound; in Biblical times, rather plummy and exaggerated.

Yod is a Y or "ee" sound.

Kaf is usually K after consonants, "ch" (as in loch) after vowels.

Lamed – as in L.

Mem – as in M.

Nun – N.

Samekh – in ancient times, a thick, buzzing Z-sound. Nowadays, an S.

Ayin – a tight "ahh" sound made in the throat. It is not a vowel, but a full consonant. Leaving the Ayin out is a mistake often made. Even Israelis say it like an alef, mostly.

Peh – P after consonants, F after vowels.

Tsadi – in Biblical times, a thick exaggerated S-sound, and nowadays, a "TS".

Kot – nowadays K, but in ancient times it was said right at the back of the mouth, like the posh English "Of course, my deah".

Res is R. Israelis use it like the French R (see an Inspector Clouseau film to help with this one).

Shin usually Sh, but sometimes spelled S instead. May originally have been a hiss like the Welsh "LL" sound.

Tav is a T.

In ancient times, Gimel, Dalet and Tav did the same changing trick as Bet, Kaf and Peh. You can still see this today, when people say Malkuth or Malkus for modern Malkut – the Tav changes to Th, or S.

Stress is usually placed upon the last syllable of a word (i.e. malKUT) except for words with two e's like CHESed.

Vowels – A,E,I,O,U as in Cat, Bed, Machine, Hole, Hubris – plus the "sheva" which is like the u in "bump". They're straightforward in Israeli Hebrew, but ancient vowels were very complex. Many dialects still pronounce the long a-sound as the "a" in "wall".

The special semitic sounds like Ayin and Tzadi are seldom stressed in modern Hebrew, as European accents are more highly thought of in Israel than Semitic ones. The parallel is that of a broad Yorkshire accent in English, which isn't seen as "educated", but is closer to the pure Anglo-Saxon. Jews from the Yemen preserve many ancient features of Hebrew, though they're a poor class in Israel.

Writing Western Names in Hebrew

First knock out all short vowels from the word. Write the name with the corresponding Hebrew letter using Vau for ooh or oh-sounds, Yod for ee-sounds. Use Tav for Th, Gimel plus apostrophe for J, Tzadi plus apostrophe for "Ch" as in "church".

Crafty Talk
by *Mike Howard*

I would suggest that modern witchcraft is the Tantra of Western man (sic)" says Dr.. Jonn Mumford in his 1975 book *Sexual Occultism*.[8] He was specifically referring to the practice of the Great Rite in modern Wicca and the sexual symbolism of traditional witches' tools such as the besom. In his book Mumford points out the similarities which exist between tantric beliefs and practices and the rites of the modern Craft. These similarities include ritual nudity, the veneration of a priestess as the personification of feminine principle, the raising of "the cone of power" in a circle, and the use of sexual symbols to represent divinity.

Gerald Gardner of course lived for many years in the East and he may well have been exposed to tantric beliefs. He was also very interested in Crowley's magical work in the O.T.O. and in the Knights Templar, who were intimate with the concept of sexual magick. In fact Gardner died en route to the Lebanon to study Templar sites. But there is also a virile tradition of fertility rites in historical witchcraft and pre-Christian Paganism which, it can be argued, Gardner may have drawn upon when he was formulating his version of "Wicca" in the 1940s.

The so-called "Great Rite" obviously has an ancient history which predates Gardner and the historical Craft by thousands of years. Bronze age stone carvings in Scandinavia depict what archaeologists coyly describe as "the sacred spring wedding". Sexual rites and symbolism were also a prominent feature of the classical Pagan mysteries. The Roman satirist Juvenal poked fun at the priestesses of the Goddess, who he sarcastically claimed used slaves and donkeys in their rituals if no priest was available. In the post-Christian period rural fertility rites survived along with sublimated sexual symbolism in the shape of Sheela-na-Gigs concealed in churches and the maypoles erected on the village green. From evidence such as this Gardner cannot be accused of inventing the concept of the Great Rite for voyeuristic reasons (which has been claimed by some of his detractors) although it is possible that he was heavily influenced by Crowley's ideas. This however does not mean that Gardnerian Wicca is an offshoot of the O.T.O., as claimed by some American and Australian Thelemites recently!

8 Now reissued under the name *Ecstasy Through Tantra* (2002), Llewellyn.

When discussing the sexual aspects of the Craft the difference between the Great Rite, performed in the third degree initiation and between the HP and HPS at certain of the festivals, and the use of sexual energy for magical purposes must be clarified. In the Great Rite per se the priest and priestess are the human representatives of the Lord and Lady. In this context the sex act is on the level of a spiritual experience during which the couple assume the "god forms" and become channels for divine forces (such use of male & female polarity is described in some detail in the Pagan novels of Dion Fortune).[9] In more traditional forms of the Craft the Great Rite was also performed during induction or admission ceremonies to "pass the power".

> *"The Roman satirist Juvenal poked fun at the priestesses of the Goddess, who he sarcastically claimed used slaves and donkeys in their rituals if no priest was available."*

In sex magick the energy raised by erotic acts is directed to produce magical effects by the participants. Doreen Valiente has revealed that Gardner's personal *Book of Shadows* contained instructions on this type of magical power raising. She however suggests that this was derived from his meeting in 1946 with Crowley rather than any historical or traditional source.[10] Despite this it is evident that the magisters of the medieval witch cult were skilled at "raising the Kundalini" and using the energy for magical purposes. This technique may have originated from the Middle East or more indigenous sources.

Certainly the early Christians were horrified by the blatant use of sexual symbols by the Pagans to represent the life force. This is obviously also of concern to contemporary fundies who have sadly inherited the tradition of sexual repression and puritanism. It is unfortunate, but the liberal Pagan attitude to sex will always be difficult for outsiders to comprehend and predictably leads to many misunderstandings and misconceptions. Skyclad rituals may be justified by modern Wiccans for valid magical/spiritual

9 Violet Mary Firth (1890 – 1946) was a British occultist and prolific author, writing under the pseudonym of Dion Fortune. She was a Theosophist and member of the Golden Dawn, and later one of the founders of the Fraternity of the Inner Light. Despite her modern reputation as something of a middle-class fuddy-duddy, several of Fortune's novels have the theme of sex magick at their core, and are well worth reading both for entertainment and instructional value: *The Demon Lover, The Winged Bull, The Goat-Foot God, The Sea Priestess* and *Moon Magic*. Also see Rodney's song based on her work: *Dion Fortune* by The Cassandra Complex.

10 She was almost certainly correct in this.

reasons, but to the average person-in-the-street they merely look like an excuse for naughty fun and games.

This attitude is not new of course, and witches had a far harder time of it in the period before the advent of the permissive society. Gardner's revelation in his novel *High Magic's Aid* that a naked woman acted as the living altar to personify the Goddess led the Sunday newspapers in the 1950s to condemn the book as "obscene". However, there seems very little need for the traditional type of fertility rites today – at least not in the EEC[11] where farmers are grossly overproducing. In the 90s the emphasis on the fertility of the land, which was responsible for much of the Pagan sexual symbolism of the past, must surely take second place to the protection of Mother Earth as environmental issues increasingly gain a more spiritual profile.

11 The European Economic Community (EEC) was the forerunner to the modern-day European Union, formed by the Treaty of Rome in 1957. It's hard to believe that the EU didn't even exist until 1993, two years after this issue of *Pagan News* was published.

Letters

From Peter Elliott, London

It would be tempting to refute the allegation that *PN* dismisses "the evidence for Satanic Child Abuse (SCA) too easily" with the riposte "what evidence?" However, entering into the spirit of the thing...

The first question is, what do we mean by SCA? Definitions vary, according to the perspective one is working from. As an occultist, I am mainly concerned with the religious SCA theory, which states that "the physical, mental, spiritual and sexual" abuse of children is a necessary part of some occult belief systems. What do we have that supports the SCA theory? On the one hand, a number of "adult survivors" (AS), none of whom can produce any evidence that supports their stories, many of whom are "born-again" Christians, and a significant number of whom suffer from serious psychiatric disorders. On the other hand we have accounts of SCA given by children after extended periods of therapy.

Despite the extensive publicity given to the issue of SCA both here and in the USA, there is not one case anywhere in the world where law enforcement bodies have obtained sufficient evidence to mount a successful prosecution for SCA. This has not stopped various media sources claiming the opposite. Most recently, an article in *The Guardian Saturday Supplement* claimed that there had been 6 successful prosecutions for SCA in the USA. Telephone calls to the FBI and Dept. of Justice revealed that this was a lie, and 4 conversations with *The Guardian* were insufficient to persuade them to name the cases.

The matter of evidence obtained from children after extended therapy sessions is a difficult one. Currently the major thrust of child therapy is to "believe the children", and that not to believe the children is the next best thing to calling them liars. But life is not so simple, and frankly anyone who thinks that it is, knows precious little about the subject.

It has been observed that, during recent years, child therapists and individuals in child protective services have begun pushing therapeutic interviews with children, beyond initial and even repetitive denials of victimisation. Doubt is only permitted until the abuse narrative is uncovered. Once disclosure begins, belief becomes resolute. Once the disclosure begins, there seem to be no guidelines for doubting. Doubt becomes untherapeutic.

This is one of the fundamental reasons for the prevalent appeal to the "adult survivor of satanic/ritual abuse" material. The latter seems to provide perplexed investigators with missing information on the motivations of alleged perpetrators. The fact that no one ever notices the "evil cults" until the adult survivors begin remembering confirms the assertion that the cult is brilliant. It has infiltrated

society so completely that bloody infant sacrifices, cannibalism and mutilation which seems impossible to corroborate, have been overlooked for generations.

One can understand why therapists want to believe, however, I also think that it is possible to reach a point where dogged devotion to belief becomes counterproductive.

When one concentrates the research focus on discovering the specific ways in which therapists come to "believe" in the reality of satanic/ritual abuse, one immediately uncovers a remarkable network of therapists, clients and investigators blending together specific idiosyncratic data into one atemporal, analytic grid.

When one examines specific adult survivor stories, it becomes immediately apparent that initially clients were not saying the same things but came to say similar things over time.

If and when a case comes to court, is tried, and the defendants are found guilty of SCA, if and when physical evidence is discovered, if and when evidence of a conspiracy of ritual abusers/satanists is found, then it will be time to re-examine the evidence.[12] Until then, I would say that *Pagan News* does not dismiss the evidence for SCA too easily, but finds the "evidence" easily dismissed.

Peter Elliot is one of the editors of ORCRO *magazine.*

From Val Dobson, Preston
The two letters about Satanic abuse in the Nov/Dec issue show ignorance and confused thinking. Nobody is denying that women and children can be horrendously sexually abused, but specific Satanic abuse allegations invariably turn out to be very shaky when closely examined. In the Nottinghamshire case, the children did not begin making their allegations until the details of ritual abuse had begun appearing in the press. There is some evidence to show that some (at least) of the children were making up stories to please their questioners. For instance, a girl claimed that her stomach scar had been made during a satanic ritual, when medical records showed that it was an operation scar. Also, when some of the children were driven around Nottingham and asked to identify places where they had been satanically abused, they picked out the house of the Chief Constable and a Baptist Chapel – and picked out the entire congregation of the chapel as abusers.

"Name and Address Supplied" had the impression that the social workers

12 We now know of at least one case where a conviction was obtained. In Texas in 1992, Frances and Dan Keller were convicted of aggravated sexual assault on a child and each sentenced to 48 years in prison. They were only released in 2013 when the "expert witness" in the case finally recanted his testimony and their conviction was overturned, after they had spent 21 years in prison. A horrific travesty of justice.

involved were not fools – that is not my impression. I seriously question the competence of anybody who presents a child's drawing of the Manchester United Red Devil as proof of Satanic abuse, or who believes that sheep sacrifices and Devil worship can take place in the back garden of a semi-detached council house without anybody noticing.

The claims made by "Adult Survivors" are even more suspect. The young North-West woman referred to first started telling her psychiatrist about her Satanic abuse in the early part of 1990 – the police have yet to take action, even though her abusers are presumably still around and active. Certainly, a physical examination showed scars, needlemarks, and signs of dislocated joints and sexual abuse – but Satanic abuse is not the only explanation for such injuries. Like the Nottingham children, she has undoubtedly suffered abuse, but as yet there is no proof that this was anything to do with ritual abuse.

Other "Adult Survivors" show the same pattern of behaviour – they remember all the gory details when with their therapist (or talking to the media), but their memories get unaccountably hazy when police ask them about names, dates and locations. This is in great contrast to the behaviour generally shown by other trauma survivors, who are noticeably reticent about their experiences, even with their families. However, when called to give evidence they will dig deep amongst their most painful memories to extract any shred of hard information that will convict their abusers. Survivors of rape, incest and childhood abuse all show an active desire to nail their abusers – those who claim to be Adult Survivors of Satanic abuse alone differ from this pattern.

Another reason to doubt that organised Satanic abuse has ever existed in this country is the complete lack of reports of any activity resembling Satanic abuse before late 1988, when details of Satanic activities (distributed entirely by Reachout & Co.) began appearing in the British press. Yet according to the "Adult Survivors" (including three young women in the Nottinghamshire case) ritual abuse has been organised and widespread in this country for a decade or more.

By all means listen to what abused women and children have to say – but I don't see how uncritically accepting every flagrant fabrication or delusion from them can possibly help them recover any sort of mental equilibrium.

Quite. Take for example the claim reported in The Independent, *which presumably came from Adult Survivor Caroline Marchant, of "involvement" with the Baader-Meinhof group. If we took this seriously, bearing in mind that Baader-Meinhof operated between '70 -'77, then she would have been involved between the ages of 4-11. – Ed*

Pagan News

THE BI-MONTHLY NEWSMAGAZINE OF MAGICK & THE OCCULT.

75p
March/April 91

LOVE NOT LAWS-CRIMINAL JUSTICE BILL
PHILLIPA BOWERS INTERVIEW
LETTER FROM SPAIN

Rochdale Case – Dismissed

On Thursday, 7th March, 10 out of the 14 children taken into care by social services were returned to their families. Mr. Justice Douglas Brown dismissed the allegations that the children had suffered "Satanic Abuse" and heavily criticised the local authority and social services over their conduct in dealing with the affair. Sir John Woodcock, a senior police chief interviewed on Radio 4's *Sunday* programme admitted that there does not (at present) seem to be any evidence to support the Satanic Child Abuse "hype".

Community workers on the Langley Council estate in Rochdale from where all the children were taken are now saying that the "appalling" press hysteria over the Rochdale case has frightened many other parents who live on the estate, and there is a rising tide of agreement that the Rochdale case has undoubtedly caused those involved in it a great deal of suffering. The NSPCC has recently backtracked on its support of the Satanist Child Abuse claims, admitting that there "was not a shred of evidence" to support the campaign which it initiated back in 1989.

The Mail on Sunday devoted seven pages to analysing the events that led up to Rochdale, and identified Maureen Davies (ex Reachout Trust) as being involved in "advising" Social Workers in the (allegedly) "Satanic Abuse" cases in Manchester, Nottingham, and Rochdale. Strange that wherever Ms Davies goes, tales of Satanic Child Abuse follow, yet all three cases were resolved with the verdict that **no** Satanic Child Abuse was taking place. *The Mail* noted that some of the evidence presented to justify the children being taken from their parents was very flimsy – in one instance they acted on the basis of an anonymous phone call, while one boy stated that he had eaten a cat – which turned out to be a pasta cat in a bowl of soup! Despite the huge "Children don't lie" campaign put out by the NSPCC, it is now being admitted that children do lie and, moreover, do confuse fact and fantasy, especially when offered leading questions.

The government are now promising to revise social services assessment procedures, and the new Children's Act will enable parents to contest court orders within three days of them being issued. The families involved in the Rochdale case are said to be considering legal action against the council authorities. Great, but it isn't enough.

Despite all evidence to the contrary, pro-Satanic Child Abuse activists such as Maureen Davies and Dianne Core are still convinced that there is a huge conspiracy acting to cover up the "reality" of Satanic Child Abuse.

Dianne Core told *The Mail on Sunday* that she believes that 4,000 babies a year are born into covens to be used for sacrifices and cannibalism. Maureen Davies is going ahead with her plan to set up The Beacon Trust, now that The Reachout Trust has been discredited.[1] Doubtless the outcome of the Rochdale case is just another setback in her fight to make us aware of the reality of "Satanic Child Abuse" and she and her ilk will continue to spread their tissue of lies and confusions, no matter who gets hurt.

And while we're on the subject of dangerous loonies, spare a thought for those self-styled Pagan "leaders" who have been actively supporting the myth of "Satanic Child Abuse" while grabbing the limelight for five minutes:

> *There will be groups who have set up since the 50s in the name of something called Wicca, which is kind of an established Witchcraft, which is evil – in certain ways.*

> *Bondage, flagellation, sex; girls are abused sexually on the altar, and many are blackmailed. They are told if they join a coven there is no way they can get out otherwise they will have mystical powers used against them or worst of all they will be killed off. I mean, this does go on in this country.*

That was Kevin Carlyon,[2] from the Covenant of Earth Magic[3] talking on Channel 4 last year, casually denouncing mainstream Wicca as something that condones ritual murder and sexual abuse. So far, he has declined to comment on his views. Every time a Pagan buys into the Satanic Abuse virus, it gives the fundies more ammunition, especially when they can use the statement as "evidence" that Pagans and occultists are "admitting" that it goes on, although the finger is invariably pointed at someone else. Thanks a lot folks.

The outcome of Rochdale has led to a lot of red faces on the part of those who were hyping the Satanic Child Abuse cause, but fundies are still continuing to try and hurt occultists in any way they can. More details next issue.

1 The Beacon Trust doesn't seem to have operated for very long before fading away. Davies appears to now be retired from witch-hunting, though she still occasionally posts anti-Satanic and pro-Donald Trump memes to the 147 people who follow her on Facebook.

2 Known as "Kev the Witch", Mr. Carlyon has for many years appeared in various populist publications wearing a purple bathrobe and proclaiming himself to be the High Priest of British Witches (in his own mind at least). He now advertises on the Internet that he will perform spells for the low, low price of only £90, though he actually appears to spend most of his time ranting about immigration on Twitter.

3 This group was formed in the 1980s by Carlyon and his then-wife Ingrid Way. It doesn't appear to have had more than a dozen members.

Children Seized in
Orkney 'Orgy' Allegations

As the Rochdale case was being wound up, social services in Orkney took nine children between the ages of eight and fifteen from their families. The children were whisked off without any personal effects and no prior warning was given to their parents. The allegations against the parents are broad and unspecific, mentioning "orgies" and "ritualistic music, dancing and dress". Police also went to the home of a local minister and removed a black cloak, broken crucifix and a torn religious picture. Sinister, eh? Of the four families involved, one family are Quakers and the other Jewish. A Quaker mother, interviewed on Radio 4's *Sunday* programme said that the police had quizzed her on her religious beliefs and practices, implying that they were somehow not "normal". A member of Orkney Island social services Committee said that they had acted after "receiving information" which made the seizures necessary, and denied that there was a current fashion for looking for evidence of "Satanic Ritual Abuse". It may be significant that there is an Evangelical Ministry on the island. We await further details.

Brighton Dolphins Released

As reported in *Pagan News* last year, the Temple of Psychick Youth have been actively campaigning for the closure of Brighton's Dolphinarium, and the release of its two remaining dolphins, Silver and Missie, into an open water facility.

The campaign has come to a successful conclusion with the announcement that the Dolphinarium is being closed, and that plans are under way to rehabilitate Silver and Missie in the Caribbean. To celebrate the release of the two dolphins, Psychic TV performed at the Brighton Zap Club, which was followed by a candle-lit vigil to the sea. A victory over stupidity and ignorance. The dolphins are free. Are we?

Athame Case Quashed

Following last issue's report on the progress of the Birmingham athame case, we have since been informed that the Court have recognised that the defendant's athame was a religious artifact, and has been returned to him; the case being thrown out of court. We offer our congratulations, and hope that the successful outcome of this case might be beneficial for future dealings between Pagans and the law.

Stonehenge Lies?

Last year the English Heritage claimed that at the Autumn Equinox, 250 "hippies" staged a "dawn raid" on Stonehenge, "overwhelming wardens and police standing guard". EH claim that while some just "chanted", others "chiseled grooves" on the stones themselves. EH say that "the invaders" hacked out two parallel lines on one megalith, about a quarter inch deep and over a foot long! Oddly though, visitors who have since gained access to the stones have not been able to see these "highly visible defacements" and one wonders how anyone could have attacked the stones in such a fashion without being seen. Regular visitors to Stonehenge are asserting that there are no signs of "damage" to the stones, and that press stories about the so-called "raid" are a further attempt to discredit those who visit the stones with the intent of celebrating the festivals.

LOVE NOT LAWS

Geoffrey Dickens; Clause 25 and The Criminal Justice Bill

Phil Hine examines the possible implications for Pagans & occultists.

I n case you didn't know, crusading MP Mr. Geoffrey Dickens, not content with being quoted in the tabloid press every time they find something that reeks (to them) even faintly of Satanism, has been trying to tack on an amendment to the Criminal Justice Bill which is currently going through Parliament, which could potentially make life very difficult for Pagans & occultists. A few weeks ago he appeared on Channel 4's *Free for All* programme, being questioned by Wiccans Dot & Reg Griffiths[4] about his proposed amendments to the Bill, which would make it illegal for anyone under 18 to attend, or be in the same building as, an occult ceremony or meeting. During the programme, Mr. Dickens stated that he considers Paganism to be "Anti-Christ", and that he considers witchcraft to be "totally unhealthy and is leading to many sinister things". The details of Dickens' Amendment to the Criminal Justice Bill are as follows:

(1) A person who permits, entices or encourages a minor to participate in, or be present at a ceremony, or other activity of any kind specified in Subsection 3, below, commits an offence.

(2) A person who commits an offence under this section shall be liable on conviction on indictment to imprisonment for a term not exceeding five years.

(3) The Ceremonies and activities to which this section applies are those of, or associated with Satanism and other Devil Worshipping, black magic, Witchcraft or any activity to which Section (1) of the Fraudulent Mediums Act (1951) applies.

For completeness, here's an extract from The Fraudulent Mediums Act (1951):

An act to repeal the Witchcraft Act (1735) and make institution for certain provisions of Section 4 of the vagrancy Act (1824) expressing provision for the punishment of persons who fraudulently purport to act as Spiritualistic mediums or to exercise powers of telepathy, clairvoyance or other similar powers.

4 Reg Griffiths (1935 – 2007) and his wife Dorothy (Dot) ran a Witchcraft School in Milton Keynes during the 80s.

(1) Subject to the provisions of this section, any person who (a) with intent to deceive purports to act as a Spiritualistic Medium or to exercise any powers of telepathy, Clairvoyance or other similar powers, or (b) in purporting to act as a spiritualistic medium or to exercise such powers as aforesaid uses any fraudulent device shall be guilty of an offence.

(2) A person shall not be convicted of an offence under the foregoing subsection unless it is proved that he acted for reward and for the purposes of this section a person shall be deemed to act for reward if any money is paid or other valuable thing given, in respect of what he does whether to him or to any other person.

In effect, this Amendment covers most everything, since It's a safe bet that the people deciding what constitutes "black magic" are not going to be sympathetic to different Pagan/magical traditions, at least not if the example of the Orkney Police interrogating a Quaker parent is anything to go by.

News of Dickens' anti-occult amendment was first given by the campaigning Sorcerer's Apprentice Fighting Fund, and a campaign of letter-writing to John Patten and other MPs was instituted. By mid-February, the Home Office confirmed that Dickens' amendment was rejected as being "beyond the scope" of the Bill, and therefore would not be considered when the Bill gets its third reading.

All breathe a sigh of relief, eh? Doubtless the government doesn't consider occultists enough of a threat to social stability to legislate against us – yet. If they ever do, then there is no doubt (at least in my mind) that they will legislate into existence similar draconian measures to the ones that Dickens was proposing. It's also still possible for Geoffrey to try and get a Private Member's Bill through Parliament, which could amount to the same thing.

On a personal level, I am less worried about Dickens' proposals and their implications for Pagans, and more concerned with the Criminal Justice Bill's Clause 25, referring to gay men. Briefly, approaching another male in a loosely-defined "public" place (read – street, bar, disco, or even someone's house) and asking for a date, or doing it via someone else ("Oi, my mate fancies you") will, under Clause 25, come under the criminal offence of procuring. This also applies to situations where, for example, a straight couple let a gay couple sleep in their spare room overnight. Two men kissing or holding hands in a public place (previously an arrestable offence under the behaviour likely to cause a Breach of the Peace" laws) will also become a more serious criminal offence and "victimless" sexual acts between consenting adults are being placed on a par with genuinely serious sex offences. The government is also considering an amendment to the Criminal Justice Bill which will force "offenders" (including those convicted under Clause 25) to undergo compulsory medical and psychiatric treatment for up to five years, following their release. What's next, I wonder – castration & electric shocks?

What is a good sign is that for the first time, the government is at least acknowledging public concern over the implications of the Criminal Justice Bill. Early in March, the government made slight amendments to the Bill, removing three "consensual" gay offences and refining the definition of what constitutes a "serious sexual offence", although further attempts by Labour and Liberal Democrat MPs to amend Clause 25 were shelved. John Patten maintains that Clause 25 is only to be brought into play when children and women need

> *"A wide range of minority groups are under attack, and it is significant that, at least for occultists and homosexuals, we need look no further than the fundamentalist, conservative pressure groups who have demonstrated most ably their power to influence both the media and the government."*

protection from serious and violent crime by homosexuals or heterosexuals.

Having said that, Clause 25 has been very loosely worded so that it can be brought to bear on a very wide range of areas indeed. The section dealing with "procuring" could, for example, cover contact advertisements; where the producers of the magazine could be prosecuted for allowing gay men to get in contact with each other. This could mean that gay Pagans could follow people "on the Left-Hand Path" as being persona non grata as far as the Pagan contact 'zines are concerned. In fact, just think of the legislative chaos which would ensue if Dickens managed to get a Private Members Bill through Parliament enforcing his anti-occult laws, so that those such as myself, who are both occultists and gay, could potentially get prosecuted under both Acts. Wonderful!

What I would really like to know is why New Agers are walking around saying that the 90s will be a wonderful decade – so far we've had the Western powers reliving *Apocalypse Now*[5] in the Gulf, a Right-Wing resurgence in the Soviet Union, the further erosion of human rights in the UK, and a steady rise in right-wing orgs flexing their muscles both here and in Europe (more of which in a future issue). Or maybe I'm just not spiritually evolved enough to see where this is all going?

What is clear is that a wide range of minority groups are under attack, and it is significant that, at least for occultists and homosexuals, we need look no further

5 *Apocalypse Now* is a magnificent 1979 movie about the Vietnam War, directed and produced by Francis Ford Coppola, and starring Marlon Brando, Robert Duvall, Martin Sheen, Laurence Fishburne, Harrison Ford, and Dennis Hopper. It is a must-see masterpiece.

than the fundamentalist, conservative pressure groups who have demonstrated most ably their power to influence both the media and the government. Remember Dame Jill Knight and her "Private Member's Committee on Satanic Child Abuse" – which accepted information from The Reachout Trust et al, but refused to listen to the S.A.F.F.? The findings of this committee may well end up in Virginia Bottomley's[6] "In Tray", since she has promised that the government will convene a meeting this month (March) to discuss "ritual sex abuse". Dame Knight is also known for not being exactly sympathetic to the gay community either.

Pagans & occultists have, in the past, been characterised by a tendency to be seen as "apolitical", apart from a few notable exceptions such as Pagans Against Nukes. Over the last five years, this has begun to change, with the rise in ecological consciousness, the work of Starhawk,[7] and more recently, the Gulf War. Calls for "Pagan rights" are slowly being changed to calls for "human rights", since It's obviously a much wider issue than one particular minority acquiring the stamp of legitimisation.

Surely one of the by-products of any form of occult development or Pagan philosophy, when practically applied to oneself, is a more expansive worldview, and a greater tolerance for others. You'd think so, but the most visible evidence suggests that "bitchcraft" still has a pretty strong hold on occultists" perceptions of those on different paths, and the tendency to convert personal prejudice into "spiritual laws" is still rife.

Perhaps this is a tendency "built into the system" as it were. Western Esoteric Traditions (and those which have become "Westernised") tend to place more emphasis on what goes on in an abstract, "spiritual" space, from whence it would appear to be difficult to translate "spiritual development" into meeting the concerns and problems faced in everyday life. Since It's almost impossible to authenticate another person's claim to being an adept or whatever, surely it would be more useful to look at them as people. Anyone can accumulate knowledge, but wisdom is born from applying that knowledge to living.

Sources: S.A.F.F. news bulletins; *Gay Times* (Feb '91); *The Pink Paper;* C4's *Free For All.*

6 Virginia Hilda Brunette Maxwell Bottomley, Baroness Bottomley of Nettlestone (1948 –) is a British Conservative Party politician. She sat in the House of Commons from 1984 to 2005, when she was given a seat in the House of Lords in 2005. At the time of writing this article she was Minister of State at the Department of Health.

7 Miriam Simos (1951 –) known as Starhawk, is an American feminist and author. Her 1979 book *The Spiral Dance* was hugely influential on the Goddess movement, particularly in the USA. Since then she has become a prominent activist in the fields of ecology, feminism, and neoPaganism.

THINGS TO DO...
and THINGS TO READ

Ganzfeld

by *Julian S. Vayne*

The Ganzfeld is a method of inducing a state of tranquility and relaxation, by providing constant, unchanging, auditory/visual stimulation. The Ganzfeld method can be used for a wide range of purposes, from basic relaxation, to psychic training.

Find a room in which you will not be disturbed. It should be warm and well-ventilated.

Take two opaque, plastic spheres (such as ping-pong balls) and cut them in half, discarding the section with the maker's logo. The spheres should be taped over your eyes with micropore tape when you are ready to begin a session.

You should sit in a comfortable chair, or lie on a couch; in either case, make sure your spine is straight.

The room should be illuminated by a red light – a red 60 Watt bulb placed about two feet away from your chair/couch is ideal.

For the duration of a session, you should wear comfortable headphones through which is played "white noise" – this can be obtained cheaply by playing a blank audio cassette loudly through the headphones.

Relax and see what happens.[8]

8 The Ganzfeld technique was originally developed by German psychologist Wolfgang Metzger (1899 – 1979) and expanded upon by Charles Honorton (1946 – 1992) in the 1970s as a system for helping enhance potential psychic powers through sensory deprivation.

On the Moon by *Anthony Roe*

Life means change. This is typified by the course of the Moon which mirrors growth and decay, birth and death, good and evil. In the sublunar world the Moon governs the genesis of all things. Since the most ancient times it has represented the feminine principle. The Moon is as important as the Sun, and the two are closely linked.

The Moon is associated symbolically with Nature. On the one hand this represents the womb of life, on the other, it surges in our psyche, arcane and mysterious, a deep power we have always been aware of, even feared, and which if denied can be the root of misogyny and abuse.

With the Ascendant and the Sun, the Moon represents a most significant element in any horoscope. The Sun represents the masculine side of a personality, the Moon the feminine. In a female chart its position details a woman's sexual identity, and how she feels about motherhood. Her femininity may be passionate, wild and bold, or receptive, passive and gentle, according to the Sign which contains the Moon at the moment of birth.

In a man's chart, the position of the Moon shows how he behaves with women, whether mother or partner, and reveals his emotional nature, and tells what his early surroundings were like as well as what he will need as an adult to feel safe and comfortable.

It matters not whether you consider the Moon as feminine or masculine. The Moon is the Second Luminary, whose pairing with the Sun produces the rhythm of life. Their syzygy[9] in conjunction or opposition are focal points in the universe as we know it.

The Moon certainly favours the feminine power: in crescent it helps women perform magical acts – a period suitable for men to pursue operations of the art

9 A syzygy is a straight-line configuration of three or more celestial bodies, in this case, the Sun, the Moon, and the Earth.

with a passive content. The decrease is propitious for aggressive operations and active works.

Operations of the Elements may be performed according to the phases of the Moon. From new to first quarter the waxing Moon is of Air, from first quarter to Full it is categorised as Fire, the third quarter is Earthy in quality, and the last quarter is Watery. Secret names of the Moon are used, bequeathed by the Watchers of Old, appertaining to the quarters. In order, they are ASONJA, EBLA, BENASE, and ERAE.[10] Utter them at night to achieve consecration.

If you want to get a feel for lunar power as the pregnant progenitor of life, just stand naked on a deserted beach at midnight in summertime as the waves break, and you will sense the pulse of the warm, moist matrix of life, the fecund darkness of Nature.[11]

> *"It matters not whether you consider the Moon as feminine or masculine. The Moon is the Second Luminary, whose pairing with the Sun produces the rhythm of life. Their syzygy in conjunction or opposition are focal points in the universe as we know it."*

The points where the Moon crosses the Sun's path, the north and south nodes, the head and tail of the Dragon, are significant in practical work. The Head is of the nature of Jupiter and Venus, considered fortunate; the Tail is of ill fortune, of the nature of Saturn and Mars. The Ancients considered the Head a fount of pure power: its presence enhanced good and evil; similarly the Tail lessened force, and inhibited both good and evil.

Modern theory suggests that the Head increases fortune and lessens evil, the Tail magnifying evil tendencies, unless the planets affected be angular and strong. Certainly the presence of the Tail in a configuration is often indicative of things coming to nought.

The keyword of the Head is self-expression, of the Tail, self-denial. The nature of a passing planet adheres to the time when it is present with the node, and points up the moment for hieratic acts and ritual work. Thus Mercury at the

10 Book of Enoch, Chapter 78. "*And the names of the sun are the following: the first Orjares, and the second Tomas. And the moon has four names: the first name is Asonja, the second Ebla, the third Benase, and the fourth Erae. These are the two great luminaries: their circumference is like the circumference of the heaven, and the size of the circumference of both is alike.*"

11 Do make sure It's deserted though, we don't want our readers being arrested for public indecency!

north node (i.e. conjunct with the Head of the Dragon) promotes hermetic and other communications; Venus with the Tail would countenance celibacy, at the Head, amatory indulgence; the presence of Saturn combined would portend restriction as appropriate.

To translate these general provisions into personal practice, take the degrees of the Head and the Tail in your own nativity, and operate when the required planet occupies that position, i.e. transits the degree where the node was in your birth chart, or is connected thereto by aspect. You can thus unlock the potential of your own genesis in the here and now.

An apposite means for the work of Luna would be hydromancy. Use a shallow bowl, filled with spring water: to facilitate vision dissolve some few crystals of ferrous sulphate.[12] This vitriol colours the water green (a very old lunar colour); otherwise silvery colourings should be used in adornments, or pearls, in multiples of nine. The names to call upon are BILETH, MIZABU, ABUZABA. The rite may be used in common for what you will of a lunary nature.

12 Ferrous sulfate (or sulphate) is a medicinal supplement commonly used to treat and prevent iron deficiency anaemia. As such it can readily be bought over the counter at any drugstore.

Pagan News

THE BI-MONTHLY NEWSMAGAZINE OF MAGICK & THE OCCULT.

75p
May/June 91

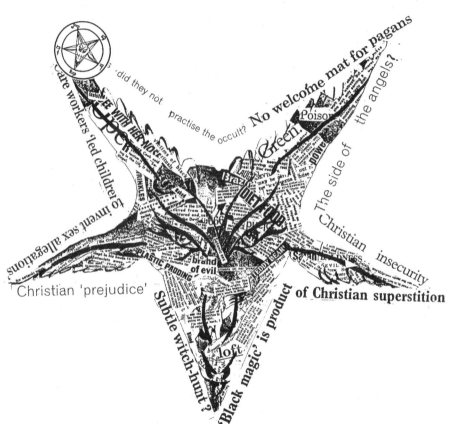

SATAN: A MORAL PANIC EXPOSED

TONY WILLIS ON RUNES

SUMMER EVENTS LISTING

Fundamentalists "Holy War" Hits Lincoln

Bridge of Dreams is a new occult/New Age shop that has recently opened in Lincoln only to meet with an organised campaign of opposition by fundamentalists. The shop's owners, Sarah & Chris Townsend, take up the story:

We opened our shop at 7 Monks Rd, Lincoln at 8.30am on the 1st December, 1990. Almost straight away a well-dressed gentleman came in and looked around. He asked us if we were anything to do with the Sorcerer's Apprentice in Leeds and when we replied that we were not he warned us that we would "know about it if we upset Mr. Bray". He was extremely eager to get this point across and left taking one of our leaflets with him.

Several days later we received copies of the same leaflet and also the Bridge of Dreams advert from the local paper, but with the Sorcerer's Apprentice name superimposed across the top and the slogan "Don't go to Leeds. Visit the new S.A. in Lincoln". These forgeries were also sent to Chris Bray in Leeds who in turn replied with a letter which showed us he was obviously not very happy. After several phone calls we all realised that we had been victims of a fundamentalist set up to try and close down Bridge of Dreams and create trouble for the occult world in general. The police began an investigation into this but no real evidence could be found.

In the following weeks there was a press campaign orchestrated by The Reachout Trust and allies, along the lines of "fight this evil in our city", and the Townsends received letters from the city council questioning planning permission for their retail outlet and threatening legal action for distributing leaflets in a car park. Their landlord informed them that his solicitor had asked him if he "now wanted to stop our lease going through – in view of what we sell". Apparently a visit to the local ward councillor drew a blank, as did an initial letter to the MP for Lincoln. By the third week of trading, with the press campaign ongoing, the Townsends began to receive threatening phone calls, hate mail, and individual visits from fundamentalists. Then local radio got in on the act. BBC's Radio Lincolnshire broadcast a phone-in programme about Bridge of Dreams (without bothering to inform them beforehand) featuring a local Reachout Trust director. By the end of January the city council held a Policies & Resources meeting to discuss if Bridge of Dreams could be closed down. The S.A.F.F. came to the rescue with an "action call" which led to hundreds of supportive phone calls to the council, faxes, and letters. In early March, a psychic fair the Townsends had organised in Stafford was cancelled by the hotel manager on the evening before it was to run, thanks to pressure from fundamentalists, and they are now taking legal advice on this matter.

Sue and Chris are now members of the S.A.F.F. who have proved invaluable in supporting them in their fight. In addition to lobbying the council, the S.A.F.F's support pressured one local newspaper editor into printing a retraction of earlier defamatory statements, and an apology. But It's not over yet.[1] Despite feeling "much beleaguered" Sue and Chris are committed to overcoming the "ignorance that breeds fear" of Pagans and occultists. They need all the support we can give.

German Caliphates in Christian Courtroom Clash

News just in from our German correspondent relates that over there, the Caliphate O.T.O. is fighting a court case against a Christian publishing company who brought out a book defaming the O.T.O.. The book's title translates as *Are Our Youth Going to the Devil?* and it alleges that the O.T.O. was an organisation that orchestrated ritual child abuse (and all the usual hype). The O.T.O. at first politely asked the publishers to retract their statements, but they refused, assuming that the Order would be too poor or too scared to go to court. Oops. They are currently facing over 20 separate libel suits. More news as it comes in.[2]

Re/Search Cleared of Obscenity Charges

As reported in our Jan/Feb issue, copies of the Re/Search publication *Modern Primitives* were seized last year by police. In March, Bow Street Magistrates acquitted bookseller Richard Waller, of the Book-Inn on Charing Cross Rd, of charges brought against him under the Obscene Publications Act. Apparently a police witness at the trial took particular exception to a photo depicting the North American Indian Sun Dance, during which thongs are inserted into the pectoral muscles and the participant is suspended from them. The prosecution also objected to a photograph of a man who had bifurcated his penis (a not uncommon practice amongst Native Australians), but the magistrate declared that in his view, the photograph was unlikely to inspire emulation.[3] *Modern Primitives* was ruled to be informative rather than obscene (the standard rule for judging material deemed to be obscene is demonstrating that it is likely to "deprave and corrupt" readers).

1 Indeed it was far from over. The hate campaign became increasingly heated and culminated in an arson attack on the Bridge of Dreams store, doing £50,000 of damage and driving them out of business. Thankfully no-one was seriously injured.

2 The German O.T.O. (assisted by a member of the *Pagan News* staff) eventually won their case and all copies of this book were withdrawn from sale and pulped. The resulting legal precedent pretty much prevented the Satanic Ritual Abuse myth from gaining any significant traction in the German-speaking world.

3 British court judges are notorious for their dry humour.

SATAN
A MORAL PANIC EXPOSED
Phil Hine

By the time you've read this line, It's a pretty safe bet that someone, somewhere will, on seeing the cover, have chosen not to buy *Pagan News* this issue. We may even get a cancelled subscription or two. That's the power of SATAN for you.

For the last two and a half years we've been subjected to a barrage of SATANIC advertising. The papers, TV, preachers, Pagans, "white witches", social workers, psychiatrists, professionals and lay pundits—all pointing their fingers at SATAN (backstage sound of diabolic laughter). SATAN sells newspapers – the gutter press loved the scam; "tits out for the Devil worshippers" and fell over each other to present new depths of prurience for their jaded readers. The headlines screamed of shocking revelations and the pundits thrilled with their fifteen minute fix of media fame.

Reverend Kevin Logan's voiceover on *The Cook Report*: "Satan's Press Representatives are doing a very good job, and the churches are not combating it as they should" ... yeah, right, Rev. but if it weren't for SATAN, who'd have heard of you? You and your friends in Christian Response to the Occult, Reachout, File 18; the "Satanic Child Abuse" experts, and the "white witches" eager to whitewash themselves and stand on the sides of the accusers, you've helped create and reinforce a media–profile of SATAN that he hasn't enjoyed since the Middle Ages. Were it not for the spectre of SATAN–an image that you fed and fostered, none of you would have been quoted in the press, allowed on prime-time TV or been able to impress nervous social workers with your "expertise". Your cheque's in the post. Thank you and goodnight.

The myth was sown in the rich earth of a society unsettled by the revelations of the reality of child abuse. The Cleveland sex abuse scandal raised so many demons out from the darkness that could not be faced, and so you promoted SATANISM as the catch-all for anyone who threatened "traditional" values, and the media-mob screamed "witch-hunt". Like previous witch-hunts, innocents invariably suffered, the families torn apart in Nottingham, Rochdale, Orkney and the rest–sacrifices to SATAN all; can you face those whose lives you indirectly wrecked and justify yourselves to them? I think not.

Like previous witch-hunts, the accusations had a mythical quality, following a standard formula that has been used against witches, Jews, Moslems, communists, anarchists, even against the early Christians themselves! You unearthed a "folk devil", erected an altar, and raised up a moral panic. Powerful magic indeed.

Unfortunate that the very innocents that you oozed concern over got caught in the crossfire. Talk about "suffer the little children", eh?

Critics of the "Satanic Child Abuse" hype have pointed out that it all seems to stem from a relatively small, but highly organised network of Evangelists and fundamentalists, most of whom have been identified through their activities. They attacked what they saw as SATAN, and to a large extent, created that problem. By pointing the finger at the (largely mythical) SATANISTS, they gave us more and more information about whatever it is that SATANISTS are supposed to do. Anyone wanting to take on the mantle of SATANIST as seen by the "evangelical experts" can get access to all the information they need, without reading all those stuffy and boring occult books which aren't half as interesting as Doreen Irvine's latest revelations. At the end of *The Cook Report*, a helpline number was given for those who had suffered "satanic abuse". Apparently, it was taken up by people who wanted to know more about SATANISM. A SATANISM which is the massed projections of the obsessions and guilts of a Christian-based society in crisis.

Over the ages, Christianity has weathered many crises; internal schism, heresies, Darwinism, science, communism, social change, the rise of the pleasure principle over asceticism and, more recently, the problems of openly "gay" priests and the call for the ordination of women. In the United States, the bible-thumping empires of Bakker, Roberts, & co. have been revealed to be edifices built on corruption and criminality. So too, as we approach the Millennium, "End Times" fever is running high,[4] and now that Glasnost has effectively removed the "Red Menace" as an image for End Time fever, SATAN has taken over as the fuel for the hell-fire thundering from the pulpit. By and large though, Christianity as a religion has adapted, becoming more liberal and responsive to the complexity of modern living. Hence the need for the fundamentalists and their ilk to reject the established Church as not being a "true" expression of Christianity. fundamentalism projects a worldview that is starkly White or Black–no shades of grey are allowed, you're either with them, or you're an enemy. They are projecting the myth of the "traditional Christian family" who exist in the kind of reality created by advertising, where dad goes out to work, mum happily does the housework and the children bounce cheerfully around. To them, SATAN embodies anything that threatens the safety of this image–from teenage rebellion to secularisation, from feminism to alternative religions. That Christ said "Thou shall not kill" is much quoted,

4 It may be difficult for younger readers to comprehend the insanity around "the end of the Millennium" when we were being told that Satan was going to return to Earth and all of our computers were going to stop working. No, really, that's what millions of people actually believed would happen after 1999. Because of the calendar.

but if SATAN threatens, then presumably It's okay to firebomb abortion clinics and occult bookshops.

Before the Satanic Child Abuse (SCA) hype began, the media tended to regard occultists as harmless loonies. What is worse from the fundamentalist perspective, is that the rise of Green Consciousness was actually allowing many Pagan beliefs to become more acceptable in the mass market. In casting their net of accusations so widely, the SCA pundits miscalculated the amount of resistance that they would run into. They accused Pagans and occultists of continually trying to pressure people into becoming involved, and of "masterminding" a huge network to keep our sins under wraps. Again, this is a projection of their own tactics. They turn no one away and indeed, grasp to their bosom anyone

> *"The very diversity which is a strength of Paganism is a weakness exploited by the fundamentalists–but then 'divide and rule' is a common tactic resorted to by inquisitions. With occultists and Pagans, this worked very well, with a sudden flurry of people standing up and saying 'It's not us, we're nice and harmless, It's those nasty SATANISTS–get them!'"*

who has (or says they have) former involvement with the occult–as in the case of the unfortunate Caroline Marchant. It would be nice to say that Pagans and occultists (I'm never quite sure where the distinction lies) tend to be responsible, self-determining individuals who are respectful of other people's paths and individuality. However, as anyone with long involvement in "the scene" will attest, that's not the case. Despite all the books written on the subject of personal growth and inner development, there is still a good deal of rumour, "bitchcraft" back-biting and exposure of other people as SATANISTS. So-called Adepts slag each other in print, issue writs and libels, and orchestrate campaigns against each other. The very diversity which is a strength of Paganism is a weakness exploited by the fundamentalists–but then "divide and rule" is a common tactic resorted to by inquisitions. With occultists and Pagans, this worked very well, with a sudden flurry of people standing up and saying "It's not us, we're nice and harmless, It's those nasty SATANISTS–get them!"

I am indebted to Dave Lee for his image of "The City and the Sewers". Picture a shining city, towers rising like mythical Oz, where everything is clean and whiter than white. The higher the towers climb, the deeper are dug the sewers that carry waste products and fossil fuels. This is the mythic city that the fundamentalists

and their kin are attempting to live within–wherein anyone who "gets their hands dirty", whether it is by attempting to deal with the waste-products, or at the very least, pointing out that the pipes are blocked and the shit is flowing into the streets—become non-people or outcasts. On an internal level, the city is the conscious ego, the sewers, the unconscious, wherein all that is repressed and cannot be faced up to, is buried. This whiter-than-white image must be maintained at all costs, especially when a wind of change whistles through the streets. Anyone who dares go down into the sewers and worse, who says "look at all this crap we're creating", must be branded as SATANIST and outcast (as in the case of Dr.. Marietta Higgs, one of the Cleveland case Doctors).[5]

This is the cry of a society that cannot look its own demons in the face; that cannot own up to its excrement and the contradictions of adhering to a whiter-than-white myth which does not allow for incest, child abuse, family violence, drug addiction, rape, poverty, xenophobia and alienation.

Both Evangelists and occultists speak glibly of the necessity for "Healing", but merely papering over the cracks in the facade is not enough. SATANISM and its "unspeakable horrors" have become an attractive myth, because deep down, we all know that the true demons are breeding in the cities, in our neighbour's houses–and especially, in ourselves.

5 Marietta Higgs and her colleague Dr. Geoffrey Wyatt used a controversial diagnostic practice called RAD (reflex anal dilatation) to "recognise" if abuse had taken place in children. This led to criticisms of misdiagnosis in dozens of suspected cases. Despite this, astonishingly Dr.. Higgs still practices in children's medicine at an NHS hospital to this day.

SPOTLIGHT

Tony Willis – Evolving The Runes

Tony Willis has been studying and practising magick for over thirty years. He began with the Qabalah and moved on to looking at the more native traditions. He has written two books, The Runic Workbook *and* Magick and the Tarot, *both issued by Aquarian Press. The* Runic Workbook *has just been re-released by Aquarian Press in a new format entitled* Discover Runes; *and* Pagan News *conducted the following interview at Tony's Bradford home.*

PN: Why do you think that Runes are currently so popular?

TW: I think It's because they relate very strongly to the native tradition, as a large proportion of the British people are descended from the Anglo-Saxons, naturally. The Anglo-Saxons were descendants of people who used the runes, and used the runes themselves, originally. I think runes appeal to peoples" native folk-magick. I get feedback from a lot of people who come into contact with runes for the first time and they say, "I feel I know this", and although runes hadn't been popularised until about 10-12 years ago, people do come into contact with runes, and they do "speak" to them. I find that happens again and again. Also, It's not a complex system, like the Qabalah or Abra-melin.[6] Runes are something which work almost without you having to do very much. They work more or less automatically.

6 The *Book of Abramelin* is a semi-fictional 17th century work which explains how the Egyptian magician of that name taught his magic to Abraham of Worms. The magical system described became highly influential through the publication of a translation by Golden Dawn head S.L. Mathers in 1897, and later used by Aleister Crowley.

PN: How did you become interested in the runes yourself?

TW: I was introduced to them by my grandmother, who introduced me to magick anyway. She introduced me to the type of casting-runes, and a little bit about the runic alphabet, though she didn't know very much about that. As time went by, I simply became interested myself, and revived some of the ideas and things that she taught me, adding that to research other people were doing, particularly Murry Hope,[7] or Athene Williams, as she was then.

PN: In your book, you advocate the usage of the so-called "Blank Rune", which is a subject of some controversy amongst students of the runes.

TW: Yes, indeed. My point of view is that the runes are an evolving system, as is true of most magical systems. The "Blank Rune" has been added to the set, as it became apparent that it would be useful to use a blank rune, and I've always found it so. I don't know who first suggested it, when I came across it in the late 70s, but it just seemed to fit.

PN: An opposing point of view might be that the idea of the blank rune doesn't fit with chanting runes, and that it is outside the numerological attributes of the runes as a system.

TW: Now, that I don't agree with. It seems to me that the runic system, when it has 25 pieces in it, becomes much more interesting. It becomes 5x5, and 5 is the Mercury number, which is equivalent to Odin, the guardian of the runes. For me the numerology fits in perfectly. I do understand people who want to do it the traditional ways, using 24 pieces. I don't believe that people must use the blank rune. It's just that I've found it useful, particularly in readings where the runes, for one reason or another, don't want to tell you a facet of what's going on.

PN: So you feel that runes should evolve, rather than being kept to traditional arrangements?

TW: Yes. I think that when people started reviving the runes, they began with the traditional approaches, and certain things evolved out of that. I don't think that magick can ever stand still. It has to keep pace with the needs and wants of the people who are using it, and we are changing all the time. Our consciousness has changed dramatically in the last hundred years, and all magical systems have to keep up with that. Those systems that haven't had a rescencion of their essential factors are those which have fallen by the wayside.

PN: So what do you think of the attempts to fit Runes and Tarot together?

7 Murry Hope (1929 – 2012), English writer, occultist, and priestess. She published numerous works of variable quality, most notably *Practical Egyptian Magic* and *The Way of Cartouche: An Oracle of Ancient Egyptian Magic.*

TW: Not a lot. They are two different systems and they don't overlap at all. You can say that every divinatory system must have in it common factors, like there must be something dealing with love, marriage, death, birth, etc., so obviously those things correspond. You can look at a rune which represents love such as Jofu, and you can look at a Tarot card which represents love, such as the Empress or the Lovers, but there's no complete match between the two systems.

PN: So what do you think of systems like The Norse Tarot or Runecards?

TW: I have no objection to people making runecards, but I think you will get problems when you try to put the runes onto Tarot cards, and I know a lot of people who disagree with the attributions which were made in the Norse Tarot. It changes some of the symbolism considerably. For example the medieval symbol of Justice as a female figure is changed in the Norse Tarot to a male figure, who has specific myths associated with him which have nothing to do with the Justice concept as it is in the Tarot.

PN: Why do you think people are attempting to blend the two systems?

TW: I think that It's a sign of the age. People now are very interested in making a syncretic system out of everything. The runes are one of the few things which are not incorporated into the Golden Dawn system, which is the most syncretic system around. I feel that people have tried to incorporate the runes into that, because they feel that everything should match up in some way. I don't know that It's always a good idea – people will often want to equate the 24 runes to the 22 cards of the Tarot, but that leaves you with two extra you have to find something to do with.

PN: There are those who are saying that therefore there should be two extra Tarot cards to get around that problem.

TW: I think the Tarot is fine as it is. I don't like people messing around with the Tarot. That may seem strange, when I have said that I'm quite happy to add a blank rune to the runes, but I'm not happy to see anything added to the Tarot.

PN: Could you expand on the subject of Bind-Runes, which are covered in your book?

TW: We see examples of Bind-Runes on runic carvings and they've continued to be used in Iceland, where the tradition doesn't seem to have wholly broken. You can buy Bind-Runes in Reykjavik airport, if you want to. They are simply another form of rune-script. Some people do worry about the name Bind-Rune, because they tend to think that It's about binding something or someone, but It's just that the runes are overlaid, so that the runes are bound to one another.

PN: The names for runes that you use in your book are different to those used by other exponents of the runes. Why is this?

TW: You mean like "Uruz" for "Ur" and so forth. Those words, which are used by writers such as Blum – we have no way of knowing whether or not they are real

words. They are words invented by linguists, based on what the pronunciation of words is now, and what they think the pronunciation of words was in Middle English. They then work backwards and say "this is how they pronounced this word". If we're lucky, some of them are correct, but we don't know that they are. We also don't know if they correspond to the period in which the runes were invented. That may have been the word back in 2000 BC, but the runes don't really seem to have come about until 500 BC.[8] The names that I use are the ones that come very closely to the words that you'll find in historical research on the runes, such as R.W.V. Eliott's *Runes*[9] and R.I. Page, also called *Runes*.[10]

PN: Do you think that the runes have finally been severed from their association with fascism?

TW: No, I'm not sure that they have. There is no real association. It just came about for a short time, when the Nazis began to take over the research of Guido von List[11] and Frederick Marby,[12] and to pervert that work. I think that It's not a problem outside of magick, I think the problem is that it is going to be difficult, if we still have people in magick who do work the two together. I keep getting reports of certain groups who take extreme political stances, until they fall apart due to internal politics and form separate organisations. Edred Thorsson[13] talks a little bit about something like that at the beginning of his *Book of Troth*. My own stance is that the runes have no inherent political stance. I'm also willing to teach anybody who's got it in them, to learn the runes, whether they are of Anglo-Saxon origin or not.

8 Modern scholarship places the earliest known runes at around 150 CE. They may have existed before then, but we have no evidence of that.

9 Ralph Warren Victor Elliott (1921 – 2012) was a German-born Australian professor of English whose most famous work is *Runes: An Introduction* (1959).

10 Raymond Ian Page (1924 – 2012) was a British historian who specialised in the study of Anglo-Saxon runes and wrote several books on the subject, most notably *An Introduction to English Runes* (1973).

11 Guido Karl Anton List (1848 – 1919), was an Austrian occultist, writer, and huge racist asshole. He devoted his life to "reviving" a completely imaginary religion of the ancient German race which he called Wotanism. His ideas became the foundation for much of early Nazi "spiritual" thought.

12 Friedrich Bernhard Marby (1882 – 1966) was an important figure in 20th century German rune occultism, particularly for his use of the Armanen runes. He fell out with the Nazis in the mid 1930s and was imprisoned in the Flossenbürg, Welzheim, and Dachau concentration camps for a period of eight years until the war ended in 1945. Never trust a Nazi.

13 The pseudonym of Stephen Edred Flowers (1953 –), American professor, runologist, and author of numerous books. He received a Ph.D. in Germanic Languages and Medieval Studies in 1984 with his dissertation *Runes and Magic: Magical Formulaic Elements in the Elder Tradition*. Flowers has done a great deal to publicise Germanic occultism in modern America, not without some controversy.

PN: So you don't ascribe to the idea that you can only use the runes successfully if you're from an Anglo-Saxon background?

TW: I don't believe that, because It's not my experience. All can use the runes. What I do is that before I take a student on, I look at their horoscope to see if they have a runic link in the past. You might be an Anglo-Saxon descendant in this life, but you might have been living in Japan or somewhere in your previous incarnation.

PN: Have you any other books in the pipeline?

> *"I don't think that magick can ever stand still. It has to keep pace with the needs and wants of the people who are using it, and we are changing all the time."*

TW: I'm doing another book on Tarot divination. *Magick and the Tarot* was about magical uses of the Tarot, so this time I'm looking at just plain divination work. After that, I've got two ideas that are on the boil. One is a book on Angelic Magick – Enochian,[14] and the other, a book on Templar work. The Enochian book I'd like to start five or six paces back from the Golden Dawn Enochian stuff. They come at Enochian after they've taken you through a complex Qabalistic process, which is fine, but some people can't manage that kind of work. There are other ways of approaching the system which don't take you through the Qabalah at all.

PN: Have you come across Gerald Schuler's works on Enochian?

TW: The first book is a very good overview of the Golden Dawn approach to Enochian, but the books that have gone on are going in a direction which is not mine. To my mind, they are going too far forward, and become increasingly complicated, whereas what I want to do is to go back and deal with some of the simpler elements of Enochian. The Golden Dawn work is complicated enough; you could spend a lifetime just working through that methodically, but most people can't get to that point with safety, without having gone through the Golden Dawn system first. Enochian is a very powerful and immediate system – start making the Enochian calls and things will happen, sometimes whether you want them or not. That's when people get into a mess, because they don't really understand the basis of the system.

PN: Tony Willis, thank you for talking to us.

14 Enochian is a language/magical system first recorded by the Elizabethan magician Dr.. John Dee (1527 – 1609) and his assistant Edward Kelley (1555 – 1598). Dee believed that Enochian was the language of the angels, and was given its name because the Biblical patriarch Enoch was supposedly the last human who could speak it. For further information see Lon Milo DuQuette's masterful introduction to the subject *Enochian Vision Magick*.

VIEW POINT

A Long Hard Look
by *Digambaranath*[15]

Most of us are aware of how conventional education conditions people for failure, stifling natural abilities, underusing our potential and manufacturing stupidity. How many *Pagan News* readers, I wonder, would admit that conventional occultism can do exactly the same? Consider: out of all the "psychics" with their myriad mantic methods, how many predict the future, or even interpret the present, with any accuracy? Of all the demonologists, how many can conjure a demon to physical appearance? Of all the t'ai chi "masters", how many could last two rounds with a half-decent boxer? And for all the "results magic" performed, how many results do we actually see?

Of course we can point to parapsychology to demonstrate that magical powers do indeed exist, but we should remember that most of these experiments are performed on naive subjects, not occultists. Using a nuts and bolts approach, scientists frequently get results from Joe Public that would be the envy of any magician, while the bulk of occultists remain stuck in a swamp of self-delusion and fantasy. It is time we took a long hard look at our theory and practice.

Pseudo-Science

Pagans, by and large, have an irrational fear of hard science (indeed many have an irrational fear of being rational). Science, so we are told, is cold, patriarchal,

15 Another pseudonym of Frater Impecunious, used during his more Tantric phase.

mechanistic, and not the kind of thing nice people get up to. As an alternative we are supposed to tune in to Mother Nature, contemplate our wombs and use our right brains. Oops, did I say "right brains"? A piece of scientific jargon, of course, but then while condemning science with one breath, occultists and New Agers are quite happy to invoke pseudo-science in the next. Drawing questionable analogies from scientific research, they glibly announce that science has "proved" one of their pet theories.

Scientific method proves nothing, it simply provides models, usually far more reliable than those of magic or religion, for describing the physical world. And that, folks, is where the action is. Cape Canaveral is the most impressive piece of results magic I've ever seen.[16] To be fair, applied science has also given us nuclear weapons, but then you have irresponsible technology just like you have irresponsible sorcery, It's just that technologists are more efficient.

Dogma and Superstition

The flight from reason leads us to dogma and superstition. A dogma is any element in a belief system considered immune to criticism; a superstition forms no part of any coherent system at all (on a Catholic a St. Christopher's medallion[17] might be evidence of dogma; on an atheist it would be superstition). Occultists like to think themselves above such rigidities, but are as vulnerable as anyone. We say we choose our belief-systems for their practicality, but more often choose them for their romantic appeal. This is fine if you know you're being romantic but It's pretty unreliable in the real world (defined as that which doesn't go away if you stop believing in it). Plenty of American Indians adopted the appealing belief in the Ghost Dance until they found it didn't stop bullets. Had they been British occultists they'd still be doing it. Wild speculation and flights of fancy are all very well, but as soon as they rigidify into dogma or degenerate into superstition they encourage stupidity, which in a world where real bullets kill real people is something we can do without.

Rejection of analysis and logic leads to a decay of our critical faculties. If we can't criticise our beliefs (with nasty left-brain linear thinking) they seduce us into ignorant bliss. Again this is fine if you don't have to deal with the real world,

16 We assume he is actually referring to Kennedy Space Center, located at Cape Canaveral, not the actual geological features of the area itself.

17 For those without the "benefit" of a Roman Catholic upbringing, St. Christopher is the patron saint of travellers, which makes him highly popular with taxi drivers and other road users. He is also the patron saint of archers, bachelors, boatmen, soldiers, bookbinders, epileptics, fruit dealers, fullers, gardeners, market carriers, sailors, surfers, mountaineers, and transportation workers. He is a very busy guy.

but the New Age will be ruled by people with a grasp of physical, political and psychological realities, not by some woolly-headed Aquarians who think they're acting on orders from Atlantis.

Laziness and Inertia

In *Magick Without Tears* Crowley tells his student that if she devoted as much time to magic as to contract bridge she'd be an adept in no time.[18] Alas, this criticism could be applied to most of us (myself included). For every person who is seriously attempting the Great Work there are dozens who are content to read books about it. Of course there are others with the opposite problem, who fling themselves into every weird occult experience available and turn their brains to putty in the process. A lack of patience and persistence is common to both types, though.

Laziness (or foolhardiness) are at least commonplace and easy to identify. More pernicious is inertia: persisting in practices out of faith or habit even if they don't work. This is the sorry history of magic and religion alike. Occultists are quite happy to devote hours to practices which are clearly doing them no good whatsoever. All magic produces results of some sort; the question is whether they are the results asked for, or even worth having at all. Look at all the vampiric circles of healers who spend all their time being sick, the mystics with massive egos, or the therapists who are clearly nuts. Persisting with inefficient or dangerous techniques would be understandable if there were no others, but with the amazing wealth of both traditional and modern techniques available there is no excuse. Experiment; analyse; evaluate.

Our minds and bodies are precious tools. For Goddess' sake let's use them.

18 This from a man who devoted a considerable amount of his time to playing chess.

THINGS TO DO...
and THINGS TO READ

Hand Jobs
by *Bryn Ormsford*

This article is an introduction to practical palmistry, as applied to sexual characteristics. Whose idea was this? [guilty – Eds].

Firstly, when searching for "the" person to make the earth move for you, the shape of the entire hand is a general significator to the person's character, bearing in mind that he/she doesn't catch you looking – this should be done subtly.

1. Square Palms (square nails, blunted fingertips).
These are physical people. The width of the wrist is equal to the width of the knuckles. These can be orderly, precise, and "square", being very conservative, and undemonstrative. They can be aroused over money & status but definitely need a push in the romance dept. However, once the ice has broken (difficult tho' it is) they do let their hair down, once in a while. But if It's hot sweaty windows you're looking for, then I suggest you read on.

2. Elementary (coarse skin, thick flesh, short fat fingers).
These hands are here to experience the basic physical existence, and hands are usually small in comparison to the body. They're a bit sex-mad and constantly talk about it. Once these little fat fingers have you in their grasp you'd need more than industrial lubricant to prise yourself free. Males particularly do not know their own strengths and can be gropers. But they can be very loyal creatures if shown tolerance, tight clothes, and a very broad mind. Beware though, when I mean basic I mean "basic"!

3. Conic Hand (oblong w. straight, tapering fingers that have oval tips).
These are intuitive, imaginative, affectionate, sensual, charming, convivial, and to some, rather overpowering in their attentions. They will fall in love easily but moody, mercurial bouts are their downfall. This lot are a bit sex-mad as well, but are more likely to ask first. Very romantic but get "very deeply hurt" and whine a lot. They are sensation-seekers and myopic neophytes, but then with their egos they are likely to talk about nothing but themselves until they grow up.

4. Sensitive (rectangular palm forming oblong shape that is quite narrow – mostly women).

These are usually very attractive with sex-appeal. They love attention but tend to look for others for emotional and material support. Square fingertips: egotistical, jealous, negative, insensitive and sexually demanding. Pointed fingertips: fond of colour, music, tastes, and very emotional. Very easily hurt so treat them with kid gloves. Almond-shaped fingernails: quiet, gentle, confident, honest, and usually beautiful. Tend to be psychic and sexually... well as they say, still waters run deep.

5. Philosophic (angular-shaped hand, long palms & fingers, bumpy finger joints & squarish nails).

A searching, analytical mind is indicated here. Independent, idealist & mysterious. Tend to be cynical, with often stupid sarcasm. Their sexual nature is indicated as sensual & intense, but one would wonder if It's not themselves they would adoringly do it with as "don't get heavy with me" or "I hate pressure" are common statements, but sex is just fine – because until these blimps switch on upstairs and realise input develops output – you'll never know.

6. Spatulate (fingertips wider at the top, the hand appears to have a waist, large thumbs & broad wrists).

These are very active, motivated, & fast workers. They resent interference and are perpetually busy. They love adventure and are very creative, with a smouldering sexual aura if you can get them to stand still long enough – mind you give 'em 10 minutes and they could do it twice – if they liked you. They are fussy perfectionists and tend to talk about work far too much. He/she might float your boat but don't get too keen.

Nails

Pointed Fingertips – usually very lazy dreamers and like to do it all night.
Square Fingertips – reliable, down to earth, courteous & generous.
Conical Fingertips – artistic, imaginative, sensuous and gentle.
Spatulate Fingertips – sports lovers, energetic and over the top.

A final note about nails is, if the condition of both skin and nails is both soft, smooth and shiney, this represents sensuality & sex-drive. A nail-biter is harmless & a nervous wreck, usually insecure, lacking self-confidence and hiding behind sarcasm. So stop nibbling! Some can see just how vulnerable-unhappy-desperately want to be loved & cuddled bag of nerves you are, of course to the outside world, you're an island. I've seen one male, after his romantic bust-up actually chew all over the thumb, nail, flesh, cuticle – disgusting but very sad.

Crafty Talk
By Mike Howard

On Initiation

Initiation can be defined as the admission of a person into a society or mystery, usually within a ritual context. However, the actual word "initiate" also means to begin or originate. Therefore initiation should not merely be seen as a formal admission into an elitist group, though obviously it has those connotations, but more importantly as marking a fundamental change within the person's life and consciousness which has led them to seek initiation. The latter is a symbolic act representing an inner desire by the neophyte to transform their perception of the world, their relationship to others, and to make contact with the Divine.

Traditionally there has always been an accepted format of initiation into the mysteries featuring stages or degrees. These involved rites of purification, a probationary period, tests or ordeals, an Oath of Secrecy, oral teachings, the showing of sacred objects, the re-enactment of myths, baptism (or similar), a symbolic journey to the underworld, and a death and rebirth experience. Depending upon which Craft tradition you encounter these aspects will be present to a greater or lesser extent.

Some of the more cloak-and-daggerish elements of initiation into the Craft may date from the Persecution. For instance, elaborate oaths of allegiance and secrecy were elevated to some importance to prevent infiltration by spies and informers. Such traditional initiation rites as the one from the Fen tradition where the neophyte is blindfolded, bound and kneels with a sword blade held at their throat to take the oath are slightly melodramatic. Hopefully they could be relaxed today as few fundamentalists are likely to risk their immortal souls by joining the Craft!

In revivalist Wicca the system of using three degrees has been commonly adopted from the Gardnerian original. It has been suggested that it was borrowed by the Old Man (or the New Forest coven) from Masonic usage.[19] However it does have historical precedents and was used by the Celtic Druids, in the classical mysteries, and the medieval French Craft. Modern Wicca features a progression

19 It now seems very probable that Gerald Gardner's "Wiccan" initiation rites were heavily derived from Freemasonry, probably via Aleister Crowley's variations used in the O.T.O. initiation rituals.

through the degrees to priesthood. More traditional branches of the Craft have a probationary period followed by an induction or admission into the mysteries,

All the above of course has dealt with the ritual mechanics of the initiatory process. It has not touched upon the inner significance of the act as defined in the opening paragraph. Initiation should act as a catalyst which opens up the seeker on a psychic level. This is represented in traditional terms as "the passing of the power". Unless the participant can establish a link with the spirit world and make contact with the Old Ones then the ritual of initiation is empty and meaningless. Whatever ritual is performed on the physical plane must also have its equivalent action on the non-physical for it to be effective.

In old stories of country witches it was said that they could not die until they had passed on their familiar spirits to their chosen successor. This folk tale conceals an important fact about initiation and the contact that the initiate must make with their spirit guides or helpers in the Otherworld. The psychic and spiritual resonances of true initiation make the "conveyor belt system" which we have seen operating in Wicca during recent years laughable. You may well be a seventh degree Wombat with a 10' wand and an ancient pedigree dating back to the prehistoric Tupperware[20] folk but without the contacts you are just another moronic poseur with an inflated ego!

This point brings us rather neatly to the controversial subject of self-initiation and the quaint idea that a sincere seeker can only be initiated by a coven or another witch. This dogmatic view has largely been generated by modern followers of the Craft who do not wish to see their "power" eroded by a lot of self-initiated upstarts. They forget (or just do not know) that in the old days the solitary witch working alone was the norm. She may have met up with like-minded companions for a little spellweaving at full moon or to dance in the woods at the great festivals, but by necessity the majority of her work was done alone. The village wisewoman tradition and the path of the shaman are ancient and respectable professions.

There is absolutely no valid reason why those who feel an attraction to the Old Ways should not attempt to make contact with the Powers and seek initiation. After all, in any initiatory ritual the initiator is taking the role of the human representative of the Lord and Lady. Those who can make the spiritual and psychic links without benefit of Pagan clergy are merely cutting out the middle person. After all m'dears, there is much wisdom in the old country adage that a true witch or wizard is born (reborn?) not made.

20 The famous Tupperware plastic container system was invented by Earl Tupper in 1942, which ironically probably does mean it predates Gardener's invention of Wicca.

Letter from Scandinavia

by *Olav Hagen*

N orway, Sweden and Denmark are obviously not the countries most likely to receive attention from the well-established British occult scene. But things are certainly happening up here as well, and over the past few years we have seen a steady growth in different groups and directions. I find it natural to start this survey with a closer look at the Caliphate O.T.O., since it is the oldest and most established group here in Scandinavia. The development of the Norwegian O.T.O. started in the early 80s, and the heads of the three camps were all "educated" directly in the UK and USA. These three camps are the only Scandinavian branches of the O.T.O., though members are scattered widely over the three countries.[21] Here in Scandi we don't have the tradition of publishing material relating to magick, and that obviously restricts overall growth in any direction whatsoever. That is due both to difficulties in obtaining relevant literature as well as language barriers – very few foreign books on magick and the occult are translated into Scandinavian language. The Caliphate are steadily growing in Norway, and the element of Wicca is quite dominant as an undercurrent, especially in Bergen.

Apart from the Caliphate, both AMOOKOS and TOPY have initiates in Scandinavia, and although they are few in numbers, their activities can hardly be overestimated in terms of influence and competence. Special attention should be given to the excellent magazine of TOPY Europe, *Fenris Wolf*. This magazine started up in '89, and is highly recommended.[22]

It is a very sad and intolerable situation Scandinavian Pagans are faced with concerning their own inheritance, the Norse religion. We have been witnessing the fast and steadily growing interest in Norse religion and mythology in England, and as well as being fascistic and ignorant of basic facts, it is very often blended with an almost unbounded fanaticism. I think it should be quite obvious

21 At the time of writing, O.T.O. in Scandinavia now has active local bodies in Norway, Sweden, and Finland.

22 Under the editorial guidance of Carl Abrahamsson, the early issues of this magazine have now been collected into an excellent single book-length volume *The Fenris Wolf Issues 1-3*. We reiterate the original author's high recommendation.

that love of one's country and culture isn't an excuse for racial discrimination and arrogance towards elements that aren't British or Nordic. Everyone knows what a nice job fellow Aryans Hitler and Quisling did to promote the Norse mythology, and it has suffered enough mistrust and scepticism since those days already. If those people that call themselves Odinists tell you differently, let them be a true centre of pestilence, because this is not what old Norse ethics are about! Norse magick is Thelemic both in terms of basic ethics and bias, and anyone peeping through our mythology will see how nicely the different aspects of our faith are interwoven with the 93 Current.

Another significant aspect of Pagan culture in our part of the world are the Lapps, or Samii as they are called here in Norway. The Lapps form a closed circuit community which is spread across the northern parts of Norway, Sweden, Finland and the Soviet Union. They have a common culture, although they are both spread over a vast area, and often isolated (as are the Soviet Lapps). The

> *"We have been witnessing the fast and steadily growing interest in Norse religion and mythology in England, and as well as being fascistic and ignorant of basic facts, it is very often blended with an almost unbounded fanaticism."*

Lapps have always been treated like shit both by the non-Samii people and by the governments, and this of course created a backlash from the Lapps, who generally are very careful not to expose any secrets about their religion, magick, and culture. The only sources we have regarding this is what Christian missionaries wrote down during the last three centuries, and that is obviously tainted by hostility, oversimplification, and ignorance. The missionaries did a very nice job in their eagerness to wipe out Samii culture, and the result is that most Lapps are ignorant towards their shamanistic practice, which is very similar to the practice of other northern archaic cultures. But it must be stressed that there has always been a powerful line of shamans in the Samii culture, but it is a practice the "Njads" are careful to protect from non-Samii people. Current day research on these matters is futile because of the strong element of Christianity among Lapps now. It is only recently that Lapps in general have understood how important their struggle for independence and fight for rights is. Therefore it is in a way both tragic and good to see American anthropologists teach the Lapps their own magick. This is necessary, as the shamans are generally infamous for their often malicious intentions, and therefore slightly detested by the average Lapp. There are a couple of self-styled shamans here in Norway who hold weekend courses

in shamanism. I agree with the mocking attitude Samii shamans hold against this sort of practice. There are of course value in these rituals, but then again I would claim that shamanism is closely linked with ethnic heritage and culture, and one can only try to make one's own practice in the light of how and where one is living. Shamanism and rituals out of context are worthless unless one's prime goal in life is to serve as a mumbo-jumbo "New Age" sod. And they are making the majority of people interested in the occult here in Scandinavia, the wastelands of American crapculture.

The foul breath of Christian fundamentalism has recently been detected here in Norway too, as the Norwegian TOPY spokesman was attacked by some people calling themselves "Crusaders" shortly after an article on TOPY appeared in one of Oslo's newspapers. This article wasn't hostile to TOPY, but anything that could be classified as occult is also Satanic for these Crucifux, and the press here in Norway is naturally no better than the British in these matters.

Several spirits from all sorts of areas within the Norwegian occult realm have now joined forces to give these fundies something to suck on, and will publish a magazine dealing with everything from the Tunnels of Set to the Bifrost, and it also might appear in English! With this I hereby close the briefing from hurdyburdy land.

PAGAN NEWS

MANY VOICES, ONE SPIRIT

FEB '92
£1.50

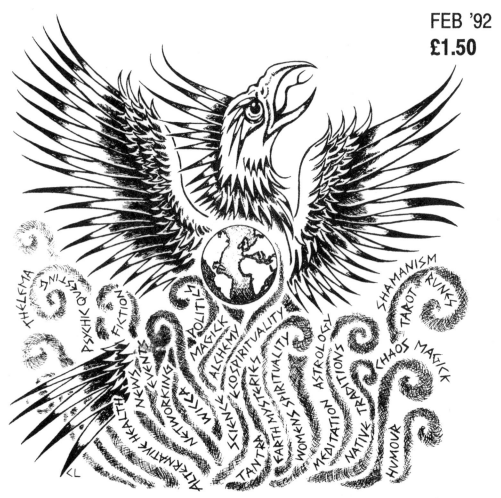

THELEMA · PSYCHIC QUESTING · FICTION · POLITICS · MAGICK · ALCHEMY · SPIRITUALITY · SCIENCE · ECOSPIRITUALITY · EARTH MYSTERIES · WOMENS SPIRITUALITY · ASTROLOGY · MEDITATION · NATIVE TRADITIONS · SHAMANISM · TAROT · RUNES · CHAOS MAGICK · HUMOUR · TANTRA · WICCA · NETWORKING · NEWS & EVENTS · ALTERNATIVE HEALTH

MAXINE SANDERS INTERVIEW
PSYCHIC QUESTING UNRAVELLED
NEWS & EVENTS LISTING

Fear & Loathing in Luton

For editors of local newspapers, there's nothing like a scandal, and back in December, Luton's *Herald & Post* provided a forum for public outrage about the plans of a Mr. Daniel Hussey, who planned to open an occult bookshop in Luton.

Fun for all concerned perhaps? Luton South's MP, Graham Bright (Con.)[1] expressed concern, as did the Bishop of St. Albans. News of the debacle spread to London's *Evening Standard*, where one Jim Lees (former editor of *The New Equinox* magazine) was quoted as saying "...the occult scene is virtually dead ... they're all rather tedious and working class these days." Cheers, Jim.[2]

According to news reports, Mr. Hussey was also planning a "chain" of occult shops across the country. Curiously enough, he also announced plans to open a chain of occult shops back in 1981. In April '89 he announced to the media he was opening up an occult shop in Bath. In July '89 the story was again a chain of shops, including one in Blackwood, Gwent. Last year, he announced plans to open occult shops in Sunderland, Bolton, Edinburgh, Aberystwyth, Dartmouth, Grimsby, Luton & Grantham. None have so far materialised. What does happen is that anti-occult fervour is fuelled by sensationalist stories in the newspapers. Whatever the intention behind Mr. Hussey's press statements, they are giving ammunition to the fundamentalists and anti-occult crusaders.[3]

Lakota Tribal Elders Condemn New Age Rip Offs

Recent articles in the *Lakota Times* have expressed the concern of Lakota Tribal Elders with the proliferation of "phony medicine men" who are selling purported

1 Sir Graham Frank James Bright (1942 – 2024) is a British Conservative politician who served as a Member of Parliament from 1979 to 1997. He has been responsible for such vitally important initiatives as a bill to ban young people from holding parties (the Entertainments (Increased Penalties) Act of 1990) and a crackdown on "anti-social and dangerous" cyclists. It's good to know that there are people like him keeping the world safe against such existential threats.

2 *The New Equinox: The British Journal of Magick* ran for a tedious 5 issues between 1980-1981. It mainly featured articles on an incomprehensible and utterly useless system of Thelemic numerology invented by Lees and his contributors.

3 In recent years Mr. Hussey appears to have associated himself with the self-styled Magus Lynius Shadee. This person was, until fairly recently, still claiming to be "King of all Witches" and still supposedly opening occult centres in various places that fail to manifest, or even on occasion attempting to run for Parliament. Still shadee.

"Medicine Ways" to gullible whites, for whom Lakota spirituality has become a fad.

The International Indian Treaty Council,[4] based in California, is also investigating the credibility of certain "medicine men". A Council representative, Aaron Two Elk, an Ogata Sioux, said that the medicine men "do it (spiritual exploitation) for sexual rewards, to naive young white girls who don't know any better. It is intense abuse. They entice them by telling them that they are the great-great-grandson of Crazy Horse or Sitting Bull.' Tribal Elders say that this not only defames honourable ancestors of the Sioux, but also violates their sacred beliefs and practices.

The Council is currently investigating fraudulent medicine men and intends to use the Native American Religion Act and the Native American Arts and Crafts Act to pursue them for consumer fraud.

OBITUARY
Sri Gurudev Mahendranath Dadaji

On the 30th August, 1991, Sri Gurudev Mahendranath died at Naidad Hospital in India, at the age of 80. He had been admitted with a broken hip, and, due to his advanced years, was considered a poor prospect for surgery. According to reports, his last words were to the effect that he would not talk any more, and that he began to hyperventilate as an act of magical intent. His body was cremated on the banks of the River Vatrak and the ashes distributed amongst his friends and disciples. Sri Mahendranath, or "Dadaji" as he was known to many, was a wild and contradictory Guru figure who drew much of his experience from the Adinath and Uttara Kaula Tantrik traditions of India. He was an Englishman who had travelled widely, experimenting with spiritual patterns. Following the advice of Aleister Crowley, he went to India to investigate the occult yogas. The "English Paramahasma's" wisdom, humour and wide learning will be missed by many who knew him personally or through his writings. The tradition of enjoyment and liberation that Dadaji made available to a new generation of Tantriks throughout the world, will continue to blossom long after his name has been forgotten.

4 The International Indian Treaty Council (IITC) was formed in 1974 by delegates from 97 Native American tribes and Nations. It works for "the Sovereignty and Self Determination of Indigenous Peoples and the recognition and protection of Indigenous Rights, Treaties, Traditional Cultures and Sacred Lands."

INTRUSIONS OF THE UNCANNY
PSYCHIC QUESTING UNRAVELLED

Phil Hine

The Black Alchemist, Sacred Swords, UFOs, fried egg sandwiches & Mary Queen of Scots – what links them? The answer is Psychic Questing, possibly the biggest thing to hit the psychic world since the Fox Sisters.[5] Bemused? Me too, so off I went to the 1991 Psychic Questing Conference at Conway Hall, to find out what it was all about...

The most public advocate of Psychic Questing is Andy Collins, author of *The Black Alchemist* and *The Seventh Sword*. It all began for Andy back in the 1970s when he was a researcher for the British UFO Research Association (BUFORA). Andy was interviewing witnesses of UFO encounters, and found that many of the witnesses had a parallel background of psychic talents and experiences.

He began to feel that UFOs were just one facet of a much wider phenomena, and so began to look at the subjects themselves. Whilst moving along this new line of research he met Graham Phillips, who was at that point researching poltergeist phenomena, and who had also found links between psychic experiences & UFO contacts.

Graham & Andy then began to look at psychic experience in a new light. Instead of trying continually to "prove" the existence of psychic events, they decided to take the information at its face value and work directly with psychics. They created a magazine called *Strange Phenomena* and formed a group called Parasearch, which set the pace for working with information derived from psychics, which led to the discovery of the artefact known as "The Green Stone".

In 1981 Graham & Andy went their separate ways. Andy formed the EarthQuest group in Essex to continue working with psychics, using a combination of hypnosis and meditation, which led to more artefacts being discovered.

By this time, both Andy & Graham had published their own accounts of the Green Stone saga, which, Andy says, caused a furore in esoteric circles. It seems

5 Leah, Maggie, and Kate Fox were the sensation of the 19th century when the 2 younger sisters began communicating with disembodied spirits by means of "rapping" (cracking or knocking sounds produced during seances), and by so doing basically kickstarted the Spiritualist movement. Later in life Maggie would confess that it had all been a hoax, but the Spiritualist movement went on without them regardless.

that some people couldn't handle the idea of psychics coming up with information that could be apparently verified, and positive results being forthcoming.

Sitting in Conway Hall, listening to Andy Collins describing the uncanny crop of coincidences and hidden history surrounding the discovery of the "Swords of Meonia", I could see why some people would be shaken up by this questing. Through the last decade, there has been an increasing tendency to "water down" magic so that it is more "acceptable", to the point where one author likens magic to making a cup of tea!

In a similar way, the increasing tendency to explain the esoteric by the use of scientific theories has perhaps lessened the sense of the mysterious which draws many people towards the occult in the first place.

Listening to the speakers describe their experiences, I found myself nodding in sympathy & agreement. My overall impression was of people who, having had truly strange experiences, felt prompted by them into a "quest" by which they made sense of the experience, and that the key wasn't so much discovering strange artefacts or unravelling tangled historical links, but self-knowledge, which is of course, the admonition to the initiate undergoing the Eleusinian Mysteries.

The "Swords of Meonia", the story of which is given in *The Seventh Sword*, were partly discovered by a team of "superpsychics", but Andy is quick to point out that anyone can get involved with Psychic Questing. He mentions the importance of meditation, centering (or banishing), of getting to know the history of your local

area, attuning yourself to sacred sites, and the rhythms of the eight festivals. So Questing involves elements of Paganism, earth mysteries, and magic. He also stresses the importance of keeping a magical diary.

If nothing else, Questing seems to involve a good deal of running about in the fresh air, and requires meticulous discipline when researching historical links against psychic sources.

In both *The Black Alchemist* & *The Seventh Sword*, there is mention of a "sinister" group of "black magicians" known variously as "The People of Hexe" or "The Friends of Hecate" – just one cell of an illuminatus-style conspiracy called "The Wheel", managed by "The Dark Council". These are an alliance of black magicians who are trying to gain control of Britain's matrix of ley-lines, by

> *"I'm not doubting the Questers' experiences, but I know only too well how some occultists have a fixation for seeing black magicians everywhere, just like Evangelical Christians see Satanists everywhere."*

working "twisted" rituals at various sacred sites. In the books, Andy and his psychic guides have various "psychic" encounters with members of "The Wheel", which tends to lend a Wheatleyesque flavour to the proceedings. The idea of ley-networks being "misused" is a recurring New Age theme, which has led various groups of New Agers to plant crystals at sacred sites in attempts to "realign" the energies. The "conspiracy" theme of "black" organisations using the ley-lines for their own ends has even been used as a plot in comics – see back issues of DC's *Hellblazer*.

In *The Seventh Sword*, one of the psychics working with Andy Collins makes special mention of Arbor Low stone circle in Derbyshire as "a hub of earth energies radiating across the country". I find this personally intriguing as I have regularly worked at this site, with various friends & groups, over the last few years, including the period when Andy & co. were having their run-ins with the "black magicians". If "The Wheel" are systematically working at sacred sites across the country, how come no one else seems to have noticed them? I'm not doubting the Questers'' experiences, but I know only too well how some occultists have a fixation for seeing black magicians everywhere, just like Evangelical Christians see Satanists everywhere. I can see a situation developing where a group of psychics become convinced that the "black magicians" out there are, in fact the (insert name of any large magical order/network who you think are "weird").

So too, acting on the premise that all psychically-derived information is absolutely true can lead to problems. It should be stressed that in most of the

cases detailed in Andy's books, the "superpsychics" involved either had a very high verification record, or, their information was backed up by other psychics, independently of each other. Another problem for occultists is that we often have a tendency to become convinced of the "absolute truth" of psychic messages and intuitions. Self-skepticism, to some degree, is healthy, lest we believe every "communication" from psychic sources, especially the ones who flatter, lie and warn of apocalyptic darkness.

Another telling point which comes out from reading Andy's books is that Crone-Goddesses are given a bad press. In *The Black Alchemist*, Kali is described as being "a hideous Indian She-Ogre", Hekate as "the hideous crone of darkness", and generally, Crone-goddesses are seen as manifestations of evil and destruction – again, a common New Age attitude, but not one generally shared by Pagans & occultists. Indeed, some of the psychics mentioned in Andy's books have a very negative view of witchcraft, however, this is presumably very much an individual view, and I heard speakers at the conference refer to the works of both Aleister Crowley & Kenneth Grant, whilst describing how they made sense of their uncanny experiences.

Much of the "sense" of Questing was given in Steve Wilson's entertaining account of a series of "apports" – that is, the mysterious appearance of, in this case, fragments of a rough cut rose quartz into his back garden, which seemed to be related to a number of other weird phenomena in a "time window". Steve spoke about experiencing a "sense of normality" around his experiences – that the strange appearances around his house were not announced by any sense of the uncanny, but that they were often only noticed upon a second glance – the way one does when one is preoccupied, and the strangeness of something appearing doesn't always immediately sink in.

The Conference itself was a very polished affair, ably organised by Caroline Wise. Chaos Caterers provided a wide range of vegetarian food, and there was a lively disco afterwards. The attendance was good, and it seems that interest in the Psychic Questing phenomena is growing rapidly.

With its emphasis on sacred sites, history, psychic experience and entry-level magical techniques, Questing could become very popular indeed, especially if it continues to produce tangible results. If people who get into Questing on a regular basis can avoid the cloak-and-dagger temptation of the battling "black magicians" glamour, but continually verify psychic information through historical research, then Questing will surely encourage the acceptance of psi abilities on a wider scale.[6]

6 Psychic Questing seems to have remained a uniquely British New Age phenomenon in succeeding years, and it hasn't had much influence on occultism as a general practice; although it could be seen as a literary forerunner to later popular fiction such as that by Dan Brown and *Hellier*.

SPOTLIGHT

An Evening with Maxine Sanders[7]

Interview by Steve Wilson[8]

Maxine Sanders became famous in the 1960s and 70s as the media-dubbed "Queen of the Witches". In this Pagan News *exclusive she reflects on the state of the Craft in those days and how Wicca has changed since.*

PN: How did you get involved with the Craft, and with Alex in the first place?
 Maxine: People have surmised lots of things, but Alex knew my mother very well – he was working with the handicapped, and could get very good results with them (this was just after the war). My mother was a nurse in that particular place, and she and Alex got on very well, so if you like, Alex knew me before I was born. He knew me as a child, but later, he and my mother lost contact. She became involved with an organisation called "Subud",[9] which is Indonesian, and used to meet in a cafe called "The Seven Circles" in Manchester. She was in there one evening, and Alex walked in, and she said "Oh dear, I do hope the rot isn't setting in here", but they were good friends. My mother was an artist,

7 Maxine Sanders (1946 –) founded Alexandrian Wicca along with her late husband Alex Sanders. As a young attractive woman at the time, her pictures were widely published in populist magazines during the 70s, and she appeared in several movies and TV shows. Her autobiography is a fascinating study of the early witchcraft movement in the UK. Maxine currently lives in London where she still runs the Coven of the Stag King.

8 Steve Wilson (1955 – 2017) was a Pagan activist and organiser. He was, at various times, an arch-priest in the Fellowship of Isis, a Druid, and a regional coordinator for SE London Pagan Federation. He helped start up a wide range of regular events in London, such as South East London Folklore Society and Talking Stick. He was the author of *Robin Hood: The Spirit of the Forest* (Neptune Press, 1993) and *Chaos Ritual* (Neptune Press, 1994).

9 "Subud" is an acronym for the Sanskrit terms suśila (good-tempered), buddhi, and dharma. The movement referred to was founded in Indonesia in the 1920s by Muhammad Subuh Sumohadiwidjojo (1901 – 1987).

and the strangest people came to her home, and she invited Alex. I was furious, as I was then a Roman Catholic. He came, and I phoned the parish priest up and said that my mother's doing it again – she used to read all the forbidden books, and doing all the things that good Catholics weren't supposed to do, and Father George just said to me "Oh well, It's your mother's way" and I sat there very frightened.

PN: Was this the first time he'd mentioned the Craft in your presence?

Maxine: The first time I can consciously recall. I'd been over to Paris, and met a lot of occult "authorities" because my mother was a dabbler, and thought nothing of it, but for me the mere mention of the word "witchcraft" was pretty horrific – I was shocked. He was quiet, unassuming, very gentle; but I refused, because of my bigotry, to accept any of this – this was a wicked witch. But then he continued to come, not on a regular basis, but every couple of months, and one day he started to talk about Angels. I said "Surely, you're more involved with the Devil, and Devil worship, and demons, what are you doing talking about Angels?" And he discussed it some more. I was doing a secretarial course at the time, and I wanted to get some practice in typing, and he said "Well you can type my notes up" and they were all about Angels – the different aspects of Angels and so forth. By doing this I became fascinated, not necessarily with witchcraft, but with the study of the occult, and that's how it started.

PN: How did you actually get involved with the Craft?

Maxine: That came later. I was still very young – far too young to be initiated. Alex had moved to Chorlton-cum-Hardy in Manchester, and started his coven there. He'd been involved beforehand, with a woman called Pat Crowther. He'd seen her on television, waving her mysterious athame, and so went to Pat seeking initiation. Alex was a very good materialisation medium, and the first man to give spiritual healing in hospital, and he was eventually initiated, and progressed from there, and out of that came his coven, in Chorlton-cum-Hardy. I used to go along, instead of going to Mass on Sunday, and of course my fascination grew and grew. My initiation into the Craft was straight into 2nd & 3rd degree – I wasn't initiated into the 1st degree.

PN: That's going to surprise some people. There's been a lot of controversy about Alex's initiation and how he got his *Book of Shadows*. Where and when did the "grandmother story" start?

Maxine: As far as is known, It's even from his mother. The whole Sanders family was acutely and frighteningly clairvoyant. His younger brother Tom was a full-materialisation medium for instance, but they weren't occultists. Alex's mother was Welsh. She used to say "There's no need for taking your clothes off, all I have to do is work my magic to get it here," and she could too. She was a sharp little Welsh woman. There were thirteen in the family, and even she spoke

about her mother. I never really had any doubts about it. I think the reason he sought initiation was because he was so young when he received initiation from his grandmother. To see a ritual on television, whilst thinking that you're the only one in the world, must have been quite a shock to him and the only way in was to seek initiation.

PN: How about *The Book of Shadows*?

Maxine: How about it? I daresay some of it came from Pat Crowther, and I do know that he had quite a strong correspondence with Gerald Gardner.

PN: There's been a lot of hostility between the Gardnerian and Alexandrian Craft movements. How do you see that that's changed?

Maxine: I don't think there's any hostility. I never found it so, and I know Alex never did. I find that the Gardnerians tend to be more intellectual, and the Alexandrians tend to be more practical in their Craft working – the Gardnerians are the academics and the studiers.

PN: There was the occasional complaint that Alex "mixed other things in" the Craft.

Maxine: Why not? I do find that the Craft, which is my first love in the occult world, is a scavenger religion – it uses what works. You test it, and if it works, use it.

PN: Did you ever actually use the title "Queen of the Witches" yourself?

Maxine: No. Never, ever, and neither did Alex. Always "witch Queen". I can tell you about one particular experience in Madrid. I was being interviewed, and I told the interviewer that I wanted it made quite plain, that I am not, nor have ever been "Queen of the Witches", and I'm not a witch Queen any longer – I'm too old. It's publicity-grabbing, the phrase "Queen of the Witches". In the Craft, the Priestess represents the Goddess, but only in human form. She can never be "Queen of the Witches" – It's only the Goddess who can be Queen of the Witches. A witch Queen is someone who has several covens – I think It's thirteen – stemming from hers. They're supposed to be full covens, but you tell me, what's a full coven? You know you can have a full coven with two people, so there are dozens of witch Queens.

PN: When a coven reaches thirteen people, isn't it supposed to start hiving off anyway?

Maxine: Again, that's another falsehood, isn't it? I've had covens where there have been 40. There is no set number, and I find that the perfect number to work with all together is about nine. With that number you can get a good group soul going, and good group activity. It's not too small to get perfect harmony and It's not too big to get out of control.

PN: A lot of people don't know what happened to you, after you split with Alex.

Maxine: I was in thousands and thousands of pounds" worth of debt, Alex had put everything in my name, which was quite clever. I was devastated. You never want to become a teacher – when you're told that one day you'll be a teacher, you never accept it, and you never think that you're capable of doing it. You're not, until your students teach you that you are. Or that they come and they demand, and you somehow manage to teach them – and that's what happened. After Alex left, I was lucky enough to have people around me who taught me the ways of earth. Before that, I'd always been the High Priestess up on a pedestal, and I never touched earth – I didn't know earth – it was all "out of this world", and so I had to learn the art of survival. It was good for me to learn this.

PN: **When did the split take place?**

Maxine: 1973.

PN: **To some extent the Craft started taking off around that point. It had already begun to grow in the late 60s and early 70s ...**

"In my day, covens were independent of each other and didn't socialise, apart from the 'Grand Sabbats' where you'd get 15-20 covens meeting. They were amazing. Nowadays you don't get Grand Sabbats – you get a 'workshop'. This is a bit cheap – It's not Grand anymore, It's almost as if they're doing what the Catholics did – they're taking the awe and magnificence out of ritual."

Maxine: I think it was taking off just before Alex & I moved to London. The very first publicity Alex got was over some witches who belonged to the local church. The newspapers had found out about this, which could have ruined their careers, so Alex offered the newspapers a better story. He said "I'll bring somebody back from the dead". He took them up to Alderley Edge; had a fake GP with full credentials, and got this "body", which they proceeded to pronounce dead, and the man was mummified. Alex proceeded to read a swiss roll recipe backwards, and of course, all the press were there! This must have been the early 60s. At least he had taken away the focus from the other people, and their jobs. That was the first breakthrough. The next breakthrough was that I was going to do work up on Alderley Edge. I was standing there on the altar stone, having the Goddess invoked, and I could see these blue flashes out of the corner of my eye. I thought "I'm really psychic tonight" – and it was the press again. An article appeared in a little paper called *The Comet*, and then the national press came in. We never

invited publicity deliberately. The publicity came along when other people asked Alex for interviews – he never charged for anything. When we moved to London, in 1966, top occultists of the day came round to find out "who this man was", to check us out. I think they might have found us peculiar, as we were not your normal Gardnerian witches – and in those days, we weren't Gardnerians, we weren't Alexandrians – we were witches. Even to this day I say that I'm a witch. If you ask if I'm an Alexandrian, I'll say no, nor am I Gardnerian or Traditional or anything else. But people would flock to see Alex back then – it was amazing. If the papers didn't have any news, they'd write a story about Alex. It was said, by *The People* magazine years ago, that they had more publicity about the Sanders than they did on any politician.

PN: Would you say, from 1973 onwards, witchcraft became an organised movement in various different forms?

Maxine: Absolutely. Alex moved down to Sussex, and became quieter, and the Gardnerians started to come and talk to him, and found that this man wasn't something outrageous at all; that he was quite a nice man, in fact a bit shy. He started to suggest that they would have to get organised. He was very forward-thinking. I'm not very into the "organisational" side of the Craft. In my day, covens were independent of each other and didn't socialise, apart from the "Grand Sabbats" where you'd get 15-20 covens meeting. They were amazing. Nowadays you don't get Grand Sabbats – you get a "workshop". This is a bit cheap – It's not Grand anymore, It's almost as if they're doing what the Catholics did – they're taking the awe and magnificence out of ritual.

PN: How do you feel about the general growth of Paganism since?

Maxine: Wonderful. In the 70s , a lot of people came here, and said "We don't want to be initiated but we do want to worship the Goddess." They needed that, and I think that today, it allows people to express their inner souls, and I think that's wonderful. I feel peculiar when I meet modern day… I prefer to call them occultists, I feel strange because they're not trained the way they used to be. You know the witches in the 60s went through rigorous, rigorous training and initiation processes. Nowadays, when I speak to these people that are quite new, It's initiation of the mind, rather than of the soul. But it doesn't matter, because everything evolves. The Craft is an ever-evolving religion, so when for example you say that Alex was accused of using different things, of course he did. He was an evolving creature, and would use anything he could to further his evolution.

PN: Do you think, as has been said, that the Craft today is a modern form? Something that Gardner put over on top of an older system?

Maxine: Yes, I think so. I had a phone call from a priestess in Scotland about exchanging information. She turned out to be a little old lady in brogues, suit, and eighty-five if she was a day. Her coven had been in activity since she was a

child – she was a practising Christian. The last time they had done an initiation was forty years ago, and I got a lot of information from her. There are occult ethics that don't seem to be taught any more. In the past, a coven didn't ask someone if they wanted to be initiated – they had to ask. Yet nowadays people are offered initiations by groups.

PN: What do you think of developments of the Craft abroad, like America & Australia?

Maxine: In Australia they've got it cocked up because they don't follow their seasons – they try to follow old England's. The same in America, to a degree. In America, you need your certificate; your pedigree – a good recommendation isn't enough over there. I just wish they'd give over – I don't mind a good gossip, just don't rip anyone to pieces. They're evolving – it is their point of evolution. I just wish that there were some better teachers of the Old Religion around.

> *"Right from the beginning. I remember saying in one article that "One day the Craft will be an accepted religion in England". It was always a hope, because I was standing in the street. I took persecution, first-hand. I was actually stoned once in Manchester – a very frightening experience."*

PN: On the question of the Old Religion, there are quite a few competing claims for it at the moment. There are some people promoting Celtic, some people promoting Anglo-Saxon, others Nordic. What's your attitude towards that?

Maxine: It all depends on the individual's evolution. Now we're in 1992, aren't we? You have to look at that which you're interested in at your own point of evolution. If it works, use it!

PN: Do you think the media's attitude has changed?

Maxine: Very slowly. What I do find wonderful today is all these Pagan movements and meetings, like "Talking Stick" who are doing a superb job. People are now able to express their feelings towards the Goddess much more easily, and in a serious, rather than a secretive way. I think that there are things within the Craft that have to remain very quiet. I think that the Craft is a minority cult, and that it isn't for everybody. I think that people forget that once you receive initiation, you're a priestess, which means you have a great deal of responsibility. You listen to people saying "Well, I'm a witch" and you listen to them, and they're full of superstitious nonsense. "I had this psychic attack, I had that psychic attack" etc. But yes, I think the media is changing its attitude – there are more factual articles.

PN: **Back in the early days, did you actually foresee a time when the Craft would be widely accepted?**

Maxine: Right from the beginning. I remember saying in one article that "One day the Craft will be an accepted religion in England". It was always a hope, because I was standing in the street. I took persecution, first-hand. I was actually stoned once in Manchester – a very frightening experience.

PN: **There's quite a trend within the occult in general to see the deities as psychological, rather than independent beings. What do you feel about that?**

Maxine: I believe in God – or Goddess, please yourself, but I don't even begin to comprehend God. I'm a practising witch, because at those moments which give one the spark, that is so brilliant and wonderful. Well if I was a Buddhist, I guess I'd still have those moments, but my way is of the Craft. But do I know what God is? No.

PN: **So you don't feel that the Craft is an exclusivist religion?**

Maxine: No, and I know some very good Jewish witches, who are very good Jews, too. There are some excellent Roman Catholic witches.

PN: **There's an attitude that says that the Craft should be done in the open air.**

Maxine: I've got to admit that when I moved South, I found that southern witches wouldn't go out without their wellies on. I find that there is a difference in the Craft wherever you go. Scottish witches, for example, are very secretive, because the persecution's still rife up there, as it is in certain parts of Wales. The type of magic that people work changes according to the weather conditions and the harshness of the way of life. But I don't agree. I'm all for raising power and energy, but It's about doing something with it. I find that nowadays, a lot of people raise energy and let it dissipate. They don't do a thing with it. So long as you can raise energy and work with it, that is what really counts.

Maxine Sanders, thank you very much.

Dire Signs by *Anthony Roe*

"The die is cast", said Julius Caesar as he crossed the Rubicon in March 51 BCE on the day of a solar eclipse. Such celestial occurrences have ever been regarded as fateful occasions, pointing to crises in the affairs of nations, and drastic review in the lives of individuals. Ancient mythologies figured the event as the assault of a dragon or serpent upon the orb of the Sun. Complex performances were enacted to forestall ill effects attendant upon the loss of light. In the Egyptian *Book of Overthrowing Apep*,[10] the great adversary of the Sun, his image, named Saatet-ta, (Darkener of the Earth), the serpent with its tail in its mouth, is placed in fire, and spat upon several times each hour during the day, "until the shadow turneth round".

In judgements it is most important to distinguish between mundane and natal astrology. Eclipses in a personal chart are considered unsettling if the degrees involved are conjunct the radical Sun, Moon, Ascendant, Midheaven or any malefic planet. But eclipses are by no means uniformly evil. An eclipse in close favourable aspect to a benefic planet can be provocative of much good. Effects may generally not be felt until some time later when a planet such as Mars excites the effect by transit. It is evident that the eclipse degree itself remains powerful for a long time. This acts as a source of energy that is excited by transits, or itself acts as the catalyst of influences suggested by an important configuration of transits or progressions.

In natal astrology any effects are likely brought to fruition within six months of an eclipse. Reverberating effects are not really dissipated until the sensitive degree is sealed by a subsequent transit of Saturn. The eclipse degree sensitizes part of a radical chart well in advance of events and the actual eclipse acts as

10 *The Book of Overthrowing Apep* forms part of the *Bremner-Rhind Papyrus*, dating from 305 BCE and in the possession of the British Museum since 1865. It consists of spells for the protection of Osiris (and, by extension, his earthly representative Pharaoh) from the attacks of the demon Apep and his minions. See https://www.britishmuseum.org/collection/object/Y_EA10188-13

the final impetus. In the absence of an eclipse the celestial influences would likely appear in relation to an ordinary new, full or progressed Moon, or transits which would unfold the energy of the progressed patterns. It cannot be doubted however, that posited astrological events in our lives may often be noticeable by their absence.

Dire signs may produce little apparent result. One reason for this is that transiting effects can well manifest in the lives of those around us, or may occur as unaccountable movements within the psyche. Our opinion on this connects with our view of astrology. There are those who dismiss astrology out of hand as of no worth. For them no effect will be acknowledged. Those who flirt with astrological readings become apprehensive and shy away when anything untoward is intimated. Liberal minded free-thinkers accept the forecast of trends in circumstances as pointers to self-knowledge but remain somewhat passive in their acceptance. This leads to unfavourable wish fulfilment. Yet there is no need to let the sky fall on your head. The whole purpose of any divination is that due preparation before an event can mitigate or indeed subvert any supposed ill effect. Astrology at its best is proactive and teaches how to achieve fullness of expression in all areas of life.

Traditionally the rays of the Sun dispel ill omens, and darkness heralds the influx of malign forces. The grimoires instruct that evil spirits are to be invoked during an eclipse of the Moon. Lunar eclipses have effect in the same way as those of the Sun though on a lesser timescale. Note should also be taken of the eclipse of the planets by the Moon, referred to as occultations. The idea of a necessary reappraisal in that area of life ruled by the planet, allied to an applied astrology, means we have a powerful agent for determining the beneficial direction of our lives.

Though we may not be able to alter our basic character, we can certainly change our stance to produce tangible effect. The moments to grasp control are at times of eclipse, the power points of astrology.

Darkness preceded the creation of light at the fountain of the world, and eclipses echo the darkness of the primal void. If we align ourselves with the cosmic forces at such times we may act as demiurge in our own lives. Our voice may utter "Fiat Lux!"[11]

Consult an almanac for the relevant eclipse dates, then devise devotions to the appropriate deities. Purify yourself, invoke, and meditate. Once stimulated, eclipse degrees can be sources of energy and great joy.

11 Latin: "Let there be light!"

PAGAN NEWS

MANY VOICES, ONE SPIRIT

MARCH '92
£1.50

JOHN MALE INTERVIEW
NETWORKING - THE POSSIBILITIES
A WASICU IN KYLE

Bridge of Dreams Bombed!

On Tuesday, 28th January the Lincoln shop Bridge of Dreams was firebombed. Nothing was taken from the premises, which was gutted in the blaze, and we can only presume that the motive behind the attack was purely malicious. Since the time of its opening, Bridge of Dreams has been under constant attack by fundamentalists in Lincoln. In the weeks following the shop's opening, there was a massive local press campaign attacking the shop, including a phone-in programme on Radio Lincolnshire featuring a local director of The Reachout Trust. With help from The Sorcerer's Apprentice Fighting Fund, who lobbied the local council & pressured one local newspaper into printing a retraction of hysterical anti-occult comments, Bridge of Dreams remained trading. Late last year, however, the owners moved to a less prominent site in Lincoln, hoping to avoid further harassment. They opened a temporary stall in the local market, but were continually subjected to demonstrations and intimidation by members of a local fundamentalist group. Their most despicable tactic was to distribute leaflets inferring that the shop owners were involved in Satanic Child Abuse! The shop owners closed their stall and opened their new premises. It had only been open a few weeks when the arsonists struck.

Fear & Loathing ... The Sequel

Following last issue's item on the non-existent chain of occult shops, Psychic Quester & journalist Andy Collins sent us this special report...

I was intrigued to read the Feb '92 Newsdesk feature about the apparent occult shops proposed across the country by a "Mr. Hussey". In 1989 I was contacted as a "spokesperson of the occult" to give comments on the planned opening of shops by Mr. Hussey in no less than six towns in England and Wales. These included Brentwood in Essex, Crawley in Sussex, and Gwent in South Wales. On every occasion notification was given of the alleged plan to one newspaper only who, seeing the potential of the story, ran it directly from a prepared press release syndicated by a "Mr. Hussey". Never was the location of the intended shop given. The response was always the same – an outcry from fundamentalists, Church Leaders, and Councillors. However, because one newspaper had been given the story in the first place, its main rival would sniff around for a follow-up story with a different angle. This is when they would contact the likes of myself.

The reporter on the "rival" would have "found" from a contact that the plan had been put forward in the press release by this "Mr. Hussey". A contact telephone number was given and when rung it would never be answered. One astute reporter traced the London number to a temporary office unit in Lewisham and sent someone down there. It was locked up and not in use. It would also be found that no application would have been received by the local council for not just an occult shop, but any new or unusual shops. In Gwent this caused a virtual paranoia scare with shop-keepers and fundamentalists scouring the streets at night looking for signs of life in empty shops, and a thousand-strong anti-occult march. As a journalist and writer, I was certainly beginning to believe that Mr. Hussey never had any intentions of opening occult shops, merely fuelling the fire of the fundamentalists.

The backlash was blatantly apparent to me, at least. The week after the occult shop story broke in Brentwood, I announced a lecture at a wine bar hired for the evening in the same town. The venue was forced to cancel the booking after manic threats of physical damage to the windows if the event was allowed to go ahead. I was even run out of town by police when, without a venue, I tried to give a free lecture in Brentwood.

The same thing happened in Crawley. There, a local solicitor came forward and announced through the newspapers that he would fight any occult shop or venture that tried to enter the town on moralistic grounds. He was, of course, backed by a Church Minister and other local figures.

So what are we to make of all this debacle? "Mr. Hussey" certainly exists. He spoke to a colleague of mine working at the time in Psychic News Bookshop in London. He mentioned his "plans" on that occasion. He is also known to have opened a single "occult shop" in Lewisham around 1981, but this failed miserably. If the guy's intentions are truly genuine, then he should think carefully before causing a furore through half-hearted press releases, issued only to test a community's reaction to an occult shop in their town. For whether he is conscious of it or not, he is playing right into the hands of the fundamentalists hell-bent on stopping the likes of you and I expressing our own beliefs. Any further comments would be appreciated.

Oxleas Wood Update

The latest development in the campaign to save Oxleas Wood, which has been given considerable input from Pagan & occult groups in and around London (everything from letters to Parliament to magical workings) is that the Transport Minister's plan to drive a four-lane highway through the ancient forest will be challenged in the High Court by Greenwich Council. The European Commission

is also threatening legal action over the attempt to develop the highway, which would destroy an 8,000 year-old site of Special Scientific Interest.

These latest moves to block the development are a serious blow to the Transport Ministry's plans, as the cases are unlikely to be heard for at least nine months. So keep up the good work![1]

Pro-Pagan Prince Puzzles Press

Prince Charles has just founded a new Institute of Architecture, and apparently a recent speech he made giving his reasons for doing so has left the press scratching their heads in bafflement. The Prince not only acknowledged Pagan religion as being equally valid to Christianity, but also talked of the need for "architecture of the heart" and his wish for modem planners to take into account "profound human feeling" when designing buildings. As we might expect, press write-ups tended to portray the Prince as a well-meaning but burbling twit. Well we can't have the heir to the throne rambling on about Pagan religions and sacred architecture, can we?

1 Oxleas Wood is located in Greenwich in southeast London, and dates back to the end of the last Ice Age. The campaign to save it succeeded and the plans to bulldoze were withdrawn in 1993. As we have pointed out earlier, protest works. At least some of the time. Well worth visiting if you are in the area.

NETWORKING –
THE POSSIBILITIES EXPLORED

by *Phil Hine*

N etworking has become an increasingly popular development on the Pagan/occult scene over the last few years, and I first came across the idea of networks in Marilyn Ferguson's book *The Aquarian Conspiracy*,[2] where it was pointed out that unlike hierarchies, networks were organic, systemic, based on mutual cooperation, and based at a "grass-roots" level of interaction. These statements are true, in the broad sense, but don't actually give many guidelines when it comes to the practicalities of running a network. Looking at recent efforts on the Pagan scene, it seems to me that with the best will in the world to avoid this, networks end up being hierarchical. Heresy? Perhaps, but the clearest distinction is between the people who "do" things, and the people who do sod all. If what I have read about networks is true, they shouldn't be affected all that much when one supporter drops out as, theoretically, everyone involved is investing the same effort into running the thing. Unfortunately that hasn't been the case for some contemporary Pagan networks where, when the central "facilitator" steps out (due to burnout & being sick of other people's apathy) the structure, such as it is, crumbles,

Why? At the simplest level, I don't think that people are clear on what networking is about. Basically, a network is a group of people who share a common interest or concern and interact with each other on this basis. There has been a distinct lack of this with regard to Pagan attempts at networking, where all communications tend to go through a few central facilitators, and not between people themselves. Networks survive & develop by those involved investing energy, time, effort, and money into them. In the ideal networking situation, the more you put in, the more you should get out, and each individual is the "centre", so to speak. If one person is doing all the running, then at least as I understand it, this is not networking. They might call themselves a "central facilitator" instead of a "leader", but in effect, if everyone else goes to them for advice, and waits for their okay before doing anything, what are they if not "leaders"?

2 Marilyn Ferguson (1938 – 2008) was an American author and founding member of the Association of Humanistic Psychology. She edited the science newsletter *Brain/Mind Bulletin* from 1975 to 1996 and served on the board of directors of the Institute of Noetic Sciences. Her circle of influence included such luminaries as inventor Buckminster Fuller, guru Ram Dass, chemist Ilya Prigogine, media mogul Ted Turner, and former US Vice President Al Gore.

Now this might sound overly critical of networking as a whole, but really I'm very much behind the basic concept, and I have been involved with Pagan networking groups since around 1987. I'm not criticising the people who get involved with networks either, It's just that if we start off on the wrong assumptions, we can quickly get into problems. Networking is still an evolving form of social organisation, and I feel that networking in Pagan/occult circles has its own particular problems that other forms of network don't have.

To gain a closer understanding of the possibilities of networking, I went off and did some research...

Leeds Squatters network began through a group of people who had the idea of squatting a large building in the city centre, as a protest to highlight lack of housing and community facilities. It was during the Miners' Strike,[3] at the peak of the Thatcher years, and the group were united by a common political & social alienation. With a few exceptions, most of the group had no experience of squatting or political actions. The first meetings were advertised through Leeds University, leafleting various gigs, and through the London-based squatters" magazine, *Crowbar*.[4] Out of the group's first action – the squatting of Leeds' Rates Building, evolved the Leeds Squatters Network, which in turn, developed various spin-offs. These included: a housing co-op (which now houses over 12 people); a food co-op, which now runs a wholefood delivery service; and a street theatre group which put on public performances. The network also gave a boost to the local Claimants Union, which, together with Scottish C.U.'s, went on to initiate the National Campaign against the Poll Tax;[5] Leeds University Hunt Sabs[6] were given more support, and a non-University group was set up, making both groups more dynamic. A band promotions group was formed to hold weekly gigs and occasional benefit concerts. Three women's groups sprang from the network: Women's Action on Benefits, Maternity Emergency (a benefits advice group) and Girls in Need (which campaigned to set up a hostel for runaway girls). A women's only squat was opened; five large buildings in the city centre were squatted for

3 The UK Miners' Strike of 1984–85, when the National Union of Miners protested against pit closures. The strike dragged on for a long, bitter year and polarised the British people. Some of us have still not forgiven Margaret Thatcher and the Conservative Party for their actions against the miners then, and we never will.

4 So named because a squatter would carry a crowbar in order to prise open the door of an unused property.

5 The Poll Tax, or to give it its official name, the Community Charge, was a system of taxation introduced by Margaret Thatcher's government in 1990. It was widely hated and led to violent protests across the UK until it was dropped in 1993.

6 The Hunt Saboteurs Association (HSA) was founded in 1963 to foster direct action against the detestable English aristocratic pastime of hunting foxes with horses and hounds. Despite being currently illegal in the UK, fox hunting is still widely practiced.

benefit gigs; a "squat cafe" flourished briefly, and there was a wide variety of political occupations & demonstrations including Leeds' own version of "Stop The City".[7] A tools co-op was created, and a shared-skills network so that people could get their houses re-wired and re-plumbed. In addition, publications were issued such as *Who Owns Leeds,* and *Cabaret* (a collection of situationist[8] agit-prop). This buzz of activity was helped along by a weekly magazine, *No Limits.* Its great attraction (that got people reading it) was that it published the week's TV listings from the *Radio & TV Times.*[9] *No Limits* was run on an "anybody who wants to do it – does" basis, though eventually, this devolved to a team of about eight people who produced the mag on a rotating basis. No-one knew anyone else's address, but there was a team who were responsible for picking it up and distributing it within their own postal area.

Within Leeds Squatters Network, there were no "leaders" as such – people may have been responsible for one particular task, but they had no "leadership" status outside it, something that consistently confused the authorities. Through a box number, the Network connected nationally with other squatters networks, and with anarchist groups, women's groups, animal rights activists, and Travellers.

What I found particularly interesting was how people became involved with the Network. Due to the (ahem) clandestine nature of many of the Network's activities, there was never any publishing of names and addresses, nor was there any "central database" of the same. People joined the Network entirely through personal introductions and social gatherings. Only in the case of very large events were they advertised in advance. *No Limits* publicised what people had done – not what they were thinking of doing (for obvious reasons).

All well and good, you might think – but what has this to do with Pagan networking? Well, after talking to people who'd been involved with the Squatters Network at various points, I was amazed by what they had achieved. I also began to see some key points emerging. A crucial point is that most of the people

7 Stop the City was a series of demonstrations taking place in 1983 and 1984, including a blockade of the City of London financial district which involved 3,000 people and succeeded in causing a £100 million loss of earnings. The Leeds action in 1984 included members of the band Chumbawamba, who would later go on to fame with the song "Tubthumping", and more importantly as the printers of *Pagan News.*

8 The Situationist International was a political art movement founded on the philosophy that capitalism was creating false desires in people via omnipresent advertising and the glorification of accumulated capital, and by the commoditization of human life. (And this was well before the development of Instagram and TikTok influencers.) The founding manifesto of the movement, *Report on the Construction of Situations* (1957), advocated for a solution by the creation of performance art style **situations** as "the concrete construction of momentary ambiances of life and their transformation into a superior passional quality."

9 Back in the Jurassic Age before smart TVs and Internet streaming, people had to read actual paper magazines to find out what was going to be shown on broadcast television that week.

involved in L.S.N. were homeless, and shared the same political stance. This gave them a common commitment perhaps lacking in Pagan circles – where people have different beliefs, and are often suspicious of each other's motivations. Another key point is that L.S.N. quickly evolved into a multiplicity of groups all exchanging information & support with each other. There were weekly meetings where people would pool information and resources. Specialists came in and shared their skills with others. To do this, a network needs to be small, and highly adaptive. Also, the continual stream of events – actions, gigs, the weekly newsletter; all helped people feel they were engaged in something "busy".

"When I first became involved in the occult, I was helped greatly by attending the local moots in Leeds, Bradford, & Manchester. This was back in the late 70s. Nowadays, It's much easier to meet other people who share Pagan/occult interests. Most magazines carry listings of meetings up and down the country. There are more magazines too, and more public meetings and events, of course. In part, at least, I feel that we have the Pagan networks to thank for this."

Pagan networks are often large, country-spanning webs of contact addresses, and the degree of local activity from place to place varies hugely. What a network does, depends entirely on the perceived needs of those involved in it. Problems arise when people get conflicting ideas of what the network is about.

It may be a fine distinction, but I think differences need to be identified between networks, Services, and Campaigning Groups. All may exist independently of course, but I feel that each type of organisation has different aims, and should be approached in different ways. At a basic level, a network is a group of people all of whom share the same concern, and who interact with each other on that basis. For example, if a group of people decide to share information about a particular subject – the willingness to do is all that is required. There's no need for "facilitators" because, as soon as you get a situation where one person acts on behalf of other people, the network has become something else.

Services are something different. If I decide to do something on behalf of all and sundry, that's a service. There's a distinction between the person who "provides" and the "consumers".

Again, Campaigning groups are different. Campaigning groups need to be organised, have clear aims, and a message to put across. Dedicated supporters

and money come in handy, too. The Sorcerer's Apprentice Fighting Fund is a good example of a Campaigning Group.

The problem that Pagan networkers come up against time and time again, is that some people are quite willing to "take" from a network, but less willing to invest in it. I don't think that this necessarily means that these people are lazy – just that they are not sure what networking means. A common problem that arises is that people don't want to give their own addresses out to others. My sympathies – there are a lot of "strange" people that I wouldn't want turning up on my doorstep unannounced. On the other hand, this defeats the whole "grass roots" approach to networking, because It's very easy to get into a situation where there are only one or two "open" addresses, through which all the mail comes. Inevitably, facilitators get lumbered with incessantly organising events and writing to everyone, by which time they're providing a Service, really.

A possible way around this problem is to encourage people to decentralise right from the word go. Instead of having one or two "central" addresses, encourage other people to start their own local networks. To some extent, this is already going on in the Pagan scene, except that you get PaganLink Moots, Pagan Federation Moots, Green Circle Moots – where within each there is a certain degree of suspicion & competition, which is probably due to, er, "magical differences" between individuals which then get projected onto the whole group. I would personally rather see a wide range of small networks on a local basis up and down the country, than one or two huge networks that are unwieldy, unresponsive, and starting to appoint "Councils", and issue policy statements and the like. If, as the networking cliches run, "each individual is the centre", then how do you end up with a situation where someone else decides something on behalf of everybody else? One reason for this is that people often lack confidence in initiating something, and tend to turn to someone else for "permission" instead of "just going ahead". Again, this is natural enough, but a network is a system for helping people communicate, rather than a "society" which has specific policies, and a hierarchical structure. If you want to do something, and if you wait to see what everyone else thinks first, then It's quite likely that you'll be subject to delay after delay as arguments become circular. If individuals are working together on an equal basis, "seeking permission" isn't necessary. If the original activists who set up PaganLink had waited for "permission", it might never have come about – besides which, who was there to ask?

As far as networking goes, I've yet to meet someone who is an "expert" – networking is still evolving, and so more ideas & input on the subject are needed. As far as I can see, networking is one of the best ways open to us for building a sense of community between the differing paths, groups, traditions within the great Pagan & occult diversity open to us. And don't forget the many small press

magazines, the businesses & shops which also support the community – they are equally important.

When I first became involved in the occult, I was helped greatly by attending the local moots in Leeds, Bradford, & Manchester. This was back in the late 70s. Nowadays, It's much easier to meet other people who share Pagan/occult interests. Most magazines carry listings of meetings up and down the country. There are more magazines too, and more public meetings and events, of course. In part, at least, I feel that we have the Pagan networks to thank for this. The first year or so that PaganLink was around generated some amazing energy – with meetings across the country. There were also, it must be admitted, some bitter arguments generated as different groups of us wanted to pull the entire Network in different directions – perhaps missing the point (I know I did) that there was room enough for lots of different approaches. Through going to meetings and writing to groups who I'd previously only known as ads in magazines, I made a lot of friends, and, if it wasn't for PaganLink, I wouldn't be holding forth in this magazine which, in its very first incarnation *Northern PaganLink News*, was four pages long and we ran off 25 copies. And the rest, as they say, is history. The key to networking, as far as I see it, is – don't ask what the network can do for you – think what you can do for the network. Then do it. You might surprise yourself.

SPOTLIGHT

PaganLink Network

John Male, proprietor of "The Something Else Shop" in Dartford, Kent, is one of the activists for PaganLink Network. In the following interview he gives a personal viewpoint of PaganLink and his ideas on networking.

PN: What is PaganLink Network, John?

JM: PaganLink is more of a verb than anything else – PaganLinking. The basic idea is to help people communicate amongst themselves, all those who honour the spirit of the Earth, who feel a need to communicate their ideas and to meet. It's not, as I see it personally, a faction within the Pagan Community, but hopefully, a service for that community. A way of bringing factions together. Unfortunately it does have the problem which any networking facility has, which is that people have a desire to belong to something. This is probably because of the society we live in, and what people expect from joining something. They want to feel a certain pride in that they actually belong to something. I became involved with PaganLink very much through the writings in *Moonshine*, of Rich Westwood, yourself and other people, and I felt that for the very first time in the Pagan Community, there was an expression of empowerment actually encouraging people to do something themselves, rather than just sending off their subscription for a magazine, or sending off their subscription for somebody else to do it all for them. Actually saying to people, you can change things – you can bring about a more harmonious environment. You can actually do something about people building on your little bit of local woodland – by being empowered, and learning from each other.

PN: So how did PaganLink come about, as an idea?

JM: That, I'm not really sure. As I say, I tuned into it through the writings of the other people who actually started PaganLink – they basically got off their backsides and did something. They automatically attracted a lot of flak from established groups, I think because they were encouraging public

access – they were actually saying "We can do it out in the open" – that we can, for instance, hold large celebrations in a local park; that we can actually communicate with people. That we have nothing to hide, rather than being a secretive organisation. Obviously that did bring up initial fears in organisations which were already in existence – that it might cause a backlash. I think perhaps that was one of the mistakes in the early development of PaganLink, that other people weren't reassured, that it wasn't in any way intended to endanger their personal positions. As I see it now, PaganLink should be at the forefront of access to the general public. Especially now, when "Green Awareness", in the words of the government think-tank, It's "political suicide" for a Conservative MP not to appear "Green". This is a time when Paganism should be at the forefront – we are representative as a whole of Green Spirituality – the understanding that you honour the Earth. Whereas if you dishonour the Earth, you automatically bring about your own downfall.

PN: What, in your view, are the aims of PaganLink?

JM: Initially, to communicate, to get people talking to each other. To actually encourage people to do something themselves, rather than saying "Who's going to do it for me?" It very much follows the idea of People Power.

PN: How well do you think this has worked so far?

JM: Certainly, initially, PaganLink brought people together, from very diverse paths and opinions. It had the effect of getting them to come out of the closet and to communicate with each other. A lot of people who otherwise might have remained in the background came forward, and I would put myself within that category. Prior to PaganLink I probably went along in my own little way, feeling that there wasn't anything that I could connect into, that everyone would think that I was mad if I openly celebrated my beliefs. What I think was very inspiring to me was a network which was encouraging you in your individual beliefs, not saying "this is the way it is, and that you must abide by the rules". It was giving you your power; encouraging you to express yourself, and leaving you to practice in the way that you considered was relative to you.

PN: There was some wariness expressed at PaganLink meetings at the presence of Thelemites or chaos magicians, and some people from very "orthodox" Wiccan traditions seemed to be wary of meeting all these diverse people, but the meetings helped, in my view, to break down the barriers between people's paths. What do you think?

JM: Very much so. I spend most of my time figuring out what's right for me. I would never put myself in the position of telling other people what's right for them. I have my own personal beliefs and faith, and that's down to me. I'm able to laugh at my beliefs and make a joke of my beliefs, and that way I know that I'm

not just another dogma-junkie. We can all learn from each other. I don't think I will ever be in a position where I feel that I have nothing to learn from another person. Everybody that I meet has something that I can learn from.

PN: Would you say that, by PaganLink becoming more active, that some of the other, older Pagan umbrella organisations have, by the same token, tightened up their act as well?

JM: Yes I would. I think that there's two areas that that brings up. One is the direct effect which PaganLink has had, on hopefully making Paganism more accessible, and I think I would use the term Neo-Pagan – for a Paganism which is relevant for today. It has actually brought that into a wider awareness. It has meant, I think, that existing religions within Paganism have realised that they have to grow; that they have to embrace change, both within new discoveries in archaeology and history, and within modern science and technology.

PN: What would you say were the main problems you've encountered, as a PaganLink activist?

JM: I think you have to understand a distinction clearly: that there are people who already profess to be Pagan, and that there are people who maybe have a mild interest, or who are beginning to tune in individually, to the need to re-integrate with the natural world. Take the example of a guy who comes in the shop and says that he's sure the trees talk to him, but he can't talk to his mates about it, and asks me if he's gone mad. Hopefully I can reassure him that It's okay and that It's worthwhile to pursue that. That's the sort of person whose initial reaction, if you actually said to them, "I'm a Pagan" which might stem from the media stereotypes. So PaganLink is helping people make their first steps into Paganism, and to find their own individual path. Then of course, PaganLink has a role in the existing Pagan community, of actually helping them to actually communicate amongst themselves, to share their ideas. Helping them to celebrate together, or, for those who wish to work alone, respecting that right but giving them a channel, by which they can communicate, if they so wish. So I think you have a clear definition there of two different roles which PaganLink as a network has to meet. Certainly I have encountered problems within the existing Pagan community. One of the difficulties has been that those who already have a faith, a religion, realising that they do have common ground; that they can share and work with people of a different religion. It's something that you have to be respectful of, that someone has had an enlightenment, leading to a faith. You have to respect their faith, and not offend them in any way. They have a right to their belief, but at the same time, if Pagans can't work together, there isn't much hope. Unless we can start to work together for our common aim, which is to bring about an understanding of the sacred nature of the Earth, then there isn't much hope for the Earth.

PN: **Why do you think there is so much suspicion between people on different Pagan & occult paths?**

JM: I think that a lot of it stems back to socialisation. There's a desire to belong. Human beings are by their very nature, tribal; they want to belong to a tribe. If somebody comes along who is not of that tribe, there's an immediate suspicion, and an immediate alienation. That because that person has not enrolled in the other's tribe, there's a suspicion that they may be detrimental.

PN: **How do you think we might get over that?**

JM: I think, firstly by getting over the idea that the human race is a tribe. We are all the children of Gaia, regardless of race, creed, colour or belief. That we are all part of the human race, and that we do not need to confront each other. That we can actually respect our individual rights and work together.

PN: **Do you think there's a degree of confidence in your own path involved in that? People who are not very confident in their own beliefs sometimes get very threatened when they meet people who are coming from a very different perspective.**

JM: Yes. If there's any question as to the validity of your own personal belief, somebody bringing up information which causes you to question it, is liable to bring about a crisis of faith. There are really two ways in which a human being can cope with that. The first way is to take the new data on board, and to reassimilate their faith. The second way is the fundamentalist approach, which is to say "You are the enemy – you are the baddie" and to become more fanatical, in order to block out the unwanted information.

PN: **This highlights one of the problems in Pagan networking – that there is such a vast multiplicity of beliefs which people aspire to and hold very emotively, that you have to get over when you try and bring people together.**

JM: Yes. If somebody asks me what I "am" for instance, the obvious question "Are you a witch?", my reply to that would be "Will you define what you mean by witch?". If pursued along this, I would be inclined to answer, as I have in the past – "I'm John". A "John", not "the John". My path is inevitably different from anyone else's because I'm an individual. Choose a group of extreme fundamentalists of any belief, and get them to discuss amongst themselves, and you'll find that they all disagree with each other, because they are all individuals. But the basis of any group of people coming together is finding common ground. If that common ground is kept as simple as "All who honour the spirit of the Earth", then I see no problems in people of many paths coming together.

Anyone involved in PaganLink has to keep their own moral judgement out of decision-making as to what is "best" for Paganism. For instance, I would personally abhor anyone who would harm an animal. I think within the guideline of "All who honour the Earth" is an unwritten understanding that life is sacred.

I don't eat meat, for instance, but should I desire to, I would take the life of the animal. Now someone else might say "to eat meat is bad", but I would say that that's down to the individual.

PN: So we wouldn't see a situation where someone sends a circular around saying "No meat-eaters in PaganLink?"

JM: No. I would try very hard to stop that sort of thing happening. If someone wishes to express their own personal view, then by all means – they've every right to, but not as PaganLink "policy".

PN: Given that, does PaganLink have any policies?

JM: No, not really. I think this is a problem because a lot of people expect a policy, and would assume that PaganLink doesn't exist because it doesn't have a policy. There is a National Moot planned for the 7th of March, where we'll be looking at policy, and where we might actually reach an open vote on policy decisions which may come up. My hope is that any policy decisions that are reached will be an overview. We want to avoid dogma, and thereby alienating any section of the Pagan community.

PN: How do you see PaganLink interfacing with other organisations, such as the Green Circle or the Pagan Federation?

JM: As PaganLink is primarily a communication network, it can play that role for other organisations – we can communicate to Pagans what, for example, the Pagan Federation represents, and is doing. Unfortunately, a lot of other organisations have refrained from seeing PaganLink in this light. One of my intentions is to produce a Directory which will be available for anybody enquiring. I see this as a way of showing the existing Pagan organisations and religions that PaganLink is there for them. There is no bias in PaganLink – it is there for the Pagan community as a whole.

PN: Your present role in PaganLink is as a "central" facilitator, but PaganLink very much depends on local action as well.

JM: I personally feel that I do what I can do best. Other people have other skills and will do what they can do best. Often people have skills which are latent – that they're unaware of. I see my role as a catalyst, of hopefully empowering people, and giving them the confidence to do something themselves. Sometimes it does seem that the burden falls on a very few people. It's perhaps an utopian view, but one I hold, that one day the Pagan community will function without me.

PN: People talk about "community", but it does take a lot of energy and effort to create a community.

JM: Yes, especially if the burden falls to a few people, it can be quite exhausting. I would like to see people expressing more self-motivation. I would feel that I had achieved a great deal for PaganLink if people were actually able to do it on their own. That would be my work done. One of the problems has been the endless

round of "talks". It's inevitable that we could disappear up our own arseholes in intellectual waffle. The time for talk is now being turned into the time for action.

PN: The idea that networks are "organic" has become a bit of a cliche, but within that there is the idea that networks are continually changing.

JM: PaganLink, from its very inception, has gone through a constant change, which I think is quite healthy. I think that It's a tragedy that in the past some people have become disillusioned, and are no longer actively involved. If there's any of them out there, then they are welcome back. They are needed!

> *"We are all the children of Gaia, regardless of race, creed, colour or belief. That we are all part of the human race, and that we do not need to confront each other. That we can actually respect our individual rights and work together."*

PN: If someone out there was thinking of becoming involved in PaganLink, what would you say to them?

JM: Get in touch with us – send in an SAE (or you won't get a reply), and we will send you contact addresses, we will let you know of any national events that are on, and we will also give you guidelines as to how to get things going on a local level, such as with setting up pub moots – a good way getting a social meeting going, and for providing an access point. A large number of diverse groups have started from small pub moots. The basic rule is "nothing in, nothing out". We'll help in any way we can, but ultimately we can't come and do it for you. There are no "experts" – just people who, from the very beginning, felt inspired and decided to do something.

I think that a lot of people have forgotten the way that PaganLink was initially started, by people producing a product which they saw as valuable and useful to the Pagan community, which was the small booklet *Weaving The Web*. It didn't preach at you, but encouraged you to do something for yourself.

This is really how PaganLink will reach public awareness, by presenting a high profile. By being and doing. I see Paganism as of the Earth and as a Pagan I intend to do things, and hope that by example that will encourage others to do likewise.

John Male, thank you very much.

PAGAN NEWS

MANY VOICES, ONE SPIRIT

APRIL '92
£1.50

LILITH BABELON INTERVIEW
SPIDERWOMAN EXPLORED
LETTER FROM EGYPT

Channel 4's *Dispatches* – Another Devilish Debacle

On the 19th of February, Channel 4's *Dispatches*[1] programme gave the Satanic Child Abuse exponents their biggest boost of publicity since the Epping Forest case. The entire programme was angled to give the impression that SCA exists on a massive scale, yet due to public incredulity and the legal system, it goes on unchallenged.

All the usual standards were trotted out; child sexual abuse, human sacrifice, cannibalism, "hereditary" satanists, and Crowley's well-worn leg-pull about "sacrificing his own children" (i.e. his own semen). Interviews with a wide cross-section of professionals gave credence to the allegation that a tide of ritual abuse is sweeping the country. One source claimed, for example, that a survey of care workers showed that 68% of them had received "threats and intimidation" – though from whom was not made clear. The picture being painted was that, due to an increase of "evidence" from children and adult survivors, with similar themes and symbolism emerging, that ritual abuse is an international problem.

It was interesting that none of the familiar faces involved with the hyping of SCA were present: no mention of Dianne Core, Audrey Harper, Maureen Davies, the Rev Kev, or Geoffrey Dickens MP. While the programme did feature researchers who were sceptical of SCA, and who pointed out that there is a COMPLETE LACK of "hard" evidence to support the allegations, the programme hinted that this was because "survivors" feared ridicule, the stress of going through the courts, or more sinister reprisals. One of the "survivors" on the programme said that she hadn't considered going to the police about her allegations, as "top people would block it".

It was stressed that while evidence of sexual abuse can be medically substantiated, evidence of ritual abuse often cannot be so. As one "expert" put it, by the time the evidence has come to light, the trail has "gone cold". Apparently, "satanists" make great use of acid-baths to dispose of the remains of their ceremonies.

This time, the programme-makers had a powerful "hook" with which to grab viewers' attention. A video which showed "proof" of satanic ritual abuse taking place. It was so horrific, we were warned that Dispatches had to be screened

1 *Dispatches* is an undercover investigative journalism programme that has been running on UK's Channel 4 since 1987 to the present day. Some of its investigations have aroused controversy, with claims made by those featured in some episodes about the accuracy of their accusations and findings.

later than usual. This is the broadcasting media's version of wrapping girlie mags in brown paper and marking them "adults only". The video turned out to be *First Transmission*, a ritual performance art piece made by members of Psychick Television Ltd, back in 1982. An adult survivor named "Jennifer" was shown, her face blacked out, describing how scenes in the video were of a pregnant woman having her baby aborted, and of children being ritually mutilated. It was claimed that she was a former member of the "evil cult" who had made the video. No mention of the cult's name was made, although both the Temple of Set and the Temple of Psychick Youth had been mentioned earlier in the programme.

A few days before the screening of *Dispatches*, Brighton police visited the home of Psychick TV frontman Genesis P-Orridge and removed videos and other material. Despite attempts by the press to link this event with the screening of *Dispatches*, the police have stated that the removal was part of a year-long investigation, and *PN* has no reason to believe that the two are in any way connected. Again, despite speculation in the press, there has been no suggestion of criminal charges being brought up. It should also be made clear that the video *First Transmission* is in no way connected with the Temple Of Psychick Youth. Individuals of Psychick Television Ltd may have been involved with TOPY at the time, but that was ten years ago, and none of the people who made the video are now associated with TOPY.

However, despite some inaccuracies in press coverage of this affair, some interesting tid-bits have come to light. Firstly, that Wendy Savage[2] was shown the alleged abortion scene, and commented that she did not think an abortion was taking place – adding that "some people must have a very fertile imagination". Her comments, nevertheless, were not included in the programme. The police have also expressed a desire to interview "Jennifer" about her allegations – particularly her claims of witnessing human sacrifice and of taking part in the murder of her own child. Reportedly, Channel 4 have refused to give the police details of the whereabouts of "Jennifer", saying that they have to protect their sources. It has also come to light that "Jennifer" did not actually begin to recall any of these events until she had spent some months in a Christian commune, and another member had a "vision" of her sacrificing her own child. Derek Jarman,[3] who was featured in the video, is also reportedly "very angry" about its misrepresentation.

2 Professor Wendy Diane Savage (1935 –) is a British gynaecologist and campaigner for women's rights in childbirth and fertility. In the 1960s she became the first woman consultant to be appointed in obstetrics and gynaecology at The London Hospital. Amazingly before her *all* gynaecologists there had been men. And it was founded in 1740.

3 Michael Derek Elworthy Jarman (1942 – 1994), English film director, set designer, and artist. Notable works include his remarkable set design for Ken Russell's masterpiece *The Devils* (which all of our readers should definitely go watch), his iconic video for the Pet Shops Boys song "It's a Sin", and his own movies including *Sebastiane*, *Jubilee*, and *Caravaggio*.

Editorial Comment

Once again, the exponents of SCAM (Satanic Child Abuse Myth) have shown that their best talent is in shooting themselves in the foot, as it were. The entire *Dispatches* case was built around the Psychick TV video as "hard" evidence for Satanic Child Abuse, and now this has been thoroughly exploded. The *Dispatches* presenter, Andrew Boyd, has just had published a book *Blasphemous Rumours*[4] which is another attempt to set forth the case for Satanic Child Abuse. Readers might like to know that the book is published by HarperCollins, the same Murdoch-owned publishing group who own Aquarian Press and Mandala.

Channel 4 seem to have suffered a brainstorm of late, since part of the video *First Transmission* was shown a few years ago as part of a programme on modern art movements. The *Dispatches* slot is not afraid to take on controversial issues. Its report on child care *Holding the Baby* expounded the theories of an American group of therapists who are claiming that young children left in care while their mothers go out to work later go on to develop behavioural problems – with the implied message that women with children should not go out to work, but stay at home and look after them. *Holding the Baby* has outraged child care professionals, researchers, and the NCB. We might speculate as to whether there is a fundamentalist cabal at C4, since the idea of women staying at home is another view being pushed by fundamentalists.

Throughout this whole affair, members of TOPY have maintained a "no comment" policy, despite pressure to make statements. In the absence of meat for the media beast, it begins to feed on itself. It has been a common experience of occultists who have made press statements in the past to find their words twisted and turned against them. Denying allegations only serves to fuel them, yet it should also be pointed out that some journalists, in the absence of concrete information, will go ahead and make it up anyway. It should be obvious by now that the SCAM exponents will not go away, and are willing to go to any lengths to attack members of our community – including smear campaigns and violence as seen in the Bridge of Dreams case. Speaking of which, the Lincoln shop is being reopened. Perhaps *Dispatches* would consider this unsavoury affair a worthy subject for investigation?

4 *Blasphemous Rumours: Is Satanic Ritual Abuse Fact or Fantasy?* (1991), a book notable only for having one of the shittiest covers in the history of publishing. The contents are no better than the cover. Boyd then followed it up with *Dangerous Obsessions: Teenagers and the Occult* (1996) which covered all of the classic signs of teenage occult obsession: astrology, Tarot, rock music, and fantasy games. Looking at your editors, he may have had a point.

VIEW POINT

Ufology
by *Andy Roberts*

If books dealing with UFOs written by the likes of Tim Good[5] and Budd Hopkins[6] are to be believed the Earth is under perpetual siege from scalpel wielding extraterrestrials who are out to rape the women and bugger the men, with the intention of creating a hybrid species, subjugating the world and making us all slaves. Phew, and you thought it was bad enough just having demons to deal with!

But thankfully ufology isn't that simple and there is a great deal within the subject to interest those of a Pagan/magical persuasion.

Almost all UFO sightings tend not to be of the saucer-shaped craft but rather of lights in the sky which suggest a shape rather than define one. Human perception and the desire for a cultural myth does the rest and hey presto – the aliens are coming. But the core phenomena of balls of light have a history going back far beyond the "modern era" of ufology which began in 1947, and have been seen for centuries and recorded in the folklore of native peoples of many countries.

In the British Isles for instance they have been known as Will O' the Wisp and Jack O'Lantern, and they are often seen in upland areas such as the Pennines, and the Welsh and Scottish highlands. Often they have been seen at low levels

5 Timothy Good (1942 –), English author and violinist. Good has written several successful books on ufology. Some of them even contain factual information in places.

6 Elliot Budd Hopkins (1931 – 2011), American artist and ufologist. His books *Missing Time: A Documented Study of UFO Abductions* (1981) and *Intruders: The Incredible Visitations at Copley Woods* (1987) popularised the myth of alien abductions, which was later put to very good use in works such as *The X-Files*.

and even on the ground, in many cases appearing to shape-shift into ghost-like phenomena: human perception again or the property of the phenomenon itself?

Ufologists on the whole prefer to concentrate on people who claim to have seen a "flying saucer" type of UFO, and it has been left to other people to examine the other type. Earth mysteries researcher Paul Devereux[7] has ably demonstrated in his books *Earthlights* and *Earthlights Revelations* that there is evidence for a proportion of all UFO sightings being the result of some as yet poorly understood natural process which our ancestors might have known about, interacted with, and built sites to mark and experience.

Despite the failure of mainstream ufology to take any interest in this theory, the basic premise is accepted by scientists who agree that the Earth can produce light forms and cite lights produced during and after earthquakes as evidence. Ufology has much to say about how we interpret the world.

Ufology has also taken the wonderful world of crop circles under its wing although at present there is some tussling going on between the subject and crystal-crazed New-Agers who are convinced that its Big Mummy Gaia telling us off for not eating enough brown rice. Sadly the New Age bandwagon has misread the subject and has been well and truly fooled by the hoaxers. It seems that those circles which are not hoaxed, i.e. the simple rings, not the insectograms,[8] are caused by a complex meteorological phenomena going under the name of a "descending vortex". One for Pagans if ever there was one as it demonstrates yet again the complexity of the natural world and our need to understand it before giving supernatural attributes to natural phenomena.

The other area of interest to *Pagan News* readers is that of UFO Abductions – you know, silver space ship lands, takes human, does medical tests, returns human, UFO investigator messes up case. That kind of scenario. The media and more than a few ufologists (many UFO buffs are actually closet E.T. believers but won't admit it!) would dearly love this phenomenon to be caused by Gweeb and his pals from Zeta Reticulli, but as yet no physical evidence of an external origin for these experiences has been found.

When examined closely abductions parallel encounters with fairies and other beings and the very nature of the abduction experience is redolent of an

7 Paul Devereux (1945 –) is an English author, artist, researcher, and editor of *Time & Mind – the Journal of Archaeology, Consciousness and Culture*. He has been a research associate with the Royal College of Art and a Research Fellow with the International Consciousness Research Laboratories (ICRL) group at Princeton University. His theories of archaeoacoustics, although controversial, stimulate much food for thought.

8 In 1991 two gentlemen from Wiltshire in Western England, Doug Bower and Dave Chorley, confessed to having begun the modern fad of creating crop circles. Way back in 1976. Yes, turns out they were all hoaxes.

enchanted or altered state of consciousness. Author Jenny Randles[9] was the first ufologist to comment on the fact that many witnesses both in abduction cases and other UFO encounters noted their perception of the world changed prior to, and during the UFO experience, with a dropping away of external noises and alteration of time flow. Jenny named this the "Oz Factor" for obvious reasons, and it bears further examination.

Another way of interpreting the strange visitations and messages bestowed on us by the ufonauts has been given in many books by Jacques Vallee[10] (on whom the scientist in Spielberg's *Close Encounters*[11] was based). Vallee has speculated that there may be some kind of inter-dimensional contact going on which would explain the apparent (to us) nonsensicalities inherent in many close encounter cases. It also brings ufology closer to a magical viewpoint and the works of Kenneth Grant[12] and Crowley may well be able to shed some light on extraterrestrial communications.

Finally there is much phenomena "leakage" in the subject. UFO witnesses and abductees will often claim psychic abilities and many go on to study other aspects of the paranormal. Both former UFO investigators and witnesses were involved in the development of the Psychic Questing scene featured in the February issue of *PN* and there are many witnesses and investigators working together at this moment in some very strange areas of research. Whilst ufology is largely populated by "anoraks" the subject is rich in material for magicians and Pagans and deserves attention by anyone interested in anomalous phenomena of person and planet and more importantly, the relationships between them.

Andy Roberts edits the wonderfully irreverent UFO Brigantia[13] *magazine & also holds forth occasionally in* Fortean Times.[14]

9 At the time this article was written, Jenny Randles was director of investigations with the British UFO Research Association (BUFORA). She has written several books on ufology.

10 Jacques Fabrice Vallée (1939 –) is a French computer scientist, astronomer, and ufologist, and perhaps surprisingly, a successful venture capitalist. His books are among the more scientifically rigorous works on the subject of UFOs.

11 *Close Encounters of the Third Kind* (1977) is an American science fiction film written and directed by Steven Spielberg. A classic of the genre.

12 Kenneth Grant (1924 – 2011) was an English Thelemite and author who throughout the 70s and 80s had pretended to be Head of the O.T.O. – although he had actually been expelled from it in 1955. His many books concentrating on the "dark" side of Thelema, Qabalah, Lovecraft etc. have been very influential despite being largely nonsense academically controversial. As a young man he acted briefly as secretary to Aleister Crowley who described him as "...the most consummate BORE that the world has yet known." His *Images and Oracles of Austin Osman Spare* is quite excellent though.

13 *UFO Brigantia* ran for 25 issues from the early 1980s to 1993, and included in-depth interviews with most of the people cited in this article.

14 The UK magazine *Fortean Times* has been running in one form or another since 1976. It specialises in running articles about weird phenomena inspired by the American researcher Charles Fort (1874 – 1932).

Famous Occult Stereotypes

Sidney Herbert - Tantric Pervert

Of course, my dear, the moment I set eyes on you I realized you were a spiritually advanced person. That's why the spirit guided you to seek me as a master. You will have some sherry won't you? Now, your tuition fees might be reduced a little bit, considering you'll be acting as my High Priestess. What does that entail? Well, naturally you'll be practising advanced tantric magicks with me, and then there's the Great Rite ... of course my dear, 17 is quite old enough to be a High Priestess, especially considering your natural, er, gifts. Now if I might suggest a preliminary chakra massage to begin your training..?

PAGAN NEWS

MANY VOICES, ONE SPIRIT

MAY '92
£1.50

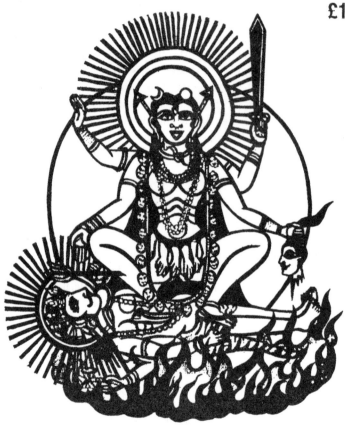

SPOTLIGHT ON TANTRA
SCOUTING FOR PAGANS
LETTER FROM CANADA

Gay Times slams Spiritualism

It all began with a story in *Psychic News*[1] about an Essex medium who claimed that mediums tended to be either coy or prejudiced when it came to passing on "messages" from departed lesbians & gay men to their lovers or friends. The item was picked up by Terry Sanderson,[2] editor of the Media Watch column in *Gay Times*. Sanderson took the opportunity to make some snide comments about spiritualism in general and the late Doris Stokes[3] in particular. In a reply published in *Psychic News*, the editor Tony Ortzen said that the majority of male mediums were gay and that the paper had, in the past, raised over £4,000 for AIDS-related charities. We would also like to point out that both occultists and homosexuals have a shared heritage of persecution by Church and state since the 12th century. What price "gay pride" if it rests on sneering at alternative beliefs?

Vicar Exorcises School!

Following a demonstration of mediumship at a psychic fair in a Bedfordshire school recently, a local vicar took it upon himself to perform an exorcism in the school's gymnasium. The demonstration attracted over 250 people, and also brought the organisers to the attention (not entirely favourable, it seems) of local newspapers and radio. The vicar also delivered a Sunday service on the "evils" of alternative thinking.

1 *Psychic News* is a British Spiritualist newspaper which has been running almost continually since May 1932. Its name is reputed to have been inspired by a message from a spirit guide of one of the founders. If the name *Psychic News* can be considered to be inspired at all.

2 Terry Sanderson (1946 –), English activist, author and journalist whose Media Watch column ran in *Gay Times* from 1982. He was president of the National Secular Society from 2006 – 2017.

3 Doris May Fisher Stokes (1920 – 1987) was a hugely popular British medium, and author – so popular that a performance by her could sell out the Sydney Opera House for 3 nights in a row. Like many mediums it has been alleged that she used audience plants and "cold reading" during her sittings in order to persuade her audience that she was really in touch with "the other side".

A Spanner in the Works?

Following the collapse in February of the appeal by five men convicted of assault in the Operation Spanner case, the House of Lords has been asked to make a decisive ruling over the future legality of S&M sex. The case may not be heard for another year, but the issue has led to much wibbling in the press over how Lord Lane's ruling that "consent is no defence" for any assault (whether extreme or not) if it is "not justified by good reason."

One wonders how this might affect some spiritual practices – such as ritual scourging, body piercing, sundances – that sort of thing – all done for good clean "spiritual" reasons. As is Opus Dei's recommendation that teenagers wear belts made from barbed wire. The lobbying organisation Stonewall,[4] have been quick to point out that the entire prosecution & appeal process has been influenced by the fact that all of the 16 men originally involved in the Operation Spanner trial were bisexual or gay. What's the betting that whatever the Lords come up with, it will be applied with the usual British legal finesse of distinguishing between acts committed by "deviants" (i.e. Homosexuals, "Satanists" – state favourite scapegoats since the 12th century), "nice" people, and the "untouchables" – MPs, Judges, etc.

4 Stonewall is an LGBT rights charity formed in 1989 in the UK, and is the largest LGBT rights organisation in Europe.

SCOUTING FOR PAGANS:
THE KINDRED OF THE KIBBO KIFT

by *Terry Baker*

*We tend to think of the rise of NeoPaganism and ecological awareness as fairly recent phenomena. I'm sure readers will be surprised to learn that a movement which blended both elements very effectively was active in post-WWI Britain. The movement was the **Kindred of the Kibbo Kift**, and its founder was John Gordon Hargrave. In this essay, Terry Baker outlines the history of the Kibbo Kift and the work of John Hargrave.*

John Hargrave (1894 – 1982) was a dreamer and pioneer. From an early age, he was interested in the woods and hedgerows of England, and, seeing an outlet for these passions in the new Boy Scout Movement founded by Lord Robert Baden-Powell in 1907-8, Hargrave joined, and quickly became Baden-Powell's right-hand man. He held the post of Chief Administrator, whilst working for the *London Evening News* as a cartoonist.

Soon however, Hargrave began to find fault with the Scout Movement, perceiving it to be too Christian-based and militaristic. Hargrave expressed the view to Baden-Powell that his organisation was too militaristic and falling into the hands of old soldiers and vicars.

Hargrave's idea was a breakaway movement – one which was based more on ecological awareness and tribalism. Hargrave reaffirmed a quote from G.K. Chesterton,[5] to the effect that the only serious rival to Roman Catholicism is Paganism.[6] His movement, the Kibbo Kift, would therefore use Pagan "teachings" and practices.

The Kindred of the Kibbo Kift was formally inaugurated on the 20th of August 1920 in a cafe in St. Martin's Lane, London. Hargrave termed the Kift as originators of New Paganism or Modern Barbarism. One of the intentions of the Kift was to lead the young out of the industrial wasteland of post-war

5 Gilbert Keith Chesterton (1874 – 1936), English religious writer famous for the Father Brown detective stories.

6 "I think I am the sort of man who came to Christ from Pan and Dionysus and not from Luther or Laud; that the conversion I understand is that of the Pagan and not the Puritan; and upon that antique conversion is founded the whole world that we know. ...Paganism was the largest thing in the world and Christianity was larger; and everything else has been comparatively small." – *The Catholic Church and Conversion* (1926).

Britain to an ecological, and maybe intellectual, perfection, via a Pagan scouting organisation with the emphasis firmly on "healthy" outdoor pursuits.

Hargrave began to produce a series of broadsheets called the Wikiup Sketches in which he wrote under his Kift name, "White Fox." These newsletters extolled the merits of the Kibbo Kift, encouraging kinsmen and kinswomen to adopt personal totems, use Haida totem-poles, produce personal signs, and participate in the Kift camps. These latter consisted of: Althing (Whitsuntide); Gleemote (Autumn); Kin Feast (Winter) and the Easter Hike (Easter). The Kift also began

> *"The Kift actively declared that the Conservative Party had no solutions to social or industrial problems and Hargrave's book, The Confession of the Kibbo Kift states, at a time when Victorian work ethics met head on with the diseases of industrialisation, that the Kift saw an ultimate goal in people working less and less – that "enjoyment", not employment, was the key to life."*

to formulate an ambitious project – a countryside headquarters which would be known as Kin Garth. This grand scheme was to be a commune, rather than a national campground, but alas, the money to fund such a project was not available.

The Kibbo Kift numbered about 500-600 active members, and it has been suggested that rank-and-file membership may have been in the thousands. Prominent members included H.G Wells,[7] D.H Lawrence,[8] and Ezra Pound.[9] Angus McBean[10] (known in the Kift as "Angus Og") was the official photographer and his studies of the Kift include side-on profiles of naked men, arms

7 Herbert George Wells (1866 – 1946), English author and one of the pioneers of both Science Fiction and tabletop wargaming. The first true nerd hero.

8 David Herbert Lawrence (1885 – 1930), English writer and poet. During his life many of his novels, including *Women in Love* and *Lady Chatterley's Lover* were called pornographic filth and censored or banned, but are now considered classics. Ken Russell's 1969 movie adaptation of *Women in Love* is a must-see.

9 Ezra Weston Loomis Pound (1885 – 1972), American poet who was a major literary figure in the early part of the 20th century. He later moved to Italy and became a leading supporter of the Fascist movement during WWII, leading to him being more generally known now as a contemptible shithead.

10 Angus McBean (1904 – 1990) was a Welsh photographer and surrealist who became one of the most significant photographers of the 20th century. He created a multitude of stunning celebrity portraits, including several album covers for The Beatles, despite his career being almost ruined when he was jailed for being homosexual, because that was still illegal back then.

outstretched in the "K" signal of the Kibbo Kift, astride Glastonbury Tor, as well as pictures of John Hargrave wearing a black hooded robe!

As the Kift developed, it began to take on a more political bias. The Kift actively declared that the Conservative Party had no solutions to social or industrial problems and Hargrave's book, *The Confession of the Kibbo Kift*[11] states, at a time when Victorian work ethics met head on with the diseases of industrialisation, that the Kift saw an ultimate goal in people working less and less – that "enjoyment", not employment, was the key to life. The adult members of the Kift were asked to read various books on economics and utopian philosophy, while children were recommended Mark Twain's *Huckleberry Finn*.

The Kift also produced a set of "policies". For example, the emerging Feminist movement was praised, but resolutely forbidden in the Kift as "everyone stood equal". The Kift perceived that establishment education only served the industrial state, and was therefore detrimental to "real" education. In *Confessions*, Hargrave writes that:

> ...deeply flowing in the Kindred, undefined and unanalysed, floods that dim creative chaos which the modern psychologist has termed the unconscious... The Kindred exists to enter into the everyday life of the people... sending roots into their most vital regional traditions and feelings, in order to combat nonentity.

The Kift was seen as the guardian of a Britain that had lost itself in a meaningless and devastating commercial scramble.

Hargrave's writings show that he had an erudite knowledge of mythology, religion, and spirituality, mentioning Mme. Blavatsky and being aware of the term "shaman". What is very interesting, in terms of recent magical & philosophical developments, is a sentence in the *Confessions* which reads:

> ... the principles of a "philosophy of truth" come from the Assassins" "Nothing is true, Everything is permitted".

In 1923 Hargrave had come across the economic writings of one Major Clifford Douglas,[12] and it was via these that the Kift began to develop itself into a political

11 *The Confession of the Kibbo Kift. A Declaration and General Exposition of the Work of the Kindred.* (1927).

12 Major Clifford Hugh "C. H." Douglas (1879 – 1952), English engineer and developer of the social credit economic theory. His books *Economic Democracy* and *Credit-Power and Democracy* (1920), and *Social Credit* (19124) were based on his application of engineering principles to economic theory and were quite influential at the time.

movement. In the late 1920's a split occurred in the movement where, just as Hargrave and his followers split from the Scout Movement, a group who were concerned about the increasing politicisation of the Kift splintered off to become "The Woodcraft Folk" – an organisation which is still in existence today.[13] In 1931, the Kibbo Kift was formally disbanded, and Hargrave's new platform became The Green Shirts – the Social Credit Party. This new organisation saw the economic divide as between "finance and the community", rather than "capital and labour". The original demands of the party, as outlined in the socialist publication *The New Age* was to seek to solve the chronic deficiency in purchasing power by issuing additional money to consumers and rendering subsidies to producers in order to liberate production from the price system, without altering private enterprise and profit. Hargrave, who was becoming a minor celebrity with weekly printed and radio armed forces messages, saw Capitalism as an excellent system in terms of production, but lacking an adequate system of distribution. He wrote of the Social Credit Party's economic strategy as an economic Runnymede.[14]

The Social Credit Party grew from strength to strength and membership reached many thousands. In 1932, an active campaign of public meetings, marches, newspapers, leafleting and even mild acts of industrial sabotage was initiated. Many attacks on the banking system in general, and the Bank of England in particular (which the Party saw as the real power of the wealthy) were published.

On the 27th June 1934, members of the party threw a green-painted brick through the window of 11 Downing St.[15] Three years later, the Green Shirts were to come under the restrictions of the Public Order Act of 1937, which was designed to bar groups such as Oswald Moseley's Black Shirts,[16] but also led to the demise of the Social Credit Party as well. For a while, members marched holding their green shirts on six-foot poles in front of them. Another of the repercussions of the Act was that the general public identified the Green Shirts with the Fascist groups whose marching had been banned by the Act. The Kindred of the Kibbo Kift unfortunately share those letters with the Klu Klux Klan, and the Kindred greeting gesture – a raised open hand, was unfortunately very similar to the Nazi salute for Adolf Hitler.

13 Despite this, the Woodcraft Folk continued to maintain a strong alignment with progressive politics including ties with the pacifist, feminist, and trade union movements.

14 Runnymede is a meadow alongside the River Thames, about 30 km west of central London, where the Magna Carta was signed.

15 The traditional residence of the UK Chancellor of the Exchequer since 1828.

16 Sir Oswald Ernald Mosley (1896 – 1980), English aristocrat and Member of Parliament, and leader of the British Union of Fascists, colloquially known as the Black Shirts. Footage of him and his neo-Nazi followers holding rallies and getting their asses kicked by protesters is widely available via the Internet. It's always fun to watch a Nazi getting punched.

The party struggled on, and in 1940, a Mr. R.J. Green, later dubbed "the Robin Hood of Downing Street", strode to the opened door of No.10 and fired a green arrow, on the shaft of which was written "End Hitlerism – War demands a debt-free Britain – Social Credit the only remedy – Social Credit is coming." He was led away to join his naval launch which was leaving for active duty the next day.

However, for all their confidence, publicity stunts, and efforts, the Party was formally dissolved in 1943. In 1944, it was announced that Hargrave had discovered that he had "healing powers".

In his later years, Hargrave turned to the career of a novelist, writing books such as *The Imitation Man*, which is a thinly-disguised attack on the banking system, and, in 1951, *The Life and Soul of Paracelsus*, a fictional account of the life and work of Paracelsus,[17] a subject on which Hargrave was considered an authority. He did consider standing for parliament again, as either an independent member, or by revamping the Social Credit Party, but neither of these moves ever came about.

His final appearance in the public eye came in 1976, when he entered into a legal battle with the government over the patent of a device known as The Hargrave Automatic Navigator which he had devised with a Mr. Williams during the war years. His patent on the device, a navigation system for aircraft, lapsed in 1946. In 1960 the government announced the invention of a similar device by Kenneth Honnick of the Royal Aircraft Establishment in Farnborough. Hargrave saw an opportunity here, and legal battle was joined, with him claiming compensation of nearly £2 million. Though Hargrave and Williams satisfied 5 of the 7 requirements for proving their claim, they lost the case. In court, Hargrave apparently gave a "rousing performance":

"There is no gain, save the fact that the government has wasted nine years of my life; I ask for justice and fair play. This process of quietly lifting useful inventions has been going on in this country since the reign of Elizabeth 1st."

17 Paracelsus, or to give him his awesome full name Philippus Aureolus Theophrastus Bombastus von Hohenheim, was a Swiss physician and alchemist who pioneered medicine during the Renaissance, particularly in the field of toxicology. His works on astrology and divination were a major influence on early Rosicrucianism.

SPOTLIGHT

Tantra

Tantra is a subject which most people associate with either sexual magick or yoga. This issue, Phil Hine talks to Vishvanath, an exponent of modern Tantra and a member of AMOOKOS, the East-West Tantric Order.

PN: How long have you been involved with modern Tantra?

V: Since 1981. In 1978, Lokanath, the then head of AMOOKOS, was initiated by Dadaji. At the time, I subscribed to a magazine called Sothis, and the publishers were producing a series of booklets on Tantra. I eventually plucked up enough courage to get in contact with them, and found out about AMOOKOS.

PN: What does Tantra involve?

V: It's very difficult to give a postcard sketch of Tantra. The thing that most people come across first is Tantric iconography, which often portrays sexual symbolism, which is a code for particular states of being. The first impressions people often get is that it is an extremely sexual path – which is true. What you don't see is the work that goes on behind, which relates to the way that you are bound up by your background, upbringing, and kleshas (obstacles). Karma, in the sense of the baggage that you carry around with you – conditioning and beliefs.

The main aim of Tantra is to push beyond your existing conditioning, which is a constant struggle. To allow yourself to have more choice the old texts sum this up with the words "enjoyment and liberation." The idea of liberation isn't anything to do with transcending the material, It's more about creating a greater amount of choice for yourself, instead of remaining locked up inside your own anxieties. The work enables you to create enough space for you to do those things which you want to devote time to.

PN: How old is Tantra, as a spiritual path?

V: It's difficult to put a date on it, simply because the Asian records are notoriously wooly as regards dates. It's estimated by a number of scholars that the Tantric path is at least 4,000 years old. Certainly the Nath line, which I form part of, goes back to the 17th century, which was when Matsyendranath formulated it from older paths.

PN: Are not the Naths credited by some scholars for formulating the Yogic disciplines?

V: The Naths have always had a reputation for being sorcerers and alchemists. Laya Yoga, which has become known as Kundalini Yoga, was developed by Goraknath, a disciple of Matsyendranath. He is also credited as being the founder of Hatha Yoga.

PN: The Nath tradition is often called the Vama Marg, or Left-Hand Path. Could you explain more about what that means"!

V: In the West, the idea of Left-Hand and Right-Hand Path has been associated with Latin terms like *sinister* – left. But in the East the whole idea was that "normal" religion was Right-Hand Path. That was for people who wished to live a "normal" existence, without any wish to delve into the occult, and wanted to live by the orthodox way, which was Dakshina Marg. However, those who were questing, would go for a whole range of different experiences – that path was the Varna Marg. To go on to the Left-Hand Path meant that you stepped outside the normal bonds of society. Men and women had equal stature, because they ceased to be governed by the orthodox rules of society. They were spiritual outcasts, in effect. That gave them the freedom to discover the delights and terrors of the big world.

PN: How would the orthodox have viewed these spiritual wanderers?

V: On the one hand, it was accepted that these individuals needed to be fed and clothed, simply out of reverence for the courage it took to step outside the caste system. But there was also a degree of fear there, which came from the stories about strange magical practices, and sorcery associated with these people.

PN: Could the ancient Naths be perhaps compared to some of the early Christian Saints?

V: No, I don't think that would be a fair comparison. What I would say is to think of them as tribal shamans or shamanka. Part of the whole initiation into the Tantric way allowed them to adopt a new persona. Their names became suffixed with the term Nath, which implies a certain degree of mastery over themselves, or whatever their chosen discipline was. That particular epithet was something that often formed part of tribal living.

For example, there was a "shaman" who lived in Essex in the 1800's known as "Cunning" Merrol. Cunning would be equivalent of Nath for that particular ethos. The same is true of the term "Merlin" in Celtic culture.

PN: There is an idea in the West that a lot of the Tantrics were wandering Sadhus, or holy men. Are you saying that some of Naths worked in communities?

V: That's certainly true. There were whole communities and clans of Tantric people. There were certain areas of India which were associated with Tantric communities – usually areas with sacred pilgrimage sites, for example the area around Kamrup, which was associated with Kali, and densely populated with Tantric families.

PN: How did Tantric ideas come over from the East into the West?

V: Before the great influx of Eastern ideas at the turn of the century and in the 1960's, there is evidence to suggest that certain individuals carried Tantric

> *"The idea of liberation isn't anything to do with transcending the material, It's more about creating a greater amount of choice for yourself, instead of remaining locked up inside your own anxieties."*

teachings into the West beforehand. There are enduring rumours of a Kali Temple in London during Victorian times, brought back by British officers from the Raj.

As for AMOOKOS, an Englishman, who later became known as Dadaji, was recommended by Aleister Crowley to go and explore the spiritual patterns of the Asian subcontinent. He travelled around Asia in the 1950's, exploring India, Nepal, Thailand and Southern China, and investigating the spiritual paths of the land. He was lucky enough to be initiated by the Adiguru of the Adinath sect, which was a Shivaite sect credited with the founding of the Kaula Tantric schools. He was also initiated by the last surviving Guru of the Uttara (Northern) Kaula Tantric schools. So in a way, the two schools that had separated, met back in Dadaji.

The methods of working from those schools were passed by Dadaji to another westerner, Lokanath, who set about propagating those ideas in the west. AMOOKOS was an attempt to try and reframe the Tantric knowledge for the modern world, for global conditions, and to try and turn them away from a culture-specific path, to something which could move around the world, to change its teachings to meet different situations.

PN: The Nath tradition is dying out in India, isn't it?

V: The Tantric communities were broken up by the British Raj, and Christian indoctrination also had a heavy effect. More recently, the trend towards western consumerism has badly affected the tradition of the wandering sadhus (holy men), as they no longer have a place in society. Also, Tantra itself is frowned upon in modern India. There's a classic story of how Lokanath went into a bookshop

in India and asked for a book on Tantra, and was handed a copy of a Masters & Johnson book on sex.

PN: How do you think Tantra has been accepted into the West?

V: It has taken root. Tantra will never be a mass-appeal path, except in its more sensational glamours – the sexual magick for example. The fundamental core of Tantra, which stresses that you learn through your own experience in the real world (rather than books), which requires quite difficult conditions, will never gain a mass following.

PN: How much is Tantra a devotional path?

V: Not very. Some Tantric cults in the past have been devotional. In India, Tantra was divided by the cardinal points – south, west, north and east. In southern India, the Tantric cults had a much more devotional emphasis, whereas in the north, they were much more geared towards action and knowledge. The Adinath and Uttara Kaula paths both have a strong emphasis on knowledge and action.

PN: A few concepts drawn from Tantra, such as the chakras and kundalini, have been absorbed into western occulture. How far do you think these concepts are misrepresented by being taken out of context?

V: The idea of kundalini, and the particular set of chakras which one sees in books & publications sprung from a particular system developed by Goraknath. I have to say that part of the beauty of Tantra from my point of view is that it represents a very personal path. The advice I've always been given is to discover my own maps of the subtle bodies. You have to remember that in Tantra, there are literally hundreds of such systems. Each one founded by an individual who has developed a particular approach.

When you take Tantric initiation, you are not necessarily adhering to what your first guru tells you, but beginning your own exploration. You can move on to different systems and draw what you need from them. Each individual system is complete in itself, though inevitably there will be similarities. But there is a great deal of variation in the fine details of the systems. So to pull the chakras and kundalini out of only one Tantric philosophy perhaps misrepresents the Tantric path as a whole. In some ways, the Tantric approach is very close to Chaos Magick – you have absolute freedom in being able to move between systems, each of which has its own specialities.

PN: Perhaps the problem is that people see one map, and mistake the map for the territory. What do you think of the claims of some New Agers who purport to be able to "detect" chakras using computers and techniques based on Kirlian photography?

V: I must confess that I do wonder if these things are possible. I don't honestly believe that there is one map to the Universe.

PN: **Do you not find it ironic that whereas ideas such as kundalini and the chakras have been "accepted" within western occultism, a lot of the other Tantric practices are still spurned?**

V: There are some glamours within Tantra that people tend to fix their gaze upon. Most people have a vested interest in staying away from things which are likely to cause them to re-evaluate themselves and who they are. Inevitably, there will be a certain reluctance to face areas of yourself that you're none too pleased with. There's a difference between the name and the practice.

PN: **Again, despite the current "trendiness" of shamanism, there hasn't been much interest shown in Kaula shamanism.**

V: Some people, I think, feel, and perhaps rightly so to a certain extent, that It's not of their culture. I don't feel that there's anything in modern Tantra, certainly not in AMOOKOS, that clings on to Asian culture.

PN: **But doesn't AMOOKOS emphasise working with Indian Goddesses and Gods?**

V: No. Some of the material we study and work with is from original Tantric sources, so you can do devotional rituals to Kali or Ganesha, and learn from those systems. But one of our aims is to develop a more global system which incorporates modern elements.

PN: **Do you think that Tantra will become a new "fad" within the New Age & modern occultism?**

V: There are certainly signs at the moment that many people are starting to employ the Tantric glamour. It remains to be seen how many of them will touch all those areas which Tantra as a path used to go into.

PN: **There seems to have been a crop of Tantric sex-manuals recently. It's as though people have recovered from the impact of AIDS in the last decade, and there is another resurgence of hedonism coming to the fore.**

V: Yes, tips on how to revamp flagging relationships with a hit of Eastern spice. Which is not really the approach a Tantric would take.

PN: **How attractive would you say that Modern Tantra is to women?**

V: That's a difficult one. To be honest, I don't think that Tantra has been particularly attractive to women for quite some time, going right back to the Mogul invasion of the Indian subcontinent. So many Judeo-Christian ideas, coming in through Islam initially, then Christianity later, made a culture which denied women the space to express themselves spiritually.

These days, part of the reason that Tantra hasn't been attractive to women is partly due to the writings of people like Blavatsky, who portrayed Tantra as "Black magic", and also the way that people like Philip Rawson, who wrote popular books on Tantra back in the 70s , tended to dwell too heavily on its sexual aspect. It's easy for women to imagine that approaching a Tantric Guru

means that you're going to be thrown into a sexual relationship. Whereas the essence of the Adinath school is that you only do what you want to do – there's no dictat.

There are a lot of men on the occult scene who try to present themselves as adepts of Tantra – using spiritual glamours to try and get themselves laid.

PN: **What's your view of lesbians & gay men becoming interested in Tantra?**

V: Lesbianism and homosexuality do form part of the overall Tantric tradition in India, so there should be room in modern Tantra for people to express their sexuality in whatever way they choose to.

PN: **Who would someone go about getting in contact with the Nath tradition?**

V: At this stage, It's really a matter of keeping your eye on the publications. There are a number of contact addresses for the Nath community both in the UK and internationally. If someone is sufficiently motivated to write in, then they will be put in contact with someone that they can talk to, so that they can make up their minds. Anyone coming for initiation usually has some kind of agenda, whether It's hidden or not, which has to be discussed openly before initiation can proceed. Tantra is very much a minority path, and people often find out that it is not for them after all.

PN: **What do you think are the general strengths of Tantra?**

V: The fact that it has come from a tradition that was hit by Judeo-Christian morality very late on. Whereas the European esoteric paths were heavily stamped on very early on, the Naths for example, were in their heyday in the sixteenth & seventeenth centuries. So the idea of plurality – many different systems wasn't suppressed. So you don't have the idea of there being "one right way" constantly being raised as a spectre. So Tantra is very open-minded and genuinely Pagan, in that sense.

The other big strength is that it should teach you to be open-minded, and genuinely courageous in the way that you deal with yourself and the conditions about you. It's very much bound up with the idea of expressing yourself, and not the shadows which are projected onto you by social conditioning. This is true of any truly esoteric path – It's a continual, twenty-four hours a day process, removing the glamours and obstacles which we continually gather around us.

Vishvanath, thank you very much.

PAGAN NEWS

MANY VOICES, ONE SPIRIT

JUNE '92
£1.50

SEX - SAFE DOESN'T MEAN SANITISED
SPOTLIGHT - A PRIESTESS OF THE SHADOWS
20 THINGS YOU NEVER KNEW ABOUT CRYSTALS!

New Orkney Revelations

As the enquiry into the Orkney Satanic Child Abuse Myth allegations proceeds, some interesting evidence concerning social worker procedure is coming to light. Such as, for instance, how a WPC[1] has expressed concern over the intensive interviewing of children by social workers investigating (i.e. looking for evidence of SCAM). It has also been revealed that social workers refused to pass on messages and cards from friends and relatives to children that they had taken into care – choosing instead to interpret them as containing "satanic messages". Normal activities such as riding horses, traditional island games, and Hallowe'en parties were also misconstrued as "Satanic".

It seems that the social workers, during their intensive "interrogations" of the children, noticed that they were "distressed" by having someone present taking notes. So they decided to defer writing case notes until three or four days after an interview had taken place – hardly professional practice.

Meanwhile, you might like to know that SCAM champion Dianne Core, doubtless pining for the glare of publicity, has recently appeared on German television, making her usual ridiculous claims about Satanic conspiracies. She has been mouthing off since 1988, and her allegations have probably led to thousands of wasted man-hours for the police and social workers. Mind you, the gutter press must love her and her ilk. A Glasgow newspaper, reporting on the Orkney enquiry recently, admitted that there was no evidence whatsoever for Satanic Child Abuse, but its editor still felt bound to "warn people" about the rise of interest in the occult. And doubtless most of you know by now that the BBC's daffy "supernatural" series, *Moon & Son*, was cancelled due to pressure from fundamentalists.[2] I wonder if the telephoning tactic would work in reverse – if every time the TV stations mentioned Paganism/ Occultism in a positive light, we all rang up and congratulated them? It's worth trying.

1 Woman Police Constable.

2 *Moon & Sun*, produced by well-known TV writer Robert Banks Stewart, ran for one 13-episode series in 1992, and featured a professional fortune teller, Gladys Moon (Millicent Martin), and her son Trevor (John Michie) as they solved a multitude of mysteries. We really want to see this sometime, it sounds delightfully terrible.

Vegetarians From Hell

Not content with their campaign against occultists and Pagans, Fundamentalists have also begun to target Wholefood shops! "Nutmegs Wholefoods" in Houghton-le-Spring, came under attack when fundies decided that decorative panels in the shop depicting Eygptian religion "proved" that the shop was a front for devil-worshippers – some excuse, eh? According to the store's owner, Janice Butler, the publicity generated by the fundies has helped her business.

Islamic Exorcists Jailed

Two Muslim "holy men" have been jailed at Manchester Crown Court for killing a 20-year old girl during a ritual exorcism. The girl died after eight days of violence during which she was deprived of sleep, food, and beaten with sticks. A Home Office pathologist told the court that her injuries were consistent with her being jumped and stamped on. The "holy men" apparently told the girl's parents that it was the evil spirit, not their daughter, who was suffering.[3]

3 Over the past years since this was written, Islamic exorcism of supposed evil spirits has become a booming business with a multitude of "Ruqya Centres" performing exorcism rites on a daily basis. A quick Google search brings up half a dozen located not far from where I sit writing this in London. But if you can't make it to an exorcism in person, don't worry – they will test and treat you for "sihr (black magic), jinn possession and evil eye/envy" via Whats App for the low, low price of only £70. Though you do have to make sure you keep a vomit bag handy while you are on the phone with them. Yes, that really is in the instructions.

SPOTLIGHT

A Priestess of the Shadow Realm

Linda Falorio is an American magician who has spent five years producing The Shadow Tarot, *a set of paintings and accompanying meditations exploring the Tunnels of Set – Kenneth Grant's convoluted metathesis of the "Night side" of consciousness.[4] An accomplished painter and writer, her pictures have appeared in* Skoob Occult Review,[5] *and her essays in* Dark Doctrines: The Nox Anthology,[6] *and* Starfire *magazine. A book of her short stories –* Lost Souls – *was published in the U.K in 1990 by Sarcophagus Press.*

PN: You're best-known in the U.K for your paintings and writing – are they the main expressions of your magick?

LF: In my personal life, I don't do a lot of external ritual, so it all comes out through my paintings & writings. I'm hoping to do more of that, and I'm preparing to launch into new projects, such as videos as well.

PN: You've done the *Shadow Tarot* – the exposition of Kenneth Grant's Tunnels of Set.

LF: In "83, Kenneth Grant told me about the Nightside Project and asked me if I'd like to get involved. So I did one of the images. Then Fred and I decided to get a house, as we felt that we needed access to the Earth energies and the Stellar

4 *Nightside of Eden* (1977). An influential, if somewhat controversial, exploration of the Qabalah, in which Grant aspires to explain what's on the "other side" of the Tree of Life. Apparently no-one explained to him that the word Sephiroth means a sphere, and that the Tree of Life diagram shown in most books is a two dimensional representation of a three-dimensional figure, thus it doesn't actually *have* an "other side". In other words, It's all balls.

5 This was a noble, but short-lived, publication which ran from 1990-1991.

6 Published in 1991, this volume contained works by such luminaries as Stephen Sennitt, Linda Falorio, Ramsey Dukes, Genesis P. Orridge along with some geezer called Phil Hine. Despite this last bizarre inclusion, it was still a fine book.

energies, which we see as our work – connecting the two. So we did more work on the Tunnels, in a very non-linear way. After we'd done several we decided to do them all because we got so much, personally, from doing each one. In "88 we finally finished them, and I'd written a little exposition. And people saw them and said "Oh we want those", so we started making them available to people.

The Shadow Tarot will only be available until the end of August, because I want to withdraw my energies for a while.

PN: Could you explain a little about your magical background?

LF: That's a long tale. I've been on the path for as long as I know about, with a family tradition (they were Italian) of being village healers, so magick has always been an important part of my life. When I was in my teens, I realised that orthodox religion didn't have a lot to offer me, so I began looking into other things, such as Buddhism or Taoism. I became very involved in Meditation and did a lot of experimentation with mind-altering drugs back in the late "60s.

I understand that in the U.K there were quite a lot more magick books around at that time. In the U.S.A. there was very little. So I didn't come across Crowley until 1973. I thought, "My god, if I had come across this five years ago I would have been dangerous!

I'd come across the writings of other people, such as Louis Culling,[7] but while they were interesting, they didn't have the "meat" to it. But Crowley I found more interesting. I'm really into exploring the outer edges of what's possible for human realities.

When I was in High School, I was part of a group called "Extra-Terrestrial Mining & Manufacturing". We actually got a contract with NASA to develop rocket fuel. We put in a bid, which was the lowest, as we didn't have a factory to support, and we won. So NASA called us up, and they spoke to one of my friends" mother. She said "Jimmy's not home right now", and they realised we were kids and not actually able to produce rocket fuel!

I think that this was part of my same "reaching out". That's a way that in our culture is accepted and rewarded – space travel – great. Of course, It's the Inner Technologies that are not rewarded, which interest me a lot more. So I was interested in "reaching out" from an early age. My way now is exploring spaces through a kind of Inner Alchemy. Part of the reason that I want to explore these spaces is to make them available to others. I think I have a way of exploring things that makes them interesting and available to myself and others.

PN: You're very much associated with Thelemic approaches to magick...

LF: Well, it depends what one means by that.

7 Louis T. Culling (1894-1973) was an American initiate of O.T.O. and author of several works on magick, most notably *A Manual of Sex Magick*.

PN: Okay, Kenneth Grant's work; Cthulhu Mythos magick.

LF: I very much believe in "Do What Thou Wilt" in the sense of getting in touch with one's Higher Self and moving in an integrated manner to whatever one's being is.

PN: This is interesting. A lot of women in the UK say that they are wary of the whole Crowleyan approach to magick.

LF: There are very few women who are drawn that way in the States as well. Many more are attracted to Wicca. I often think about the differences.

> *"I think that Babalon is more an office of power, in her own right, and I'm more into helping women to realise that. That they can be the sexy, wonderful, powerful person, but that they don't have to do it in relation to a male magician."*

PN: Some female magicians say that the whole Crowley & Grant approach to magick is too male-based, and that it puts down women.

LF: Well I can hear that. But I consider the source. Crowley did a lot to get beyond his culture, but he was still very bound by it and I can't blame him for that. I look at what he wrote that is useful to me. Actually, I'm currently involved with a group of women who are trying to redress that imbalance and bring women back in. We're bringing out a book on Babalon in the next few months, with all-women contributors, including Nema, Mishlen Linden and myself. A couple of years ago I had this idea of a "School for Babalons" because women often do feel shut out. I think that I'm probably a very masculine woman, and so I can deal with this kind of male head-trip, and get out of it what I want. I think that I have a lot to share with other women, and these other, very powerful magical women that I know got together and said "yes, there are a lot of women out there, and we have to show them that they can use this system." So we see the lack, and we're working on it.

PN: A comment that's been made to me recently is that some male magicians see Babalon has their "cosmic fuck", whereas there's a lot more to her than that.

LF: That's right. They do. You'll find out (laughs).

PN: Do you think It's a positive step that more women are recovering the Babalon current?

LF: Absolutely. But of course I define Babalon in my own way, and that is not as the cosmic fuck. To me, the Scarlet Woman is the cosmic fuck, and that's a valid path for any woman – or man (I'm gender-neutral). But I think that Babalon is

more an office of power, in her own right, and I'm more into helping women to realise that. That they can be the sexy, wonderful, powerful person, but that they don't have to do it in relation to a male magician. Nor do they need to do it strictly in terms of the Wicca tradition, which is a wonderful tradition also, but It's a different orientation.

PN: How do you see magick changing in the States?

LF: Well, I don't exactly have my finger on the pulse. I'm very, very solitary. There are these huge gatherings, though, which are fun. There are lots of people getting interested in magick; not just the hardcore element – there's a lot of fringe people being drawn in and its getting bigger and bigger with the new kids. Having been involved in magick for more than 20 years, It's interesting to see all the kids coming up and getting into it. That's great. We've just visited Kenneth Grant, and we talked about the idea that there has been a sudden twist in the magical current. Nobody really knows what It's about. I feel it most strongly, and I feel that my next series of paintings and writings are going to reflect this. I don't know what it is yet. But I certainly feel that I'm on the cutting edge out here, and there are all these other plateaux and interesting places and safe places that people will settle in.

PN: In making these forays into darkness, we often find ourselves in areas where we can't quite grasp what's going on, yet we know that something is.

LF: Well, I guess It's that way by definition. It's often difficult to analyse or express, which makes art a good way of dealing with it and articulating it.

PN: A lot of books which try to explain magick try to make it too scientific and cut-and-dried. What they fail to get across is the sense of the wonder of magick.

LF: Well, some people like that. Last year, at one of the gatherings, we did a Shadow Working, which was really fun. I think that communicated to people a sense of awe and mystery.

PN: Weren't some people freaked out by the Shadow Working?

LF: The first year that we did it, we heard that there was an anti-rite going on. Which was amusing, because all we were doing was showing slides, and there were people watching and eating popcorn like it was Saturday Night at the Movies. There wasn't anything particularly earth-shaking, but people had apparently done an anti-rite.

Last year was different. It seems that the more we talk about it, and the more we let people see who we are, that It's really safe, and is just a different thing to explore, then more people take to it.

We did the *Shadow Tarot* in total isolation for five years – we didn't see anyone or go anywhere. When we went to this gathering to show the slides I didn't know what would happen. I had this "plunging off a cliff" kind of feeling. But people

loved them! I was really excited and surprised. In the States there is a real sense of mixing and melding between all kinds of magick – Wicca, Tunnel Workings, the O.T.O's, Buddhism, Tantra, and Voudou. They are all coming together and people are feeding off of everything – no one's saying "Oh I'm just this and I'm not interested in anything else" – people are taking bits and pieces from everywhere.

I really do believe in the value of all paths, including Christianity. I do psychic and astrological counselling, with all sorts of people. I have fundamentalist Christians consulting me, and I have no problem with that. They see all my strange books and things.

PN: Do you find that when people meet you for the first time, they say "you're not like we imagined you to be"?

LF: Often, yes. Especially when they come to my house. We have all my paintings, and our esoteric objects in plain view. My father occasionally asks me why I have black candles. But we have a very orderly, very peaceful house. I need that. They say "Well you're into all this dark stuff, we thought it'd be chaotic and dangerous to be here – and we feel at home, and warm and loved, and this is so great".

PN: Have you run into any problems with the anti-occult hysteria?

LF: No. I was really shocked to hear what's going on in the UK Sometimes at big gatherings, there'll be infiltration by protestors, but I've had no problems directly. Things are so diffuse in the States, and most people think these anti-occult crusaders are crazy. The worst we've had to put up with is political in-fighting with other occultists. I feel that I have important stuff to do – at least It's important to me, and others, so I really don't want to waste my time with that sort of thing. If someone does see value in my work, then I'm happy to share whatever I can with them. If they don't like it, then I'm elsewhere. I don't want to convert anyone – I simply don't care whether anyone accepts my work or not. If they do, I think that's great.

Linda Falorio, thank you very much.

VIEW POINT

The Question of Sacrifice
by *Andrew D. Chumbley*

The Question of Sacrifice, its acceptability or its denunciation, is a sensitive issue in the moral climate of today, but since it is such a burning issue it is a question that must inevitably be broached. In considering this issue one must attempt to be conscious of the wide variety of viewpoints, taking into consideration the moral, social and magical implications involved. One must be realistic and primarily accept that sacrifice has a role and function in the whole field of magical work. By "sacrifice" I mean the voluntary act of an offering, and this applies to the sacrifice of Time, Possessions, and Personal Wealth, as well as to the sacrifice of Life. All genuine practitioners of magick, whatever their persuasion, would agree that Time must be sacrificed if one is serious about the pursuit of any magical discipline; this also applies to the offering and devotion of the individual's personal resources and assets to the Path. No-one would disagree with the necessity of these forms of sacrifice, but when it comes to the issue of the sacrifice of Life – the so-called "Bloody Sacrifice" – there is a great deal of contention between occultists, and indeed between any persons concerned with the subject of religious devotion.

Historically there are references, incidents, and traditional practices of Bloody Sacrifice too many to mention or isolate if one is to judge from an accurate historical overview; each act having its own circumstantial and cultural relevance which must be seen in its own context, and not from some modern pulpit of

moral self-righteousness. The relevance we have to question is the role of such sacrificial practices today – whether or not there is a role.

Can we justify the taking of another's life for our own ends? If we were to ask an authority of rabbinical law he would say "yes", and justify such a sacrifice by his belief that his God has deemed the bloody sacrifice an acceptable offering. Quite simply, his faith is the only justification required.

The same justification would be given by a Hindu devotee of Kali or by a Voudoun Houngan. And yet if we were to ask most Pagans they would probably give us the same answer as most Christians – a categorical "no". Their justification would be that their God/Gods do not demand it of them, do not need or accept such offerings in this day and age, and that they themselves have no right to take

> *"Historically there are references, incidents, and traditional practices of Bloody Sacrifice too many to mention or isolate if one is to judge from an accurate historical overview; each act having its own circumstantial and cultural relevance which must be seen in its own context, and not from some modern pulpit of moral self-righteousness."*

another's life. The only right they assert in this matter is the right to lay down their own lives for their faith or their fellow beings.

In a social situation where one does not even have the necessity to kill in order to survive or even eat meat at all, then perhaps this justification has some ground, but if such Pagans were to find themselves dependent on hunting and gathering in order to survive then they would soon discover their "right" to kill.

In societies where people raise their own livestock and are dependent upon such for their survival, the slaughter of animals is necessitous, and in such societies the Gods play a vital role in the day-to-day struggle. So for them to offer their very means of survival to their Gods is indeed a true and worthy sacrifice. The confusion in this matter sets in when occultists view sacrifice as "technique" rather than a heartfelt and necessitated act.

To the Voudoun Priest, not to sacrifice is not to please your Gods and your ancestors, it is not to live. To cease the offering of life is to starve your Gods and your family. So it is not mere "technique" in his way of life, but rather, it is a vital part of his cultural heritage. Neither is such a sacrifice a disservice to the slain animal, it is an honour for it to die to feed the Gods, neither is the meat wasted since it is eaten by the people once its "essence" has been taken up by the Gods.

To the 20th Century magician the offering of a specific animal to a god or a spirit is not given under the same exterior pressure. It is given out of a belief in some principle or technique which states that power/ life-force released by the sacrifice is conducive to the manifestation of the evoked entity, or is conducive to the attainment of some desire or other. If that magician is of the genuine persuasion, believing his magick is not a mere past-time or some self-glorifying ego-trip, but an all-consuming passion indivisible from his life, then perhaps the same justification as that of the True Priest applies.

A personal viewpoint of mine is that the present body of a magician is the sum of his past states of Being and thus his own blood is the blood of all beasts that he has been. Therefore to offer one's own life-blood is as efficacious as the offering of another's. Some might think this is some sort of intellectual cop-out, an attempt to avoid the nasty business of killing animals in ritual – maybe! But in a time when magicians have no excuse for ignorance or lack of thought about these matters, I feel that this is perhaps one answer to the question of sacrifice. At least the offering of one's own blood is genuinely "felt" and is a true "sacrifice", a giving of oneself to the Gods.

This issue will not go away; it is of no use bowing under the moral pressure of one's Pagan peers or becoming a victim of the scandal-mongering hysteria of the media. We must each decide what we as individuals believe to be right; we must discover for ourselves what our Gods desire from us. Be aware that the actions of a single magician can reflect upon all of us, yet if the acts of your faith exhibit reverence for Life and for the Living, then you may walk your Path with dignity.

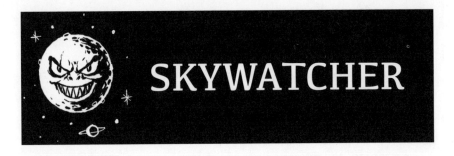

On Mars
by *Anthony Roe*

A recent TV poll revealed Mars as the pre-eminent planet in popular consciousness. The general feeling for the Red Planet is an anticipation of menace, admirably conveyed by Gustav Holst in his *Planets Suite*. Interestingly Holst completed his composition before the horrors of the First World War, and he had indeed no personal bellicose experiences on which to draw.[8] This points to an inherent understanding of the Mars archetype. Its ancient lineage echoes uncompromising characteristics as the harbinger of War. The sevenfold titles of Nergal-Mars from Chaldea affirm sinister aspects. Mars is named "The Sultry", "The Luminary Reigning over the Star of the Hyena", "The Hostile", "The Enemy" and "Wolf".

Until the middle of the 18th Century the year in England began on 25th March. The month was named after Mars, and indicates an essential feature of the planet's nature: that of "opening", or "piercing". The Sign of Mars is Aries, Fire of Fire. Crowley defines this elemental categorisation as "the swift violence of onset".[9] Mars gets things going, as the initial spark, and ignites desire for further activity.

The cycles of Mars are very important in anyone's life. Mars transits act as energising, exciting, activating influences. Such transits are usually accompanied by strong desires and an impulse to action. Martian energy can be expressed usefully, but if the energy is not properly dealt with, it can show itself in anger, violence, or wilfulness.

8 Gustavus Theodore von Holst (1874 – 1934) was an English composer. He was introduced to astrology by writer and occultist (and long-time friend of Aleister Crowley) Clifford Bax in 1912, which inspired the creation of his most famous work *The Planets*. Although Holst did begin work on this suite before the beginning of World War I, it was not premiered until the end of the war. Holst remained a keen astrologer for the rest of his life.

9 *The Book of Thoth*.

Transits through the natal houses indicate those areas or affairs of life that are influenced. If Mars makes good transits to natal planets and is well-aspected in the natal chart, this furthers ambition and leads to worthwhile achievements, albeit with effort. If Mars is afflicted in the natal horoscope and makes unfavourable transits, a person can be exposed to peril, according to the nature of the house. Impatience and ill temper at least is evident, at most, rash, ill-considered acts can be provoked and lead to conflict or loss in matters ruled by the house transited by Mars.

The stationary and retrograde periods of Mars are important too. Mars can occupy a single sign or house for periods of up to six months. Major changes result in the affairs ruled by the sign or house. When Mars is stationary while progressing from retrograde to direct motion, new trends in activity will begin, becoming more noticeable when Mars moves forward again. When Mars is stationary from direct to retrograde motion, delays occur and it may be necessary to retrace a path already taken to sort out neglected details. The house and natal planets subject to the retrogradation will suffer unsettling attention.

It takes Mars approximately two years to pass through all the Signs of the Zodiac, and during this cycle transiting Mars forms major aspects to each natal planet about once every six months. These transiting aspects of conjunction, square, or opposition set off what can be recurrent crises in affairs ruled by the respective planets. These cycles should be observed carefully by every serious student of astrology. They often mark the start or finish of important or significant matters.

Those seeking to control their lives during such critical periods may care to carry out an astral ritual, for confidence, courage, or to further some enterprise. Stand a candle on a newly cut slip of clean paper, freshly scribed with the magical square of Mars. Write your petition succinctly on the reverse. Face south, light the candle and intone a worthy word sixty-five times, the lineal sum of the square. This enables you to focus your mind and draw together the fibres of your being. Thus tensed, you may direct your will in accord with the view of your mind's eye, and accomplish the object of your desire, as expressed in the petition. The degree of your success will depend on the intensity of feelings you are able to arouse. Breathe over the flame to extinguish the light, and let your desire drift into the void as the smoke trial dies.

The Magical Square of Mars

It may well serve to use the mystical names of Mars according as you work in one or another of the four seasons. A manuscript in the British Library preserves these as HALANU, MATANNIS, YHE-DAMICHELYN and HECHETRADA

for the elemental seasons of Spring, Summer, Autumn and Winter respectively. Alternatively, the invocant may incant the divine name ISCHYROS for spiritual elevation under the aegis of Mars. Devotees of old England may well call Mars effectively by the Romano-Celtic names of the deity, as BELATUCARDROS,[10] the "fair-shining, homed one" of Northern Britain, for example, or BRACIACA "the intoxicated one" (Derby), COROTIACUS (Suffolk), or TEUTATES (Hertfordshire),[11] depending on the location of the practitioner who would conduct the rite.

11	24	7	20	3
4	12	25	8	16
17	5	13	21	9
10	18	1	14	22
23	6	19	2	15

According to the Roman writer Minucius,[12] Mars is fire, summer, strength; so when you work be of ardent desire and firm intent. A sign of success is the generation of heat. Sweat is a libation of Mars. The petition itself may be consumed in the flames to precipitate the desired result. The planet rules Tuesday, and Friday night, though in this latter respect Al-Biruni,[13] writing in the 11th Century, gives Mars dominion over Saturday night. But whether or not you choose a planetary day or hour, properly observed the cycles of Mars will tell you when best to make that "leap of faith" for whatever is the matter at hand. If properly applied, Mars gives victory. The research of Gauquelin[14] shows Mars as prominent in the charts of those who have a combative spirit. The arousal of Mars in your everyday consciousness will enable you to assert your true self.

10 Belatucadros or Belatucadrus, was a god worshipped in Celtic northern Britain. Roman soldiers stationed in Britain adopted his worship as a form of Mars. Dedications to him can still be seen inscribed along Hadrian's Wall.

11 Other Celtic deities adopted by the Romans in Britain as forms of Mars.

12 There were many notable Romans of the Minucius family – we assume the one referred to here is Marcus Minucius Felix, author of *Octavius*, a dialogue on Christianity between the Pagan Caecilius Natalis and the Christian Octavius Januarius.

13 Abu Rayhan al-Biruni (973 – 1050) was an Iranian scholar of physics, mathematics, astronomy, natural sciences, history, religion, and linguistics; and who is now generally accepted as the first anthropologist.

14 Michel Gauquelin (1928-1991), French psychologist who attempted to prove that astrology had a scientific basis. He discovered the "Mars Effect" – a correlation between the astrological position of Mars in a birth chart to the athletic prowess of the subject.

PAGAN NEWS

MANY VOICES, ONE SPIRIT

August '92
£1.50

SPOTLIGHT- OLIVIA DURDIN-ROBERTSON
ARTEMIS OF THE GREEKS
STEPHEN MACE ON INITIATION

August 1992

NEWS

Spiritualists Attacked in Swindon

Last month, two Spiritualist Healers were beaten up outside a Psychic Fair in Swindon by born-again Christians. Shirley Poyntz, aged 53, was punched in the chest by a 28-year old schoolteacher, whilst her colleague, 46-year old Ian Richards, sustained injuries to his knee which have left him on crutches.

The trouble flared up at a Psychic Fair, where a group of people, believed to be fundamentlist Christians, were leafleting visitors, who complained of harassment. Ms Poyntz asked the group to desist, and, on returning to the foyer, was surrounded by three men from the group, one of whom punched her to the ground. Mr Richards came over to help her, and the same assailant tackled him to the ground as well. Another man stood over them laughing, saying that it was "God's hands which had done this." Ms Poyntz claimed that this second man also proclaimed himself a minister from the Baptist Church. The two healers were taken to hospital, and doctors described Mr Richards' injuries as acute.

Mr Richards says that he was "disappointed" with the way police responded to the situation, as, although a statement was taken from the caretaker at the school where the Fair took place, no extensive enquiries were made. Mr Richards claimed that the man guilty of the attack was taken away by the police but let off with a caution for a first offence.

New Research into Spiritual Experience

One person in three will have a spiritual experience that may radically change their lives, according to a report from the Alister Hardy Research Centre[1] in Oxford. However, the report goes on to say that most people who have such an experience are unwilling to reveal it to others, due to fear of ridicule. The report also claims that people who report transcendental experience are above "average" in emotional stability and expression of concern for others. The centre has over 5,000 first-hand accounts of spiritual experiences and is open to receiving more. They hope to establish as to whether there is a "common core" to all spiritual experience regardless of race or belief. Anyone who feels like relating a spiritual experience should contact the Alister Hardy Research Centre, Westminster College, Oxford.

1 Alister Clavering Hardy (1896 – 22 May 1985), noted English marine biologist, founded the Religious Experience Research Unit in Oxford in 1969.

OBOD Convention

The Order of Bards, Ovates & Druids held their first London Convention at Conway Hall, on the Summer Solstice. A glittering array of speakers was promised, but punters who had already paid £3 to get in through the doors were faced with the prospect of paying a further £3 for each lecture/workshop. The day was confused somewhat by the OBOD membership nipping off to Primrose Hill for three hours or so in the middle of the afternoon, no doubt to do something "Druidic",[2] leaving confused members of the public wandering around the massed stalls present. Choosing the Summer Solstice, though historically significant for OBOD, on reflection, was not the best possible day for a public gathering, since many folk would be out doing their own thing – let's face it, who wants to stay in London on the Solstice?

Carylon Calling

Kevin Carlyon, self-proclaimed "King" of the Witches and media superstar has apparently been "at it" again. His latest stunt has been to claim that he has set up an "Occult Grid" – talismanic symbols have been planted at 40 sacred sites around the country (including Stonehenge, Avebury, Rollright and Kitts Coty) to ensure that only "justified" rituals are allowed to work and, best of all, to ensure that all energy raised at the sites by other occultists & Pagans (and even mere "visitors") is channeled into the central talisman.

This isn't particularly an original idea – groups of New Agers have been planting crystals at sacred sites for years. What is more "sinister" (if we can seriously use that term with reference to the antics of the "King"), is the idea that one person, or group, feels that they have the right to decide for the rest of us what is a "justified" ritual.

SPUC on Warpath in Belfast

Plans to open a Brook Advisory Centre in Belfast have met a barrage of threats and vilification by churches and religious pressure groups, led by SPUC – the

2 This event turned out to be the 200th anniversary celebration of Iolo Morgannwg's formation of the Gorsedd of Bards of the Isles of Britain on Primrose Hill in London in 1792. It also marked the investiture of Dwina Murphy-Gibb, Irish-born wife of Robin Gibb of BeeGees fame, as the Order's Patroness.

Society for the Protection of Unborn Children.[3] The Brook Advisory Centres are a respected counselling service which provide contraceptives & information for teenagers. Anti-Brook lobbyists are threatening tactics such as taking photographs of clients & displaying them in shop windows. One Church leader admitted that two hundred volunteers were ready to picket the centre on a rota basis, and that they intend to force the Belfast Brook centre to close.[4]

Row over New Stone Circle

Christians in Derbyshire have been protesting recently over a circle of stones which have been erected at the new Severn Trent Reservoir at Carsington. Local objectors, including a vicar, have been complaining that the stones, a "sculpture" by landscape architect Lewis Knight, are a celebration of Paganism.

Knight admits that holes pierced in the stones are aligned to catch the rising sun of the summer & winter solstices, but says that the sculpture is merely a bit of "monumental" fun.

Ahmed Osman under 'Death Sentence'

Ahmed Osman,[5] author of the controversial book *House of the Messiah*,[6] which has managed to offend both Christians & Muslims due to his questioning of the historical identity of Jesus Christ, has recently been threatened with "death" by fundamentalists. He has had to cancel a European tour and a radio debate about his views, and police are worried that he could suffer the same treatment as Salman Rushdie.

3 Set up in 1966, this heinous organisation not only opposes abortion, but also contraception, right-to-die legislation, and same sex marriage. And we bet they don't do anything to help children once they *are* born either.

4 Unbelievably, they are still picketing that same centre as we go to press with this book. You have to give them credit for persistence, though you'd think that after nearly 30 years they would have figured out they are wasting their time. If only they could spend the same amount of time and energy on something to actually make the world better, instead of harassing vulnerable young women and medical professionals.

5 Ahmed Osman (1934 –), the Egyptian-born author of several controversial books about Ancient Egypt, Judaism, and Christianity.

6 *The House of the Messiah: Controversial Revelations on the Historical Jesus* (1992)

Publishing News

Despite the endless parade of crappy New Age titles flooding the market, a few gems do occasionally surface. Books to look out for at the moment include *A Chariot Drawn By Lions* by Ashpodel Long (The Women's Press), and in August, Cthonios Books are to release *The Goddess Hecate*, a collection edited by Stephen Ronan which includes translations of *Hymns to Hekate*, and an extensive range of Chaldean material examining this much-misunderstood Goddess.

Judicious use of phone-taps & spy-servitors has also turned up at least one biography of Austin Osman Spare being written for future release. And finally, in the wake of Andy Collins' new book on crop circles, *The Black Alchemist* is to be reprinted, followed by a sequel – just when you thought it was safe to go back into the bookshops!

Religions Ally vs Supreme Court Case

There have been interesting developments on the religious front in the States recently. Religious organisations which, on the surface, seem to have very little in common, have been supporting each other with respect to a case in the Supreme Court. The case concerns the "right" of the Hare Krishna movement to hand out tracts and ask for money from travellers in New York's airports. The Krishnas are being supported by the National Council of Churches, Catholic, Jewish & evangelical organisations, as well as civil liberties advocates, claiming that First Amendment liberties are at stake in the case.

Religious organisations in the USA are now showing an increasing concern over the erosion of their legal rights. Two years ago, the Supreme Court ruled against two members of the Native American Church, who had sued for unemployment benefits after being fired from their jobs for using peyote, which is considered a sacrament in the church. A number of religious groups are now mounting a legislative offensive, backing the "Religious Freedom Restorative" – a federal message aimed at overturning the so-called peyote decision. Another case due to come before the Supreme Court in its next term has arisen over a group of followers of Santeria, who are fighting a law banning animal sacrifice. Santeros believe that the ritual killing of doves, goats, and other animals is essential to their worship. Believe it or not, the Santeros' case has the support of groups such as the National Association of Evangelicals and the Mormon Church.

Events such as these do much to define the difference between the American and British attitudes to religious freedom. In the U.S.A. the government is the common enemy, and both Christian and Afro-Caribbean groups unite to protect their rights. In Britain, the government and Church are on the same side, and

so the non-conformists get dumped on. The religious groups in the States are worried about legislation which will put religious constraints into the hands of civil authorities, which runs contrary to the First Amendment's promise of free exercise of religious worship.

The Unkindest Cut

Doubtless many readers will be familiar with the story of the Curse of Tutankhamun, which over the years has struck over a dozen of the archeological team who originally unearthed him. As if to add insult to injury, it has now been revealed that Tutankhamon's willy has gone missing! Although clearly shown on original photographs of the mummy, it has now been revealed that, in true Osirian style, it is no longer where it should be. It seems that Carter, the guy who dug up the boy King's remains, mutilated the body when stripping it of its gold. Perhaps he disposed of the willy in a fit of Victorian prurience, or detached it with some other purpose in mind? Sounds like a good idea for a Psychic Quest – any takers?

Karnak Temple Bombed

Droves of New Agers swarming over to Egypt have apparently stirred the ire of Islamic Fundamentalists who see them as infidels, who are attempting to revive the ancient "Pagan" religion of the Pharaohs. Egyptian officials, sensing an easy way to make money, have lifted the ban on allowing visitors to meditate inside the Great Pyramid at Giza, and now groups of New Agers commune with "the energies" for a fee. But last month, the 4,000 year-old Temple at Karnak was struck by two bomb blasts – religious extremists are thought to have been responsible, and Egyptian tourist officials are worried that further attacks could scare off visitors and one of the country's main sources of income. New Agers have held "harmonic convergences" in Egypt to waken the world's collective unconscious. So far, they appear to have raised the consciousness of the Islamic Fundamentalists – who wouldn't recognise a crystal if they sat on one, and want to ban all "Pagan worship" and impose traditional Islamic law.

Uri Geller Axed from *That's Life*

Confusion seems to be reigning at the BBC over the circumstances around the sudden cancellation of an appearance of Uri Geller, on Esther Rantzen's programme *That's Life*. Geller had been booked to appear alongside housewife Nita Nettlewood, whose watch had stopped mysteriously eighteen months previously while watching a programme about the famous psychic. Geller was

to have attempted to fix her watch on the air. The BBC paid for Nita and her husband to stay at a luxury London hotel while the programme was being recorded. However, mere minutes before they were due to be driven to the studio, the BBC called them to say that the show had been cancelled. The Beeb told Nita that they had been told that Geller had flu and so could not appear. But the tale took a new twist a few days later when Geller rang Nita, and asked her if she had recovered… He said that the BBC had called him and cancelled the programme because she had flu! *That's Life* refused to make any comment.

Prat of the Year!

We ocasionally award this honour to people who do really stupid things. This year's title goes to the anonymous person who has been sending out "curses", under the pseudonym of the "Odinic Order of Kent" – a group which does not exist. A couple in Kent received an anonymous "death threat" which consisted of a bunch of runes and a quote from the Bible – Thou Shalt Not Suffer a Witch to Live. The man and his pregnant wife were, understandably, worried by this. They contacted the Pagan Federation who passed the details on to Freya Aswynn, one of the world's foremost authorities on the runes. Freya herself received a similar letter, and the *PN* graphological analysis team is currently having a good look at the handwriting. It's unfortunate that the sort of scum who do this sort of thing are attracted, and more unfortunately, tolerated in the Pagan scene. It's just the sort of thing that the gutter press would love to get hold of. We'll be following this story up, so more information would be welcome!

Walsingham Shrine Damaged

Fundamentalist Christians are thought to have been responsible for recent damage to a statue of the Blessed Virgin in the Slipper Chapel, at Walsingham. The Slipper Chapel dates back to the Medieval era, and was originally restored in 1890 by Charlotte Boyd. In the 1950's, the Bishop of Northampton paid for its restoration, and commissioned a 15' tall statue of the Virgin Mary holding the child Jesus in her arms. In recent years, on Spring Bank Holiday Monday, the statue has been carried around Walsingham by a procession. A group of born-again Christians have taken to hurling abuse at this event, saying that it is an example of idolatry! At the end of June, an intruder entered the Chapel, picked up the statue, and hurled it to the ground in front of the altar, damaging it. Perhaps the Fundies are getting ready to take on anyone who doesn't fit into their narrow view of religious acceptability!

ARTEMIS OF THE GREEKS

by *Steve Moore*

How do modern Pagans interact with the ancient deities? It seems to me that there's a range of approaches: at one end of the spectrum a desire to make the deity relevant to our own times and circumstances, at the other a wish to understand the deity as known to the ancients. I'm not implying that either approach is right or wrong, and many people steer a middle course; but for the sake of discussion It's easier to talk about the extremes. This piece was prompted by Lynne Morgan's article on Dianic Crafte *(She Speaks,* May "92),[7] so I want to concentrate mainly on Artemis. To me, this seems to be both typical of a lot of Dianic writing, and tending toward the "goddess for our times" approach. I hope I won't do Lynne an injustice by summarising her view of the Goddess as follows: Artemis is the Goddess of the hunt and the Moon; being virgin, she personifies women as sexually autonomous and independent of men; she's concerned for victimised women and wild creatures; and she's connected with the Moon, lunar cycles, and magic.

This may be fine as far as it goes, and Lynne is perfectly entitled to her interpretation. But It's a view heavily influenced by the Jungian theory of archetypes, which is psychological rather than mythological, and doesn't appear to pay much attention to the historical data.

So, very briefly, I want to deal with two questions: how was Artemis understood by the ancient Greeks, and how does this relate to the modern "Goddess for our times' model? Given the choice, I'd rather refer directly to original Greek authors, but It's not the *PN* style to overload things with footnotes[8] and the material I want to look at first can be found in any decent mythological dictionary anyway. I'm using Pierre Grimal's *Dictionary of Classical Mythology* (Blackwell, 1985), which includes the original source-references if anyone wishes to check further; and I really only need brief summaries to make my point.

So, concentrating on the mythology first, this is Artemis as the Greeks saw her. Artemis and Apollo were Olympian deities, the twin offspring of Zeus and Leto. Artemis is a virgin and a huntress of both animals and mortals, and her arrows bring pain to women who die in childbirth. She and Apollo were responsible

7 Not included in this "best of" anthology. We had to cut quite a few articles that didn't quite make the grade.

8 It wasn't our style then, because we had such a limited page count to fit things into, but I think we are more than making up for it now...

for killing the children of Niobe, who'd insulted Leto by boasting about her own offspring: Apollo shot the six boys, Artemis the six girls. Apollo and Artemis also killed the giant Tityus, who had tried to violate Leto. Acting alone, Artemis continues in the same vein. Several reasons are given why the huntsman Orion offended her: he challenged her at throwing the discus, or he tried to kidnap one of her male companions, Opis, or he tried to rape her. All the versions end the same: Artemis kills Orion. When Actaeon saw Artemis bathing naked, she caused his own hounds to tear him apart. When Ocneus forgot to sacrifice to Artemis, she sent the Calydonian boar to ravage his country. In pursuit of the boar, several huntsmen were killed, and the affair led eventually to the death of Meleager. When one of her Nymphs, Callisto, became pregnant by Zeus, Artemis killed her. When Agamemnon offended Artemis by boasting of his hunting skills, she becalmed his fleet; the wind could only be raised by sacrificing his daughter Iphigenia to the Goddess. In one version of the story, he did so; in another Artemis substituted a doe and carried off Iphigenia to Tauris, where She presided over an Artemis cult that practiced human sacrifice.

This has been very abbreviated, but here we have all the major myths of Artemis. Virtually all relate to hunting (and little else), and every single one has resulted in the death of other individuals. Whether we call her vindictive, justify her actions by saying she was jealous of her privileges, or say that in some cases she was correctly avenging wrongs, the simple fact remains: Artemis kills, and she kills women as well as men. This aspect is entirely absent from Lynne Morgan's portrait of her.

Turning to ancient Greek religion we find a similar picture. This time I'll use Walter Burkett's *Greek Religion* (Blackwell, 1985) as a handy reference, as it too contains the original sources. To save space, I'll pass by identifications with Asiatic Goddesses like Artemis of Epheseus and concentrate on the purely Greek context.

In Homer, Artemis is known as Potnia Theron – the Mistress of the Animals, and by extension the whole of wild nature. She protects animals, but she also kills them, and is worshipped by hunters. She was offered animal sacrifices, and worshipped by both men and women. In Attica, blood was drawn from a man's throat at the festival of Artemis; in Sparta, young men were scourged in her honour until the blood flowed. Whether these practices, together with the myth of Iphigenia, point to a very ancient practice of human sacrifice to Artemis is a moot point; but perhaps not to be discounted entirely.

Let's now turn to Artemis as a Goddess of women. Her role of easer of childbirth depends mainly on her identification with the extremely ancient Cretan birth-goddess, Eileithyia; but we have also seen that she causes pain and death in childbirth. In her own right, Artemis presided over initiatory festivals for young

girls who were reaching marriageable age. Now, a girl of marriageable age was known as a nymph; the literal meaning of the Greek nymphe is "bride". Obviously, to be a bride implies the presence of a husband, and the sexual relations to follow. This explains why the Nymphs, as a general order of beings (with the exception of those in the train of Artemis) were extremely heterosexually active. We can also understand why the festivals of Artemis were regarded as important social occasions and opportunities for young men to meet girls. So, while the image of Artemis as sexually autonomous and independent of men may make a fine psychological archetype and role-model for independent women, it doesn't give a true picture of her major religious function, which is that, while remaining

"Artemis and Apollo were Olympian deities, the twin offspring of Zeus and Leto. Artemis is a virgin and a huntress of both animals and mortals, and her arrows bring pain to women who die in childbirth."

virginal herself, Artemis actually presides over the ending of virginity, and the beginning of sexual relations with men.

It hardly needs pointing out that nowhere in any of this is there an identification with the Moon. This is simply because Artemis was not originally the Greek Moon-goddess. The ancient Greeks already had lunar and solar deities, Selene and Helios, with their own mythologies, but from around the 6th century BCE they were superseded by Artemis and Apollo, largely as a result of scholarly speculation. Thereafter, the names Selene and Helios came to refer more to the physical Moon and Sun, as seen in the sky, rather than to the deities. There seem to be two aspects to this change. Firstly, Apollo became identified with the Sun, and as a result his sister Artemis was made Moon-goddess, almost as an afterthought. Secondly, Helios and Selene were not Olympian, but of Titan stock. There appears to have been a move to replace them with Olympian deities; which means that (if we wish to use the terminology) It's the patriarchal religion which is entirely responsible for making Artemis the Moon-goddess.

It can also be pointed out that the original Artemis had no connection with magic. This aspect came about because of her identification with Hecate. But all the varying aspects of the Goddess (Moon, magic, huntress, virgin, childbirth, etc.) appear to have been in place by the time Artemis was identified with the Italian Diana, again in the 6th century BCE and probably through the Greek states of southern Italy. And from all this developed the Diana of late antiquity, who in turn has carried through to today.

Which brings us back to Lynne Morgan and the view I've taken her of representing. I have no quarrel with that view if It's presented as an archetype, a role-model, or (to some extent) as a "Goddess for our times". But it does seem to me that It's been selectively distorted from the original, and I don't think it would

> *"Now, it seems to me that however we regard the ancient goddesses and gods (as aspects of the psyche, role-models, self-existent deities, or whatever), we really ought to look them full in the face and accept them as they are, not just take them as we'd like them to be."*

be a picture of Artemis that was familiar to the ancient Greeks, especially before the 6th century BCE. It lacks any sort of historical perspective, and it omits a great deal. But what worries me most about it is that It's just too nice: it omits all the darker aspects of the deity.

Now, it seems to me that however we regard the ancient goddesses and gods (as aspects of the psyche, role-models, self-existent deities, or whatever), we really ought to look them full in the face and accept them as they are, not just take them as we'd like them to be. We may, for instance, prefer to see Hermes as the messenger of the gods and guide of souls, but we also have to accept that he was a liar and a thief. And we have to accept that Artemis wasn't exclusively a goddess of women, and that she was a savage deity who hunted and killed. If we can't face the fact that our deities have their darker sides as well as their light, then surely we run the risk of constructing ethereal and meaningless fairylands. And if we can't accept the reality of our deities, how are we supposed to deal with the realities of our everyday lives?

Steve Moore is a contributing editor to *Fortean Times,* and author of *The Trigrams of Han: Inner Structures of the I Ching* (Aquarian Press, 1989).

SPOTLIGHT

A Priestess of Isis
Olivia Durdin-Robertson
Interview by Steve Wilson

Since its foundation, the Fellowship of Isis has grown to over 11,000 members. Membership is free, and open to all who seek communion with the Goddess. Many members of the F.O.I. are affiliated to other groups, such as The Craft, or the Church of Isis in Nigeria (which accounts for one-third of the membership). The F.O.I. is a multi-faith, multicultural federation. Members work in Iseums & Lyceums, where the liturgy is performed and training given to those who wish to be ordained into the priesthood. For a copy of the Manifesto and membership details, send an International Reply Coupon & SAE to: Clonegal Castle, Enniscorthy, Eire.

PN: How did you become involved in matters psychic & mystical?

Olivia: It's in my family blood, I think. My cousin Robert Graves wrote the book *The White Goddess* and my mother said that the Graves family went in for things which she regarded as very strange. My family were friends of W.B. Yeats. I remember once they were going to a seance at the home of Mr. & Mrs. Yeats, and that I had tea there. I try to remember what W.B. Yeats said, but all I remember is having Chocolate Cake!

My father designed Yeats" tombstone, which carried the inscription:
"Cast a cold eye On life,
On death Horseman, pass by!"
Later, my mother met Mrs. Yeats and asked her if she liked the tombstone, and she said "Yes, and Willie's delighted too!"

PN: What were your first magical experiences?

Olivia: I had curious dreams. I didn't think of them as being psychic, but I knew when things were going to happen, such as when people were going to die. My brother and I had what we called "extensions" – that is, in this ancient castle I dreamt that you could go through a magical doorway and down long passages into another world. I use this now in our trance rituals.

With regards to the mystical side of life, I more and more became aware that this world is an illusion, compared with the real world which I experienced in waves, like a space between seconds. I want to emphasize a big mistake some

people make when they have this experience. They think that they can do anything here, as it is all an illusion. But It's an illusion to test us. It gives us choice. It's teaching you through experience, and therefore the choice between good and evil, laziness and activity, intelligence and stupidity – all this is provided for by a trick story. In other words, the Great Mysteries of the Passion, which are very much like those of Isis and Osiris, are put on for us by an unseen but ever-present family of spiritual beings who are organising our life whereby we have a maximum of choice. I think sin is making a wrong choice – you lose the capacity to exercise choice. Take smoking – first you smoke because you wish to, then, because you have to! It's the same with drink, excessive sex, or even the habit of being a serial murderer! My brother and I believe free will is something you have to strengthen. One usually makes one mistake a day so perhaps one should do one act of will a day – even getting up in the morning!

I realised this world is a delusion put on for us as a mystery play, which is why I write so many mystery dramas, so that the participants can act the parts of deities.

PN: When did you first come across the Goddess?

Olivia: It was fairly late in life when I had actual total experience – I was about 29. I described it in my book, *The Call of Isis*. I saw this lady made of crystallised white light. I know a lot of people don't believe in UFOs, but she seemed to come in this great spaceship, and there appeared to be an intermediary craft which brought her here. It's a touch embarrassing talking about these things! I associated her with the Moon. The things which struck me were that we could communicate telepathically, yet I can't remember a word she said. Her clothes were hyper-modern, too. Different strips of material ran into each other, with no stitching – an amazing dress of mauve and pale green. Her neat black hair was drawn up into a lace scarf. I have always worn my scarves like it since. People often comment on this distinctive style – but I'm copying her spiritual headgear! She had the beauty of an athlete, the elegance of a dancer, but she was also a Queen. I think these beings evolve through the four elements – Earth, Air, Fire and Water. Possibly they begin as Elemental Spirits, on a parallel evolution to us. Possibly most beings, including those seen in UFO cases, never get lower than the Etheric realm, which is the higher part of the Physical realm. The Higher Physical seems to be the place of apports and Etheric Doubles. It's not Astral, It's here, but like the sound of a bat we're not normally aware of it.

PN: When did you first get involved with organising groups?

Olivia: At first my own experiences were enough, then I went through a period of reading – I read every book going – Indian Religion, Theosophy, Gurdjieff – and then I began to get spiritual guidance and was told that I could stop reading.

My brother and I were evolving in the same way, but separately – he was a clergyman, and was with his wife, who was very psychic. We were concerned with social welfare. In 1963 we got together and started the Clonegal Castle Centre for Meditation and Study. We just had a few heads of Orders come and stay, and shared ideas. From 1964 I became involved with very deep occult work, studied at the College of Psychic Studies,[9] and did a Spiritualist course at the SAGB,[10] which I loved. I joined with everyone – the Druids, the Alice Bailey people, and the Steiner people who were splendid. I enjoyed all of them and thought that it would go on forever. Then things began to develop. In 1971, my brother and I became aware of the imbalance in the world. Everybody was beginning to wake up to that. I still went to church and accepted Christianity as part of the package of world religions. Suddenly I realised the missing factor was the total ignorance of, and deliberate attack on, the religion of God the Mother. My brother came to this conclusion first – he's much more of a fighter than me. I tend to see other people's point of view, but his determination enabled us to found the Fellowship of Isis at the Vernal Equinox, 1976. It began as my brother, his wife and myself, and the aim was to draw together people who sought communion with the Goddess and the spread of knowledge of her. We thought we'd have about 12 people – we got one lady who wrote asking to be ordained as a Priestess, so we thought we'd have one Priestess! We went to our little town of Bunclody and had our manifesto printed very badly! To our amazement people like Geoffrey Ashe and Maxine Sanders joined, and people have gone on joining. The time has come!

PN: How did people get to hear about the Fellowship?

Olivia: By advertisements in *Prediction* and other magazines, and by networking. People just seemed to hear about us, and now we have over 11,300 members in 72 countries, from Africa to Siberia and Estonia.

PN: How did you come to create the beautiful and potent ceremonies which have become the Liturgy of the Fellowship?

Olivia: They were inspired. I was quite a well-known author published by people like Jonathan Cape and Random House, but I never wrote anything which was inspired. Then, through spiritual experience I began to be guided, and received a flow of inspiration. So I sit down and tune in. I do seek the jewels in great religious writings. I'm happy to say that I've had a wide

9 The College of Psychic Studies, dedicated to the exploration of psychic and spiritual phenomena, was founded in 1884. Originally called the London Spiritualist Alliance, its first president was the Reverend William Stainton Moses, and Sir Arthur Conan Doyle was president between 1926-1930. It has been located in South Kensington, London, since 1925.

10 The Spiritualist Association of Great Britain, established in London in 1872, whose most notable member was Arthur Conan Doyle, author of the Sherlock Holmes stories.

education so I know the jewels for instance, in the Bhagavad Gita. I'm still a school mistressy type so I want to make those jewels known to everybody – you know, Plato's Cave, the Ages of Brahma, the Incarnations of Vishnu, African religions, the Descent of Ishtar – I use a lot of Æ,[11] but usually It's something old like Ovid or Hesiod. To me, It's like a gold mine and I use these sources with the myths of the planets. I have a temple where I let the deities know what I want to do, and then sleep on it, and then wake up knowing how to. I never write anything that isn't inspired. I get up at 5.30am, have a bath like the Hindus do, then meditate in the temple.

PN: How did your Environmental Order of Tara come about?

> *"We believe in working for the good in all people. We don't believe in fighting over theology. The Goddess is in all people, as she is the mother of all."*

Olivia: The Order of Tara manifested because I was so flaming mad that our sacred mountain, Mt. Leinster, was threatened with open-cast mining – desecration. It's a pre-diluvian mountain. It was Beltaine, and we needed a sword to inaugurate the Order, but in the past I'd been a pacifist, so all our swords had been put away. Looking through outhouses with the aid of a torch, I found one, but on pulling it out of the scabbard, found that the blade had rusted away. Finally, I found one which could be drawn – Swish! – a huge sword with the crown of Queen Victoria and the star of the Archangel Michael. I also received the initiation ceremony for the Order in a curious way – while lying in bed, a white light came through the top of my head – it was like being struck by lightning. That was in 1989.

The aim of the Order is to save the Earth from pollution and destruction through entirely non-violent means – to use the sword or spear of spirit. We're more discriminating with Tara than the F.O.I., where we accept anyone who accepts our manifesto. In Tara we expect people to really work for the environment. They have to be prepared to clean up beaches, or campaign, for example, to save Oxleas Wood. Members of the Order are all active in Italy, Wales, Eire, Scotland, the U.S., and England.

PN: What inspired the Order of Dana, your Druid Order?

Olivia: On a more personal level I felt rather embarrassed bringing it through.

11 George William Russell (1867 – 1935) known as Æ, was an Irish poet, painter, and mystic. He was a well-known figure in the Irish Literary Revival circle and a leading Theosophist. He was also largely responsible for the founding of numerous co-operative banks and credit societies which assisted the Irish rural farming class to rise out of poverty. An all-round excellent human being.

I had performed Danean[12] workings with Ross Nichols,[13] but I wasn't interested in Druidry. I thought it was very patriarchal. What I did know about it I wasn't attracted to. My mother had told me that Irish Druids were older and generally better!

I felt the need to develop the Sidhe[14] gifts of telepathy and clairvoyance. It's very tiring working for the environment and I was afraid I was losing my psychic gifts with all the work organising the F.O.I. as well as Tara. I realised that the Gifts of Dana would be more Ying – more receptive. Tara was Yang – active. I felt guided by my original vision of Dana.

I looked back through my life and realised that my brother and I had been initiated into a pre-druidic religion by a hermit who lived by the River Slaney, called Daniel Fox. He initiated me as a little girl. We used to go there in a donkey cart from 10 to 15. He had complete vision and recall, and showed me the pre-Celtic little dark people who rose and drank from the water of the well, bathe in the Slaney, and assemble round the altar stone. There was a wonderful place called the Faerie's Seat, with the water rushing around it, and the Bee's Rock, an enormous stone with a natural cross on it. Across the river was east, and the fairies would wait for the sun to rise. They didn't worship the sun, but the power behind the sun – the source. I used to paint pictures of all this when I was 16, but one's childhood is rather private. I didn't like to share it with others. But the time had come for the Goddess aspect of Druidry to be manifested. I then discovered that my name meant "Olave" – a Druid bard. I had thought it was from the olive tree! My second name, Melian, is a Welsh Celtic name, only used by my family. It means "nymph of the Ash tree". I was given a ritual, following what we had been taught by Mr. Fox. We had a well within our temple, and a ruined abbey which we used for Danaen work! We had our sacred megalith, and a healing stone.

PN: How do you see the occult, Pagan, and Goddess "scene" in general around the world? A lot of people on different paths are in the F.O.I.

Olivia: We believe that as the Goddess is whole, so must we be whole. We can't divide up. I see it in Ireland, Catholics and Protestants killing each other. We

12 Danu (or Anu) is the supposed mother goddess of the supernatural Irish race called the Tuatha Dé Danann.

13 Philip Peter Ross Nichols (1902 – 1975) founded the Order of Bards, Ovates and Druids in 1964. He was a journalist, editor, and educator with strong socialist, pacifist, and vegetarian beliefs. He notably edited Gerald Gardner's classic *Witchcraft Today*.

14 Pronounced *shee* (as in *banshee*), the Sidhe are the fairy folk of Irish mythology. Not to be confused with modern Disneyfied versions of fairies, the Sidhe are not dissimilar to elves as portrayed in Tolkien or later fantasy fiction. They are said to live either in underground forts and/or in another dimension parallel to ours. The Irish traditionally called them "The Good Neighbours" or "The Fair Folk", probably because they were known to wreak terrible havoc on those who disrespected them. You don't fuck with the Sidhe.

believe in working for the good in all people. We don't believe in fighting over theology. The Goddess is in all people, as she is the mother of all. Our Nigerian members have more than one wife – we believe in following conscience. We welcome people.

PN: Tell us about the Convention?

Olivia: The Fellowship of Isis World Conventions are for people to meet each other from all over the world. London is very much a focal place, and most people want to go there. It's the occult capital of the world now, and It's lovely for people of other races to come. The day is full of presentations and talks from F.O.I. members. The night before, we have a lovely party for members and non-members, and they have a happy convention which is with them forever, in Eternal Reality and the real Earth.

This year's convention includes Steve Wilson, Nigel Pennick, Cathy Jones, Nigel Bourne & Seldiy Bate, Lilith Babalon and Caitlin Matthews.

PN: You are a great believer in equality between people in groups, aren't you?

Olivia: Yes I am. There are beings more advanced than others, older souls, more spiritual or nicer; those who sit at the back. My brother and I have never claimed to be "heads" of the F.O.I. – we're just the founders. Titles must say what you do – a secretary, or a priestess is just a definition of work undertaken. The title does not suggest that you are superior to anyone else. The equality extends to all. We have the animal family of Isis and the children of Isis. We can learn from them, too.

I was talking to some visitors once when my nephew came in, absolutely delighted. He said "Is it true about your new English member Wilfred the rat?" His wife said an English lady had rung up terribly upset in case Wilfred couldn't be accepted because he was a rat. Of course he was accepted. David wanted to go and meet Wilfred! So you see we are all equal, aren't we?

PN: What future do you see for the F.O.I., and the Orders of Dana and Tara?

Olivia: As we enter the new aeon, whatever alarms and excursions we have, the Golden Age is returning, and It's coming through telepathically. You couldn't torture someone if you felt their pain yourself. You couldn't eat an animal if you saw and felt how it died. So I think that there is an over-sensitizing of the human race. Pagans live healthier lives, usually vegetarian. We will be able to choose more and know when we are going to the Spirit World.

Olivia Durdin-Robertson, thank you very much.

SHE SPEAKS

Kiss The Sky! – On Channeling Babalon

by *Linda Falorio*

Though the terms "Scarlet Woman" and "Babalon" have traditionally referred to currents channeled exclusively by biological females, I find no compelling reason that this should be so, and believe that in our current state of psychological and spiritual evolution, our only limitation in what energies we are able to experience, explore, and embody, are our own imaginations. I hope that all readers, regardless of gender, will find here inspiration for their own creative paths.

To walk the path of BABALON is to seek to allow oneself to experience existence as pure sensation, suspending value judgements of pleasure-pain, good-bad, attractive-repulsive by which we commonly limit and define our everyday human experience.

To walk the path of BABALON is to seek to allow oneself to totally yield to sensations of pleasure and desire in encountering all facets of existence, without fear or dissolution of the "I".

To walk the path of BABALON is to allow oneself the freedom of initiating passion, within others, within oneself.

Among the five faces of the Goddess – Maiden, Nymph, Mother, Warrior, Crone; Babalon is Warrior. Babalon is that individual of power who is open and aware and in touch with her magical sexuality, yet is defined by no other individual, only by her own will to experience existence. She is that individual able to stand in for the Goddess in channeling the unconditional love of the universe for all things in creation – regardless of perceived beauty or ugliness, attractiveness or repugnance, gender, or age, or personal emotional reactions. Secure in her self and in her magical power, one who walks the path of BABALON is free to be totally yielding to desire – the desires of others as well as her own, yet retaining her personal integrity, independence, and power.

Able to open her heightened sensitivities to an awareness of existence as pure sensation, Babalon is the Tantric adept, with all the powers that this implies. Babalon functions as skryer, as psychic medium, and oracular voice, in the voicing of her own dreamings of reality, and not those of another. As warrior, one who walks the path of Babalon actively works for the positive transformation of culture & society, in a role of leadership, and through the application of courage, will, creativity, love, and above all, the Feminine Voice.

Encountering the Other, Encountering the Self
Take What They Give

In each encounter in your daily life, take whatever the other gives you. If they are angry, accept that. If they are sad, let that pass into your consciousness. If they are sexually attracted to you, let that into your energy field as well. No matter what your personal reaction might normally be, whether fear, attraction, boredom, repulsion, accept the individual before you without judgement. Absorb their energies into yourself through touching them lightly on the shoulder, take their hand in yours, let essence flow from their eyes into yours. Radiate back to them both love and acceptance. Realize that this has nothing to do with your "personal" reactions, but is the Channeling of Babalon as s/he touches the human sphere.

As an extension of the above, imagine yourself having sex with everyone you encounter, whether attractive or not, whether old or young, regardless of gender, and traditional sexual taboos. Continue this practice until you are able to imagine such encounters without excitement, repulsion, guilt, shame or fear. All such emotions having lost their power over you, you will have developed kindness and tolerance for others" differences, for we love that best which is most like ourselves. Dissolve ego-boundaries via the moment of "the kiss". In that ineffable moment, the boundaries between oneself and the other blur. Prolong this moment until you feel an energy and awareness other than "yourself" move through you. Kiss a plant. Kiss an inanimate object, such as a stone or a car, a pencil, your athame. Kiss an animal. Kiss another human being. In so doing, you will for that moment of the kiss, merge your interior essences and learn something of the being of the other. Be warned that the other in turn will have taken away a part of you as well.

The Mirror

Using your imagination, stare into the eyes of another person until you have "become" that person, looking back at yourself who has thus become "the other". This can be very intense, even unsettling for both parties. When successful there is a flash of union with the other – a reaching out & identification with them. For the adventurous: try this with someone you are angry with, or someone you don't like.

Mirror, Mirror

Gaze at your reflection in a mirror until it is no longer familiar to you, until the face has become that of the other gazing back. Radiate kindness to that other in

the mirror, give it your acceptance, let your love flow out to it and then return as it is reflected back to you.

Magical Monogamy

When we seek the muse of inspiration via union with another, we encounter this difficulty: the muse lies within us, not the other. No individual can therefore give us what we do not already possess within ourselves. Though, we may find in that first thrill of a new lover the spark which ignites the elusive inspiration which we seek – at least temporarily. Yet, if one persists in tantric practice with one given individual, there is a deepening of power as masks are shed. Rather than becoming familiar and boring, there is a point at which the lover becomes totally mysterious, totally OTHER – and thus a transcendent channel of creative magical force.

Orgasm Magicks

Orgasm is energy. Voluntary rhythmic movements of body and breath build energy patterns, inducing deep primal responses in body and psyche. At the moment of orgasm the sense of personal "I" enlarges its boundaries, merging with the life stream of the universe. The mind and body are aglow with a thousand pin-pricks of dancing energy and light. Orgasm creates a gate into other dimensions. Where the ordinary person merely loses consciousness of self, falling happily asleep, the tantric adept rides the stream of orgasmic discharge into astral worlds, where s/he accesses creative realities where the power to will a thing is enough to make it so.

Breathing Orgasm

In your sacred space, establish a breathing rhythm. Visualise the life force around you as brilliant dancing points of light. Breathe this light into your body; allow yourself to experience the surrounding ocean of vibrating energy in which we constantly swim, and from which we derive our being. As the breathing rhythm becomes established, you will move deeper and deeper into a meditative state; your consciousness will calm, becoming lucid and clear. Experiment with each of the following practices until there arise distinct physical sensations, which indicate success:

Imagine that you are breathing in and out, not through your nose and mouth, but through the bones of your legs; breathe through the bones of your arms.

Breathe through the pores of your skin, until your body feels cleansed, entirely alive, and open to sensation. Breathe through the top of your skull, continuing until your mind expands, opening to the universe.

Breathe energy up from the base of your spine to the top of your skull. Breathe energy back down from your head to the base of your spine, your body becoming charged with energy and light as you do so.

Breathe energy up and out through the top of your head, then down and around your body, appearing as the brilliant blue of your protective aura, growing into the bright blue of the circle that encloses you within your sacred space, a circle that becomes brighter, more vital with each breath. Breathe through the seven vital centres or chakras each in turn, awakening them to vibrate with living light.

Tantra of Earth and Sky

With arms upraised, breathe in sun, moon, and stars. Reaching up to them, let their energy flow through you. Experience their benediction as a prolonged kiss. Placing hands upon the earth (if indoors, the floor, yet visualising earth), send streaming orgasmic energy into the all-accepting body of the Earth. Experience the blessing of her all-embracing love as a profound opening of the heart into stillness, silence, peace.

PAGAN NEWS

MANY VOICES, ONE SPIRIT

No.35
£1.50

SPOTLIGHT: CHURTON FAIRMAN
THE THIRD EYE
LETTER FROM ANKARA

NEWS

Row over Occult Church Plans for a Temple

A media-born row has been brewing over the last month or so, following a declaration by a group known as "The Occult Church" that they have plans in hand to open an "Occult Temple" in Chatham, Kent, so that the public can "make up their minds" about the occult. The Chairman of the Occult Church, Mr. Peter Mills, who is described in *Kent Today* as head of "an international group of occult churches – well known in occult Church society" has been quoted in several media sources as wanting to build a temple to bring occult Church practices out into the open.

For those not familiar with this particular group, investigation from *PN* reporters shows that the Occult Church have been advertising themselves in both *Psychic News* and *Prediction* since the late 80s. From their material, they seem to be a fairly innocuous group of Christian Qabalists, offering free books such as "Jesus the Occultist."

In a recent letter to *The Chatham Standard*, Mr. Mills protested what he called "the almost unbelievable amount of false information resulting from the media coverage of our proposed public occult temple." In defence of the Occult Church, he said that "If people can only be allowed to use their own minds to think clearly on this issue, they will see that we feel spiritually secure and sound in any holy building because we know that we are right and are worshipping the one almighty God in what we see as a completely correct and righteous way."

Given earlier "Occult Temple" wind-ups (see Feb & March '92 issues) we had at first wondered if the Occult Church's announcement was a deliberate attempt at stirring up anti-occult sentiments, especially since when asked, the local planning department said that they had no record of any "official plans" from anyone wishing to build a temple in the Chatham area. Since the Occult Church appear, though, to be a genuine and well-intentioned group, we can only speculate as to whether their announcement was "leaked" to the media, or whether they have merely been naive, considering the current climate.

Fellowship Of Isis Convention

The Fellowship Of Isis Convention is always a huge success, but this year's was the best yet, dubbed by many as "the conference of the year". Highlights of the day included a mystery play with a Spider Dance performed by Olivia Robertson, Caitlin Matthews, Steve Wilson, Goody Ho, and Chrys Livings. Lilith Babalon spoke eloquently on Sacred Queens as Priestesses of the Goddess, consciously

playing out their roles in life (and death). Nigel Pennick shed light on the many divisions between Goddesses, Elementals, and Fairies in the Northern Tradition, and Frank Mumford's puppets went down a storm with the audience. Presenters, organisers, and helpers put a lot of effort into making this event such a success.

Winter Greenwood Celebration

On Saturday 5th December there will be a "Winter's Greenwood Celebration" at Charlton House, Charlton, South East London. Guests include Marian Green on the "Winter Mysteries", Leo Vinci on The Great God Pan, Andrew Collins giving more elucidation on the subject of the Green Man, and Dwina Murphy-Gibb on the Feminine Side of Druidry. Other speakers will be announced in due course. Tickets are £9 from "Greenwood Celebration", PO Box 196, London WC1A 2DY. Please make cheques out to AISLING and all requests for information should include an SSAE. Proceeds from the Celebration will go towards a donation to the OWCH (Oxleas Wood) fund.

Cerullo 'Cure' Followed by Drowning

Many readers will no doubt have been bemused by the Morris Cerullo[1] Roadshow, who promised "awesome events – miracles" at Earl's Court earlier in the year. Numerous complaints were made about his advertising campaign featuring discarded wheelchairs and broken white sticks, yet the Advertising Standards Authority refused to uphold complaints, saying that they didn't think anyone would take them literally.

Unfortunately, this has not been the case, and Southwark Coroner's Court recently held an inquest on one of the people who believed in the power of Cerullo's "Miracle Cures".

Audrey Reynolds, a devout Christian from South London suffered from epilepsy, which was controlled by medication. After attending Cerullo's meeting at Earl's Court, she became convinced that Cerullo's prayers had brought about a cure, and discontinued her medication. Six days later, her mother returned home to find her daughter dead in an empty bath. The pathologist's report was that Audrey Reynolds had died from drowning during an epileptic fit – her thrashings had pulled the bath plug out. Sir Montague Levine, the Southwark Coroner, said that it was a "tragedy"

1 Morris Cerullo (1931 – 2020), yet another American evangelist and con man. He hosted the *Victory Today* television programme, and published more than 80 books, none of which we have read and which we do not intend to. In 2007 he was indicted for tax fraud in California, but miraculously managed to evade prison due to a mistake made by the prosecutor.

that Audrey had gone to the Cerullo meeting, and spoke of the dangers of people believing that they have been "miraculously" cured of serious conditions.

Cerullo's religious chicanery will soon be televised throughout Europe via his European Family Network satellite channel, which promises Christian pop music, prayer, dedications, and much more.

Crowley's *Equinox* Back

Good news for all avid collectors of Crowleyana is that Mandrake Press Ltd. have recently issued an unabridged (paperback) facsimile of Crowley's *The Equinox*. Bound as five volumes, with colour laminated covers, the set is available from Mandrake for a mere £150 (incl. P&P). Mandrake are currently expanding their range of Crowley material, including some MS which have until now, remained unpublished. For further details, contact your local supplier or telephone Mandrake direct on 084 421 7567. Now you know what to ask for at Crowleymass this year!

Dwina Gibb sends Aid to Hurricane-struck Indians

Dwina Murphy-Gibb has been in the UK press recently thanks to her efforts to help mount a rescue operation for the Miccosukee Indians, whose Everglades home has been devastated by Hurricane Andrew. Dwina has launched an appeal in the USA to help the Indians, whose plight has so far been ignored by both the American government and aid organisations alike. She is leading a relief convoy to help the Miccosukee rebuild their homes, which were destroyed by the hurricane. It's nice to see the press recognising such efforts, even if they didn't mention Dwina's Pagan interests, as they were far more interested in the fact that she is married to Robin Gibb of the Bee Gees.

If the Sight of Skin Offends

"Only sailors and bikers have tattoos." Untrue. How untrue this belief actually is, was demonstrated in glorious colour at the 1992 Tattoo Convention in Dunstable, Beds, in September. The tattoo is a growing art, designs being far removed from the faded, bleeding, red heart, emblazoned with the words "I LUV MUM/CAROL/MY DOG." From the most simple black spiral (possibly a sigil?), to elaborate designs which covered the entire body, the work of talented artists was displayed with justifiable vanity and pride.

As a newcomer to the scene, I was seized by the urge to surrender to the needle. Unfortunately, even with my own personal design in mind, the only thing I surrendered to was "Tattoo Excuse no. 496."

Cameras whirred from somewhere within the mass of strutting, scantily-clad peacocks, as smiles were flashed and hidden roses and rings revealed. International names were signed across huge white banners, while the background rock music could not quite drown out the gentle, yet distinctive sound of buzzing. Relaxing. Inviting.

Tattoos aside – an impossibility in Dunstable for the two days of the convention – stalls spread through the building selling everything from jewellery, leather and incense oils, to dried, encased, scorpions.

Feeling thoroughly ashamed that I was not yet brandishing my tattoo and vowing to rectify my skin as soon as possible, I contributed by buying a scorpion. And who knows, next year, if you show me yours, I might just show you mine! – Talios

The Rumour Mill

Although most of the rumours one hears about oneself are dull and nowhere near as "good" as the true situation, I cannot possibly resist commenting on the latest one – that I am supposed to have put a bid in to buy a Birmingham nightclub! I'm afraid this one is definitely untrue, folks! – Phil Hine.[2]

PN Reader Service

We've recently struck a deal with those nice people at Atlantis Bookshop, so that you, the reader, can help *Pagan News* continue to get even better than we are already. A booklist flyer is enclosed with this issue, and Atlantis will give 10% of the cover price from all titles ordered using this flyer to *Pagan News.*

Vatican Says Sacred Mountain is of no Significance

Over the last few months, Apache Indians in the San Carlo area have been struggling to prevent an Astronomical Observatory being constructed on Mt. Graham, which they say is a traditional Sacred Ground – the home of Apache Crown Dancer spirits since time immemorial.

The observatory project is being funded by the University of Arizona, the German Max Planck Institute, and the Vatican. In March of this year, Jesuit priest Father Charles Polzer – the Vatican's "authority" on ethnohistory, issued a statement declaring that Mt Graham cannot be sacred, because it lacks religious shrines and other "documentary or archaeological evidence" of its use by Apaches.

2 I so wish this had been true – Rodney.

Naturally, this statement has outraged the Apache, who feel that it trivialises their spiritual beliefs, and could lead to further undermining of their religious rights. They are continuing to attempt to halt the project, using legal and legislative channels, co-ordinated by the Apache Survival Coalition, an organisation of Apache medicine people, tribal elders and council members, and non-Indian conservationists. Meanwhile, three of the seven planned telescopes have been completed and construction continues. For further details contact the Apache Survival Coalition, PO Box 11814, Tucson, AZ 85734, USA.

God is a Republican!

Shock news from America is that not only is God (as many of us have long suspected) an American citizen, but that he also apparently intends to vote Republican in the forthcoming election campaign! This is what we hear from our correspondent who has the interesting task of following the Bush/Quayle campaign trail as it sleazes its way across the states.[3]

New Ager takes on 'Evil' of Chaos

Tourists visiting an old castle on the borders of Austria & Hungary were unwitting spectators to a full-scale magical conflict which broke out between a German New Ager, and massed hordes of "evil" black T-shirt wearing chaos magicians. Apparently the New Ager had been invited to the castle to conduct workshops for a seemingly innocent "Chaos Seminar", and did not realise what was "really" happening there – that participants' souls, minds, and in a few cases, bodies, were being corrupted with the taint of Chaos. Pausing only to collect several thousand Austrian schillings, which he had earned by having groups of people sit in the sun and chant "We all come from the Goddess", he then proceeded to give battle on the astral plane against the massed power animals of the chaos magicians, who showed their prowess at magick by being able to work against him astrally, whilst sitting around eating and ordering drinks – clear indication of their "dark" power.

According to our correspondent, the Chaos crew finally delivered the coup de grace by sitting in a circle, holding hands, and beaming "love" at the beleaguered New Ager, who instantly discorporated into a shower of rainbow sparkles.

3 Although from our vantage point here in the 21st century this may not seem like news (since everyone in the world now knows God is a Republican), back in the 90s we were still only seeing the tip of the iceberg when it came to Christian evangelical support for right-wing political leaders. A movement which achieved its apotheosis in the person of Donald Trump.

Poland: Church Fans Fear of AIDS

In the late 80s, the Polish government launched a campaign to inform the public about AIDS. Since the fall of communism however, the Catholic Church has successfully pressed for an end to the poster campaign, with a result of growing public ignorance about AIDS. Last month, a drug-treatment centre bought two houses in a village outside Warsaw for eight children of drug addicts who are infected with the HIV virus. Local villagers staged protests to this move, and despite assurances from the government, attacked the houses, which were later damaged by an arson attack. Polish president Lech Walesa has suggested that the treatment centre be relocated in a more "isolated" place. Poland's bishops, concentrating on their crusade against abortion, have so far declined to comment.

Black Moon Archives

The Black Moon Archives is a worthy project which has been running for a few years now. Its purpose is to make photocopies of MS, drawings, photographs etc. immediately and inexpensively available to occultists & other practitioners of esoteric subjects. The Archive welcomes contributions of MS etc., and a catalogue of material currently held is available on request. For further details write, enclosing an IRC to, Black Moon Publishing, Box 19469, Cincinnati, Ohio 45219-0469, USA.[4]

Another Council Bans Psychic Fairs

Hounslow Leisure Services Managers have recently taken the decision not to allow Chiswick Town Hall to be used as the venue for Psychics & Mystics Fairs. Apparently this decision was taken after "members of the public" expressed concern to their local councillors.

And Finally ...

Plans to erect statues of Egyptian Gods Sobek & Horus, in Hamilton, New Zealand, have been shelved because local churches objected to the setting up of "graven images".

4 Astonishingly, after some ups and downs, this archive is still a going concern and can be reached at https://www.blackmoonpublishing.com/archives

SPOTLIGHT

The Many Lives of Churton Fairman[5]

Churton Fairman has led "many" lives. Currently a sculptor, he has also been a pirate-radio DJ, worked in television, starred in three Hammer Horror films, trained with the Royal Ballet, and published several books, including a Spanish travelogue and a collection of action photos of ballet. In this interview, he discusses the esoteric symbolism inherent in his works.

PN: When did you first become interested in the occult?

CF: My mother died when I was six, and I was brought up by three maiden aunts. One of them had quite definite psychic gifts. When I was nine, I could read palms. Later on, I began collecting quite a large library of occult literature. In those days, the influences which struck me the most were Eliphas Levi and A.E. Waite. I was fascinated by the whole history of the occult for many many years, particularly the Tarot. I found that the Tarot was the occult "tool" which was most in tune with my personality. When I would do readings, I would have the person write their question down on a piece of paper, and not look at it until I had finished the reading, to see if there was any correspondence between my reading and the original question.

As I studied the whole Hermetic stream, I came to the conclusion that there is only one stream of development, which has been winding its way through human history, and I think I can see some of the tracks fairly clearly. One of my

5 Austin Churton Fairman (1924 – 1997) was a well-known British DJ and TV presenter in the 1960s and 1970s under his stage name of Mike Raven, and became known later as a sculptor under his real name. His *Mike Raven Blues Show* was broadcast on the very first day of BBC Radio 1 in September 1967, and would continue weekly until 1971. Contrary to the introductory paragraph, our proof reader notes that he appeared in one Hammer film, one film for Amicus and two independent horror films

major interests is the movement of "mystical" thought, and how it has moved across the world.

When I was working in the ballet, I went to lunch with a chap one day who had been asked to raise money for a pirate radio station.[6] I was very interested in this idea, and so became involved with pirate radio. The first of them was Radio Atlanta, and then Radio Caroline started up. This would be around '63 – '64. Later, I was asked to go and start up another pirate station on one of the anti-aircraft forts in the Thames Estuary. It was called Radio King at first, and I was broadcasting daily. Later, it became Radio 390, and had the most powerful of all the pirate transmitters. Of course, I wasn't doing this under the name of Churton Fairman. When we started up in pirate radio, everyone was asked to invent a simple name, so I became "Mike Raven" – a pseudonym which became more famous than me!

PN: That was the name you later used for TV and film?

CF: Yes. When the laws were changed and pirate broadcasts became illegal, Harold Wilson made it a condition that the BBC would take on the pirate DJ's, and myself and umpteen others were moved in to start Radio One. After four more years of broadcasting on the BBC, I was approached to make a horror film. In my youth, I did look rather like Christopher Lee, and somewhat like Vincent Price. I made *Lust for a Vampire*[7] with Hammer, and then there was *I, Monster*[8] and *Crucible of Terror*.[9] The final one I was involved with was called *Disciple of Death*.[10] By that time, the entire horror field was collapsing – there wasn't any more money to make films, and the British film industry was in decline.

6 The 1960s were a heyday for unlicensed radio stations in the UK which would broadcast from transmitters anchored outside the limits of British territorial waters and thus were not subject to British radio licensing laws. Thus they weren't only "pirate" by nature of operating outside the law, but also because they largely were run on board ships. See the criminally underrated movie *The Boat That Rocked*, directed by Richard Curtis, with a tremendous cast including Philip Seymour Hoffman, Bill Nighy, Rhys Ifans, Nick Frost, and Kenneth Branagh.

7 *Lust for a Vampire* (1971), directed by Jimmy Sangster. Fairman (credited as Mike Raven) played Count Karnstein, though apparently his voice was redubbed by another actor in the final cut!

8 *I, Monster* (1971) directed by Stephen Weeks, starring Christopher Lee and Peter Cushing, with "Mike Raven" as Enfield. This was an adaptation of Robert Louis Stevenson's 1886 novella *Strange Case of Dr.. Jekyll and Mr. Hyde*, with the names changed, though we have no idea why.

9 *Crucible of Terror* (1971), directed by Ted Hooker and starring "Mike Raven", Mary Maude and James Bolam. Fairman financed the majority of the movie's low budget of £100,000. Unfortunately for him it was a critical and financial failure.

10 *Disciple of Death* (1972), written and directed by Tom Parkinson, starring "Mike Raven" as The Stranger. It was notoriously reviewed by critic Chris Wood, who described it as "the worst film I have ever seen. It is quite simply a stinker of remarkable ineptitude – featuring the worst performance by a leading man in the history of celluloid, some truly pitiful special effects, a story which beggars belief and camerawork and direction which... well, I despair."

PN: **So what did you move onto after the Horror scene collapsed?**

CF: My wife and I decided to move to Cornwall. We bought a ruined cottage for one thousand pounds, and lived near Boscastle, which is a magic spot. While I was there – I was about fifty by this time – I suddenly, without any prior interest or training, began to do these carvings in wood. I went from wood to stone, and then finally, bronze. So suddenly, a new career had started, and to mark the change, I reverted to my former name, Churton Fairman.

PN: **One of the key things I noticed about your sculptures is the blending of male & female characteristics.**

> *"I hope also to convince people that they are bisexual to some degree, and until they realise that, their own personalities will never reach the maximum of its potential."*

CF: The origin of this partly comes from my Hermetic studies, and also, the fact that I've been very interested in the works of Carl Gustav Jung.[11] One of his basic ideas is that in every man there is a woman, and in every woman there is a man – the animus and the anima. I recognise this very clearly in myself, and it comes out more and more in the sculpture, because one of my basic beliefs is that people must integrate with their opposing sex within themselves to develop their own character fully. I bring this idea out in many of the sculptures, to try and get it into people's subconscious – It's the only way I can preach it at them.

There is a spiritual element overall, because I believe that we do have immortal souls. I'm struggling to make the best use of mine. I've now reached the last quarter of my life, and I doubt if I shall be doing anything other than sculpture. I think that if you show people an image, there's a chance that it will strike chords within their inner consciousness, in a better way than words, sometimes. I've had three people in the gallery today, who I know I have made contact with their spirits. That is what the powers want me to be doing at the moment.

PN: **There's a strong element of sexual imagery in a lot of the works. How do people react to that?**

CF: To tell the truth, amazingly well. I'm trying to bring out more of an awareness of sexuality, beyond guilt. I hope also to convince people that they are

11 Carl Gustav Jung (1875 – 1961), Swiss psychiatrist and founder of analytical psychology. He was the originator of such concepts as archetypes, the collective unconscious, the psychological complex, and extraversion & introversion. He was also deeply interested in alternative spirituality, particularly Gnosticism.

bisexual to some degree, and until they realise that, their own personalities will never reach the maximum of its potential.

PN: What I find particularly interesting is the blending of sexuality with Christian imagery. People don't usually associate Christianity with open displays of sexuality.

CF: That's where I am sticking my neck out. However, this exhibition is taking place within the crypt of a church![12] I think people recognise that the images are not there to "shock", or just for the sake of "shock", but to demonstrate my own beliefs and theories. If I had just produced pornography, then people would react accordingly. If I say that I have done a picture of Christ on the cross with an erection, they might react "Shock! Horror!" but not when they see it. That is the nearest to success which I think I shall ever get.

PN: In particular, I'd like to ask you about the *Jacob* piece which we are using on the cover. That has very blatant sexual associations.

CF: Yes, you see that's a strange story in the Old Testament. Jacob was a bit of a wimp, a useless character and nasty piece of work. Suddenly he comes out one morning, says "Listen boys, I've had a dream, I wrestled with an Angel, and now I'm a changed man. My name is no longer Jacob, I'm now Israel, leader of the people, and from now on we're going to bash the Philistines and so forth." There is a complete character change in Jacob's life, which is what interests me. I think that what it was, is that here is this wimpish effeminate mother's boy, someone who, exactly as I had to, came to terms with himself, who was called to do something else – being given a new role. Okay, you can say that the story is about giving the leader a slightly better image than he had, but I think he did, in fact, change. I think he did undergo a kind of mystical torture – I know I did, and that's why that image is powerful, and why it affects so many people.

PN: One of the strong themes in the image is the divine presence forcing Jacob to accept it.

CF: That's right. That's why It's a rape, you see. It wasn't a gentle transformation by any means. I do think that God does force people, on occasion. It may not happen to everybody, but it certainly happened to me. God "raped" me, so there!

PN: Another image I'd like to ask you about is the female crucifixion scene, where the woman willingly suspends herself on the cross, with the snake between her legs.

CF: That one has got some very interesting factors to it. I've read a lot of the Hebrew Talmud, and that image brings out one of the Talmudic stories, which accounts for the creation of all the non-Jewish people in the world. The story says that Cain and Abel, the sons of Adam & Eve, were of course, the first Jews,

12 This was his exhibition in the crypt of St. George's Church, Bloomsbury, London.

not the first human beings. So, where did the rest of creation come from? The answer to that is that after Eve had caused all the trouble by giving Adam the apple, the serpent enters her and engenders all the other races on earth! I had read this, and I was very interested at the time in the ordination of women into the Christian Church. Some of my friends were nuns, and some of them were very keen to be ordained. If you look at the image, the woman is not nailed, but hanging on of her own accord. The snake is a combination of images – one being of the male "wisdom" taking it out on her for what she's doing, and there is also a link with the story of Alexander the Great was conceived by his mother being entered by a snake during a religious ceremony. So there are three different sources coming together in the one image. These images come to me almost as a complete conception, and then I just have to hack around with the material to bring it out.

PN: *Churton Fairman, thank you very much.*

THE MAGICAL INFLUENCE OF ROCKS
by *Barry Ye Ex-Pedant*

This article results directly from experiences that I have had since childhood. In order that it may be of positive use to the reader I have resisted the temptation to be too specific because of my own subjectivity. My main thesis is that different types of bedrock & geological features can have subtle effects upon our state of consciousness.

Introduction

There are three different types of rock:

- SEDIMENTARY rocks are found in layers which were deposited by or in water, wind, or ice in times gone by. The deeper you go, the further back in time the layer was laid down. Rocks of different ages may be found in one area due to movement & change in the shape of the ground & erosion, which of course provides the raw material for what will be the sedimentary rock of the future; mud, sand, shingle, soil, etc. These rocks may contain fossils.
- IGNEOUS rocks were once liquids like lava on the surface or magma beneath it, which at some point in their history went too far, cooled down & crystallized. These are often very old, very hard rocks from deep down (scientists refer to such as "plutonic"). Sometimes we are unaware of their presence as sills & dykes (sheets & ridges) on or not far below the surface.
- METAMORPHIC rocks were once identifiable as sedimentary or igneous but now they are not, because something like heat or pressure has altered their structure and composition. They are often good sources of the precious crystals which most people get from the Brazilian Mining Industry.

Sorts of Places

The best places to get involved in working with geological energies are places where one or more kinds of rock are actually visible (& touchable!) on the surface. Such surfacings are called outcrops. The best places to look are coastlines, gorges, mountains & quarries. To start with, don't discriminate against places that have been made by human beings. Later on if you pursue this avenue of exploration you will have to take this into account & will become aware that just as cities are geologically interesting in terms of their architecture, there is a subtle link with the places from which their building materials were derived.

How to Get Into It

Go & meditate out of doors! (Take appropriate precautions re: psychic hygiene & physical safety!) Touch rock with bare feet & hands for extended periods of time! Feel! Listen! Study the origin of the rocks with which you are working. They will help you to visualise it. Make libations, sing to them. Don't just start collecting like mad. The conservation of geological sites is important but often neglected by the likes of avid fossil collectors. Take home feelings instead!

Varieties of Experience

Sedimentary rocks are the best ones to start with because they have a wide variety of different kinds of story to tell & as a rule they are less likely to blow off unsuspecting heads. Not that certain localities with a sedimentary base won't sometimes prove to be very powerful. Springs, wells & caves are often associated with them, for instance.

Igneous rocks generate incredibly powerful dragon energies with a high degree of possible modulation & focussing available to the human operator. However, they can release sudden bursts and be dangerous if approached insensitively. Their energy will often manifest in an EVOCATIVE or PROJECTING way, animating stuff from the erstwhile operator's unconscious as effectively as certain proscribed chemicals. This can cause considerable confusion & panic in the unprepared. These effects are generally more potent in some places than others.

Metamorphic rocks tend to affect body awareness quite strongly and can therefore be useful in healing or introversion work. In terms of their impact they can be as intense as igneous rocks, but will usually build up to it, allowing greater conscious control of the process. Time factors vary from minutes to literally days. They are very much intermediate, having sedimentary characteristics such as landscape & lifeform memory to different extents. The key word is transformation.

GEOLOGICAL FEATURES, such as faults, tend to be places where energy flow is dynamic, cyclical, and independent of a human activator. UFO, haunting & other "multidimensional" phenomena are often concentrated in areas with lots of major faults. So-called ley lines, which are not necessarily "straight", often have their sources & sinks in such areas. Seasonal cycles are often very significant when working with bedrock in such localities

Qualifications to the Above

These descriptions are general and are not offered as a substitute for genuine intuition & insight. There are no hard and fast rules. The science of geology is complex. Geological maps are useless unless you make the effort to learn what they really say. You cannot divorce geological factors from the gestalt of a particular place & time.

Conclusion

The taking into account of geological factors can be of great importance in geomancy, earth healing, and other forms of outdoor ritual and meditation. A generally neglected area of study, it can provide a key of vital significance to those prepared to work at it. Rocks can give us contact with the distant past and the Primal Ground, not to mention the non-human Titanic energies with whom we have always had an intimate relationship but of whom we are remarkably ignorant. A female Titan called Gaia springs to mind!

OUTLETS

e of Rods General Pagan Contacts 'zine. £7.50 ' 8 issue sub from Acca & Adda, BCM Akademia, ndon WC1N 3XX.

frost Monthly newsletter of the Bisexual Network. nd £5 for subscription to Bifrost, PO Box 117, rwich, NR1 2SU.

aos International The Leading Edge of Magical ange! Issue 13 out now at £2.95 from Chaos ternational, BM Sorcery, London WC1N 3XX.

allisti Irrerevent Discordian journal. £1.50 from N.J arris, PO Box 57, Norwich, NR2 2HX.

lking Stick Wide-ranging 'zine of news, views, & liness. Sample issue £2 from Suite B, 2 Tunstall d, London SW9 8DA.

e Cauldron Veteran Wican/Pagan 'zine. Annual bscription £6 from Mike Howard, Caemorgan ottage, Caemorgan Rd, Cardigan, Dyfed, SA43 QU.

ouchwood Magazine of British Hereditary radition. 4 issues for £6 from Touchwood, PO Box 6, Whitley Bay, Tyne & Wear, NE26 1TN.

he Freethinker Secular Humanist Monthly. Sample sue 60p from the editor, 117 Springvale Rd, /alkley, Sheffield S6 3NT.

he Unicorn Pagan Quarterly. £5 for year's bscription from S. Class, PO Box 18, Hessle, orth Humberside, HU13 0HW.

ates of Annwn Pagan Contacts & News 'zine. £5 r a subcription from BM Gates of Annwn, LOndon /C1N 3XX.

ragons Brew Magick, Paganism & Progressive Vicca. Four issue sub £5 from C E Breen, Hookland d, Porthcawl, CF36 5SG.

-HA A Magazine of the New Aeon. Enquiries to -HA, Breite Str. 65, 3134, Burgen, Dumme, ermany.

reenleaf Robin's Greenwood Gang. Sample issue 0p from George Firsoff, 96 Church Rd, Redfield, ristol 5.

nubis, Postfach 45, a-1203 Wien, Austria

Albion Gallery 1a Market St, Glastonbury, Somerset.
Atlantis Bookshop 49a Museum St, London WC1A.
Caduceus Books 14 Holgate Rd, York.
Golden Dawn Books Unit 15, The Corn Exchange, Hanging Ditch, Manchester.
Id Aromatics 12 New Station St, Leeds 1.
Mercurius 291 Portobello Rd, London W11.
Mushroom Books 10 Heathcoate St, Nottingham.
Occultique 73 Kettering Rd, Northgampton.
Prince Elric's 498 Bristol Rd, Selly Oak, Birmingham.
The Inner Bookshop 34 Cowley Rd, Oxford.
The Something Else Shop 25 East Hill, Dartford, Kent.
Skoob Two 15 Sicilian Ave, London WC1.
Watkins 19 Cecil Court, London.
Zagor Grotestr. 9, D-3000, Hannover 91, West Germany.

Distributors

Heart Action PO Box 2055, Moseley, Birmingham B13 9NB.
Australia Julia Phillips, PO Box A486, Sydney South, NSW 2000, Australia.

Advertising Rates

☐ Eighth Page Ad - £12.50 each

☐ Quarter Page Ad - £20 each

☐ Half Page Ad - £35 each

☐ Full-Page Ad - £65 each

Block Rates available on request

Unless a prior trade relationship has already been established, advertising must be paid in advance of publication. Send Camera-Ready copy, or we can design Adverts to suit your requirements.

NEXT ISSUE:

☐ **Gareth Meday on The Man Who Invented Satanism**

☐ **Hair-Raiser _ Episode Three**

☐ **Lilith's Babelogue**

SUBSCRIPTIONS

A Subsription to PN costs £12 (12 issues) in the UK and Europe. USA/Canada £14 (Zone 1), Australia £16 (Zone 2). All cheques should be UK bank cheques, Postal Orders, Sterling Money Orders, Eurocheques, Cash Sterling or US dollars. All orders payable to *Phoenix Publications*. Zone 1 & 2 orders are sent Airmail Paper rate.

PAGAN NEWS

MANY VOICES, ONE SPIRIT

No.36
£1.50

INSIDE: THE LEO TAXIL STORY
SPOTLIGHT: RAISING HELL
ASTROLOGY WITH ATTITUDE

NEWS

Animal Sacrifice Scares

A recent bulletin from the S.A.F.F. warns that now that the Satanic Child Abuse Myth is beginning, in the light of recent investigations such as *Panorama*, to look a little lame, that the scare-mongers are trying shift the focus of attention onto "Satanic Animal Abuse".

A few cases of Satanic Animal Abuse hysteria have come to light. There was much fuss made about the burnt carcass of a cat found on the beach at Clevedon in Avon. The RSPCA[1] declared that the cat had been a "victim" of Satanic Rites, and a schoolgirl identified an 18-year old man as the "Satanist" who had "sacrificed" the cat. In a subsequent court case, the girl admitted having made up the story. It was left to the *South Avon Mercury* to solve the mystery by locating the cat's owner. The paper later reported that its owner, an elderly lady, had merely given her cat a cremation send-off.

Last year, a woman living in North Kensington was harassed twice, after she left a bloody deerskin (the deer had been originally found dead by the roadside) on her balcony to dry. Firstly, two policemen called on her, as neighbours thought that the animal had been butchered in a "Satanic" rite. Shortly afterwards, she answered the door to a young woman who spat in her face and screamed abuse at her accusing her of torturing the animal. In the end, she removed the deerskin (intended as a present to her aunt), and threw it in the dustbin.

Circle Sanctuary Harassed by Fundies

Selena Fox, High Priestess of the Circle Sanctuary[2] has been recently involved in a court case against a televangelist. Last summer, Circle Sanctuary received reports that Jeff Fenholt,[3] a right-wing fundamentalist preacher, had named Selena Fox and Circle as the "next targets" in his anti-witch campaign. Last

1 Royal Society for Prevention of Cruelty to Animals, founded in Britain in 1824, is the oldest and largest animal welfare group in the world.

2 Selena Fox (1949 –) is an American Wiccan priestess and environmentalist. She founded Circle Sanctuary in 1983.

3 Jeffrey Craig Fenholt (1950 – 2019) was an American rock singer and Christian evangelist. He had a long and extremely bizarre musical career, beginning with playing Jesus in the original Broadway production of *Jesus Christ Superstar,* and (briefly) as lead singer for Black Sabbath! He converted to Christianity and sold 3.5 million Christian rock records, often playing to live audiences of over 100,000 ~~gullible idiots~~ people. The culmination of this extraordinary career came in 2008, when he got the job as executive producer of the Beijing Olympics concert series.

Samhain, he travelled from California to the town of Mt. Horub near Circle Sanctuary and held a rally which featured anti-witch & Pagan propaganda, which mentioned both Selena and Circle. Selena obtained a temporary restraining order to prevent him or his followers from coming within one mile of Circle property or disrupting their Samhain celebrations. For the first time, Circle hired off-duty police officers to guard Circle Sanctuary throughout their Samhain festival. On Friday, 13th November, Selena Fox faced Jeff Fenholt in court, in an attempt to make the temporary restraining order permanent. The courtroom was packed with Fundamentalists, with a team of lawyers associated with the infamous Pat Robertson's 'Center for Law and Justice'[4] to defend Mr. Fenholt and fight the restraining order. The order was not made permanent, though Mr. Fenholt publicly promised on television not to harm or harass Selena or Circle. Selena feels that although the case was dismissed, she and Circle won it in the public arena, with favourable media coverage. However, she is concerned that despite his public promise, the fundamentalist's activities remain a significant threat to the rights and security of Pagans, witches and occultists everywhere.[5]

Carlyon Blames Oxford Horse Mutilations on Occultists

Yes folks, self-proclaimed "King" of the "White Witches" and media bigmouth Kevin Carlyon has been at it again. This time, he has issued a press release saying that the recent wave of horse mutilations in Oxfordshire is being done by "black magicians". According to free paper *The Oxford Herald*, the Carlyons claim to have discovered the presence of a horse-worshipping sect on the border of Oxfordshire & Wiltshire. They are also claiming that The White Horse of Uffington[6] is a centre for "black magic sacrifices". Needless to say, local Pagans in the Oxfordshire area are horrified by these accusations and general opinion is that it is high time someone had "a quiet word" with the Carlyons. A spokesperson from the Pagan Federation said that the PF were "on the case".

Oxleas Wood Case Thrown Out of Court

On February 19th, the High Court threw out the action to block the government's development of Oxleas Wood. The London Borough of Greenwich, the "Oxleas Nine", and environmental groups were claiming that the government's offer

4 The American Center for Law & Justice (ACLJ) was founded in 1990 by evangelical minister and well-known right-wing TV pundit Pat Robertson "to protect religious and constitutional freedoms" – which in true Christian style practices the exact opposite of what it preaches.

5 Luckily since he's now dead he can no longer threaten anyone.

6 The Uffington White Horse is a 3,000-year-old prehistoric hill figure, 110 m long, created by filling 1 metre deep trenches with crushed white chalk. It is located near Uffington in Oxfordshire, England and is a must-see for Pagan visitors to the region.

of creating a site at nearby Woodlands Farm, was "simply absurd". A six-lane highway is to be built through the wood to link the East London river crossing, the A2 and the North Circular Road. Oxleas Wood is the last piece of ancient woodland in London, and a designated site of special scientific interest. Campaigners who have fought long and hard to save Oxleas Wood are now considering the possibility of an appeal against the decision. Adrian Harris, of the ecoPagan group DRAGON, says that more can be done and that the fight is not over yet. A wide variety of Pagan and magical groups have been supporting the action since it began.

Santeria Goes to the Supreme Court

The US Supreme Court has been hearing arguments regarding the right of Santeria followers to sacrifice roosters, pigeons and goats in a Miami suburb. The case is challenging the city of Hialeah's restrictions on Santeria, a religion with an estimated 60,000 practitioners in South Florida. In addition to resolving the Santeria dispute, the decision of the Court could signal future trends in religious freedom and other individual-rights cases. It is also being related to the so-called "Peyote Decision" of 1990, when the court ruled 6-3 to uphold the punishment of Native Americans who ingest peyote as part of their religion. A wide range of religious and civil-liberties groups have attacked the Peyote Decision, seeing it as government intrusion into religious matters and an erosion of First Amendment rights. Civil authorities in South Florida, New York, and other areas with sizable Cuban-American communities have clashed previously with Santeros over allegations of cruelty to animals; but officials have generally acted under laws governing animal treatment and public health. The city of Hialeah went a step further when it passed special ordinances in direct response to the opening of a Santero Church. Reaction was swift, and in 1987 hundreds of people picketed city council meetings, condemning Santeria as "an abomination to the Lord". In the end, the council made it a misdemeanour to kill animals for religious purposes, even if done humanely, though the city preserved the right to kill for food, sport, medical research, and the elimination of strays. The Jewish practice of Kosher killing is also exempted. Hialeah officials are asserting that Santero sacrifices, even if swift, amount to torture.

Ed's note – we have just received an as yet unconfirmed report that the case has been given in favour of the Santeros.[7]

7 This was Church of the Lukumi Babalu Aye, Inc. v. Hialeah, 508 U.S. 520 (1993). On June 11, 1993, the Supreme Court unanimously concluded that the city's ordinances violated the Free Exercise Clause of the United States Constitution. Justice Anthony Kennedy's opinion stated that "religious beliefs need not be acceptable, logical, consistent or comprehensible to others in order to merit First Amendment protection".

THE MAN WHO INVENTED SATANISM

by *Gareth J. Medway*

Words change in meaning. The terms "Satanism" and "Satanist" were originally used to signify heretics. The earliest use of "Satanism" recorded by the OED is in a Catholic pamphlet, where it is used of the Protestants. "Satanist" first appeared in 1559, in an attack on the Anabaptists. There was no connotation of an organised cult of Devil worship, for which the term "witchcraft" would have been used. In the 19th century, "Satanism" was used to describe the poetry of Lord Byron.[8]

So when did Satanism come to imply a conspiracy of diabolical orgiasts, as it does today? The OED is quite clear here: "The worship of Satan, alleged to have been practiced in France in the latter part of the 19th century." The first representative quotation is from a magazine article of 1896: "There are two sects, the Satanists and the Luciferists – and they pray to these names as Gods."

Since allegations of Satanism have been going on ever since, it is worth looking at the genesis of the term in detail. Was the worship of Satan widely practiced in late 19th-century France? Not at all; the whole affair was one of the most successful practical jokes in history.

In April 1885, the Catholic Church believed that they had secured an important convert. Gabriel Jogand-Pages, better known by his pen-name of Leo Taxil, a leading light of the anti-Clerical movement, had gone to a priest saying that he had been moved by the Holy Spirit, and become reconciled to the Church. Previously editor of journals such as *The Mud-Slinger* and *Down with the Clergy*, he had also turned out a large number of anti-clerical and pornographic books, including *The Debauches of a Confessor* and *The Pope's Mistresses*. He said he was determined to devote the remainder of his life to undoing the mischief worked by his former writings.

Taxil's conversion became highly celebrated, and in 1887 he even received an audience with Pope Leo XIII,[9] whom he had previously accused of being a poisoner. However, his change of heart was fraudulent. He had merely decided that he could attack the Church more effectively from the inside.

8 George Gordon Byron, 6th Baron Byron (1788 – 1824) was an English poet, revolutionary, and total badass. His poetry is as magnificent as he himself was.

9 Pope Leo XIII (1810 – 1903) was something of a moderniser of the Roman Catholic Church. For example in 1891 he issued the encyclical *Rerum novarum*, which advocated for the rights of workers to a fair wage, safe working conditions, and the formation of trade unions.

Taxil's first book, after his pretended repentance, was an attack on Freemasonry, which Leo XIII had condemned in a bull of 1884.[10] It should be explained that the Church's fundamental objection to Freemasonry is its religious tolerance. To become a Mason one is expected to declare a belief in God, but one's actual creed does not matter. Indeed, in Jerusalem at the present day there is said to be a lodge where Christians, Jews and Moslems meet together in perfect amity.[11] The Roman Church, by contrast, has always had an official attitude of intolerance. Since only Catholics can be saved, they should not gather together with non-Catholics, since that might prejudice their own salvation. Therefore, Masonry, said the Pope, like everything contrary to the Church's teachings, must be the work of the Devil.

Though Leo XIII no doubt only meant this accusation to be understood in general terms, Taxil took it literally. He professed to find evidence of Satanic allegiance in the rituals of Freemasonry (which were even then well-known from exposures). He did this by using now familiar methods such as reading things backwards. The traditional furnishing of a Masonic lodge includes the two pillars Jachin and Boaz, meaning "Beauty" and "Strength". According to Taxil, the real significance was found in reading them in reverse, giving "Zoab" and "Nichaj", which, he said, meant "penis" and "copulation", showing that Masonry was really a fertility cult in disguise. (The joke was that these names, like much else in Freemasonry, were taken from the Bible, so that if Taxil's interpretation was correct then it would reveal much more about Christian origins.)

This book was so successful that it was extended to a three-volume series. He decided to go much further. He claimed that while the lower-grade mason might not be aware of the cult's Satanic connection, there was an inner circle who knew exactly what they were doing. Now, regular Freemasonry confers only 3 degrees of initiation. However, there are several extras, known as the "side degrees", of which

10 *Humanum genus*, promulgated on 20 April 1884, condemns Masonic belief in the equality of all people: "Then come their doctrines of politics, in which the naturalists lay down that all men have the same right, and are in every respect of equal and like condition; that each one is naturally free; that no one has the right to command another; that it is an act of violence to require men to obey any authority other than that which is obtained from themselves." It also condemns the separation of Church and State: "It is held also that the State should be without God; that in the various forms of religion there is no reason why one should have precedence of another; and that they are all to occupy the same place." Note that at the time of writing, this prohibition of Masonic teachings remains intact. Cardinal Joseph Ratzinger, later Pope Benedict XVI, stated in the 1983 *Declaration on Masonic Associations*: "Therefore the Church's negative judgment in regard to Masonic association remains unchanged since their principles have always been considered irreconcilable with the doctrine of the Church and therefore membership in them remains forbidden. The faithful who enroll in Masonic associations are in a state of grave sin and may not receive Holy Communion."
11 It may be said, but we can find no record of it. Although there are 4 Arabic speaking Lodges in Israel at the time of writing.

the best-known is the 'Scottish Rite'. This offers an additional 30 degrees, from 4 to 33. These grades, though they sound higher, do not in fact confer any authority over the "lower" grades; but since Masonry is not well understood by the general public, it has always been easy for conspiracy theorists to claim that they do. (An exact parallel is Wicca, where there are normally 3 degrees of initiation; anyone claiming to be a 33rd degree Wiccan would rightly be identified as a poser.)

At this time the head of the Scottish Rite was Albert Pike, of Charleston, USA.[12] Taxil circulated forged copies of "Secret Instructions" purporting to come from Pike, concerning the Masons' attitude to God. They "showed" that, at the Higher degrees, members were informed that Lucifer, God of Light, was the True God, and that Adonai, God of the Christians, was the principle of darkness. For clarification, he explained that Lucifer was not identical with Satan, and that Satanism was a heresy from the true Luciferian Creed.

At this stage Taxil clearly needed to be able to hint at wild orgies, comparable to those of the Witches' Sabbats. But Masonic Lodges only admit men, which would limit them to one particular type of sexual debauch.

He therefore invented a group called the Palladian Order, which was said to involve both men and women. *Are There Women in Freemasonry?* (1891) gave supposed texts of the crudely blasphemous Palladian rituals:

Grand-Master: What is the sacred word of the Mistresses of the Temple?
Grand Lieutenant: Lucifer.
G-M: Do you not tremble when you pronounce that name?
G-L: The wicked and the superstitious tremble, but the heart of a Mistress of the Temple does not know fear. Holy, holy, holy Lucifer! He is the only True God.
G-M: What is the work of a Mistress of the Temple?
G-L: To execrate Jesus, to curse Adonai, and to adore Lucifer.

Included was a picture of the Order's evil female chief, 'Sophie-Sapho'.

In the preface to this book, Taxil was able to cite letters of goodwill written to him by seventeen bishops, archbishops and cardinals. He must have realised that some of his audience were capable of believing anything.

12 Albert Pike (1809 – 1891) was an American author and prominent Freemason. His work *Morals and Dogma of the Ancient and Accepted Scottish Rite* (1872) is still considered a standard text on Masonic degree structure and symbolism. Unfortunately for modern Masons, Pike was also a General in the Confederate Army and an avowed racist, stating that "...the white race, and that race alone, shall govern this country. It is the only one that is fit to govern, and it is the only one that shall." His racism extended deeply into his (erroneous) interpretation of Masonic beliefs. In the official *Proceedings of the Grand Lodge of Free and Accepted Masons of the State of New York* (1899), he wrote: "I took my obligation to White men, not to Negroes. When I have to accept Negroes as brothers or leave Masonry, I shall leave it!"

He now obtained the collaboration of a certain Charles Hacks, a doctor who had traveled widely in the Far East. Together they wrote *The Devil in the Nineteenth Century*, a massive work which appeared in serial form from 1892 onwards, and eventually ran to nearly 2,000 pages. The book purported to be the memoirs of Dr.. Bataille, who had been a ship's surgeon in the French Merchant Navy (as Hacks had).

The story begins in the authentic style of a horror novel. On a voyage to Ceylon, Bataille noticed an Italian passenger named Carbuccia, who seemed inexplicably sad. Eventually he learned why: Carbuccia confessed to him that he was a Freemason, and hence condemned to eternal damnation.

Bataille decided boldly to infiltrate Masonry. He sailed to Naples, where he was able to obtain high Masonic grades for a fee of 500 francs. On his return to the Orient, he found that he was now welcomed into every kind of diabolic ceremony. What he witnessed would have confirmed the worst fears of his most paranoid readers. The omnipresent Freemasons were in league with the Hindus, the Buddhists, the Spiritualists, and the English, all of whom worshipped the Devil.

On a visit to Calcutta, he was taken to Mahatawala, a complex of 7 temples on a rocky plateau outside the city. In each of these temples a different satanic ritual was enacted, by Hindus – who were depicted as calling on such deities as 'Shiva-Beelzebub' – and Englishmen. In the first temple, Bataille underwent the "Baptism of Serpents"; in the second, the sanctuary of the Phoenix, he witnessed the blasphemous marriage of the Apes, during which the celebrant washed his hands in molten lead (being servants of darkness they could do many things normally impossible); in the third, consecrated to Eve, what he witnessed was said to be so obscene he dared not print it; in the fourth, a Rose-Croix sanctuary, he witnessed Indian girls dancing and then dematerialising; fifthly, in the Temple of the Pelican, there was a lesson in Masonic charity; sixthly, in the temple of the Future, a hypnotised girl tried unsuccessfully to divine what was being done in the Vatican; finally in the Temple of Fire there was the inevitable sacrifice.

In China he attended a seance (seances are also devilish, according to the Church) where Lucifer materialised and made a prophecy of the coming of the Antichrist ("there will be nine more popes, then I will reign.")[13] On a boat to Singapore, he met a young Scotswoman, a Presbyterian, named Arabella D***. Now the Presbyterians, as all good Catholics know, are Socinian heretics, hence they are Gnostics, a type of Satanist. It was not too surprising then, that when Arabella took Bataille to a Presbyterian church in Singapore, it transformed at

13 The ninth Pope after Leo XIII was Benedict XVI. That implies that his successor, our current Pope at the time of writing, Pope Francis, is secretly working for the reign of Lucifer.

the touch of a button into a Masonic Lodge, where he witnessed the initiation of a Mistress of the Temple (one of the Palladian ceremonies given previously in *Are There Women in Freemasonry?*) The climax was the desecration of the host:

"A deathly silence fell on the assembly. The Grand-Mistress raised her voice and spoke in a metallic tone, her throat contracted:

"The Priests say – This is your body. We say: it is the body of a traitor."

...Then the Grand-Mistress raised the host, with an imperious gesture; but Miss Arabella had no need of encouragement; the dagger in her hand, she lashed out in rage at the host, crying out like a demon:

"Holy, holy, holy Lucifer! Curses on Adonai and his Christ!"

Bataille's accounts of the infinite wickedness of the English must have helped boost the book's sales. The Rock of Gibraltar, which Bataille visited, proved to be hollow, and filled with infernal factories making Satanic regalia, and weapons to be used in a future war against Catholic countries.

The Palladian Order proved to be the controlling body behind Freemasonry and every other type of Satanism. It was based at Charleston along with the Scottish Rite. Every Friday afternoon Lucifer appeared there in person to give instructions to his disciples, which would be carried out by conspirators all over the world.

Bataille's personal reminiscences were interspersed with historical material. Much of this would have been overlooked by most students of demonology. For example, an account of *An Authentic Apparition of Satan* was quoted from *Blackwood's Magazine*, without mentioning that the original was fiction.

The Devil in the Nineteenth Century became one of the bestsellers of the decade. It is evident from the public reaction that many people believed even its most outrageous claims. Soon others were jumping on the anti-Satanist, anti-Masonic bandwagon. Some of these authors were (unlike Taxil) also violently anti-Semitic. Indeed, the notorious *Protocols of the Elders of Zion*, which was written in Paris at about this time, may well have been influenced by the Taxil hoax.

One of France's leading clergymen, Leon Meurin, a Jesuit and Archbishop of Port Louis, published *Freemasonry, the Synagogue of Satan*, in which he pointed out that Masonry is based on the Kabbala, and the Kabbala is Jewish. Amidst a muddled series of numerological arguments, he casually repeated stories about Jewish ritual murder. Other writers brought in their own pet obsessions. A certain Louis Martin combined attacks on Masonry with anti-Semitism and Anglophobia, turning out such titles as *Are the English Jews?* and *England Governs France by Means of Freemasonry*.

Catholic journals, determined to combat the powers of darkness, published letters supposed to have been written by Sophie Walder (as Bataille had learned Sophie-Sapho's real name to be) and Diana Vaughan, another High Priestess of

Lucifer. These last were written by Taxil's secretary, to give them the authentic feminine touch. She also posed for photographs in Masonic vestments.

Splits were said to have occurred between the Satanists and the Luciferians. Then Diana Vaughan quarrelled with Sophie Walder, and came to Europe, where she founded the "New and Reformed Palladium", whose journal was put on sale in Paris. Clergymen, horrified by the blasphemous Luciferian creed enunciated by this magazine, prayed incessantly to St. Joan of Arc for Miss Vaughan's conversion. Sure enough, in June of 1895 it was announced that like Taxil she had seen the error of her ways. The New and Reformed Palladium journal ceased publication, to be replaced at once by *Memoirs of an ex-Palladist*.

This latest production continued to make allegations in the familiar vein. By now all sorts of people were accused of belonging to the Satanic conspiracy: Alice Booth, the daughter of General Booth, the founder of the Salvation Army, held a leading position, as did Queen Victoria, who had been "given over to vice and drunkenness from her youth"; also the Manchester Unity of Oddfellows,[14] who worshipped Satan and Lucifer indifferently; Lord Palmerston;[15] and William Wynn Westcott[16] (founder of the Golden Dawn) was "the actual chief of the English Luciferians". The Satanists were now said to have their own man almost in the Vatican, in the person of Adriano Lemmi, an Italian politician and a chief of Scottish Rite Masonry. When the owners of the Palazzo Borghese in Rome, where Lemmi rented an apartment, insisted on inspecting the whole building, they found that one of his rooms had been converted into a Palladian temple, complete with a tapestry of Lucifer, and lit by electricity. He was also said to have stuck a crucifix down the drain of his lavatory, so that it might be regularly defiled.[17]

In 1896 an anti-Masonic congress was held at Trent. By now doubters were appearing. The rationalists present refused to believe in the very existence of Diana Vaughan, since she was associated with supernatural events such as appearances by the Devil. 'The Count C.H.' read a paper in which he stated that he had tried to check out some of the facts given in *The Devil in the Nineteenth Century* and found that they were totally wrong. A member of the Asiatic Society

14 The Independent Order of Oddfellows Manchester Unity Friendly Society is a fraternal order and mutual aid society founded in Manchester, England in 1810, as a form of peer-based insurance system. Not even remotely Satanic.

15 Henry John Temple, 3rd Viscount Palmerston (1784 – 1865) was British Foreign Secretary and then Prime Minister in the mid-19th century. He famously argued for the stealing of land from farmers in Ireland and personally evicted 2,000 Irish people from their homes in the midst of the Great Famine. Not a Satanist, just a huge asshole.

16 William Wynn Westcott (1848 – 1925), English coroner, Theosophist, and Freemason. He was a Supreme Magus of the Societas Rosicruciana in Anglia (Rosicrucian Society in England) and one of the three co-founders of the Golden Dawn.

17 We love the ingenuity of this plan, if not the impracticality.

of Bengal had written to him saying that there was no complex of 7 temples named Mahatawala on a plateau outside Calcutta, and could not be, since the countryside around the city was totally flat. It was also noted that a picture of a "sacrificial victim" given by Dr.. Bataille was in fact taken from the *Hong Kong Telegraph*, and showed a murderer executed by dismemberment in Canton. (In England, Arthur Waite had observed that parts of the ceremonies of the Palladian Order, supposed to have been written in the Eighteenth century, were copied from the writings of Eliphas Levi.)

> *"Reverend Fathers, Ladies and Gentlemen: I must first of all offer my thanks to my colleagues and the Catholic Press who have given support to my campaign during the past twelve years. But now, in addressing you, I must confess that the campaign is something quite different to what you supposed it must be ... Sophie Walder, a myth! Palladism, my most beautiful creation, never existed except on paper and in thousands of hot minds!"*

In April 1897 Taxil decided to bring the affair to an end, and called a meeting at the Geographical Society in Paris, where it was announced that Diana Vaughan would appear. Instead he made a speech himself:

"Reverend Fathers, Ladies and Gentlemen: I must first of all offer my thanks to my colleagues and the Catholic Press who have given support to my campaign during the past twelve years. But now, in addressing you, I must confess that the campaign is something quite different to what you supposed it must be ... Sophie Walder, a myth! Palladism, my most beautiful creation, never existed except on paper and in thousands of hot minds! ... It will never return ... Although there are some who will not do so, I hope there are a few who will take this little comedy that I have staged in good part."

After speaking for an hour about how he had created his "mystification", whose purpose had been to make fools of the Catholics, Taxil left hastily. Pandemonium broke out in the hall, and the police had to be called to break the meeting up. The churchmen present refused to believe that they had been duped, and declared that Taxil had been "bought" by the Freemasons.

Taxil was wrong to declare that the joke was over. People have believed in the Satanic world conspiracy ever since, though it is usually now detached from its specifically Masonic background. Taxil's inventions have never ceased to be quoted by sensational writers. There are "factual" books in print to this

day giving the yarn about a Palladian temple in the Palazzo Borghese. The story was also repeated by Dennis Wheatley in Chapter 3 of *The Devil Rides Out* in order to establish the credibility of the novel's theme, though for some reason he placed the Borghese in Venice. Indeed, Wheatley's ideas about black magic in general seem to be largely derived from Taxil. His Satanists are organised in a Masonic conspiratorial fashion, a feature absent from old-style allegations concerning witchcraft.

Moreover, the Taxil hoax, admitted to be such 95 years ago, has certainly played a part in the building of the contemporary Satanic Child Abuse Myth. Tim Tate, in *Children of the Devil*, talks about *The Devil in the Nineteenth Century* as if it were a serious treatise. The "Instructions" on the worship of Lucifer, attributed to Albert Pike, are quoted in Kevin Logan's *Paganism and the Occult*, Andrew Boyd's *Blasphemous Rumours*, and several other recent works. What is certain is that no-one had heard of Satanism, by that name, until the 1890s.

SPOTLIGHT

Raising Hell
Les Miller – Crowley on Stage

Raising Hell *is a black comedy based around the life of Aleister Crowley. Set in the 1990s, it revolves around the relationship between Martin Rosenberg, a young magician, and Aleister Crowley, whom Rosenberg calls forth to become his Master and guide. As the play proceeds, it transpires that Crowley believes Rosenberg to be the reincarnation of Victor Neuberg, his pupil and lover. Various people from Crowley's past speak to him through Martin, showing the audience the complexity of Crowley's character. Crowley is played by David Hargreaves and Adam Lewis is Rosenberg.*

Les Miller is the author of Raising Hell. *He has been for several years the Artistic Director of the Inner City Theatre Company, and his previous productions include* Hot Stuff *and* The Lambada Transaction. *This interview takes place following rehearsals for the play.*

PN: **What prompted you into writing a play about Aleister Crowley?**

LM: Well, I came out of the 60s, and I think my awareness of his "name" stemmed from the interest in him during the 60s – his reputation for outrageous and excessive behaviour – and I think that's what drew me to his character.

PN: **Could you give us a brief summary of the play?**

LM: It is really a fantasy. I wanted to explore Crowley's character, and some of the biographical details of his life – the shape of his life. I didn't want to do it in a linear fashion, starting from day one, as it were. That would be predictable. What I wanted to do was create a sort of fantasy where Aleister Crowley arrives in the 1990s (in the flesh) and so there is a clash between Crowley's outrageous attitudes and opinions, and the modern 90s "political correctness"; the generally restrictive era that I feel we've entered into. In a way, this parallels some of the restrictions

that Crowley had to face. So Crowley arrives and challenges the accepted norms and values of our consumer, packaged society – this appeals to me.

PN: This is Crowley in his element – kicking over the traces.

LM: Yes. And there are a lot of traces to be kicked over. It may be a terrible generalisation, but I do feel there's a feeling of discontent at the moment, with no sense of spirituality at the centre of things, and very much a feeling of repression and restriction; a hollowness in people's lives. The character of Martin (who calls Crowley into the flesh) is a bit of everyman in a way – a person who feels that there's no purpose or direction to his life; someone who is wandering in the wasteland. So he calls in Crowley, who fills that vacuum.

PN: How do you think that the play demonstrates this theme of the "emptiness" of modern life, and indeed, does the play overcome this theme?

LM: Through the character of Martin. Martin embarks on a journey and is "freed up", both sexually, imaginatively and spiritually. This is the effect of Crowley; of his "system", of his force and energy on Martin's character. I think there is a critique in the sense that, in Crowley's time, inadequates were drawn to him and Martin is clearly an inadequate, and is drawn into a system which he doesn't have any means of looking at objectively. So it is through Martin that I characterise the 20th century.

PN: As the play proceeds, Martin, who at first is this rather confused character, seems somewhat apprehensive of Crowley and his forthright opinions. Do you think Martin comes to enjoy his relationship with Crowley?

LM: Yes, very much so. It's what he wants, really. A centre to his life; somebody to provide leadership. I think there's something frightening about that, because people are looking for simple solutions. Towards the end of the play, Martin becomes quite Nietzschean, when he takes on Crowley's philosophy, and becomes almost a chilling figure. In a way, this is a warning about how Crowley had been misunderstood and misused. Again, It's a comment about the late 20th century – how people are much cooler and passive and "taking". I think the sympathy goes to Crowley here, and I think one sees that Crowley was misunderstood, when Martin is seen at the end of the play to be a rather negative figure.

PN: This is in contrast to Crowley. At the beginning of the play we have the Mythical Crowley who challenges the values of the 90s. As the play progresses, he becomes more human and almost pathetic, as Martin becomes more self-assured.

LM: This is the intention. It has to do with the pupil-teacher relationship. Crowley needed Neuberg much more than Neuberg needed him – to me this says that Crowley loved Neuberg, but couldn't leave him, so he was trapped. Which shows me Crowley's Achilles heel – his vulnerability – and is important in the play.

PN: Do you think then, that Crowley destroyed the people he loved?

LM: Very much so. I think that must have caused him regret, guilt, and shame. There's a supernatural storyline which I'm following. At the beginning, Crowley has been cast into limbo at death, in which he remains in the same condition as the day he dies. He's trying to find out who cast him into limbo, and he suspects that It's one of the "Secret Chiefs", but at the end of the play, we find that his situation is very much bound up with his mother. So in a way he does end up in a Hell – one that he created for himself, because I think he never escaped his childhood upbringing. The ending has a judgemental aspect to it, but It's more than a simple moral message.

PN: Crowley is a very complex figure; we have Crowley the myth and Crowley the man. How far do you think "Crowley the myth" was a prop for "Crowley the man"?

LM: I just feel he's looking for peace. The real "man" for me is someone who is wounded and tortured, but can never admit that. So the myth, I think, hid this little boy inside, who was constantly seeking attention and love. I guess that's a very Victorian character, really.

PN: This is important. People do tend to concentrate on "Crowley the myth" – the mountaineer, the sexual athlete, the drug addict, the prophet of a new aeon: yet his human face is ignored.

LM: That's very true. I don't know how successful the play is in getting underneath all that, but there is so much bombast there. He did so much that to find those moments of humanity underneath is difficult. This is why I decided to make the relationship between him and Martin the focus of the play. It's a love story (I hope) which means that we can sympathise with it. It's not just a parade of mythological events and excesses. I think the good thing about doing a play about him is that, having that character in front of you, you will sympathise with that character. If we get it right, then despite all the excesses that you see, you accept them, and you find yourself warming to the man.

PN: Let's talk about the excesses; the scenes which some people might find problematic are those where Martin fucks Crowley, and also the turd-eating and blood-drinking. Why those scenes?

LM: For me, a theme in the play is the search for ecstasy; of going to the edge. I see Crowley's life as a journey almost equivalent to mountaineering – going for it. I think that drove him to seek the edge of experience. I wanted to show people going to the edge; breaking taboos.

PN: Do you think there's a shrinking in our society away from taboo areas?

LM: Absolutely. There is a feeling that areas are being closed down – It's happening around us, and It's slightly frightening. It worries me. Whilst I'm not

condoning Victorian morality, by any stretch of the imagination, I'm in a way standing up for Crowley's subversiveness and anarchic qualities.

PN: Do you think these taboo-breaking scenes in the play will draw undue attention to it?

LM: Obviously, I do intend the play to be, in some ways, provocative. I think the humour lightens it, also it should be a releasing appearance for people. If a play provokes reaction, then at least It's making someone think.

> *"People do tend to concentrate on 'Crowley the myth' – the mountaineer, the sexual athlete, the drug addict, the prophet of a new aeon: yet his human face is ignored."*

PN: Crowley does have this attitude that sex is an act of Will, and nothing to do with sexual preferences. This is another area which has become so politicised and hedged about with beliefs, that reaction to those acts could be quite interesting.

LM: There's a very interesting debate there. There has been an attempt to redefine sex as not being about power relationships. In my opinion, this is crap. Sex is a power relationship, and I think that Crowley knew that good sex involved power.

PN: How do you think that people will react to the magical elements?

LM: Obviously, the play is for a popular audience, who may know very little apart from Dennis Wheatley and Hammer Horror. So what I've tried to do is approach it on two levels. One is the "horror" level – hooded figures and candles. That level is easy for the audience to come to terms with. But the other level, the astral projections and projection of characters into themselves, I hope the audience will find more imaginative.

PN: Would you say that you are hoping to lull the audience into a position of complacency, and then surprise them?

LM: That's right. I think It's important to do that. I think there is a validity in any system which allows people to go into areas that they wouldn't normally explore. There is for me a psychological foundation here, rather than a spiritual one.

PN: How have the cast reacted, then?

LM: Well, there's so many aspects to Crowley's life that the play becomes very complex, so It's a very technical show. I think they are imaginative play – for shifting roles. It's a double act – the two characters, Martin & Crowley, have to work out how to work off each other.

> *"There is a new puritanism arising, and Inner City Theatre very much deals with contemporary issues which here include spirituality and homosexuality. We're presenting very graphic homosexuality on stage, and I think It's important to acknowledge that area of sexuality. The thing that holds the play together is, as I've said, a love story. It's the shared experience between Crowley & Martin going to the edge, and finding some genuine poetry to their lives."*

PN: I understand you had some difficulty with initially finding actors for the roles?

LM: Yes I did. Some people walked out, refusing to be auditioned, once they'd read the synopsis of the play, let alone the script. I think this was due to two factors: the excess of sexual behaviour, and also the attitude to the occult generally. Which disappointed me, as I hope that the play offers a reasonably objective view of occult practices in the late 20th century. It certainly isn't intended to blacken anybody's name – It's meant to be a "warts' n' all" biography.

PN: In the current atmosphere, with the "Satanic Child Abuse" myth, and investigative journalists doing their best to "blacken" the occult, do you think that *Raising Hell* will cause any kind of furore?

LM: I think that if they want to go for you, then you can't do anything about it – they'll just make it up. It's a risk that you have to take. I have been a bit concerned about the laws of blasphemy, I have to say. There's plenty that's blasphemous in the play – Crowley's attitude to Christ, for example. It's a fringe play, and I think that people are more relaxed about fringe plays. People know what they're coming to see.

PN: How long did you spend researching Crowley's life?

LM: I've been working on the project for eighteen months. In the end, I didn't read everything, and I adopted a serendipity approach looking for events that I could use.

PN: In the play, Crowley seems to be almost bluffing his way through the world of the 90s.

LM: Yes. When Crowley first appears, he has lost his powers and forgotten a great deal. So throughout the first act, he uses Martin in order to rejuvenate himself – which is also a device for telling the audience about his life.

PN: **There's an incredible range of characters thrown up before Crowley in the play – Mathers,[18] Yeats,[19] Leah Hirsig,[20] Neuberg,[21] Aiwass,[22] Crowley's mother. Did you have to do a lot of side research on them?**

LM: Yes, particularly Neuberg. I found Jean Overton Fuller's book[23] useful there. It was good getting different people's views on Crowley – she took Neuberg's side, for example.

PN: **Crowley seems to be very hard to take in the play – he is too forthright and opinionated for the 90s.**

LM: Absolutely. He's racist, misogynistic, class-ridden – there's a very ugly side to him, which I feel is important to show. Otherwise It's not a rounded portrait. I became very concerned about his anti-semitic attitudes, but that was a product of the time.

PN: **What's your view on the use of ritual elements in the play?**

LM: I feel that for Crowley, magick was similar to any other activity – mountaineering, chess, etc. He wanted to find a field he could excel in. When he could not excel in poetry – because he was not very good; when he was drummed out of mountaineering circles because of his behaviour; I think he found magick to be an area where he could invent himself – inventing his own order; suddenly promoting himself to high levels of spiritual attainment; I feel he found a means for success keeping his position and status. At the same time, it became a genuine spiritual retreat for him, and I think he genuinely did want to find a system which reduced life to its very essences. I think that although he did a huge amount of work to effect that goal, his guilt brought him down. And that's an interesting point – I don't know how many people these days are able to finally eradicate guilt. I don't want to denigrate his magick, but I do think he used it to create his own myth. I think he also genuinely thought it would provide

18 Samuel Liddell MacGregor Mathers (1854 – 1918) was one of the founders of the Golden Dawn, and responsible for writing much of their material. He also translated (with varying degrees of accuracy) many important works of classical magic, including *The Goetia, The Key of Solomon* and *The Book of the Sacred Magic of Abra-Melin the Mage*. He was thus a pivotal figure in the Victorian magical revival.

19 William Butler Yeats (1865 – 1939), Irish poet, playwright, author, and occultist. He was a leading member of the Golden Dawn, a co-founder of the legendary Abbey Theatre in Dublin, and after Ireland declared its independence from England, served as a Senator in the newly-formed Irish government. Also in this editor's opinion, the greatest English language poet of all time. Seriously, read his stuff.

20 Leah Hirsig (1883 – 1975) was Crowley's "Scarlet Woman" from 1919 to 1924.

21 Victor Benjamin Neuberg (1883 – 1940) was an English poet, and an early disciple and lover of Crowley.

22 Aiwass was the name of the entity who Crowley claimed dictated *The Book of the Law* to him in Cairo in April 1904 (coincidentally exactly 117 years to the day while I am writing this footnote).

23 *The Magical Dilemma of Victor Neuburg* (1965).

an answer to other people's needs, but that the baggage he brought with him hindered him. I see the end of his relationship with Neuberg as the watershed in his life, after which he was eclipsed by larger events.

PN: Does *Raising Hell* bring forwards this issue of magick as an escape route, or means to solving problems?

LM: I hope it does. Certainly, for Martin, it solves a few problems. I hope the play also shows that Crowley used it to get away from his Plymouth Brethren upbringing. It also relates to the search for ecstasy, which is important for people. It's something that we don't get. I hope that the play conveys the need for ecstasy.

PN: Some people might argue that there is a danger in a search for ecstasy which brings one into conflict with social taboos. The occult is often seen as being "beyond the pale", and I think that there are elements in the play which show that too.

LM: I have to say that the play ridicules some aspects of occult practices. I hope though, it shows underneath that, the need for a spiritual centre in one's life. It's certainly not condoning some of the practices in the play. Some we should be aghast at, others laughed at, but hopefully also drawn to some of the other experiences. It becomes very sordid, where we see Crowley abusing his own magick in order to gain money and feed his heroin habit. I think he abused what he discovered.

PN: It's interesting how the play centres around the relationship between Crowley & Neuberg, as this is an aspect which is often underplayed. Some occultists are very loath to acknowledge Crowley's homosexual behaviour.

LM: Again, this was part of the impetus for doing the play. There is a new puritanism arising, and Inner City Theatre very much deals with contemporary issues which here include spirituality and homosexuality. We're presenting very graphic homosexuality on stage, and I think It's important to acknowledge that area of sexuality. The thing that holds the play together is, as I've said, a love story. It's the shared experience between Crowley & Martin going to the edge, and finding some genuine poetry to their lives.

PN: Les Miller, thank you very much.[24]

24 The play ran at the Old Red Lion in London, starring David Hargreaves as Aleister Crowley. Reviewing it in *The Independent*, Sarah Cumming wrote that "the play is written and performed at such a hysterical pitch that it soon palls. You learn more about Crowley from reading the programme note."

THINGS TO DO...
and THINGS TO READ

The Magick of Jinxing
by *Steve Moore*

Some dictionaries will inform you that "Jinx" means "a bringer of bad luck, a curse, a hoodoo", and then go on to blithely tell you that It's an American slang word. Which just shows you how much dictionary-compilers know about magick. The origin of the word is pure ancient Greek, and it refers to a magical wheel originally used, not in cursing, but in love magick. It was called a Iynx, which is pronounced, roughly, "yunx"... and from that we get "jinx".

A Iynx is basically a small wheel, suspended at the middle of a loop of string. It's wound up and then, as the string winds and unwinds, the wheel spins to make a humming sound. These days, It's the sort of thing which is given away as a free gift in kids" comics... but the Iynx is actually an extremely ancient magical tool.

Before we get into the details of how to make one, let's take a look at the mythology and the ancient uses. Iynx was the name of a nymph, the daughter of Pan and either Echo or Peitho (whose name means "persuasion"). With parentage like that, It's not surprising that Iynx specialised in love-potions, and it was one of her potions that caused Zeus to fall in love with Io. Hera wasn't at all pleased about this, of course, and vengefully turned Iynx into a bird, the wryneck, which bears her name in Greek.

The wryneck is a bird which, when in danger, can extend its neck considerably. At the same time its head-feathers will stand up, and it will twist its head and neck around to give a fair imitation of a snake. Most of the commentators seem to think that the wryneck is connected with the magick wheel because it can turn its head right round; the phallic imagery of an extended neck and "swollen" head seems to have passed them by completely.

The original, and perhaps purely mythical, form of Iynx-magick was invented by Aphrodite, who fastened a wryneck to a wheel and set it spinning. This she gave to Jason, who used it to seduce Medea. Its powers were obviously sufficient to overcome Medea's own considerable witchcraft.

As a simple magical wheel, the Iynx produces a rushing, windy, humming sound, though this isn't constant, as the wheel winds up and unwinds by turns.

The end result sounds rather like heavy breathing which, in context, again has obvious passionate connotations. And in ancient paintings, the Iynx is occasionally seen in the hands of love-deities like Eros and Himeros... or, in more realistic scenes, in the hands of women.

So the mythological scenario includes witchcraft, sexual symbolism, and potent sexual deities. In ancient magical practice, though, there's also a strong connection with the Moon. Mythologically, of course, Iynx's father Pan was the seducer of Selene (though we have nothing to suggest he used a magical wheel). Hekate is also associated with the Iynx, and besides having lunar associations, she was also the supreme goddess of Greek witchcraft. Besides, the main practitioners of Iynx-magick appear to have been women (not surprising if the victim was supposed to react physically like an endangered wryneck) and female witchcraft is essentially carried out under the sign of the Moon.

The best description we have of a ritual involving the use of a Iynx is found in a poem by Theocritus, written in the 3rd century B.C. Here the goddesses Selene, Artemis, and Hekate are called upon (the Moon Goddess in her celestial, terrestrial and chthonic aspects). Then a number of magical acts are performed – wax is melted, barley burned, a bull-roarer whirled, etc.) with simultaneous incantations such as "So may my lover melt". In between these acts, the operator uses her Iynx, with the spoken refrain: "Draw into my house my lover, magic wheel". The Iynx is used nine times, and then the operator enters into a conversation with Selene, telling of the progress of the love-affair. The whole rite ends with a salutation to Selene.

At this period then, the Iynx was used in love magick, to draw the target to the operator and bind him to her. This binding aspect was probably further symbolised by the way the two strings intertwine and coil around each other as the wheel spins. There also seems to be some suggestion that the Iynx was used by Thessalian witches to "draw down the Moon", and again we have the notion of drawing the target, in this case the goddess, to the operator and binding them to their will.

There doesn't seem to be much surviving evidence of the Iynx being used for sorcery after the beginning of the Christian era, and the practice may have faded into obscurity. It seems, though, to have been revived by the Neoplatonists some three or four centuries later, as one of the practices of Theurgy (divine work). Here the Iynx was closely associated with Hekate, who was of great importance in the Neoplatonic theology that derived from the Chaldean Oracles.

Here the name referred to both the magick wheel and also (in the plural, Iynges) to a triad of entities in the upper realms who act as messengers between the worlds. The Iynges are also known as "Binders Together" and "Masters of Initiation", and they are again associated with Hekate, whose power is said to manifest as a spiralling force.

On a practical level, we hear of the Iynx-wheel being used by Theurgists for rain-making, where it serves as a messenger between the upper and lower worlds, drawing down the rain, or manipulating daemons and sending them out to give prophetic dreams. Most importantly, though, the Iynx appears to have been used to invoke (and later release) the deities, drawing them down to possess a spirit medium. The rushing, windy sound of the Iynx may be associated with the approach of the divine pneuma (wind, breath, spirit – and so, inspiration). And lastly, as a whirling force, the Iynx was used simply to empower the ritual and make it work.

Some would argue that magick and theurgy should be widely distinguished, and obviously there is a difference of emphasis here. But both traditions share common characteristics, using the Iynx as a messenger that draws and binds together. Basically, though, the Iynx is a magical tool, whatever purposes it is put to. And so that you can think of a few of your own, let's get into the details of how to make one.

Although there seem to be some mentions of spherical or triangular Iynxes, the standard Greek model was a flat disc, or spoked wheel. This would normally have saw-like teeth round the edge, to increase the noise, but as I can't draw, the diagram just shows a disc. This would have been made of metal or wood. Something like plywood would be good, but if you just want to experiment, try thick cardboard. The heavy, compressed stuff, about an eighth of an inch thick, would be best, as this gives you some weight and rigidity. Light cardboard will

flap about and fall to pieces, and you need a bit of weight to get a decent noise out of the thing.

Whatever you're using, cut a disc about 6" across. Anything larger is a bit unwieldy, anything smaller doesn't have the weight to keep the momentum going. Now bore two holes, one on either side of the disc's centre, no more than half an inch apart. If they are wider than this, the disc will tend to flap sideways on the string. Cut about 5' of strong string, thread an end through one hole, and then back through the other, and tie the ends together.

Hold one end of the loop in each hand and let it go limp so the disc slides to the centre. Rotate one wrist and swing the disc in a circle, so the disc winds up the string. Keep doing this until the string's wound fairly tight. Now pull your hands apart horizontally, with a smooth, gentle movement. The string will start to unwind rapidly, spinning the disc. Keep pulling, but relax just before the string goes completely taut. There's a knack to this, which you'll pick up with practice. With the string relaxed and your hands moved a little closer together, the disc will keep spinning and wind the string up again. Just as the disc stops, pull your hands apart to increase the tension. If you keep doing this smoothly, moving your hands in and out by turns, you can build up the speed of the disc considerably. And as it speeds up it'll start to hum. If you're working with cardboard, the sound won't be all that loud, but if you amplify the sound through a microphone, or have several people using them at once, the result will be quite interesting.

A couple of points. Your disc is going to be spinning quite fast, and if It's made of wood or metal it could be quite dangerous, especially with a toothed edge. So keep it away from other people, and your own face. Also, if you're holding the string round one finger of each hand, you'll find it tightening and squeezing your finger quite painfully after a while, so you might like to wear gloves or add handles. It is also a good idea, with a cardboard disc, to reinforce the centre holes so that the string doesn't eventually wear through them. The Iynx doesn't have to be circular of course, though it should be reasonably symmetrical. So experiment; pentagrams, Chaospheres, whatever you will.

Further Reading

Theocritus' poem is available in *Arcana Mundi* by Georg Luck, Aquarian. For Hekate and the Iynx, Stephen Ronan's *Hekate's Iynx*, in Alexandria, No.I (Phanos Press); for Hekate in general, his *The Goddess Hekate* (Chthonios). My thanks to Steve for letting me use some of his information in this piece, though he's not responsible for what I've done to it!

The GODS say...

"I never knew there was so much in it!"

PAGAN NEWS

Appendices

HAIR-RAISER![1]

By *Clive Barkbrush*

Chapter 1

It was August, and my old friend Sir Guy Suit had invited me down to his country estate for a spot of shooting. As the last Iranian crumpled bloodily to the ground, we shouldered our Kalashnikovs and were walking back to the Hall, when Sir Guy's butler, Jones, came running across the field. He seemed to be waving a telegram in the air. Suddenly, the man seemed to vanish downwards.

"Hope the letter's still in good nick," remarked Suit five minutes later, as we unpeeled the unfortunate servant from one of Suit's more interesting anti-trespasser devices. Luckily, the paper had escaped the more vicious blades and spikes, and I recognised the writing at once – it was that notorious young rake, Charlie Richbastard.

Lounging in his elegant, sunlit study, Suit slipped his letter-opening athame under the flap, and read the message. "Well, well – looks like young Charlie has happened on something interesting."

He showed me the letter.

1 This would be the last novella Barry Hairbrush would write for us, and was never previously published in its entirety, since *Pagan News* folded before the serialisation was complete. We are very happy that with this collected edition we can finally make the whole thing available to our readers.

DEAR CHUMS
IN ISTANBUL STOP INVESTIGATING BIZARRE MANIFESTATIONS
IN HAUNTED SURGICAL SUPPLY SHOP STOP BEEN LOCKED UP IN
JAIL A COUPLE OF TIMES – FOOD DECENT STOP HOPE TO SEE YOU
SOMETIME, CHARLIE STOP

"Fascinating," I remarked. "Do you think we should hop out there and give him a hand?" Suit shook his head. "I think the young lad can handle himself." Sir Guy sat back and was starting to browse through the latest edition of *Decadence Monthly* when Sylvestenegger came into the room.

"That French window's coming out of your pay" said Suit as the crazed gunman picked himself up off the floor, brushing shards of glass from his clothes. "But there's an urgent message for you boss..." he held out a crumpled telegram. It read,

DEAR CHUMS
MONSTROUS EVIL DISCOVERED STOP DOUBTS FOR MY OWN SANITY
STOP EVEN NOW I HEAR IT CRAWLING OUTSIDE MY DOOR STOP
REGARDS CHARLIE STOP

"Well, Guy, looks like the young tyke has landed himself in the soup again."
"You're probably right, Barry. We"d better investigate. Sylvestenegger, go and pick up Jones from the hospital – he"ll probably be in intensive care – and get him to pack our bags. Then order some tickets for the Orient Express."
When we met that evening at the station, I noticed that Sir Guy had brought along some interesting equipment which Sylvestenegger had been helping him develop. There was the new "smart" blasting rod which electronically locked onto a target before letting go with the old astral bolt; the latest Stealth Magical Circle, invisible to all Qlippothic entities; plus a series of fire-and-forget Enochian Calls which could be automatically triggered at the touch of a button.
As for myself, I had packed a couple of pretty snazzy tweed blazers, a hamper of pâté and cold meats from Fortnums, and the trusty shortbread tin which held my Uncle Sedgewick's Ninja gear; a family relic of the days when Johnny Chinaman was British, and jolly glad of it, too.

As the train pulled away, Sylvestenegger went off to stake out strategic areas of the carriage roof. Suit and I got out the portable altar, and were enjoying a quick couple of Goetic demons, when two rather suspicious types knocked on the door.
"Yes?" asked Suit. They came in, rather glassy eyes and fixed smiles. One of them

spoke up. "We'd like to talk to you, if you've got a spare moment. About our religion, and the good news we have for you!" Too late, I saw him draw *The Watchtower* from a concealed holster. I tried to make a grab for it, but the other chap pulled a copy of *Jesus's Promise for a New World* on me, and I froze – I'd swear that I could see right up the spine of the book, as he levelled it between my eyes.

"Satan's Nostrils!" Suit cried, "It's the Jehovah's Witnesses Heavy Mob!"

Will our plucky British heroes be all right – or will they end up selling God's Double Glazing door-to-door? Find out in the next spunking episode of Hair-Raiser!

Chapter 2

The unthinkable had happened at last. After years of setting the Dobermanns on them, and laughing as they limped raggedly off, the Jehovah's Witnesses had finally cornered Sir Guy Suit and myself.

We gritted our teeth as we were offered God's eternal salvation at only fourteen pounds a month. I saw out of the corner of my eye that Suit was edging his hand very slowly towards the Genie bottle he had cleverly disguised as a decanter ("For the odd Djinn and tonic" he had explained). At that moment, there came a knock and a little man poked his head in.

"Tickets please!"

Unaccustomed to people knocking on *their* door, the pair swung round in surprise. Suit seemed to hesitate for a moment as if wondering whether to invoke the Genie, and then just brought the bottle down with a smart clack on the baddie's head. I used to box for my old school, and I dealt the man a sound British uppercut that laid him out cold.

"Everything all right, sir?" asked the inspector.

"Absolutely!" beamed Suit, handing over a few fifty pound notes with the tickets.

When the man had gone, we had a look at the villains. To our surprise, both

had pretty rocks on strings around their necks. Suit examined their copy of *The Watchtower* and made an amazing discovery.

"This is just the front cover stuck on! It's some kind of New Age magazine about flower remedies." The other one had two grainy photographs in his pocket. One was of Suit, posing for the local paper by the smouldering remains of a church last Beltane, and the other I recognised from the picture in my passport.

"This can only mean one thing, Guy. Somebody knew we were taking the train, and wanted to stop us."

"Yes, Barry. Somebody who's very interested in crystals and flower remedies!"

Late the next afternoon, the train pulled into Istanbul, dragging – thanks to an ingenious contraption of ropes which Suit had thought up – the two imposters behind it. The station was packed and bustling, but Sylvestenegger's rather conspicuous collection of combat weapons cleared a wide path in the crowd.

Within the hour we were installed in the luxurious Human Scissors Hotel, and Sir Guy had visited the bar and engaged two slim-looking young men as his personal masseurs. Meanwhile, I did a quick sacrificial invocation to Set and Typhon and dressed for dinner.

Suit joined me in the restaurant, looking considerably relaxed, and we were inspecting the hors d'oeuvres when there was a loud bang from outside. The wall disintegrated in a shower of glass and brick, and a car swerved in and came to a stop in the middle of the restaurant. It was young Charlie Richbastard! Clambering over a few struggling locals, we dragged him from the wreckage. He was gibbering insensibly, but he managed to pull something out of his trousers to show us. It was a small, glittering box, covered in strange designs!

"We'd better take him up to my room to recuperate, Barry", said Suit.

"Jolly decent of you to pay for all the damage, Guy", Charlie said, finishing off his third brandy. He was propped up in an armchair, and looking more like his normal self. Outside, the evening sun was cooling into orange and scarlet clouds, the murmuring of a thousand minarets lulling it to fiery rest...

"Barry, stop reading that travel guide, and look at this!" Suit had the box in his hand, and was examining it closely. There was a small inscription on the box: "Wildflower and Angelhands – Healing Crystals".

"Fascinating, Charlie. And this is what you sent us the telegram about? Tell us how you got it."

Charlie began his story.

"I had a few weeks spare, so I thought I'd come out here and slouch about in a white Panama hat, taking drugs. It's all the rage in the smart set at the moment. I'd not been here long when I noticed a sinister gloom around the alchemist's

shops: I got chatting to the local dervishes, and it seems that terrible things had been happening lately. People suddenly going off and buying expensive crystals for no apparent reason. Frightening apparitions stalking the streets at night, giving out holistic knee massages.

"And worst of all, a terrible demon box which turns anyone who opens it into a New Ager.

"I thought it was a lot of nonsense, Johnny Native getting the wind up and all that, but the next day I was at the bazaar, shopping for souvenirs, when I saw this exquisite lacquer box. Just the thing to keep the chemicals of a decadent youth in, I thought, and offered the man a few quid for it. I should have caught on when he told me to have a nice day as I was leaving, but it was only when I got back to my hotel that I noticed this was the notorious demon box itself!

"I opened the lid, and there was this terrible explosion of uncontrolled psychic energy – remember what it was like when "Squiffy" Thompson tried to sacrifice a goat that was high on mescaline? – the room was filled with some unspeakable presence, and I felt a terrible urge to give up fox-hunting and go out to love the trees. Luckily, I remembered a good banishing, and the thing disappeared back into the box. And, as is usual in circumstances like these, I then found myself clinging to the ceiling, doubting my very sanity."

"A terrible story!" exclaimed Suit, "No wonder you were in such a state."

"Oh, no," said Charlie, "It's because I went down to the bar straight after, and spent the next three days getting totally rat-arsed before I drove down here."

However, I wasn't yet convinced. "But Charlie, all this New Age stuff is a lot of rubbish."

"I wouldn't be so sure" said Suit. "I've made *a very careful study* of this subject, and It's my opinion that the entire thing is getting out of hand. Just look at this book I bought last week." He showed me a brightly-coloured volume about Channeling.

There were pictures of people holding little bits of rock in the air, and others gathered around them doing some weird and perverse practice called "Sharing the Experience". I was shocked. "Suit – if this kind of thing ever gets into the hands of impressionable young diabolists..."

"Precisely, Barry. The New Age is a very real threat indeed. And anybody opening that box is likely to be drawn into it. We must find some way to destroy it, before It's too late."

Can our heroes save the world? How will Charlie get replacement parts for a 1937 Bentley Touring Car in downtown Istanbul? Provided the New Age hasn't dawned, we"ll be back next issue with part three of Hair-Raiser!

Chapter 3

As midnight crept by, I sat on the balcony of the Human Scissors hotel, nervously fingering the New Age box which young Charlie had discovered. In the middle of the floor, a chalice buzzed and sparked as Sir Guy's new high-tech banishing field pumped psychic energy out of the room. This had, unfortunately, led to the energy manifesting in the rooms of other guests; there had been nothing but complaints from some chap on the fourth floor who was now sharing his en suite bathroom with the Fungi from Yuggoth. Sir Guy had settled matters by striking the man soundly with his cane, and sending young Charlie to get tickets on the next plane out of Istanbul.

All of a sudden, a glint of light in the street below caught my eye. Sir Guy peered over the balcony.

"Did you see that, Barry? The green car down there. Damn sure it was binoculars."

"We're being watched, then. These new-age Johnnies are a pretty clever bunch."

"Yes – we have to find some way of smuggling that box out of the hotel, and destroying the beastly thing."

A taxi pulled up in front of the hotel, and Charlie got out, waving up at us. I started to wave back, and then, to my horror, I saw the window of the green car across the street wind down, and some kind of crystal wand being aimed at him.

"Charlie! Get DOWN!" Suit yelled. Charlie spun around to see what was happening, and a bolt of pretty, rainbow-coloured light arced past his head and struck the facade of the hotel, which rocked under our feet with the impact. As Charlie ducked, the door of our room flew open, and Sylvestenegger charged in, pulling a Dragon Ground-to-Ground missile launcher behind him.

"Green car across the road," advised Suit, wisely diving for cover under the table. Sylvestenegger aimed, squeezed the trigger, and the baddies" car suddenly lost its no-claims bonus in a dull orange fireball that shattered windows for streets around.

We rushed down to the street. Charlie was a little shaken, but all right. While Sir Guy was paying off the police – even in our high-tech world, Johnny Foreigner remains refreshingly corruptible – I examined the hotel wall; where the

strange energy bolt had hit, the wall had been transformed into part of a holistic massage clinic!

"There's no time to waste," said Suit as he observed the bizarre phenomenon. "We'd better get to the airport right now."

"Haven't we time to pack?" asked Charlie.

"One of my elementals will do it. Did you get some tickets?"

"Yes, the two a.m. flight. We should make it alright if we hurry."

"Splendid. Barry, you're our linguist; make this taxi driver understand that if he's late, he'll be getting the thrashing of his life."

We walked as quickly as we could through customs, hoping that Sir Guy's camouflage spell would conceal our cache of weapons and Satanic equipment. Sylvestenegger was arguing with a customs man that his rocket launcher was really a hubble-bubble pipe he'd picked up in the bazaar. As for the New Age box, it spat and fizzed in the bottom of my travelling bag.

We were finally let into the departure lounge. "Glad that's over," I remarked, "I don't much fancy being put in a Turkish prison."

"Oh, I don't know..." said Suit, with a rather wistful smile.

Within the hour, we were airborne. I asked Suit what he planned to do with the box. "Well Barry, I daresay it couldn't survive being immersed in the Chaos Pit of Boleskine House. We can get a connecting flight to Scotland."

The stewardess came by with drinks, and we were just helping ourselves to large scotches when she said, "This message is for you, effendis", and handed over a folded sheet of paper. The message on it read: HAND OVER THE BOX, OR THERE WILL BE TROUBLE.

We turned around to look, and sitting directly behind us were the two bogus Jehovah's Witnesses who had tried to do away with us on the train. I looked round for Sylvestenegger, but by the characteristic mutterings of "Nam... VeeCee's... send in the choppers... the horror..." I could tell he was asleep.

"Well, well," one of the villains sneered, "Sir Guy Suit, Charlie Richbastard, and Barry Hairbrush. The time of you decent British Satanists is long past." I felt the unmistakable prod of a gun in the back of my seat. Suit turned angrily round to Charlie.

"This is your fault," he hissed, "Next time, you damn well get us first class tickets!"

What will happen next? Will our heroes be forced to "share the experience" of rainbow loving energies? Tune in for the next soul-searing episode of...Hair-Raiser!

Chapter 4

The clouds parted and below us I could see Heathrow getting closer and closer. The journey from Istanbul had not been a comfortable one, what with Wildflower and Angelhands, the creators of the New Age box, holding us at gunpoint all the way. Sir Guy Suit and myself racked our brains as to how we could avoid handing back their powerful demon box. Young Charlie had tried to wake Sylvestenegger up, but the crazed manservant had pinned him to the floor and threatened him with a knife without even stirring in his sleep. Was there no way we could keep the evil box from falling into the wrong hands?

Suit called the stewardess and ordered scotches. For a moment, I thought he was chatting in Turkish with her, but then I realized he was saying in Enochian:

"Barry – get my wand from the overnight bag under the seat!"

Whilst he dealt with the drinks, I ducked down and opened the bag. There was the New Age box, its exquisitely polished faces glittering cruelly. But at last, my hand closed around Sir Guy's rod and I gently eased it out of its sheath. I slipped it to him and he deftly slipped it down his trousers and began fiddling with some of the controls on the handle.

"If only I can set it to transmit at the right frequency..." he hissed, his hands working furiously up and down. I hoped the baddies couldn't understand Morse, or we'd be done for. One of the two villains leant forward – I could feel the gun pressing against my seat, and smell the holistic chakra oil as he whispered,

"You will hand over the box as we leave the plane. No tricks or you are all dead."

The runway loomed beneath us... the plane's gear dropped into place and with a bump, we were down on the ground... the gun pressed even harder against my spine...

And then Charlie cried out, "Ooh, look at that!"

With a screech of brakes, a black van had skidded onto the tarmac and was racing the plane down the runway. I turned to see another van race up. The plane lurched and slowed, and a loud explosion blew a section of the roof in. Then, black-clad balaclava"ed figures were running along the wings

and swinging into the cabin on ropes, screaming "Get down! Get down! Get down! Get down!"

"Great Scott!" I exclaimed. "The plane's being stormed by the Typhonian S.A.S.!"

Everyone ducked as jacketed hollow-point bullets began flying through the air. Wildflower and Angelhands spun round and returned fire with bursts of channeled Atlantean wisdom that scorched walls and blew out windows. Sylvestenegger took advantage of the distraction to cock his M16 and, with the icy professionalism only the US marines can instil, began shooting wildly in all directions.

"Good job they got my astral message," Suit commented as we cowered beneath the seats. He reached for his hip flask to pour us a couple of scotches, but then one of our rescuers dragged us all off, yelling "Go! Go! Go! Go! Go!"

I was about to ask why a fellow with such an obvious stutter had been picked for this sort of job, when we were bundled down the runway, and Sir Guy left Sylvestenegger and Charlie to wait by the escape chute for our luggage to be unloaded while he went off to trade some senior masonic signs with the officer in charge. As I was waiting, I caught sight of two chaps in smart business suits climbing out of a hatch beneath the plane and hurrying off. The disguise was almost perfect, but with a shock I saw that they had left their South American native-weave-look slipper socks on!

"Look – the baddies are escaping!" I shouted.

Suit said, "That's not important right now, as long as we have the box. We'd better get it to Boleskine straight away so the nasties our Uncle Aleister collected can get to work on it."

So once again we were in the air, as Sylvestenegger's helicopter gunship soared down Loch Ness. I pored over the radar screen, trying to make some sense of the thing. Charlie was fumbling with the map.

"Looks like Boleskine's dead ahead," he commented, as we lined the map up with the radar. Hearing this, Suit sat up in the plush leather armchair he'd insisted Sylvestenegger install, and brought out the box.

"Right – Barry, you'd better help me with the invocations to open Uncle Aleister's chaos pit." But at that moment, there was a loud bang and the gunship rocked and shuddered. I looked out of the window.

"God's trousers! There's someone in another chopper!" A second craft had swung in behind us. With a sinking heart, I knew it had to be our two foes. Suit leaned out too, and squeezed off a couple of Djinn that flashed and ricocheted off the enemy's hull. It wasn't long before they shot back with a pretty tinsel light

that blasted one of the undercarriage struts to organic wholefood. Sylvestenegger yanked the controls and we swerved to one side, the icy waters of the loch spinning only feet below us. The baddies roared past, then started turning for another attack. Then we were over the trees, and the greyish stone walls of Boleskine House could be seen in the distance.

Inside the cabin, Suit and myself were muttering our Uncle's weird incantations. The box started to spark and jump in the powerful magical field. Suddenly our craft lurched as the villains swooped close by us. Sylvestenegger pulled the door open as our gunship slowed to hover over Boleskine. Suit leaned out with the box in his hands. And then his arms were grabbed violently and pulled to the side!

Mr. Angelhands had climbed onto our landing gear on their last attack. Charlie and I fell over each other racing to help Suit, but it was too late. With a curse, he let go of the box, and as Angelhands caught it, the top opened. Horrible ambient seashore music poured out. Sylvestenegger jumped out of his seat, levelled a portable surface-to-air missile at the evil maniac, and let fly. Angelhands disintegrated with an interesting *plop* noise as the missile screamed off. Wildflower brought his chopper round, guns blazing, and the missile hit him smartly in the rotor section. The helicopter exploded in a most un-right-on display of tactical firepower.

The box spun as it fell, and out of it poured an awful apparition: beads, kaftan, some sort of horrid sandals, and as we saw it, we all realised what terrifying force lay behind the New Age.

"Cripes," commented Charlie, "It's the Eternal Hippie!" The vile thing grew in size and opened its fanged mouth to roar. But as it did so, Suit completed his invocation.

The whole front garden of Boleskine House slid back to reveal a dark pit full of writhing tentacles and primal chaos. A thousand meathooks on chains shot up out of the pit and dragged the phantom hippie in. With a grinding of eldritch machinery, the garden slid back into position.

And then there was silence. A silence broken by the tinkle of Suit helping himself to some Gordon's and tonic in the rear of the craft.

"You know," I said, as Sylvestenegger laid in a course for a decent London restaurant we knew, "we've certainly given the New Age a chakra-balancing it won"t forget in a hurry."

Suit replied, "Very true, but I've no doubt it"ll be back as soon as it can. You chaps – indeed, all decent-minded satanists everywhere – had better keep an eye out, just in case. Is that clear?"

"Yes," we all said, "*Crystal clear!*"

The End.

Remembering *The Lamp of Thoth*
by *Phil Hine*

The Lamp of Thoth (LOT) magazine was a significant milestone in the history of my own interest in the occult, and reading through the old issues – finding favourite snippets of writing I hadn"t seen for some twenty-odd years – cast me into a wave of nostalgia and reflection.

Published throughout the 1980s by the Sorcerer's Apprentice, the *LOT* was by turns eclectic, sometimes provocative, and above all, contemporary, providing a glimpse into current events and concerns in the occult/Pagan scene of that period. Its contents ranged through every possible permutation of esoteric thought at the time, and in addition to the articles which might range from Abramelin to chaos magic. It also featured "contact ads", Aunt Sally's often acerbic "problem page," and something which the few other "zines of the time lacked – a sense of humour, expressed through cartoons such as Dave Brown & Dave Lee's "Arthur Micklethwaite: Yorkshire Zen Master" and the continuing adventures of "Arfur Wizard "the Mill-Hill magician".

When I first became interested in the occult in the late 1970s I read anything and everything I could get hold of from my local library, which wasn't very extensive, and was dominated by the writings of Madame Blavatsky. Inevitably perhaps, the first esoteric society I made contact with, was the Theosophical Society, and I went along to their Leeds lodge for the first time in 1978. There I fell into conversation with another attendee (the only other person present under the age of 50) and he pointed me in the direction of The Sorcerer's Apprentice in Burley Lodge Road – the first occult shop I ever visited. The "shop" with its blacked-out windows and visored door, had from the outside, a forbidding air, tinged with the kind of backstreet seediness associated at that time with sex shops. Soon I was a regular, visiting as often as I could and spending my student grant on acquiring a library. And it was in the SA one afternoon that I picked up a copy of *The Lamp of Thoth*.

It was through *The Lamp of Thoth* that I slowly gained an entry into the wider world of the British occult scene – indeed, until I began to hang out at the SA coffee shop – a lock-up across the road which held a table, a couple of benches and a coffee machine) where Sorcerer's regulars could gather and discourse learnedly about matters esoteric – and read each new magazine, I didn't have much awareness that there was an occult scene past the books I'd been reading. It was through the Sorcerer's and the *LOT* that I first found out about the local Pagan moot scene. It was through the "contact ads" in the *LOT* that I took a leap of faith and made contact with the Wiccan coven into which I was (eventually)

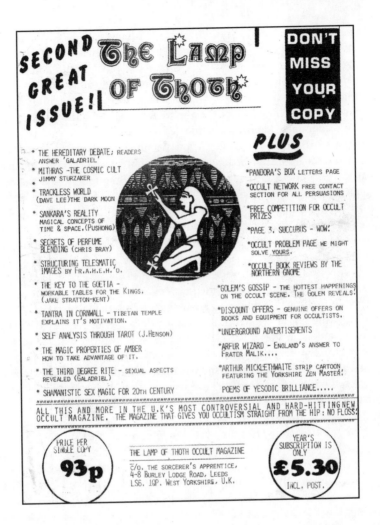

initiated into, and the *LOT* was the first "occult" magazine that I began writing for. I received a very encouraging letter from *LOT* editor Chris Bray following an early article entitled "On the Dark Night of the Soul" which was published in *LOT* Vol 2 no.6.

The *LOT* was also an influence when Rodney Orpheus and I started to publish *Pagan News* in the late 1980s. Like the *LOT*, we wanted *Pagan News* to be eclectic, and not bound by any sense of there being a divide between Pagans and occultists for example. Another feature of the *LOT* which I certainly was influenced by was "Golem's Gossip". Golem seemed to know everyone of note, and for me, part of the fun of reading the latest misdeeds to befall various luminaries was beginning

to gain some degree of familiarity with those being lampooned. "Golem's Gossip" ranged between reporting on various spats between Thelemites (particularly groups with a "T" in their acroynm) – for example in Volume 2 no.4 Golem reported on how a member of one such order was detained before London magistrates for possession of electronic incendiary devices – apparently there was some plot to destroy books in a warehouse belonging to Routledge Keegan and Paul. The column also kept readers updated on the activities of fundamentalist Christian groups, media abuse and various occult-oriented scams.

Golem and the *LOT* also shed much-needed light on more serious incidents – such as the very public declaration of one Barbara Brandolini ("spiritual leader and high priestess of the Church of the Silver Blade") that she was going to purchase a chapel in the tiny village of Heptonstall and turn it into a "Pagan temple" – a scheme which didn't do Pagans any favours at all. However, the most outrageous scandal reported by the *LOT* (to my mind) was the Galadriel Affair. From the first issue of the *LOT*, there was a regular contributor writing about various aspects of Witchcraft under the pen name of Galadriel. Galadriel's first article basically pointed out that for the most part, "modern witchcraft" was mostly made up – but that there was a hereditary tradition of which Galadrial was an initiate. This article drew counter-responses from both Raymond Buckland and Alex Sanders. Undeterred, Galadriel followed trhough with an article in issue 3 of *LOT* claiming that those of the "hereditary clans" do advocate cursing enemies, and even more controversially in issue 4, with the claim that Galadriel's clan practice both animal sacrifice (at feast times) and human sacrifice (actually a ritual form of voluntary suicide). This was strong stuff, particularly when you consider that this was 1981.

In 1982 the infamous (and now thankfully defunct) the *News of the World* newspaper ran a series "exposing" various British occultists as "Devil Worshippers" and so forth. In the 1980s, being "exposed" in the press as an "evil occultist" could well result in losing one's job, having one's windows broken, and lengthy public harassment. The *News of the World* was generally regarded as "the enemy" by many Pagans and occultists. In *LOT* vol. II no.4 there appeared an article written by Stewart Farrar entitled "WHY GALADRIEL MUST GO" in which he makes a number of interesting statements about the *News of the World* exposés – and the role that he and his wife Janet played in them. It seems that the Farrars were so concerned about Galadriel's articles in the *LOT* – the argument being that they were "bringing the Craft into disrepute" that they co-operated with the *News of the World*'s "sting" operation when the paper approached them for information about "Black Magicians". In particular, they assisted two journalists in gaining the confidence of a couple whom they believed to be responsible for the Galadriel articles, giving the journalists a letter of introduction, so that they could pass themselves off as "genuine seekers" asking the couple to extend Craft hospitality to them." Farrar claims in the article that he acted in this way not only for the

THE LAMP OF THOTH

Volume III - Number 4

good of the Craft in general, but at the behest of a number of "responsible Craft leaders and senior occult figures" (who needless to say, remained anonymous) and closed with:

> *Without toning down or apologising for our beliefs in any way, we must present a true image of the Craft, in all its multiform variety but essential unity. Anyone who muddies the waters must be netted – and fast.*

The next few issues of the *LOT* saw a flurry of letters and strong editorial comment condemning Stewart Farrar's actions – and Galadriel's column continued to appear. None of the "Craft leaders" or "senior occult figures" that Farrar claimed to have the support of stepped forwards. If nothing else, this incident shows how much Paganism has changed over the last thirty years or so – were such a thing to happen nowadays one can easily imagine the furore that would explode across the Pagan blogosphere. Despite Farrar's appeal to "unity" the Galadriel Affair highlighted the deep divisions in the UK occult scene – and the power of spokespersons acting on behalf of others. It was a pattern that was to repeat itself in the late 1980s with the onset of the "Satanic Child Abuse" moral panic, which also saw various occult authors – notably Gerald Suster – being "exposed" in the *News of the World*.

THE

SATANIC PANIC

1988 – 1992

Looking back from 2024

Phil Hine

"If we are to protect children from their sordid, sexual and diabolical grasp we must bring in new laws to wipe witches off the face of the earth."

Geoffrey Dickens MP, House of Commons debate, April 1988

Early in 1988, British national and regional newspapers began to feature allegations that children were being threatened by hidden occult presences in society. Not only was it alleged that the easy availability of occult books, the popularity of Halloween, and "Eastern" practices such as yoga were potentially harmful to children; but also that children were being routinely sexually abused and even murdered by secretive cults of Witches, Black Magicians and Satanists.

The Panic Begins

On 3rd January 1988, *The Sunday Sport* tabloid kicked off with **EVIL – Satanic Guides are sold to kids**. The article hit out at the Leeds-based Sorcerer's Apprentice occult mail order business and quoted Geoffrey Dickens MP stating: "We are living in a mad society when perverted cults which worship the devil can freely publish guides on how to dabble in the occult. The Home Office must act." Throughout March 1988 there was a flurry of stories in regional newspapers and nationals such as the *Daily Telegraph* on the subject of the dangers of Satanism in the UK – particularly to children, and more "experts" appeared, such as the supposedly ex-witches Audrey Harper and Beth Gurevitch, and Dianne Core of the Hull-based charity Childwatch. Audrey Harper, for example, told her story of Satanic initiation in *The Sunday Sport*, on 13th March. Under the heading **I was Satan's virgin sacrifice** it was revealed how she was "stripped by women witches"; "daubed with the blood of a sacrificed cockerel"; and "ravaged by a sadistic high priest". There is no mention however, of children being sacrificed or of women being "brood mares" – that would come later. There are vague allusions to the effect that Childwatch has a "dossier" relating to Satanic activity in Britain.

By the end of March, the first brief reports of the Broxtowe (Nottingham) case started to appear in the press.

On the 15th April Geoffrey Dickens made a speech in the House of Commons. He stated that: "witchcraft is sweeping the country" and requested a debate on the workings of the Fraudulent Mediums Act of 1951, saying: "We need a

chance to discuss the working of witchcraft and how it can be controlled in this country."[1] Once again, there were mentions of Dickens being in possession of a dossier which he intended to present to the Home Office.

A few days later, on the 19th April, LBC Radio ran a phone-in segment about Dickens' controversial remarks and the alleged dangers of Satanism and witchcraft. Up popped one Brian Leftwich – a self-described "black witch" who claimed to have information about human sacrifices. Leftwich reappeared in a front-page story in the *Hull Daily Mail* the next day, under the header **Satanist Backs Childwatch Concern** – supporting Dianne Core's claims about children being drawn into black magic cults.

On the 27th April, Geoffrey Dickens made a much longer statement in the House of Commons. He stressed the dangers to children that came from dabbling in black magic; called on all Christians to "unite in prayer, word and deed" to condemn Satanism, and said that the Home Office should be both aware and alert to the "rapid growth in the United Kingdom of black witchcraft and Satanism." He mentioned cases where graves had been desecrated, police reports, and the growth of shops selling witchcraft regalia and books. He specifically mentioned Astonishing Books in Leeds, and said that he thought the Fraudulent Mediums Act was inadaquate for checking the spread of witchcraft and satanism.[2]

Chris Bray, the owner of *The Sorcerer's Apprentice* mail order company and the retail outlet, *Astonishing Books*, later said that he was "besieged by reporters" the day following Dickens' speech.

More news stories appeared throughout May, quoting Dickens, Kevin Logan, and Dianne Core. On 13th May, Central Television's *Weekend* programme screened a debate on witchcraft and allegations of child abuse. It featured Audrey Harper, Beth Gurevitch and Geoffrey Dickens; and representing the UK's occult community, Temple of Set member David Austen, and Wiccan High Priestess Dot Griffiths. Audrey Harper related lurid tales of what goes on in covens, including the sexual abuse of children and unregistered babies being used as sacrificial victims. She claimed that since breaking away from witchcraft, she had undergone psychiatric treatment for 17 years. More newspaper reports followed these revelations. *The Sunday Express*, on the 15th May, named the Ordo Templis Orientis (O.T.O.) as an organisation which had "brought misery and degradation for hundreds of children", whilst on 20th May the *Evening Mail* ran a story, **Occult will Rot Mind**, asserting that the Midlands had become the "witchcraft capital" of Britain, with Walsall as its main centre.

1 https://api.parliament.uk/historic-hansard/commons/1988/apr/14/business-of-the-house#S6CV0131P0_19880414_HOC_201

2 https://api.parliament.uk/historic-hansard/commons/1988/apr/27/occult-societies

On 3rd June, *The Star* devoted its front page and two inside pages to the revelations of Marion Unsworth "one of Britain's former top witches" under the headline **HUMAN SACRIFICE**. Unsworth claimed to have participated in the ritual murder of a thirteen year-old girl in the 1970s. The article also brought in Canon Dominic Walker, head of the Christian Deliverance Study Group, who was quoted as saying that occult initiation rites are always photographed so that the participants can be blackmailed later, and that such rites "always include homosexual and paedophile acts."

In July came the first brief mentions of the Nottingham child abuse case. For example, on July 19, *The Courier and Advertiser* reported **Judges hear allegations of "Satanic" child sex abuse**. The article stated that **A "SATANIC" child abuse scandal was revealed by three top judges in London yesterday**. Allegations had been made against 15 people, including parents, that 17 children had been abused by public sex acts, and the children, aged up to 12, had been forced to drink their own blood and the blood of sheep."[3] The story also appeared in *The Guardian*, under the header **"Satanic child sex" ruling** albeit without mentioning the blood drinking.[4]

August saw the birth of a new tabloid – *The Sport*, a spin-off from *The Sunday Sport*. Pride of place in its first edition on 17th August was a two-page spread **Please Save My Baby from Satan**. The story featured an informant who was a former member of a Satanic cult known as "Scorpio". It also revealed that Geoffrey Dickens' dossier which he intended to pass on to the Home Office had gone missing. This dossier, the article stated, had been passed to Dianne Core of Childwatch by a former member of the Ordo Templis Orientis – "whose depraved rituals end in unbridled black magic orgies of sex and violence". By September, the BBC's *Today* radio programme had joined in the fun, interviewing the Reverend Kevin Logan, who asserted that he had information about ritual murders taking place in the area of Pendle Hill.

The stories continued throughout September. The 19 September saw a rash of reports. The BBC Radio 4 *Today* programme interviewed Kevin Logan about the dangers of witchcraft. *The Evening Post* ran the story **Babies offered to devil claims Tory**, stating that **BABIES and young children are being sacrificed to the devil in witchcraft rituals all over Britain**. Geoffrey Dickens is quoted: "Six hundred children go missing every year. At least 50 of these children are never found again. Murder is horrible enough to contemplate but in most cases of this

3 *Judges hear allegations of "Satanic" child sex abuse* The Courier and Advertiser, July 19, 1988, p6.
4 *'Satanic child sex' ruling*, The Guardian, July 19, 1988.

nature the child's pitiful body is eventually discovered. With witchcraft sacrifice nothing is ever found."[5]

October 1988 brought a bumper crop. On the 7th October, ITV broadcast *The James Whale Radio Show* – despite its title, a live television programme hosted by Leeds-based shock jock James Whale, with guests, live music, and phone-ins. The subject of this programme was the occult. Beginning with a visit to Manchester-based witch Barbara Brandolani, Whale then met up with Kevin Logan, showing his book *Paganism and the Occult: A Manifesto for Christian Action*. Logan made a distinction between followers of the "Old Religion" and the "serious people", for whom, "child abuse is part of it." He also stressed that his book was intended for Christians, to wake them up to a "spiritual war." Back in the studio, Whale was joined by a priest, Mgr Michael Buckley, and Geoffrey Dickens MP. Dickens stressed that Pagans had nothing to fear from him (although he didn't approve of them because they were anti-Christian), but that he was at war with the "black witches" and the "Satanists". Later in the programme, Whale visited *Astonishing Books* and met the owner, Chris Bray. As they talked, the camera lingered over some books on "sexual magic" and then panned to show a variety of Pagan statuary. Chris Bray tried to put over the complexities of magic, and stressed that the shop didn't sell to people under the age of 18. Back in the studio, Buckley and Dickens were joined by Wiccan High Priestess Patricia Crowther. She hotly contested Dickens' claims, and said that the allegations against occultists were made in order to deflect attention from members of the Christian Church who were guilty of child abuse. Chris Bray came on the line, and stated that Buckley and Dickens were "devoid of any intelligence about occultism at all". He asked Dickens to come up with some actual proof of his allegations, but Dickens would only answer that there were cases coming to court and he didn't want to breach sub judice rules by talking about them – and advised Bray to watch the national newspapers over the next few months.[6]

Later in the month, there was a rash of warnings about the dangers of Hallowe'en, with Geoffrey Dickens sounding warnings that "there are evil people who will use any situation to their advantage, and the Association of Christian Teachers stating that "the increasing popularity of Hallowe'en goes hand in hand with the growing acceptance of Satanism".[7] The BBC's *Six O' Clock National News* did a segment on the dangers of Hallowe'en, with Kevin Logan talking about the "broken lives" of children and adults drawn into the

5 *Babies offered to devil claims Tory*, The Evening Post, 19 September 1988,

6 https://www.youtube.com/watch?v=jzZbYp8Axec

7 *Trick or Treat*, Daily Mirror, October 27, 1988, p7.

Occult, often enticed by using Tarot cards. The programme also included a film clip showing "robed witches" performing a ritual outdoors – actually some members of a Yorkshire magical group who had agreed to be filmed for the *Lucifer Over Lancashire* documentary. Pride of place though, should go to *The Sunday Mirror's* **Babies Sacrificed to Satan** story. An American former "black witch" – Jaquie Balodis – claimed to have witnessed human sacrifices on three separate visits to the UK. Her allegations were supported by Dianne Core of Childwatch, who was quoted as saying "Women are being used as brood mares. They are made pregnant at occult ceremonies and then their babies are used as sacrifices."[8]

December started with a bang. On the 1st December, ITV's *The Time, The Place*, an audience-participation live talk show, ran a feature on the occult. Amongst those present were Audrey Harper, Wiccan High Priestess Barbara Brandolani, and an actual Satanist – Ramon Bogart. Bogart presented himself as a psychologist, but an investigative reporter John Merry for the *Sunday Sun*, who was present in the audience, stood up and alleged that Bogart was a convicted sex offender. Bogart stormed out of the studio. The next day, the story was front-page news in *The Daily Mirror* under the heading **Doctor Satan – TV guest exposed as sex attacker**. The *Mirror* revealed that Bogart had a conviction – 20 years before – for unlawful sexual intercourse with a schoolgirl. Bogart stated that he "did my time for it – I did four years".[9] On the 4th of December *The Sunday Mirror* claimed that ex-witch Audrey Harper, who had claimed on the programme to have taken part in the sacrifice of a baby in Virginia Water, Surrey in 1967, was to be questioned by the police.[10]

On the 19th December, Geoffrey Dickens made a speech in the House of Commons on the subject of child abuse. He expressed alarm at the levels of child abuse throughout the UK, criticized the Social Services and again drew MPs attention to the growth of occultism, black witchcraft and satanism "because it is worse than any Hon. Member would dream".[11]

The Main Players Emerge

By the close of 1988, a number of advocates for the reality of Satanic abuse could be identified.

8 *Babies Sacrificed to Satan*, Sunday Mirror, October 30, 1988, p7.

9 *Doctor Satan – TV guest exposed as sex attacker*, Daily Mirror, December 2, 1988, pp1-2.

10 *Satan baby death probe*, Sunday Mirror, December 4, 1988, p23.

11 https://api.parliament.uk/historic-hansard/commons/1988/dec/19/child-protection

Geoffrey Dickens

Geoffrey Dickens (26 Aug 1931-17 May 1995) was a Conservative member of Parliament. He was MP for Huddersfield West between 1979 and 1983, then elected MP for Littleborough and Saddleworth until his death in 1995. A traditionalist, Dickens was oppposed to the decriminalization of homosexuality, campaigned for the return of hanging, banning the importation of crossbows, and the re-introduction of corporal punishment. He was a member of the All-Party Group on Family and Child Protection. He was a supporter of the Campaign for Law and Order, led by Charles Oxley. The CLO's mission was "the restoration of law and order by effective punishment including capital and corporal punishment".[12] Dickens was the Parliamentary representative for Childwatch, the Hull-based charity founded by Diane Core. In 1990 he wrote the foreword to Audrey Harper & Harold Pugh's *Dance with the Devil: A Young Woman's Struggle to Escape the Coven's Curse.*

Kevin Logan

The Reverend Kevin Logan (of St. John's Great Harwood, Lancashire) first came to national attention in the programme *Lucifer over Lancashire* (Open Space, BBC2, 30 March 1987) which focused on his campaign to erect a 6 metre high cross atop Pendle Hill in order to "purify" the hillside and the surrounding area. His campaign was rejected by local authorities. During the programme, Logan claimed that Pendle was the witchcraft capital of Britain, with 30 covens operating in the area. He began to promote himself as an expert on the occult, and in 1988 published the first edition of *Paganism and the Occult: A manifesto for Christian Action.*

Dianne Core

Dianne Core was the founder of the Hull-based charity *Childwatch*, set up in November 1986.[13] A former residential social worker, she had worked for Esther Rantzen's *Childline*. In 1979, she suggested that the government should form a "Ministry of Marriage" in order to prevent divorces and re-establish the status of marriage.[14] Throughout the mid-1980s she often appeared in media reports related to child abuse – particularly stories related to paedophile rings and the existence of snuff movies. For example, in 1985 she was quoted as stating: "I am sick and tired of trendy lefties in this country who are so blinkered by their politics they have not time to look after the children they are supposed

12 Harlow, Carol, Rawlings, Richard. *Pressure Through Law.* Routledge, 2003. p180.

13 https://register-of-charities.charitycommission.gov.uk/charity-search/-/charity-details/518067/ governance

14 *Ministry of marriage "could save Britain millions"*, Liverpool Echo, 10 May 1979, p7.

to be looking after."[15] Interestingly enough, one of the first newspaper stories which quotes both Dianne Core and Geoffrey Dickens expresses concerns about paedophiles in the Church of England. Dianne Core is quoted saying: "churches in Britain are becoming havens for perverts" whilst Dickens says "the figures for child abuse by clergymen are uncomfortably high."[16]

Audrey Harper

Audrey Harper claimed to have been a former witch who had since turned to Christ. In her book *Dance with the Devil*, she claims she was introduced to Satanism at a party in 1961, aged 21. After a series of suicide attempts, drug overdoses and spells in psychiatric hospitals, she was finally saved by Roy Davies, a minister of the Emmanuel Pentecostal Church in Stourbridge, Birmingham, who drove demons out of her.[17] Her account bears strong similarities to that given by Doreen Irvine in her 1973 book *From Witchcraft to Christ*. Harper was a member of Maureen Davies' Reachout Trust, and toured the UK, lecturing to audiences about the dangers of the occult.

The Reachout Trust

The Reachout Trust, established in 1982, is an Evangelical Christian charity. From 1989, it circulated "confidential papers" to social work departments, describing Satanic rituals and how "children are taught to hate God, Jesus, the Church, and everything that is good". "Teenage girls and women have to sacrifice their own children ...After the sacrifice, they take out the heart, spleen and eyes and eat them ...the fat is used for candles and bones ground down and the powder is used for an aphrodisiac." Core, Dickens, and Logan were all involved with the Reachout Trust.

1989 – A Question of Evidence?

On 16 February, Channel Four's *Not on Sunday* took a look at witchcraft and the occult. The cameras visited a Wiccan coven run by Nigel Bourne and Seldiy Bates and filmed them celebrating Imbolc, then interviewed a feminist witch, Felicity Wombwell. In the studio, pitted against each other, were Dr.. David Burnett of the Worldwide Evangelisation for Christ, and Leonora James of the Pagan Federation.

15 *A pain that never fades*, Liverpool Echo, 10 October 1985, p5.
16 *Church "hiding sex pest vicars"*, Daily Telegraph, 2 January, 1988.
17 Audrey Harper and Harry Pugh, *Dance with the Devil* Eastbourne, Kingsway Publications 1990.

The Nottingham Case

Later that month, the Nottingham Child Abuse case came to trial. On February 26, *The Sunday Telegraph* announced **Devil worship linked to Child Sex Abuse**. The piece featured comments from an interview with Judith Dawson, an officer for child protection with Nottingham Social Services. Dawson stated that she was planning to hold a conference to investigate "the ritualistic abuse of children". However, Detective Sergeant Alan Breeton, who had also been involved in the Nottingham case, was quoted as saying that the police "have not found any evidence to support that it took place."

The Broxtowe (Nottingham) Child Abuse Case began in 1987 when seven children from an extended family were removed from their parents on suspicion that they had been sexually abused by their relatives. At the trial, ten adults (both male and female) were charged with 53 offences of incest, indecent assault and cruelty against 23 children. Long terms of imprisonment were imposed, and the judge, in his summing up, said that he "had never, never come across a case quite so dreadful". There is no doubt whatsoever that the children in this case suffered horrific abuse. However, there would be considerable doubt cast on whether or not the abuse was Satanic or ritualistic.

The children concerned were made wards of the court and placed with foster parents. They were asked to keep diaries of anything that the children said which might help in understanding the experiences they had suffered. The diaries showed that the children were describing bizarre experiences such as witnessing the sacrifices of animals and other children and being forced to drink their blood; of being filmed by strangers and being abused in tunnels and caves. It was agreed, at the time of the trial, to exclude such details, so as not to prejudice its outcome.

In August 1988 Nottinghamshire Police conducted an investigation into these allegations – Operation Gollom. This investigation concluded that there was no evidence of ritual abuse or witchcraft involvement nor were there any other perpetrators of abuse outside of the immediate family network. Some Social Workers involved in the case contested this finding, and it is clear from reading official documents that there was considerable tension between the Police and Social Services over the existence of Ritual Child Abuse. Gary Clapton, in his review of social work literature during the panic, notes that between 1988 and 1992, there were 106 contributions to social work journals on the subject of Satanic abuse, only 28 of which were "sceptical" of the subject.[18]

18 Gary Clapton, *The Satanic Abuse Controversy: Social Workers and the Social Work Press.* University of North London Press, 1993.

In July 1989 a Joint Enquiry Team was set up comprising a Detective Sergeant, a Detective Constable, and two Senior Social Workers, jointly managed by a Detective Superintendent and an Area Manager. Its remit was threefold: to enquire into the family whose abuse of children had led to the Crown Court prosecutions; to enquire into the statements of children which suggested that serious offences had been committed against them; and finally, to gather information from anyone which was relevant to investigations of child abuse, past, present or future. Their report – the JET report, was not published.

In 1997 three journalists – Nick Anning, David Hebditch, and Margaret Jervis made the news when they released a digital copy of the revised JET report on the worldwide web. Nottingham County Council applied to the British High Court for an injunction ordering the journalists to remove the report from the web, with the immediate result that several other websites published it online (an early example of what would later be known as the "Streisand Effect"). Anning, Hebditch, and Jervis argued that the report's authors "were officially banned from talking about their investigation or publicising their findings and recommendations" but that they believed that had the report been issued in 1990, it might have prevented further allegations of Satanic Child Abuse – as occurred in Rochdale and Orkney. The injunction was eventually lifted; the JET report remains in circulation on the web and there is a clear public interest in its findings being made available.*.

In the wake of the publicity over the Nottingham case, the stream of newspaper stories about Satanism and witchcraft continued apace, gathering momentum.

On April 9, *The Sunday Sport* featured an exclusive story based on the ramblings of Jaquie Balodis under the title of **I Skinned my baby for Satan**. Her lurid revelations were supported by one Ted Gunderson, described as an FBI agent.

Then, on April 16th, Occult author Gerald Suster was exposed in *The News of the World* as a member of a "vile occult sect" – the Ordo Templi Orientis. According to the paper, "parents of children of the £2,460 a term school (where Suster was a teacher) will be horrified to learn about the sickening practices of Devil-Worshipper Suster and his sinister friends". The headmaster of the school was said to be "shocked" by the revelations, and the paper hinted that Suster was to be sacked from his job – which he duly was. Channel Four's *Hard News* programme covered the story, interviewing both Gerald Suster, along with the occult author Lionel Snell. Suster had spoken to a stranger following an occult

* http://www.users.globalnet.co.uk/~dlheb/jetrepor.htm

meeting in London, who taped their conversation, and sold the story to *The News of the World*.

May opened with a flurry of stories focusing on Michael Aquino, the head of the Temple of Set. *The Daily Star*, *The Daily Mirror* and *The News of the World* all made much of Aquino being flown into the UK to feature on the forthcoming episode of *The Cook Report*. The Mirror's feature for example, ran under the header **Satan's Children**, asserting that Aquino was "under investigation for allegedly having sex with a two-year old girl". Kevin Logan, described as "one of the Anglican church's leading authorities on Satanism" was quoted as saying "One of the horrible things coming home to us is the tremendous increase in paedophiles who are going into Satanism and using the occult as a front for their activities".

On May 21st, *The Sunday Mirror* ran a two-page exclusive **My eight abortions in name of Satan – by schoolgirl**. Beginning with the startling assertion that "Two girls say a total of 13 foetuses were taken from them and offered as ghastly human sacrifices to Satan", the report detailed the story of "Samantha" who had gone to live with her grandmother at the age of 11. The grandmother was a witch, and had introduced the girl to Satanists – which led to her becoming pregnant eight times, and the aborted foetuses placed in a freezer. "Samantha" was to feature on the forthcoming *The Cook Report*. Maureen Davies of the Reachout Trust was quoted as saying that there were no records of the pregnancies because the doctor was a member of the coven.

The Cook Report

On July 17 at 10pm Central Television ran *The Cook Report: The Devil's Work*, hosted by investigative reporter Roger Cook. The programme opened with host Roger Cook speaking with the Reverend Kevin Logan in his church, who stated that "Satanism is on the increase. In fact It's going through an explosion at the present time. And has been over the last 30 years."

Cook replied: "So Satan's P.R. is pretty good."

Logan: "Satan's P.R. is doing a very good job these days and the problem is that the churches are not combating it as they should do."

The Cook Report featured interviews with Kevin Logan, Judith Dawson, Audrey Harper, and various "survivors" of Satanic activity. The highlights however, included the arrival in the UK of Michael & Lilith Aquino, heads of the magical order the Temple of Set (it was not mentioned that the programme makers had paid for the Aquino's flight to and stay in the UK). The Aquinos were ostensibly in the UK to ordain a new high priest – who Cook revealed had been in the past, a member of the National Front.

The camera then shifted to a shot of *Astonishing Books*, on Hyde Park Corner, in Leeds, followed by some archival footage of Chris Bray being interviewed. It later transpired that this footage had been edited so that it seemed that Bray didn't care what his customers did.[19] Moving back to the scene outside *Astonishing Books*, Cook says: "We wanted to question Bray about his publication, the *Lamp of Thoth*, which has carried want ads for dead bodies, published articles advocating sacrificial murder, and is the platform for Michael Aquino's new British recruiting drive." Chris Bray and his staff were shown getting into cars, wearing masks, whilst Cook shouted questions at them.

After a clip of a lecture by ex-Witch Audrey Harper, who implied that all occultists were sexual perverts, and another short speech by Kevin Logan, the focus then shifted to Nottingham. Cook outlined the case, and admitted that the police did not find any evidence to prove "the Satanic Connection." Cook hinted that the programme-makers had passed along new evidence that would allow police and social workers to re-investigate the Satanic aspects of the Nottingham case.

For the "climax" of The Cook Report, Cook turned to the accusations against Aquino at the Presidio military base, specifically that he had ritually abused young children at the bases" child day care center. The Aquinos denied the allegations. Cook interviewed a lawyer who claimed she'd been taken into the desert at gunpoint whilst investigating the Aquinos. The Aquinos denied any involvement with this, and described the accusations as a "witchhunt". The programme closed with another shot of Reverend Kevin Logan performing a Church service. As the closing credits scrolled, a confidential helpline number is displayed for anyone who's been involved in Satanism to call, manned by specialist counsellors.

The Devil's Work received mixed reviews in the press. Some critics were more concerned that *The Cook Report* indicated a trend towards US-style "Trash TV" than its revelations about Satanism and child abuse, which, despite all the vague hints and insinuations, had little substance to them.

The next day, several newspapers reported that the *National Society for the Prevention of Cruelty to Children* (NSPCC) had issued a warning about the ritualistic abuse of children in occult ceremonies. Dr.. Alan Gilmour, the charity's director, was quoted as saying "The information about this type of abuse is very limited, but it is becoming increasingly clear that this is a very real area of concern."[20]

Chris Bray made a formal complaint to the Broadcasting Complaints Commission about *The Cook Report*, and the Commission found in his favour. A statement to that effect was broadcast and published in April 1990.

19 http://tabloidtv.nfshost.com/

20 *Child-Abuse Alert over worship of the Devil*, Liverpool Echo, 18 July 1989, p5.

In early August, reports surfaced of a "self-styled wizard" who had been jailed for 15 years for a variety of sexual offences against young girls. Peter McKenzie lured young girls into having sex with him in return for turning them into witches, swearing them to secrecy. McKenzie admitted 24 sexual offences.[21]

In the early hours of Saturday, 13th August, *Astonishing Books* was broken into by persons unknown. Books on witchcraft and Aleister Crowley were piled on the floor in the centre of the shop then set alight. Fortunately, a passing customer alerted the fire brigade, but the ground floor of the shop was seriously damaged. Chris Bray felt that the firebombing was a direct response – possibly by Christian Fundamentalists – to the allegations made in *The Cook Report* and elsewhere in the media.

On the 9th September, a number of allied Pagan networks, including Paganlink and the Pagan Federation were due to hold a two-day event at Leicester Polytechnic. But as a result of But as a result of local complaints, the Polytechnic's board of governors withdrew permission for the event to be held, and it was cancelled at short notice. The deputy director of the Polytechnic issued a statement saying that the permission had been withdrawn because the Polytechnic had been told that the event was a "small exhibition of folk history" and not a Pagan gathering. The event took place on a campsite at Groby, and was a great success.

Later that month, several newspapers reported on a Conference on Child Abuse issues in Reading at which an "American Expert" – Pamela Klein – advised professionals to be "on the alert for tell-tale signs of child abuse by black magic and occult groups".[22] Also present at the conference were Detective Robert J ("Jerry") Simandl of the Chicago Police; Maureen Davies, then Director of the Reachout Trust; and Judith Dawson, from Nottingham Social Services.

On October 8th, the *News of the World* ran an expose of two British members of The Temple of Set. One of them, a housing estate manager, was suspended by Kingston council, but kept his job. Another, a day-care nursery worker, resigned from his job.[23]

1990 – More Cases, More Controversy

The NSPCC Announcement

On the 12th March, The National Society for the Prevention of Cruelty to Children (NSPCC) made a shock announcement at a press conference to launch

21 *Child-abuse "wizard" jailed*, Press and Journal, 8 August 1989, p10.

22 *U.S. experts warn of child sex abuse in devil worship*, Press and Journal, 23 September, 1989, p2.

23 *"Satan" cult man quits*, Sunday Mirror, 8 October 1989, p5.

its annual report. "Children throughout Britain are being exploited by abuse which is highly organised and planned. ...The NSPCC has voiced its increasing concern as evidence is mounting of child pornography, ritualistic abuse and sex rings involving children... Children as young as five are being forced to take part in bizarre sex and Satanic rituals... Rites involving drugs, animal sacrifices and the drinking of urine and blood were one of three areas of organised abuse". It was also stated that seven of the NSPCC's investigating teams had reported examples of "ritualistic abuse".

This announcement, by the head of a respected children's charity, gave a stamp of official credibility to the stories that had been circulating for the past two years or so. However, none of these allegations were in the official report issued by the NSPCC, they were comments made by the NSPCC's childcare director, Jim Harding, reading from briefing notes.

The next day, the comments were widely reported in a variety of ways. The *Times* report was headed **NSPCC says child abuse rife** whilst *The Guardian* went with **NSPCC uncovers Satanic Abuse**, and *The Independent*, **Children Abused in bizarre sex rituals**. *The Daily Mirror* ran with **Kids forced into satan orgies**.

Not everyone was convinced though. Melanie Phillips, writing in *The Guardian*, pointed out that most newspapers who reported on the NSPCC's announcement, failed to mention that the charity had stated that "the overwhelming bulk of child sex abuse occurred within the home and the family." She also highlighted the lack of evidence to support the claims, and that "the problem with highlighting Satanism, though, is that it provides a convenient let-out for those that don't want to admit that child abuse occurrs as a matter of grisly routine in utterly ordinary families ...It becomes instead something practiced by weirdos who live bizarre lives and therefore can all the more easily be marginalised."[24]

The Rochdale Case

Rochdale, in the metropolitan county of Greater Manchester, was the setting for the second major UK case focusing on Satanic Ritual Abuse. It began in November 1989, when a six-year old boy, living with his family on the Langley estate was found hiding in a cupboard at his school, refusing to come out. The boy had a history of behavioural disorders, but the story he was coaxed into giving – about ghosts, cemeteries and babies being killed – concerned both the boy's teacher and headmaster enough for them to contact his mother, and to refer both the boy and his mother to social services. The child was brought with his mother to an assessment centre, where, according to the social workers who

24 *Futile foray into a world of darkness*, The Guardian, 16 March 1990, p23.

interviewed him (an interview which was not videotaped) he told of pink ghosts in his bedroom, and disclosed that his parents had taken him to cemeteries at night to help them dispose of the bodies of babies they had killed with hammers. A Place of Safety Order was secured and the child was taken into care, to be followed shortly after by his older sister and two younger brothers.

By the time of the Rochdale case, there had been three major conferences in the UK on the subject of ritual abuse, and it was later revealed that two weeks prior to the Rochdale case, some members of the local social services department had attended a conference in which American experts had disseminated material including the infamous lists of "Satanic Abuse" behavioural indicators. Rosie Waterhouse, in an article in *The Independent On Sunday* pointed out that: "two Weeks before Satanic child abuse was "diagnosed" on a Rochdale council housing estate, social workers and a police officer from the area attended a seminar on the subject. At the course in London in March, they and the council director of social services were warned of a nationwide increase in Satanic sexual abuse and given literature on the signs and symptoms to watch for. They soon thought they had found them".[25]

In interviews, the children made reference to other children being involved in the abuse, and this led, in June 1990, to a "dawn raid" on the Langley estate by police and social services in which 15 children were removed, at very short notice, from five families. The children were made wards of the court, and all contact with their parents – including written contact – was forbidden. An injunction was placed on the parents preventing them from speaking publicly about the case, or from speaking to voluntary organisations or counsellors.

On 11 May 1990 one of the parents whose children had been removed made a call to a local paper, the *Moston Middleton & Blackley Express* which subsequently ran a story: **Couple lose children after "black magic charges"**. The paper quoted one of the mothers as saying: "I am sickened by these accusations. The social workers have read something into my son's fantasy that just isn't here. One of his favourite pastimes is watching Dungeons and Dragons cartoon videos over and over and we've even let him watch some horror movies. He used to laugh at them."

A local Labour councillor, the late Peter Thomas, arranged a meeting between local journalists and other parents. Rochdale County Council issued a press injunction barring all reporting on the case – which was successfully challenged in September 1990 by the *Mail On Sunday*. It was ruled that although the press could not speak to council officials, social workers or children involved in the case, but they could speak to the parents involved and publish, providing children were not identified.

25 *Satanic cults: how the hysteria swept Britain*, The Independent on Sunday, 16 September 1990, p3

As with the Nottingham case, the Rochdale Case was reported widely in the press. This time, the tide was changing. An advocacy group – Parents Against Injustice (PAIN) supported the parents and called for a public enquiry into the case. Eventually, the mother of the child whose ghost story had kicked off the case came forward and blamed his outburst on a diet of video and comic books.

The social workers however, stuck to their guns and stood by their belief that this was a ritual abuse case. Three of the children were allowed to return home, but social workers insisted that even if the ritual abuse had not happened, they had conclusive evidence that other kinds of serious abuse had taken place on the estate, and petitioned the courts for permanent wardship orders.

The actions of the social workers were supported by statements from both the NSPCC and by The British Association of Social Workers. When the story broke in the press, the social services department responded with press conferences. At one conference, Rochdale's Director of Social Services, Gordon Littlemore, stated: "It is the view of social services and the police that the abuse the children describe is real and not the product of their imaginations, fuelled by watching video horror films."

On the 14th September the Chief Constable of Manchester, James Anderton[26] issued a statement that police investigations into allegations of Satanic ritual abuse in Rochdale had resulted in no evidence to justify criminal charges.[27] Peter Thompson, a member of Rochdale council's social services committee, was quoted as saying "the children should be returned home, and this whole mumbo-jumbo should be stopped."

The Wardship case was heard on 7 March 1991. Following a 47-day hearing, Mr. Justice Douglas Brown found that the accusations of ritual abuse were unfounded, and there was no evidence that persons had gone missing, been mutilated or murdered. Although he emphasized that the staff of Rochdale Social Services Department had acted in good faith, he said that they made serious errors of judgement – a "gross breach of good practice". Brown also castigated the parents of the child whose ghost stories had begun the case, for letting him watch violent videos, and ruled that the child and his siblings should remain in care. All of the other children were released back to their families. Within a day of the judgement Gordon Littlemore resigned from his position as Director of Social Services in Nottingham.

In January 2006, *The Guardian* reported that the five families involved with the Rochdale Case were bringing legal action against Rochdale Council.

26 The same James Anderton who said in 1987 that people with AIDs were "swirling around in a human cesspit of their own making".

27 *Police drop Satanic ritual abuse cases*, The Guardian, 14 September 1990, p3.

March 25th brought *The Sunday Mirror's* **I sacrificed my babies to Satan.** The article described the activities of Caroline Marchant, a former High priestess of Satan and her participation in child murders and "drug-crazed black magic orgies". The NSPCC said that her story confirmed their worst fears about child sacrifice and ritual abuse by Satanist cults in Britain.[28]

Inside, a two-page spread entitled **Sex rituals and the Devil's death trap** revealed that Caroline had "poured out the story of her life to Mr. Kevin Logan whilst staying at his Blackburn vicarage." He is quoted as saying "It is a strong possibility she sacrificed her own foetus. She had witnessed others do it. She was too distraught to go into details but I feel certain that was what happened to her baby." She had become a born-again Christian in 1988 in order to escape from the Satanic cult.[29]

May brought an unexpected development – a rash of reports about "bogus social workers" – perhaps because people were more afraid of social workers knocking at their doors than Satanists or witches. Some papers managed, though, to link these visitations to the activities of Satanists. The *Evening Post* for example, quoted Dr.. Robert Wilkins, head of Reading's family and child abuse unit: "To knock on the door of a complete stranger's house is very bizarre and very worrying because it means they are showing a boldness and recklessness they've never shown before. ...It could be some sort of bizarre dare to sexually initiate a stranger's child."[30]

June brought news of another alleged case of Satanic child abuse. On 26 June, police in Liverpool carried out a series of "dawn raids" on houses, and eight children were reportedly taken into care. It was the result of a six-month long investigation named "Operation Clementine".[31]

By mid-1990, amidst the continuing torrent of lurid tales in the tabloid and regional papers, there were signs of more skeptical attitudes towards Satanic child abuse emerging. In early July, a short piece by Claire Dyer in *The Guardian* dared to question the notion that children must always be believed. Professor John Newson of Nottingham University's Child Development Centre was said to believe that the idea that children always tell the truth about sexual abuse had become an article of faith for many social workers. Newson, who had consulted on the Nottingham case, was of the opinion that it was the interviewer's style of questioning that elicited false information. "In some instances, undoubtedly the child responds to

28 *I sacrificed my babies to Satan*, The Sunday Mirror, 25 March 1990, p1.
29 *Sex rituals and the Devil's death trap*, The Sunday Mirror, 25 March 1990, pp6-7.
30 *"Black Magic" link to bogus social workers*, Evening Post, 16 May, 1990, p3.
31 *Raid on Satan cult sex beasts*, The Daily Mirror, 27 June 1990, p5.

what the questioner wants to hear, particularly where the questioner has strong beliefs."[32]

On August 12 The *Independent on Sunday* published a piece by investigative journalist Rosie Waterhouse titled **The making of a Satanic myth**. She explored how the Satanic abuse myth had originated in the United States and spread, thanks to the influence of Lawrence Padzer's *Michelle Remembers* and that survivors of Satanism had become a growth industry. In Britain, information on Satanic abuse was being circulated by the Evangelical Alliance. Waterhouse detailed the influence of a list of "Satanic indicators" which had obtained from Pamela Klein. Waterhouse pointed out that the Nottingham JET report, which had been leaked to Central Television, found no evidence of ritualistic abuse, and that most of the evidence arose out of the therapeutic methods used by social workers.[33] Waterhouse concluded that there was no evidence of an international conspiracy of Satanists who sexually abused or sacrificed children as part of their beliefs. The article was republished on 15 September by *The Daily Mail*, under the headline **Death of a Satanic Myth**.

On 13 September, reports came that 13 children had been taken into care in Manchester, in another suspected case of ritual abuse. The first of the children had been taken into care late the previous year, and others removed from their parents earlier that year.[34]

On 16 September Rosie Waterhouse, writing in the *Independent on Sunday*, gave a detailed account of how the notion of Satanic abuse had affected the Rochdale, and other, cases. Under the title, **Satanic cults: how the hysteria swept Britain**, she explored how, two weeks before social workers in Rochdale had "diagnosed" that Satanic abuse was taking place, they had attended a conference on the subject in London, and been given literature that told them what signs to watch out for. She named those spreading the stories of Satanic abuse: Maureen Davies, Kevin Logan, ex-witches Doreen Irvine and Audrey Harper, and Dianne Core of Childwatch. Waterhouse pointed out that of three conferences on Satanic abuse for social workers, police, and other child care professionals which had run in 1989, one had been organised by the Association of Christian Psychiatrists, and the other two (at Reading and Dundee University) had been organised by Norma Howes and Pamela Klein. One of the speakers – a Chicago police officer (Robert J. Simandl) had told of how four babies were "cooked" in a microwave oven. A week later, one of the NSPCC child protection teams reported this to have happened in Derbyshire.

32 *Beyond belief for child's benefit*, The Guardian, 4 July, 1990, p23.

33 *The making of a Satanic myth*, The Independent on Sunday, 12 August 1990, p8.

34 *Children in care after allegations of ritual abuse*, The Independent, 13 September 1990, p1.

On 23 September, Waterhouse followed up with **Children's games that bred alarm over "Satanism"**, this time focusing on the Nottingham case. She began by explaining that the sexually abused children had been encouraged by social workers to play with "witches" costumes, rubber snakes, toy babies, monsters, animals and a syringe for extracting blood." This was a therapeutic technique from an NSPCC social worker, the toys representing good and bad symbols, to "encourage the children to act out roles, and illustrate how they had been abused." It was soon after this therapy commenced, that "the children began telling their foster mother strange stories of witches, snakes, monsters, babies and blood." The foster mother had kept a diary of the children's statements and passed them on to Nottingham social workers, who, alarmed, sought advice from sex abuse experts on "witchcraft". They were told about the Satanic child abuse that was happening in the USA, and given a list of "Satanic indicators".

There were, Waterhouse wrote, strong similarities between the Nottingham and Rochdale cases. The stories from the children about slaughtering sheep, drinking blood and killing babies "can all be related to various versions of Satanic indicators which have been circulated to all NSPCC and most council social workers, as well as to police and other child-care professionals." As with the Nottingham case, the identification of Satanic activity came "a few weeks after a police officer, at least one social worker, and the director of social services, Gordon Littlemore, attended a seminar on the subject." The inquiry into the Nottingham case (the as-yet unpublished JET report) had, Waterhouse stated, discovered that "children's talk of monsters and witches came only after the "disclosure" interviews of four children by an NSPCC social worker. Waterhouse said that the enquiry established that the "Satanic panic" in Nottingham was produced by a combination of factors: the NSPCC's story-acting technique; the the reliance on the "Satanic indicators"; the sharing of stories between children in care; unreliable testimony from adult witnesses; "and above all, the conference on the subject in Reading, in 1989."[35]

On 26 September it was announced that Merseyside police had decided not to charge 17 adults arrested in May for alleged Satanic Child Abuse in Liverpool and Knowsely. Detective Superintendent Albert Kirby, who was head of the Serious Crimes Squad, was understood to have said there was insufficient evidence. Eleven children had been taken into care, and later released, although five were still wards of court. The 17 adults were arrested after a joint operation by police and social services.[36]

35 *Children's games that bred alarm over "Satanism"*, Independent on Sunday, 23 September 1990, p6.
36 *Merseyside police drop Satanic abuse cases*, The Guardian, 18 September 1990, p3.

By the end of September, reports were circulating that the NSPCC had been "sacked" by eleven local authorities, including Manchester and Rochdale, who were taking back control of child protection registers.[37] The NSPCC said that these reports were "false and misleading", but stood by its report on widespread ritual abuse and organised sex rings that it had made last March, but that it had not used the term "satanic."[38] Similarly, Gordon Littlemore, Director of Social Services in Rochdale, speaking on BBC's *Newsnight*, said that "We are not, and have never, used the term Satanism, devil worship or anything of that kind." Rosie Waterhouse, in the *Independent on Sunday*, wrote that a senior social worker had made a court application, saying that the children were victims of "ritualistic or Satanic abuse" and that questionnaires sent by the NSPCC to its teams did say that "child abuse increasingly had a ritualistic or Satanic element".[39]

Dispatches: 'Listen to the Children'

On the 3rd of October, Channel 4's *Dispatches* aired *Listen to the Children*, hosted by Beatrix Campbell. The programme promised to reveal evidence of Satanic child abuse "for the first time on British television". It featured two women who were involved in the Nottingham case, giving testimony. One woman said that children were sacrificed, and that their bodies would be buried in existing graves in the graveyard. Then the viewers were taken to a cemetery near Sherwood Forest in Nottingham. The cameras lingered on candle stubs, drawings of crosses, and something that could have been a small altar. A search by torchlight of the cemetery lodge turned up a brochure on making home movies, pamphlets on child fostering, some smutty magazines and a large dildo. This was the "evidence".

Rosie Waterhouse, in *The Independent on Sunday*, wrote an extremely damning review of *Dispatches*, pointing out that the programme did not mention that one of the social workers on the team was victimised because she did not believe the claims of Satanic abuse; that according to the police, the two witnesses featured in the programme were "found to be lying in every way that could be checked"; that there was a third adult in the case that had recounted stories of Satanic abuse, but later admitted they were lying. "Nor did it question the fact that most of the disclosures of witch parties, the killing of babies, and the slaughtering of sheep were supposed to have taken place in the

37 *NSPCC faces sack over "Satanic" abuse role*, The Independent on Sunday, 23 September 1990, p1.

38 *NSPCC defends record on child abuse*, The Guardian, 26 September 1990, p2.

39 *NSPCC questions led to Satan cases*, The Independent on Sunday, 30 September, 1990, p8.

living room or garden of a semi-detached house on a council estate, without neighbours noticing."[40]

The chief of Police in Nottinghamshire, Dan Crompton, was quoted saying that he was deeply concerned that "an orthodoxy of belief" about Satanic abuse is becoming established among some child-care professionals and is sweeping Britain "like an epidemic of Asian flu". He said that he is sending a confidential report to the Home Secretary, to "kill off once and for all" stories that children from Nottingham have been victims of Satanic abuse. Crompton also stated that "in our thirst for disclosures" the continual questioning and medical examination of children, sometimes lasting for years, constitutes another form of abuse.

On 5th October, *The New Statesman and Society* published an article co-written by Judith Dawson and Christine Johnstone, two of the social workers involved in the Nottingham case, which was sharply critical of the police. Dawson also scorned the idea that Satanic child abuse was a myth propogated by evangelical Christians, stating that her team was secular, and did not believe in God, the power of the devil, nor in witchcraft. Rosie Waterhouse however, revealed that Dawson had appeared in a video entitled *Doorway to Danger* published in July by the Evangelical Alliance.[41]

Nottingham Chief Constable Dan Crompton responded with a press release, stating that the checkable facts had all turned out to be false. Compton stated "Surely, standards of evidence gathering, investigation and presentation have to be maintained if we are not to revert to the ducking-stool form of justice."

November 1990 saw Kevin Logan mentioning *Pagan News* in a letter which appeared in *The Independent on Sunday*, 4th November. He claimed that "Caring Christianity in no way wishes to launch a witch-hunt" and that Christians were not the "extremists" responsible for the fire at the Sorcerer's Apprentice. He wrote that all Christians wanted was "The freedom to voice our warnings against witchcraft" and "the freedom to respond to a Pagan campaign to persuade children that the occult is best for them". He went on to assert that "*Pagan News* (August 89) called for occult primers for the schoolchildren of our land. They called for occult authors not to forget "our duty to teach, train or at least interest the next generation."[42] This was a reference to a column by Julian Vayne in that

40 *Satanic inquisitors from the town hall*, The Independent on Sunday, 7 October 1990, p6.

41 *Satanic inquisitors from the town hall*, The Independent on Sunday, 7 October 1990, p6.

42 *Christians only ask for freedom to be concerned about the occult*, The Independent, 4 November 1990, p19.

issue which discussed the need for more magically-themed children's books such as the works of Alan Garner. Hardly a "campaign to persuade children that the occult is best for them"!

<center>∗∗∗</center>

On Saturday 3rd November, *The Guardian* ran a two-page feature titled **Talk of the Devil** by Valerie Sinason. There was a theme throughout the piece that suggested that Satanic abuse was a real phenomena, and that the public were in denial, and the press had attacked, for example, the NSPCC for delivering unpalatable truths. According to Sinason, according to the Dissociative Disorder Syndrome Association, 65% of clients with multiple personalities resulting from traumatic abuse were involved in Satanic abuse.[43]

<center>∗∗∗</center>

On 18 December, the outcome of the Manchester case was reported. After an 11-week wardship trial in Manchester's High Court, Mr. Justice Hollings ordered the immediate release of eight of 13 children who had been taken into care. He stated that NSPCC social workers had been "obsessed with the belief" that they had uncovered a Satanic cult but that it became obvious that there was "a great deal of fantasy" in the children's stories.[44]

<center>∗∗∗</center>

On 30th December, *The Independent on Sunday* ran a three-page feature by David Hebditch and Nick Anning on the life and death of Caroline Marchant. Titled **A ritual fabrication**, it was a detailed account of Caroline Marchant's life, and the result of investigations by police forces in Norfolk and Blackburn, both of whom had failed to find any evidence for the claims of her involvement with Satanic cults. Former friends and foster parents of Caroline all refuted her claims to have been pregnant and involved with Satanism. A Leeds pathologist who had examined Caroline's body, admitted that his initial findings had been influenced by Marshall Ronald (a Liverpool solicitor and supporter of The Reachout Trust) who had told him to look for evidence of "Satanic signs", anal abuse, and confirmation of pregnancies. The pathologist, Michael Green, had since withdrawn his original report. This was a second, private post-mortem, carried out after the coroner at the initial inquest, on 7th March 1990, had recorded an open verdict.

The reporters also discovered that Caroline had only begun to talk about her alleged involvement with a Satanic coven *after* she had read Doreen Irvine's

43 *Talk of the Devil*, The Guardian, 3 November 1990, pp12-13.
44 *Return of eight children in abuse enquiry ordered*, The Guardian, 18 December, 1990.

From Witchcraft to Christ in 1986 and that her diary repeated key passages from Irvine's book. In 1988, Caroline went to live with a Christian couple on a farm in Grittleton, Wiltshire. By December 1989, her relationship with the couple had deteriorated and they gave her a letter listing a variety of conditions which she would have to meet if she were to stay in the household. Some of these were fairly ordinary – requests to eat properly, cut down on her smoking, etc., but others were more religious in nature – requiring her to confess her sins and renounce Satan.

Soon afterwards, Caroline Marchant telephoned Maureen Davies and recounted her story. She stayed with, and was interviewed, by various members of The Reachout Trust, who claimed that she had been involved in arms-smuggling, and terrorist groups such as the IRA and Baader-Meinhof. Only hours after arriving at the Reverend Kevin Logan's vicarage on the 16th February, she swallowed over 70 200mg capsules of amitriptyline, a powerful antidepressant, and died at Blackburn and East Lancs Royal Infirmary without recovering consciousness on 5 March.[45]

1991 – Orkney and Epping

On 20 February, *The Guardian* published a piece entitled **Satanic abuse and the law: devil of a mess**. With the Rochdale case drawing to a close, Malcolm Dean reviewed the situation so far. He noted that although "fundamentalist Christian sects" have claimed that Satanism is widespread across Britain, so far they have not produced any evidence that teenage girls are being used as "broodmares" so their foetuses can be sacrificed and eaten. He also noted that of all the successful prosecutions of paedophile rings or familial child abuse, there had only been one case so far – Nottingham – where there was "evidence of ritual abuse."

Under the same headline, Beatrix Campbell shared some of the children's stories that had come out of the Nottingham case. She noted that "the children's continuing commitment to the ritual abuse allegations, omitted from the prosecution, produced a crisis. She closed by posing the question "But why, then, have different children in different foster homes, on different occasions, told similar stories about the same places, practices and people?"[46]

In late February came the Orkney case, and the papers reported how, on the 27 February, police and social workers had, in a dawn raid, removed nine children

45 *A ritual fabrication*, The Independent on Sunday, 30 December 1990, pp8-10.
46 *Satanic abuse and the law: devil of a mess*, The Guardian, 20 February 1991, p3.

(aged between 8 and 15) from their parents on South Ronaldsay after allegations of both sexual abuse and Satanic practices.

Again, the "dawn raid" tactic used by police and social services in Rochdale was employed, with careful planning. A private aircraft had been chartered to fly children directly back to the mainland and the teams arrived at the four homes of the unsuspecting families in groups of eight. At the same time, the police searched the house of the Reverend Maurice McKenzie for evidence of his alleged ritual abuse of children. None of the parents had been informed either by police or social services beforehand, nor had any consultation with or assessment of the parents taken place. The parents were only told that their children were being taken away on the basis of Place of Safety warrants. Police removed from the home of Rev. McKenzie a priest's robe and a broken crucifix. Searches of the houses of the children turned up a few books, a statuette, and a written quotation in Latin and French.

Once they reached the mainland, all of the nine children, with the exception of two sisters, were split up and placed in separate care homes. Letters sent to the children by relatives and friends were not delivered, neither were letters sent by the children to their parents. Nor were they allowed to view any written material pertaining to their case. It was only after four weeks had passed that the children were visited, in turn, by a child psychologist.

The approach taken to interviewing the children was called "disclosure therapy". The children were repeatedly asked how and when the alleged rituals and sexual abuses had taken place. If children denied that these events had taken place, the interviewers stated that they knew the rituals and abuses had occurred. The assumption was that any denial on the part of the children indicated a dependence on the authority of their parents and that full disclosure would only occur once familial ties had been broken.

On 3rd April 1991 the case came to court and was heard at Kirkwell Sheriff Court. Sheriff David Kelbie dismissed the case without hearing the evidence as being fatally flawed and indicated that the children should be returned to their homes. In his summation, he stated that "these proceedings are so fatally flawed as to be incompetent". An appeal was launched against the ruling and on 12 June 1991, the Court of Session upheld the appeal, and expressed criticism of Kelbie's handling of the case. The case was returned to the Sheriff Court, but the decision was taken that, given the various factors, including the intense publicity, the case was severely compromised.

On 6 March, *The Guardian* reported **Orkney children "involved in ritual sex"**:

Place of safety care orders on nine Orkney Islands children taken into care last week were extended for 21 days yesterday after the island's children's panel heard a series of allegations involving "ritualistic" sexual acts between adults and children during darkness. Parents attending the hearing were told that the orders were sought after children were exposed to acts of "lewd and libidinous" behaviour during and up to last November. This involved sexual intercourse or simulated sexual intercourse "between adults and children and between adults" and the use of ritualistic music, dance or dress.[47]

Two days later, *The Guardian* gave its verdict on the Rochdale case. It was "a terrible botch":

> The mistakes by Rochdale social workers in the latest Satanic abuse saga were grievous. Far from protecting children, they have traumatised 20 children in six families. For some, the scars may last a lifetime. By the end of the 47-day hearing, only four were left in care. ...Rochdale is not a case of ritual abuse, but of procedural abuse by social workers and the legal system.

The piece went on to say that none of the allegations of Satanic or ritualistic abuse had been upheld, and that the judge had concluded that it was "highly likely" that the children's stories had emerged because they were allowed to watch unsuitable films. It was a six-year old boy whose stories of "ghost children being killed" had triggered the entire operation.[48] The *Daily Mirror* was equally damning:

> There can NEVER be an excuse for social workers snatching a child on suspicion alone from innocent and loving parents. There can NEVER be an excuse for them not to seek the expert advice which is available.

The comment piece stated that the children were denied Christmas and birthday cards from their parents because social workers believed "that the cards might contain Satanic messages in code."[49]

On 10 March came an announcement from the police that "the extent of Satanic abuse of children has been grossly exaggerated". Sir John Woodcock, HM Inspector of Constabulary, interviewed on the BBC Radio 4 programme, Sunday,

47 *Orkney children "involved in ritual sex"*, The Guardian, 6 March 1991, p2.

48 *Rochdale: simply a terrible botch*, The Guardian, 8 March 1991, p20.

49 *No Excuse*, The Daily Mirror, 8 March 1991, p6.

said "there was no reason to believe that Satanic or ritual abuse of children was happening on any great scale."[50]

On 28 March, it was announced in the House of Commons that Professor of Anthropology Jean La Fontaine of the London School of Economics was to head a government enquiry into the extent of Satanic child abuse.

On 5 April, the *Daily Mirror* blasted the Orkney social workers:

> Every parent knows that children often dream up fanciful tales. Experience tells them how to distinguish between a fertile imagination and the facts. The social workers who stole the children of Orkney in a dawn raid which would have disgraced a police state apparently do not. It was their heads which were filled with horror stories of ritual abuse. It was they who believed without proper evidence the incredible tales spun about a whole community by three children who had suffered abuse.[51]

May 26 brought the news that another supposed case involving Satanic abuse had collapsed. Mary Hartnoll, Grampian Regional Council's director of social services, confirmed that charges laid against six adults who had been arrested in dawn raids in Aberdeen, in a case involving 14 children, had been dropped. Grampian police said that the case involved allegations of ritual abuse. The case had started when two children had been taken into care, for reasons other than sexual abuse. In June 1990, social workers had alerted the police that there were allegations of sexual abuse, and six adults arrested in October, and a further 12 children all taken into care under Place of Safety orders. All 12 children had now returned to their families.[52]

In November came the trial for the Epping Forest case at the Old Bailey. Two girls, aged ten and fourteen, accused their parents and other adults of systematic ritual sexual abuse dating back to 1982. The girls alleged that they had been taken to Epping Forest in Essex late in the night, and forced to drink the blood of a rabbit from a chalice whilst adults, their parents included, danced naked in the light of bonfires and candles, after which they were sexually abused. One of the girls said that babies were placed on a monument stone in the forest and killed by her godfather using a knife. Sometimes he made the sisters dismember the bodies. The allegations had emerged early in 1990, when the younger of

50 *Satanic abuse "exaggerated"*, The Guardian, 11 March 1991, p4.

51 *Just no excuse*, The Daily Mirror, 5 April 1991, p2.

52 *New Satanic abuse case collapses*, The Independent on Sunday, 26 May 1991, p1.

the two sisters complained of feeling sore after a visit to her father. Both girls were wards of court, and living with their grandparents, after their parents had split up. After a few months, the elder of the two girls began to talk about being sexually abused by her parents, godfather and a family friend. She thought this was normal family behaviour.[53]

In September 1990 the elder of the two girls had begun to talk about being taken at night to the stone monument. She said she had been given a drink of weak orange juice after which she had fallen asleep and woke up later in a car, either on the way to or back from the stones, feeling sore. The girls also alleged that similar rituals had taken place in their home, that babies were murdered, and their bodies buried in a forest grave, or put in a cupboard at the girl's home under the stairs, to be burned later.[54] The police had investigated the case, but found no evidence to corroborate the girl's stories.

On Saturday, November 16, *The Guardian* reported on how the case was proceeding under the headline **Girl tells of Satanism five nights a week**. The younger of the two sisters, giving evidence for the second day, told of how her mother had warned her that the "gypsies" would come and hang her if she told anyone what had been done to her. She also described how she was made to take bites out of the bodies of babies or young girls who were sacrificed.[55]

On 19 November, the case collapsed after the prosecutor told the judge that he could no longer rely on the evidence of a ten year-old girl. Mr Justice Turner, presiding, agreed, saying that the girl's evidence was "so uncertain, inconsistent, and improbable" that it would not be correct to proceed. The elder of the two girls had said that she could not be sure if she had "imagined" the baby killings. The judge directed the jury to return Not Guilty verdicts on the five adults accused. The children's godmother was later quoted: "It was a tremendous waste of public money. There are highly educated people in that court and they do not have the sense to tell when children are telling lies."[56]

1992 – Dispatches: "Beyond Belief"

After the events of 1991, when case after case of alleged Satanic child abuse collapsed amidst growing anger against the actions of social workers, when agencies such as the NSPCC were backing away from their previous testimony

53 *Sex case sisters "thought abuse was the norm"*, The Independent, 14 November, p3.

54 *Girls abused in "forest devil rituals"*, The Guardian, 14 November, 1991, p5.

55 *Girl tells of Satanism five nights a week*, The Guardian, 16 November 1991, p5.

56 *Satan case collapses after girl's evidence*, The Guardian, 20 November 1991, p3.

about Satanic abuse, and criticism was mounting, we might have been forgiven for thinking that the fuss was, at last, dying down. There was time, though, for one more attempt to prove the reality of Satanic abuse.

On Sunday 16 February *The Observer* announced **Video offers first evidence of ritual abuse**. A video showing a "bloody satanic ritual" was to be featured in a Channel 4 *Dispatches* documentary later in the week. The piece, written by Eileen Fairweather, one of the researchers who had worked on the *Dispatches* episode, went on to say that that both Scotland Yard's Obscene Publications Squad, and two medical experts had stated that the video was genuine.

The next day, *The Guardian* reported that a house in Brighton had been raided by Scotland Yard detectives "as further evidence emerged about the activities of an alleged ritual abuse ring in which a woman claims she was forced to sacrifice her prematurely induced baby."[57] It later emerged that the Brighton house belonged to musician Genesis P. Orridge, and that police had removed a "lorry load" of "evidence".[58] At the time of the raid, Genesis P. Orridge and family were in Nepal.

On 19 February 1992, Channel 4's *Dispatches* news programme aired "Beyond Belief" – an episode which claimed to provide definitive evidence of Satanic Child Abuse, in terms of both survivor accounts and video evidence. *Dispatches* was directed by Graham Addicott. Research for the programme was provided by journalists Paul Hatcher and Eileen Fairweather. Andrew Boyd (author of *Blasphemous Rumours*) was employed as a consultant and also presented the programme. The programme featured a range of professionals, including a psychiatrist, two clinical psychologists and a psychotherapist. The Police were represented by Superintendent Michael Hames of the Obscene Publications Unit and Detective Inspector Kath Adams of West Yorkshire Police. Two academics, both skeptical of the "reality" of Satanic Child Abuse were also featured – Professor Bill Thompson (Reading University) and John Newson (Nottingham University). Beginning with "Jennifer" a survivor of a satanic cult who told how she had been forced to kill her own baby at a satanic ceremony, "Beyond Belief" ran through the entire gamut of satanic panic tropes: Aleister Crowley; the ready availability of satanic literature; the dangers of occult groups such as the Temple of Set and the Temple of Psychick Youth. Boyd then turns to the video evidence, with "Jennifer's" interpretation that it showed an abortion being performed, taking place in the basement of a house in East London. This was followed by

57 *Police examine video in "Satanic abuse" enquiry,* The Guardian, 17 February 1992, p2.

58 *Scotland Yard seizes videos and books after TV film of "ritual Satanic abuse",* 23 February 1992, p11.

interview clips with skeptical academics, other female survivors, and a Harley Street doctor who claimed to be treating several survivors of ritual abuse. Immediately following the programme was an advertisement for a helpline for concerned viewers. It was commissioned by Channel 4 staffed by counsellors from the Ritual Abuse Information Network (RAIN).

It didn't take long for journalists to discover that the video footage shown, far from being evidence of ritual abuse, was in fact *First Transmission* – an experimental film which had been produced by members of the Temple of Psychick Youth, and featured musician John Balance (later of the band Coil), film-maker Derek Jarman, and tattooist and body piercer Mr. Sebastian. Moreover, the video had received partial sponsorship from Channel 4, as part of a season showcasing experimental film in the 1980s!

On 23 February, *The Independent on Sunday* reported that the video footage shown in "Beyond Belief" had been made nine years ago as a piece of performance art, and that the director Derek Jarman had been featured as a visual presenter. A spokesperson for TOPY also pointed out some curious errors; that "Jennifer" had claimed that the rituals she took part in were held in a basement, but that the house shown did not have a basement; of a scene that "Jennifer" said showed an abortion performed by another pregnant woman, that the woman was "just fat" and the scene not an abortion, and that tools described as obstetric grips were coal tongs.[59]

The Observer also reported that the video shown in "Beyond Belief" was "the work of Mr Orridge … and an associated organisation known as Thee Temple of Psychick Youth, TOPY." Some readers had contacted the *Observer* saying that they had seen parts of the video shown at Psychic TV concerts. The *Dispatches* team however, were still adamant that "talk of performance art is an inadequate explanation for the repellant nature of TOPY's activities. They say that the victims of the type of ritual depicted are young, vulnerable people who are induced to participate with drugs and "mind control" techniques." Observer journalist David Rose pointed out that "There is no doubt that Mr Orridge and his acolytes, both in the video and in internal literature *The Observer* has seen, employ occult ritual vocabulary and images."[60]

On the same day, *The Mail on Sunday* ran the story, **Ritual Abuse `Evidence" is promotional film for deviant cult**, reporting that the video shown on "Beyond Belief" was "a nine-year-old promotional film by an outrageous rock group". They also quoted Dr.. Wendy Savage as saying that the film did not show – as had been claimed – an abortion taking place: "I told the film makers this, but

59 *Satanic video shows "art, not abuse"*, The Independent on Sunday, 23 February 1992, p2.

60 *Scotland Yard seizes videos and books after TV film of "ritual Satanic abuse"*, 23 February 1992, p11.

they chose not to use it. I also told them that in my opinion someone had a very fertile imagination."[61]

On 26 February, Rosie Waterhouse, writing in the *Independent*, stated that the Metropolitan Police "may be forced to invoke the law to compel Channel 4 Television to reveal the identity of a woman who claimed on a *Dispatches* documentary that she was made to take part in the murder of children, including her own baby, during Satanic rituals."[62]

On the 1st March *The Mail on Sunday* announced that it had tracked down "Jennifer Evans", the ritual abuse survivor. She was named as Louise Errington, a one-time born-again Christian, and the mother of two children. In 1990, according to the newspaper, Errington had stayed at a Christian Healing Centre in Lancaster. She said that one day, the Centre's spiritual leader, had experienced a vision of Errington "standing over a tiny baby, helping a devil priest to wield a knife. We cut into the baby's chest and the blood was collected and we drank it. The baby's body was a sacrifice to Satan." Up until the spiritual leader's vision, Louise Errington was not aware that she had had this child.

Beyond *Dispatches*

Following the *Dispatches* debacle, its promise of first-time evidence for the most part debunked, and the survivor's account discredited, media interest in Satanic child abuse dropped off dramatically.

In May, various Scottish papers gave space to a report by a Church study group that had found no evidence for ritual abuse taking place in Scotland. "Despite persistent reports of the existence of ritual abuse, it must be acknowledged that there is a lack of hard evidence that it is occurring in Scotland."[63]

On the 30 September, the NSPCC issued a report, *Child Abuse Trends in England and Wales, 1988-90*. According to *The Guardian*, "Debt has become a key factor in family stress associated with child abuse." The review concluded that "Child abuse is inextricably linked to deprivation and family instability."[64] There was, needless to say, no mention of ritual or Satanic abuse.

In October, there was a spate of news stories about the outcome of Lord Clyde's report into the Orkney case. On 28 October *The Guardian* announced that the

61 *Ritual Abuse 'Evidence' is Promotional Film for Deviant Cult* The Mail on Sunday, 23 February 1992.

62 *Legal threat to Channel 4 over "satanic" woman,* The Independent, 26 February 1992.

63 *No evidence of ritual abuse – Churchenquiry,* The Courier and Advertiser, 13 May 1992, p13.

64 *Debt stress blamed for child abuse,* The Guardian, 30 September 1992, p5.

parents of the children taken into care were preparing to sue for damages in Scotland's highest court.[65] The next day, it was announced that the Royal Scottish Society for the Prevention of Cruelty to Children (which had come under severe criticism in the Clyde report) was changing its focus to "prevention and support work."[66]

The official enquiry into the Orkney case began in August 1991, chaired by Lord Clyde and a report was published in October 1992. It was not within the remit of the inquiry to investigate or comment on the allegations of abuse (which were never put to proof) but only to investigate the circumstances which surrounded the removal of the children and their subsequent return. The Clyde report was heavily critical of the procedures carried out by the Orkney and RSSPCC social workers and the police. Some of Lord Clyde's criticisms of the interviews carried out with the nine children related to the interviewers" difficulties when some children denied that any abuse had taken place. Also, that "stress on the interviewers" belief that allegations were true might very easily have led children to consider that there was little point in saying anything at variance with what the interviewers had said, as they might feel that they would not be believed." Clyde was also critical of the use of leading questions, which is "recognised as evidentially hazardous."[67] The report made over 190 recommendations for improvement in child care practices.

By the end of 1992, it seemed that the Satanic panic had come to a close. The bombardment of hysterical reporting which we had been treated to between 1988-1991 had, for the most part, dried up. Child protection agencies had backed away from terms such as "Satanic" or "ritual" abuse.

In June 1994, Professor Jean La Fontaine's UK government-commissioned report *The Extent and Nature of Organised and Ritual Abuse* (HMSO) was published. Of a total of 84 cases alleged to have elements of Satanic or ritual abuse, none were considered to be "Satanic" in character and only three were found to have ritual elements, where abusers had claimed to have magical powers and used these claims to entrap children and discourage them from speaking out. "In such cases", stated Professor La Fontaine, "the aim is sexual and the ritual is incidental to it". She defined "Satanic Abuse" in the following way: "Rites that allegedly include the torture and sexual abuse of children or adults, forced abortion and human sacrifice, cannibalism and bestiality may be labelled Satanic or Satanist. Their defining characteristic is that the sexual and physical abuse of children is part of rites to a magical or religious objective."

65 *Orkney families to sue for damages*, The Guardian, 28 October 1992, p3.

66 *Child care agency to drop abuse enquiry work after Orkney report*, The Guardian, 29 October 1992, p7.

67 Report of the Inquiry into the Removal of Children from Orkney in February 1991: return to an Address of the Honourable the House of Commons dated 27 October 1992 [James J. Clyde] Edinburgh: (Her Majesty's Stationery Office 0 10 219593 5), p260.

In her study of transcripts of interviews taken in 38 cases, Professor La Fontaine said that child witnesses often said what they thought adults wanted to hear. Sometimes they were pressured to conform to expectations: the transcripts showed evidence of leading questions, refusal to accept a child's denials, repeating questions, and supplying other children's statements. In some cases the interviewers had invented information in order to pressure a child to speak up.

The Health Minister, Virginia Bottomley said that the report "exposed the myth of Satanic Child Abuse". Of course that was by no means the end of the "Satanic Panic".

Bibliography

Aquino, Michael. 'Extreme Prejudice: The Presidio Satanic A Bill'. *Raising the Devil: Satanism, New Religions, and the Media*. University Press of Kentucky, 2021.

Fabian, Robert. *London After Dark*. London. Naldrett Press, 1954.

Furedi, Frank. *Moral Crusades in an Age of Mistrust: The Jimmy Saville Scandal*. Palgrave Macmillan, 2013.

Harper, A and Pugh, H. *Dance with the Devil*. Eastbourne, Kingsway Publications 1990.

Hoyle, Carolyn, Speechley, Naomi-Ellen, Burnett, Ros. *The Impact of Being Wrongly Accused of Abuse in Occupations of Trust: Victims' Voices*. University of Oxford Centre for Criminology. 2016.

Hughes, Sarah. 'American Monsters: Tabloid Media and the Satanic Panic, 1970-2000', in *Journal of American Studies 51* (2017), 3, pp691-719.

Introvigne, Massimo. *Satanism: A Social History*. Leiden/Boston. Brill. 2016.

Irvine, Doreen. *From Witchcraft to Christ*. London. Concordia Publishing. 1973.

Jenkins, Philip. *Intimate Enemies, Moral Panics in Contemporary Great Britain*. Aldine Transaction. 1992.

Kelly, Liz., Scott, Sara. 'The Current Literature About Organized Abuse of Children'. *Child Abuse Review* Vol. 2: 281-287 (1993).

Kirby, Danielle. 'Transgressive Representations: Satanic Ritual Abuse, Thee Temple ov Psychick Youth, and First Transmission'. *Literature & Aesthetics* 21 (2) December 2011 134-149.

La Fontaine, J.S. 'Defining Organized Sexual Abuse'. *Child Abuse Review*. Vol. 2. 223-231 (1993).

La Fontaine, J.S. 'Diabolic Debates: Replies to Stephen Kent'. *Religion*. 1995. 25, 91-92.

La Fontaine, J.S. 'Believe or Disbelieve? With Particular Reference to Satanist Abuse'. *Child Abuse Review* Vol. 6: 80-81 (1997).

La Fontaine, J.S. *Speak of the Devil: Tales of Satanic Abuse in Contemporary England*. Cambridge: Cambridge University Press. 1998.

Lanning, Kenneth. *Investigator's Guide to Allegations of 'Ritual' Child Abuse*. Behavioral Science Unit, National Center for the Analysis of Violent Crime, Federal Bureau of Investigation, FBI Academy, Quantico, Virginia, 1992.

Laycock, Joseph P. *Dangerous Games: What the Moral Panic over Role-Playing Games Says about Play, Religion, and Imagined Worlds*. University of California Press, 2015.

Luhrmann, Tanya. *Persuasions of the Witch's Craft*, Harvard University Press, 1991.

Monod, Sarah Wright. *Making Sense of Moral Panic: A Framework for Research*. Palgrave Macmillan, 2017.

Morrison, James. *Familiar Strangers, Juvenile Panic and the British Press: The Decline of Social Trust*. Palgrave Macmillan, 2016.

Nathan, Debbie and Snedeker, Michael. *Satan's Silence: Ritual Abuse and the Making of a Modern American Witch Hunt*. San Jose. Author's Choice Press. 1995.

Nava, Mica. 'Cleveland and the Press: Outrage and Anxiety in the Reporting of Child Sexual

Abuse'. *Feminist Review*, No. 28, Family Secrets: Child Sexual Abuse (Spring, 1988), pp103-121.

Nelson, Sarah. Time to break professional silences. *Child Abuse Review*, 1998, Vol. 7 Issue 3.

Office of Criminal Justice Planning Research Update. Special Edition. Winter 1989-1990. Vol. 1, No. 6. *Occult Crime: A Law Enforcement Primer*. State of California.

Ofshe, Richard and Watters, Ethan. *Making Monsters: False Memories, Psychotherapy, and Sexual Hysteria*. Berkeley. University of California Press. 1996.

Pilcher, J and Wagg, S. (eds). *Thatcher's Children?: Politics, Childhood and Society in the 1980s and 1990s*. London/Washington. Falmer Press. 2005.

Prendergrast, Mark. *The Repressed Memory Epidemic: How it Happened and What We Need to Learn from it*. Springer International Publishing 2017.

Rabinowitz, Dorothy. 'From the Mouths of Babes to a Jail Cell: Child abuse and the abuse of justice: A case study'. *Harper's Magazine* May 1990.

Scott, Sarah. 'Beyond Belief: Beyond Help? Report on a Helpline Advertised after the Transmission of a Channel 4 Film on Ritual Abuse'. *Child Abuse Review* Vol.2: 243-250 (1993).

Sealander, Judith. *The Failed Century of the Child: Governing America's Young in the Twentieth Century*. Cambridge University Press, 2009.

Self, Robert. *All in the Family: The Realignment of American Democracy Since the 1960s*. New York. Hill and Wang. 2012.

Sinason, Valerie (ed). *Treating Survivors of Satanist Abuse*. Routledge, 1994.

Strain, Christopher. *Reload: Rethinking Violence in American Life*. Vanderbilt University Press. 2010.

Thompson, Bill and Williams, Andy. *The Myth of Moral Panics: Sex, Snuff and Satan*. New York and London. Routledge, 2014.

Waterhouse, Rosalind Theresa. *Satanic abuse, false memories, weird beliefs and moral panics: Anatomy of a 24-year investigation*. PhD Thesis, City London University, January 2014.

Waters, Thomas. Cursed Britain: *A History of Witchcraft and Black Magic in Modern Times*, Yale University Press, 2019.

Williams, Daniel K. 'Reagan's Religious Right: the Unlikely Alliance between Southern Evangelicals and a California Conservative'. In Hudson, Cheryl and Davies, Gareth (eds) *Ronald Reagan and the 1980s: Perceptions, Policies, Legacies*. New York. Palgrave Macmillan. 2008.

Woodiwis, Jo. *Contesting Stories of Childhood Sexual Abuse*. Palgrave Macmillan, 2009.

Wright, Lawrence. *Remembering Satan: A tragic case of recovered memory*. New York. Vintage Books. 1995.

Valiente, Doreen. *The Rebirth of Witchcraft*. Ramsbury: The Crowood Press, 2017.

Young, Francis. *A History of Exorcism in Catholic Christianity*. Palgrave Macmillan, 2016.

de Young, Mary. 'One Face of the Devil: The Satanic Ritual Abuse Moral Crusade and the Law'. *Behavioral Sciences and the Law*, Vol. 12, 389-407. (1994).

de Young, Mary. 'Speak of the Devil: Rhetoric in Claims-Making About the Satanic Ritual Abuse Problem'. *The Journal of Sociology & Social Welfare*. Volume 23, Issue 2. June 1996.

de Young, Mary. 'Satanic Ritual Abuse in Day Care: An Analysis of 12 American Cases'. *Child Abuse Review* Vol. 6: 84-93 (1997).

de Young, Mary. 'The Devil Goes Abroad: The Export of the Ritual Abuse Moral Panic'. In Mair, George and Tarling, Roger. *British Criminology Conference: Selected Proceedings. Volume 3. Papers from the British Society of Criminology Conference, Liverpool, July 1999*. British Society of Criminology, 2000.

de Young, Mary. *The Day Care Ritual Abuse Moral Panic*. Jefferson, North Carolina. McFarland & Company, Inc. 2004.

ACKNOWLEDGEMENTS

Phil and Rodney would like to thank all of our contributors, co-editors, columnists, artists, and small businesses who supported us over the years and particularly the unsung heroes who ran around London and other cities helping distribute *Pagan News* in its various incarnations.

Special thanks for their assistance with making this volume happen go to Krent Able, Richard Bancroft, David Clarke, Janet Cliff, Fred Fowler, Barry Hairbrush, Phil Legard, Alan Moore, David Southwell, Stephen Thrower, the late Rich Westwood, Caroline Wise, Mark Pilkington and Jamie Sutcliffe at Strange Attractor Press.

Contributors no longer with us:

Linda Falorio (1 July 1949-31 Jan 2022) was an internationally recognised artist, author and creator of *The Shadow Tarot*.

Mike Howard (1948-2015) was the editor and publisher of *The Cauldron*, a magazine devoted to witchcraft that ran for 39 years. He was also the author of 30 books related to witchcraft and magic.

Steve Moore (11 June 1949-16 March 2014) was an acclaimed comics author and writer, contributing *2000AD*, *Starburst* and *Dr.. Who Weekly* among others. He also wrote for *Fortean Times*, and was a scholar of the I ching, writing *The Trigrams of Han* (Harper Collins 1989). His first novel, *Somnium: A Fantastic Romance* was published by Strange Attractor/Somnium Press in 2011. For further details of Steve's extraordinary life, see https://www.comicsbeat.com/steve-moore-1949-2014-a-personal-appreciation/

Editors' Note:

While compiling this book we attempted to contact all of our former contributors, seeking permission to reprint their work. However, in some instances were either unable to track people down, or never received a response from them. If you didn't hear from us, we hope that you're happy to see your work included here, and would love to hear from you again. Thanks, Phil and Rodney.

Index

Index